GOOD EATS [4]

THE FINAL YEARS

GOOD EATS⁴

THE FINAL YEARS

ALTON BROWN

ABRAMS, NEW YORK

⁴ So it's not really to the fourth power; it's just the fourth *Good Eats* book.

This book is dedicated to the *Good Eats* crew,
whose collective talents and artistry made it all go.
What a long, strange, wonderful trip it's been.

Editor: Michael Sand
Designer: Headcase Design
Design Manager: Danielle Youngsmith
Managing Editor: Lisa Silverman
Production Manager: Anet Sirna-Bruder

Library of Congress Control Number: 2021946811

ISBN: 978-1-4197-5352-7
eISBN: 978-1-64700-250-3
Barnes & Noble Exclusive Edition ISBN: 978-1-4197-6398-4
Signed Edition ISBN: 978-1-4197-6429-5

Published in 2022 by Abrams, an imprint of ABRAMS.
All rights reserved.

Printed and bound in the United States
10 9 8 7 6 5 4 3 2 1

Abrams books are available at special discounts when purchased in
quantity for premiums and promotions as well as fundraising or
educational use. Special editions can also be created to specification.
For details, contact specialsales@abramsbooks.com or the address
below.

Abrams® is a registered trademark of Harry N. Abrams, Inc.

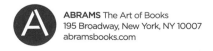

ABRAMS The Art of Books
195 Broadway, New York, NY 10007
abramsbooks.com

CONTENTS

Forget the guy pointing— the important one is over his shoulder: key grip Marshall Millard, who's been with me since episode #1.

INTRODUCTION
(and a bit of instruction)

The first *Reload* set was bare-bones.

WHEN WE STOPPED PRODUCTION (the first time) on *Good Eats* in 2011, I knew it wasn't gone for good. The sock puppets went into cold storage along with those silly bongos and the terrible shirts. Bessy, the fiberglass cow (at one time the most expensive prop we'd ever bought), went on the road with me as I launched a couple of live culinary-variety tours. Television-wise, I moved on to make two hundred episodes of a show called *Cutthroat Kitchen*, and I wrote a cookbook called *EveryDayCook*.

Then, in 2017, something made me watch some old *GE* episodes (don't remember why), and I was struck by how old they felt. Things had changed so much since then. I had changed. The food world had changed. And, truth is, I'd just gotten a lot of things . . .

. . . wrong.

Repairs and renovations were clearly in order. And honestly, I wanted an opportunity to make fun of myself, because with age often comes the realization that your younger self was an irritating gasbag, albeit with a full and sensuous head of hair.

I called up the president of Food Network and said, "I'd call it *Good Eats: Reloaded* and it'll be a lot cheaper than making new ones."

A week later we had an order for twelve episodes.

Deciding which shows to reload was easy. Just go onto the Food Network Forum and pick the recipes with the fewest stars and the most complaints. The only problem was that we'd need several more seasons to cover them all.

Production on the first *Reloaded*s was difficult, because the original set had not survived, so we ended up re-creating the main counter, oven, and fridge; everything else was shot in front of a massive green screen so that we could composite me into the old footage whenever possible. With that season as an appetizer, it was easy to start thinking of brand-new shows, and so season 1 of *Good Eats: The Return* followed.

INTRODUCTION (AND A BIT OF INSTRUCTION) *(continued)*

We needed an updated set, and I'm fortunate that my wife, Elizabeth, is a designer who grokked not only what it had been, but what it could be. Launching into *The Return* was both comfortable and challenging. Filmically, technology had evolved to the point that we could produce things not possible a mere decade ago, so the director in me had to ante up. Culinarily, everything had changed, from the ingredients made attainable by the web to the fixation on edible imagery made ubiquitous by Instagram. We started from scratch and had a blast.

Then came the second season of *Reloaded*, and after that another *Return*, which was really tough, because production took place in the summer of 2020. Covid was in full rage, and taking the required precautions to keep people safe made shooting a nightmare. When we finally wrapped, I looked at the show list for *Reloaded* 3 and thought . . . I can't. Understand, I own the production company, and, honestly, I just didn't feel I could take any more risks, either with people's health or with my savings account (you can't insure against Covid). So we finished developing the *applications* for the third season (that's what I call recipes, in case you're just tuning in) but didn't actually produce the shows. I'm not saying they'll never be made, but as I stand here typing on June 27, 2021 . . . well, never say never.

So what you have here is five seasons' worth of shows: three *Reloaded*s and two *Return*s. They're in chronological order, because I couldn't think of a better way to arrange them. I've included the applications as well as the "knowledge concentrates" that form the basis of each script. As for

the final *Reloaded*s, since there aren't any scripts to pull clever bits and pieces from (one day, maybe), starting on page 363, I include only the reasons for choosing the dish and maybe a thought or two on how we fixed it. As it happens, this section includes some of my favorite *Good Eats* applications ever, and I'm glad to get them in your hands.

If you have any of the other three *Good Eats* books, you'll notice there are a lot more photographs in this one. Back in the day, we didn't have set photos taken or thumbnails for recipes because we were still using AltaVista for internet searches via dial-up and no one ever thought we'd need food shots. Now we take photos of everything, including behind-the-scenes stuff, and some of the better bits are included herein. Also, I finally took the time for some of my own food photography, something I've dreamed of doing for years. A lot of the full-page pictures here are mine, and I hope you like them.

Regarding footnotes:[1]

A few notes about the applications:

You'll notice that each dish has a "tactical hardware" list. I'm operating here on the assumption that if you've purchased this book, you probably possess a basic *batterie de cuisine*, as well as the skills necessary to employ the devices therein. So the "tactical" lists are not roll calls of every knife,

1 All my favorite books are heavily annotated, and footnotes are, for me, the best way to do that. I will never put mission-critical information in a footnote, which means you can ignore them if you like. But rest assured, I live in the footnotes.

All those books back there were rented . . . Law books—yuck!

pot or pan, spoon or spatula that you'll need to replicate the dish, but rather the specialty items that may not reside in the average American kitchen and are hard to replace—e.g., blenders, stand mixers, cheesecloth, parchment, etc.

As to measurements: Books like this tend to adhere rigorously to an accepted system of weights and measures. I have no such code and will, in each instance, tell you the method by which I feel something should be doled. If something is listed by weight, then I think you need to weigh it, and in most cases that will be by grams. In most cases, I'll give you an alternate method, unless it's something like a half teaspoon of dry oregano, which weighs, like, 0.25 grams.[2] Above all, I intend the measurements to be practical, and that means I may mix weights and volumes, metric and avoirdupois, in the same application. Some of you will be driven crazy by this; others will fall easily into the groove. In any case, you really must own two things in order to successfully put any of the following food on the table:

- A decent digital scale with a tare function (meaning it can be "zeroed out") that can switch between standard and metric weights. As of this writing, I believe the best *for the money* to be the Escali Primo digital scale. For $25 it's hard to beat. That said, if you want an upgrade, go with the Acaia Lunar scale, which is made for baristas and costs ten times more than the Escali. Worth it?

- A quality instant-read thermometer like the Thermapens made by ThermoWorks. Temperature control is critical to full culinary functionality, and nobody makes better thermometers than ThermoWorks.

So, stride forth, home cook. This is the best I've got. Remember, no matter what, that cooking should be fun, and if it isn't, don't do it . . . unless you're quite hungry. Also remember that nothing will ever taste better than food made for you by someone who loves you. Also remember that, despite recent trends, cooking is not a competition.

It's an adventure.

2 I will never ask you to weigh an amount that would be reserved for Kid Charlemagne (meaning an anal-retentive drug dealer).

GOOD
EATS
RELOADED

season one

STEAK YOUR CLAIM: RELOADED

When we shot our pilot episode back in the summer of 1997, steak cookery was in something of a dark age, where myth and legend ruled over science and reason. Folks who dared to cook their own typically tossed them on flaming grills, poked them mercilessly with giant forks, then delivered shoe leather to the table, all the while insisting that searing "sealed in the juices." Resting was almost unheard of. As for bi-level cooking . . . sorcery.

In an effort to get everyone as close to a quality steakhouse steak as possible, we focused on five factors: choosing a flavorful yet forgiving piece of meat (rib-eye), pan selection (cast iron), seasoning (kosher salt), thermometer use (digital instant-read), and methodology (pan-roasting). Pan-roasting involves searing the meat in a very hot pan then moving the pan to a (relatively) hot oven to finish. It's a superior move if for no other reason than that it removes an unknown factor from the equation: None of us can really know how hot our pan is, but a 500-degree oven is a 500-degree oven . . . no mystery there. Folks who tried the procedure seemed more than happy with the outcome, and frankly, so was I—for a while. Today I stand behind everything in that first show, except for the method. There is a better way.

So, this was the first of many USDA "agent" scenes. A lot of people thought they were inspired by the "agents" in "The Matrix," but this shoot predated that by two years. We were actually riffing on "Men in Black." The female agents changed through the years, but the male agent was always my key grip, Marshall Mallard.

THE REVERSE SEAR

While testing procedures for our "Celebrity Roast" episode in 2001, I got frustrated that no matter what I tried, only about half of the roast's interior (a beef standing rib roast) was cooked to medium-rare, leaving at least a third at medium and the rest medium-well. What we figured out was that if we started the roast in a relatively low oven, then finished it at high heat to sear, we got an evenly cooked interior that was more like 80 percent medium-rare. Since it's critical that the meat be pulled from the first stage while the temperature is still about 10 degrees below the final temp, the "reverse sear" method requires the use of a remote probe-style thermometer. Luckily, such devices were becoming more common at the time and are ubiquitous today.[1] If you think of a thick steak as essentially a miniature, personal roast, it makes sense to apply the reverse sear, especially when you consider the fact that it produces a lot less smoke.[2] The only way to get a steak closer to perfection is to employ an immersion circulator, but that's another show.

THERMOMETERS

Thermometers have changed more in the past twenty years than any other cooking technology. And no piece of hardware, not even a scale, can up your cooking game more. As far as I'm concerned, every carnivore should aspire to owning two thermometers. First, you need a proper digital instant-read thermometer. Look for features like a narrow probe, orientable readout, and a backlight. This is your workhorse for temping everything from meats to baked goods. Also, a remote probe thermometer, which allows you to keep a probe in the meat while it's in the oven. I vote for simplicity here. Skip the fancy Bluetooth Wi-Fi models and go for a simple temperature alarm and . . . well, a magnet on the back is nice too. Oh, and here's a tip: Serious manufacturers always include a certificate showing when the unit was calibrated and by whom.

1 Modern remote probe thermometers even come in Bluetooth versions that will send data directly to your phone. Ah, technology.

2 The number-one complaint cooks had regarding the original recipe was the prodigious smoke produced. Any time I cooked a steak indoors, I covered my smoke alarm with foil, which I'm pretty sure isn't recommended by any fire-fighting organizations.

CURING CAST IRON

To those of you who took me to task for not explaining how to cure cast iron on the original episode, I've got one word for you: polymerization. This refers to the ability of some fats and oils to create solid tangles of molecules that, if properly arranged, form a darned near impenetrable shield. Polyunsaturated fats, especially those high in alpha-linolenic acid such as canola, walnut, and flaxseed oil, form especially rigid polymers.

A lot has been written regarding the use of flaxseed oil as a curing agent, but it's quite expensive, and so prone to rancidity that you have to keep it away from all light, in the refrigerator, and basically never look it in the eye lest it go insane. I prefer canola oil, because I usually have it around, it's cheap, and it keeps a long time even if it isn't resting on a satin pillow. Besides, as is so often the case in cooking, technique matters most.

1) Pop your clean cast iron in a cold oven and set it to 200°F or whatever your lowest setting is.

2) When the pan is warm, rub it all over with about 1 teaspoon of the oil. In my experience, warm iron, like laughing brains, is more absorbent. Total coverage is key, not just the bits that touch the food. Once the pan is thoroughly covered, grab a paper towel and rub off as much as possible. Getting rid of the excess oil is critical.

3) Now, place the pan *upside-down* on the middle rack of the oven and crank the hot box to its highest heat for 1 hour. If you have the time, carefully remove the pan, let it cool for a few minutes, then oil it again and cook it again. I generally find that curing a new pan requires three rounds.

4) Kill the heat and leave the pan inside the oven until it's completely cool. If you can possibly spare the time, repeat this cycle twice more. Yes, that means it'll take about 8 hours to cure a pan, and yes, it's worth it.

CLEANING CAST IRON

As for washing cast iron, there seems to be an online cult that holds that washing an iron piece in soap and water is akin to saying "Candyman" three times into a mirror. Hogwash. Here's what I do every time I use a cast-iron pan.

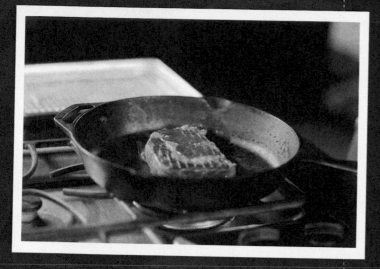

1) While it's hot I wipe it out. I add about half a teaspoon of oil and a couple teaspoons of kosher salt. I grab a paper towel and scrub around until the salt is dark gray. I (carefully) dump out the salt and inspect the surface of the pan. If it's clean and slick, I rub on a little oil with the same paper towel and set the pan aside to cool prior to storage.

2) If, upon inspection, if I see any patches of schmutz stuck to the pan, I return it to high heat. When it's smoking, I add about a third to a half cup of water, depending on the size of the pan. As it rapidly boils, I scrape the pan with the flat edge of a wooden spatula. Nine times out of ten, the schmutz boils off. If, however, it doesn't . . .

3) I let the pan cool enough to comfortably handle, then I wash it in soap and water with a non-metallic scrubby (what's known universally as a "green scrubby" in the restaurant trade). When the schmutz is gone, I dry the pan thoroughly, rub it with a bit of oil, and store it.

The point is, I don't always wash my iron pans with soap and water, but if they need it I don't hesitate, and neither should you. What is awfully important, though, is that the piece be lightly (very lightly) coated with oil, inside and out, before storage. And . . . if I were you, I'd resist the urge to stack something else inside the pan, like a smaller pan. That surface really should breathe.

More steaks exist today than when this show was made. For example, the "flat iron" was invented in 2002.

MEAT GRADES

All beef processed for commercial distribution in the United States is overseen by U.S. Department of Agriculture inspectors, who ensure that slaughter takes place under wholesome and sanitary conditions and that carcasses are free from any apparent disease or injury. This inspection is mandatory. Grading, however, is a voluntary process paid for by the packer or processor. Grades, such as select, choice, and prime, are a function of color, weight, fat-to-body ratio, age, and other physical considerations. Non-graded or no-roll meat is not necessarily an inferior product. The processor or packer has simply opted to save money by forgoing the process.

REVERSE-SEAR RIB-EYE STEAK: RELOADED

YIELD:
1 steak[3]

Although this application is written for a rib-eye steak, you can modify it for any steak from the short loin or loin, as long as it is at least an inch and a half thick. Just keep in mind that cook times will vary depending on the size and shape of your particular steak. Trust the thermometer you must.

SOFTWARE

1 (1½-inch-thick) boneless rib-eye steak (about 14 ounces or 400 g)

2 teaspoons kosher salt

1½ teaspoons peanut oil or other neutral oil with a high smoke point such as avocado or safflower

TACTICAL HARDWARE

- A small sheet pan with a wire rack that fits inside[4]

- A cast-iron skillet in the 10- to 12-inch range[5]

- A digital probe-style thermometer with a base unit that remains outside the oven and attaches to a sharp probe via a metal cable. The base should feature an alarm that can be set to go off at a preset temperature.

- A stopwatch (optional)

PROCEDURE

1) Season the steak on both sides with the salt and place on a wire rack set inside a rimmed sheet pan. Refrigerate for 6 to 12 hours (see "Pre-Salting" below). You'll want to start this process early in the morning for steak dinner at night.

2) When ready to cook, insert the probe thermometer horizontally through the side of the steak and push in far enough to get the tip of the probe close to center mass. Place the steak in the center of the oven, still on the rack and sheet pan. Turn the oven to 200°F (or its lowest "bake" setting) and set the thermometer's alarm to 120°F.

PRE-SALTING

Once upon a time, salting ahead of time was considered blasphemy because people (mostly chefs with accents) insisted that salt will pull juices out of the meat. This is true . . . but it's a good thing! Think of a steak as a sponge full of liquid. Now, the structural part that is the sponge is protein, but it really doesn't taste like much. The liquid, however, is full of minerals, ribonucleotides, free amino acids, some carbohydrates, and what's called "globular" proteins, which, when the critter is alive, go about all kinds of critter business. All this dissolved stuff is highly reactive and flavorful, and if we can encourage some of it up to the surface, we can brown it. That means . . . the Maillard reaction, named after French chemist Louis Camille Maillard.

Those are the lovely brown flavors produced when certain amino acids are exposed to high heat. In steak jargon: sear. That's reason enough to pre-salt your steaks, but there's more. Salt pulls moisture to the surface of the steak through osmosis, but once that liquid dissolves the salt, much of the salty solution migrates back in via capillary action, meaning the inside of the steak itself will be seasoned. But it does take time. Heck, I let one sit in the fridge for 72 hours once and it was magical. So . . . 8 to 10 hours is ideal.

3 My wife and I usually split a steak, but if you want to cook multiples just make sure they're basically the same weight and use the thermometer for just one. It's safe to assume the second steak will cook at the same rate. Technically, you could cook up to four at a time, but the more you cook the less reliable the temps will be unless the steaks are all literally the same weight.

4 I use a quarter sheet pan and a matched cooling rack from a local restaurant supply store. Absolutely required equipment and I keep mentioning that because it bears repeating.

5 Cast iron is dense stuff and it takes its sweet time getting hot, but once hot, it stays that way for a long while. That means when the steak hits the pan, the heat won't drop quickly the way it would in a lighter pan made out of aluminum or even stainless steel.

REVERSE-SEAR RIBEYE STEAK: RELOADED (*continued*)

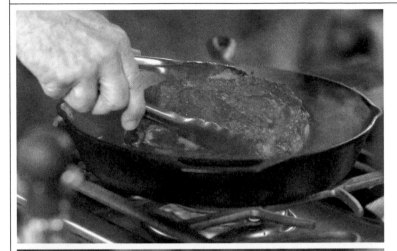

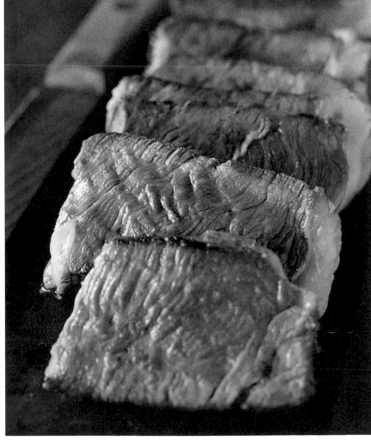

RESTING

A steak or any piece of meat is kind of like a kettle. When you're cooking it, you've got heat pushing on the tissues, squeezing the juice in the steak. If you were to poke into it or cut it at this point, the heat would just squeeze the juices out onto the plate and you'd be left with, well, a nasty, dried-out piece of meat sitting in a pool of juice, which isn't so nice. Resting the meat is like turning the heat off from under this kettle, although not as fast. You take it away from the heat and give the pressure of heat time to recede, and the juices redistribute through the meat. What could have been a piece of leather is now a juicy steak.

Since we've violated the cellular structure of the steak with several hundred degrees of heat, there will be some juice loss. You don't want the steak to sit in a growing puddle, because those juices can dissolve the brown crust we've worked to get. Rest it right on the rack it was cooked on. If it's chilly in the kitchen, lightly tent the steak with foil.

4) Brush a very light coating of peanut oil onto both sides of the steak. Transfer to the hot skillet and sear on each side until deeply browned, 45 seconds per side. Use a stopwatch![7]

5) Transfer the finished steak back to the rack/pan and let it rest for 5 minutes, then slice diagonally across the grain to serve. And no, you don't need no stinkin' sauce. But, if you have any herb butter around, I'll allow it. (See the Schnitzel Kiev butter on page 240.)

TIP

I once believed in allowing meat to come to room temp before cooking, but I've tested and tested and, honestly, if your oven can run at 200°F to 225°F, I just don't think it matters. If your oven only goes down to 250°F, let your steak warm to room temp for half an hour first.

3) When the steak hits 120°F (about an hour), remove it and let it rest on the rack, uncovered. Meanwhile, place a 12-inch cast-iron skillet over high heat for a solid 10 minutes, during which time it should get up to around 600°F.[6]

6 If you don't have an infrared thermometer, you'll know you're close when ½ teaspoon water dropped onto the middle of the pan completely evaporates in 5 seconds.

7 If you don't have a stopwatch, your smartphone does.

THE DOUGH ALSO RISES: RELOADED

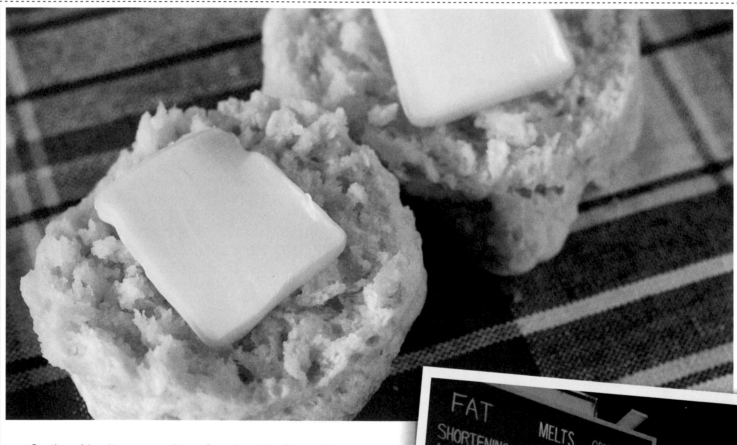

Southern biscuits are something of an obsession for me. One might gather, from watching the original episode, that this had a lot to do with my grandmother Ma Mae, who fed me biscuits throughout my life and still would be had she not been cut down in the prime of life by old age. Ma Mae guested on the show with me, and I'm so glad I have that to look back on. Her biscuits were all about technique, a technique I eventually came to understand, but not until she was gone. Anyway, my original biscuits from the show were okay but just okay, so I tinkered with them through the years until I finally got a biscuit she'd be proud of.[1]

1 My actual most favoritest biscuit is the gluten-free version on page 402.

A BITE OF HISTORY

Biscuit (the word) comes from the Latin *biscotus*, meaning "twice baked." The rock-hard Italian cookies known as biscotti are indeed baked twice, once as a loaf and then as individual pieces. This method of driving away moisture was also used to make ship's biscuits (nautical hardtack) to prevent them from going bad during the long sea voyages of the seventeenth and eighteenth centuries. This less-than-comforting form evolved into the "beaten" biscuit of the northern U.S. states, which gets its flakiness from literally being beaten and folded and beaten and folded. The southern iteration became possible in the late nineteenth century with the advent of commercial baking powders, canned concoctions containing a dry acid (monocalcium phosphate, tartaric acid, or sodium aluminum phosphate) and baking soda. Breads that get their lift from either baking powder or a combination of baking soda and an acidic ingredient are called "quick breads," and the southern biscuit is, in my opinion, the definitive form.

THE FLOUR

Time for a confession: In the original episode, I went on and on about how a good biscuit depends on the use of flour finely milled from soft red winter wheat, a relatively low-gluten variety commonly grown in the South. This is, in fact . . . hogwash. Although successful biscuiting does rely on proper ingredients, what I really should have stressed back then is that, as is so often the case in cooking, technique is what matters most. So, if all you have is bread flour, go ahead and use it . . . just don't knead the dough any more than necessary.

THE FAT

As stated in the confession above, flour is flour, and good biscuits can be made from all sorts. The critical element is the fat, the composition of which goes a long way toward determining the character of a biscuit. To her dying day, Ma Mae used shortening, vegetable oil that's had hydrogen added to it so that it's solid at room temperature. Back then, I augmented shortening with butter to up the flavor and to enhance browning (milk's fat and sugars are good at that). I still use butter in this reloaded version, but instead of shortening I'm reverting to the ways of my great-grandmother and reaching for lard, specifically leaf lard, which is taken from around the internal organs of pigs. Due to its relatively high average melting point of 115°F (butter melts between 90°F and 95°F), and the crystalline configuration of its fat molecules, leaf lard helps biscuits achieve both lightness and flakiness—the holy grail of biscuithood.

THE BUTTERMILK

The true southern biscuit is a buttermilk biscuit. The history of buttermilk in the South is complex, because what we call buttermilk today ain't. Once upon a time, buttermilk was the light, watery stuff left over from churning butter. Jars of it were cooled in pump houses (the coldest places around in the days before iceboxes), and the stuff was consumed like a sports drink, more hydrating than mere water alone, or so they say. Sour milk, or milk that was allowed to sour via naturally occurring bacteria (no, not the same as what happens when milk goes bad today—that's more like rotting), was closer to what we call buttermilk today, which is heated and inoculated with bacteria to convert milk sugar to acid. The change in pH also affects the proteins thickening the resulting liquid. The reason for using it in biscuits: acidity for leavening, tenderness, tang (for flavor), and viscosity for a dough that's wet but workable. In other words, southern biscuits evolved as they did because the South is hot and the North . . . ain't.

These days, leaf lard is easily found via the interwebs.

BUTTERMILK BISCUITS: RELOADED

YIELD:
8 big biscuits

SOFTWARE

340 grams (2 cups plus 6 tablespoons) all-purpose flour, plus an additional ½ cup for dusting

20 grams (4½ teaspoons) baking powder

¼ teaspoon baking soda[2]

¾ teaspoon kosher salt

60 grams (¼ cup) leaf lard, chilled

30 grams (2 tablespoons) unsalted butter, sliced into ⅛-inch-thick pats and chilled (plus more melted butter for brushing the tops, if desired)

1 cup (237 ml) low-fat buttermilk, chilled

TACTICAL HARDWARE

- A biscuit cutter in the 2½-inch range, or better yet a set of ring cutters. They come in a very handy round tin and you can easily procure a set from the interwebs. (Also, very necessary for the next application.)

After cutting, biscuits can be frozen and then baked without thawing. Just increase the baking time by 5 to 10 minutes.

PROCEDURE

1) Heat the oven to 450°F.

2) In a large mixing bowl, sift together the flour, baking powder, baking soda, and salt.

3) Working quickly (so the fats don't melt), use your fingertips to rub the lard and butter into the dry mixture until it resembles small, coarse chunks—not quite crumbs.[3]

4) Make a well in the center and pour in the buttermilk. Stir until the dough just begins to come together. It will be very sticky. While it's still in the bowl, fold the dough over itself two times so that it takes up any remaining flour, then turn it out onto a lightly floured work surface.[4]

5) Dust the top of the dough with flour and, with floured hands, gently fold the dough over itself eight more times, turning one quarter turn between each folding motion. Press the dough into a 1-inch-thick round, then cut out biscuits with a floured 2½-inch cutter, being sure to press

My grandmother always pushed her thumb lightly down in the middle. I'm not sure if it keeps the tops flat, but I do it anyway.

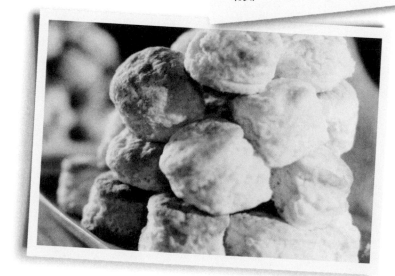

2 What? Why bother when baking powder will do all the lifting? True, but there's acid aplenty in the buttermilk, so throwing some baking soda at it will create even more lift. That said, ¼ teaspoon isn't nearly enough to counteract said acid and that's good, because without that acid there would be no twang, and that buttermilk twang is absolutely the flavor hallmark of a good southern biscuit.

3 This is it, the critical and crucial key to biscuit making. Why am I hiding it in a footnote? To make sure you're paying attention. Here's why it's important: The longer the fat can stay in solid form, the larger the openings that will be created when it melts. This is one reason leaf lard, with its high melting point, is such an important player. Keep the fat cold and work it in quickly, leaving visible hunks. If you work it into a fine meal consistency, all will be lost.

4 This is the second big technique point: Do not overwork the dough. It will be sticky. You will be tempted to add more flour and work it "smooth." Fight this impulse with every fiber of your being. Sticky and wet is good. I discovered this "under-kneading" method while watching Ma Mae, who had really bad arthritis in her hands and couldn't bend her fingers to knead the dough.

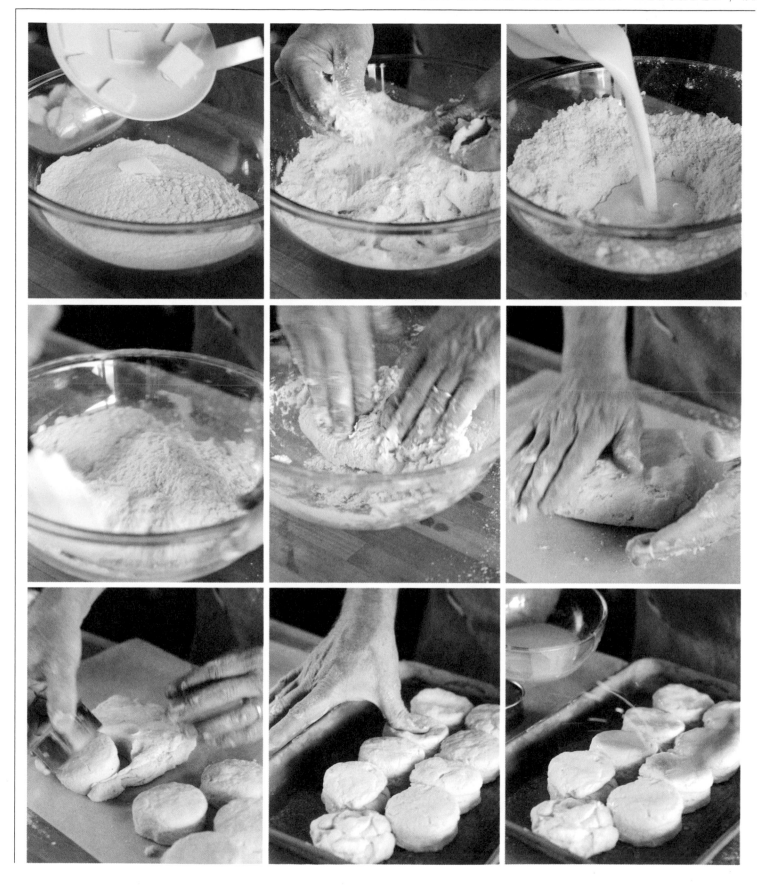

BUTTERMILK BISCUITS: RELOADED (*continued*)

straight down through the dough without twisting until the cutter reaches the board. You'll need to flour the cutter between cuts.

6) Center the biscuits on a baking sheet, shoulder to shoulder, so that they just touch.[5] Re-form the scrap dough, working it as little as possible, and continue cutting until you have 8 biscuits total. If you end up with 9, you're not doomed, but next time . . . 8.

7) Bake in the center of the oven for 10 minutes. Rotate the pan 180 degrees in the oven and continue baking until the biscuits are tall and light gold on top, 8 to 12 more minutes depending on your oven and the temperature of the dough.

8) Remove to a clean kitchen towel set in a bowl and fold the towel over to preserve warmth and steam the biscuits. Serve with butter and jam, or mustard and thin-cut ham, or sausage patties, or . . . just eat them.

Totally optional, but topping with melted butter will produce browner tops.

5 You'll get a better rise out of your biscuits if they're just touching. If you crowd them too much, the heat won't be able to get in between the biscuits.

A NOTE ON SIFTING

Back in the day, a lot of ingredients like flour were stored for much longer than they are now and hard lumps were common, not to mention crunchy things with legs, thus: sifting. Some say it's still good for aerating mixtures, but I've baked a lot of biscuits and can't report any difference at all. That said, I sift because Ma Mae left me her sifter and it's a ritual I enjoy. Cooking isn't just about eating, you know.

A NOTE ON HANDLING FAT

The subject of how to work fat into biscuits is almost as contentious as the type of fat. Here's how I do it. I dip my hands in cold water for a few seconds, dry off, then quickly rub the fats into the flour. This is a fingertip-only procedure, and it doesn't have to result in a completely homogenous integration. In fact, it's better if it's not all completely perfectly worked in. In summertime, I usually buy myself some thermal insurance by stashing the dry goods in the chill chest for a few minutes before handling.

HOT GLAZED BONUTS: RELOADED[6]

YIELD:
8 large doughnuts and 12 doughnut holes

Back in the '80s, when I would eat literally anything, I fell in nasty/shameful/disgusting love with the cinnamon-raisin biscuits at a fast-food operation called Hardee's. (I probably should have trademarks or something on that, shouldn't I?) They came two to a box, and despite the presence of raisins, I adored them. They were literally just biscuits, stuffed with the occasional raisin and glazed with cinnamon roll icing. With black coffee . . . I still shudder at the memory. Well, my Bonuts are deep-fried, and completely glazed, and there's not a stinkin' raisin anywhere in sight.

This is pretty much identical to the biscuits on page 20, only they have holes punched out of their centers, they're fried, and they're glazed.

SOFTWARE

¼ cup (60 ml) whole milk

1 teaspoon vanilla extract

230 grams (2 cups) confectioners' sugar

10 cups (1.8 kg) solid vegetable shortening (8¼ cups/2 liters melted)[7]

340 grams (2 cups plus 6 tablespoons) all-purpose flour, plus an additional ½ cup for dusting

4½ teaspoons (20 g) baking powder

¼ teaspoon baking soda

¾ teaspoon kosher salt

¼ cup (60 g) leaf lard, chilled

2 tablespoons (30 g) unsalted butter, sliced into ⅛-inch-thick pats and chilled

1 cup (237 ml) low-fat buttermilk, chilled

TACTICAL HARDWARE

- A spider
- A microwave for making the icing
- A 2½-inch doughnut cutter, or a 2½-inch and a 1-inch cutter

PROCEDURE

1) To make the glaze, microwave the milk in a large heatproof bowl for 15 seconds. Whisk in the vanilla, followed by the confectioners' sugar, until smooth. Set aside until the bonuts are fried.

2) To make the bonuts, melt the shortening in a large Dutch oven fitted with a deep-frying/candy thermometer and place over medium-high heat until the oil reaches 350°F. Keep an eye on the thermometer so the shortening doesn't rise above the target temperature. When it reaches about 300°F, turn the heat down to medium to cruise to your target temperature.

3) While the shortening is heating, line a half sheet pan with paper towels then top with an upside-down cooling rack.[8] Sift the flour (all but the stuff you put aside for dusting), baking powder, baking soda, and salt together in a large mixing bowl.

4) Working quickly (so the fats don't melt), use your fingertips to rub the lard and butter into the dry mixture until it resembles coarse chunks and crumbs.

5) Make a well in the center and pour in the buttermilk. Stir with a wooden spoon until the dough just comes together. It will be very sticky. While it's still in the bowl, fold the dough over itself two times so it that it takes up any remaining flour, and then turn it out onto a lightly floured work surface.

6) Dust the top of the dough with flour and, with floured hands, gently fold the dough over itself eight more times, turning one quarter turn between each folding motion. Press the dough into a 1-inch-thick round.

7) Cut out the dough using a 2½-inch doughnut cutter, or a 2½-inch and a 1-inch cutter (for the center hole). Make your cuts as close together as possible to limit waste. Re-form the dough and cut as many doughnuts as possible. Whatever scrap is left should be cut and formed to match the holes, which is why in the end you'll have more holes than bonuts.

8) Using chopsticks[9] or a slotted spoon, carefully move 3 or 4 bonuts into the shortening. Cook until puffed and golden brown, 1½ to 2 minutes per side. When the cold dough hits the fat, the temperature will fall quickly, so

6 I thought about calling them Douscuits, but . . . no.

7 Pro doughnut cooks use shortening instead of oil because it solidifies at room temperature, preventing the finished pieces from looking or feeling greasy.

8 Why inverted? Because if the paper towels are touching the metal of the rack, they'll wick away the errant fat. If the rack is upright, the fat will just hang and eventually head back into your bonuts.

9 I like to flip with wooden chopsticks.

HOT GLAZED BONUTS: RELOADED (*continued*)

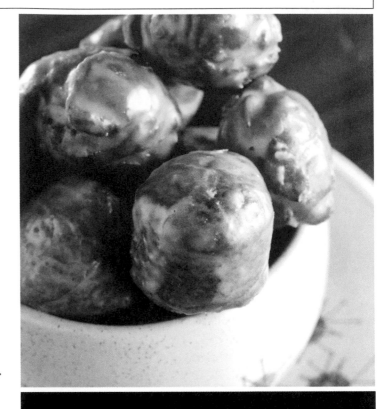

you'll want to boost the heat back to medium-high and keep an eye on the thermometer. Finish up by frying the holes in two batches until golden brown, 1 to 2 minutes per side.

9) Remove the golden-brown rings-of-wonder with a spider to the prepared rack. Cool for 2 minutes before glazing.

10) To glaze, gently dip one side of each bonut into the glaze, give it a twist, then lift straight out. Allow the excess to drain off and return to the cooling rig. To glaze the holes, I usually drop them in then lift them out with a dinner fork. Or, just go bobbing for them!

I'd say cool before eating, but we both know you won't.

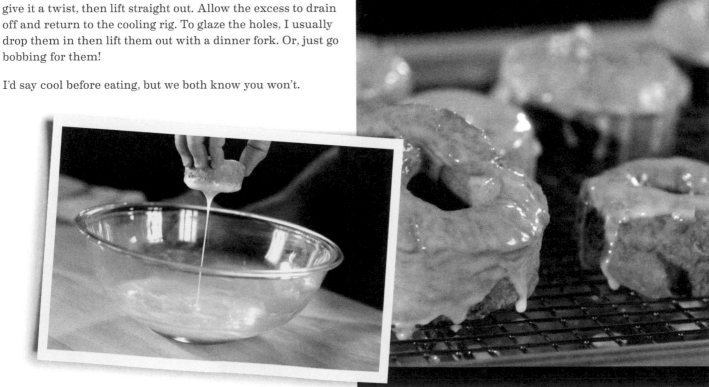

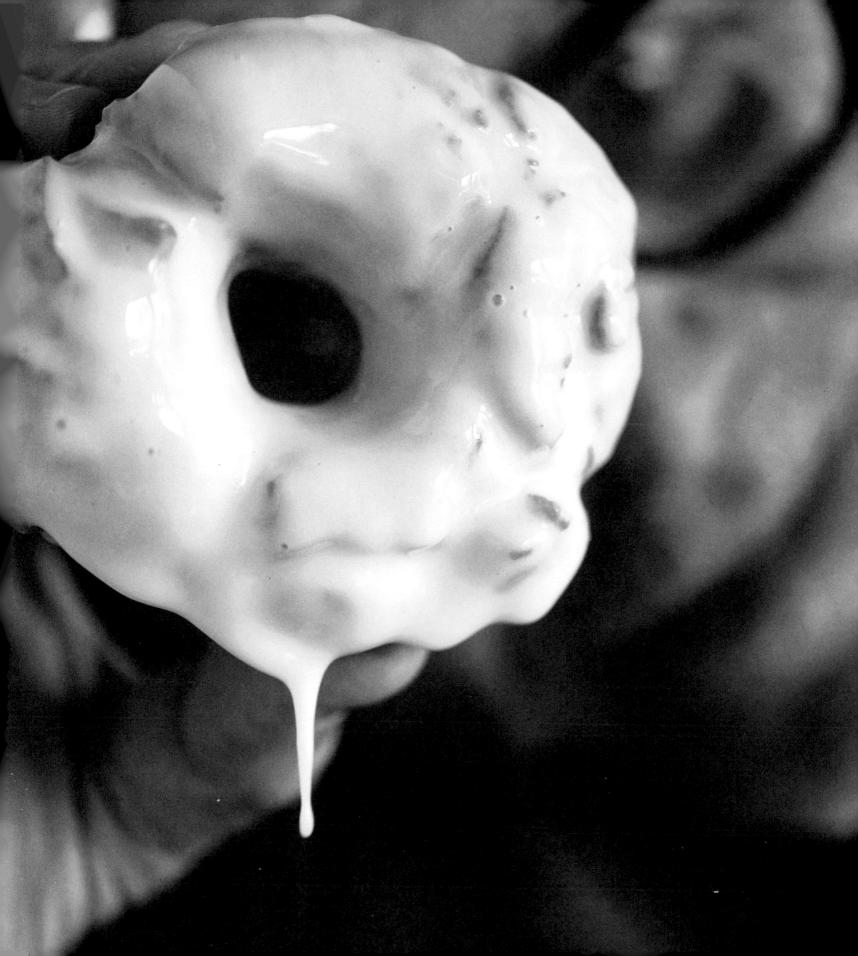

PANTRY RAID I: USE YOUR NOODLE: RELOADED

In the reload we used puppets to address an off-screen scooter mishap.

I have always been overly fond of using the word *why*. This made me irritating as a child, disrespectful as a teen, pushy as a young adult, tiresome in middle age. During my culinary school years, instructors (especially the French ones) avoided me whenever possible. Their answer to "why" reminded me very much of my parents' answer: "because." They did things because that's how they were done, and understanding "why" didn't enter into the equation. Part of the *Good Eats* mission has always been to ask "why" and to challenge any answer that smacked of "because." The

classical culinary canon is chock-full of tradition-bound rules that have no place in modern cookery, and I'd like to think we've helped put a few to pasture. But not in this show. Nope. In this half hour I perpetuated one of the biggest of culinary lies: You need a big ole pot of boiling water to cook dry pasta. In the last twenty years, research and experimentation have proven that dry pasta can be cooked in a very small amount of water, and that the water can be started cold, and that starchy water left behind can, and should, be used for finishing sauces. Before we cook, we review.

DRY PASTA

Except for coloring and flavoring agents like spinach and squid ink, most of the hundreds of different dry pasta shapes come from a simple concoction of water and a flour called semolina, a rather coarse flour ground from a high-gluten form of wheat called *durum*, traditionally grown in the Middle East, southern Europe, North Africa, and now in North Dakota and Montana. Durum's high protein content and grain shape help prevent the release of starch from the pasta into the cooking water.[1] This protein also makes durum dough very tough stuff. I've seen a home machine actually fall apart trying to roll it out. So maybe don't try this at home.[2] Fresh pasta, that you can do, but that's another show.

Dried semolina pasta was first widely produced in Italy during the nineteenth century.

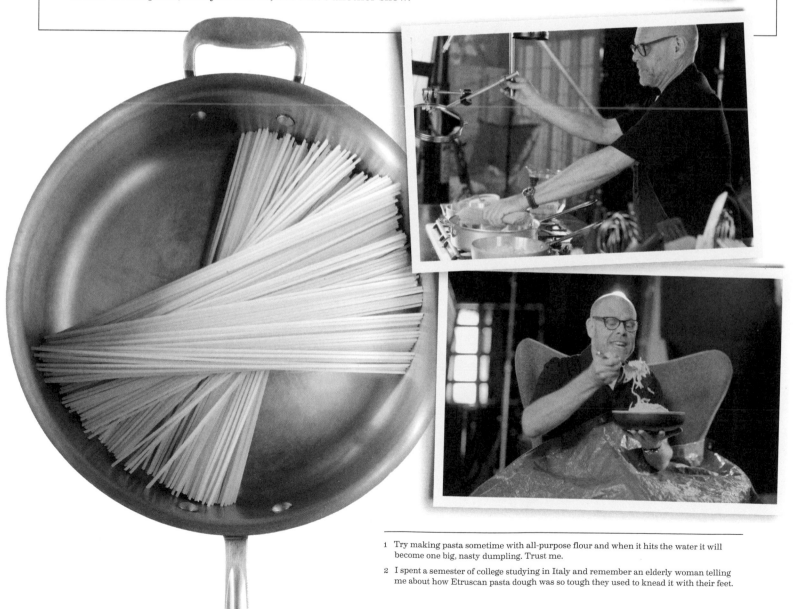

1 Try making pasta sometime with all-purpose flour and when it hits the water it will become one big, nasty dumpling. Trust me.

2 I spent a semester of college studying in Italy and remember an elderly woman telling me about how Etruscan pasta dough was so tough they used to knead it with their feet.

DRY PASTA (continued)

OKAY . . . THE WATER

Although fresh pastas do require a fair amount of water to cook properly (being able to move around is part of it), dry pasta is another story altogether, because, despite its dehydrated state, it's actually been kinda-sorta cooked already.

During the manufacturing process, the proteins glutenin and gliadin cross link to form gluten, the strong yet elastic matrix that gives pizza crust and many other breads their chewy tooth. Also, some of the starch molecules, which would usually be packed into tight granules in the raw state, gelatinize and unfurl like the big chains of energy storage

they are. So, before we home cooks bring our pots of hot water to the party, gluten structures are in place and free starch molecules such as amylose are wandering around near the surface of the noodle. These starches can start to take in water at relatively low temperatures, which helps to reinforce the gluten structures. This also may explain why starting pasta in cold water helps prevent the noodles from sticking to each other, and that holds regardless of whether the target pasta is a strand or tube or other shape. As for the amount of water, cooking in just enough to cover does require more stirring, but that seems a fair trade-off for using less energy and

less water. But that's not really the reason for embracing this method. The real reason is the leftover water itself.

As pasta cooks, free starch molecules leach out into the water. The less water, the more concentrated the starch. The best Italian cooks I know thicken or "finish" their sauces with heavily starched pasta water. So, instead of straining the finished pasta through a colander and sending the magic down the drain, fish the noodles out of the water with a pair of tongs or a hand strainer, reduce the heat to a simmer, and keep that water standing by to finish your sauce. That water is literally the secret to the following application.

CACIO E PEPE

In the original episode we opted out of presenting an actual dish (we spent way too much time on the pasta factory in San Francisco) and simply suggested various ingredient combos for topping. Here, I finally want to present the dish I would have cooked had we had the time: cacio e pepe, which was oddly missing from American restaurant menus back in 1999. This is a very old Roman dish whose moniker translates to "cheese and pepper." Although spaghetti is the standard strand

for modern incarnations, it's not historically accurate. Tonnarelli, aka spaghetti alla chitarra, is a lot like spaghetti, but it's cut on a device with wires like a guitar (more like a zither, if you ask me), which creates noodles with a square cross section. Tonnarelli dough often includes eggs so it can behave more like the fresh pasta you may have made by working whole eggs into a pile of flour. Me, I just stick with spaghetti. One of the biggest misconceptions about this dish is that folks think it contains eggs, like carbonara. It doesn't. Its smooth sauce comes from the use of that magical starch water.

CACIO E PEPE: RELOADED

YIELD:

4 servings

SOFTWARE

110 grams (3 cups) finely grated Pecorino Romano cheese, divided

50 grams (1½ cups) finely grated Parmigiano-Reggiano cheese[3]

⅓ cup (79 ml) extra-virgin olive oil

2 tablespoons (14 g) freshly ground black pepper, plus more cracked pepper for serving, if desired

1 pound (454 g) dry spaghetti

2 tablespoons (20 g) kosher salt[4]

Cold water, for the pasta

TACTICAL HARDWARE

- A large wooden spoon

- A straight-sided sauté pan wide enough to allow the spaghetti to lie flat. I use a 12-inch model that came with a lid. If you don't have a pan as wide as the noodles are long, just break the noodles in half; odds are no one will notice.

- A 4- to 6-ounce ladle. If you don't have one, use a coffee mug or something else heatproof with a handle; just remember you'll have to guess on the measurement.

- Spring-loaded tongs or a hand strainer for fishing out the cooked noodles. I know, some of you are thinking about that weird-looking ladle thing with the vertical teeth that came with one of the three kitchen utensil sets you got as a graduation/wedding/divorce present. You can use that, but it's a unitasker, so I'd say you shouldn't even own it. If you want to use a strainer, I'd go with a spider that looks like this:

"Spider" with bamboo handle

Pasta forks appear on my list of the most hated unitaskers of all time.

PROCEDURE

1) Combine 100 grams (2¾ cups) of the Pecorino, all of the Parmesan, the oil, and pepper in a large, deep mixing bowl. Work the ingredients together with the back of a wooden spoon until a thick paste forms, 2 to 3 minutes. Set aside.

2) Put the pasta and salt in a 3-quart, straight-sided sauté pan. Add enough cold water to cover the pasta by about ½ inch. Set over medium-high heat, and bring to a boil, about 10 minutes, checking every few minutes to scoot the noodles around with your tongs just to insure against stickage.

3) When the water reaches a boil, drop the heat to whatever heat level maintains a simmer. Give the pasta a stir every minute or so.

3 Unlike in most of the other culinary-civilized countries in the world, the word "Parmesan" can be used to label just about anything in a cheese case that's gold-ish and gratable. So for this dish I really must insist you go for Parmigiano-Reggiano . . . it's the only way to be sure.

4 I know this seems like a lot, but remember, the amount of salt needed is always a factor of the water amount, not the pasta. With strands you're going to need a much wider pan and a relatively large amount of water compared to what you might use with shapes like elbows or penne.

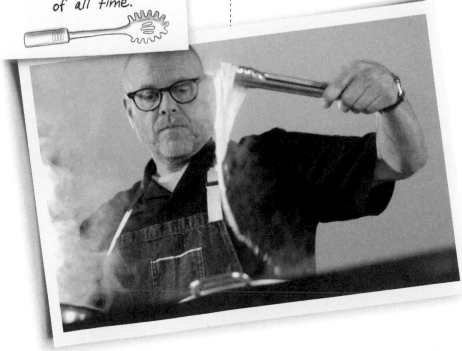

CACIO E PEPE: RELOADED *(continued)*

4) When the pasta has been simmering for 5 minutes, ladle 1 cup of the cooking water into a measuring cup, then slowly drizzle ¾ cup of that water into the cheese paste, mixing with the wooden spoon until smooth, about 2 minutes.

5) At this point, check the pasta for doneness; you want it to be just barely al dente,[5] as there will be some carryover cooking in the next step. If it isn't al dente, continue to check on the pasta every 30 seconds until you are happy with it.

6) Evacuate the pasta from the water using your tongs or a strainer and allow it to drain briefly before adding to the bowl containing the cheese paste. Grasp the pasta with the tongs and stir vigorously for 2 minutes.[6] The pasta will continue to release starch and the sauce will emulsify. After around 1½ minutes, you will see cheesy water magically transform into a proper sauce. If you find your sauce clumping, add a bit more of the reserved pasta water and continue working the pasta.

7) Portion the pasta into six bowls, top with the remaining Pecorino and additional freshly cracked black pepper, if desired, and serve immediately.

WHY BOTH?

A lot of folks have inquired via social media why I call for both Pecorino Romano and Parmesan cheeses. The answer is simply flavor. Parmesan is a cow's milk cheese that's aged, typically for a minimum of a year.[7] It's nutty and buttery and full of umami. Pecorino is a sheep's milk cheese (*pecora* = ewe), and it's far spicier and tangier than Parm. This dish needs both. Could you make it with just one or the other? Of course, it's your food, but . . .

Pecorino Romano Parmesan

THE COLD-WATER METHOD

Starting dry pasta in a small amount of cold water is especially easy if the shape in question is penne, farfalle, or even rigatoni—anything that doesn't require a wide pan. In these cases, I use a medium saucepan and cover the pasta with ½ inch of water, but I always measure the water as I add it, typically a pint at a time, so that I can calculate the amount of salt needed (I go with a rounded teaspoon of kosher salt per cup of H_2O). After adding the salt, I give the noodles a stir and put the pan over medium-high heat. When it hits a boil, I drop it to a simmer, just as with the application above, and cook until al dente, from 5 to 10 minutes depending on the pasta. I make sure I stir it every minute during the cook. When it comes to fishing out tubes and shapes, tongs won't do you much good, so go with your spider (just make sure it will fit in the pan before you get started).

5 Few things in the culinary realm are worse than overcooked pasta, so keep checking.

6 Really use a lot of elbow grease here—this is not a light toss.

7 I say "minimum" because the consortium that oversees the production of Parmigiano-Reggiano won't even actually call it that until it passes inspection at twelve months. Most of the Parm I find in my neck of the woods is between eighteen and twenty-four months old.

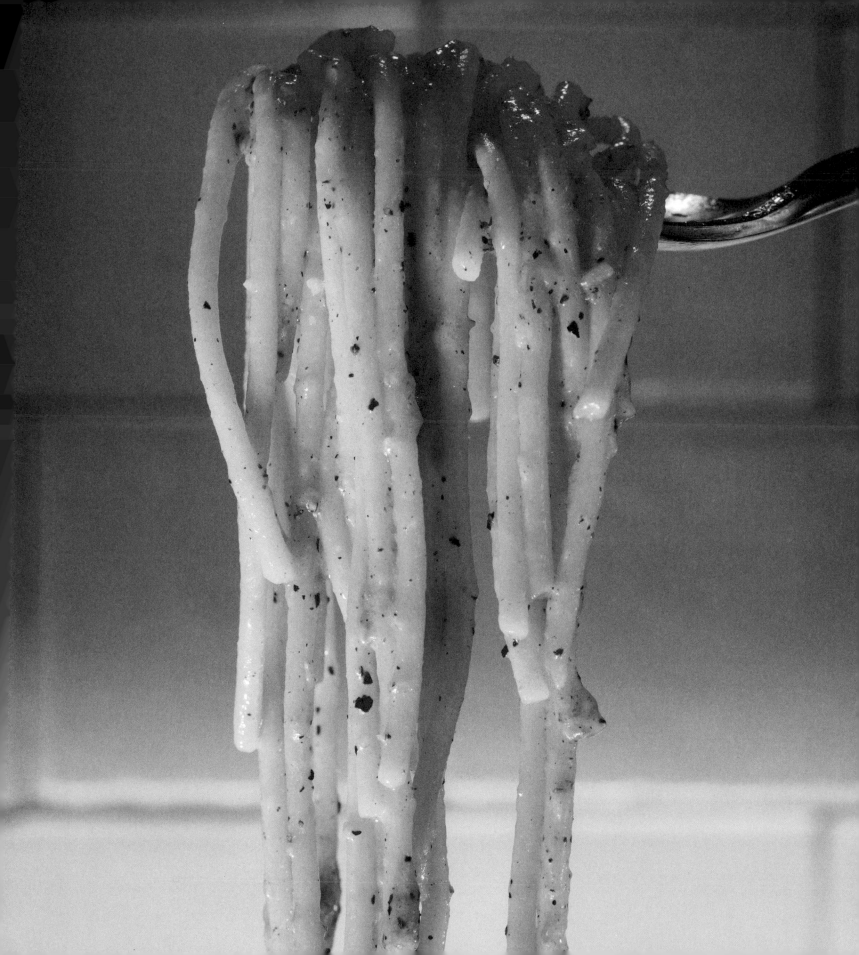

FOR WHOM THE CHEESE MELTS: RELOADED

Fondue is from *fondre*, the French word for "to melt."

A great deal of this book wouldn't exist were it not for the fact that I am prone to mistakes, many of which I'm not aware of having made until years after the fact. Consider "For Whom the Cheese Melts," which premiered in January 2000. The subject was cheesy applications requiring maximum meltage. The problem recipe was for a fondue, and in designing it I committed a classic blunder: I underestimated the effects of switching out an ingredient whose role I didn't fully comprehend. The result was that for a lot of folks out there, the cheese didn't so much melt as degrade into gooey sand. Some of you took to the internet to let me know (in no uncertain terms) that I'd earned my first full-on recipe fail. I relish this opportunity to repair the recipe and my reputation. But first, let's talk cheese.

Paul Merchant has been on *Good Eats* since he was, like, twelve. He's a prop guy but also plays Lever/Lactose Man.

In its stable, room-temperature state, cheeses are gels,[1] and how they behave depends on the nature and proportions of protein, water, and fat they contain. Supporting players such as calcium, phosphate, and salt factor into the equation as well, as does time, because as cheese ages, moisture evaporates out, allowing the remaining proteins to knot into tight bundles. That translates to a harder cheese that's tough if not impossible to melt smoothly (I'm talking to you, Parmesan). So, when choosing a melting cheese, you want a fair amount of moisture, a fair amount of protein that isn't too old, and a relatively low amount of fat (as compared to water). The safe bets are semi-firm cheeses such as Asiago, Taleggio, Fontina Val d'Aosta, young Goudas, and my favorites, the "Alpine" cheeses such as Gruyère, Emmenthaler, and Appenzeller, which of course appear in many classic fondue recipes.

FONDUE

The dish, most often associated with Switzerland, specifically the French-speaking, western side of the country, is nothing more than a cheese sauce into which one dips cubes or small hunks of bread.[2] Fondue is an old dish, going back quite possibly to the time of the ancient Romans, and only has three required ingredients: cheese, wine, and a starch of some type—e.g., flour. Seems simple . . . or so I thought. That's because I assumed that the wine was there simply to provide moisture and flavor. What I should have thought about more—a lot more—was acidity.

Acidity is critical in fondue because we've got to break down that cheese into a smooth sauce. Without sufficient acidity to break up the calcium "glue" that holds stringy cheeses together, the cheese will simply pull into a long, stretchy curd, which might be great for Instagram shots of pizza but not for fondue. The only reason my fondue worked on camera during the original episode is that I was using a specialty hard cider that was high in acid. Many of the folks who attempted to manufacture the dish at home did not have access to this particular ale and so ended up with nasty, stringy clumps. Had I stuck with wine, odds are there wouldn't have been a problem. Alas, it was only our second season and I needed to be clever and different because that's how I thought I'd make a name for myself. Boo.

There is a bit of molecular insurance we can take out against stringiness: starch, specifically cornstarch. As cheese melts, the fat and water phases want to separate out and join with others of their own kind, but the starch granules swell in the hot liquid and block the way like sumo wrestlers at a senior prom. Best chaperones ever. But we still have to manage the

heat. High heat will break the emulsion of the cheese and wad the proteins up like angry little fists, so keep your thermometer close and never allow the temp to go above 150°F.

THE BIRTH OF FONDUE

Culinary mythology states that fondue might be the original halftime food. Back in 1531 Switzerland was badly torn by civil war set in motion by the Reformation.[3] Catholics from the rural Cantons and Protestants from the cities had laid siege to each other for months, and both sides were near starvation. Being Swiss and therefore efficient, they realized that if they starved to death, they couldn't keep killing each other. So a truce was drawn up so the two warring parties might pool the remaining edible resources. A fire was built on the middle of the field of battle and a pot placed upon it. The Protestants brought bread and wine. The Catholics brought homemade cheese. And thus, was fondue *supposedly* born.

1 A gel is a lot like an emulsion, only the fat globules are suspended in a semi-solid matrix of protein (casein). When we melt it, however, it becomes a liquid in a liquid and so is technically an emulsion.

2 Although I've seen fondue menus in America offer everything from pineapple to marshmallows . . . no.

3 Should one have interest in learning more, look up the wars of Kappel, which were set in motion by the "Affair of the Sausages," which you can also look up.

FONDUE: RELOADED

YIELD:

8 as an appetizer,
4 as a meal,
2 if you're lumberjacks,
or just 1 if you're me

SOFTWARE

1 clove garlic, peeled and halved

1 cup (237 ml) Sauvignon Blanc or other acidic white wine

2 tablespoons (30 ml) Applejack or other fruit-based brandy

1 tablespoon (15 ml) freshly squeezed lemon juice

200 grams (2½ cups) grated Emmenthaler cheese

170 grams (2 cups) grated Gruyère cheese

85 grams (1 cup) grated Gouda cheese (the younger the better)

11 grams (1 tablespoon plus 1 teaspoon) cornstarch

¼ teaspoon ground white pepper

½ teaspoon prepared horseradish

Bread, for serving

TACTICAL HARDWARE

- Despite what W[4] said back in 2000, electric fondue pots cannot evenly maintain the low temperatures necessary to melt cheese without burning or breaking it, or squeezing its proteins into an industrial glop. A double boiler is one way to go, but I prefer a small, cast-iron Dutch oven with a heavy lid and a handle or wire bale. It's dense so it heats evenly, which is key for fondue, and with the rustic lid, it's great for delivering to the table. Plus, all that density means it can keep its contents warm without fussy candles or alcohol burners.

- You'll need both a rubber or silicone spatula and a stout whisk. I'm listing such common devices here simply because there's no real substitute for either.

- A fairly heavy-duty box-style grater is, in my opinion, the best tool for dealing with semi-firm cheeses. Invest in one with a wide stance and a comfortable, secure handle.

PROCEDURE

1) Rub the inside of a small (2-quart) Dutch oven[5] with the cut garlic, then add the wine, brandy, and lemon juice. Place over medium heat until the liquid just begins to steam and hits 135°F.[6]

2) While the liquid is heating, toss the cheeses, cornstarch, and white pepper together in a bowl. Even coverage is key, so use your fingers.

5 Because you're using cast iron, the pot should remain warm enough to keep the fondue pliant for about half an hour. If you want to keep it warm longer than that, consider nestling the Dutch oven in a bowl with a standard drugstore heating pad set to high. You can also reheat the fondue very gently over low heat if it gets too cool to dip.

6 You can also use a double boiler. To do so, pick out a stainless-steel bowl that will nestle inside a tall saucepan without touching the bottom. Bring about 1 inch of water to a simmer in the saucepan. Rub the bowl with the cut side of the garlic. In a separate small saucepan, bring the wine, brandy, and lemon juice to a simmer, then pour into the garlic-rubbed bowl. Stir in the cheese as directed above, using a whisk instead of a spatula. You will likely need to serve fondue prepared this way while still set over the saucepan of warm water.

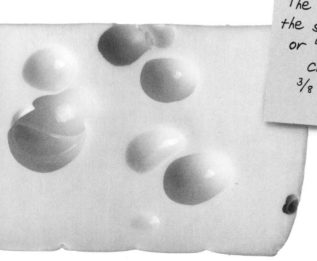

The USDA requires the size of the holes or "eyes" in Swiss cheese to be 3/8 to 13/16 inch in diameter.

4 Every few years I have to bust the early myth that W stood for *wife*. The character was based on Q from the Bond films, and *W* was the first letter after Q that sounded halfway cool.

3) When the liquid hits 135°F, start stirring in the cheese, a handful at a time, using a spatula. Wait until the last addition is almost melted before adding the next.

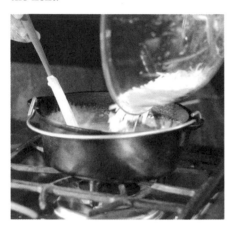

4) When all the cheese is in the pot, increase the heat slightly and switch from the spatula to a whisk and whisk constantly until the mixture lightens noticeably and smooths out. Then add the horseradish and keep whisking until the fondue pours in a ribbon off the whisk and kind of coils up on the surface a bit like a rope before dissolving, about 5 minutes.

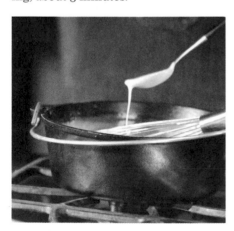

5) Remove from the heat and take to the table. Serve alongside bread chunks for dipping. I like to mix up torn and toasted pieces of sourdough, pumpernickel, and challah. Some folks will tell you to serve with vegetables . . . I'm not sure I trust such people.

TIPS

>> You can make fondue ahead of time, but fight the urge to put the lid on it to keep it warm. If you do, the condensed water that will settle on the top will lead to the sauce breaking. Trust me on this. Just remove the pot from the heat and leave the lid off. The fondue will stiffen as it cools but if you simply stir patiently over low heat, creamy wonderment should be restored.

>> Cheese contains live cultures and storing it improperly could shut down respiration and even result in the formation of calcium lactate, which can make melted cheese feel sandy in the mouth. The best way to store it? Waxed paper or parchment paper, carefully folded, secured with a rubber band, labeled with the type of cheese and the day purchased. Stick the wrapped cheese in airtight containment— because cheese contains fat and fat is like Velcro for odors—and store in the warmest section of your refrigerator, which is in the door, for no more than a week. Parmesan and other hard cheeses can last up to a month.

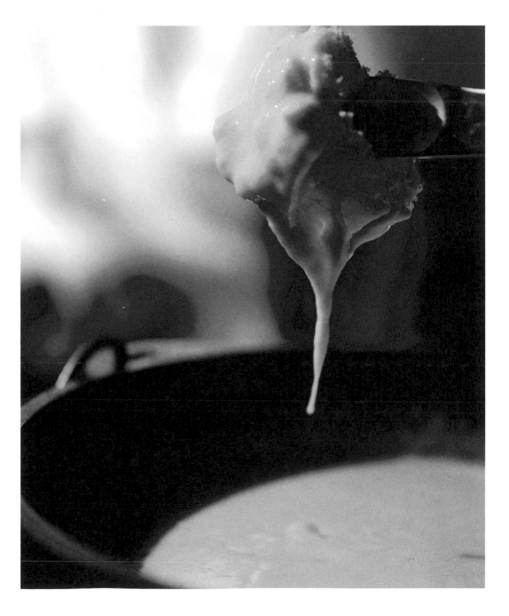

A GRIND IS A TERRIBLE THING TO WASTE[1]: RELOADED

Despite the fact that one of the applications in this episode is among the most popular in the show's history, the episode is marred by rambling diatribes, ill-conceived dramatic conceits, ugly food, and at least one history lesson that has since been disproved. (Neither the Hun nor the Mongols tenderized steaks for later enjoyment by placing them under their saddles; they placed meat under their saddles to help soothe their horses' sores.) All that aside, the real reason for the reload is that the original applications have been improved significantly over the years. And, since the burger reload has already appeared (in almost the exact form) in another of my books, I'm including a bonus application for these pages only: the Patty Melt, my favorite diner sandwich of all time.

1 All my records say that this episode is indeed titled "A Grind Is a Terrible Thing to Waste," and yet the network that paid for it has always referred to it as "Daily Grind," the reason for which I haven't a clue.

Depending on where you shop, you may see up to five or six different types of ground beef at ye olde megamart. Ground meats labeled with the name of the primal from whence they came (chuck, sirloin) are generally reliable in terms of flavor and cooking characteristics, but those simply calling themselves "hamburger" or "ground beef" are often made from trimmings and could come from anywhere on the steer, depending on what that particular store sells the most of. You could luck out and get a hamburger blend made from rib-eye and filet, or you could wind up with trimmings from . . . elsewhere. Another downside to store-ground beef is that it is often overprocessed. I personally prefer a larger grind size than standard, as I feel it gives me a meatier texture. I also don't want my ground meat compressed, as is typically the case when plastic wrap and polystyrene trays are employed. I'm also way too fond of medium-rare beef to entrust most markets with the grind. If there's going to be an issue with foodborne illness, odds are good it's going to happen at the grinder. This is especially true if a shop grinds trim that's been gathered during the day.[2]

My final argument for grinding meat at home: You can customize your blend. My go-to cuvée is 50/50 chuck/sirloin, which delivers plenty of beefy flavor and just enough fat to hold things together and feel succulent in the mouth. Prefer a leaner blend? Up the sirloin and dial back the chuck. Wanna go wild? Switch out 25 percent for spare rib meat.

There are four ways to home-grind. If your mixer accepts a grinder attachment, you're home free; just be gentle, as they're not known for their stoutness. Hand grinders are inexpensive, reliable, and simple to use, but maybe a little too "down-home" for most folks. If you're really committed to the sausage lifestyle, you might want to invest in a dedicated countertop electric grinder. For me, a sturdy food processor does an amazingly good job at chopping meat, which, although not exactly the same as grinding, does turn out a darn good burger.

The key to successful grinding or chopping is preparation. All the meat should be trimmed, cut into 1½-inch cubes, and chilled. I pop my cubed meat into the freezer for about 15 minutes before grinding or chopping (no matter what method I use) to prevent the meat and fat from smearing together as they run through the blade.

2 I'm not saying that this is a problem, I'm saying it could be a problem, which is enough for me.

MEATLOAF: RELOADED

YIELD:

6 to 8 servings

SOFTWARE

18 ounces (510 g) chuck roast, trimmed of excess gristle and silver skin, cut into 1½-inch cubes

18 ounces (510 g) sirloin steak, cut into 1½-inch cubes

½ cup (140 g) ketchup

¼ cup (60 g) tomato paste

2 canned chipotle chiles in adobo, seeded and finely chopped (23 g)

1 tablespoon (15 g) adobo sauce from chiles

1 tablespoon (3 g) cocoa powder

2 teaspoons (8 g) dark brown sugar

1 teaspoon (2 g) garlic powder

3 cups (170 g) garlic-flavored croutons

1 teaspoon (2 g) chili powder

1 teaspoon (1 g) dried thyme

½ teaspoon (1 g) freshly ground black pepper

½ teaspoon cayenne pepper (optional)

½ onion, roughly chopped (135 g; 1⅓ cups)[3]

1 carrot, peeled and broken into a few pieces (90 g)

½ red bell pepper, seeded and cut into a few large pieces (55 g)

3 cloves garlic, peeled (10 g)

1½ teaspoons (5 g) kosher salt

1 large egg (adds moisture and acts as a binder)

TACTICAL HARDWARE

- Nonstick spray
- A 9 × 5 × 3-inch loaf pan
- 2 sheets of parchment paper
- A half sheet pan[4]
- A food processor with chopping blade
- A remote probe-style thermometer[5]

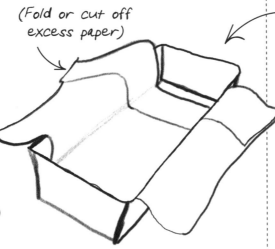

(Fold or cut off excess paper)

LOAF PAN WITH PARCHMENT SLING

PROCEDURE

1) Thoroughly combine the meat cubes in a small bowl. Cover with plastic wrap or move to a zip-top bag and refrigerate for at least 1 hour.[6]

2) When you're ready to assemble, park a rack in the middle of your oven and crank the oven to 325°F. Lube the loaf pan with nonstick spray, then line it with a piece of parchment paper, creating a sling. Even if you're using a nonstick pan, the sling will aid in de-panning the finished loaf. Also line the sheet pan with parchment.

3) Whisk the ketchup, tomato paste, chipotles, adobo sauce, cocoa powder, brown sugar, and garlic powder together in a small bowl. This is your glaze. You'll need ¾ cup for brushing on the loaf. The rest you can serve alongside the finished dish.[7]

4) Load your food processor's work bowl with the croutons, chili powder, thyme, black pepper, and cayenne (if using) and pulse to a coarse crumb consistency. Transfer to a large mixing bowl.

5) Reload the work bowl with the onion, carrot, bell pepper, and garlic and pulse 8 to 10 times or until finely chopped. You'll probably need to scrape the sides of the bowl with a rubber spatula about halfway through the process. When done, add to the breadcrumbs.

4 Commercial sheet pans are aluminum pans typically around 18 × 26 inches, with a slightly angled 1-inch lip all the way around. These are too large for most home ovens, but half sheet pans, at 13 × 18 inches, are perfect for home ovens, and quarter sheet pans, at 9 × 13 inches, are ideal for most toaster ovens. Sheet pans, in all their guises, are cheap and plentiful on the web and at literally every single restaurant supply store in the world. Having, say, four half sheet pans will change your culinary life the first time you bake cookies.

5 I'd suggest a model with a base that connects to the probe with a long, braided metal cable. Ideally, the base will have an alarm that can be set to go off once the target temperature is reached.

3 Yes, even though it's ultimately headed for the food processor, you should still chop it first.

6 I often do the chilling and grinding the day before. As long as it's tightly sealed the meat will keep for a couple of days.

7 You're about to ask me if you can use this on burgers. Why, yes, you can.

6) Process the meat in two batches, until it resembles a coarse grind, 10 to 15 one-second pulses. Add the meat to the crouton and vegetable mixture, along with the salt, and mix with your hands to combine. Quickly work in the egg . . . yes, with your hands. Try not to squeeze or overwork the meat in the process.

7) Pack the mixture into the parchment-lined loaf pan. Smooth the surface with a spatula, then cover with the second piece of parchment and the sheet pan, upside down. Place one outstretched hand on the middle of the sheet pan, hold the loaf pan with your other hand and turn the whole thing over. Then gently pull the ends of the parchment sling to coax the pan off the meatloaf, which should be left sitting in the middle of the sheet pan like the magnificent monument to meat that it is.

8) Insert the thermometer probe into the top of the loaf at a 45-degree angle, aiming to position the tip right in the middle of the loaf. Set the alarm for 155°F and park the pan in the middle of the oven.

9) After the meatloaf has been cooking for 15 minutes, carefully slide out the rack and quickly brush the loaf with approximately ¾ cup of the glaze. Continue cooking until the alarm sounds at 155°F, 45 to 60 minutes longer.

10) When finished, transfer the sheet pan to a cooling rack for 15 minutes. Then, holding one end of the parchment, slide the loaf onto a cutting board. Slice it right on the parchment using a long slicer or an electric carving knife. Do not use a serrated bread knife, as it will tear the meat. If you want to slice thinly for sandwiches, allow to cool completely, then refrigerate for a couple of hours before cutting.

THE BURGER: RELOADED

YIELD:
4 servings

SOFTWARE

8 ounces (227 g) chuck roast, trimmed of excess gristle and silver skin, cut into 1½-inch cubes, and chilled

8 ounces (227 g) sirloin steak, trimmed, cut into 1½-inch cubes, and chilled

½ teaspoon kosher salt

1 quart peanut oil, for frying[8]

1 quart safflower oil

2 cups (142 g) grated cheddar cheese

1 teaspoon garlic powder

1 teaspoon smoked paprika

4 brioche hamburger buns, split

Mayonnaise and mustard, for serving, as desired

16 to 20 dill pickle slices or chips, for serving

TACTICAL HARDWARE

- A food processor with chopping blade

- A heavy Dutch oven for frying

- A metal tortilla press. You can find simple, metal models for thirty bucks or so, and they're fine multitaskers, but if you don't have one and you don't want to get one, use a heavy book . . . like this one. Just be sure to line it with plastic wrap first.[9]

- A wire spider strainer. I prefer those with bamboo handles.

8 Although I originally advocated for 100 percent peanut oil, I find I get better flavor and more reuses out of a 50/50 blend of peanut and safflower.

9 In a pinch, you can use the smooth underside of a dinner plate for shaping the burgers, but the press is more precise and a lot more fun.

RELOADING THE "BURGER OF THE GODS"

The burger in the original episode was griddled, and this enraged all the grillers out there who believe only flame-licked burgers are worthy. While I enjoy a smoky critter puck from time to time, most of the great burgers of my life have come off commercial griddles, where short-order cooks mash the patties thin with large spatulas to speed the process. Mashing (or "smashing," as it's called in popular burger parlance) helps create the crusty exterior that results when protein-laden liquids and fat mingle at the thermal scrimmage line of meat and metal. The problem is that griddled burgers can only cook on one side at a time and therefore require at least one flip, thus exposing the patty to the risks of physical damage and drying due to the time required to sear the second side.

The answer is, of course, to fry it. A fried burger can develop an even better crust because the hot oil can attack nooks and crannies more effectively than a hot slab of steel. Moisture and fat do still escape, but as the crust quickly forms that process slows, and many of the proteins that might have escaped now remain to become part of the crunchy goodness. With a large pot, a few quarts of oil, and a decent thermometer, you can crank out a dozen burgers quickly without having access to a commercial griddle. (Don't get me wrong, I'd still really love a commercial griddle, but dang, they take up a lot of space and they really heat up a kitchen, and that means you need a huge vent hood, and, well, you can see where this kind of thing can lead.)

PROCEDURE

1) Place the chuck, sirloin, and the salt in the bowl of a food processor and pulse until it resembles a coarse to medium grind, about 10 one-second pulses.

2) Divide the meat into four 4-ounce (113 g) portions and roll into balls. Place one of the meat balls between two sheets of waxed paper on a tortilla press and flatten completely into a 5- to 6-inch-wide disk (see opposite). It will be irregular around the circum-ference. That's good, as all those irregularities will become crunchy goodness. The meat will shrink back down to bun-size as it cooks. Set the smashed meat sheet aside, replace the waxed paper, and repeat the flattening process with the remainder of the meat balls, then refrigerate all of the smashed patties while you heat the oil.

3) Pour 2 to 3 inches of oil into the Dutch oven. Install your fry/candy thermometer to the side of the pot and crank the heat to medium-high. Your thermal destination is 320°F.

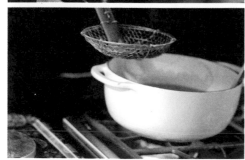

4) Toss the cheese, garlic powder, and paprika in a medium bowl and set aside. Ideally, the spices will stick well to the cheese, but if they don't let it warm at room temp for a few minutes and toss again.

5) Heat the broiler and place the rack in the top third of the oven.[10] Spread a thin layer of mayo on the bottom halves of the buns and mustard on the tops, then cover both with the cheese mixture and broil briefly to melt the cheese. I wouldn't walk away, as this will happen pretty quickly, 30 seconds to a minute at most.

6) When the oil hits 320°F, remove the meat patties from the refrigerator. Cook one at a time by peeling the waxed paper from one side of the patty then flipping it onto the spider and peeling off the other piece of paper. Gently lower the spider into the fat and jiggle until the patty floats free, taking care not to let the patty fold in half. Cook for 1 minute—no more, no less. If you're feeling ambitious, you can add a second patty to the oil, but watch the oil temperature and don't let it drop under 300°F.

7) Using the spider, transfer the fried meat to a paper towel to briefly drain, then move it to a bun bottom. Top with the pickles then the bun top. The ideal order: bread, mayonnaise, cheese, meat, pickles, cheese, mustard, then bread.

8) Consume or wrap in aluminum foil and hold for up to 30 minutes.

10 This is the perfect time to use your toaster oven if you have one.

THE PATTY MELT

YIELD:

Just 1 sandwich, but the recipe can easily be doubled as long as you've got the griddle space.

SOFTWARE

½ medium yellow onion (150 g)

1 teaspoon kosher salt, divided

3 ounces (80 g) chuck roast, cut into 1½-inch cubes and chilled

3 ounces (80 g) sirloin roast, cut into 1½-inch cubes and chilled

2 slices American cheese (about 45 g)

2 slices Swiss cheese (about 55 g)

2 slices rye sandwich bread

3 tablespoons (43 g) unsalted butter, divided

2 teaspoons ketchup (or more if you like)

1½ teaspoons mustard (ditto)

1 teaspoon onion soup mix (optional but *highly* recommended)

TACTICAL HARDWARE

- A food processor with chopping blade

- A square cast-iron griddle. While a wide cast-iron skillet could be used for cooking, I find the square shape makes for easier flipping. My own griddle is by Lodge and measures 12 inches square. If you have one of those fancy ranges with a built-in griddle, you know what to do.

PROCEDURE

1) French slice your half onion and toss it with ½ teaspoon salt in a medium bowl and set aside.

Overhead view—onion, peeled

and halved—trim root and stem ends. Then...

end view—slice radially, thus creating pieces like this. →

2) Take the chuck and sirloin for a quick spin in your food processor, pulsing 10 quick times or until the meat resembles a coarse to medium grind. Remove the meat (carefully) and press (gently) into a ¾-inch-thick oblong patty that roughly matches the shape of one of your bread slices. Sprinkle on both sides with the remaining ½ teaspoon salt, then set on a plate near your cooktop.

3) Park your cast-iron griddle over medium-high heat for 3 minutes. Meanwhile, tear your cheese slices into 1-inch strips and have them standing by, along with the bread, butter, ketchup, and mustard. (By the way, you don't really have to measure those last two out; you're a grown-up and know how much ketchup and mustard you can handle.)

4) Once the griddle is hot, add 1 tablespoon of the butter and swirl to melt. Add the onions and cook, stirring occasionally, until golden brown and crispy on the edges, about 6 minutes. Stir in the onion soup mix, then pile the onions over on one side of the skillet so they can continue to steam off the hot spot.

5) Melt another 1 tablespoon butter in the center of the griddle and transfer the patty onto the bubbly puddle. Press down on the patty with a metal or nonstick grill spatula to ensure contact and cook for 2 minutes. You want some char on the patty, so check after a minute and adjust the heat as needed. You'll see plenty of steam, but if it starts to get too smoky, lower the heat a little. Carefully flip the patty and cook for 1 to 2 more minutes.

6) To build the sandwich, arrange half of the cheese on one slice of the bread, top the cheese with half of the onions and the mustard. Then place the cooked patty on top, followed by the ketchup, the rest of the onions, and the rest of the cheese. Finally, top with the second slice of bread.

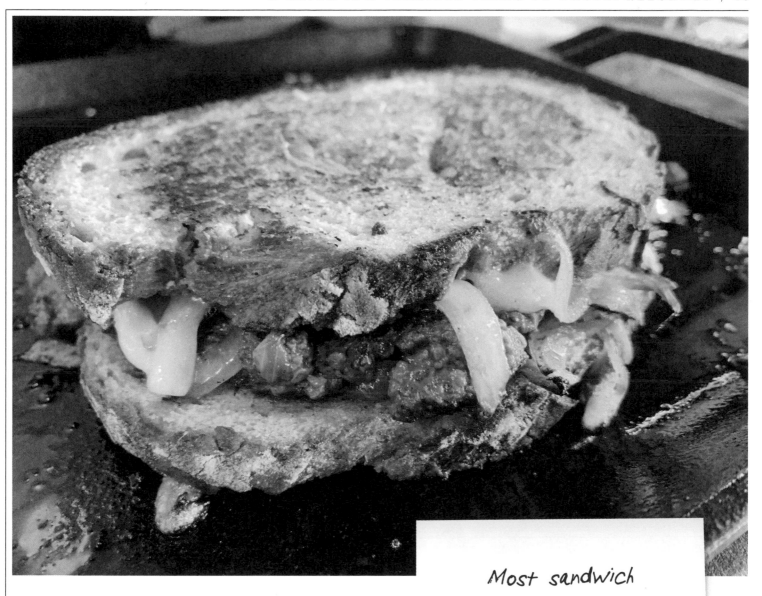

7) Add ½ tablespoon of the butter to the griddle and drop the heat to medium-low. Transfer the sandwich to the griddle and press down to ensure a solid sear. Cover with a metal mixing bowl and cook until the bottom bread is dark golden-brown and crispy, 1 to 1½ minutes. Remove the bowl and scoot the sandwich off to the side of the griddle. Melt the last ½ tablespoon butter, then carefully flip the sandwich over onto the butter so that the un-seared bread gets the heat. Re-cover with the bowl and cook for another 1 to 1½ minutes. Remove the bowl, transfer the sandwich to a cutting board, and cover with the bowl yet again and allow the sandwich to rest for 1 minute. Trust me, this time is necessary for the sandwich ingredients to meld.

8) Bifurcate and devour.

Most sandwich historians agree that the patty melt was born at an L.A. drive-in called Tiny Naylor's, sometime in the mid-1950s.

FRY HARD I: RELOADED

Our first foray into the art of the fry, produced in the spring of 2000, focused on a dish that exemplifies two distinct methods: fish-and-chips, which features a batter-fried item along with the foundational building block of the American diet—the chip, aka the French fry. I also thought this would leave me just enough time to get in some science to hopefully assuage the fears of home cooks who would never think of deep-fat frying for themselves.

Turns out people have very strong ideas about batter-fried fish. Online comments were not kind; some felt the batter too thin, others too thick, while some rejected the entire dish as not being "authentic." After tinkering with the application for a couple of years, I decided the problem was that I really didn't want fish-and-chips at all. What I wanted, as a child of the '60s, was fish sticks and fries, and that's another thing altogether. As for the "chips" themselves, back then I promoted the double-fry method, which requires frying first at a lower temperature (blanching), then finishing at a higher temperature. The results were satisfactory but so time-consuming and messy that I abandoned the process altogether. A few years ago, I stumbled onto a new method that changed my world, and that's the one you'll find below. But first, let's reload the frying process in general.

FRYING

Frying is a perfect "dry" cooking method because hot oil can conduct heat to the entire surface area of the food at the same time, and, when done properly, very little of the fat is absorbed in the process.[1] And lest we forget, frying facilitates the manufacture of Maillard Reaction Products (MRPs), a long and delicious list of colored and volatile flavor molecules created as heat drives sugars and amino acids to react with one another. (Some of these products, such as the melanoidins, put the "golden brown" in "golden, brown, and delicious.") Effective frying depends on a lot of factors, from the size of the food, to the depth of the vessel, to the exact composition and temperature of the oil. In this episode I used a model train to discuss the difference between saturated and unsaturated fatty acids.

THE THREE FATTY ACID TRAINS

The original idea for the "fat train" was to show hydrogen riding in a "polyunsaturated" car that had gone rancid because the empty seats had been taken by stinky molecules.

The train thing is a fairly decent metaphor, but, as is the case with so many *Good Eats* science models, in an effort to communicate the basics I left out details because they either didn't fit the model I could afford or took too much screen time to convey. (I'm also a firm believer in the theory that when watching TV, people will gladly swallow three new facts but if you try to force in a fourth, not only will they balk, they spit up the other three.) So here are two things I left out and have felt bad about ever since:

1) Although this model makes it look like all fatty acids are straight, they're really not. Every one of those empty

1 Yes, frying is a dry-heat method. Just because it's a liquid doesn't mean it's "wet."

FRYING (continued)

seats I talked about means that there was a double bond to the next carbon, and that means a bend in the shape of the molecule. Monounsaturated fats only have one kink, while polyunsaturated fats have several. These physical shapes explain why fats high in saturated fatty acids are solid at room temperature while those high in unsaturated fatty acids, with their less uniform structures, are liquids. They literally can't pack together as closely. These differences also explain the way these fats act inside the human body, but I don't even play a doctor on TV, so I'll just leave that right there.

2) Fat structures change during frying—a lot. Hydrolyzation, oxidation, and polymerization are the three horsemen of the fry oil apocalypse, working to break triglycerides down into diglycerides, monoglycerides, and free fatty acids (oh my), or bond them together into thick and sticky films. And yet, early on in the process, volatile flavor compounds are produced, which is why great fry chefs never replace 100 percent of their oil with new. The old stuff just plain tastes good. (If it's the right oil. Keep reading.)

WHICH OIL?

Since their carbons are all full up with hydrogen, making their fatty acids straight as laser beams, saturated fats like lard, palm oil, butter, and beef tallow, as well as "hydrogenated" shortenings, made by adding hydrogen to vegetable oils, are solid at room temperature. Their chemical stability means they resist rancidity, which explains their popularity with manufacturers looking to extend the shelf life of their products. Saturated fats can bring flavor to fried goods, and I know a few cooks who add a little beef tallow to their fryers, though never more than 10 percent, because beef tallow foams miserably when food hits it. Shortening, on the other hand, is typically the fat of choice for frying doughnuts, because it solidifies at room temperature, preventing the doughnut from feeling greasy. But for most home frying I stick with liquid oils.

Although the original versions of these recipes called for frying in safflower oil, chosen for neutrality and its relatively high smoke point, in the new versions we've opted for peanut oil, which in its refined state is considered safe for people with peanut allergies.[2] While still low in saturated fats, peanut oil contains a nice balance of monounsaturates, which break down more slowly during frying than polyunsaturates, and linoleic acid, which, although polyunsaturated, enhances that lovely fried-food flavor. For my own home frying I now blend peanut and safflower or, when I can't find safflower, corn oil. Although I often used canola oil for sautéing in early episodes, it contains way too much linolenic acid in it for deep-frying. (It is indeed annoying that the fry-friendly "linoleic" is only one letter away from the fishy-tasting "linolenic.") When perusing the oil aisle of your local megamart, you may notice that "fry oil" blends combine peanut and soybean oil, but I suspect the latter is included for its low price in the United States. I'm not a fan.

The original episode introduced my sister, Marsha, who is in real life the actress Merilyn Crouch. I don't have a sister in real life. I do have a mother and a daughter in real life, but in this episode they were played by actors too.

Merrilyn Crouch reprising her role as Marsha (not my real sister)

2 The allergen is typically in the protein, which is removed during refining. My daughter is allergic to peanuts but is fine with peanut oil. Still, you should always check with your doctor or allergist if you're in doubt.

FISH STICKS

We didn't get too much into the history of fish-and-chips in the original show because no matter what you say, someone is going to disagree. My research (mostly books and journals, as the internet still required a phone modem back then) uncovered little more than amusing apocrypha, though several sources suggested that during the Victorian era, the batter was merely a vessel inside which the fish steamed and wasn't meant for consumption.[3]

Fish sticks, on the other hand, have a well-documented and, for a food nerd like me, fascinating history. In the decade following the Second World War, America witnessed an explosion of technological advancement, industrial innovation, governmental tinkering, and social evolution. The fishing industry grew into a kind of mechanized monster of efficiency, capable of scooping massive amounts of life from the seas with nylon nets and freezing it with new technology that then spurred advances in supermarkets and home refrigeration.

Housewives, looking for faster and easier ways to get good food on the table, slowly turned from the old-fashioned convenience of cans to the space-age allure of manufactured foods from the freezer. Many of the items being marketed were brand-new and therefore suffered a lack of demand until another American industry created it: advertising. The original fish sticks, which hit the market in 1953 accompanied by advertising aplenty, were cut by bandsaw from blocks of frozen fish meat, breaded, fried, then refrozen. The *Wall Street Journal* called fish sticks "the first really new process-

ing development in a quarter century for one of the nation's oldest industries."

I believe that some 90 percent of the protein I ingested during my first seven years of life came from fish sticks, not to mention their fast-food permutation, the Filet-O-Fish™ sandwich.[4] I'd all but forgotten about fish sticks until my daughter and I were watching the reboot of *Dr. Who*, with Matt Smith as the eleventh iteration of the Time Lord. Upon invading the young Amy Pond's kitchen, he discovers he's quite fond of "fish fingers" and custard. My daughter asked me what fish fingers were and I told her that in America they're called fish sticks. She said "Gross," and I said "Delicious!" We bought a box, and they were indeed gross. So, in an attempt to redeem my gustatory childhood, I rebuilt them from scratch.[5]

3 My good friend and culinary historian/explorer Simon Majumdar supports this scenario, though he admits the evidence is anecdotal.

4 Another fascinating history, though often relegated to footnotes like this. The F.O.F. was invented by a Cincinnati McDonald's franchise owner who needed a sandwich to sell to members of his mostly Catholic community on Fridays.

5 Just for the record, my preferred Doctor is the tenth.

FISH STICKS: RELOADED

YIELD:

4 servings
(12 fish sticks)

SOFTWARE

1 pound (454 g) cod fillets[6]

1¼ cups (85 g) panko breadcrumbs,[7] divided

3 large eggs, divided

1 tablespoon (12 g) mayonnaise

1 tablespoon (15 g) Dijon mustard

2 teaspoons kosher salt

1 teaspoon onion powder

¼ teaspoon cayenne pepper

½ cup (70 g) all-purpose flour

1 quart (950 ml) peanut or safflower oil, or a 50/50 combination

TACTICAL HARDWARE

- A heavy Dutch oven (preferably enameled cast iron) in the 5 to 6-quart range
- A clip-on-style deep-frying thermometer[8]
- A spider or other hand strainer to remove the food from the hot oil

PROCEDURE

1) If the fillets are frozen, allow them to thaw in the fridge for 30 minutes or so, then finely chop. If they're already thawed, park them in the freezer for 30 minutes or until firm, then finely chop.

2) Put the fish in a bowl along with ¼ cup of the panko, one of the eggs, the mayonnaise, mustard, salt, onion powder, and cayenne pepper. Combine thoroughly with your hands or a large spoon.

3) Shape the fish mixture into 1½-ounce finger-shaped sticks. Set on a sheet pan and refrigerate for 30 minutes to firm.

4) Beat the remaining 2 eggs in a shallow pie pan and place on the counter between two other pie pans, one containing the flour and the other the remaining 1 cup panko.

5) When the fish sticks are firm, roll each stick in the flour, knock off the excess, then dip in the egg. Drain, counting to three, and follow with a roll in the panko. Place the breaded pieces back on the sheet pan and let them rest while you move on to step 6.

6) Pour the oil into the Dutch oven, attach the thermometer, and bring to 350°F over medium-high heat. Line a half sheet pan with paper towels, then place a wire cooling rack upside-down on the paper towels.[9]

7) Fry half of the fish sticks until they're golden brown, about 2 minutes.[10] Using a spider, transfer to the prepared rack. Repeat with the remaining fish sticks. Serve hot with your favorite tartar sauce (see recipe on page 123).

6 If sustainability is a concern, look for farm-raised Atlantic cod or wild-caught Pacific cod. If you don't have access to cod, haddock or pollock will do just fine.

7 Do not attempt to substitute regular or "Italian" breadcrumbs. Panko or Japanese breadcrumbs are a completely different beast, and we need their jagged shape to pull off a decent crust.

8 I prefer a clip-on alcohol column style of thermometer over spot-checking with a digital instant-read because it's a better tool for spotting the trend of the heat—that is, the speed at which it's rising or falling.

9 I've long been convinced that putting the paper toweling directly in contact with the wire of the rack is more efficient at wicking oil away from the food.

10 If you want to be a stickler for doneness, you can use your instant-read thermometer to check the interior, which should be at or around 145°F.

CHIPS, AKA FRENCH FRIES

As previously stated, French fries are my favorite food on Earth, and although I can and do enjoy them at just about any restaurant that will serve them to me, I hold fast to the belief that one should be able to prepare one's favorite food in the comfort of one's own kitchen.[11] Ergo, I've made a lot of fries and I have made a lot of big, greasy messes while trying to make fries. But no more. Instead of double frying, I bake, then fry. Here's why.

The russet potato is basically a fuel tank full of starch granules and water. Baking is a gentle cooking method that slowly allows the water inside to heat and then be taken in by the swelling starches. Around the same time, pectin, the glue of the plant world, loosens, allowing the starch granules to separate, resulting in the characteristic we call "fluffy." If allowed to chill afterward, some of the gelatinized starches eventually revert to crystalline form, a process known as "retrogradation." When this happens, the potatoes can be cut into various shapes. When you fry these, you'll notice there won't be a huge eruption of steam the way there is with raw fries. That's because so much of the water inside them has become tied up by the starch molecules. Less steam means the hot oil makes more uniform contact with the fries and that results in more even browning. And last but by no means least, since the interior is already cooked, our fry is all about the golden brown and delicious. And, since the spuds are already cooked when they go into the oil, there's very little of the foaming and boiling over that can be experienced with raw potatoes. The only potential downside is that if you want fries tomorrow you need to have bakers today.

11 Back in 2019 I made a note that if a terrible pandemic were to strike the planet, I'd hate to be deprived of decent fries. Ironic . . . don't you think?

BAKED POTATO FRIES: RELOADED

YIELD:
4 servings (You and I both know it's actually one serving, don't we?)

SOFTWARE

3 large russet potatoes,[12] scrubbed and rinsed

2 teaspoons (10 ml) safflower or vegetable oil,[13] plus 2 quarts (1.9 L) for frying

1 tablespoon kosher salt

Freshly ground black pepper

TACTICAL HARDWARE

A heavy Dutch oven (preferably enameled cast iron) in the 5- to 6-quart range

A clip-on-style deep-frying thermometer (see footnote 8, page 49)

A spider or other hand strainer to remove the food from the hot oil

PROCEDURE

1) The day before frying: Heat the oven to 350°F and position a rack in the top half of the oven. Set an empty sheet pan on a lower rack.

2) Using a dinner fork or paring knife, poke several holes in the potatoes to allow water vapor to escape during cooking. Coat each potato lightly with 2 teaspoons of the oil and sprinkle generously with the salt.

3) Bake the potatoes directly on the oven rack until tender or until an instant-read thermometer inserted into the center of a potato reads 185°F to 195°F, 45 minutes to 1 hour. Cool to room temperature and then refrigerate overnight, unwrapped if possible.

4) The next day, pour the 2 quarts oil into a large Dutch oven fitted with a deep-frying thermometer. Heat the oil over medium-high heat to 375°F. As the temperature crosses 350°F, turn down the heat to medium so that you don't shoot through the target temp. Line a rimmed baking sheet with paper towels, then top with a wire cooling rack.

5) Meanwhile, slice the cold potatoes into ½-inch-thick batons, leaving the skin attached. Boost the heat back to medium-high. Add 8 to 10 fries and cook until golden brown, 2 to 3 minutes.[14] Adjust the heat to maintain the oil temperature at 375°F. Use a spider to fish the fries from the oil to the prepared rack. Sprinkle with

additional salt, if desired, and the pepper.

TIP

Like any decent fry cook I reuse my oil. Having cooked both these applications, I would cool the oil and then strain the leftover oil through two folds of cheesecloth set into a fine-mesh strainer. I'd seal the oil tightly (probably in its original container) and use it two more times, cooling and filtering after each use. After three sessions I'd cool and filter and then pour off 50 percent of the old oil and replace with new. As for getting rid of that old 50 percent, let it cool to room temp and then pour into an old milk carton or other containment, seal it, and throw it away with your trash. If you have more than a gallon, you can consider giving it to a recycler for conversion into bio fuel. Do not pour it down the drain (fatburgs are real) or out in nature.

12 No, you cannot use boiling or "red bliss" potatoes. Those are for potato salad and that's another show.

13 You can use peanut oil or a combination of peanut and safflower.

14 Since the fries have already been cooked by baking, there won't be as much bubbling and foaming in the oil, which is nice. Even better: The fries will be ridiculously crisp on the outside while still creamy-soft on the inside.

FRY HARD II: RELOADED

Once upon a mid-morn dreary, as I pondered with eyes quite bleary,

Over many a curious volume of culinary lore,

On a latte I was sucking, and yet suddenly there came a clucking,

As if some salesman were a-mucking, mucking 'bout my kitchen door.

"'Tis some salesman," said I. Only this and nothing more.

And yet presently the noise repeated. So, I hollered, no longer seated,

"Beat it, pesky husker, mucking about my kitchen door."

"At my business I'm now working, so my chain you'd best stop jerking."

Then throwing wide the kitchen door, I found there a chicken and nothing more.

Leapt I back then with a stutter, as the phantom bird did with a flutter

Mount the folk-art bust of Julia Child there upon my kitchen floor.

Perched and sat and nothing more.

Then the pallid poultry most perplexing did set my meager mind to guessing . . .

"From whence did you come to perch upon the bust of Julia on my kitchen floor?"

Quoth the chicken, "Fry some more."

Boy, did I think I was clever with that opening scene. But looking back, that's about the only thing I didn't end up changing when we reloaded the episode. The subject was fried chicken, pan-fried chicken to be exact, a very specific method preferred and preserved in the cuisines of the American South. Unlike deep-fried chicken, pan-fried chicken features a more restrained and (for the lack of a better term) shell-like breading that's punctuated with blackened bits where the breading touches the bottom of the cast-iron skillet. In other words, this is not your Colonel's chicken. Well, you certainly let me know that despite being delicious, this WAS NOT THE CHICKEN YOU WANT. You want deep-fried chicken with lots of crusty crunchiness. And I get it. There is a scientific reason for your desire. Our brains like contrast, which is probably why crème brûlée is one of the most popular desserts on the planet. Deep-fried chicken, with its super-crunchified golden exterior and buttery soft, meaty interior; is kind of perfect in the same way. But procedure-wise, deep-frying changes things. And frankly there were a lot of things I wanted to change anyway.

THE BIRD

One thing I wouldn't change is the bird, and yet the bird changed on us, or at least the packaging did. Once upon a time, the perfect frying chicken was packaged and sold as a "broiler/fryer," but today the term is rarely used, and when it is, it isn't applied consistently. Luckily, age is relative to weight, so let's just say that for deep-frying (which is a faster method than pan-frying) you're going to seek out a chicken in the 4- to 5-pound range. Anything bigger will be old enough to have developed the kind of connective tissue that necessitates longer cooking methods such as roasting or even stewing.

BUTTERMILK

One thing we're holding over from the original procedure is buttermilk, and for two main reasons. First and foremost, its viscosity makes it an ideal substrate, a primer if you like, for holding on to and hydrating the breading. The second reason is acidity. Cultured buttermilk typically hits the pH scale between 4.4 and 4.8, so it's acidic, though not as much as even the average cola, which has a pH around 2.5.[1] Acidic foods don't brown as well (or as quickly) as alkaline foods, which is why we boil pretzels in a solu-

tion containing lye, which has a pH of 14.[2] This means buttermilk retards browning reactions in the breading, preventing the outside of the chicken from browning too deeply before the chicken inside can cook through. However, this time we are skipping the overnight buttermilk soak. I know . . . I claimed in the original episode that "after a night's soak, the acids and sugars in the buttermilk have actually invaded the chicken meat, which is going to give it a nice tangy flavor." While the acidity will indeed affect the meat, I've come to believe that's not necessarily a good thing, as acids can produce both toughness and conversely mushiness in chicken without really doing much in the way of good, or at least not enough to justify an overnight bath. Instead, we're opting for a more strategic approach: microbrining.

Microbrine (n): the small amount of surface brine that is created when fresh meat is sprinkled with salt and left for several hours. During this time moisture, bearing water-soluble proteins, rises to the meat's surface via osmosis. The moisture dissolves the salt, creating a brine that is then drawn back into the meat by diffusion. Also see: magic.

Our new procedure calls for salting and spicing of the meat followed by several hours of just hanging around in the refrigerator. Having fried countless batches of chicken over the last two decades, I truly believe this beats a long buttermilk soak, hands down.

1 Whether something actually tastes acidic or tangy has more to do with titratable acidity than pH, which is a measure of dissociated or "free" hydrogen ions, blah, blah, yakety yak.

2 Lye is extremely caustic. Remember the "chemical burn" scene in *Fight Club*?

KNOWLEDGE CONCENTRATE (*continued*)

DEEP-FRYING

We covered a lot of territory on this subject in the last section, but I do want to point out that deep-frying is far more temperature dependent than pan-frying, which, due to the shallow fat, allows more steam to escape directly into the air, thus having less effect on the temperature of the fat. And since a higher percentage of the fat is actually in contact with the pan, it rebounds a bit more quickly when food enters the picture. Since the food is pretty much surrounded during deep-fat frying, you'll have to ride the heat control a bit more to maintain the target temp, or so experience has convinced me.

THE FRY FAT

Comparing procedures, you may notice I've switched from shortening to peanut oil or a combination of peanut and safflower. My grandmother used shortening for her pan-fried chicken because it was in her kitchen, it didn't stink up the place, and the leftover chicken never seemed greasy. It was there because she used it for biscuits. It didn't smell up the place because it's highly refined and it's a trans-fat, which doesn't tend to break down into aromatics quite as readily as unsaturated fats. As for the lack of greasiness, shortening is solid at room temperature, so once cooled, the chicken didn't seem as "wet" as it would have had it been cooked in an oil that's liquid at room temp. The reason I switched out the fat here is that deep-frying requires a lot more fat than pan-frying, and in my experience shortening doesn't recy-

cle nearly as well as peanut oil, which I can buy in gallon containers. For those concerned about peanut allergies, the FDA excludes "highly refined oils" as major allergens, which is why my daughter can have peanut oil–fried food all day despite the fact that if she touches a peanut she blows up like a puffer fish. The key here is "refined." "Cold-pressed" or "virgin" oils are not highly refined and often contain the proteins allergic folks usually allergicize to—and no, that's not a real word. The point here is that just because you can't eat peanuts, don't assume you can't have refined peanut oil. Of course, I'm not a doctor, your doctor is, so talk to that person first. I'm just a cook.

OTHER CHANGES WORTH POINTING OUT

We've added cornstarch to the flour dredge in order to up the overall percentage of amylose, a starch molecule that when cooked forms glass-like structures that enhance crispness. And, since cornstarch doesn't contribute to gluten formation, it can increase crispness without becoming chewy. We've also added an egg to provide stabilizing protein, to enhance color, and to reduce oil uptake.[3] Sumac has been added to dynamize the flavor, as has bourbon, because . . . bourbon.

SUMAC

We're not talking about the poisonous bush that grows in the southern United States, but the fruits of a Mediterranean bush in the cashew family. Its flavor is earthy yet tart and was used to bring acidity to Middle Eastern dishes in the days before the Romans brought lemons to the party.[4]

3 Egg whites in particular are good for blocking oil absorption.

4 There is also sumac grown in the States that is not poisonous and produces fruits very similar to the sumac grown in the Mediterranean.

CHICKEN DISASSEMBLY

There are thousands of videos on the interwebs that will show you how to disassemble a chicken, and many feature a chef's knife in use. I prefer a rigid boning knife, as the gentle curve helps to cleanly cut through skin and connective tissue and a thin blade makes maneuvering joints a cinch. I also use a pair of shears.

1) Use the tip of the boning knife to cut around and remove the wishbone.

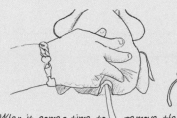

When it comes time to remove the breast lobes, this will really get in the way! Take it out first!

2) Pick up the bird by the wing, and let gravity loosen the wing joint. Then slice through from the back. Tip: Always slice— don't stab. Use the curved tip to get into tight/tricky spots.

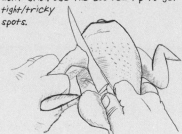

3) Push the leg away from the breast, pulling the skin taut, then slice through, following the line of the pelvis. Repeat on the other side.

4) Once you've cut through the skin between the legs and the body, turn the bird over and pull back on the leg quarters to dislocate the hip joints.

5) With the hip joints out of commission, you can easily bend the leg quarter back and slice to remove. And yes, repeat on the other side.

6) To separate the thigh and leg, squeeze them together to push the joint. Carefully slice into the joint just until you feel it give way.

7) Move the leg quarter back to the board and finish the cut, separating the leg/thigh. Repeat with the other quarter.

8) Use your finger to feel the keel bone running down between the two breast lobes. Slice down one side to the bone, then...

9) ...turn the knife and use the blade to peel the breast piece off the rib cage. (This is when you'll be glad the wishbone is gone.)

10) When the lobe comes off, it ought to look something like this. Repeat on the second side (then save the carcass for the stockpot).

11) If desired, cut each breast lobe across the grain into 2 pieces. Or trim off the "tender" (odds are it will easily pull away from the underside). Then slice the remaining piece lengthwise— with the grain.

FRIED CHICKEN: RELOADED

YIELD:

Serves 4, or maybe 2? Definitely 1 . . . depending

SOFTWARE

1 (4- to 5-pound/1.8 to 2 kg) chicken, cut into 10 pieces (see page 55)

2 tablespoons (18 g) kosher salt

1 tablespoon freshly ground black pepper

1 tablespoon ground sumac

1 teaspoon cayenne pepper

2 cups (240 g) all-purpose flour

2 tablespoons (18 g) cornstarch

1 cup (237 ml) low-fat buttermilk

1 large egg

2 tablespoons (30 ml) bourbon[5]

2 quarts (1.9 L) safflower or vegetable oil

TACTICAL HARDWARE

- Kitchen shears[6]
- Metal cooling rack, ideally paired with a half sheet pan of the same size
- A 5- to 6-quart Dutch oven
- A clip-on-style deep-frying thermometer[7]
- A digital instant-read thermometer for checking doneness of meat
- Spring-loaded tongs (helpful for moving bird parts around)
- Spider or other metal strainer for retrieving bird parts

PROCEDURE

1) Set the chicken pieces on the cooling rack set over a half sheet pan and sprinkle on all sides with the salt. Set aside at room temp for 1 hour.

2) Combine the black pepper, sumac, and cayenne in a small bowl. Sprinkle the chicken on all sides with the spice mixture, then refrigerate, uncovered, for at least 4 hours or up to overnight.

3) When ready to cook, remove the chicken from the refrigerator. Whisk the flour with the cornstarch in a large bowl. In a second bowl, whisk together the buttermilk, egg, and bourbon.

4) Dip the chicken into the buttermilk mixture, drain briefly, then dredge in the flour mixture. Use your fingers to massage the flour coating onto the chicken.[8] Return the coated pieces back to the cooling rack and let rest for at least 10 minutes and up to 1 hour at room temperature.

5) Meanwhile, heat the oil to 350°F in a large Dutch oven over medium-high heat, about 15 minutes. Line a rimmed baking sheet with paper towels and place a wire cooling rack upside-down on the paper towels.

6) When the oil is hot, fry the chicken in three batches, rotating the pieces every 3 to 4 minutes, until the chicken is golden brown and its interior temperature is 155°F, about

DP Lamar Owen and me, shooting with "the Beast"

6 Scissors (which have symmetrical finger holes) and shears (asymmetrical holes) are absolutely some of the most powerful multitaskers in the kitchen, and I suggest spending at least fifty bucks on a good pair. Look at it this way: We start using them in kindergarten . . . knives, much later. Just don't run with them.

5 Although I'd argue bourbon needs no reason, it does contain ethanol, which evaporates at a lower temp than water. Using it in batters can result in a crisper crust, but still . . . bourbon don't need no reason.

7 As discussed in the previous chapter, I prefer these to digital models because they make it easier to track the temperature trend—that is, the speed at which the temperature is rising or falling.

8 When it comes time to dredge the chicken in flour, think of it as more of a pressing and squeezing motion than a massage. Or at least more shiatsu than Swedish.

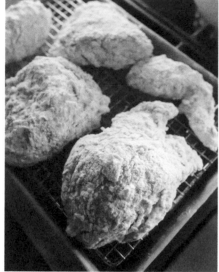

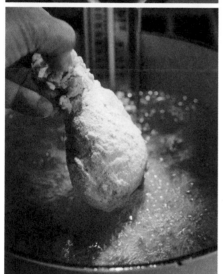

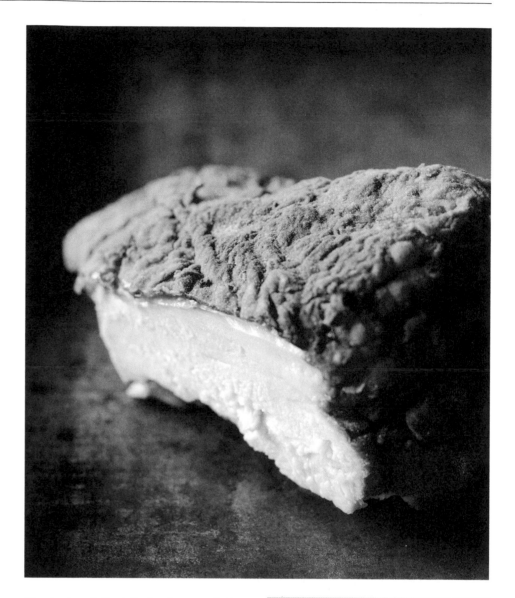

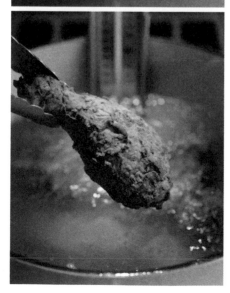

10 minutes. Adjust the heat as needed to maintain 325°F.

7) Rest the chicken on the prepared rack for at least 5 minutes before serving. The chicken is equally good at room temperature as it is hot, so don't worry about keeping it warm between batches. I personally prefer fried chicken at room temperature.

TIPS

>> To help prevent cross-contamination, raw meat should always be stashed on a pan in the lowest section of the refrigerator.

>> Although proper technique can minimize oil absorption in fried food, some oil is always going to get in. So, repeat after me: Frying is not a low-fat cooking method. (But it is delicious.)

>> To reheat fried chicken, place directly onto the rack of a 400°F oven for 5 to 6 minutes. (A pan on the lower rack will catch any crumbs.)

ART OF DARKNESS II: RELOADED

Chocolate is a deep, dark, delectable well into which we oft dipped on the original *Good Eats*. In 2002 we contemplated cacao's arid incarnation, cocoa powder, with a triumvirate of applications: chocolate syrup, hot cocoa mix, and, of course . . . brownies. The first two required but minor retouches; the brownies, however, despite having garnered nearly a thousand positive reviews online, were in need of real renovation.

Scabigail is good at playing herself.

Another day, another science model

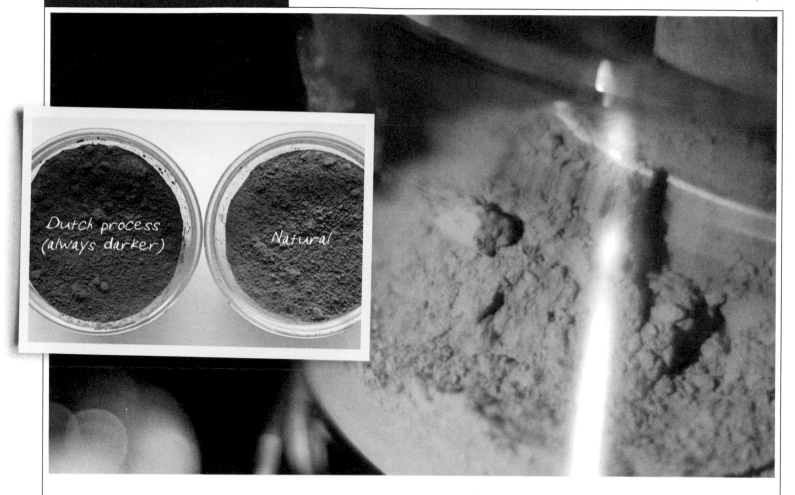

Dutch process (always darker)

Natural

When utilized properly, cocoa powder tastes more chocolaty than chocolate. To understand how this can be possible, we must review how chocolate is made:

1) Once the cacao beans are removed from the ripe pods, they're allowed to dry and partially ferment in open air.

2) After a slow roasting, the outer hulls are removed, revealing the inner nibs.

3) The nibs are then rolled under a heavy stone or metal wheels to produce a brown paste called chocolate "liquor," despite containing no alcohol.[1]

4) The chocolate liquor is squeezed in a press to remove the fat, or cocoa butter. The remaining cake is crushed, and bingo: cocoa powder.

5) If "Dutch-process" cocoa, which is darker, less acidic, and more easily soluble in water, is desired, alkaline salts are added during the pressing stage.[2]

So, cocoa powder is the actual essence of chocolate, at least from a flavor standpoint. But since all the fat is gone, and there's no sugar or milk or anything else to make it, well . . . edible, it's up to us to add things like fat, sugar, and milk.

1 From the time of the Maya to the eighteenth century, this substance was simply mixed with a few spices, frothed into water, and served. This bitter but stimulating brew became so popular with the Spanish settlers in Mexico that women started taking gourdfuls of the stuff with them to mass just to stay awake. When a powerful bishop in Chiapas spoke out about the habit, he was assassinated with poisoned cocoa.

2 We have a Dutch chemist, name of Coenraad Johannes Van Houten, to thank for this extra-dark cocoa powder.

HOT COCOA MIX: RELOADED

YIELD:
5½ cups, enough for around 22 cups of cocoa

By simply toasting the milk powder before adding it to the hot cocoa mix, we can capture a wide array of flavors, including caramel, toffee, and malt. Basically, one extra step creates the best cup of hot chocolate ever.[3]

SOFTWARE

2 cups plus 2 tablespoons (272 g) non-fat dry powdered milk

2¼ cups (260 g) confectioners' sugar

1⅓ cups (105 g) Dutch-process cocoa powder

2 teaspoons cornstarch

1 teaspoon fine salt[4]

1 pinch cayenne pepper (optional), plus more to taste

Hot water, for serving

PROCEDURE

1) Heat the oven to 300°F.

2) Line a half sheet pan with parchment paper and spread the milk powder on it in a thin, even layer.

3) Bake until golden brown and crumbly, about 20 minutes.[5] Remove from the oven and cool. Odds are good the milk powder will be stuck together in lumps, and if that's the case, simply pulse it in a food processor a few times.

4) Transfer the toasted and cooled milk powder to an airtight plastic container and add the confectioners' sugar, cocoa powder, cornstarch, salt, and cayenne, if using. Cover and shake to thoroughly combine. Tightly sealed, the powder will keep nearly indefinitely in the pantry.

For one serving of hot cocoa:

1) Heat ¾ cup (6 fluid ounces) water to a boil, then remove from the heat.

2) Spoon ¼ cup of the cocoa mix into a heavy mug and whisk in ¼ cup (2 ounces) of the water to create a paste.

3) Slowly whisk in the remaining hot water and allow to sit for about 30 seconds, because otherwise you'll scald your face while attempting to chug the deliciousness.

History books tell us that at the height of his power, the household of Montezuma II consumed fifty gallons of hot chocolate a day, every day of the year.

3 Due to milk powder's very specific chemical makeup, it actually starts to brown at a relatively low temperature, around 248°F. Part of that is caramelization. Part is Maillard reactions. But it all tastes good.

4 If, like me, you only have kosher salt, simply blend a few tablespoons to a fine dust in a spice grinder.

5 Toasting the milk powder is technically optional, but personally, I think the flavor is worth it.

TIPS

>> Whenever I need fine salt for pickling or popcorn or whatever reason I just take a cup of kosher for a spin in my coffee/spice grinder for about 30 seconds. Remember, friends don't let friends buy fine-ground salt!

>> If you ask me, hot chocolate should be frothy. Although you can pull this off with a bamboo matcha whisk or even a traditional Mexican *molinillo*, I'm fond of using one of those little motorized milk frothers that are sold for whipping lattes. And no, they're not unitaskers, because they're good for mixing salad dressing, too.

CHOCOLATE SYRUP: RELOADED

YIELD:
3½ cups

Not only does this version of my classic chocolate syrup follow a much simpler procedure than the original, it also features another improvement in the form of black cardamom, which tastes kinda like somebody put a menthol cigarette out in a cup of dark, sweet coffee into which one drop of pine resin had fallen, along with some dirt . . . only in a good way. Basically, it makes the chocolate taste even more chocolaty because it shares some of chocolate's flavor compounds, such as alpha terpinyl formate, alpha-pinene, beta-pinene, and linalool. Black cardamom is harvested from two distinct members of the ginger family, neither of which is closely related to green cardamom, and so are not interchangeable.[6]

SOFTWARE

165 grams (2 cups plus 1 tablespoon) Dutch-process cocoa powder

¼ teaspoon kosher salt

1½ cups (355 ml) water

600 grams (3 cups) granulated sugar

40 grams (2 tablespoons) light corn syrup

1 tablespoon (15 ml) vanilla extract

2 teaspoons finely ground and sifted black cardamom[7]

PROCEDURE

1) Pulse the cocoa powder and salt in the bowl of a food processor several times until smooth.

2) Whisk together the water, sugar, and corn syrup in a medium saucepan and bring to a boil over medium heat.

3) Turn the food processor on and let it run continuously while carefully pouring the boiling-hot sugar syrup down the feed tube. Follow with the vanilla and cardamom.

4) Cool for 15 minutes before transferring via funnel into a large squeeze bottle. Then cool completely before refrigerating for up to 3 months. Or divide into two containers, refrigerating one and stashing the other in the freezer, where it will keep indefinitely. Unless, of course, you come back and eat it the next day.

6 I also use black cardamom in all my chocolate ice creams to help bring out flavors tamped down by low temperatures.

7 After grinding the cardamom finely in a spice grinder, you'll have to sift out the fibrous threads. Yes, it's worth it. Or you can just purchase it in ground form . . . convenient but not quite as flavorful.

First off, let's straighten out some brownie history, which I played pretty loose with back in 2002. Popular food mythology holds that Mildred "Brownie" Schrumpf, who held the post of food columnist for the *Bangor Daily News* from 1951 to 1994, invented the brownie. She never actually made the claim as far as I can tell, but she did argue (often) that the "brownie" was created in Bangor, Maine, in 1912, when a home cook left the baking powder out of a chocolate cake recipe. This may have indeed happened, but what Mrs. Schrumpf may not have known was that the 1906 edition of the *Boston Cooking-School Cookbook* by Fannie Farmer contained a "brownie" recipe (which was really more a blondie, as it contained no chocolate), and that the Palmer Hotel in Chicago had been making brownies for inclusion in their box lunches since the World's Columbian Exposition of 1893.

The oldest recipe I can find in print, however, does come from Maine—Machias, Maine, a good eighty-five miles east of Bangor. Published in 1899 (four years before Brownie was born), the *Machias Cook Book* contains a recipe for "Brownie's Food" that, just to mess with the mind even more, was contributed by one Marie Kelly of Whitewater, Wisconsin. Anyway . . . back to Mrs. Schrumpf: Seems she's credited with the creation simply because her maiden name was Brown and her nickname was Brownie!

And that was probably Brownie's nickname long before she even knew that brownies existed; though one must remember that a brownie is also a form of little elf or hobgoblin from English and Scottish mythology that supposedly helps with house chores. The point is, we have no freakin' idea who actually invented the brownie, but it sure as heck wasn't Mildred "Brownie" Schrumpf.

BROWNIE PAN PREP

As with most baked goods, pan preparation is crucial. This is especially true of brownies, which need to be de-panned while still warm and gooey so they can still be cut before they get crusty on the outside and ornery. Now, you could use a nonstick pan—and we are—and you could use nonstick spray—which we are. But that wouldn't be enough, because even then you could break up during exit. In this case we're using nonstick spray because when freshly sprayed it actually is sticky, at least enough to hold a piece of parchment paper, which in this case isn't so much a nonstick barrier as a physical sling. We're going to use that to lift the brownies out later.

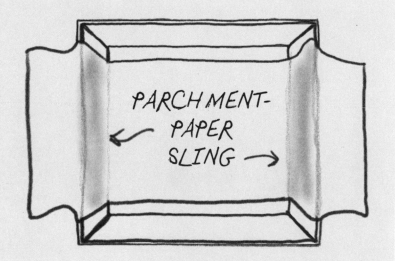

PARCHMENT-PAPER SLING →

BROWNIES: RELOADED

YIELD:
16 brownies

Proof positive that technique is just as important as ingredients, especially when it comes to chocolaty goodness. This is brownie version 2.0—a change-up in the baking procedure creates an ooey-gooey brownie that's quite different from the original. Oh, and we've updated this with weights. I know you say, "No way," but I say, "Yes . . . weigh!"

SOFTWARE

200 grams (1 cup) granulated sugar

170 grams (¾ cup plus 3 tablespoons) light brown sugar

160 grams (2 cups) natural cocoa powder, not Dutch-process

70 grams (½ cup) all-purpose flour

½ teaspoon kosher salt

4 large eggs

226 grams (8 ounces) unsalted butter (2 sticks), melted

2 teaspoons (10 ml) vanilla extract

PROCEDURE

1) Crank the oven to 300°F.

2) Lube an 8-inch square baking pan with nonstick spray. Trim a piece of parchment paper so that it fits just inside the baking pan with a 2-inch overhang on two sides and place it inside the pan. (See the note on pan prep on page 63.)

3) Sift together the sugars, cocoa powder, flour, and salt into a medium bowl.

4) Using a stand mixer fitted with the paddle attachment, beat the eggs on medium speed until fluffy and light yellow, 2 to 3 minutes. (You can also use an electric hand mixer if that's what you've got.) Reduce the mixer speed to low and slowly introduce the sugar mixture, followed by the butter and vanilla. Mix just until smooth and scoop into the prepared pan. (If the batter is too thick to pour, you're doing it right.)

5) Bake for 15 minutes, then remove from the oven and cool for 15 minutes.

6) Return the pan to the oven and bake until an instant-read thermometer inserted into the middle of the brownie reads 195°F, about 30 minutes.

7) Cool in the pan for 30 minutes, then use the parchment as a sling to transfer the brownie to a cooling rack for 10 minutes before cutting into 16 pieces using a pizza wheel or long slicer.

BROWNIE BAKING

The entire goal of baking a brownie, or any cookie—and yes, a brownie is just a big ole cookie—is to coordinate the setting of proteins, the gelatinization of starches, and the hydrating of other carbohydrates, namely sugar and soluble fiber. Getting all of these in alignment during cooking is amazingly difficult and often ends in disaster. However, by pulling the brownies out after 15 minutes and giving them a short rest, we extend the time they spend around the 125°F mark, which appears to help align the three factors, allowing them to complete their respective processes by the time the mass hits 195°F.

TIPS

>> When it comes to sticky, thick batters, I really do like a flexible plastic dough blade for transport. It's a lot faster than a handled spatula because it can conform to the bottom of the bowl. You can really scrape out every little bit of batter, and that is a good thing.

>> My rule is if it's baked, I use natural cocoa powder, because it's sharp enough to cut through the fat and the sugar in those kinds of recipes.

>> I use Dutch-process any time there's not enough fat in the recipe to foil the acid of natural cocoa powder.

>> Cocoa powder and mixes made from cocoa powder will keep a year in the pantry, as long as they're sealed tight and kept away from light. Of course, higher-quality powders—easily distinguished by their higher prices—have more fat, so they're not going to last quite as long. Why? Because fats oxidize.

>> I'd tell you how to store them by stacking them in an airtight container, separating the layers with parchment or waxed paper, and keeping them at room temperature, but you know good and well that isn't going to happen, don't you?

I PIE: RELOADED

The contradicting concepts of flaky and tender have long tortured me.

Many of you took issue with my original lemon meringue pie recipe. The reasons were myriad—runny fillings, rubbery meringues, crusts that cracked and crumbled. Sure, when I made it everything seemed fine, but that does not a good recipe make. Truth is, I'd say it was a pretty crappy recipe, so we redesigned all three phases—crust, filling, meringue—from scratch.

The light, and fluffy, yet finicky and uncooked French meringue has been replaced with a far more stable cooked, Swiss-style meringue. The soft yet sliceable lemony-fresh custard interior is now weep-free, and as for the crust, that's now one of my favorite things ever—flaky, buttery, and sturdy enough to support the entire weight of this device during transfer from pan to serving plate.

The history of lemon meringue pie is unclear. While some believe it to be an invention of the Swiss and others of the English, Philadelphia's own Elizabeth Coane Goodfellow is most often credited with the innovation. The founder of one of America's first cooking schools was known for her "lemon pudding," which she topped with meringue made from leftover egg whites. Although Mrs. Goodfellow would serve the dish both inside and outside a pastry crust, we all know darned well that without a crust, it ain't pie. So, we'll start there.

YIELD:
1 pie crust

THE FINAL PIE CRUST[1]

The lard is out. Its crystalline structure and melting point tenderized the dough, making it far too fragile to support a pie slice on its way to a plate. Going all butter translates to better flavor and color and, since butter contains water, better gluten formation. But the real difference here is the double inverted-pan process, which allows excess fat a way out and guarantees quick and even cooking, thus reducing shrinkage. If you just peruse the procedure, you might think me crazy, but trust me on this: It works, and it isn't nearly as fussy as it reads.

SOFTWARE

113 grams (8 tablespoons) unsalted butter, sliced into ⅛-inch-thick pats[2]

150 grams (1 cup plus 1 tablespoon) all-purpose flour

½ teaspoon kosher salt

¼ cup ice water

TACTICAL HARDWARE

2 identical nonstick, heavy-duty 9-inch pie pans. Yes, you need 2 pans to make 1 crust!

Parchment paper

PROCEDURE

1) Place the butter in the freezer for 15 minutes, along with the pie pans.[3]

2) Put the flour and salt in the bowl of a food processor and combine with a few one-second pulses. Add the butter and process with 10 one-second pulses or until the texture looks mealy and the butter has formed small uniform "pebbles." Drizzle in the water while pulsing until you can no longer see large pieces of butter and the mixture holds together when squeezed in the hand; 5 one-second pulses should do the trick.

3) Turn the dough out onto a sheet of plastic wrap and draw the plastic up around it, squeezing and pressing the dough into a ball. Flatten this into a 1-inch-thick disk, check that the plastic is covering everything, and refrigerate for 30 minutes.

4) Remove the dough from the refrigerator, unwrap, and place on a lightly floured piece of parchment paper. Lightly flour the top of the disk and top with a second sheet of parchment. Roll the dough out into

1 Honestly, when it comes to prebaked crusts, this is it . . . I'm done. You should also use this for the new and improved Sweet Potato Pie recipe on page 395.

2 This crust is formulated for butters with a fat content in the 81 to 84 percent range and water in the 18 to 16 percent range. That is . . . most of the leading supermarket brands.

3 You can use both light- and dark-colored pie plates for this recipe, but keep in mind that the baking time for the pie crust will change dramatically depending on the pie plate you choose. Darker plates will accelerate cooking, so begin checking after the crust has been baking at 375°F for 20 minutes. If you use light metal plates, expect this second baking time to be closer to 30 or 40 minutes.

a circle approximately 10 inches in diameter and ⅛ inch thick. If the dough is too firm to roll at first, give it 5 minutes on the counter to soften, but not much more or the fat may start to melt. That would be a bad thing.

5) Remove the pie pans from the freezer and set one upside-down on the counter. Lay the dough, still between the parchment sheets, over the inverted pan and peel off the top sheet of parchment. Flip the second pan and nest it over the first so that the dough is sandwiched between them. Gently press down to shape the dough. Flip the assembly, remove the top pan, peel away the second piece of parchment, and place the top pan back on top. Invert the pan-dough sandwich and trim away excess dough. Then,

move the crust to the freezer, still upside-down, and chill for at least 30 minutes, or up to overnight.

6) When ready to bake, position a rack in the center of the oven with a second rack just beneath it. Place a sheet pan on the lower rack. Crank the oven to 300°F.[4]

7) Place the inverted pie pans in the oven directly on the top rack and bake for 1 hour. Then crank the oven to 375°F and continue to bake until you can see the edges of the crust turn deep brown, 15 to 20 minutes. Remove from the oven, flip right side up, remove the top pie pan, and cool completely before filling or wrapping in plastic wrap and storing at room temp for up to 2 days.

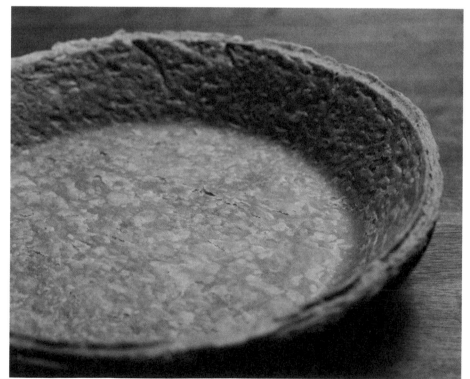

4 Why 300°F? Because with a 1-hour bake, nice and low, we're going to help to reduce the chances of that crust shrinking on us and we're also going to develop great flavor. As for the pan below, that's to catch any fat that might exit the crust, though there rarely is any.

	YIELD:
# LEMON MERINGUE PIE FILLING[5]	Enough for 1 pie

So, this is the part that most of you took issue with, and the issue is that a day after the pie was made, the filling went to goo. The fix isn't in the parts list, though we have made some small updates there for flavor's sake. The real change is in the procedure, and it's all about emphasizing one particular operation. I'll let you know when we get there.[6]

SOFTWARE

280 grams (1 cup plus 6 tablespoons) sugar, divided

4 large egg yolks (save the whites for the meringue)

37 grams (¼ cup) cornstarch

355 milliliters (1½ cups) water

¼ teaspoon kosher salt

118 milliliters (½ cup) fresh lemon juice

10 grams (1 packed tablespoon) finely grated lemon zest

45 grams (3 tablespoons) unsalted butter, cubed, at room temperature

TACTICAL HARDWARE

- **A reliable instant-read thermometer**

PROCEDURE

1) Put 140 grams of the sugar in a medium bowl, along with the egg yolks and cornstarch, and whisk until very smooth and thick, 2 to 3 minutes.[7] Set aside near the cooktop. Place a fine-mesh sieve over a second medium bowl and place next to the first bowl.

2) Combine the water, salt, and the rest of the sugar in a medium saucepan and place over medium-high heat. Cook, whisking frequently, until the mixture hits 160°F, 2 to 3 minutes. Whisk in the lemon juice and zest and remove from the heat.

3) Slowly ladle about one-third of the hot mixture into the egg mixture while constantly whisking the latter.[8] (The mixture will be quite thick at first.) Once the hot mixture has been

incorporated, reverse the flow, whisking the now-tempered egg mixture back into the saucepan. Return the pan to medium-low heat and cook, whisking constantly, until the filling begins to thicken and bubble, 3 to 5 minutes. Continue to cook until the mixture begins to turn translucent and registers 200°F, 1 to 2 more minutes.

Ah, now we reacheth the crux. The all-important thermal destination, the importance of which I will stress by interpolating the relevant information into a piece of dialogue all Monty Python fans will understand . . .

For shalt thou not count, neither count thou 199 degrees, excepting that thou then proceed to 200 degrees. 205 degrees is right out. Once the number 200, being the two hundredth degree of temperature to be reached, lobbest thou the filling into the sieve positioned over the clean bowl.

In other words, it really needs to be 200°F, and if I were you, I'd do what I say.

4) Immediately pour through the prepared sieve into the clean bowl to strain out any rogue bits of egg that may have coagulated when we weren't paying close enough attention. Once strained, whisk in the butter, a few cubes at a time, until smooth. (Let each addition completely incorporate before adding the next few cubes.) Pour into the cooled pie shell and allow to cool completely before making the meringue, 2 to 3 hours.

5 Technically, this filling is a curd and not a custard, because it's based on sugar, eggs, and butter rather than milk.

6 Oh, and I should mention that this procedure has changed yet again since we filmed the reload; I don't think this procedure exists anywhere but in these pages.

7 The mixture will be very thick at first, but it will smooth out before 3 minutes are up.

8 Many of you will recognize this procedure as "tempering," wherein we slowly add a hot liquid to an egg mixture to slowly bring up its temperature before adding it back to the pot. This is to guard against curdling the eggs.

THE MERINGUE (AND FINAL PIE ASSEMBLY)

YIELD:

Enough for
1 pie,

with some left over for
just licking out of the bowl
like the animal you are

Our original pie was topped with a French meringue—that is, a raw foam composed of nothing but egg whites, sugar, cream of tartar (to assist the denaturing of the egg proteins), and air. This is the simplest of all meringues, and using it on a pie is a real mistake unless you plan to eat the entire pie right away. That's because the attraction that the sugar has for the water in the walls of all those little bubbles just isn't as strong as gravity, and so, within hours, the liquid will start to weep out of the meringue. The solution: a Swiss meringue, which has us cooking the mixture before whipping. A bit denser than a French meringue, the Swiss derivation is stable and capable of holding its own for at least a week in the fridge.[9]

SOFTWARE

4 large egg whites (reserved from harvesting the yolks for the filling)

125 grams (½ cup plus 2 tablespoons) sugar

½ teaspoon cream of tartar

¼ teaspoon kosher salt

TACTICAL HARDWARE

- **The instant-read thermometer from above**

- **A stand mixer. In a pinch you could use an electric hand mixer and a metal mixing bowl, but the process will take a good bit longer.**

- **A hardware-store propane torch[10]**

PROCEDURE

1) Place a folded kitchen towel in the bottom of an 11-inch straight-sided sauté pan or large skillet and add 1 inch of water to the pan.[11] Put over medium-high heat and bring to a bare simmer: 190°F. You will see steam and tiny bubbles, but the bubbles shouldn't rapidly break on the surface.

2) Meanwhile, whisk the egg whites, sugar, cream of tartar, and salt together in the bowl of a stand mixer until smooth and foamy, about 30 seconds. Place the bowl on the kitchen towel in the hot water, tilting the bowl as needed. Whisk constantly, until the mixture reaches 165°F, 5 to 10 minutes.[12]

3) Mount the bowl onto your stand mixer, install the whisk attachment, and beat on high speed until soft peaks form, about 1 minute. Reduce the speed to medium and continue beating until stiff peaks form, 3 to 5 minutes more.

4) Top the pie with the meringue, making sure to spread the meringue all the way to the edges of the crust. If desired, use a spoon to create swirls and waves in the meringue. Finally,

use a culinary or propane gas torch[13] to brown the top, if desired, and you know you do because who doesn't want to torch a meringue?

5) Cut the pie or just eat the whole thing. If there are leftovers cover the pie pan with a mixing bowl instead of plastic wrap, which will just stick to the meringue and make a mess.

9 The third common meringue is an Italian meringue, which is made by drizzling a very hot sugar syrup into the egg whites as they're whipped. Italian meringue is highly stable but also quite dense and best reserved for other uses.

10 Honestly, those little refillable culinary models sold at kitchen stores as "crème brûlée torches" just piss me off. Plus, other than lighting cigars, they have no secondary use. With a real torch in the house, you can braze pipes, char wood for crafts projects, and do a thousand other awesome things.

11 The towel is there as a buffer, preventing the bowl from sitting directly on the bottom of the pan. As long as there's an inch of water there's no danger of setting the towel on fire. So, don't skip the water.

12 This is another case where I really mean it . . . 165°F!

13 Propane gas torches are highly flammable and should be kept away from heat, open flame, and prolonged exposure to sunlight. They should be used only in well-ventilated areas. Follow the torch manufacturer's instructions for use.

TRUE GRITS: RELOADED

Coproducer Jim Pace as my attorney

I feel I have unfinished business with a few of my early episodes, and never was that more the case than with "True Grits," a 2004 episode in which, despite making some tasty vittles, I got darn near everything wrong. I was obsessed with the idea that grits and polenta are essentially the same thing, rendered different by technique alone. Although process is indeed important to the distinction, so are historical precedent, cultural relevance, botanical reality, and chemical fact. So, I want to make my position on the matter clear, even if others disagree with me, which they often do anyway.[1]

1 Truth is, the more I read on the subject the more I'm certain that no one agrees on the subject . . . it's just too multifaceted.

Legally, grits can be marketed as polenta and vice versa. Both are (typically) dry field (as opposed to sweet) corn, ground to various degrees of fineness, simmered in a liquid to produce a porridge. So, what are the differences between the two, other than the fact that one is associated with the American South and the other with a boot-like land mass on the other side of the planet? Well, it's an interesting story.

Corn, or more exactly *maize*, was unknown in Europe before the discovery of the New World. And yet there was polenta. That's because before the sixteenth century, Italians made polenta from other grains, including buckwheat, spelt, even chickpeas. When the European "conquerors" of the lands now known as "the Americas" found indigenous people living on a "new" grain, maize (*Zea mays*), they didn't pay any attention to the details of how it was processed. They may have seen maize being soaked in hot water spiked with *cal*, aka "slaked lime," but cared not. After all, back home they had sophisticated milling technologies that could reduce grains like wheat, rye, and spelt into meal, or even flour. And so maize, which grew very nicely in southern Italy, became the go-to polenta grain, a panacea for the poor, many of whom became dependent on it for a majority of their calories. As a result, many of these people died of pellagra, a particularly nasty disease caused by a deficiency of niacin, the symptoms of which are known as the "four d's": dermatitis, diarrhea, dementia, and death.

If only those smarty-pants European "conquerors" had paid better attention, they might have learned about nixtamal. A mashup of the Nahuatl words for "flour" and "ash," nixtamal is the product of nixtamalization—that is, adding calcium hydroxide, aka slaked lime, aka cal, to the hot soaking water, thus raising the pH of the grains and introducing calcium to the mix. Physically and chemically, this turns maize into a whole new food. The kernels swell, hemicellulose in the cell walls converts to soluble gums, lipids undergo saponification, starches partially gelatinize, and lo and behold, a wealth of niacin (thanks to interactions with calcium) becomes available to the humans who eat it. The resulting product, known to many as hominy, can be ground into a dough, masa, that holds together when kneaded, which is why you can make tortillas out of it, something you can do with no other corn product. When hominy is dried, then ground in a mill, you get a product that is essentially a hybrid of New and Old World food tech.

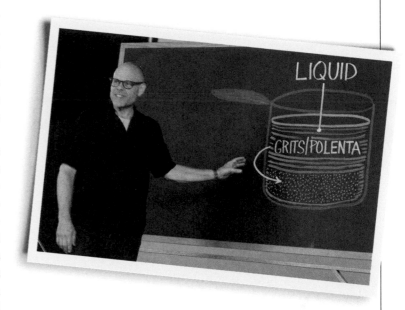

Vinny Gambini: What is a grit, anyways?

Cook: It's made out of corn. Them hominy grits.[2]

Thank you, *My Cousin Vinny*, for providing me with such culinary clarity. And thus, I derive my conclusion: Grits are made from hominy. If the porridge in question is made instead from non-nixtamalized corn, it is polenta. If you happen to be preparing breakfast in the southern United States, you are free to call polenta "grits," but I scoff. If, by the way, you cool your polenta and cut it into pieces, that's *cornmeal mush*, and that's another show. The size of the grind doesn't matter. The color of the corn doesn't matter. If you're a cornmeal processor, you are legally free to call your product whatever you like, but as far as I'm concerned, no hominy, no grits. The horrible irony here is that when cooked correctly, grits aren't actually gritty, while polenta, to me at least, always is . . . at least a little.

Go ahead . . . come at me. I can take it.

The added bonus, of course, it that due to nixtamalization, hominy grits can be cooked to a much creamier consistency than polenta, which requires the addition of cream and cheese and the like to come across as "creamy."

2 *My Cousin Vinny*, directed by Jonathan Lynn (1992; Los Angeles, CA; 20th Century Fox).

SHOPPING

Believe it or not—all four of these samples are sold as cornmeal and grits!

Although the internet is probably the best place to land top-quality cornmeal for polenta or ground hominy for grits, you may be able to dig some up at the local megamart as long as you're willing to do a little bit of reading. If the package bears the words "quick" or "instant," just walk away. These are overprocessed goods and cannot be trusted. What you do want to see are the words "stone ground." Most stone-ground meals are whole grain and as such, contain the fatty germ of the kernel, which will eventually go rancid. So, either use them quickly or contain them in a heavy, zip-top freezer bag and store in the freezer. Many southern, "artisanal" brands come to market in folksy cloth bags. These do nothing to slow rancidity, so I always place the cloth bag inside a zip-top, even if I plan on cooking them right away. Also, keep an eye out for an expiration date that's at least six months after the date of purchase. I treat polenta the same way, not to mention the coarse cornmeal I keep for dusting my pizza peel.

Enough talk, we cook.

Colonel Boatwright got an updated look with a new eye patch.

GRITS OR POLENTA: RELOADED

YIELD:

4 servings

This time around, I'm cooking these two (very different) corn products exactly the same way, resulting in two perfectly tasty bowls of corny goodness.

SOFTWARE

4 cups (946 ml) cold water; *or* 2 cups (473 ml) water and 2 cups (473 ml) whole milk[3]

1 cup (147 g) stone-ground grits or polenta (we'll refer to either as "meal" going forward)

1½ teaspoons kosher salt

4 tablespoons (57 g) unsalted butter, cubed

TACTICAL HARDWARE

A fine-mesh sieve

The word grits comes from the Old English grytt, meaning coarse meal. Polenta is related to the Old English polente—which comes from the Latin polenta, meaning peeled barley—and the Latin pollen, meaning mill dust. English borrowed polenta again from the Italian in the nineteenth century.

PROCEDURE

1) Add the water to a medium saucepan, then stir in the meal and salt. Allow to sit, off heat, until the meal has settled to the bottom and any chaff has risen to the top, about 5 minutes. Use the sieve to skim as much of the chaff as possible from the surface of the water.

2) Place the pan over medium-high heat, bringing the water to a simmer while whisking frequently. Continue to simmer, and whisk until the meal

has released enough starch so that the individual particles are suspended in the water, 5 to 7 minutes. Reduce the heat to low, cover, and cook, stirring every 5 minutes, until the meal is cooked, about 1 hour.

3) Remove from the heat, whisk in the butter, and cover until ready to serve. (You can let it sit this way for up to 1 hour before serving. If held longer than 1 hour, you will need to add warm water, 1 tablespoon at a time, to loosen up the grits/meal.)

3 I prefer water alone, because I think it produces the cleanest corn flavor. Milk, while certainly "creamier," conceals that a bit. But I include it here as a possibility because everyone else seems to really like it.

ALL-CORN CORNBREAD: RELOADED

As far as I'm concerned, both polenta and grits are best when they work together. This is the corniest cornbread I can make.

SOFTWARE

85 grams (½ cup plus 1 tablespoon) stone-ground white hominy grits

225 grams (1½ cups plus 1½ table-spoons) stone-ground yellow cornmeal

1½ teaspoons kosher salt

2 teaspoons baking powder

½ teaspoon baking soda

2½ cups (591 ml) low-fat buttermilk

2 large eggs

3 tablespoons (42 g) unsalted butter, cubed

TACTICAL HARDWARE

- A well-cured 10-inch cast-iron skillet
- Parchment paper
- Wire cooling rack

PROCEDURE

1) Position an oven rack in the lower third of the oven. Place the skillet on the rack and crank the oven to 450°F.

2) Spin the grits in a blender on high speed for 30 seconds.[4] Transfer to a large bowl and add the cornmeal, salt, baking powder, and baking soda. Set aside.

3) Thoroughly combine the buttermilk and eggs in a large measuring cup. Add this wet mixture to the dry cornmeal mixture and whisk until smooth.[5]

4) Open the oven and pull out the rack with the skillet. Swirl the butter around the bottom and sides of the skillet, then dump the butter into the batter bowl. Stir to combine, then quickly pour the batter into the pan. Jiggle the skillet to evenly distribute the batter, then slide it back into the oven.

5) Bake until the cornbread is golden brown and springs back when touched, 25 to 30 minutes. An instant-read thermometer inserted at the center should read 200°F to 205°F.

6) When the bread hits between 200°F and 205°F, remove from the oven. Place a piece of parchment paper over the skillet and top with an upside-down wire cooling rack. Then carefully flip over so that the cornbread releases from the pan onto the parchment on the rack.

7) Cool for at least 10 minutes, then consume hot with butter and a glass of cold buttermilk on the side if you know what's good for you.

4 If it's possible with your model, start at low speed and slowly increase the speed to high.

5 Fans of *Good Eats* are used to me instructing to do this quickly . . . 10 strokes at most, then walk away. Well, that doesn't apply here, because there's no wheat flour in this mixture and therefore no possible gluten, ergo overmixing isn't much of a danger.

DENT VS. FLINT CORN

Most of the corn we grow in the United States is dent corn, and it is what is traditionally used in the manufacturing of grits. Each kernel's got, fancy that, a dent in it. On the other hand, flint corn is often grown in Italy and is traditionally used to manufacture polenta. It, well, doesn't have a dent in it. They look different on the outside and are even more different on the inside.

There are two basic types of starch on the inside of corn. We have the hard starch, or hard endosperm, and the soft starch, or soft endosperm. As you can see, flint has a very large amount of the hard endosperm, while dent corn has a much higher amount of the soft endosperm. Now, what's really bizarre is that when polenta from flint corn is property prepared, it is actually grittier than grits made from dent corn.

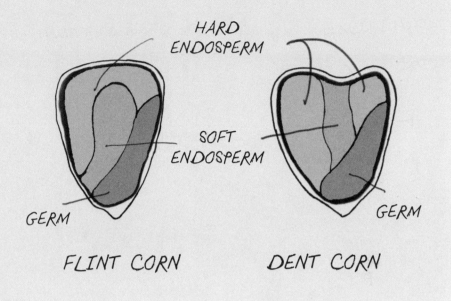

STARCH

When ground corn, be it grits or polenta, goes into water, it just sinks, and if we leave it down there without stirring, when we add heat, we'll end up with one giant disk-shaped blob. By constantly agitating while heating, we help to hydrate the free starch available from the endosperm and produce a liquid phase akin to a pudding, in which the swollen corn nuggets are suspended. Think of it as a kind of pudding that must be stirred to thicken. Once we reach that phase, after about 5 minutes of heating, you'll notice that the liquid will thicken, and if you look closely, you'll see that the individual grains are actually suspended in a thickening gel. And yes, that is definitely a gel, just like pudding. Now the heat can be reduced, and you can cut back on the stirring, regardless of what all those Italian cookbooks say.

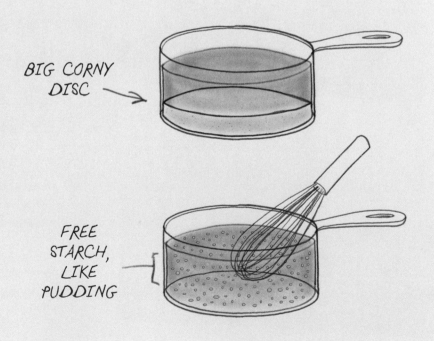

A BIRD IN THE PAN: RELOADED

Key grip Marshall Millard, who played an agent starting in 1997

The goal of the original episode was to help viewers get a simple roasted chicken on the table, a goal not fully realized due to the fact that it was only our fifth show, and I thought a long ingredient list would make me look like I was working harder. Over the decades that list has shrunk considerably. The gremolata has been replaced with Middle Eastern spices that were virtually impossible for average American cooks to get their hands on back in '99. A drying period has been added to increase skin crispness. And since broiler performance differs wildly between different makes and models, we now make our own.

THE BIRD

In 2017, the USDA modified the definitions of five poultry classes to reflect current industry practices and standards. Across each category, age standards were lowered: rock Cornish game hens are now younger than five weeks old, broiler/fryers are less than ten weeks old, and roasters are now between eight and ten weeks old. Each of these birds can be either sex, but capons are castrated males less than four months old. These days, broiler/fryers range from 2½ to 4½ pounds, while roasters weigh at least 5 pounds. For me, the sweet spot is 3½ to 4 pounds.

ORGANICS

If you're interested in serving an organic bird, read on. We avoided the organic issue in the original show because the standards continue to evolve. As of today, the requirements for organic labeling are: Animals for slaughter must be raised under organic management from the last third of gestation, or no later than the second day of life for poultry. Producers must feed livestock agricultural feed products that are 100 percent organic, but they may also provide allowed vitamin and mineral supplements. Preventive management practices must be used to keep animals healthy. Producers may not withhold treatment from sick or injured animals. However, animals treated with a prohibited substance may not be sold as organic. All organic livestock are required to have access to the out-

doors year-round. Animals may only be temporarily confined due to documented environmental or health considerations. Finally, organically raised animals must not be given hormones to promote growth or antibiotics for any reason. By the way, the labeling of organic products is managed by the USDA, not the FDA.

THE BRINE

All *Good Eats* faithful are aware of the marvels of brining, but back in 1999 not too many qualified science types had held forth on the subject. I marinated in all the information I could find at the time and decided to focus my explanation on osmosis, the movement of a liquid containing fewer dissolved solids across a membrane into a liquid containing a higher concentration of dissolved solids.

During brining, some osmosis does take place, but it's nowhere near as big a factor as *diffusion*—that is, the movement of particles dissolved in water from areas of high to low concentration. Since a brine contains more dissolved stuff, getting it into the meat requires diffusion, which is made possible by the fact that a chicken has about a zillion microscopic openings. But wait, there's more. When salt dissolves in water, it breaks into a bunch of sodium and chloride ions, which move into the meat and instigate chemical changes in the protein structures, thickening the liquid in the muscle fibers and pushing the fibers themselves to hold on to more moisture. When

Trying to straighten out the whole osmosis/diffusion thing

KNOWLEDGE CONCENTRATE *(continued)*

ZA'ATAR

Za'atar is a Middle Eastern spice mixture typically composed of sumac (not the poison kind), sesame seeds, marjoram, thyme, and oregano. Za'atar can also refer to a specific herb in the mint family that's often used in za'atar (the mixture), but wherever you see the ingredient called for in one of my recipes, it's the blend we're after. Za'atar was still tough for the average cook like me to get back in '99, but now it's available in many a megamart, though I strongly urge you to acquire yours from a web-based spice seller. Try it on hummus sometime.

ALEPPO PEPPER

Aleppo pepper, or Aleppo-style pepper, is named for Aleppo, Syria, its original growing region. Due to the civil war, many growers have moved their operations to Turkey. Aleppo pepper, which is actually a chile, looks a bit like chopped red pepper flakes, but the heat is much lower and there are flavors of sun-dried tomatoes, cumin, and raisins. Quality Aleppo pepper will keep for 6 months if properly sealed and stored in a cool, dark cupboard. In a countertop spice rack with clear glass jars they'll keep about a week, which tells you something about my feelings about counter-top spice racks.

cooked, the muscle structures can't squeeze as much of the liquid out. So brining gets more fluid into the meat and keeps it there . . . and it tastes good.

Although brining traditionally requires soaking the target food in a liquid, brines can also be produced right at the surface by rubbing the bird inside and out with salt and ground spices and parking it on a wire rack–lined sheet pan in the fridge for a few days.[1] The salt pulls water to the surface, dissolving the salt and creating a brine (osmosis), which is then absorbed, to some degree, into the bird. The only downside: You have to find room in your fridge. But the upside is that during the days it takes for this to happen, the skin can also dry, and that will result in a crunchy, flavorful skin, which is half the reason you're roasting a bird in the first place.

THE OVEN

In my opinion, radiant heat is the best thing for producing crisp chicken skin. Back in '99, I relied on the broiler to produce directional radiance from above, but if there's one thing all the online comments taught me through the years, it's that broilers are all different and cannot be set to an exact temperature. So I started playing around with placing a heavy (¾-inch-thick) pizza stone on a rack in the second position from the top of the oven with a second rack about 6 inches below that. I set my oven to its top temp of 550°F and let it heat for an hour. (Remember, we have to heat not only the oven but the pizza stone, which has considerable mass.) There are several advantages to this method. The stone heats more evenly than the roof of my oven, and so it can radiate heat more evenly to the surface of the bird, and since it can absorb a great deal of heat, the stone also helps to even out the fluctuations that result from the oven cycling on and off, which is something just about every home oven does. The result: a faster cook and a crispier skin. Just remember: Always start with the pizza or baking stone(s) in a cold oven.

1 This is often referred to as a *dry brine* or *dry brining*, but since there's no such thing as a brine that's dry, let's call it a quick *cure*.

SPATCHCOCKING

According to the *Oxford English Dictionary*, the term *spatchcock* comes to us from Irish vernacular for "dispatching a cock," as in sudden seizing, killing, plucking, splitting, roasting, and eating of a chicken or game bird. In practical use, it means to flatten or "butterfly" the bird by removing the backbone and keel bone. The flatter the bird, the faster and hotter you can cook it, and that is what produces crisp brown skin with juicy meat below.

Place your bird breast-side down and, with a pair of kitchen shears, cut the ribs down one side of the backbone and then on the other. Save the backbone for another application, like stock. Next, open the chicken up like a book and take out the keel bone that separates the two sides of the breast: There's a thin membrane that you'll want to slice through with the tip of a paring knife, then crack the ribs open, reach in with a finger on either side of the bone, and just lever it out. Now the breast will lay flat. Turn the bird back over and spread it out like a butterfly.

1) Position bird breast side down. Grab hold of the "pope's nose" at the very back end and use heavy-duty kitchen shears to cut up one side of the backbone.

2) Once you've cut up the backbone on one side, carefully repeat on the other to free up the backbone, which makes excellent fodder for the stockpot.

3) Open up the bird and locate the underside of the keel bone, which runs vertically right down the center of the bird like the spine of a book. Lightly slice through the membrane covering the keel bone.

4) Bend the bird open (just like the school librarian told you never to do) to split the membrane open, exposing the bone.

5) Use your thumb and index finger to lever out the keel bone. This will allow the bird to lie flat.

6) Although not strictly required, I like to bend the wing tips and fold them underneath the first wing segment.

BROILED, BUTTERFLIED CHICKEN

YIELD:

4 to 6 servings

This is roast chicken the way you'd have it if you were invited to my house for dinner. Crunchy, flavorful, a little bite from Aleppo pepper and za'atar . . . and it's just as good cold.

SOFTWARE

1 (3½- to 4-pound/1.6 to 1.8 kg) chicken

2 tablespoons (23 g) kosher salt

4 tablespoons (57 g) unsalted butter

2 teaspoons (5 g) Aleppo pepper (see box on page 80)

1½ teaspoons (4 g) za'atar (see box on page 80)

TACTICAL HARDWARE

- Heavy kitchen shears
- A pizza stone(s) large enough to completely shadow the chicken when said bird is placed on the rack below
- A remote probe thermometer

PROCEDURE

1) Early on the day you plan to serve, spatchcock the chicken, following the diagram on page 81.

2) Place the chicken on an oven-safe wire rack set inside a half sheet pan. Rub the chicken on both sides with the salt, position skin-side up, and refrigerate, uncovered, for 8 to 12 hours.

3) About 2 hours before you're ready to serve, place a rack in the top of the oven and place the pizza stone(s)[2] on it. Place another rack 6 inches below the top rack, then crank the oven to its highest temperature, 550°F if possible.[3] Give the oven and stone(s) 1 hour to come up to temperature. Your patience will be rewarded.

4) While the oven is heating, remove the chicken from the refrigerator and let it sit on the counter at room temperature.

5) After an hour of oven heating time, combine the butter, Aleppo pepper, and za'atar in a heavy metal measuring cup or small saucepan, place over low heat, and cook, stirring occasionally, until the butter is red and fragrant, about 5 minutes.

6) Flip the chicken skin-side down and brush with half of the butter mixture. Transfer to the oven rack below the stones and roast the bird for 10 minutes.

7) Carefully remove the pan with the chicken, flip the bird skin-side up, and brush the skin with the remaining butter mixture. Insert a remote probe thermometer into the breast and set the alarm to 160°F. Return to the oven and continue to roast until the alarm sounds, about 25 minutes later.

8) Remove the chicken to a cutting board and let it rest for 10 to 15 minutes. Carve and serve.

2 Although plenty of folks use large, single pizza stones, I prefer smaller, thicker stones that can be arranged in various patterns in the oven. Most sets that I've used have come with five stones that can be arranged differently to suit various oven shapes and sizes. Smaller stones, in my experience, tend to break less often. But that's just me.

3 There could be some smoke, especially if your oven's interior isn't exactly immaculate. So turn on your vent hood, or open a window. If you've got a ceiling fan, turn it on too. And, if you have a smoke detector in your kitchen . . . well, I can't tell you to temporarily cover it with a piece of foil, but . . .

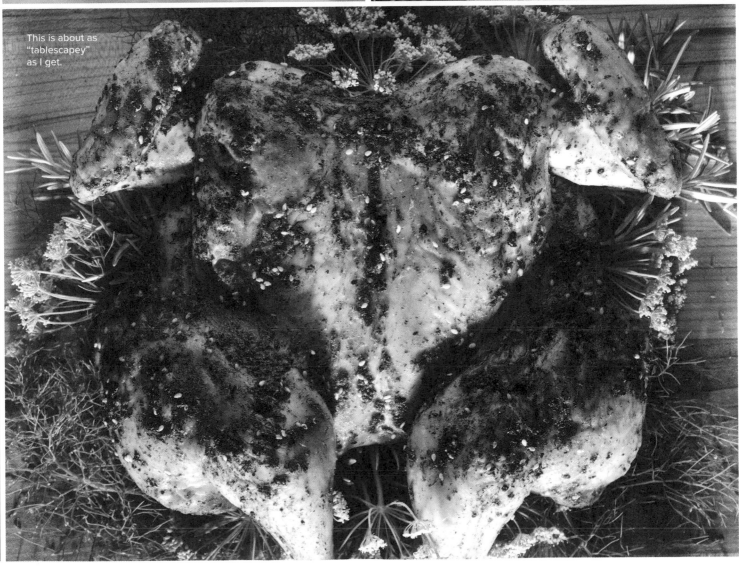

This is about as "tablescapey" as I get.

PRESSURE: RELOADED

Back in 2001, most cooks (not to mention professional chefs), viewed the pressure cooker not as a culinary time machine, but as a kitschy and potentially deadly anachronism best left high and forgotten on thrift-store shelves. The show originally aired in April 2001 and since then the online recipe has garnered a mere eighteen reviews, which I attribute to the fact that only eighteen people had pressure cookers back then.[1] But now, twenty years later, I'm happy to report that pressure cookers are happily whistling away in kitchens across America. I'd like to think I had something to do with this renaissance, but we all know damn well it's about the rise of the Instant Pot, an electronic device that functions (quite successfully, I'm told) as a slow cooker, a rice cooker, and a pressure cooker. More on these devices later.[2]

The setup for the episode has Marsha (my imaginary, uber-whiny sister) showing up at my place with a bad case of the flu and

The first pressure cooker, called the "ingester," was designed in 1679 by French physicist Denis Papin. It blew up a year later.

Our longtime nutritional anthropologist, Deb Duchon

a prescription for beef broth she expects me to fill. Wanting to speed her exit, I turn to the pressure cooker to extract as much goodness as possible from tough beef cuts in the shortest possible time. I still like the original recipe, but it is a bit simplistic by today's standards, and I really wanted to produce something a bit more complex, and lot more craveable.

1 Some of the reviewers called me out because I made a reference to giving the leftovers to the dog. Bad Alton. You should never feed onions to a dog. As soon as I realized the mistake I reedited the show. And I never mentioned feeding things to pets ever again.

2 For the record, I'm not a fan.

PRESSURE

We all live under physical pressure, and how much depends on the amount of sky over our heads. Standing on a beach (which can greatly reduce the other pressures we live with), on a 59°F day, a barometer would read 29.92 inches of mercury, which is very close to 14.7 pounds of pressure per square inch. If we were to boil water in a pot on that beach and stick a thermometer in it, it would reach a temperature of 212°F—no more, no less. That's because the boiling point of water (the temperature at which it converts from a liquid to a gas) is relative to the atmospheric pressure, and that is relative to elevation. If we were to boil that same pot of water on the shore of the Dead Sea in Israel, which is 1,300 feet below sea level, the thermometer would read 214.4°F. On Mt. Everest, at 29,032 feet, the thermometer would read a mere 154°F. There is a lot less sky pushing down on Everest than there is on the Dead Sea. I live in Atlanta, Georgia, at 1,050 feet above sea level, so my water boils at 210°F, while in Leadville, Colorado, at 10,151 feet, it boils at 193°F.

Pressure cookers speed up cooking times by increasing the atmospheric pressure, and therefore the boiling point of water inside the pot. First-generation cookers accomplished this by placing a weight called a "jiggler" atop a narrow steam vent. Second-generation cookers use a spring-loaded valve (all my cookers are second-generation models), and then there are the aforementioned multi-cookers powered by computer chips and genies. Although the exact pressures exerted depend on the particular model of cooker (always read the manual), the average recipe writers use is 15 psi. That's basically one atmosphere, so the boiling point (again figuring the pot is at sea level) is close to 250°F. Foods placed in such a culinary warp drive cook in two-thirds less time than they would in an open vessel.

COOKING UNDER PRESSURE AT HIGH ELEVATIONS

Anyone who lives in Denver or Albuquerque knows that elevation changes everything when it comes to cooking, because the boiling point of water is just so darned low. Pressure cookers can certainly help rectify this situation, but you still have to take your elevation into account, because when you sealed the cooker, its internal pressure was equal to the ambient pressure. The general rule is to add 5 percent to the cooking time for every 1,000 feet above 2,000 feet of altitude. So, if you live in Leadville, Colorado, elevation 10,151, and your pressure-cooker recipe calls for 30 minutes of cooking, I'd drop the 151 feet and say:

$$10,000 - 2,000 = 8,000$$
$$30 \times .05 = 1.5$$
$$1.5 \times 8 = 12$$
$$30 + 12 = 42 \text{ minutes}$$

The big shift in the use of pressure cookers in the last twenty years is really all about an electronic cooking device called the Instant Pot, which comes in myriad sizes and models. Those who own them seem to adore them, as they can function as slow cookers, rice cookers, and pressure cookers. I didn't involve them in the show for a few reasons. First, we're not allowed to mention brand names. Second, I didn't want the multifunctionality to get in the way of communicating principles. Finally, those machines cook according to their own particular peculiarities, which have to do with the fact that they're electronically programed and controlled.

For instance, most models of Instant Pot can attain 15 psi, but they do so only during their initial heating phase. They actually "operate" closer to 11.6 psi. Most stovetop pressure cookers will actually operate close to or at 15 psi, and some high-end European models can cook beyond 20. If your model has two pressure settings, the low one is probably between 6 and 7 psi. All my pressure cooker recipes are written and timed for 15 psi. So, if you're converting for an Instant Pot, you're going to have to add a few minutes to the cook time.

GETTING SOME DEFINITIONS STRAIGHT

The words *stock* and *broth* are often used interchangeably, and while they're not mutually exclusive, they are not technically the same. To make a stock you need two ingredients: water and bones. Seasonings, aromatics, and various vegetation may be added, but in the end, it comes down to water and bones. The goal of stock making is not flavor, it's the conversion of a protein-laden connective tissue found in the bone joints called collagen into gelatin, the stuff that lends lip-smacking body to many a luscious liquid and sets up solid at refrigerator temperatures (Jell-O gets its name from gelatin). Stock is typically an ingredient, not a final culinary destination.

 Broth is medieval-speak for *brew*, and that's exactly what it is: water in which meat and/or vegetables have been cooked, or "brewed." Strain out the bits and pieces and you have broth. Leave them in and you've got soup. A stock can be a broth, if meat and or vegetables are cooked in it. And a broth can be a stock, if enough connective tissue was brought to the pot. This nomenclatural morass has been further clouded by the introduction of "bone broths" to the marketplace, which near as I can tell from the packages are simply stocks with flavors added, including a crap ton of salt. Make the original recipe from this episode, easily found online or in *Good Eats: The Early Years*, or the one detailed in the pages that follow, add a bunch of salt, and bingo: bone broth. Just thought you should know before you shell out eight bucks for that 12-ounce carton.

(top) A good stock should set up into a gel.

(bottom) Bart Hansard as "Bone Broth Bob" (we did a lot of green screen shots for the reloads, so we could insert new stuff into the old footage)

FISH SAUCE

Whether you're talking about Vietnamese nuoc mam, Thai mam pla, patis from the Philippines, or Korean aek jeot, all true fish sauces contain but two ingredients: fish, specifically anchovies, and salt. Take a big barrel, fill it with anchovies and salt at a ratio of 3 to 1, stick it in the sun for about a year, filter it, bottle it, and you've got fish sauce. Does it go bad during that year? Well, yes and no. Fermentation does occur as the fish decompose, but the salt regulates the process so that in the end, the liquid is deeply funky but also fully preserved. The aroma is worse than the insides of a Tauntaun, but since it contains such a complex stew of amino acids, it's an umami bomb capable of enhancing darned near anything it touches. Just remember: A very, very little goes a very long way. When purchasing, look for sauces in small glass (not plastic) bottles and check that only two ingredients are involved: salt and fish. High-end examples will often feature a degree symbol with a number like 40 or 50. That's a technical statement of the sauce's nitrogen content, which is an indicator of protein content and thus quality. I'm a fan of sauces in the 40°N range, and my favorite brand is Red Boat, which is easily obtained from the interwebs.

PALM SUGAR

Just as maple sugar is made from boiled-down maple sap, so is palm sugar produced from the sap of several different members of the palm family, including the palmyra palm. The sap is tapped from immature flower buds (inflorescences, if you want to get technical) and boiled down, often in large woks over wood fires. Once it crystallizes it's poured into molds. Typically, they come to American markets as unrefined, hard cakes, usually domed, and two to three inches across. A rasp, Microplane, or even box grater can be used to harvest off desired amounts. Could you use muscovado or some other raw brown sugar as a substitute? Sure. But palm sugar is easily found in any ethnic market or megamart with a well-stocked international aisle, and the distinct flavor brings more than sweetness to the party. Best of all, tightly wrapped, it keeps pretty much forever at room temp. One of my favorite things is to grate it over sour cream on pound cake.

SPICY BEEF BROTH & BREAKFAST BOWL

YIELD:

4 servings

SOFTWARE

For the broth:

8 whole cloves

3 star anise pods

2 teaspoons fennel seeds

1 (2-ounce) piece fresh ginger, un-peeled and roughly crushed (about a 5-inch-long piece)

1 onion, peeled and cut into thick slices

4 pounds (1.8 kg) beef oxtails

½ large Fuji apple, unpeeled

5 teaspoons (16 g) kosher salt

10 cups (2.4 L) water

2 tablespoons (30 ml) fish sauce (see sidebar, page 87)

1 tablespoon (6 g) palm sugar (see the other sidebar, page 87)

For the soup:

14 ounces (397 g) thin rice noodles (banh pho)

8 ounces (226 g) beef eye of round

5 scallions, thinly sliced

3 Thai bird chiles, thinly sliced

1 cup (85 g) bean sprouts

2 cups (24 g) fresh herbs, such as cilantro, Thai basil, and mint

2 limes, quartered

PROCEDURE

1) Make the broth: Toast the spices in a large pressure cooker set over medium heat until fragrant, 3 to 5 minutes.

2) Add the ginger and onion and continue to cook until slightly black-ened, 8 to 10 minutes. A few of the spices may burn a bit, and that's fine.

3) Add the oxtails, apple, and salt, then cover with the water. Attach and lock the lid according to your pressure cooker's instructions and bring to high pressure over medium-high heat. Once the cooker is steaming and whistling, back down on the heat to just maintain high pressure (most pots will just be hissing at this point) and cook for 30 minutes.

4) After 30 minutes on high pres-sure, kill the heat and leave the pressure cooker to cool for 5 minutes. Then slowly open your cooker's pressure relief valve (please make sure the handle is toward you so that the vent will face away from you) or simply park the whole thing under cold running water until the safety lid-lock disengages, usually around 30 seconds.

5) Remove the lid and use a slotted spoon to transfer the larger pieces of meat to a bowl to cool. (When they are cool enough to handle, slice or pull the meat from the bones and set aside. Most of their flavor will already be gone, but I usually eat them with the broth anyway.) Strain the broth first through a colander into a second large bowl, then again through a strainer lined with several layers of

Modern oxtail isn't, actually. "Oxen" is a very old word once used to describe any castrated male *Bos taurus*, or *B. primigenius*. Today we use the word "steer," but in truth oxtail can come from a steer, cow, or bull.

THE MEAT

Beef cuts like shanks and oxtails do a lot of work when the animal is using them, and because of that they contain a huge amount of connective tissue. They also contain meat, of course, so cooking them results in a gelatinous broth that sets into a solid gel when chilled. (That's how to make aspic, which, due to an unappealing moniker, remains unjustly unpopular.) These cuts are also cheap, as are chicken wings, which I add not only for their connective tissue but because I think the chicken flavor rounds out the meatiness of the dish.

cheesecloth[3] set over a large bowl or storage container. Finish by stirring in the fish sauce and palm sugar and serve in a mug. Or save to assemble the bowl. (See the note below re: cooling the broth.)

6) Make the bowl: Heat 32 to 48 ounces of the spicy beef broth just to a simmer (depending on how big your bowls are).

7) Place the rice noodles in a baking dish, cover with boiling water, and soak for 15 minutes before draining thoroughly.

8) While the noodles soak, firm up the eye of round by placing it in the freezer for 10 minutes. Once chilled, slice it very thinly across the grain.

9) Distribute the noodles among four wide soup bowls and top with the slices of (raw) eye of round and a few pieces of the reserved cooked beef (if you haven't already eaten it). Pour on the hot broth to cover and garnish as desired with the scallions, chiles, sprouts, herbs, and limes.

NOTE

When it comes to cooling, I don't like leaving that much hot liquid sitting in the bacterial zone for that long, so here's my trick: I always keep a few pint-size water bottles (labels removed, of course) frozen in the freezer. If you're reusing old bottles just make sure you leave at least an inch empty at the top so the ice has room to expand. After I strain the broth, I place two of these bottles into the broth and just give it a stir every now and then. In about 20 minutes the ice will be melted and the broth cool enough to split into smaller containers for refrigeration.

ABOUT THE NAME

I implied during the episode that this recipe is for pho, the poster dish for Vietnamese cuisine, based on a clear meaty broth, laced with spice, and finished with noodles, herbs, chiles, and lime. But I'm not calling it that anymore because I'm not Vietnamese, I'm not an expert on Vietnamese cuisine, and I haven't even been to Vietnam, though I really hope to go one day. I have consumed many great, authentic phos across America, most notably in Los Angeles, where many places still serve it at breakfast. So I think I know enough to say that my dish is at best an homage, which is presented here with all due respect to its heritage and true practitioners.[4] Also, I have to say there are plenty of times I just make and enjoy the broth without the noodles and other ingredients. When I have a cold, it's my go-to.

3 In the original episode I only used two layers of cheesecloth. But in this case, six layers is better. Use clothespins to anchor cloth to colander and pour on. It's going to take a while to work its way through, but your patience will be rewarded with a clearer broth.

4 A lot of the elements of authentic pho are the result of Chinese influences in northern Vietnam (most historians agree that pho originated in Hanoi). But beef probably wasn't included until the era of French colonization in the late nineteenth century. The French were big on beef, but only the expensive cuts, so cheaper hunks became available at low prices, and enterprising pho chefs took advantage of the bargain. So, despite the long tradition of noodle soups in Southeast Asia, pho, as we know it, is only about a century old.

THE COOKIE CLAUSE: RELOADED

The tradition of leaving out cookies for Santa dates back to the Great Depression.

"The Cookie Clause" takes place on Christmas Eve, 2003, when a very irate Santa comes to call. The issue: crappy cookies. The answer: teach him to make his own. This is one of my favorite shows, because the actor playing Santa, Bart Hansard (who also played Koko Karl and countless other characters over the years), is just amazingly funny. So why reload the show? Because, like so many folks, Santa's gone gluten-free. So, with a little help from the elves, I designed a

We shoot with mirrors. A lot.

gluten-free cookie that I actually like more than the original. You're more than welcome to just jump down and dig into the recipe, but if you want a glimpse inside the science of replacing gluten, read on. Also, I realize some of these ingredients will be unfamiliar, but they're all easily obtainable from the interwebs, which is where we get everything anyway.[1]

1 There are plenty of good gluten-free mixes out in the marketplace, and you can suss out the reviews on the interwebs, so I'm not going to make recommendations here. Besides, if someone went out of business or changed their formula, I'd have to hunt down all the copies of this book. So, on second thought, just make the darned mix yourself.

GLUTEN-FREE FLOUR

Wheat flour is complex stuff; besides starch and fiber, it contains glutenin and gliadin, the proteins that combine to form gluten. Concocting a gluten-free flour mixture that will actually act like wheat flour requires mixing and matching five main categories of ingredients that bring specific functionalities to the party. What you decide to bring to the party depends on whether you're making breads, pasta, cakes, or cookies. The ingredients in each of these categories do have some cross-over, so building your own blend will likely require a bit of experimentation.

1) Neutral flours like rice flours (white, brown, and sweet), oat flour, and sorghum flour are what I call "blank-canvas flours" and they typically make up the bulk of a gluten-free blend, providing a texture and color similar to all-purpose flour. They're high in starch, but not as high as purified starches, and usually have a bit of protein and fiber in them as well, not to mention a pleasant, grainy flavor. I usually include at least two of these in any blend.

2) Starches like arrowroot, cornstarch, potato starch, and tapioca flour (aka tapioca starch) are close to 100 percent starch, which contributes binding power to the blend, as they're great at holding on to water. Each offers a slightly different starch makeup (like differences in amylose-amylopectin ratios, affecting both structure and staling), so I usually end up combining two to three in any mixture.

3) High-protein flours and powders like almond, buckwheat, chickpea, sorghum, and oat flours, as well as milk powder, can't form the same interconnected mesh that gluten does, but they can bring badly needed structure to the party. All of these options will alter the final flavor and texture of the blend though, so keep that in mind.

4) High-fiber flours and powders like coconut flour, psyllium husk powder, as well as oat and sorghum flours (again) give the blend structure, texture, and moistness by hydrating and forming gels. High-fiber ingredients are particularly useful when making gluten-free breads or any baked goods that need extra lift. Not so important in cookie blends.

5) Gums, such as guar gum and xanthan gum, are polysaccharides that thicken and emulsify mixtures by forming gels. They can also act kind of like glue, holding a batter or dough together. Xanthan gum is also used to thicken and prevent separating in many commercial salad dressings and sauces. It's made from a type of bacteria that grows on cabbage, so despite the slightly scary name, it's completely natural.

So, for neutral flours, we went with a 50/50 mix of brown and white rice flour. The brown rice flour also offers up just enough fiber for most cookies, and nonfat dry milk powder adds enough protein. I like to use a triple starch blend to ensure binding power and elasticity, so: equal parts tapioca flour (nice, chewy amylopectin) and cornstarch (nice, stiff amylose), with some potato starch thrown in to slow staling. Lastly, xanthan gum, which will glue things together so that the final cookie has just the right snap.

Enough talk ...we bake.

Bart Hansard played roles in at least fifty episodes. His Santa was one of my favorites.

GLUTEN-FREE FLOUR MIX
(for cookies and cookie-like baked goods)

YIELD:

7½ cups
(1,000 grams)

SOFTWARE

250 grams (1¾ cups plus 1½ teaspoons) brown rice flour

250 grams (1½ cups plus 2 tablespoons) white rice flour

150 grams (1¼ cups plus 2 teaspoons) tapioca flour or starch

150 grams (1 cup plus 1 tablespoon) cornstarch

100 grams (½ cup plus 1 tablespoon and ½ teaspoon) potato starch

90 grams (1 cup) nonfat dry milk powder

10 grams (1 tablespoon plus ½ teaspoon) xanthan gum

PROCEDURE

Combine all the ingredients in a large, airtight container and use within 6 months.

NOTE: I'm giving you volumes here, but I really can't over-emphasize how much better life would be if you weighed all this.

CONCERNING COOKIE CUTTERS

I admit, I was pretty excited about plastic cutters at the time of the original episode, but within a year I was having to replace them because they were so dull. And they never really felt clean no matter how much I washed them. These days I've gone back to metal, but only heavy-duty models that aren't easily bent by hand. They'll stay sharp for years, and you can wash them in the dishwasher without the dry cycle warping them.

GLUTEN-FREE SUGAR COOKIES

YIELD:

about 4 dozen cookies, depending on the size of your cookie cutters

SOFTWARE

3½ cups (440 grams) Gluten-Free Flour Mix, opposite

½ teaspoon baking powder

½ teaspoon kosher salt

1 cup plus 1 tablespoon and 2 teaspoons (227 grams) sugar

8 ounces (227 grams) unsalted butter, softened

1 large egg

½ teaspoon vanilla extract

¼ teaspoon almond extract

Confectioners' sugar, for rolling the dough

Royal Icing (see below)

TACTICAL HARDWARE

- Stand mixer with paddle attachment
- Cookie sheets or sheet pans
- Small offset spatula (not required but highly recommended)
- Cookie cutters

A lot of the ingredient shots we pull off require careful layering on plexiglass.

PROCEDURE

1) Whisk the Gluten-Free Flour Mix, baking powder, and salt together in a medium bowl.

2) Load the sugar and butter into the mixer's bowl and "cream" together with the paddle attachment on medium-low speed, scraping down the sides of the bowl as needed, until the sugar is no longer visible, about 3 minutes.[2]

3) Slowly add the egg, followed by the extracts, and continue mixing on medium-low until just combined, about 15 seconds more.

4) Reduce speed to low, add the flour mixture, and continue mixing until incorporated, about 30 seconds.

5) Lightly dust a work surface with a small amount of confectioners' sugar and turn the dough out onto it. Round with your hands, then divide in half. Shape each piece into a 4-by-6-inch rectangle and wrap in plastic. Refrigerate for at least 6 hours or up to overnight.

6) When ready to bake, remove one half of the dough to the counter for 10 minutes to soften. (If refrigerated overnight, the dough may take more like 15 to 20 minutes to soften sufficiently.) Line two baking sheets with parchment paper.

7) Lightly dust a third piece of parchment paper with powdered sugar, place the dough in the middle, then top with yet another sheet of parchment. (Don't dust the top or the resulting cookies won't be smooth.) Roll the dough into a rough rectangle ¼ inch thick. Use your cutters to punch out the cookies.[3]

2 "Creaming" is a word that always means beating sugar into a solid fat. The goal is to use the sugar crystals to punch little holes in the fat. Butter, unlike, say, shortening or lard, contains water, so the sugar will actually dissolve in that moisture, which is why you want to work with the butter when it's soft enough to be plastic but not melty. You'll know you're done when you no longer see any sugar and the mixture increases a bit in volume and lightens in color. Creaming is a critical step in establishing the final texture of the cookie.

3 I actually lay the cutters out on the dough first to strategize how to get as many cut out as possible from the first roll. You don't want to re-roll the scrap more than one time if possible.

GLUTEN-FREE SUGAR COOKIES *(continued)*

8) Transfer the cookies, one at a time, to the prepared sheet pans.[4] If the dough becomes too soft to handle during any point of the process, chill in the fridge for 10 minutes to firm. Repeat with the second rectangle of dough and second baking sheet. Gluten-free cookie doughs tend to spread in the oven a lot more than their gluten-y counterparts, which is why you want the raw cookies chilled when they go into the oven. So, refrigerate another 30 minutes.[5] Meanwhile, place one oven rack in the top third of the oven and another in the bottom third and crank the oven to 325°F.

9) Bake the chilled cookies for 8 minutes, then swap the top pan and the bottom and rotate them 180 degrees. Continue baking until the edges of the cookies just begin to brown, about 7 more minutes.

10) Park the sheet pans on wire cooling racks to cool for 10 minutes, then carefully slide the parchment off the pan onto the rack and let the cookies cool completely before icing. Repeat the rolling, cutting, chilling, and baking steps with the remaining dough.

The cookies will keep in zip-top bags or gift tins for a couple of weeks. I like them fine by themselves, but I suppose the holidays demand icing.

4 I use a small metal offset spatula for this. Great multitasker.

5 I rarely have space in my fridge for baking sheets. But I do have room in my freezer for a couple of those reusable ice sheets they make for coolers . . . the ones that look like square bubble wrap only with what I assume is some kind of distilled water in each cube. When rolled out they easily cover a sheet pan, so I cover my cookies with a clean tea towel (no fuzz) and lay the ice sheet over it for a few minutes. The tea towel will keep any condensation from wetting the cookies.

ROYAL ICING: RELOADED

YIELD:
4 cups

Our original icing was too sweet, so we've added cream of tartar (tartaric acid) and a bit of salt. The acid gives the frosting a touch of twang, and it also helps denature proteins in the egg whites, resulting in a smoother icing. Many of you who decided to go with pasteurized whites found your frosting too thick. That's because I was operating under the assumption that 4 egg whites (from the shell), are equal to 3 ounces. Truth is, the average large egg white is 33 grams or 1.16 ounces . . . big difference. What you need is 132 grams or 4.65 ounces of pasteurized whites; however, since we're not splitting atoms, you could just say 4.6.

SOFTWARE

510 grams (2½ cups plus 2 teaspoons) sugar

4 large egg whites, or 132 grams (4.6 ounces) pasteurized carton egg whites

¼ teaspoon cream of tartar

¼ teaspoon kosher salt

Gel-based food colorings if desired[6]

TACTICAL HARDWARE

- A strong blender . . . ideally a Vitamix. Spendy yes, but worth it.[7]

- A stand mixer with a paddle attachment

6 Water-based colorings will throw off the texture of the icing.

7 If you don't have a high-powered blender, your best bet is to use 1 pound of confectioners' sugar in the frosting. The flavor won't be quite as clean as when made with DIY superfine sugar, but it will still work great on top of cookies.

PROCEDURE

1) Place the sugar in the blender carafe and blend on high speed until super-fine, about 2 minutes. Weigh out 1 pound (454 grams) of the super-fine sugar and set the remainder aside, because you may need it. And if you don't, use for iced tea, because it will dissolve when other sugars won't.

2) Combine the egg whites, cream of tartar, and salt in the bowl of a stand mixer fitted with the paddle attachment. Beat on low speed until smooth, then slowly stream in the pound of sugar. Once all of the sugar has been incorporated, increase the speed to medium-high and continue to beat until a frosting-like consistency is achieved, about 4 minutes. If you'd like a thinner frosting, beat in a little water (or rum), and if you want it thicker, add a teaspoon or two of the reserved sugar.

3) To color the icing, divide it between small bowls. Add gel-based food coloring to each portion of icing, stirring well to combine. Start with only a drop or two of each color, adding more as desired.

4) Use immediately (dipping or spreading as desired), or store in an airtight container overnight. If you opt for storage, the icing may separate overnight but will smooth out with a little whisking.

FROSTING NOTE:

Remember that frosting darkens as it dries, so you might want to mix your icings to be a little lighter than you're hoping for. I always keep some plain, white frosting aside, just in case I need to lighten something up a bit.

Egg-based icing dates back (probably) to the Renaissance, but it became "royal" when it was used to decorate Queen Victoria's wedding cake in 1840.

GOOD
EATS
THE RETURN

BASTING IS EVIL

season one

AMERICAN CLASSICS X: CHICKEN PARM

Consider chicken Parmesan, a beloved, nostalgic, and delicious example of immigrant chow composed of a tasty triumvirate of tomato sauce, pan-fried chicken cutlets, and cheese layered and baked in a casserole. Sounds fantastic. Problem is, most versions aren't very good. The cheese is gummy, the sauce insipid, and the breading tends to dissolve into library paste long before it hits the plate. It's a complex case, to be sure, but well within the wheelhouse of *Good Eats*. But before we dig into the recipe, let's dispel some myths, starting with the idea that this dish is Italian in origin. It's not.

Most chicken Parm tastes like . . .

When purchasing potatoes on the black market, disguises are strongly advised.

Chicken Parmesan is a perfect example of "Italian" food, only it doesn't exist in Italy, though melanzane, or eggplant Parmesan, does. Given its moniker, it would be reasonable to think the dish hales from Parma, yet half the cheese typically used in the dish is mozzarella from Campania, home to Naples, which also happens to be the point of entry for the tomato into Italy via the Spanish, who ruled the area not once but twice. Sicilians, on the other hand, have argued that the name evolved from *palmigiana*, meaning "shutters," a reference to the layering of the eggplant slices. Since my version of the dish only includes a small amount of actual Parmigiano-Reggiano in the sauce, I guess I'm leaning Sicilian here.

Chicken Parm is considered standard pub food in Australia.

But still . . . no chicken. For that we have to go to the birthplace of "Italian" food: New York City, specifically Lower Manhattan.

Between 1800 and 1920, one out of every four immigrants entering America came from the southern end of Italy.[1] Most settled into the tight confines of the tenement homes and shops of Little Italies like the ones in Lower Manhattan and up in East Harlem. There, folks from Naples, Sicily, and Campania were squeezed together, and despite the fact that they often didn't speak the same dialect, they stuck together and fervently clung to their respective culinary heritages.

The modus vivendi forged in such cultural compactors, especially in the boardinghouses where single men, or *bordanti*, lived and ate, gave birth to what we think of as Italian cuisine: spaghetti and meatballs, cacciatore, and veal and chicken Parmesan.

By 1930, there were 409 full-service Italian restaurants in Manhattan alone.

Why did these dishes, which never existed in the old country, come into being? Because there was finally enough food. In America, even poor workers could afford meat, cheese, oil, and pasta, which wasn't nearly as ubiquitous in the old country as most of us think. Eggplant, on the other hand, wasn't so easy to find in the cities. So, one day, somewhere down on Mulberry Street, or up in East Harlem, some adaptive cook reached for a chicken and gave birth to a classic.

But first . . . the sauce. Ordinarily, this application would play down-page as an option should the curious wish to sidestep the jarred stuff. As far as I'm concerned, the sauce ties the dish together, and I've never had sauce from a jar that can make that claim.

1 Keep in mind that Italy didn't even become a unified country until 1861.

RED SAUCE

YIELD:
5 cups

SOFTWARE

¼ cup (60 ml) extra-virgin olive oil

6 large cloves garlic (20 to 30 g), minced (2½ tablespoons)

4 anchovy fillets (10 g)

½ teaspoon (1 g) red pepper flakes

2 (28-ounce) cans peeled whole San Marzano tomatoes, drained, with the liquid reserved[2]

2 teaspoons (6 g) kosher salt

1 (2-inch) Parmesan rind (25 to 30 g)

TACTICAL HARDWARE

• A large wooden spoon

Until the mid-sixteenth century, there were no tomatoes in Italy.

WHAT'S REALLY THE DEAL WITH SAN MARZANO TOMATOES?

"San Marzano" is a tricky term because it's a region, a variety of tomatoes, and a DOP, or Denominazione d'Origine Protetta, a certification based on qualifying characteristics. To be certified by the EU, the contents of the can must have been grown in one of forty-one municipalities, all in the Campania region. "Pomodoro San Marzano dell'Agro Sarnese-Nocerino D.O.P." will always appear on the label. Cans will also bear the seal of the Consorzio, which ensures the proper variety of tomatoes, how they're grown and processed, and so on. And there will be a Consorzio number. Also, real canned San Marzanos will only be sold as peeled, whole tomatoes, never chopped or pureed.

Unfortunately, the United States does not recognize Italian DOP certifications and therefore places no limitations on the use of the words "San Marzano," so cans can bear that name and include the word "certified," but neither means squat to me, nor should they to you. You can even grow the tomato variety called "San Marzano" in California, but they absolutely are no more alike than a bottle of Nebbiolo from Australia's Mornington Peninsula and a Nebbiolo from Piemonte.

PROCEDURE

1) Heat the oil in a medium saucepan over medium heat. Add the garlic and cook, stirring frequently, until it begins to brown, about 2 minutes. Add the anchovies and red pepper flakes and continue cooking, breaking up the anchovies with the back of a wooden spoon, until they dissolve into the oil, about 1 minute.

2) Add the tomatoes and salt. Break up the tomatoes with the spoon, then submerge the Parmesan rind in the sauce. Reduce the heat to medium-low and simmer, stirring occasionally, until the sauce is *au sec,* or almost dry, about 1 hour.[3]

3) Fish out and discard the Parmesan rind. The sauce is ready for immediate use, or you can cool and store in an airtight container in the fridge. It freezes exceedingly well. By the way, this makes more sauce than is needed for the chicken. You're welcome.

2 Use the extra liquid in the recipe for Chicken Parmesan Balls (page 104) . . . or mix with leftover pickle brine for Bloody Marys.

3 As the liquid reduces, you'll want to stir more frequently.

CHICKEN PARM[4]

YIELD:

4 servings

SOFTWARE

2 (8-ounce/240 g) boneless, skinless chicken breasts

2 teaspoons kosher salt

⅔ cup (70 g) all-purpose flour

2 large eggs, beaten

40 grams (1½ cups) salt-and-vinegar potato chips, *not* kettle cooked or thick-cut[5]

¾ cup (100 g) plain breadcrumbs[6]

2 teaspoons dried parsley

1½ teaspoons dried oregano

1½ teaspoons garlic powder

4 tablespoons (57 g) unsalted butter

2 tablespoons (30 ml) extra-virgin olive oil, plus more if needed

1 cup Red Sauce (opposite, and yes, you really should make your own), divided

57 grams (2 ounces) low-moisture mozzarella cheese, grated (½ cup)

57 grams (2 ounces) Italian-style semisoft Fontina cheese, grated (½ cup)

Fresh parsley, chopped, for garnish

TACTICAL HARDWARE

- 2 wire cooling racks and 2 sheet pans they can fit into/on[7]

- 3 loaf pans or pie tins for breading station

- A wide, straight-sided sauté pan

- A broiler-safe pan in the 9 × 13-inch range. My favorite is made of enameled cast iron, which is durable and looks great on the table (see page 105 for a funny story).

PROCEDURE

1) We need these breast pieces really thin, so split them butterfly-style with a sharp knife, only cut all the way through to produce two pieces (four total). Then pound them gently until they're evenly thinned to around ⅛ inch.[8] Cut each plank into six to eight even pieces. Season these with salt on both sides, place on a wire cooling rack set inside a half sheet pan, and refrigerate for 30 minutes.

2) Set up the breading station: The flour goes in the first loaf pan or pie tin; the beaten eggs in the second. Finely crush the potato chips (yes, with your fingers) into the third, and stir in the breadcrumbs, dried parsley, oregano, and garlic powder. Set the second clean wire rack inside its half sheet pan nearby to hold the breaded pieces.

A TALE OF TWO CHEESES

Why two? Low-moisture mozzarella, aka pizza cheese, is a stretched-curd, low-acid cheese, which means it is composed of a lot of long proteins that stretch even when melted. Americans love that stretchy gooeyness and the fact that it easily browns. Problem is, a big stretchy blob of mozz can become a chewy ball of glue and, let's face it, it doesn't taste like much. Adding a softer, fattier cheese like Fontina not only adds a nutty, buttery flavor, it will mitigate the stringiness of the mozz. When shopping, look for "Italian" but not "Val d'Aosta," which costs a whole lot more.

4 There's no actual Parm in this recipe, though we did use the rind in the sauce. If you're really just dying for it, feel free to sprinkle some over the finished dish at the table. Honestly, though, I never bother.

5 Though unorthodox, the chips help with the crunch and bring an acidic zing. By lowering the overall pH of the mixture, the chips also help to mitigate over-browning.

6 Yes, you could use homemade, but you definitely don't have to.

7 Do you really need two? No, but if you don't, you're going to have to wash the rack somewhere along the line between breading and frying, so . . . yeah, actually, you really do.

8 Hammer-style tenderizers tend to tear the meat, so I prefer a round model.

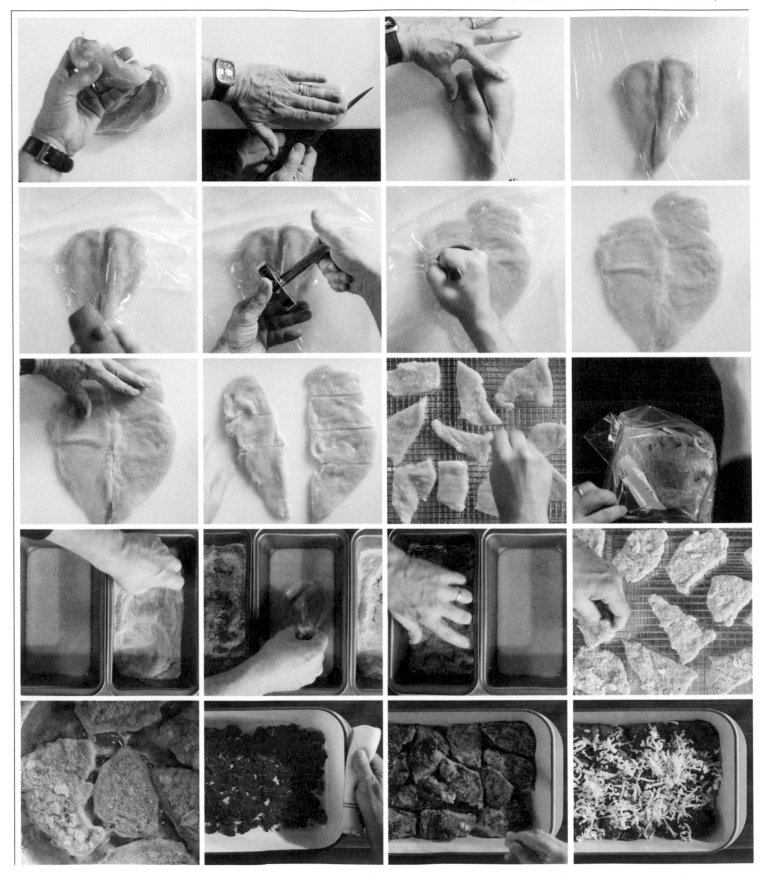

CHICKEN PARM (*continued*)

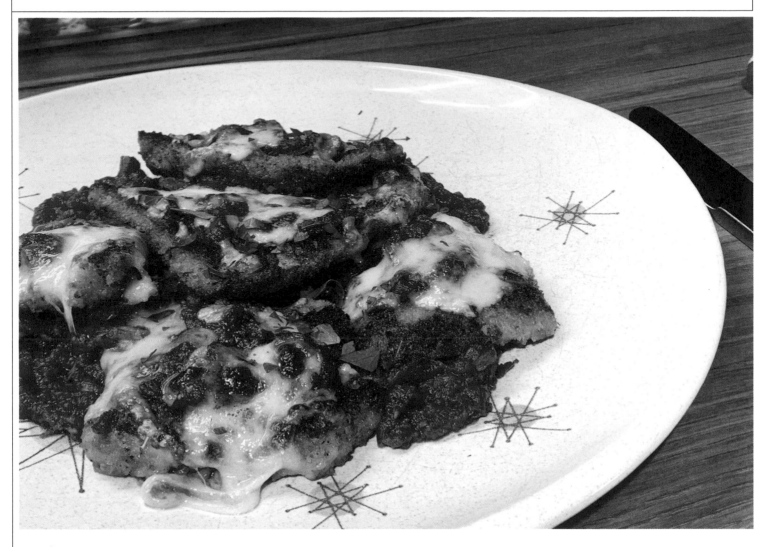

3) Retrieve the chicken and blot well with paper towels. Dredge the chicken first in the flour (shake off the excess), then dip in the beaten eggs (again, drain the excess), and finally coat with the breadcrumbs before placing on the prepared rack (don't shake off any excess). Allow to sit for 10 to 15 minutes.

4) Meanwhile, position an oven rack in the top third of the oven and crank the broiler to high. Line another sheet pan with paper towels and top with an inverted cooling rack. Have it standing by for the cooked chicken to land on.

5) Place the sauté pan over medium heat and add 2 tablespoons of the butter and 1 tablespoon of the oil. When the butter foams, add half of the breaded chicken to the pan, but don't overcrowd. Cook, undisturbed except to turn it, until crisp and golden brown, about 2 minutes per side, adding more oil as

needed. Transfer the golden pieces to the rack, wipe out the pan, and repeat with the remaining butter, oil, and chicken.

6) Spread three-quarters of the red sauce in the bottom of a broiler-safe enameled cast-iron pan and broil until the sauce bubbles and begins to caramelize, about 2 minutes.[9]

7) Remove the pan from the oven and arrange the chicken pieces in a single layer on top of the sauce. Dot with the remaining sauce, leaving bare spots to retain crispiness. Scatter with the mozzarella and Fontina.

8) Return to the broiler just until the cheese is bubbly and beginning to brown, 1 to 1½ minutes. Garnish with the fresh parsley and serve hot.

9 Two reasons for this: to get the sauce hot but also to generate a little flavor via caramelization.

CHICKEN PARMESAN BALLS

This variation on the theme is a favorite of mine and is especially well suited to entertaining (I usually serve it over spaghetti). Some of you may recognize this from an early book of mine, but rest assured this is a new and improved version I would have included in the show had there been time.

SOFTWARE

340 grams (12 ounces) boneless, skinless chicken thighs, cut into 2-inch pieces

100 grams (3½ ounces) Parmesan-style grating cheese such as Grana Padano, Pecorino, or real Parmigiano-Reggiano, if you like, cut into 1-inch pieces[10]

85 grams (3 ounces) stale Italian bread, cut into 1-inch pieces

15 grams (½ cup, loosely packed) fresh parsley leaves

10 grams (¼ cup loosely packed) fresh basil leaves

3 grams (1 tablespoon loosely packed) fresh oregano leaves

¼ teaspoon freshly ground black pepper

¼ teaspoon grated lemon zest

⅛ teaspoon freshly grated nutmeg

1 teaspoon (3 g) garlic powder

1 teaspoon (3 g) kosher salt

4 tablespoons (60 ml) extra-virgin olive oil

½ cup (115 ml) dry red wine, such as Chianti

5 cups Red Sauce (page 100)

¾ cup (190 g) reserved drained tomato liquid from Red Sauce (see above)

57 grams (2 ounces) low-moisture mozzarella cheese, grated

57 grams (2 ounces) Italian-style semisoft Fontina cheese, grated

TACTICAL HARDWARE

- A food processor with chopping blade
- A wide, straight-sided ovenproof sauté pan

PROCEDURE

1) Heat the oven to 400°F with a rack in the middle position. Put the chicken in a bowl and chill in the freezer for about 15 minutes.

2) Meanwhile, pulse the Parmesan in the food processor until it resembles coarse breadcrumbs, about 15 one-second pulses. Add the bread pieces and pulse until the mixture forms fine breadcrumbs. Transfer ¾ cup (65 g) of the breadcrumb mixture to a pie plate or shallow bowl. Add the parsley, basil, oregano, pepper, lemon zest, nutmeg, garlic powder, and salt to the food processor bowl and pulse with the remaining cheese mixture until finely chopped, 8 to 10 one-second pulses. Transfer this mixture to a large bowl.

3) Remove the chicken from the freezer and pulse in the food processor until it resembles a coarse, medium grind, 8 to 10 one-second pulses. Transfer to the bowl with the herbed breadcrumbs and combine until everything is well incorporated, and yes, you should use your hands.

4) Divide the chicken mixture into 18 to 20 meatballs, each weighing about 1 ounce (28 g), and roll them in the reserved breadcrumb mixture. Place on a half sheet pan or any other pan or dish that will hold them.

5) Heat 3 tablespoons of the oil in the sauté pan over medium heat.

When the oil shimmers, add half of the meatballs and cook until well browned, 3 to 4 minutes. Return to the half sheet pan and repeat with the second half of the meatballs, adding 1 more tablespoon of oil if needed. Remove the pan from the heat to cool for 1 minute.

6) Add the wine to the now-empty pan and bring to a simmer over medium heat. Cook, scraping the browned bits from the bottom of the pan, until the wine is reduced by about half, about 2 minutes. Stir in the red sauce and the reserved tomato liquid and return to a bare simmer. Add all the meatballs to the pan and gently stir to cover with sauce. Sprinkle the mozzarella and Fontina over the meatballs.

7) Bake until the meatballs are cooked through (I shoot for 160°F on an instant-read thermometer) and the cheese is melted and bubbly, 12 to 15 minutes. Let rest for 5 minutes before serving over pasta, or inside a hoagie roll . . . which is awesome.

10 Think of Grana Padano as P-R without the DOC pedigree. It's not exactly the same, but man is it close.

THE AFOREMENTIONED FUNNY STORY

I grew up in a Pyrex household where I learned that if you held anything bearing the Pyrex logo behind a jet engine, it just wouldn't care. Turns out my older pieces are made of borosilicate glass, which is not only tough but extremely resistant to thermal shock—like going from a refrigerator to under a broiler. Although the company that made Pyrex (Corning Glass Works) transitioned to their own newly formulated aluminosilicate glass a while back, those pieces tended to be even tougher. But, in 1998 Corning licensed Pyrex to another company that uses soda-lime glass. As a result, the baking dishes made after that can, on occasion, explode if subjected to rapid temperature changes. Indeed, if you closely examine modern Pyrex pieces, you'll see they're not recommended for use in broilers.

Well, I didn't get the memo and shame on me. When shooting the episode, of course I reached for my trusty old (and definitely not soda-lime glass) Pyrex baking dish. After the show was finished and delivered I got wise to the issue and of course had to go back and reshoot the scene with a metal pan. Point is: If you have a vintage Pyrex baking dish, you'll probably be fine to use it here, but if not, it could be a messy, sharp, hot mess. So, stick with metal just to be safe.

That really wasn't so funny, was it?

Live and learn.

EVERY GRAIN OLD IS NEW AGAIN

Somehow I doubt the real Hernán Cortés was this funny.

Meet Hernán Cortés (or at least the *Good Eats* version of Hernán Cortés), the "conquistador" who destroyed the Aztec civilization in what is now Mexico. His place in history is not for me to judge, but I'll tell you this: Due to him and his ilk, we nearly lost three of the most culinarily versatile, nutritionally potent, and culturally relevant seeds on the planet: chia, amaranth, and quinoa. Why? They played key roles in Aztec religious rituals, and since the Spanish intended to convert the entire "new" world to Christianity, they were outlawed. Indigenous Americans caught growing these grains could have a hand whacked off . . . or worse. Though their use was repressed for hundreds of years, American ancient grains are making a comeback due to their distinctive culinary properties and powerhouse nutrition, including gluten-free protein and heart-healthy fats.

Versatile, nutritious, delicious outlaws . . . sound like perfect candidates for . . . you know.

"Ancient grains" aren't called that simply because they were consumed in pre-Columbian America, but because they exist today in essentially the same form as they did millennia ago. Chia, amaranth, and quinoa are also classified as pseudocereals, because unlike true cereals, they aren't grasses. They're frequently dubbed "superfoods," but legally speaking, there's no such thing as a "superfood" outside of advertising and PR. When science types refer to foods possessing potentially positive benefits to health (beyond basic nutrition), they use the term "functional."[1]

QUINOA

Quinoa means "mother grain" in the Incan language, and quinoa is a fine mother indeed, delivering dietary fiber; vitamins B1, B2, B6, C, and E; and minerals, mainly calcium, phosphorus, iron, and zinc; not to mention it's a complete protein—that is, one that includes all of the essential amino acids, including lysine, which is often missing from cereal grains. In fact, the UN's Food and Agriculture Organization rates quinoa's protein equal to that of milk.

Back in the day, before the conquest crashed the party, this annual herb, which still thrives on the windswept highlands or Altiplano region of Bolivia, Chile, Peru, and Argentina, was used in soups, stews, and even a kind of beer. Although red and black varieties of whole-seed qui-

noa are available, as well as quinoa flakes, flour, and puffs, we'll be sticking with the more flavor-neutral white variety.

Unlike most whole seeds and grains, the germ of a quinoa seed, the botanical equivalent of an embryo, doesn't simply adjoin the larger endosperm like a remora on a great white. Quinoa's germ encircles the entire seed . . . like a big nutritious belt. When cooked, the germ breaks and hangs off like a wee tail. That's right . . . quinoa got tail.

Another important fact: Quinoa seeds are coated with substances called saponins that act as natural pesticides and might even protect the plants, which often grow up to 13,000 feet above sea level, from solar radiation, like sunscreen. As we all know, sunscreen tastes very bitter, as do saponins. Although most is cleaned off during processing, trace amounts remain, so always rinse your measured amount of quinoa in cool water; a hand sieve is perfect for the job.

AMARANTH

Amaranth, like quinoa, is a pseudocereal, and only three of the nearly seventy species are cultivated for consumption. The plants are impressive, growing up to nine feet and topped with flame-like flowers and massive seed yields, though the seeds themselves are only about a millimeter in diameter. Along with beans and maize, amaranth was one of the major staples of the Aztec world, though its use declined after Spanish colonization. Today, amaranth is widespread and raised for its grain and greens in China, Africa, Nepal, and India.

1 Terms such as *functional foods* or *nutraceuticals* are widely used in the marketplace. Since the Federal Food, Drug, and Cosmetic Act (FFDCA) does not provide a statutory definition of functional foods, the Food and Drug Administration has no authority to establish a formal regulatory category for such foods. Just want to say that up front.

A good source of protein and fiber, amaranth also delivers twice the iron of quinoa. Though tiny, amaranth seeds are intensely flavored and pop like popcorn when toasted. When cooked in liquid, amaranth seeds tend to cling together, porridge-style.

CHIA

If you grew up during the '70s or '80s, odds are you remember the ubiquitous terra-cotta figures covered with chia seeds (that is, *Salvia hispanica*, a member of the mint family) that, when soaked with water, sprouted, creating delightful "pets." Silly, perhaps, but the very existence of these chia things serves as proof of the importance of chia to the Mesoamericans, especially the Aztecs, who depended on it for energy, protein, fiber, and a mélange of micronutrients.

So important was chia that it was used in religious rites. Idols of the Aztec god Huitzilopochtli were crafted from chia mixed with amaranth and syrup or honey and allowed to dry. They were then soaked in the blood of human sacrifices, broken into bits, and consumed.

My interest in chia today is neither historical nor nutritional but rather culinary, and that's where chia has some extraordinary powers. Mix a spoonful of chia seeds into warm water for 30 minutes and behold: a gel! What sorcery is this?

Chia seeds are covered in microfibers that extend out into water when it comes into contact. Those fibers house even more fibers, some as small as 50 nanometers in diameter. When wet they intertwine, creating an extremely hydrophilic nanoscale 3-D network capable of holding about twenty-five times their weight in water, enabling the seeds to survive periods of drought. Lucky for us, chia also grabs most water-like substances like milks or juices.

Such gels can be used to create beverages like *agua de chia*, which are simply mixtures of varying amounts of water, chia, lime or other citrus, and either honey or agave syrup mixed and allowed to gel. The same can be done with a wide range of juices. I'm fond of chia breakfast puddings, not only because they taste good but because chia gels move through the gut very slowly, making you feel full for hours. You probably don't need me to tell you this, as there are more recipes for chia breakfast pudding on the interwebs than there are hairs on a chia seed, but the version on page 111 is my favorite.

You have no idea what's really going on behind my back here.

QUINOA AND BROCCOLI CASSEROLE

YIELD:

8 servings

This is my favorite way to ingest this protein-packed (and gluten-free, if you care about that kind of thing) ancient grain. Yes, the casserole has some fat, but I figure it's all balanced by the great nutrition from the quinoa.

SOFTWARE

1½ cups (260 g) quinoa[2]

3 cups (710 ml) unsalted chicken stock

3 teaspoons (10 g) kosher salt, divided

12 ounces (340 g) broccoli florets, chopped (4 cups)

8 ounces (227 g) button or cremini mushrooms, sliced ¼ inch thick (2½ cups)

⅓ cup (80 ml) water

4 tablespoons (57 g) unsalted butter, divided

½ large onion (150 g), diced (1⅓ cups)

2 tablespoons (11 g) dry mustard

1½ teaspoons (3 g) smoked paprika

½ teaspoon freshly ground black pepper

¼ teaspoon cayenne pepper

¼ teaspoon ground white pepper

3 cups (710 g) half-and-half

1 large egg

1 pound (424 g) sharp cheddar cheese,[3] grated (4½ cups)

½ cup (110 g) mayonnaise

TACTICAL HARDWARE

• A fine-mesh sieve

2 Since quinoa contains oils, store it in a glass jar in a cool, dry place.

3 This recipe works best with a relatively high-moisture, generic, grocery-store sharp cheddar cheese. Don't be tempted to spring for the fancy stuff; its lower moisture content may cause the sauce to curdle.

PROCEDURE

1) Position a rack in the middle of the oven and heat to 350°F.

2) Put the quinoa in the sieve and thoroughly rinse under cool running water. Drain well and transfer to a 4-quart saucepan. Add the stock and 2 teaspoons of the salt, place over high heat, and bring to a boil.

3) When the mixture hits a boil, reduce the heat to low, give it a stir, cover, and cook for 5 minutes.

4) Quickly uncover the pot and dump the broccoli right on top of the quinoa. Replace the lid and cook until both the quinoa and broccoli are just tender, about 5 minutes more. Remove from the heat and set aside until ready to build the casserole.

5) While the quinoa cooks, heat an 11-inch straight-sided sauté pan over high heat for 45 seconds. Add the mushrooms and water and cook until the mushrooms collapse, 2 to 3 minutes. Add 2 tablespoons of the butter and cook, stirring occasionally, until the mushrooms brown, 7 to 10 minutes. Transfer to a large bowl.

6) Add the remaining 2 tablespoons butter to the sauté pan, along with the onion and the remaining 1 teaspoon

QUINOA AND BROCCOLI CASSEROLE *(continued)*

salt. Reduce the heat to low and cook, stirring often, until the onion is translucent but not yet brown, about 5 minutes.

7) Add the mustard, smoked paprika, and black, cayenne, and white peppers to the onion and continue cooking for another minute. Stir in the half-and-half and cook until warm (160°F), about 3 minutes.

8) Meanwhile, crack the egg into a medium bowl and whisk until smooth. When the half-and-half is hot, slowly ladle about a cup of the hot liquid into the egg while whisking vigorously to prevent curdling. Whisk the egg mixture back into the sauté pan, followed by the cheese, stirring until melted. Pour into the bowl with the mushrooms along with the quinoa-broccoli mixture and the mayonnaise. Stir to combine.

9) Transfer the quinoa mixture into an ungreased 9 × 13-inch baking dish.[4] Bake until the mixture sets and an instant-read thermometer inserted into the center reads between 205°F and 210°F, about 45 minutes.

10) Move to a wire cooling rack and let rest for 10 minutes before serving. If you end up with leftovers, refrigerate them overnight, then slice into slabs about 1 inch thick. Fry in hot butter until golden brown on both sides, and serve like a hash brown for breakfast.

COCONUT OIL

There are a lot of ways to get oil out of a coconut. I stick with virgin oil, which is squeezed from the meat instead of steamed out with solvents, and yes, they do that. As for "extra" virgin, there is no such thing, though that doesn't prevent some packagers from printing it right on the label. You're free, of course, to go with organic, but honestly, I don't even know what that means anymore, so I stick with conventional. As for coconut oil's purported health benefits or lack thereof, that will have to wait for another show. This stuff has a melting point of 76°F, so unless you reside in tropical climes or don't have an air conditioner, you might need to warm it up a bit to pour.

4 If your sauté pan is ovenproof, feel free to return the quinoa mixture to the pan for baking.

CHOCOLATE CHIA PUDDING

When I was a kid, I was addicted to those little canned puddings the other kids always had in their lunches. This reminds me of that pudding, thanks to chia's silky-smooth thickening power. And, of course, this chocolate pudding has the functionality of chia: high fiber, omega-3 fatty acid in the form of alpha-linolenic acid, and a fair amount of protein. Me, I just like pudding.

SOFTWARE

2 cups (473 ml) water, divided

1 cup (70 g) Dutch-process cocoa powder

½ cup (160 g) maple syrup (Grade A: Dark Color & Robust Flavor; see below)

⅓ cup (55 g) chia seeds

1 large avocado, pitted and scooped (about 160 g)

1 teaspoon vanilla extract

1 teaspoon kosher salt

2 tablespoons (24 g) coconut oil, melted[5] (see more info opposite)

TACTICAL HARDWARE

• A heavy-duty (1500W) blender[6]

PROCEDURE

1) Microwave 1 cup water on high for 1 minute. Put the cocoa powder in the blender carafe. When the water is hot, pour it over the cocoa and blend on high speed for 30 seconds.[7] (The heat from the water will make the air inside the blender expand, so don't put on the lid too tightly at this point or you could end up with a bit of a mess.)

2) Add the maple syrup, chia seeds, avocado, vanilla, salt, and remaining 1 cup water to the blender and blend, starting on low and increasing to medium-high speed, until thoroughly combined, about 45 seconds.

3) With the blender still running, slowly stream in the coconut oil. Continue to blend on medium-high until the pudding is smooth and creamy, 1 minute more.

4) Transfer to a resealable container and refrigerate for at least 4 hours. The pudding will continue to set up as it cools.

5 Since it's prone to rancidity, I store mine in the fridge, where it sets up like a rock. A few seconds in the microwave will make it spoonable.

6 If all you've got is a traditional, lower-wattage blender, you can still make this recipe. Keep in mind, though, you may need to take a little more time blending the pudding in step 2, and the final result will not be quite as smooth and creamy as when made in a high-power blender.

7 This is called blooming, and it will help to mobilize flavors out of the cocoa solids and into the pudding and make the actual mixing a heck of a lot easier.

MAPLE SYRUP GRADES

Back in 2015, whoever the folks are who make decisions about maple syrup in the United States got together with their counterparts in Canada and came up with a new grading scale. The new grades don't exactly line up with the old ones, but here's roughly how it works, which, if you ask me, is well . . . stupid. Not only is the wording lame, but the overlapping of old and new makes it darn near impossible to keep straight, especially since every grade is now Grade A!

Old	New
Fancy/Vermont Fancy	Grade A: Golden Color & Delicate Taste
Grade A Medium Amber, Grade A Dark Amber	Grade A: Amber Color & Rich Flavor
Grade A Dark Amber, Grade B	Grade A: Dark Color & Robust Flavor
Grade C(ommercial)	Grade A: Very Dark & Strong Flavor

It takes roughly 40 gallons of maple sap to make 1 gallon of maple syrup.

A visit from the Tree-based Syrup Authority

AMARANTH COOKIES

So, amaranth got the short end of the stick because we ran out of time in the episode. But if I'd had about 10 minutes more, this would have happened.

Quinoa may be a complete protein, but its pseudocereal cousin amaranth pops like popcorn. So, naturally, I decided its tiny magic would be best put to use in a cookie. You're welcome.

SOFTWARE

½ cup (100 g) whole amaranth

½ cup plus 2 tablespoons (75 g) amaranth flour

1 teaspoon (3 g) dried orange peel

¼ teaspoon kosher salt

⅛ teaspoon baking powder

1 cup plus 2 tablespoons (200 g) dark brown sugar

4 tablespoons (57 g) unsalted butter, at cool room temperature (60°F to 65°F)

1 large egg

½ teaspoon vanilla extract

¼ cup (30 g) chopped candied orange peel[8]

TACTICAL HARDWARE

- A stand mixer with paddle attachment

8 You can buy this at a lot of megamarts, or off the webs, or you can go to altonbrown.com and look up my recipe, which isn't half bad if you ask me.

PROCEDURE

1) Heat a 2-quart saucepan over medium-high heat for 2 minutes. Flick water into the pot; if it immediately forms balls and evaporates, it's hot enough. If it doesn't, keep heating and flicking until it does. When hot, add 1 tablespoon of the whole amaranth and cover the pan. Shake the pan, right on the heat, for 5 to 10 seconds to pop the grains. Kill the heat, give the pan a few more shakes, then pour into a medium bowl. Wipe out the saucepan and continue a tablespoon at a time until all the amaranth is popped. Then set aside while you make the dough.

2) Whisk the amaranth flour, dried orange peel, salt, and baking powder together in a small bowl. Set aside.

3) In a stand mixer fitted with the paddle attachment, cream the brown sugar and butter together on medium speed, scraping down the sides and bottom of the bowl as needed, until light and fluffy, 3 to 5 minutes.

4) Add the egg and beat until smooth, about 30 seconds, then add the vanilla and beat for another 15 seconds. Turn off the mixer and scrape down the sides and bottom of the bowl.

5) Return the mixer to low, then slowly incorporate the flour mixture, followed by the popped amaranth and the candied orange peel. After 15 seconds, kill the power, remove the bowl from the mixer, cover, and chill in the refrigerator for 30 minutes.

6) Meanwhile, heat the oven to 325°F and position a rack in the middle of the box. Line two half sheet pans with parchment paper. Drop the batter onto the prepared pans by the tablespoonful, twelve to a pan, 2 inches apart. Gently press the dough into rounds about ½ inch thick.

7) Bake one pan at a time, until the cookies have puffed, formed a cracked top, and are golden brown on the bottom, 10 to 12 minutes.

8) Remove and cool for 1 minute on the pan before sliding the parchment onto a wire rack so the cookies can cool completely. Repeat with the second prepared pan, then re-line the original pan to bake off a third batch.

Sealed in an airtight vessel, the cookies will keep for 2 weeks. They freeze well too.

HITTIN' THE SAUCE II

I hear a lot from you guys via social media and one of the questions you repeatedly ask is: "Hey, Alton, is there any dish you can't cook?" "Is there any food that gives you trouble?" Naturally, you expect me to say, "No! I can cook anything." And it's true, I can cook anything, just not very well.

My Achilles' heel is . . . grilled fish. It's not that all my grilled fish are 100 percent yuck. My inedible failures are few and far between, but so too are my culinary victories. Most of the time my grilled fish are simply "meh." And yet the meals I've served guests featuring grilled seafood have brought in an average rating of 9.5. How is this possible? What's my secret? Sauce. Three sauces, to be exact: umami mayonnaise, smoky romesco, and silky salsa verde.

When you can't afford expensive historical reenactments—go with shadows.

Or so I said in the opening scene of this episode. Truth is, I rely on four sauces, it's just that we didn't have time to spoon into my tartar sauce, which I'm quite fond of and which is included herein. The best thing about all these sauces is that they can be made well ahead and stored for at least a week, if not more, in the refrigerator. Are they limited to seafood? Of course not. During grilling season, I always have two or three of them on hand.

The word *romesco* may derive from *rumiskal*, meaning "mix things together" in the medieval Mozarabic language spoken in Muslim-dominated areas of Spain following the Arab conquest of the eighth century. Romesco the sauce hails from Tarragona, which really should be the birthplace of tarragon but isn't. Originally, this seafood-friendly sauce was composed of almonds, garlic, oil, and often stale bread. But tomatoes and chiles were added after the Columbian exchange made them available on the Iberian Peninsula, and they really do pull the room together.

This sauce differs from many classic interpretations in that it is smoked . . . or mostly smoked. Any, and I do mean any, grilled white fish can be rescued or even resurrected by smoky romesco: cod, snapper, striped bass, and, if you're not a fish person, roasted potatoes all day long.

Spanish or Marcona almonds are more authentic to romesco, but they're pricey, so we'd rather save them for the nut bowl. Ditto dried nora peppers. Authentic, yes, but bell peppers are a lot easier to find.

SMOKY ROMESCO SAUCE

YIELD:

About 2 cups

This sauce is better for firmer and oiler fish such as swordfish, mackerel, or even sardines.

SOFTWARE

3 red bell peppers

1 tablespoon (16 g) tomato paste (see below for a wee tip)

1 large clove garlic, peeled and smashed

½ cup (75 g) whole blanched almonds[1]

1½ ounces (40 g) stale French bread, cut into 1-inch cubes (1½ cups)

1 tablespoon (30 ml) sherry vinegar (see opposite)

1½ teaspoons kosher salt

½ cup (118 ml) extra-virgin olive oil

TACTICAL HARDWARE

- A smoker[2]
- A food processor

NOTE

If you have a gas cooktop, you can char the peppers right over the flame, which is what I usually do. Just position them on the grate over a medium-high flame, turning them a quarter turn every 30 seconds or so until all the skin is charred. There will be some smoke, so open a window or turn on your exhaust vent, if you have one. The entire process should take about 3 minutes, depending on your burners.

PROCEDURE

1) Set up your favorite smoker and add a handful of hardwood chunks. If you have heat control, set it to whatever position will give you moderate heat: 180°F to 200°F.[3] Allow the wood to smoke for approximately 30 minutes before adding food.

2) While the smoker is heating, position one oven rack 5 inches below the broiler and another in the center of the oven. Set the broiler to high.

3) Halve the peppers lengthwise, discard the seeds, place cut-side down on a sheet pan, then broil, rotating the pan halfway through, until the skins are charred, 10 to 15 minutes. Reduce the oven temp to 350°F.

4) Transfer the charred peppers to a large bowl, cover tightly with plastic wrap, and set aside for 15 minutes. Rub gently between your fingers under running water to remove the charred skins.

5) Spread the tomato paste into a thin, 3- to 4-inch circle on a piece of parchment paper (I like a small offset spatula for this) and place on a baking rack along with the peppers and garlic. Place the rack in the smoker and smoke for 20 minutes.

6) Meanwhile, toast the almonds on a quarter sheet pan or pie plate in the oven until golden-brown, 10 to 12 minutes.

7) Once everything has been smoked and toasted, load the bread cubes, vinegar, and salt into your food processor, along with the smoked peppers, garlic, and tomato paste and the toasted almonds. Pulse until uniform but still a bit chunky, 5 or 6 one-second pulses. Scrape down the sides of the bowl. Re-lid and, with the processor running, add the oil through the feed tube in a constant stream. It should take about 10 seconds to add the oil.

8) Transfer to a serving bowl and leave at room temperature for 2 to 3 hours before serving. After that, either use or cover tightly and refrigerate for up 10 days. For long-term storage, freeze in ice cube trays, then move to a freezer bag and use within 3 months.

TIP

I typically dispense tomato paste from a tube. However, if your favorite brand is only available in little 6-ounce cans, which you open only to empty by one-twelfth, leaving the rest in the back of the fridge to grow fur, try this: Instead of the cabinet, keep your cans of tomato paste frozen solid. Then, when you're ready to use, just take your trusty can opener and cut out both ends of the can, then stick them back into the ends of the can. (If you have one of those newfangled openers that literally cuts off the top of the can, sorry.) When needed, simply

1 Blanched meaning skinned. Just don't go with slivered or sliced. Yes, it really does matter.

2 Always smoke in a well-ventilated place and always use a hardwood like hickory, maple, or oak.

3 We're not looking for a precise temperature here, just smoke as a marinade, if you will. I like to use an electric hot plate in a cardboard box rig, but feel free to use the smoker of your choice or even a wok smoker if you have appropriate kitchen ventilation.

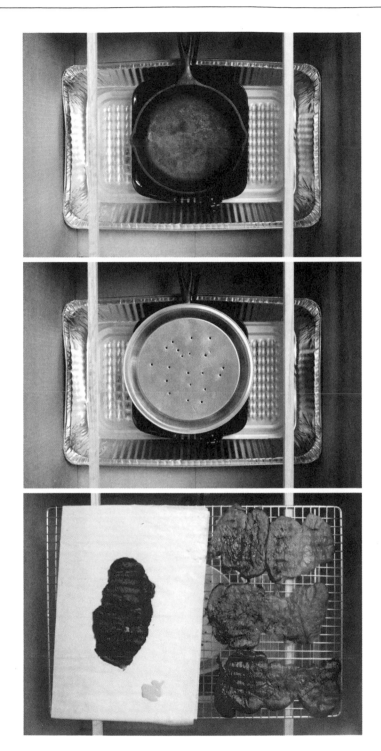

Please note: We're discussing real DOP (Denominación de Origen Protegida) sherry vinegars from Spain, not vinegars made in California or wherever. Three grapes go into sherries and therefore sherry vinegar: Palomino Fino, which are what I'd call "bright"; Pedro Ximénez, which always remind me of prunes but in a good way; and muscatel, which are tasty but a little sweet for me.

When the maker decides to go the vinegar route, he or she doesn't fortify the wine but re-inoculates it with acetic bacteria that will convert the wine into vinegar. The results are matured via the *solera* method, in which a percentage of older batches are left in the barrel and then younger vinegars go on top. The resulting complexity is also a matter of age: Vinagre de Jerez has spent six months in oak, reserve two years, and gran reserve ten years. Although I own, well, a lot of them, when it comes to sauces, I stick with vinagre de Jerez, and if a grape is listed, I shoot for palomino.

Our ship set is built so that the whole thing rocks back and forth on bowling balls.

squeeze the paste out like one of those pop things you used to lick on in the summertime when you were a kid (but I wouldn't do that with this). Squeeze out what you need—half an inch equals approximately a tablespoon. Reapply the lid for safe storage, put in a zip-top bag, and put it back in the freezer. That way, it's ready to dispense at a moment's notice. Waste not . . . waste not.

SALSA VERDE

Green sauces can be found worldwide; Argentina's chimich-urri and Italy's pesto are some of the best known. When it comes to seafood, though, I tend toward those of Mexican and Central American extraction that feature the husk tomato, or tomatillo, which, despite its moniker, is a closer cousin of the cape gooseberry than the tomato, with which it's often confused.[4] To my mind the flavor is that of cucumber and lemon and something else I like but can't exactly put my finger on. When purchasing tomatillos, seek green-brown husks, which easily peel back to reveal bright green fruit that are similar in firmness to a green tomato.[5] Store in the refrigerator, still in their husks, in a zip-top bag with the seal left open, for up to a week. Husk immediately before using and be sure to wash the berries in water to remove the sticky withanolides, which some members of the night-shade family produce as a natural insecticide.

The sauce on the right has xanthan gum, while the sauce on the left has none.

CILANTRO

Cilantro is one of the few plants that gives us both an herb (the greens) and a spice (the seeds, aka coriander). I don't know too many people who don't like coriander, but cilantro (the herb) is fiercely hated by some, who say it tastes strongly of soap. Some of you may be bona fide cilantro haters who think it tastes like soap. This is likely due to a genetic predis-position that increases your sensitivity to its aroma via an olfactory receptor known as OR6A2. One theory proposes that crushing or blend-ing the leaves of the plant can change the plant's aldehydes, which give cilantro its soapiness. Fun fact, soap is also loaded with aldehydes. If you typically don't care for it, replace half with flat-leaf parsley. If you really hate it, replace it all; my feelings won't be hurt.

4 Chasing this subject leads to a nomenclatural miasma, because even those of us with a less-than-serviceable command of Mexican Spanish know that *tomatillo* means "little tomato." However, if you go back to the original Nahuatl, tomatillos are *tomatl* and tomatoes (as we know them) are *xītomatl*. So, we probably ought to be calling tomatillos "tomatoes" and tomatoes "xitomatoes" or "jitomatoes."

5 Like tomatoes, tomatillos ripen to a bright red. Unlike tomatoes, though, tomatillos don't sweeten as they ripen and ripe ones are rarely called for in recipes, at least as far as I can find.

SILKY SALSA VERDE

YIELD:
About 3 cups

Goes well with any grilled white fish, including grouper, sea bass, and my go-to: tilapia (tacos).

SOFTWARE

1 pound (454 g) tomatillos, husks removed and rinsed

½ large white onion (152 g), peeled, layers separated

1 serrano chile (13 g), stemmed, halved, and seeded

1½ teaspoons grapeseed oil

1 cup (23 g) packed fresh cilantro leaves and tender stems (Hate cilantro? See opposite.)

1½ teaspoons kosher salt

¼ teaspoon xanthan gum (Don't be afraid. Read the box below.)

PROCEDURE

1) Position a rack 3 inches below the broiler and set the broiler to high.

2) Toss the tomatillos, onion, and chile with the oil in a large bowl to coat. Transfer to a half sheet pan and broil until blistered and slightly charred, about 7 minutes. Give the pan a shake every couple of minutes to ensure even cooking.

3) Transfer to a blender along with the cilantro and salt and puree on high until smooth, about 30 seconds. With the blender still running, add the xanthan gum and blend until thickened, about 10 seconds more.

4) Serve immediately or transfer to an airtight container and store in the refrigerator for up to 2 weeks. Return to room temperature before serving.

XANTHAN GUM

Salad dressings, soups, fruit juices, baked goods, syrups, ketchup, whipped cream, and countless other products, edible and otherwise, include this alien-sounding additive. So . . . what is it?

Simply put, xanthan gum is a high-molecular-weight exocellular polysaccharide, and no, that isn't as scary as it sounds—in fact, it's actually natural. Back in the 1950s, a chemist by the name of Allene Rosalind Jeanes, working at the Northern Regional Research Labs of the USDA, was pondering the gross black stuff that grows on broccoli and cabbages. What she and her team discovered was that the bacteria in question, *Xanthomonas campestris*, could ferment sugars, thus secreting an amazingly sticky goo.

How sticky? So sticky that it can be used to thicken mixtures and stabilize emulsions like salad dressing. And what's really cool is that xanthan gum promotes "sheer thinning," which means it thickens but then thins with physical agitation, like stirring or pouring, and then it thickens again afterward.

In this application, adding xanthan thickens and smooths the salsa and keeps the solid and the water phases from separating. But wait, there's more. By changing the shape of the sauce on the tongue, so to speak, flavor perception is altered as well, allowing more of the fruit flavors of the tomatillo to come through.

Xanthan gum is quite common in gluten-free baking, so it's easy to find these days, even in many megamarts. Since it typically comes in tiny packets, I purchase it off the web, because shipping is next to nothing. A word of note: Xanthan is powerful stuff, so always weigh or measure according to the recipe.

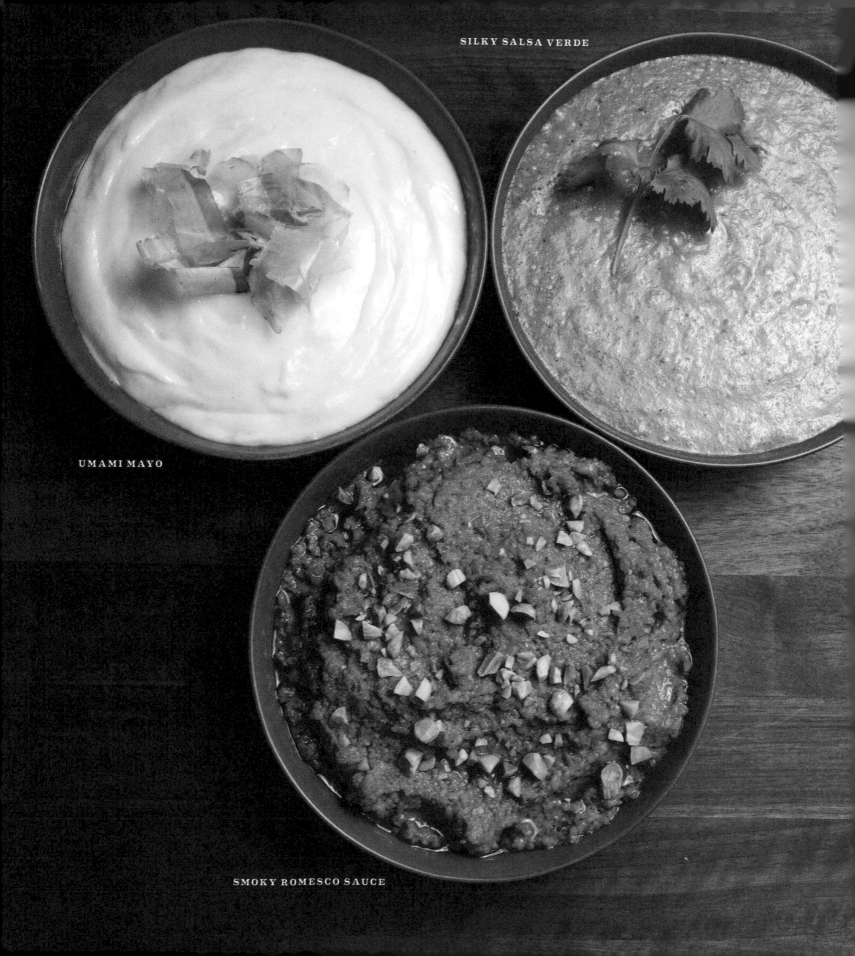

UMAMI MAYO

SILKY SALSA VERDE

SMOKY ROMESCO SAUCE

UMAMI MAYO

This sauce gains an umami kick from an ingredient that's as Japanese as Godzilla wearing a Hello Kitty backpack. Besides tuna, I'll slather this on mackerel as well as French fries. Fish grillers, especially those who tend toward questionable grate hygiene, have long relied on mayo to provide a kind of clingy, high-viscosity, edible axle grease. Unlike oil, which drips and flares and causes general mayhem, mayo, a simple emulsion of oil, vinegar, and egg, sits there nice and snug, preventing the metal grates from tenaciously seizing hold of my protein. I never grill tuna without it. Problem is, mayo is an uninspired sauce for finishing. So, I turned to Japanese bar food, where flavored mayos make the world go round.

SOFTWARE

1¼ cups (300 ml) grapeseed oil (see below)

3 cups (20 g) bonito flakes (see sidebar, below)

2 large egg yolks[6]

1½ teaspoons rice vinegar[7]

1½ teaspoons fresh lemon juice

¾ teaspoon kosher salt

PROCEDURE

1) Combine the grapeseed oil and bonito flakes in a small saucepan and cook over low heat until the oil reaches 180°F,[8] 10 to 12 minutes. Remove from the heat and cool at room temperature for 20 minutes before straining through a fine-mesh sieve into a heatproof bowl or measuring cup. Reserve the bonito flakes for another use.[9]

2) Whisk the egg yolks together with the vinegar, lemon juice, and salt in a large bowl. Add the bonito-infused grapeseed oil a few drops at a time, whisking briskly, until the egg mixture thickens and lightens in color a bit, about 1 minute. Then, still whisking, increase the oil flow to a constant, thin stream until a smooth mayonnaise texture is achieved, 1 to 2 more minutes.[10]

Umami is generally accepted as the "fifth taste" and is associated with "savory" flavors like those delivered by aged Parmesan, mushrooms, and red wine.

GRAPESEED OIL

Grapeseed oil is, yes, pressed from the seeds of grapes. It's highly polyunsaturated, so prone to rancidity, which is why I store mine away from heat and light. It has a relatively high smoke point, so it won't break down until it reaches around 400°F, but best of all, it is essentially flavorless, which means it's not going to get in the way of the *katsuobushi* (bonito flakes), which we've dealt with on this program before.

6 If you're worried about the raw egg yolks, go ahead and use pasteurized eggs—you can find them in most megamarts. Me, I like to live on the edge.

7 I used to use the term *rice wine vinegar*, which is more exact, but the word is being left off of labels more and more these days, so I'm standardizing to the form.

8 I wouldn't bother with a fry thermometer for this . . . an instant-read will do.

9 I use these flakes on pizza, in scrambled eggs, on toast, and with Manchego cheese.

10 This recipe does not make enough mayonnaise to be made using a blender; however, if you would like to skip all that whisking, you can make it using an immersion blender. Find a jar or drinking glass with straight sides that just fits the blade head of the immersion blender. After making the bonito oil, combine it along with the rest of the ingredients in the jar. Place the immersion blender in the jar and turn it on, lifting it up and down in the jar as needed, until a smooth emulsion forms, 10 to 15 seconds.

If you've ever ordered grilled shishito peppers and they arrived with pinkish things on top that seemed to be wriggling in some kind of death throes, that's katsuobushi.

KATSUOBUSHI

Take a bonito or skipjack tuna loin, dry it, ferment it, smoke it, and dry it some more until it's basically a block of wood. Run it back and forth on a device that looks like an upside-down hand plane mounted on a box with a little drawer, and you'll produce a substance you'd swear were wood shavings but are in fact katsuobushi, the poster child for umami, the "fifth flavor" associated with so many different Japanese dishes.

Luckily, we don't have to plane our own these days, because most megamarts (and certainly the interwebs) offer bagged flakes, which have a very, very long shelf life, as long as they're kept in airtight containment. These flakes, critical to Japanese basics like dashi, deliver glutamates as well as inosinic acid, which sensorily synergizes with glutamates to . . . Look, umami tastes good, okay?

AB'S SECRET TARTAR SAUCE

Here's the sauce that didn't make the show because there just wasn't time. Unlike the *sauce tartare* we discuss in "Raw Ambition" (page 152), this is actual tartar sauce, only we're making our own mayo using pickle juice and upping the flavor complexity with shallots and capers. I have never published this application in any way, fashion, or form because for a while I harbored dreams of bottling it and selling it myself. That never really got off the ground, so . . .

SOFTWARE

1 large egg yolk (18 g)

2 tablespoons (29 g) cornichon pickle juice

1 teaspoon (5 g) gherkin pickle juice

2 teaspoons (10 g) fresh lemon juice

¼ teaspoon (2 g) Dijon mustard

⅛ teaspoon freshly ground white pepper

130 grams (⅔ cup) neutral oil, such as canola/safflower mix

2 tablespoons (4 g) finely chopped fresh dill

3 cornichon pickles, minced (18 g)

1 large gherkin pickle, minced (30 g)

1 tablespoon (11 g) finely minced shallot

2 teaspoons (8 g) finely minced capers

TACTICAL HARDWARE

- A narrow jar or 500-milliliter beaker just wide enough to admit the next item

- A stick or immersion-style blender[11]

PROCEDURE

1) In a 500-milliliter glass beaker combine the egg yolk, pickle juices, lemon juice, mustard, and white pepper.

2) With a blender stick set to speed 5, or high, slowly drizzle the oil into the beaker, keeping the blender stick at a slight angle so that the oil drizzles straight into the blade. Once it starts to thicken you may need to swirl the blender stick around the bottom of the jar a bit. This will feel a bit awkward and will take around a minute to produce a stable emulsion.

3) Once all the oil has been blended in and the mayo is thick, remove the blender stick and stir in the rest of the ingredients.

4) Chill in the fridge for a couple of hours before serving on pretty much anything that swims.

11 Although I make this via the jar/stick combo, you can certainly go old school with a whisk. The problem with using a standing blender or a food processor is that it's a very small amount of liquid and the blades usually just fly right over it.

IMMERSION THERAPY

When I was growing up, I was fascinated with time travel. I read books about it, obsessed over episodes of *The Time Tunnel*, and spent hours constructing my own "time machines" out of cardboard. Then, one day, my science teacher, fed up with my nagging, turned to me and snapped, "Time travel's impossible!" So I switched to jet packs.

But you know what? He was wrong—at least in the kitchen, where time can be conquered if temperature can be precisely controlled. A specialized device called an immersion circulator now makes this possible. Only a decade ago, such instruments were costly and bulky, with not enough reliable literature in circulation to support their use by the general public. That's all changed, and I would say that the advent of affordable, reliable immersion circulators qualifies as the most significant culinary event since the food processor.

Messrs. Lea & Perrins

This model, meant to illustrate the momentum of heat, required someone to put on the chicken suit. My longtime associate Jim Pace answered the call of duty.

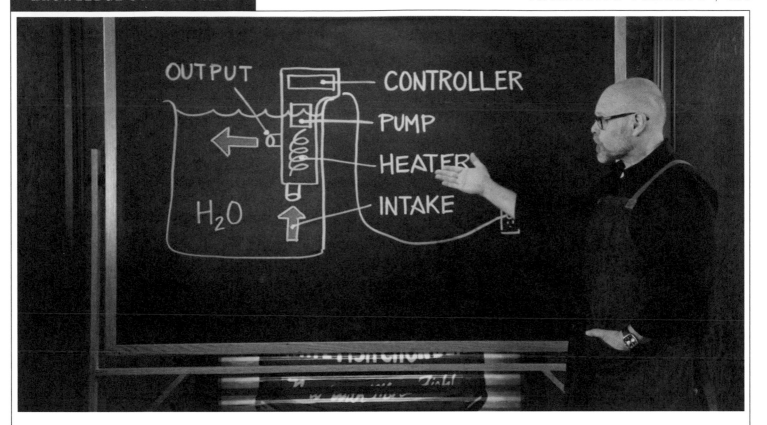

An immersion circulator is a digitally controlled heat pump that attaches to a vessel containing water (called a "bath"). The circulator sucks up the water, takes its temperature, heats it (or not), then spits it back out, thus maintaining the bath to within a degree of the set temperature, while also providing convective flow, in itself a powerful force for culinary good. The target food goes into a watertight vessel that allows for maximum contact with the bath, usually a heavy plastic bag. Since the bath never exceeds the target doneness temperature, the food never undercooks or overcooks and can be left in the bath for quite some time (hours) after reaching doneness. Properly operated, a decent immersion circulator system virtually cannot overcook food. Once removed from the bag (or whatever vessel is used) the food can be further treated, most typically with a high-temperature sear, which enhances flavor and texture and serves to kill off surface bacteria that may have survived the lower temperatures of the bath. One of the miracles of immersion cooking is that we can cook things like tough cuts of meat long enough to break down connective tissues but at temperatures low enough to avoid overcooking.[1]

Just to be clear, we are not talking about sous vide here. Although the cooking method known as sous vide does indeed rely on the use of immersion circulators, the term does not apply to us here because *sous vide* means "under vacuum" and refers to the packaging of the target food in a bag that then has all the air sucked out of it with a machine designed specifically to suck air out of bags. Sous vide involves other processes such as textural changes and is trickier to manage safely at home, plus it requires the aforementioned machine and special bags. What we're doing I call "immersion cooking," and to do it we need three things.

THE MACHINE

This is a rectangular or cylindrical gizmo, typically with a digital readout and a couple of controls at one end, a clamp on the back to connect it to the bath vessel, and a heavy-duty electrical cord. The intake and output jets may or may not be visible. Every model I've used also had a "minimum water level line." Myriad models have hit the market over the last few years (some that can only be controlled by your smartphone), and the internet is packed with reviews for them. I'd avoid models costing less than

1 The first time I cooked beef ribs in a circulator I thought sorcery was afoot, because the meat was tender and yet still pink at the same time. I'd never seen that before.

KNOWLEDGE CONCENTRATE *(continued)*

$100, and when researching, focus on issues such as ease of use, heating time (faster is better), temperature accuracy, and pump capacity—that is, the amount of water per hour the unit can push.[2]

THE BATH

You can use literally anything that can hold water as long as your circulator's clamp fits. I've used coolers, sinks, tubs, and an aquarium (albeit at low temperatures), but my go-to is a polycarbonate food storage container in the 18- to 22-quart range. Available at restaurant-supply stores, they're light, stackable, usually come with lids, and are indexed so you can easily keep up with how much water you're working with. I especially like clear containers because I can see what's going on in there from across the room.

FOOD CONTAINMENT

As you'll see if you make it down to the cheesecake application, immersion cooking can certainly be done in glass jars, but probably 90 percent of the recipes you find out there will call for plastic bags. Is it safe?[3] The answer is: It depends. Some plastics do contain harmful substances, including BPA (bisphenol A), a chemical implicated in a wide array of health issues. But good-quality, national-brand freezer bags made by Ziploc and Glad are made of food-safe polyethylene and reportedly do not contain BPA. The consensus among experts is that these bags are safe as long as they're used below 195°F. I never use them in temperatures over 165°F, so I don't feel I'm putting myself or my diners in danger. The key again is to avoid generic brands. Stick with the national name brands and go with heavy-duty freezer bags. If the box says they're "microwave safe," even better. Ziploc freezer bags are my bags of choice across the board, and no, they don't pay me to say it.[4]

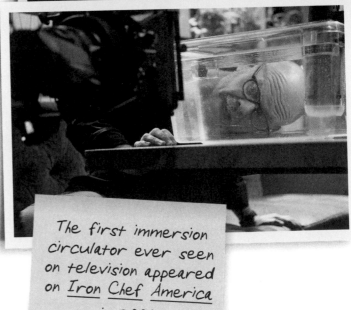

The first immersion circulator ever seen on television appeared on Iron Chef America in 2006.

2 As of this writing, I remain a huge fan of PolyScience circulators. Early-adopting chefs started bringing their machines into the kitchen of a show I used to be involved in called *Iron Chef America* nearly twenty years ago, and although they were more suited to laboratory applications, the results were amazing. Since then, PolyScience has advanced culinary immersion circulators to a high art. They are not cheap by any means, but if you can possibly swing one, you won't be sorry.

3 You have no idea how badly I wanted to work a *Marathon Man* skit into this show, but I knew it would never make it past the network brass.

4 Cooking vegetables by this method will often require higher temperatures than I am comfortable with here, so with those I use vacuum bags manufactured specifically for sous vide applications. One other option is reusable silicone containers made for immersion circulators. I've tried them and I'm not a fan, but they are out there.

I.C. RUMP ROAST

YIELD:

Exact yield depends on the roast, but odds are you'll have enough to serve 4 hungry diners with enough leftovers for a few sandwiches

Although searing of meat is usually done after the immersion cooking, in this case I want to include the seared scraps for flavor, and it doesn't make sense to sear twice, so I'm doing it up front, pre-bag so to speak.

SOFTWARE

1 (3½-pound/1.6 kg) rump roast[4]

1 tablespoon (15 ml) peanut or other neutral oil

2 tablespoons (16 g) kosher salt

2 tablespoons (32 g) Worcestershire sauce

2 teaspoons (10 g) Dijon mustard

1 teaspoon (2 g) freshly ground black pepper

1 teaspoon (3 g) garlic powder

1 teaspoon (3 g) onion powder

TACTICAL HARDWARE

- An immersion circulator

- A bath vessel capable of safely holding 18 to 20 quarts H_2O

- A gallon-size, heavy-duty zip-top freezer bag (such as Ziploc)

- 2 large binder clips (from the office supply store or interwebs)

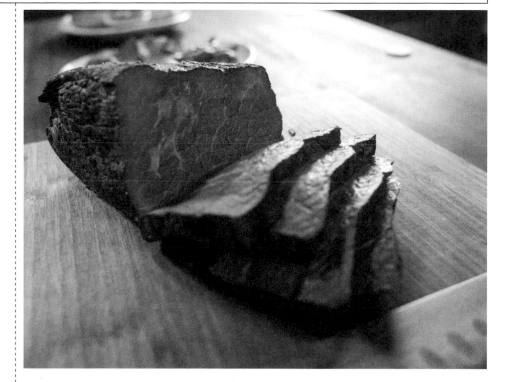

PROCEDURE

1) Install the immersion circulator in the water bath and set it to 135°F.[5]

2) Heat a 12-inch cast-iron skillet over high heat for 5 minutes. Meanwhile, trim the fat and sinew from around the exterior of the roast (reserve the trimmings). Brush or rub the roast with the oil and season on all sides with the salt.

3) Thoroughly sear the roast all over, about 2 minutes per side. Remove to a plate or pan to cool. Add the trimmings to the pan and cook until deep brown. Remove to the plate to cool.

4) Add the Worcestershire sauce, mustard, pepper, garlic powder, and onion powder to one of the freezer bags and stash near the cooktop. When cool enough to handle, add the roast to the bag and squish around to evenly coat with the liquid and spices. Add the scrap beef pieces.

5) Seal the bag, leaving one corner open, and lower it into the bath so the air is pushed out via displacement. (I

4 The rump comes from the round, which is a reference to the cross-section of the femur bone in the back leg of the beef critter. Several large and heavily worked muscles call this neighborhood home, but the rump, or "bottom round" roast, is probably the most common. You can also use the eye-of-round roast. Both are lean and tough, due to the work the leg does. There's a lot of flavor in these inexpensive cuts, and cooking with a circulator will help you make the most of them.

5 The amount of water is always relative to the size of the chosen vessel. Enough water should be added so that it comes up the side of the circulator at least halfway between the max and minimum fill lines. My general rule is that there should be three times as much water by volume as food. That provides for plenty of circulation. I'm calling for 20 quarts here because that's the amount I find myself using in most applications.

I.C. RUMP ROAST (*continued*)

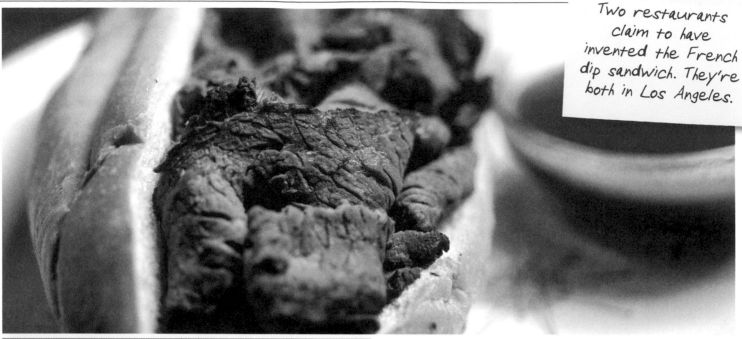

Two restaurants claim to have invented the French dip sandwich. They're both in Los Angeles.

sometimes stick a straw into the open corner and suck the air out just to speed things along.) When as much air as possible has been removed seal the bag completely and secure the top edge to the side of the bath with the binder clips.[6] Cover the water bath with plastic wrap to prevent evaporation and leave to cook for 10 hours.

6) After 10 hours, retrieve the bag from the bath. Open the bag and transfer the roast to a carving board. If you'd like, let the roast rest for 20 minutes.[7] Discard any small pieces of fat and gristle remaining in the bag. Strain the jus remaining in the bag through a fine-mesh sieve into a serving bowl. Thinly slice the beef across the grain and serve with the jus.

NOTE

As far as I'm concerned, the best way to serve this is on a sliced-open baguette toasted with Swiss cheese. The resulting sandwich should be dipped into the jus (French for "meat juice") before each and every bite. Congratulations; you've just made the best French Dip you'll ever (probably) have.

6 This is strictly to prevent water from possibly getting to the roast through the seal during the long cook time. Some people feel that double-bagging is a better way, but I find that it's a real struggle to work air out of both bags. Some practitioners argue that this method allows the roast to settle against the side of the bath vessel and that this could interfere with cooking. I say if your circulator is strong enough, the resulting currents will take care of that issue. If you're worried about it, just switch the bag to the other side of the bath halfway through the cooking time.

7 Since there is no actual temperature gradient in the meat, resting is a completely optional step in this particular case, but resting roasts is policy around here so I'm sticking to it.

I.C. MINI CHEESECAKES

YIELD:

10 servings

Immersion circulators aren't just for meat. Consider the thermal quagmire that is the cheesecake. Most recipes require that the pie (and yes, it's a pie) be cooked in a pan set inside another pan of water. What's more, the pie (yes . . . it's a pie) must be pulled before it fully sets, so it won't crack like the Grand Canyon as it cools. The answer: individual cheesecakes in jars, cooked to perfection in an oven of water.

SOFTWARE

For the batter:

340 grams (12 ounces) cream cheese, softened

115 grams (½ cup plus 1 tablespoon) sugar, divided

177 grams (¾ cup) sour cream

1 teaspoon fresh lemon juice

½ teaspoon grated[8] lemon zest

3 large eggs

For the topping:

9 graham crackers

¼ teaspoon kosher salt

4 tablespoons (57 g) unsalted butter, melted

TACTICAL HARDWARE

- **An immersion circulator**
- **A bath vessel capable of safely holding 18 to 20 quarts H$_2$O**
- **A stand mixer**
- **10 (4-ounce) canning jars**

PROCEDURE

1) Make the batter: Install the immersion circulator in the water bath and set it to 160°F.

2) Load the cream cheese and 100 grams (½ cup) of the sugar in the bowl of a stand mixer, install the paddle attachment, and beat on high until fluffy, scraping down the sides and bottom of the bowl about halfway through, around 5 minutes total.

3) Lower the mixer speed to medium and add the sour cream, lemon juice, and lemon zest. Continue beating until incorporated, about 30 seconds.

4) Drop the speed to low and add the eggs one at a time, waiting 30 seconds between each egg. Continue mixing until completely incorporated, about 1 additional minute.

5) Divide the batter among the jars, leaving ½ inch headspace. Lid tightly and, using tongs, lower the jars into the water bath and leave to cook for 45 minutes.

6) Retrieve the jars from the bath and cool for 1 hour at room temperature before refrigerating for at least 2 hours, or as long as overnight.

7) Make the topping that would normally be the crust, only this is better: Heat the oven to 300°F. Line a quarter sheet pan or 8- to 9-inch square baking pan with parchment paper.

8) Pulse the crackers, salt, and remaining 1 tablespoon sugar in the bowl of a food processor until they become coarse crumbs, 15 one-second pulses. Add the melted butter and pulse until it's the texture of wet sand, 5 more one-second pulses.

9) Pack the crumb mixture into a thin, even layer in the prepared pan and bake until browned and crisp, about 15 minutes. Cool completely, then crumble into small pieces.

To serve, de-lid the jars and top with the graham cracker crumbles. Consume.[9]

8 A micro-grater is the best tool for that job.

9 If you'd like, you can also pack the graham cracker topping into the jars before cooking. Bake the graham cracker mixture before assembling the cheesecake batter, then add 1 tablespoon to the bottom of each jar. Pack down firmly, then top with the batter. Cook as directed above.

I.C. FENNEL CORDIAL

YIELD:

1 quart

One of the best things about immersion cookery is that you can make flavored liquors and liqueurs in an hour instead of the days or weeks required by standard "steep" methods. I've made dozens with my circulator, but this one is my absolute favorite. It will keep for months, which makes it perfect for, say, holiday gift giving. The only problem is that it is sneaky-drinkable at roughly 40 percent ABV, so be careful and be responsible.

SOFTWARE

2 cups (22 g) loosely packed fennel fronds

¼ cup plus 2½ tablespoons (85 g) granulated sugar

30 green cardamom pods (7 g), cracked

1 tablespoon (7 g) fennel seeds

1 whole star anise pod[10]

1 quart (946 ml) vodka

TACTICAL HARDWARE

- An immersion circulator
- A bath vessel capable of safely holding 18 to 20 quarts H_2O
- A gallon-size heavy-duty zip-top bag (such as Ziploc)

The oldest known liqueur dates to 800 BCE and was made from anise berries and palm wine.

One of these Dutch gentlemen is actually my wife, Elizabeth.

LIQUEURS

Liqueur comes from the Latin *liquifacere*, meaning "to dissolve," and the original purpose of liqueurs was to dissolve and deliver medicinal compounds. Most historians agree that steeping stuff in alcohol is an ancient concept, but the heyday of liqueurs was in the Middle Ages, when most scientific experimentation took place in monasteries, where many a mind, when not focused on pious prayer, sought the "elixir of life" and other various cure-alls. It was from within these "fortified" communities that several stars of the modern liqueur cabinet emerged. For instance, French Carthusian monks created Chartreuse, and, in 1510, a Benedictine monk by the name of Dom Bernardo Vincelli created a liqueur supposedly containing some twenty-seven flowers, herbs, spices, etc. Today it's still called Bénédictine. While most monastery liqueurs were composed with health rather than flavor in mind, when the Dutch got involved a few centuries later they added sugar and flavors from often spoiled New World fruits and sold the heck out of them. By the mid-seventeenth century, Holland hosted some five hundred distilleries, many converting cheap French wine into liqueur.

10 Like fennel, star anise contains anethole, an aromatic oil that tastes and smells like licorice. Anethole is hydrophobic but soluble in ethanol, which typically comprises 40 percent of the volume of vodka.

PROCEDURE

1) Install the immersion circulator in the water bath and set it to 140°F.

2) Put the fennel fronds, sugar, cardamom, fennel seeds, star anise, and vodka in the freezer bag. Remove as much of the air from the bag as possible,[11] then seal and submerge in the bath for 1 hour.

3) Prepare an ice water bath in a large bowl. When the infusion period is done, transfer the unopened bag of cooked cordial to the ice bath and leave until cold, about 30 minutes. Meanwhile, assemble a straining rig with a fine-mesh sieve set over a 4- to 6-cup glass jar. Place a standard-size (7- to 8-inch diameter) drip coffee filter inside the sieve.

4) When cool, strain the cordial and discard the solids. Seal the jar and refrigerate (or freeze) for at least 2 hours or up to several weeks before serving. (The liquor will be deep green for maybe a day or two but will eventually turn green-gold. This in no way affects the flavor.

To serve, try it straight up, ice cold in a small glass. I'm sure there are other methods, but I haven't tried them.

11 I'm typically finicky about getting the air out, but at 140°F some of the ethanol is going to convert to gas anyway.

MY SHAKSHUKA

A re-creation of Ilsa's entrance in *Casablanca*

When I finally had the opportunity to feature shakshuka on *Good Eats*, I knew I had to re-create (as closely as I could with a relatively meager budget) some scenes from *Casablanca*. If I was going to play Rick, I'd need an Ilsa, and so I turned to a friend who also holds *Casablanca* in high esteem. Alex Guarnaschelli is one of the best chefs I know, and I'm lucky to be able to call her a friend. She accepted my invitation to come play and was simply perfect. My favorite day of shooting, ever.

If you've never had shakshuka, here's a scene that pretty much sums it up. I've been sitting, drinking, and waiting, just like Rick. Alex appears in the doorway . . .

I've been obsessed with *Casablanca* for most of my life. The first time I entered the wondrous world of Rick's Café Américain, I was gazing through my window on the world, a thirteen-inch black-and-white Quasar. The movie was rerunning on the late show, and I was supposed to be asleep, but I didn't care much about "supposed" at the time. A couple of months before, I had come home on the last day of sixth grade to be told my father was dead, and after that I just kinda drifted. I guess I needed a father figure, and I found it in Humphrey Bogart's Rick Blain. *Casablanca* had it all: honor, loyalty, sacrifice, chivalry, friendship, not to mention an exotic, glamourous setting. (I was probably the only kid in my town who nosed around thrift shops for a white dinner jacket.) As I got interested in cooking, I was always drawn to the cuisine of North Africa, and a few years ago, I started writing a menu for Rick's, just for the fun of it, and there's one thing for sure: brunch would feature that classic of the Maghreb: shakshuka.

Another nod to the uber-classic

Chris Smallwood plays keys on my tour show, and here he makes a damn fine Sam.

AB: Of all the TV kitchens in all the towns—

ALEX G: You're kinda mangling my favorite movie here.

AB: Sorry. But you're with me on the shakshuka, right?

ALEX G: Of course, a culinary gestalt of an Old World Ottoman stew and New World ingredients ...

AB: ... tomatoes and chiles ...

ALEX G: ... finished with perfectly poached eggs nestled right down in the sauce.

AB: I tried making it when I was eleven. It was terrible.

ALEX G: I was eight ... we sold out in an hour.

So, a richly spiced tomato stew with an egg poached in it. How did such a dish come into being? Let's jump to the marketplace scene the next day. And yes, as is so often the case on *Good Eats*, there is an appearance by the Spanish Inquisition.

ALEX G: What makes you think shakshuka ...

AB: Some say that means "mixture" in Arabic.

ALEX G: ... was invented in Casablanca? Sure, it's a vegetable stew, but Libya, Palestine, Italy all have traditions like that. Some even have eggs in them, like Turkish menemen.

AB: Ah, but those are scrambled. The issue, of course, is the tomatoes.

ALEX G: A New World crop. So, they would have been grown in Spain first because ...

AB: ... Isabella and Ferdinand funded the journeys of Christopher Columbus ...

ALEX G: ... not to mention the Spanish Inquisition.

Suddenly a trio of inquisitors busts onto the scene.

INQUISITOR: Nobody expects the Spanish Inquisition!

ALEX G (to AB): You really do juice that old Monty Python gag to death don't you?

INQUISITOR: Perhaps, madam, but the inquisition was greatly responsible for the expulsion of Muslim Moors from 1609 to 1614.

AB: Over 300,000, with many of them ending up in Morocco.

ALEX G: So you figure the Moriscos brought tomatoes and peppers with them?

INQUISITOR: The only other explanation is the Spanish occupation of Tunis.

AB: I don't have a movie reference for that. Anyway, the eggs are still troubling ...

ALEX G: That's easy: Sephardic Jews had a long tradition of eating eggs, even though most of Europe didn't for almost a millennium, and they got pushed out of Spain in what?

INQUISITOR: 1492. Us again. (sarcastic) Ooops.

ALEX G: You should be ashamed of yourselves.

INQUISITOR: Come on, fellas, let's toss one back at the Blue Parrot. (to Alex) Call me.

The inquisitors exit.

AB: So the Sephardi brought the eggs and eventually immigrated to Israel ...

ALEX G: ... where they eat shakshuka morning, noon, and night. Look, I have to go see that pig Renault about my exit visa. Wish me luck, and don't mess this up.

Alex starts to leave.

AB: Hey ... Here's lookin' at you—

ALEX G: Don't.

SHAKSHUKA

YIELD:

6 servings

Two sub-recipes are included here: Preserved Lemons and Urfa Biber Harissa. You could use store-bought preserved lemons, but the procedure is so simple, I don't know why you'd bother. I keep these around at all times, because I even appreciate their salty, citrus funk in cocktails. As for the U. B. Harissa, store-bought really isn't an option. Honestly, I know it's a bit of work, but the flavor is oh so very worth it. It's the heart of the dish.

SOFTWARE

2 red bell peppers (400 g)

2 pounds (900 g) beefsteak tomatoes, halved and seeded

¼ cup (60 ml) extra-virgin olive oil

3 large cloves garlic, thinly sliced

1½ teaspoons kosher salt

3 tablespoons (45 g) Harissa (recipe on page 136)

1 tablespoon (12 g) dark brown sugar

2 teaspoons mashed Quick Preserved Lemons (recipe on page 137)

6 large eggs (keep refrigerated until right before cooking)

¼ cup roughly chopped flat-leaf parsley, for serving

Warm bread, for serving

TACTICAL HARDWARE

- A 10-inch cast-iron skillet[1]
- A box grater
- 6 small custard cups or ramekins

PROCEDURE

1) Position an oven rack 5 inches from the top of the box and set the broiler to high.

2) Cut the peppers in half lengthwise, discard the seeds, and place cut-side down on a sheet pan. Broil until the skins are completely charred, 10 to 15 minutes, rotating the pan halfway through.[2]

3) Transfer the charred peppers to a large bowl, cover tightly with plastic wrap, and leave to steam for 15 minutes. Remove and rub the skins off under running water. Pat dry and chop into ½-inch squares.

4) Grate the tomatoes on the large holes of the box grater into a large bowl and stash near the cooktop.

5) Place the skillet over medium heat for 2 minutes. Add the oil and heat until shimmering,[3] or until it reaches 335°F to 350°F. Stir in the garlic and salt and cook until the garlic just begins to brown, about 30 seconds, then stir in the harissa, brown sugar, and preserved lemon. Cook for 30

1 Yes, I'm cooking tomatoes in cast iron. I know that there are some "experts" out there who say the acid will suck iron out of the pan and into the food. People, we're not talking about battery acid here. If your cast-iron piece has been properly cured, and I'm operating under the assumption that it has, cooking this dish in iron is fine. Would I simmer tomato sauce in cast iron for like . . . 10 hours? Probably not, but only those with severe hemochromatosis would have an issue here. (No I'm not a doctor, but I asked one.)

2 You can achieve an appropriate amount of char by laying them right on your gas burners if you have them. Cook, rotating frequently, until thoroughly charred, about 10 minutes total. Steam and peel as directed in the recipe.

3 A lot of recipes say to look at the oil and wait until it ripples. Well, oil ripples anywhere from 150°F to 300°F. If you really want to know what's going on, use your trusty infrared thermometer. Look for 335°F to 350°F.

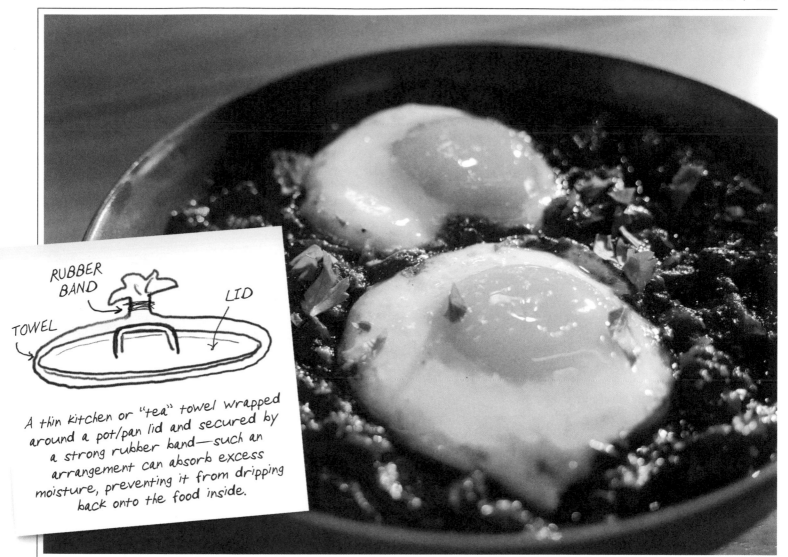

RUBBER BAND

TOWEL

LID

A thin kitchen or "tea" towel wrapped around a pot/pan lid and secured by a strong rubber band—such an arrangement can absorb excess moisture, preventing it from dripping back onto the food inside.

seconds, then follow with the peppers and tomatoes. Reduce the heat to medium-low and simmer, stirring every 5 minutes, until the sauce reduces and thickens slightly, about 20 minutes.

6) Crack each egg into a small custard cup. Place a kitchen towel on the underside of the skillet lid and tuck the corners up under the lid's center handle.[4]

7) Reduce the heat under the sauce as low as it can go.[5] Use the back of a large spoon to create 6 evenly spaced divots in a ring in the tomato mixture, making them deep enough to hold the eggs without pushing through to the bottom of the pan. Gently pour each egg into its divot, then spoon sauce over the whites of the eggs, leaving the yolks exposed.[6] Cover with the towel-wrapped lid and cook for 7 minutes, rotating the pan 180 degrees every 2 minutes.[7]

8) Kill the heat and let the eggs coast, still covered, until the whites are firm but the yolks are still runny, about 5 more minutes. Garnish with parsley and serve immediately, straight from the skillet, with crusty bread.

4 This is to prevent liquid evaporating out of the mixture from condensing on the underside of the lid and dripping back on the food. I'd tell you to simply drape the towel over the pan, position the lid, then tuck the corners of the towel up under the lid, but the last time I did that I set one corner on fire, so technically this is safer. If you use an induction cooktop, of course, this won't happen to you. Food for thought.

5 If you have a simmer burner, now is the time to use it.

6 Yolks cook faster than whites, so spooning the hot sauce over the whites should even the thermal score.

7 I know this seems silly, but I find it really does help the eggs to cook more evenly.

URFA BIBER HARISSA

Harissa is a spicy chile paste found commonly in the cuisines of North Africa. You can find it at many megamarts these days, but trust me, the best harissa starts in the home. I started using Urfa biber (aka Urfa pepper) in mine a few years ago, and it's a game changer. More on that below, if you're interested.

SOFTWARE

2 tablespoons (14 g) cumin seeds

1 tablespoon (7 g) coriander seeds

1 teaspoon caraway seeds

¼ cup (60 ml) extra-virgin olive oil

8 large garlic cloves, thinly sliced

1 medium onion, diced

1 tablespoon (10 g) kosher salt

3 tablespoons (48 g) tomato paste

1 cup (128 g) Urfa biber

¼ cup (60 ml) red wine vinegar

TACTICAL HARDWARE

• A cast-iron skillet
• A food processor with chopping blade

PROCEDURE

1) Toast the cumin, coriander, and caraway seeds in the dry cast-iron skillet until fragrant, about 3 minutes.

2) Stir in the oil, garlic, onion, and salt and cook until the garlic begins to brown, about 2 minutes.

3) Stir in the tomato paste and Urfa biber and continue cooking until aromatic, about 1 minute. Finally, add the vinegar and cook until slightly reduced, 2 minutes.

4) Transfer the mixture to the food processor and spin until smooth, scraping down the sides as needed.

5) Transfer to a pint-size glass canning jar, cool thoroughly, then store in the refrigerator for up to 1 month, or the freezer for up to 6.

URFA BIBER

My very favorite dried ground chiles are from Aleppo, in the north of Syria. Although the ground chiles from Aleppo are rightly prized, they're also pricey, while the chiles from Urfa, just over the Turkish border, are genetically identical to those grown in Aleppo. But, since Urfa biber is processed differently, the resulting flakes are darker, smokier, and quite a bit oilier than their Syrian counterparts.

Aleppo, of which I have precious little remaining, is brick red, tastes a wee bit of chocolate and salt, and delivers heat around 10,000 Scoville.

Urfa is almost burgundy in color, smoky, and quite oily, because the pods, which are almost never imported into the United States whole, are aged inside bags. The flavor is dusky and deep, and the burn is slow to come, but when it arrives it fills the mouth with a "round" heat that is the secret to my harissa. Urfa is more perishable than most dry peppers, so purchase from reputable internet vendors. In my opinion, their turnover is faster than that of brick-and-mortar stores and, to me, that matters. You can keep this for up to two years sealed in a glass jar—not plastic, because Urfa's pigments will stain plastic permanently—in a cool, dark place.

QUICK PRESERVED LEMONS

YIELD:

1 pint

SOFTWARE

4 to 5 lemons (preferably organic), scrubbed and dried

¼ cup (40 g) kosher salt

TACTICAL HARDWARE

- **A wide-mouth 16-ounce canning jar or equivalent**

PROCEDURE

1) Trim the ends off the lemons. Slice 4 of the lemons into 8 wedges, removing seeds as you go. Reserve as much of the juice as possible.

2) Layer the lemon wedges in the jar, covering each layer with a spoonful of salt. Pack the jar as tightly as possible, pressing down to release the lemons' juice as you stack, leaving about ¼ inch of headspace in the jar.

3) Cover the wedges with any reserved lemon juice from the cutting board and the lemon ends. If your lemons don't release a significant amount of juice, top off the jar with the juice of the fifth lemon.

4) Stash in the refrigerator for 4 days, then flip the jar upside-down and age for another 4 days before flipping it back over and sampling. The peel should be soft and almost jelly-like. Rinse before using . . . or not. Store it with the lid up.

Although you can expect peak flavor and texture after about a month, they'll keep almost indefinitely, as long as they're kept refrigerated.

COOKTOPS

Although I adore my natural-gas range for its responsive-ness and visual feedback, these flames have a relatively low efficiency of 50 percent.[8] And, of course, it's a burning ring of fire, just like Johnny Cash said.

Now, suppose you have a traditional electric-coil cooktop; your efficiency rating could be anywhere from 42 to 75 percent, depending on the size of the cooking vessel. But the bad part is your heat levels can be impossible to gauge or control, and hot spots are common.

Sealed-element radiant units and halogen cooktops are, to my mind, even harder to handle, despite the elevated efficiency to an average of 55 percent. This is why I make shakshuka on an induction cooktop.

8 "Efficiency" is of course relative. Although gas can spend energy that doesn't make it into the food via visible light created and convective heat that goes into the room instead of the pan, ultimately one must factor in whether an electric range is getting its power from a coal-burning plant or hydroelectric, and how much energy would be spent cooling a kitchen heated by gas flame, etc. The important consideration here is that induction is a system that creates heat only in the pan that's on it. Without the vessel (or some other ferrus object), there is no heat.

Induction uses an electrical current traveling through a copper coil to generate an alternating magnetic field, which can create heat directly inside a pan. The result is near immediate heat that's nearly 80 percent efficient, regard-less of the pan size. The cook unit itself generates no heat and only becomes hot because it's in contact with the pan. The best news is that prices of induction units have come down significantly over the past decade, putting this magical power into the hands of more cooks. There is, however, a catch.

Only pans with a high ferrous content can be heated by induction, which includes most steel and all iron and enameled iron pots and pans, but not all stainless steel and no aluminum. If you want to know if a given pan will work, just slap a magnet on it. The better it sticks, the better that pan will work on induction. Do you have to execute shakshuka with induction? Of course not, but I do.

If you do choose to cook the shakshuka via induction, increase the heat under the eggs to 2.0 (one level above low). Increase the final resting time for the eggs by 2 minutes.

GREEN SHAKSHUKA

YIELD:
6 servings

This dish is the love child of shakshuka and creamed spinach. I'd hoped to squeeze this into the episode, but once we decided to make the preserved lemons and harissa, there wasn't a chance.

SOFTWARE

4 tablespoons (57 g) unsalted butter

1 leek, white and light-green parts only, thinly sliced and washed if sand or dirt is present

1 tablespoon (10 g) kosher salt

¼ cup (35 g) all-purpose flour

1 teaspoon freshly ground white pepper

¼ teaspoon cayenne pepper

¼ teaspoon freshly grated nutmeg

1 cup (237 ml) heavy cream

1 cup (237 ml) low-sodium chicken stock

3 (9-ounce) bags (765 g) fresh baby spinach

6 large eggs (keep refrigerated until right before cooking)

Warm bread, for serving

TACTICAL HARDWARE

- A 10-inch cast-iron skillet or 11-inch straight-sided sauté pan
- An immersion "stick" blender
- 6 small custard cups or ramekins

PROCEDURE

1) Put the skillet over medium-low heat and add the butter to melt. When foamy, add the leeks and salt and cook, stirring often, until the leeks are translucent, 8 to 10 minutes.

2) Add the flour, white pepper, cayenne, and nutmeg to the pan and cook, stirring, for 30 seconds. Whisk in the cream and stock and bring to a simmer, still whisking.

3) Maintaining a bare simmer, add the spinach in big handfuls, stirring to wilt the green mounds, until you've got it all in there. This may take a couple of minutes.

4) Using your immersion blender, pulse through the spinach mixture, breaking up the greens. Do not go crazy here; we don't want a puree. Remove the pan from the heat and cover to keep warm.

5) Crack each into a custard cup. Position a kitchen towel on the underside of the skillet lid and tuck the corners into place under the handle. (For further explanation see the Shakshuka recipe above.)

6) Place the skillet on the lowest heat possible.[9] Create six evenly spaced divots in a ring in the spinach mixture with the back of a large spoon, making them deep enough to hold the eggs without pushing through to the bottom of the pan. Add the eggs to the divots, then spoon sauce over the whites, leaving the yolks exposed. Cover with the towel-wrapped lid and cook for 15 to 20 minutes, rotating the pan 180 degrees every 2 minutes.

7) Kill the heat and let the eggs coast, still covered, in the residual heat until the whites are firm and the yolks are thick but still ooze, about 4 more minutes. Serve immediately, straight from the skillet, with warm bread.

9 Again, a simmer burner is the best tool for the job here.

LET THEM EAT (ICEBOX) CAKE

A lot of dishes are named after appliances: toaster pastry, rotisserie chicken, dishwasher salmon, and freezer jam all come to mind. The oldest dessert I can find that simply couldn't exist without its associated technology is the icebox cake. A descendant of the English trifle and the French Charlotte, the icebox cake is a no-bake cake that derives its delectable texture from spending twenty-four hours at constant icebox temperatures prior to consumption.

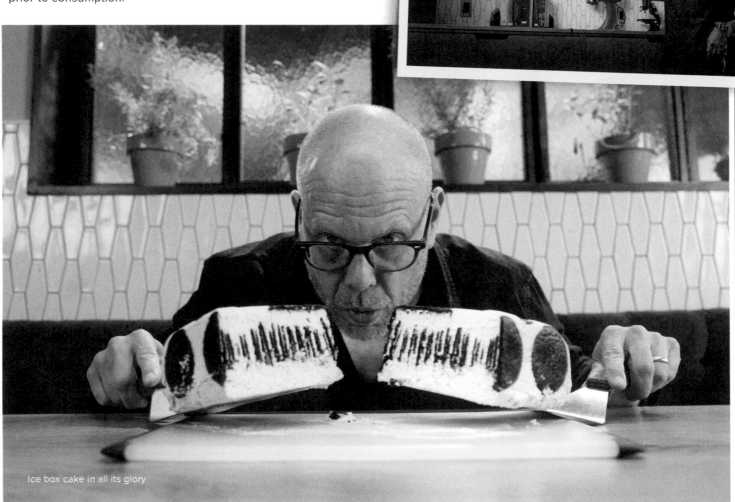

Ice box cake in all its glory

HISTORY OF THE ICEBOX CAKE

Two modern factors combined to summon the icebox cake to life. The first, the box itself. Though most of us can't imagine life without electrical refrigeration, through most of the nineteenth century and well into the twentieth, American cooks and home-makers kept their perishables in zinc-lined wooden cabinets. These iceboxes provided relatively constant coolness as long as they were fed a regular diet of ice blocks, which had to be delivered daily in the summer.[1] They also required constant draining and cleaning, and edibles still went bad, but imperfect as it was, the icebox made new things possible. Now, home cooks could not only store cream for whipping, but also chill a confection made of whipped cream long enough for liquid from the cream to seep into and soften cookies or wafers. That leads us to the second modern factor: marketing. Manufactured and packaged foods were becoming status symbols among middle-class women who would have had servants just a generation before. These "house-wives," as they became known, may have been eager to modernize, but they needed reasons to purchase industrial foods that hadn't existed a few years before. And so, manufactures hired home economists to generate recipes, which they printed on pack-ages, in pamphlets, and in newspapers. Recipes for icebox cakes were designed specifically to coax homemakers into purchasing packaged cookies, ladyfingers, and various forms of crisps and wafers. What makes icebox cakes so modern is that they cannot be made without these manufactured goods—in our case, Famous Wafers and Graham crackers, both made today by Nabisco.[2]

A VERY BRIEF HISTORY OF REFRIGERATION

The earliest refrigerators were caves or underground pits used by the Romans, Chinese, and Sumerians to store ice and snow harvested from mountains. Ice was used to preserve foods but mostly to chill drinks and make ices for the wealthy.

The first real advance toward mechanical refrigeration was achieved by William Cullen, a Scottish physician who used a vacuum pump and ether to create a small amount of ice in 1748.

In 1802, a Maryland farmer named Thomas Moore built a tin box surrounded by cedar and wrapped in rabbit fur. He called it Refrigeratory. Thomas Jefferson bought one.

In 1806, Frederic Tudor, the Ice King, started the ice trade by taking out leases on various bodies of water and hiring men to cut the ice off come winter.

In 1834, American Jacob Perkins patents a vapor compressor refrigerator. The future is coming.

In 1867, Thaddeus Sobieski Constantine Lowe, who'd built spy balloons for the Union army, patented a viable commercial ice machine.

In 1876, Carl von Linde rocked the first efficient com-pressed ammonia refrigerator.

Along comes 1890, and ice famine. No ice on the Hudson River . . . a cocktail catastrophe. After this, mechan-ical development moved along quickly.

In 1913 Fred Wolf invented the "domestic electric refrigerator," or Domelre system.

In 1918, the Frigidaire company comes along, then in 1927 comes General Electric's Monitor Top model, named for the compressor housing on top . . . which looks like the gun turret on the USS Monitor.

In 1939, GE releases the first dual-temp models with separate freezers, and thus the modern refrigerator-freezer is born. Improvements like auto-defrost, side-by-side doors, and ice makers were soon to follow.

1 The harvesting, storing, and selling of ice from lakes in the northeastern United States became a massive industry. If interested, check out *The Ice King: Frederic Tudor and His Circle*, by Stanley Paterson and Carl Seaburg.

2 While we did make our own graham crackers in another GE episode, even those don't work very well in icebox cakes.

CHOCOLATE MOCHA REFRIGERATOR CAKE

YIELD:

10 to 12 servings

Icebox cakes occupy a dreamy realm between cake and pudding, made possible by a foam composed of heavy cream (dairy from a cow containing a minimum of 36 percent butterfat) and air. Without whipped cream, there would be no icebox cake.[3]

SOFTWARE

¼ cup (60 ml) cold water

1 (7-gram) packet powdered gelatin[4]

70 chocolate wafer cookies (363 g), Nabisco Famous[5]

2 tablespoons (30 ml) coffee liqueur

4 teaspoons (4 g) instant espresso powder[6]

1 teaspoon vanilla extract

3 cups (720 ml) heavy cream, cold[7]

30 grams (¼ cup) confectioners' sugar

¼ teaspoon kosher salt

TACTICAL HARDWARE

- A 9 × 5 × 3-inch loaf pan
- A stand mixer with whisk attachment

PROCEDURE

1) Put the water in a small saucepan (or even a metal measuring cup). Sprinkle the gelatin over the water and let sit at room temperature to bloom for 5 minutes.

2) Line a 9 × 5 × 3-inch loaf pan with plastic wrap, leaving enough overhang in each direction to completely cover the top once the pan is full. Line the bottom and sides of the pan with 16 of the chocolate wafers and set aside.

GELATIN

The culinary world is thick with thickeners. There are starch-based thickeners, like arrowroot and flour; pectin, which is used in jams and ice creams; and agar-agar, a complex carb made from algae. But when it comes to cold desserts like icebox cakes, I typically turn to gelatin, in either sheet or powder form. If a perfectly clear gel is required, I'd go with sheets, but in this case powder is fine.

The magic of icebox cake is that over time, the cream softens the wafers, and the gelatin will set, forming a semi-solid, sliceable, yet non-soggy whole.

So, as you know, there is a protein-laden connective tissue in most critters called collagen, and in its native form it's a triple helix of molecules held together by a bunch of relatively weak bonds called hydrogen bonds, and a few strong covalent cross-links.

Now, when collagen is cooked—braised, for instance—the hydrogen bonds break and the helix unwinds. So now there are all these long proteins containing up to a thousand amino acids (called a polypeptide).

When nice and warm in, say, a stock, all of these proteins are just drifting around in solution, but as they cool, they stop moving around and the hydrogen bonds re-form in a network, creating a semisolid mass, one that can hold a lot of water. We call this a gel.[8] And that gel is going to preserve the structure of my whipped cream, giving it body and longevity until, of course, it melts in the snuggly warmth of my belly!

3 I know that some of you are going to scream the virtues of that curious, tub-based foam known as "Cool Whip." I would argue, however, that due to the presence of emulsifiers, its liquid does not easily migrate into the baked goods as needed here. So, though it can act as glue . . . no.

4 Don't worry about weighing the gelatin. Every packet I've ever seen weighs exactly 7 grams.

5 You can often find these chocolate wafers in the ice cream aisle of your local megamart.

6 I've never actually made a cup of espresso with this, but it's my go-to when it comes to injecting coffee flavors into a dish.

7 Cream with a fat content of 30 percent to 38 percent whips best between 45°F and 50°F.

8 With the right industrial equipment, you can purify and dehydrate a gelatin-rich liquid to produce either sheet or powdered gelatin.

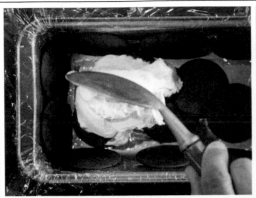

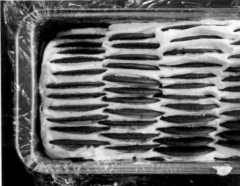

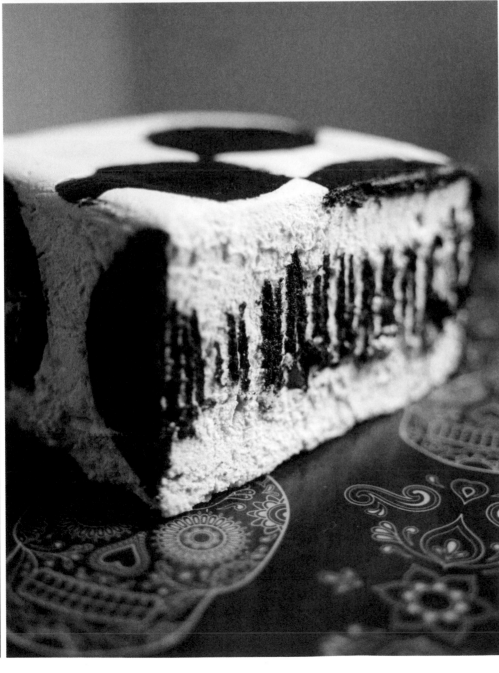

3) Place the bloomed gelatin over low heat and gently warm until the gelatin has just melted, about 90 seconds. (Don't let it boil.) Remove from the heat and stir in the coffee liqueur, espresso powder, and vanilla.

4) Combine the cream, confectioners' sugar, and salt in the bowl of a stand mixer fitted with the whisk attachment. Gradually bring the speed up to high and beat until soft peaks form,[9] about 1½ minutes. Reduce the speed to low and drizzle in the cooled gelatin mixture. Slowly increase the speed back to high and beat until stiff peaks form, about 30 seconds more.

5) Fill the prepared pan three-quarters full with the whipped cream mixture. (You'll need to use about 4 cups.) Insert the remaining 54 chocolate wafers vertically (edge first) into the whipped cream to create 4 rows of about 13 cookies each, keeping the cookies slightly separated by cream.

6) Spread the remaining whipped cream evenly over the cookie rows. Tap the pan on the counter a few times to remove any bubbles. Fold the excess plastic wrap over the cake and refrigerate until very firm and sliceable, at least 8 hours and up to 24 hours.

7) To serve, pull back the plastic wrap and invert the cake onto a serving dish. (I usually place a plate upside-down on top of the loaf pan, then flip them together.) Remove the plastic wrap, slice with a long, thin serrated knife, and serve immediately.[10] To keep leftovers, cover with fresh plastic wrap and refrigerate for up to 3 days.

9 Remember, unlike stiff peaks, soft peaks fall over easily.

10 If you're having trouble getting clean slices, you can pop the cake in the freezer for 10 to 15 minutes before slicing to firm it up even more.

STRAWBERRY PEPPER ICEBOX CAKE

YIELD:

10 to 12 servings

Luckily, once you grasp the concept of the icebox or refrigerator cake, you don't so much need a recipe as a notion. We'll maneuver this cake away from gelatin and more toward a kind of cheesecakey thing. Just make sure that you let the cream cheese soften prior to construction.

SOFTWARE

300 grams (1 cup) high-quality, mostly smooth strawberry preserves, divided

227 grams (8 ounces) cream cheese, at as close to 65°F as you can get it

227 grams (1 cup) sour cream

7 grams (1 tablespoon plus 1 teaspoon) grated lemon zest

1½ cups (355 ml) heavy cream, cold, divided

¼ cup (30 g) confectioners' sugar

2½ teaspoons (6 g) coarsely ground black pepper,[11] divided

13 graham crackers (204 g)

TACTICAL HARDWARE

- A 9 × 5 × 3-inch loaf pan
- Plastic wrap
- A stand mixer with paddle and whisk attachments

The natural ice trade peaked in 1886, with 25 million tons of harvested ice sold.

PROCEDURE

1) Line a 9 × 5 × 3-inch loaf pan with plastic wrap, leaving enough overhang in each direction to completely cover the top when the pan is full. Measure out ⅓ cup (100 g) of the strawberry preserves and transfer to the refrigerator for serving. Keep the remaining ⅔ cup (200 g) out for the interior of the cake.

2) Put the cream cheese in the stand mixer bowl and beat with the paddle attachment on high speed until fluffy, about 4 minutes, stopping to scrape down the sides of the bowl as needed. Add the sour cream and lemon zest and beat to combine, about 30 seconds more. Transfer to a large mixing bowl and wipe out the stand mixer bowl.

3) Swap the paddle for the whisk and whip ½ cup (118 ml) of the cream, along with the confectioners' sugar, on medium-high until stiff peaks form, about 3 minutes. Fold into the cream cheese mixture with a rubber or silicone spatula and transfer to a zip-top bag.

4) Cover the bottom of the prepared loaf pan with a layer of graham crackers, breaking the crackers at their perforations as necessary to help them fit. Snip the corner of the zip-top bag and pipe approximately ¼ cup of the whipped cream mixture over the crackers and smooth with a spoon or

Layer 1

Layer 1

Layer 1

Layer 2

Layer 3

11 As it is, our cake has a lot of sweet going on, and tangy and fruity too, but the results could be cloying. What we require is balance from something unexpected. Hence the black pepper.

spatula.[12] Top with about 3 tablespoons of preserves, followed by ½ teaspoon of pepper, and another layer of whipped cream.

5) Continue layering—crackers, whipped cream, jam, pepper, whipped cream, crackers—until you have 5 layers of graham crackers.[13] Fold the excess plastic wrap over the cake and refrigerate for at least 8 hours or up to 24 hours.

6) When ready to serve, whip the remaining 1 cup (237 ml) cream in the bowl of a stand mixer on medium-high until stiff peaks have almost formed, about 3 minutes. Drop the mixer to low and work in the remaining ⅓ cup (100 g) strawberry preserves and 1 teaspoon black pepper. Boost the speed back to medium-high until stiff peaks form, about 1 more minute.

7) Pull back the plastic wrap and invert the cake onto a serving dish. (I usually place a plate upside-down on top of the loaf pan, then flip them together.) Remove the plastic wrap completely and frost with the strawberry whipped cream.[14] Slice and serve immediately.[15]

Graham crackers were invented by a minister who hoped the crackers would help control lust.

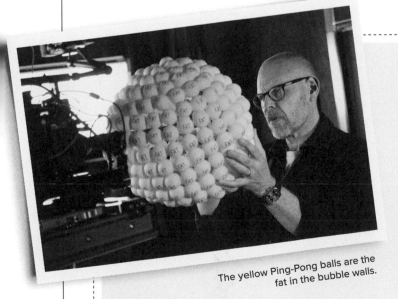

The yellow Ping-Pong balls are the fat in the bubble walls.

MILK FAT FOAMS

When we talk about egg foams, or the milk foam atop your cappuccino, this structure is stabilized by protein, but in the case of whipped cream, it's fat doing the stabilizing.

As you beat cream, introducing air and agitating fat globules, bubbles form and, in an attempt to get away from the water, the hydrophobic fat globules line up in the bubble walls. The result: a fat bubble. A very small one, granted, but once you froth up a few billion more you've got yourself whipped cream.

As long as the cream is kept cold, these bubbles are fairly stable, but remember, there's water all around and between these bubbles. Within an hour or two, it will just run out . . . gravity is cruel. What we need is thicker water.

12 It's totally fine to eyeball this; just know you'll end up with four cream layers.

13 What's most important is that the crackers always sit between cream layers, never jam. The fat in the cream keeps the crackers from becoming too soggy. Trust me, it'll make for a prettier cake.

14 This is a common maneuver for icebox cakes from the '40s and '50s.

15 Just like with the mocha cake above, you can also give this cake a short trip to the freezer, for 10 to 15 minutes, to make slicing easier.

RICH LITTLE POOR BOY

The poor boy, aka "po'boy," sandwich is simplicity itself. A long, soft French/Italian loaf is split lengthwise. Most of the interior is scooped out, leaving a ditch that is then filled with roast beef, fried shrimp, or oysters. That's all there is to it, unless of course you want it "dressed," which in New Orleans means adding mayo, shredded lettuce, tomatoes, and pickles.

Just trying to catch my flight.

A BITE OF HISTORY

Recipes for "oyster loaves" appear in cookbooks dating from the mid-nineteenth century, and New Orleans husbands who'd been out carousing often brought their wives large oyster sandwiches known as "peacemakers" around the same time. The name "poor boy" and the sandwich it represents was certainly in existence as early as the 1900s, but the humble form didn't get any real PR until Clovis J. and Bennie Martin started giving them out free from their coffee stand and restaurant in the French Market to out-of-work streetcar men (Division 194) during the strike of 1929. Then, as today, lots of things could go in a poor boy, including oysters, shrimp, or beef (which was probably the original incarnation). The bread was a variation on a French-style loaf the Martin brothers commissioned from the local Gendusa family bakery. Being Italian, the original loaves were almost certainly a great deal softer than a classic baguette, a bread that would have been fairly difficult to make in NOLA's sweltering climate.

Oh, and about the name . . . although the "po" part is certainly authentic, it is not original. The Martin brothers referred to the sandwich as the "poor boy," and as near as I can tell (a surprising amount of journalistic and academic brainpower has been spent on the subject), the "or" wasn't commonly omitted until the late 1960s or early '70s. I did publish a version of this sandwich in a book a few years ago and in that I referred to it as a po' boy. But the more I read about the history of the sandwich the less I'm okay with it. So, this version is a poor boy, and that's that.

OYSTERS

Technically speaking, there are only five oyster species available in the United States. Out west, there is the rare Olympia (*Ostrea lurida*), which is small, slow growing, and hard to find outside of its native habitat. If you want to try these specimens, you'll have to head to the Puget Sound, because they die too quickly to ship.

The Kumamoto (*Crassostrea sikamea*), a native of the Japanese prefecture of the same name, was imported to the West Coast after World War II. It has frilly shells and deep cups, and tastes sweet. Good though they are, Kumamotos are notoriously hard to shuck.

The Pacific oyster (*Crassostrea gigas*) is big and soft, and its flavor has subtle cucumber notes. This species accounts for 75 percent of the world's edible oysters. It is also originally from Japan.

The European flat or Belon (*Ostrea edulis*) is named for a river in Brittany. This species has a strong metallic flavor and a flat shape, and is being wiped out by a parasitic algae called Bonamia. I've never seen one on this side of the Atlantic.

That brings us to the Eastern oyster (*Crassostrea virginica*). Nearly every oyster harvested from New England all the way down to the Gulf is an Eastern oyster, and, geographically speaking, this is the oyster to seek when preparing a proper poor boy. You'll notice that, despite being all one species, Eastern oysters, whether farmed or harvested naturally from various locations, look different and often sport fanciful monikers like Pickle Point, Crab Slough, Moonstone, or Blue Points. That's because the flavor and even the size and shape of the shell are influenced by the environment (the tides, temperatures, salinity, etc.) in which it is grown.[1]

Here's my personal rule for serving Eastern oysters: If they come from north of the mid-Atlantic, and have a brinier flavor and firmer texture, eat them raw and unadorned, straight no chaser. If they come from warmer waters, from, say, the Gulf of Mexico, and are softer, sweeter, and meatier, slurp a few and cook the rest.

As for the old rule, "Never buy oysters in a month without an R," that was to avoid the spawning season in summer, when flavor and texture are not the best. Many oysters today, however, are "triploid." Basically, they're bred to be sterile, so instead of putting their energy into reproduction they just grow big and delicious and succulent. So, we can have great oysters all year round.

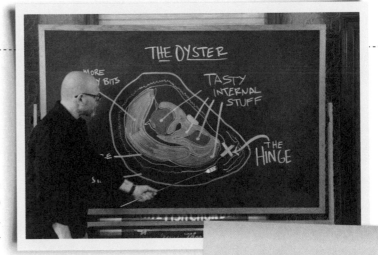

A single oyster can filter up to 50 gallons of seawater per day.

95 percent of the world's oyster production comes from aquaculture. And that's a good thing.

1 I'm a huge fan of oysters produced via aquaculture. Once upon a time, oysters grown in racks or bags up in the water column had thinner shells than naturally harvested oysters and often chipped during shucking. Now most farmed oysters are "tumbled" to chip off the shell edges, which then grow back stronger. This makes for much easier shucking . . . in my experience.

OYSTER SHUCKING SUPPLIES

I like shucking oysters. The way I figure it, why shouldn't I have to work hard and potentially poke a hole through my hand to get at a mindless mollusk I intend to devour? Fair's fair, right? To that end, I have amassed a considerable arsenal of bivalve-bifurcation hardware, including oyster knives of various styles and sizes, each with specific geographical associations.

The French oyster knife is short and leaf-shaped with a hand guard to keep you from running your hand into the shell or from running the blade too deeply into the oyster. Great on flat oysters, but otherwise, I'm not a fan.

On the opposite end of the spectrum is the Boston Stabber, which is supposedly preferred by workers in canning facilities because it can get into shells fast. It does take some practice to not mangle the meat when using.

Other, more multipurpose options include the Providence, with its stout blade and triangular tip, the Galveston, which boasts a wider 4-inch blade, better suited to large Gulf oysters than diminutive Kumamotos. For those, I'd suggest perhaps a New Haven, which rarely exceeds 2¾ inches in length, with a medium-width blade that always curves slightly upward at the tip for better leverage.

Keep in mind there is no right oyster knife, so you'll have to try them out until you get the right fit for you. And you could certainly use other things. I've shucked several thousand oysters with nothing but a Craftsman flat-head screwdriver, which, I should point out, is one of the finest multitaskers on the planet.

Now, let us speak of the other hand: the one the knife is pointing at. For protection, I typically reach for a folded kitchen towel, but some folks swear by a rubber-coated glove or even Kevlar. Bad ideas, I'd say, because neither protects very well against punctures. Chain-mail gloves are available and they're even reversible to adjust for either hand. Easy to clean, and puncture resistant, I think you could even feed a shark with one, though that is not sanctioned by the manufacturer. I'll stick with a folded terrycloth towel.

If you plan on shucking a whole lot of oysters, consider an oyster board, which can hold an oyster in position during the crack while capturing brine, shell chips, and so on. However, I cannot condone the use of this device because it is, alas, a unitasker.[2]

2 To those of you who would chide the oyster knife itself as a unitasker, drop by my place for cheese sometime and behold the way I split the Parm.

HOW I SHUCK OYSTERS

1) Examine the oyster and decide which is the cup side of the shell and which is the flat. It is easier to tell on some oysters than others, but this step is important, as shucking with the cup side down will help create better leverage and will keep all of the oyster liquor intact.

2) Firmly jiggle the point of the knife into the hinge. When I find purchase, I switch to a kind of side-to-side motion. Then twist.

3) Now, move the blade in and around and sweep upward, across that adductor muscle on the underside of the flat shell. Once the flat shell is off, use your knife to sever the bottom part of the adductor, which is attached to the cup side of the shell. Consider a scraping motion.

4) Then—here's an oyster bar trick—roll the meat over so it's pretty. Of course, that only matters if you're serving on the shell, which I usually do while prepping the sandwich.

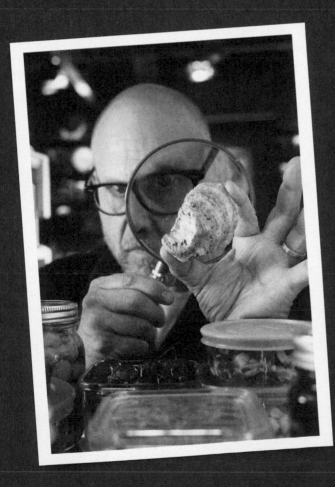

OYSTER POOR BOY

My version of the oyster poor boy substitutes a slaw for the "dressing," which I feel ups the flavor and texture game, albeit in an unorthodox manner.

SOFTWARE

½ cup (118 ml) buttermilk

2 tablespoons (30 ml) hot sauce, divided

24 farm-raised oysters, shucked[3]

½ cup (110 g) mayonnaise

1 tablespoon (15 ml) fresh lemon juice

1 tablespoon (16 g) Dijon mustard

1 tablespoon dill pickle brine

2 teaspoons kosher salt, divided

1 teaspoon dried parsley

½ teaspoon freshly ground black pepper, plus more for seasoning the fried oysters

½ teaspoon cayenne pepper

½ teaspoon garlic powder

½ teaspoon sumac

1 head (385 g) iceberg lettuce, cut into ½-inch ribbons[4]

1 cup (145 g) finely ground white cornmeal

1 cup (70 g) panko breadcrumbs

1 quart (946 ml) peanut oil,[5] for frying

4 (6- to 8-inch-long) banh mi rolls (see note opposite)

TACTICAL HARDWARE

- A heavy pot or Dutch oven for frying

- A reliable clip-on fry/candy thermometer[6]

- A spider for retrieving oysters

- Shucking equipment (unless, of course, you purchase pre-shucked oysters; a lot of people do and I'm not going to judge you . . . much)

- 2 half sheet pans with wire cooling racks

The longest poor boy ever made was filled with more than five thousand fried oysters.

PROCEDURE

1) Combine the buttermilk and 1 tablespoon of the hot sauce in a small bowl. Add the oyster meats and refrigerate for 30 minutes to 1 hour.[7]

2) Put the mayonnaise, lemon juice, mustard, pickle brine, ½ teaspoon of the kosher salt, parsley, black pepper, cayenne, garlic powder, sumac, and the remaining 1 tablespoon hot sauce in a large bowl and whisk to combine. Add the lettuce and toss to coat with a rubber spatula or your hands. Cover the slaw and refrigerate for at least 30 minutes or up to 1 hour.[8]

3) Combine the cornmeal, panko, and the remaining 1½ teaspoons of the salt in a medium bowl and set aside.

4) Heat the oil in a 5-quart Dutch oven over high heat to 350°F. Reduce the heat to medium-low and let the oil slowly cruise up to 375°F. Set a sheet pan/rack combo on either side of the pot, if possible. One will be a launch pad, the other a landing pad.

5) Split the rolls in half lengthwise. Tear out a bit of bread from the center of each roll (using your fingers or a fork), creating a trough.[9] If you wish,

3 Truth is, I just don't enjoy shucked oysters from a tub, so even when frying, I shuck my own. But then, I really like shucking oysters. If you don't—or won't—you can buy "tub" oysters, but I strongly suggest you do so only from a reputable fishmonger or fish counter (meaning one you know). They should always be kept on ice, as they're highly perishable. You may also want to keep an eye out for HPP oysters, which are pasteurized in their shells with massive amounts of water pressure, which loosens the shells and does away with most microbial baddies. And all with no added chemicals or (supposedly) reduction in quality.

4 We can use all of the lettuce, except for the little core. The easiest way to get that out is to just smack the head of lettuce on a cutting board and then simply pull the core right out.

5 I'm partial to peanut oil, but, as stated elsewhere in this book, our test kitchen has gone to 50/50 peanut/safflower.

6 I still use an old-school analog alcohol thermometer because I like being able to read how quickly the temperature is changing. Digital thermometers aren't so good with that.

7 This soak isn't to tenderize but to add flavor and to provide a primer coat for the breading to stick to.

8 Will dressing this lettuce ahead make it wilt? Yes. That's kinda the point.

9 Pulling some of the bread out of the middle will help the sandwich stay together, but you're still going to need a roll of paper towels to eat this thing.

lightly toast the rolls in a 375°F oven for 3 minutes. Honestly, I never do.

6) Remove oysters one at a time from the marinade and drain several seconds to remove excess liquid. Dredge in the cornmeal mixture, then transfer to one of the prepared racks. Once all the oysters have been dredged, rest them on the rack for 10 minutes to allow the breading to set.

7) Transfer six oysters at a time to the hot oil and fry until golden brown, 1½ to 2 minutes. Adjust the heat as needed to keep the temperature between 350°F and 375°F.

8) Carefully evacuate the fried oysters to the clean prepared rack using the spider. Sprinkle with black pepper. Repeat with the remaining oysters, bringing the oil back to 375°F between each batch.

9) To serve, line the bottom of each roll with slaw and top with five or six oysters. Consume. Notice how the slaw is kinda gooshy (in a good way) and how that contrasts with the crunch of the oysters.[10]

NOTE ABOUT THE BREAD

Since New Orleans is several states away, authentic poor boy loaves are out of reach for me. But I got to thinking: Traditionally this is a soft, French-style bread, but not a baguette, which would be a lot harder to make in the tropical climes of southern Louisiana. So, what other region fits that climatological and culino-cultural profile? Vietnam. The French pulled out after the fall of their garrison at Dien Bien Phu in 1954, but their bread culture lives on in banh mi, which literally means "bread." Vietnam is a bit of a haul, but my town happens to have a Vietnamese grocery, and if you look closely, I'd be willing to bet there's one somewhere around where you live.

10 If you're more in the mood for a shrimp poor boy, simply trade out twenty-four large peeled shrimp for the oysters and reduce the fry time to 1 minute.

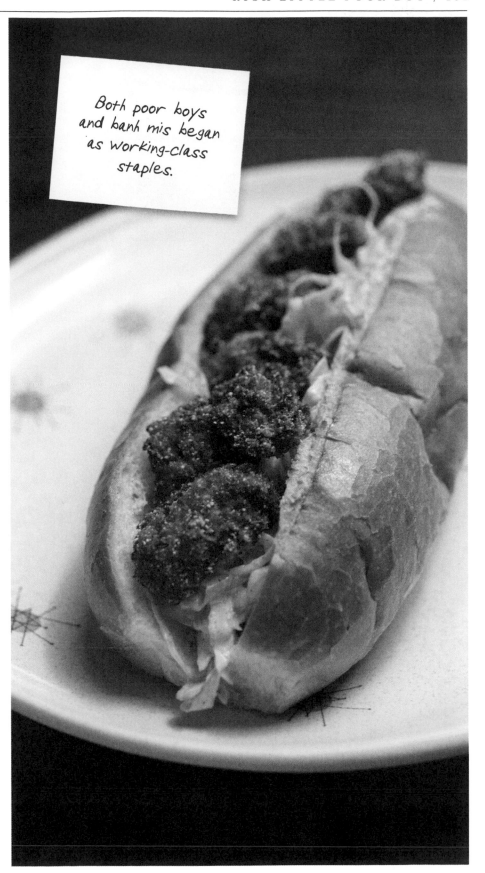

Both poor boys and banh mis began as working-class staples.

RAW AMBITION

Steak tartare is composed of high-quality *raw* beef chopped by hand, dressed with herbs, aromatics, and capers, then heaped onto a plate or lightly compressed into a kind of puck, and typically topped with a *raw* egg yolk. Typically served with toast, it is the perfect expression of meaty goodness. Is there a potential danger to the diner due to consumption of pathogenic organisms? In fact, there is. Can said danger be mitigated by judicious shopping, handling, and preparation? Indeed, it can. Will some danger persist? Yes, but life is risky business, and steak tartare is, in my estimation, well worth the gamble . . . like eating chocolate chip cookie dough or drinking aged eggnog, which as far as I'm concerned makes this dish a prime candidate for . . .

Da da da da da da da da da da.

HISTORY OF TARTARE

Although apocryphal origin tales abound, most concerning raiding Tartars riding with steaks under their saddles, steak tartare probably gets its name from *sauce tartare*, which in France is very different from the mayo-and-pickle-relish mélange we slather on fish fillet sandwiches. In fact, it contains no mayonnaise at all but is built instead on an emulsion of oil and hard-cooked egg yolks. Capers are usually included, as is parsley, sour pickles, and dry mustard. By the mid- to late nineteenth century, just about anything served in France with this sauce was called . . . *à la tartare*. This would seem to plant the French flag in steak tartare, were it not for the perplexing fact that the most famous French chef of the age— Auguste Escoffier—published a recipe in 1921 for a raw chopped steak served with sauce tartare called "Beefsteak à l'Americaine." I can't find a record of the raw egg until the 1938 edition of the *Larousse Gastronomique*, which eschews the sauce tartare. So, the parts were all out there, juxtaposed if not exactly coalesced until sometime after World War II. In any case, it's about the beef, and my favorite cut for this dish isn't the fillet or the rib-eye, it's the sirloin.

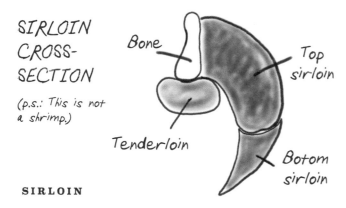

SIRLOIN CROSS-SECTION

(p.s.: This is not a shrimp.)

Bone

Top sirloin

Tenderloin

Botom sirloin

SIRLOIN

There are basically seven primal beef cuts: the chuck, rib, loin, round, brisket, plate, and flank, though some folks combine the last two and some include the shanks—I do not. Now, there are great steaks all over a steer, but it's generally held that the further from hoof and horn the more tender they will be due to a lower percentage of connective tissue. That makes the rib and the loin the big-money primals.

The loin is broken down into two sub-primals: the short loin and the sirloin. I prefer the cuts from the sirloin because I like the bit of chewiness and the minerally flavor these cuts deliver. I also appreciate the fact that they can be had at a fraction of the cost of cuts from the short loin, which are to my taste rather bland.

The sirloin also subdivides into the top and bottom sirloin, and the steaks I seek for tartare are from the top section, which may be labeled as "top sirloin steak" or even "top sirloin butt."[1]

As for the name, there does exist a tantalizing tidbit of historical hogwash claiming that during a 1617 feast at Hoghton Tower, Lancashire, King James I actually knighted someone "Sir Loin." I'm not saying this didn't happen, but it should be noted that *sirloin* was originally spelled *surloyn*, from the Old French *surloigne*, and since *sur* is French for "over" or "on," the term likely just means the top part or the "over" loin.

Okay, this is your last opportunity to turn back, and really, you probably should. I mean, raw beef and egg combined? That helicopter you hear circling is the food police, and they are not happy.

Stop.

Don't.

Okay, let's do this.

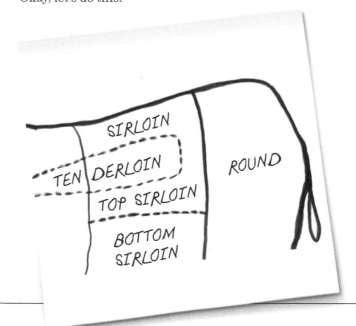

SIRLOIN

TENDERLOIN

TOP SIRLOIN

BOTTOM SIRLOIN

ROUND

1 The lack of standardization of beef cut nomenclature drives me crazy too.

STEAK TARTARE

YIELD:
4 servings

Notice there is no raw yolk parked atop the final dish. That's because it's already in the mix.

SOFTWARE

1 pound (454 g) top sirloin,[2] trimmed of excess fat and gristle

2 large egg yolks[3]

2 teaspoons (8 g) sherry vinegar

½ teaspoon (1 g) dry mustard

¼ cup (60 ml) light olive oil

6 tablespoons (60 g) finely diced shallots

2 tablespoons (24 g) capers, drained but unrinsed (more on capers below)

1 teaspoon kosher salt

¼ cup finely chopped celery leaves (16 g), divided[4]

2 tablespoons (8 g) finely chopped fresh parsley, divided

1 teaspoon (2 g) grated lemon zest, for garnish

TACTICAL HARDWARE

- A boning knife (though you can use a chef's knife in a pinch)

- 2 equally weighted chef's knives

- A large cutting board (hardwood—e.g., maple)

- A set of metal ring molds for plating[5]

PROCEDURE

1) Remove as much of the connective tissue from the sirloin as you can, using a boning knife if you have one.[6] Cut the meat into 1-inch cubes and park in the freezer for 10 minutes.[7]

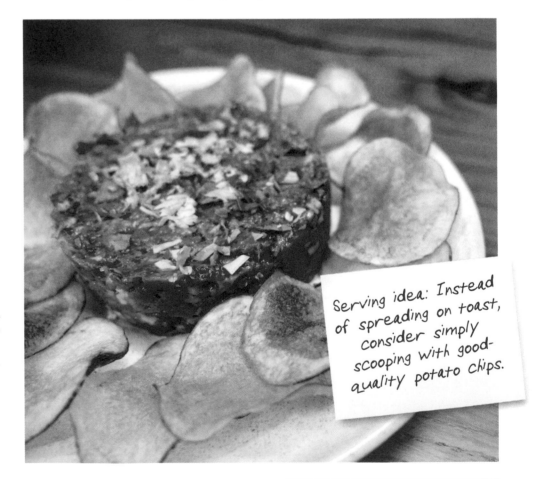

Serving idea: Instead of spreading on toast, consider simply scooping with good-quality potato chips.

2 It should go without saying that this meat better be of high quality and as fresh as you can possibly get it. If your butcher doesn't have a freshly cut top sirloin steak in the case, you should ask her or him to cut one for you so that you can be assured you'll get a piece of meat as free of potential pathogens as possible. I leave the meat intact and refrigerated until right before prepping for service, which should never be more than a day after purchase.

3 Yes, that's a raw egg, and yes, I'm going to eat it. It's a choice and it's mine to make. I also have sources for getting eggs that have never entered the commercial food chain. But, if you want to reduce your risk because you're feeding young children or the elderly, you're pregnant, or you suffer from a compromised immune system, look for pasteurized shell eggs at your megamart. But, honestly, if you're in any of those groups, odds are you're not going to be eating steak tartare anyway.

4 Fresh celery leaf is criminally underutilized.

5 Spectacular multitaskers that typically come nested in a round tin. Keep them near you always.

6 In cases like this I keep the blade pretty flat to the board and simply wiggle the fat off. A bit of paper towel can improve your grip.

7 Firmer meat is a lot easier to chop. But don't let it freeze . . . set a timer.

CHOPPING MEAT

The trick to chopping sirloin is to use two equally weighted knives and to allow their weight to do the work for you. It's kind of like drumming with knives and can be fun as long as you don't lose your grip and send a blade across the room. Meat will fly around a bit. You're going to have to gather it up, so make sure you've got a relatively large board. After running through the meat with my knife, I reshape it into a rectangle and then fold it over, the way you might fold a wallet or an old-fashioned map. Then I turn it 90 degrees and chop again. That helps to maintain evenness. Can this be achieved with a food processor? I'm not a fan, but, if that's the way you gotta go, divide the meat into four batches and pulse each batch separately three or four times in the food processor.

Center the meat on the board and start drumming out a smooth, even rhythm.

Try to position your wrists for maximum blade contact, and when meat flies around, just herd it back in.

When the meat looks like this...

Reshape into a uniform square, then keep chopping.

When it looks like this, start folding the meat over on itself like a tri-fold wallet.

At this point you should be able to work it out into a sheet.

Every 30 seconds or so, refold like the tasty meat-wallet that it is.

This is just about right... almost but not quite a paste. Most fibers gone.

2) Meanwhile, whisk the egg yolks, vinegar, and dry mustard together in a small bowl. Set on a kitchen towel to steady the bowl and stream in the oil, whisking continuously, until the dressing forms a smooth emulsion. Stir in the shallots, capers, and salt, followed by roughly two-thirds of the celery leaves and parsley.

3) Remove the meat from the chill and use two chef's knives to hand chop the meat to the desired texture. (See above.) Transfer to a medium bowl.

4) Fold the meat and dressing together with clean hands. Don't squeeze or knead; the meat should just barely hold together. Plate using a 3¾-inch pastry ring and garnish with the reserved herbs and the lemon zest.

STEAK TARTARE (*continued*)

CAPERS

Gram for gram, I can think of nothing that delivers flavor more than the pickled buds of *Capparis spinosa*, better known as capers. This wild-growing shrub of the Mediterranean flourishes in Greece, Spain, and Turkey, but I especially love those from the small Italian island of Pantelleria, which is just dry enough and hot enough to keep capers happy.

After being harvested by hand, the buds are soaked in a salt brine that supports fermentation via naturally occurring bacteria, such as *Lactobacillus plantarum*, *Lactobacillus brevis*, and *Lactobacillus fermentum*, which convert the buds' natural bitterness into a complex, astringent tanginess that somehow reminds me of goat cheese and grappa.

Capers are typically aged a month or more before being washed and re-brined. Then comes sorting or grading and packaging. Many sizes are available. Small non-pareils are most common in the United States and are perfect for tartare. They come either bottled in a vinegar brine or dry packed in salt. Although they both have a place in my kitchen, I do prefer the brined version for this application. Refrigerate after opening and your capers should keep until the next ice age.

If you're new to capering, keep in mind: If the caper buds are not picked, they bloom and go on to develop caper berries, which are larger and teardrop shaped. These are not, I repeat, not interchangeable with non-pareils, although they are delicious, especially in martinis.

Warning: Don't mistake capers for brine-soaked green peppercorns, which often come in the same type of bottles. Always read the labels!

Are there other meats to which we can give the tartare treatment? Indeed. *Poke* means "to slice" or "to cut into pieces" in the Hawaiian language. Ahi tuna poke is the perfect mash-up of traditional Polynesian foodways and Asian immigrant ingredients like rice wine vinegar and yuzu juice. Can ahi tuna be safely consumed raw, you ask? Interestingly, tuna are among the few fish the FDA approves for raw consumption, without first being deep frozen to kill parasites, because tuna don't typically harbor them and they have a long history of being consumed raw without issue.

NOTE

To store raw tuna (or any raw fish, for that matter), place it on a layer of plastic wrap over crushed ice in a vessel with holes or slits that allow the melting water to drain to another vessel below. If you want to get fancy you can go to a restaurant supply store and get a small hotel pan/steam table pan and a perforated insert.

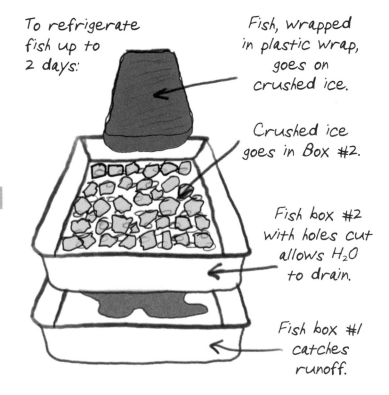

To refrigerate fish up to 2 days:

Fish, wrapped in plastic wrap, goes on crushed ice.

Crushed ice goes in Box #2.

Fish box #2 with holes cut allows H_2O to drain.

Fish box #1 catches runoff.

AHI TUNA POKE[8]

SOFTWARE

1 tablespoon (15 ml) white soy sauce

2 teaspoons untoasted sesame oil

1 teaspoon rice wine vinegar

¼ teaspoon yuzu juice (more on yuzu below)

2 scallions, light- and dark-green parts only, thinly sliced on the bias

5 to 6 dry-roasted macadamia nuts (10 g), roughly chopped

8 ounces ahi tuna, cut into ½-inch cubes

PROCEDURE

1) Whisk the soy sauce, sesame oil, vinegar, and yuzu juice together in a medium bowl.

2) Add the scallions and macadamia nuts, followed by the tuna, and fold together. Marinate for 15 minutes at room temperature before serving.

YUZU

The yuzu, ubiquitous in Japanese cuisine, is kind of a mash-up of a mandarin orange and a lemony citrus originally from China called *Ichang papeda*. Fresh yuzu are fairly difficult to find in the United States, but luckily bottled juice isn't. If you don't have an Asian market in your neck of the woods, order from the interwebs.

8 Since you'll be eating this raw, you'll want the best-quality fish you can get. I'd let the person at the fish counter know you want "sushi grade" tuna. There are also several reliable vendors on the web who ship frozen sushi-grade ahi, which is my preference.

DATE TRIPPER

I'm not sure how I made it through eleven straight years of production on the original *Good Eats* without doing a date show. Here's a fruit consumed daily by nearly half the planet's population, a massive nutrition and flavor delivery system, capable of playing in dishes both sweet and savory and all I ever did was put it in my smoothies. Truth is, I don't think I really got my head around dates until that British baking show became a big hit. That's when I started seriously thinking about sticky toffee pudding, and that changed everything. But I'm getting ahead of myself.

All Medjool dates descend from a single tree from Saharan Morocco.
There are an estimated three thousand varieties of dates grown worldwide.
A single bunch of dates may contain more than one thousand fruits.

YOUNG LEAF LEAF

HEART

NFLORESCENCE FRUIT BUNCH
(FLOWERS)

We ran out of budget on this show and couldn't shoot a date garden in California—so we built a really tall blackboard version.

Phoenix dactylifera, the date palm, was originally cultivated in Mesopotamia around 4000 BCE, though the Greeks supposed it to be of Phoenician origin, hence the moniker. The species name derives from *dactylus*, meaning "finger," a reference to the shape of the fruit. It's also where we get our word "date." The slow-growing date palm can easily exceed fifty feet, depending on the region, and can produce fruit from age seven to seventy.

Although dozens of varieties of dates are enjoyed in their native lands, in six distinct stages of ripeness, only eight to ten are seasonally available in the United States. Of those, I would say that only two are commonly available: the plump, juicy Medjool, usually sold with the pits intact, and the dryer, narrower Deglet Noor, typically sold sans pit, ergo ideal for stuffing. Both are sold in what's called the *tamar* stage of ripeness, meaning they've basically turned into raisins on the trees, maximizing their sugar and minimizing their moisture content, and extending their shelf life. When it comes to procurement, my suggestion is that unless you have a Middle Eastern market nearby that turns over its stock frequently, purchase via the world wide web. Since many date gardens handle their goods through cold storage and grading, they often ship direct, and I've found those products to be superior. A tad steeper in price, perhaps, but worth it.

DATES IN THE UNITED STATES

In 1898, the U.S. Department of Agriculture sent a group of botanical Indiana Joneses across the globe to raid not lost arks but plants and seeds that could be brought back, by whatever methods necessary, and tested as crops in the United States. These men were dubbed "agriculture explorers," and in 1900 one such agent, Walter Swingle, trekked to Algeria to study dates. After gathering data on temperatures, weather patterns, etc., Swingle realized that North Africa was a lot like the Coachella Valley. By the 1920s, growers here were growing Deglet Noor and Zahidi dates and cashing in on the national fascination with all things Arabian (thank you, Rudolph Valentino) by building pyramid-shaped stands, hosting Arabian festivals, organizing camel races, and changing the names of their towns to the likes of Oasis and Mecca. One of the famous date stands of the day even touted a lecture and slide show titillatingly titled: "The Romance and Sex Life of the Date."

> The date is mentioned twenty-two times in the Qur'an, more than any other fruit-bearing plant.

To kick off the date cookery, I must reach back into childhood and a dish that was de rigueur in the California cocktail party scene. The delectable doppelgänger of Angels on Horseback, an hors d'oeuvre of bacon-wrapped roasted oysters, Devils on Horseback are time-consuming but easy, and I rarely entertain without them. And if you're going to take the time to make them you might as well make a few different versions. All these recipes call for a toaster oven. I adore my toaster oven, because so much of my cooking seems to lend itself to a quarter sheet pan size. That said, if you don't own a toaster oven you can certainly employ whatever oven you have on hand.

Devils on Horseback is the perfect dish for the toaster oven. (Honestly, I use my toaster oven more than the big oven.)

BLUE CHEESE DEVILS ON HORSEBACK

YIELD:

20 stuffed and wrapped dates

SOFTWARE

20 pitted Deglet Noor dates (118 g)

1 cup (237 ml) dry sherry

2 ounces (57 g) soft, pungent blue cheese[1]

7 slices bacon (not thick-cut[2]), cut into 2½- to 3-inch lengths (198 g)

TACTICAL HARDWARE

- A quart-size heavy-duty (freezer) zip-top bag, or a reusable piping bag

- A toaster oven[3]

- A quarter sheet pan with a rack that fits inside

PROCEDURE

1) Put the dates in a bowl and cover with the sherry, making sure they're fully submerged. Leave at room temperature to soak until softened and slightly plump, about 2 hours.

2) Meanwhile, put the cheese in a quart-size zip-top bag, then snip one corner off the bag, leaving about a ½-inch opening. Leave at room temperature until ready to fill the dates.

3) When ready to cook dates, heat a toaster oven to 450°F and have the rack and quarter sheet pan standing by.

4) Drain but don't rinse the dates. Use a pair of scissors to open each date lengthwise. (Deglet Noor dates are typically pitted from the end, so you can just slide one blade of the scissors up and through the hole, then snip to open.)

5) Pipe roughly ½ teaspoon of the cheese into each date,[4] then wrap with a piece of bacon so that the two ends wrap around the opposite side from the slit. Set the wrapped dates on the rack with the bacon ends down and gently press to anchor.

6) Bake until the bacon is brown and crisp, about 15 minutes. Cool for 5 minutes before serving. (If your bacon is particularly fatty, you may want to move the dates from the rack to some paper towels for a minute or two before serving.)

1 This recipe works best with a soft, strong-flavored blue cheese, such as Saint Agur. If you only have a drier, crumbly cheese, microwave it for 5 to 10 seconds to soften before using in step 2.

2 Thin-cut bacon is always best for wrapping and roasting. Save the thick-cut stuff for BLTs.

3 Yes, you can cook this in a conventional wall oven or range, but I really think the toaster oven is the way to go. They're fast, and since they're small they tend to brown better than large ovens, because the radiant source is closer to the food.

4 Resist the urge to overfill.

WATER CHESTNUT SOY DEVILS ON HORSEBACK

YIELD:

20 stuffed and wrapped dates

Classic Devils on Horseback with an Asian twist. Water chestnuts offer a wonderful crunch contrast, while soy sauce tunes in the dates' savory aspects.

SOFTWARE

½ cup (118 ml) low-sodium soy sauce

½ cup (118 ml) water

20 pitted Deglet Noor dates (118 g)

¼ cup (35 g) canned water chestnuts, cut roughly into matchsticks

7 slices bacon (not thick-cut), cut into 2½- to 3-inch lengths (198 g)

TACTICAL HARDWARE

- A toaster oven
- A quarter sheet pan with a rack that fits inside

PROCEDURE

1) Combine the soy sauce and water in a small bowl. Add the dates, making sure they are fully submerged, and soak until softened and slightly plump, about 2 hours.

2) When ready to cook dates, heat a toaster oven to 450°F and have the rack and quarter sheet pan standing by.

3) Drain but don't rinse the dates. Use a pair of scissors to open each date lengthwise. (Deglet Noor dates are typically pitted from the end, so you can just slide one blade of the scissors up and through the hole, then snip to open.)

4) Stuff each date with 2 or 3 pieces of water chestnut, then wrap with a piece of bacon so that the two ends wrap around the opposite side from the slit. Set the wrapped dates on the rack with the bacon ends down and gently press to anchor.

5) Bake until the bacon is brown and crisp, about 15 minutes. Cool for 5 minutes before serving. (If your bacon is particularly fatty, you may want to move the dates from the rack to some paper towels for a minute or two before serving.)

Date palms grow from the top down, specifically from an apex bud called a heart, which is prized for its own flavor. Unfortunately, removing the heart kills the tree, so it's not exactly a renewable resource.

SPICY CREAM CHEESE PEPPERONI DEVILS ON HORSEBACK

Soaked in beer, stuffed with Sriracha-spiked cream cheese, and wrapped in pepperoni, this variation will make you feel like you're eating out of a gas station . . . only in a good way.

SOFTWARE

20 pitted Deglet Noor dates (118 g)

1 cup (237 ml) lager-style beer

3 tablespoons (57 g) cream cheese, softened

4 gherkin pickles (42 g), finely diced (¼ cup)

1 teaspoon (5 g) sriracha

10 deli-style pepperoni slices (38 g), about 3 inches in diameter, halved[5]

TACTICAL HARDWARE

- A quart-size heavy-duty (freezer) zip-top bag, or a reusable piping bag

- A toaster oven

- A quarter sheet pan with a rack that fits inside

Jim Pace—this time as "Old Scratch"

PROCEDURE

1) Put the dates in a bowl and cover with the beer, making sure they are fully submerged. Soak until softened and slightly plump, about 2 hours.

2) Meanwhile, thoroughly mix the cream cheese, gherkins, and sriracha together in a medium bowl, then transfer to a quart-size zip-top bag. Snip off one corner of the bag, leaving about a ½-inch opening. Leave at room temperature until ready to fill the dates.

3) When ready to cook dates, heat a toaster oven to 450°F and have the rack and quarter sheet pan standing by.

4) Drain but don't rinse the dates. Use a pair of scissors to open each date lengthwise. (Deglet Noor dates are typically pitted from the end, so you can just slide one blade of the scissors up and through the hole, then snip to open.)

5) Pipe about ½ teaspoon of the cream cheese mixture into each date, then wrap with half a pepperoni slice, so that the edges of the peperoni meet on the opposite side of the date from the slit. Place the wrapped date on the rack, pepperoni seam-side down, and gently press to anchor.

6) Bake until the pepperoni is brown and crisp, about 10 minutes.[6] Cool for 5 minutes on the rack before serving.

5 Now, you could do bacon on the cream cheese dates as well, but why would you do that when you can do this? Pepperoni . . . it's not just for pizza anymore.

6 These only need to cook for about 10 minutes because the pepperoni is a lot thinner than the bacon, and it's technically already cooked.

PUDDING

The first known mention of pudding in European literature took place in Homer's <u>The Odyssey</u>.

Let's talk sticky toffee pudding (STP), starting with the "pudding." Rome began its occupation of Britain in 43 CE, and some historians argue that quite a few Germans came along for the ride. Now, the Romans also brought their sausages, or *botellus*, which tangled up with the low-German word for "swollen," *puddig*. When the Romans skedaddled in 410 CE, the sausage pudding evolved into a grain mixture that was boiled in either a bag or an organ (see, e.g., haggis). Sticky toffee pudding descends directly from this line.

Although contradicting origin stories abound, I've heard that two Canadian air force officers staying in Lancashire during World War II gave a recipe for STP to innkeeper Patricia Martin, who shared it with Francis Coulson of the Sharrow Bay Country House Hotel, which claims to be ground zero for the dessert.

STICKY TOFFEE PUDDING

YIELD:
6 puddings

Sweet, yes, but the dates provide an earthy complexity that makes this more than a trip to the dentist waiting to happen. The sauce can be made well ahead.

SOFTWARE

For the toffee sauce:

160 grams (11 tablespoons) unsalted butter

300 grams (1⅔ cups) dark brown sugar

90 grams (4½ tablespoons) molasses[7]

1 tablespoon (3 g) instant espresso powder

¼ teaspoon kosher salt

¾ cup (177 ml) heavy cream

For the pudding:

85 grams (6 tablespoons) unsalted butter, melted, plus 1 tablespoon (14 g) softened, for greasing

105 grams (¾ cup) all-purpose flour

¾ teaspoon baking powder

½ teaspoon baking soda

½ teaspoon kosher salt

220 grams (1½ cups) pitted Medjool dates, divided

¾ cup (177 ml) boiling water

65 grams (⅓ cup plus 1 teaspoon) dark brown sugar

50 grams (¼ cup) granulated sugar

1 large egg, plus 1 large yolk

¼ teaspoon vanilla extract

½ teaspoon instant espresso powder

TACTICAL HARDWARE

- A Thermos (optional)
- A 6-cup popover pan (6 is a reference to the number of holes, not the capacity)[8]
- A cooling rack
- A wooden skewer
- A small metal offset spatula (a butter knife will do in a pinch)
- A wide spatula (like a pancake turner or large grill spatula)

Older STP recipes often call for adding baking soda, or "bicarb," as the Brits call it, to soften the skins of the dates, but honestly, I never bother.

PROCEDURE

1) Make the toffee sauce: Melt the butter in a small saucepan over low heat.

2) Add the brown sugar, molasses, espresso powder, and salt. Whisk to eliminate any lumps, then continue to cook over low heat until bubbles appear at the edge of the pan, about 3 minutes.

3) Whisk in the cream and bring to a bare simmer, about 5 minutes, then remove the pan from the heat, cover, and set aside. If you want to make this even a couple of hours ahead, I'd suggest stashing it in a Thermos. If said Thermos has previously been home to coffee, that'll only make the sauce taste better.

4) Make the pudding: Position a rack in the center of the oven and crank the box to 350°F. Grease the bottom and sides of each well of the popover pan with the softened butter.

5) Whisk the flour, baking powder, baking soda, and salt together in a medium bowl and set aside.

6) Put 150 grams (1 cup) of the pitted dates and the boiling water in the bowl of a food processor and leave to soak for 2 minutes, then pulse until the dates are broken into small pieces, about 6 one-second pulses.

7 The sticky toffee in sticky toffee pudding is butter cooked with cream and "treacle," an English ingredient that is a stickier, gooier, more tar-like version of molasses. They're both the liquidous remains of sugar-making, but since molasses is a lot easier to find, I sub it out, but augment with brown sugar and instant espresso powder, a truly fine multitasker if ever there was one.

8 STP is often steamed in a traditional pudding basin, but since it's mixed like a muffin, I say why not bake it like a muffin? Actually, this is the perfect application for a popover pan, which now isn't a unitasker, which means I can finally have one.

STICKY TOFFEE PUDDING *(continued)*

7) Add the melted butter, both sugars, the whole egg and egg yolk, vanilla, and espresso powder to the food processor and pulse to thoroughly combine, about 5 one-second pulses. Follow with the flour mixture and the remaining dates and pulse until the (new) dates have broken down into small pieces, about 5 one-second pulses.

> *In the baking world, granulated sugars count as wet ingredients because they readily dissolve in relatively small amounts of liquid.*

8) Fill each well of the popover pan three-quarters full with batter.[9] You may have a few tablespoons of batter left over, depending on the size of your popover pan. Make sure not to overfill the pan, because overflow it will.

9) Bake for 11 minutes, then remove the pan from the oven and tap on the oven door three times to deflate. Rotate the pan 180 degrees and bake again until the middle of the puddings reaches 210°F and the deflated centers have re-risen, 10 to 12 more minutes.

10) Remove the pan to a cooling rack. Pierce each cake several times with the skewer, poking all the way down to the bottom of the pan. Slowly pour 1 tablespoon of the toffee sauce over each pudding, using the skewer to make sure that the sauce goes both into the center of the cake and around the sides. Leave to soak for 15 minutes. Pour in another tablespoon of toffee

9 A #10, 3¼-ounce disher works perfectly here if you have one.

sauce, again making sure it goes around the sides of the cake as well, and soak for another 15 minutes.

11) Run a small offset spatula around the edges of the cakes, cover with a clean sheet pan, and invert to release. Use the wide spatula to move to individual plates.

12) Serve with additional toffee sauce spooned over each pudding. The appropriate beverage pairing: a blended Scotch whisky, with a splash of spring water.

Blimey, that's a right scrummy pud!

STORAGE TIP

Since dates can either mold or dry out, proper storage is key, and you have three options: airtight containment at room temp for 3 months, refrigeration for up to 6 months, or frozen for up to a year. I prefer pop-top containers over zip-top bags, because bags tend to hold moisture up against the dates, which can cause possible mold. Speaking of, dates are often lightly coated with what looks like a white, dusty film. These are tiny sugar crystals, and they won't hurt a thing. If they bother you, wrap the offending dates in a barely moist paper towel and nuke on high for 10 seconds to dissolve the crystals.

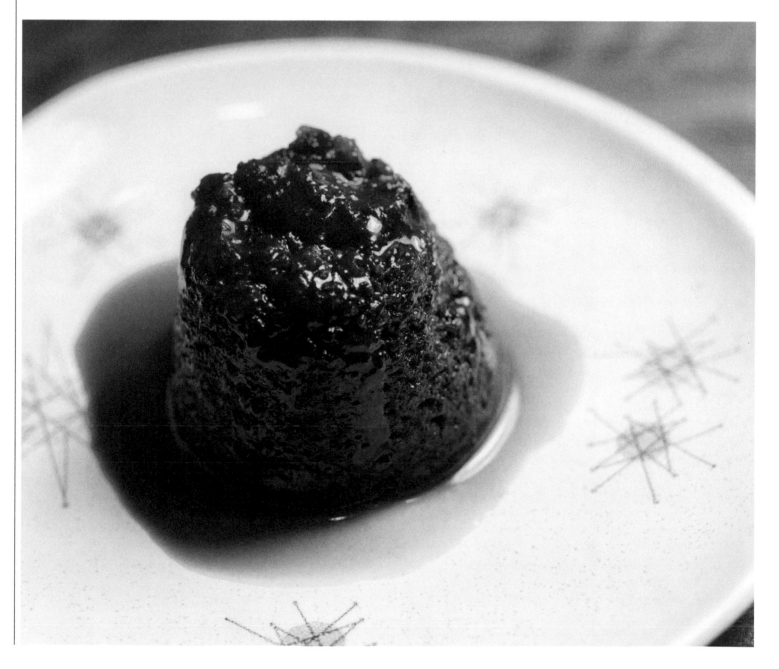

WILD YEAST RISIN'

My crew make the best zombies.

In the spring of 2019 I thought, "I want to do a postapocalyptic show where I'm stuck in a world ravaged by a pandemic, and in an effort to quickly develop a vaccine science turns most of mankind into zombies and then nukes all the major cities, leaving me and my dog to fend for ourselves, living mostly off wild-sourdough-based foods," which ironically became hugely popular during the recent . . . complications.

By sourdough I mean, of course, a wild culture, a jar of gloop that's also a thriving community of wild yeasts and bacteria living in symbiotic harmony, creating a smorgasbord of tasty substances and dough-lifting gases. Such a village is easy to build and care for, and, once mature, a powerful force for culinary good. (Patience is required but will be rewarded. The *Good Eats* faithful will no doubt recall that we never actually made bread on this show, and that's because EVERYONE EXPECTED US TO MAKE BREAD. And so, we made crackers and waffles instead . . . and, of course, starter.

<u>Yeast</u> comes from an old Germanic word for "froth," referring to the foam produced during beer making.

SOURDOUGH SCIENCE

Sourdough is the original leavened bread, dating back to prehistoric times. It is defined by the fermentation of yeast and lactic acid bacteria (LAB). Until the development of commercial yeasts, leavened bread was made using naturally occurring yeasts, which co-habited with wild bacteria, meaning all leavened bread was, technically, sourdough.

Sourdough starters work by harnessing the power of the symbiotic relationship between wild yeasts—present in the air, flour, even your hands—and LAB. LAB are unlike other bacteria in that they thrive in acidic environments and produce a variety of mild organic acids, the most important of which (for sourdough) are lactic and acetic acids. Sourdough yeasts adapted to thrive in this low-pH environment and assist in the development of bacteria by freeing needed amino acids and other nutrients. The LAB and sourdough yeasts are also naturally able to share the food (aka sugars) present in the flour; LAB prefer maltose (which the yeast cannot digest), while the yeast prefer the glucose produced when LAB metabolize maltose (which the LAB readily share). When the yeasts metabolize their preferred carbohydrates, they produce carbon dioxide, capable of leavening bread—or just about anything else you want to use your sourdough starter in.

As with other lactic acid ferments (see page 340, the fermentation episode), once established in the starter, LAB produce compounds that protect the culture from contamination by harmful microbes. And even though sourdough is thought of as "wild yeast," LAB outnumber yeasts in a typical sourdough starter at a rate of 100 to 1.

There is a lot of debate over what gives sourdoughs their distinct flavors. Some believe the individual flavors come from where the starters are kept, and the types of yeasts and particular LAB present in the air and in the flour used to feed it.[1] The types of flour used in a particular starter will impart a great deal of flavor (a rye starter will taste different from a whole wheat starter or one made entirely with all-purpose flour). However, there is also some evidence that, over time, a stable sourdough starter will contain pretty much the same LAB as any other, so the biggest flavor differ-

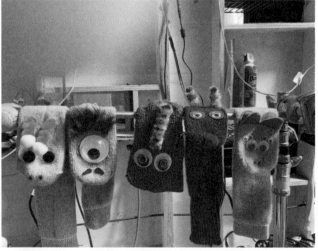

1 This is why the Sourdough Project began, to test the DNA of sourdough starters across America—and understand the evolutionary biology that underlies the differences among starters.

SOURDOUGH SCIENCE (continued)

The "Waffler" returns.

duce lactic acid as well as acetic acid, ethanol, and carbon dioxide. These LAB prefer cooler temperatures, between 59°F and 72°F, but can grow in warmer temperatures as well.[2] Heterofermentative bacteria add sharper, vinegar-like flavors to bread (mainly from the acetic acid). Stashing your starter in the fridge can promote those flavors, which I happen to like a great deal.

Louis Pasteur found and explained yeast's role in fermentation using his new compound microscope in the 1850s, and commercial bakers' yeast was sold for the first time just eleven years after Pasteur published his findings. The introduction of commercial yeast was extremely detrimental to the practice of baking sourdough breads, and eventually led to the manufacture of all the crap industrial breads sold on supermarket shelves today. These are filled with additives, such as extra yeast, gluten, fats, emulsifiers, and preservatives, to cut down significantly on leavening time and to prevent staling.[3]

Traditional sourdough bread is also considered a healthier option than mass-marketed breads, as the enzymatic action that takes place during sourdough fermentation makes the minerals in the flour more available to the body. Sourdough also produces a lower surge in blood sugar than other breads. There is even talk that LABs may metabolize wheat proteins in such a way as to reduce (but not eliminate) gluten content.

ences come from how mature a starter is, how wet it is, and at what temperature it is stored.

Sourdough LAB are generally classified into two groups: homofermentative and heterofermentative. Homofermentative LAB only (hence "homo") produce lactic acid—no acetic acid or carbon dioxide. They like warm temperatures, roughly between 80°F and 100°F, so if your starter spends a lot of time in a warm kitchen, it will likely contain more of these bacteria, which produce flavors of cultured cream and yogurt. Heterofermentative LAB pro-

2 The famous bread LAB, *L. sanfranciscensis*, is an obligately fermentative bacteria that maxes its growth at about 86°F to 95°F, so if you're looking to cultivate it, keep your starter between 59°F and 86°C.

3 This last point is a bit ironic, since the lower pH of sourdough bread helps to inhibit the growth of mold, and the LAB help to delay starch retrogradation (what we think of as staling), which means sourdough bread often lasts longer than breads leavened with commercial yeast.

SOURDOUGH STARTER

YIELD:

1¼ cups
(250 g)

Once mature, this starter possesses near magical powers, capable of lending lift, flavor, and texture to a wide array of baked and griddled goods, from breads to waffles to crackers.

SOFTWARE

125 grams all-purpose, unbleached flour

125 milliliters filtered water, at room temperature[4]

TACTICAL HARDWARE

- A clean glass bowl, a clean quart jar, and something to stir with (clean, please)

Time to put this starter to work.

PROCEDURE

1) Combine the flour and water with a clean spatula in a medium glass bowl. Cover the bowl with a tea towel and leave undisturbed at room temperature for 2 to 3 days. During this time, yeasts and bacteria from the air and from the flour will set up housekeeping in the bowl.[5]

2) When the mixture is bubbly and has nearly doubled in size, peel back any crust that may have formed and transfer 50 grams of the culture (which is technically what it is at this point) to a clean, wide-mouth glass jar. Using a clean spoon, spatula, or even chopsticks, stir in 100 grams each of flour and water. Loosely screw on the lid and stash at room temperature for 24 hours. Discard the rest of the original mixture or give it to friends for their own starters.

3) Repeat step 2 every 24 hours for 5 days. By then the culture should be very bubbly, smell yeasty-sweet-sour, and be rising and falling consistently over the course of the day.

4 Quality matters. While you can certainly use tap water for sourdough, we prefer to filter it first. Always use the best flour you can buy. I use King Arthur all-purpose for my starter, but feel free to add whole grain flours, such as whole wheat or rye, if you'd like.

5 If your culture isn't showing signs of life after 3 days, go ahead and start feeding with 100 grams each of flour and water. If after a few more days nothing happens, start over and place the culture in a different part of your home.

SOURDOUGH CHEESE CRACKERS

YIELD:
About 150 crackers

I'm not going to say these are the best cheese crackers, but they totally are the best cheese crackers and it's due to the complex chemistry of the starter. I usually make these from sourdough discard.

SOFTWARE

60 grams (⅓ cup plus 1½ tablespoons) unbleached, all-purpose flour, plus more for dusting

20 grams (2½ tablespoons) cheddar cheese powder[6]

¼ teaspoon kosher salt, plus more for sprinkling

125 grams (½ cup) *unfed* mature Sourdough Starter or sourdough discard (see Tip on page 171)[7]

57 grams (4 tablespoons) unsalted butter, softened, divided

TACTICAL HARDWARE

- A stand mixer
- 2 half sheet pans
- A manual pasta roller (such as an Atlas)
- A pizza wheel or cutter

Yes—your pasta roller can make crackers!

6 Cheese powder is easily ordered on the interwebs. You may need to buy in bulk, but it's shelf-stable and versatile; I use it all the time on popcorn, rice, and potato chips.

7 These crackers are a great way to use up discard; they don't need much leavening, so you're relying on the starter more for flavor than anything else.

PROCEDURE

1) Whisk the flour, cheese powder, and salt together in a small bowl.

2) Put the sourdough starter and 3 tablespoons of the butter in the bowl of a stand mixer fitted with the paddle attachment and mix on low speed until creamy, about 1 minute. Kill the mixer and sift the flour mixture over the creamed starter. Return the mixer to low and continue to mix until a soft dough forms, about 1 minute more.

3) Turn the dough out onto a lightly floured surface and divide into 4 equal pieces. Press each piece into a ¼-inch-thick rectangle and wrap in

individual pieces of plastic wrap. Refrigerate for at least 8 or up to 24 hours.[8]

4) Position two racks nearest the center of the oven and heat to 325°F. Line the two half sheet pans with parchment paper.

5) Retrieve one piece of dough from the refrigerator and dust both the dough and the pasta roller[9] with flour. Keep a small bowl of flour nearby to use to dust the roller and dough with additional flour, as needed.

6) Starting on the widest setting (typically labeled "1"), feed one piece of dough through the roller. Fold the dough into thirds, as you would a letter, turn 90 degrees, and run through the widest setting again. Fold the dough into thirds again, turn, and pass it through a third time.

7) Adjust your pasta maker to the second-widest setting and roll the dough through three times without folding. Roll through three times more on the third-widest setting. Transfer the rolled dough to one of the prepared half sheet pans and repeat the process with the remaining pieces of dough, arranging two sheets of dough per pan.

8) Melt the remaining 1 tablespoon butter and brush it across the dough. Sprinkle with a generous pinch of salt, then use a fork to dock the dough thoroughly (poke holes in it to keep it flat during baking), and cut into 1-inch squares with the pizza wheel.

9) Bake for 7 minutes, then turn the pans 180 degrees and switch out the top and bottom. Bake until the crackers begin to brown around the edges, 7 to 10 minutes more.

10) Remove the crackers from the oven and transfer them on the parchment to a rack to cool completely before serving, about 20 minutes. Repeat with any remaining dough.

11) Lid tightly and store at room temperature for up to 1 month. The crackers can also be frozen, but you and I know they won't last that long.

California gold miners were called "sourdoughs" because they'd often sleep with their starters at night.

8 Why the long wait? Even at refrigerator temperatures, the starter will continue to do its thing, consuming carbohydrates and creating complex (and tasty) chemical waste. Without this time, the crackers would lack in both flavor and flaky texture. So . . . your patience will be rewarded.

9 I know what you're thinking: unitasker. But if it rolls pasta and crackers, is it really? Besides, you just can't pull this off with a rolling pin.

SOURDOUGH WAFFLES

YIELD:

4 large Belgian waffles or 6 smaller waffles, depending on your waffle griddle

Sourdough waffles are pretty much the best waffles ever. That full flavor with a touch of delightful sourness balanced by malty goodness, toothy yet yielding interior, crunchy exterior . . . these things cannot be attained through speedy mechanized means.

SOFTWARE

125 grams (½ cup) unfed mature Sourdough Starter (page 171)

1 cup (237 ml) whole milk

170 grams (1 cup plus 3 tablespoons) unbleached all-purpose flour

57 grams (4 tablespoons) unsalted butter, melted and cooled

1 large egg, separated

1 tablespoon (15 g) sugar

1 teaspoon kosher salt

¼ teaspoon cream of tartar

TACTICAL HARDWARE

- An electric hand mixer
- A waffle iron, preferably Belgian style
- Nonstick spray

WAFFLE IRON

Belgian-style irons feature a much wider and deeper gridwork than American-style machines. When pillaging the remains of your local kitchen supply, I suggest you seek a heavy machine with a selective temperature control, not just a doneness range, and eschew machines with interchangeable plates, which never transfer heat very evenly.

PROCEDURE

1) Combine the starter, milk, and flour in a medium bowl and cover with plastic wrap. Let rest at room temperature until the batter is light, full of bubbles, and roughly doubled in size, about 8 hours. Although the mixture can be refrigerated overnight following this rest period, I usually just mix this up before I go to bed and leave it to rest, covered with a tea towel, on the counter overnight before making waffles for breakfast.

2) When ready to waffle (yes, that's a verb), stir the butter, egg yolk, sugar, and salt into the starter mixture until just combined and set aside.

3) Beat the egg white and cream of tartar in a medium bowl with your mixer on high speed until stiff peaks form, 1 to 2 minutes.[10] Gently fold the egg whites into the batter until just combined, then rest the batter at room temp for 20 minutes.[11]

4) Heat the waffle iron on medium heat, if possible. When hot, lightly coat both plates with nonstick spray. Ladle the batter into the iron (accord-

10 I'm not saying a stand mixer wouldn't work, but given the small quantity of egg white here, an electric hand mixer is easier. If you don't have one, you can certainly use a hand whisk, but it's going to take some elbow grease and a couple minutes more to reach stiff peaks.

11 The goal with any fold, and this is the same move you'd use with a soufflé, is to lighten the heavier base with the lighter foam without deflating the foam any more than absolutely necessary. Eight to ten folds is about all you need. After that, just walk away.

It was the Dutch, not the Belgians, who first made square, gridded waffles.

ing to the manufacturer's directions) and cook until crisp and golden brown.

Serve immediately or cool on a rack, wrap in plastic wrap then foil, and freeze for up to 3 months.[12]

TIP

You may find yourself fretting over the amount that gets tossed every time the starter is fed or refreshed. Truth is, you can easily make good use of that discard; you just need to make sure that you're using it in the right way. Sourdough discard doesn't do much for leavening, so reserve it for recipes in which you want sourdough flavor but not much air (like our crackers). If you're just getting going with your first starter, you will also need to make peace with throwing away starter;

sourdough discard isn't much good until you've got a nice, mature starter. But once you do, use the discard as much or as little as you'd like! After all, what those microbes might consider waste, I call taste.

There are a lot of methods of putting starters into hibernation. If I'm only looking for a break of a week or two, I feed, cover, and refrigerate. When I plan on baking again, I remove from the fridge and feed twice before using.

For long-term storage I use the "crumble" method. Place about ½ cup of starter in a clean bowl and top with 2 cups of flour. Work it with a spatula and then your fingers until it forms dry, pea-size nuggets. If you need more flour to get these feeling really dry, add another ½ cup. Stash this in an airtight jar for up to several months. To revive, just add more flour and water to make into a loose paste and give the little buggers time to wake back up. (I leave the lid in place during this period, but not tightened.)

12 To reheat, I just put them right back in the waffle iron on low.

HOLIDAY SPIRITS

The holidays are a treacherous time. Despite the trees and tinsel, tins of cookies, ugly sweaters, and Charlie Brown Christmas soundtracks, dangers lurk down every decked hall. Home accidents go up, car accidents go up, crime goes up. Emergency-room visits go up. Suddenly, reliably reasonable folks go rogue. Rules snap, standards sink, courtesy cracks.

The culprit, of course: alcohol. Americans double their dosage of the stuff during the holidays. Why? Family, especially of the extended kind. The doorbell rings, the punch pours, and pretty soon you're pointing out how Aunt Marge's bulldog looks remarkably like Aunt Marge. The answer is not to stop drinking (madness), but rather to switch gears to low-alcohol beverages, many of which can be gleaned from the pages of history.

Scabs gets in the holiday mood.

ABV BEVERAGES

Hard spirits like vodka are typically 35 percent to 50 percent ABV (alcohol by volume), which, by the way, is a much more useful word than "proof," an antiquated term from the days when gunpowder was used to "prove" how much ethanol, aka ethyl alcohol, was present in a liquid. Wines are typically in the 10 to 15 percent range and beers anywhere from 3 to 13 percent, sometimes even higher these days. My own definition of a low-ABV cocktail is one containing roughly 10 percent or less alcohol by volume, and that is what we're striving for here.

My low-ABV holiday bar is loaded up with liquids you need to know better: sherry, vermouth, port, and a liqueur or two, including one that most moderns haven't yet met: allspice dram. Now, although allspice dram is a rum-based liqueur, and therefore high-ABV, it is nevertheless a major player in my low-ABV cocktail game. Why? It's all in the name: *dram*, a very old word meaning an eighth of an ounce, which means it doesn't take much to create a lot of flavor. How does it taste? Like enjoying winter baked goods by a warm, crackling fire with a bunch of pirates.

Jim and Cole as pirates

Please keep in mind that low ABV does not mean no ABV, so act like the adults I know you are, and be responsible.

ALLSPICE DRAM

YIELD:

About 2 cups

SOFTWARE

½ cup (45 g) allspice berries

2½ cups (590 ml) navy-strength rum[1]

1 cup (200 g) sugar

TACTICAL HARDWARE

- Mortar and pestle
- A quart-size glass jar

Sailors in the Royal Navy received daily rations of rum until 1970.

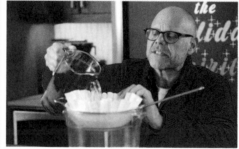

PROCEDURE

1) Heat a heavy skillet over low heat for 2 to 3 minutes, then toast the allspice berries in it until fragrant, about 1 minute.

2) Transfer to a mortar and roughly crush with a pestle. Transfer to a quart-size glass jar, pour in the rum, lid tightly, give it a good shake, and stash somewhere safe to steep for 10 days.

3) Strain the allspice-infused rum through a fine-mesh sieve into a small saucepan, add the sugar, and place over low heat. Stir occasionally, until the sugar is fully dissolved, about 15 minutes.

4) Cool to room temperature, then transfer to a glass jar or bottle and store for up to 2 months.[2]

5) To serve: Jump down to the next application.

1 Any overproof rum will work here, meaning any rum over 50 percent ABV. But navy-strength rum, typically bottled at 57 percent ABV, is my favorite. Just remember: The higher the ABV of the rum, the higher the ABV of your resulting dram.

2 It'll technically be drinkable for far longer than 2 months, but this is the max storage time for best flavor.

ALLSPICE

Allspice is often ignored in American cookery, despite the fact that the dried, unripe berry *Pimenta dioica* can, in a pinch, replace cinnamon, clove, or even nutmeg, and you know how much I love my nutmeg.

Now, unlike so many denizens of the spice rack, which hail from the Far East, allspice originally sprung from the fertile soil of the Caribbean isles, especially Jamaica, where it's called pimento, which may explain America's confusion, because for us pimentos are also the little red things in cocktail olives and pimento cheese sandwiches.

Nomenclaturally curious? Consider Christopher Columbus, who "discovered" Jamaica on May 5, 1494, while searching for the spice we call pepper and the Spanish called *pimiento*. *Pimiento* stems from the Latin *pigmentum*, which originally meant "pigment" but came to mean "spice" in medieval Latin. It then became *pimiento* in Spanish, so although they were looking for black pepper, things might have gotten confusing. When the English invaded Jamaica in 1655 they renamed the berry "allspice," because it kinda tastes like a bunch of other spices put together.

DRAM

By the turn of the eighteenth century a lot of sugarcane was being grown in Jamaica, and the leftover molasses was being distilled into a rough—and altogether unpleasant—spirit called "rumbullion," aka rum. Imbibers sought affordable ways to improve rum's flavor and struck upon allspice, which was common, cheap, and contained several active ingredients, including eugenol, all miscible in ethanol. By steeping allspice in the rum, the undrinkable firewater became something akin to liquid apple pie, perfect for the holidays. Although allspice dram enjoyed a moment during the tiki craze of the mid-twentieth century, it's become rather hard to find.

Luckily, it's extremely easy to make, as long as you can get your hands on some "overproofed" rum . . . There's that proof thing again. It has to do with a lot of things. What matters is that for this application we'll require a rum over 50 percent ABV, which in the United States is 100 proof. "Navy strength" is bottled at 57 percent ABV, or 114 proof, while some rums are bottled at 75.5 percent ABV and are 151 proof, which is enough alcohol to simply light the bottle on fire, which is probably why some distillers have stopped making it. Me, I vastly prefer the navy-strength rum.

Although allspice dram is used in some famous tropical drinks, like the Lion's Tail and the Three Dots and a Dash, my favorite allspice dram application is also my favorite holiday beverage, Clarified Milk Punch, and no, it does not appear milky in any way. It's like a magic trick, only it's totally a science trick, and one that's been performed since at least the early 1700s. Benjamin Franklin was a fan, as was Charles Dickens, who had several bottles of milk punch in his wine cellar when he died.

CLARIFIED MILK PUNCH

YIELD:
2 quarts

I know it is going to seem like you're using lot of containers, but the punch needs to strain into a container large enough to securely hold the sieve, and such a vessel would be too wide to serve from . . . except for maybe a punch bowl, which is tough to get into the fridge.

The oldest known clarified milk punch recipe dates back to 1711.

SOFTWARE

2¼ cups (532 ml) water

8 Earl Grey tea bags

½ cup plus 1 tablespoon (85 g) granulated sugar

1 cup (237 ml) ruby port (read the sidebar, opposite the application, for fun facts)

½ cup (118 ml) aged dark rum (not spiced)

¼ cup (60 ml) Allspice Dram (page 178)

¼ cup (60 ml) fresh lemon juice

1 cup (237 ml) whole milk[3]

TACTICAL HARDWARE

- A quart-size canning jar
- 2 wide jars or pitchers large enough to hold at least 40 fluid ounces (one of which has a mouth wide enough to accommodate a large sieve)
- The aforementioned large sieve
- A commercial-size coffee filter[4]

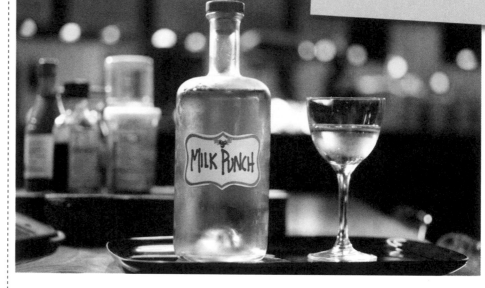

PROCEDURE

1) Heat the water to 208°F. If you have an electric kettle with a temperature setting, great. If not, bring the water to a boil in a saucepan, kill the heat, and count to 20. Pour the water over the tea bags in the quart jar and steep for 3 minutes, then remove the bags without squeezing them out.[5]

2) Add the sugar to the hot tea and stir to dissolve. Then stir in the port, rum, allspice dram, and lemon juice. Cool to room temperature, about 20 minutes.

3) Pour the milk into the large pitcher, then slowly pour in the tea mixture. And make sure the tea goes into the milk, not the other way around. Leave on the counter until the milk fully curdles, separates, and sinks, leaving behind clear liquid above, about 1 hour. During this time do not shake, stir, or fiddle with the pitcher in any way. Just let the magic happen.

4) Line a large, fine-mesh sieve with a commercial-size coffee filter[6] and strain into a wide, 4-quart container. Let sit undisturbed until all the cocktail has filtered, about 1 hour. Transfer to a quart jar or pitcher and chill completely before serving. Store tightly sealed in the refrigerator for up to 3 months.[7]

3 Not skim and not half-and-half, not heavy cream or whipping cream: whole milk.

4 Wonderful multitaskers . . . Okay, they're not really, but they're good for filtering and straining a lot of different things so I always have them on hand.

5 We Americans tend to over-steep our teas, and that would be a real problem for this application, because we don't want to over-extract tannins. When it comes time to extract the bags, resist the urge to wring them out. Again, we don't want too much in the way of tannin here.

6 I like those made for 1½-gallon brewers.

7 I'm not saying you should, but I kept a bottle refrigerated for a year and it was delicious, and I didn't die when I drank it.

MILK WASHING

To understand what's going on here we must ponder the nature of milk, which isn't actually a white fluid at all, at least not at the microscopic level. Milk is a colloid, a suspension of fat globules, whey proteins, and micelles (balls) of the protein casein that form in order to keep their hydrophobic heads away from water and their hydrophilic tails sticking out in it. In the close-to-neutral pH of milk, these micelles carry a negative charge, and so they repel each other. The result: a smooth liquid that appears white to the human eye. Spirits treated in this matter are often called "milk washed."

But if we invite acid to the party, positively charged hydrogen neutralizes the negative charges and the micelles are free to physically adhere, and you get curdled milk. Gross? Not really, because just as egg whites can be used to remove sediment from a stock, thus giving birth to consommé, milk curds can filter out astringent-tasting compounds like tannins and other polyphenols. When filtered, the milk whey remains in our drink, thus granting the punch a silky and highly quaffable texture, which I figure is okay since it's only about 10 percent ABV. Though you should not operate fireworks, firearms, or forklifts, if you pace yourself, you should be able to keep out of trouble while minimizing the annoyance of ambient relatives.

RUBY PORT

The English have always had a thing for French Bordeaux, a habit historically complicated by the fact that they also spent a fair amount of time warring with the French. Wisely, they sought another source: wines from around the Portuguese town of Porto. Problem is, the climate is hot in those parts, and the voyage to England, long and often rough.

This leads to a lot of sloshing about, which accelerates oxidation and spoilage. So, merchants fortified the wines with brandy, boosting the alcohol content and shutting down fermentation, making the wines sweet and strong. Although port wines are amazingly complex, they all fall into two basic catagories: ruby, which age in bottles, and tawny, which age in wooden barrels. Ruby ports are fruitier than tawny, and their fruity character lends itself to use in punches. That said, ruby port "vintages" are declared only a few times per decade, so save those for sipping.

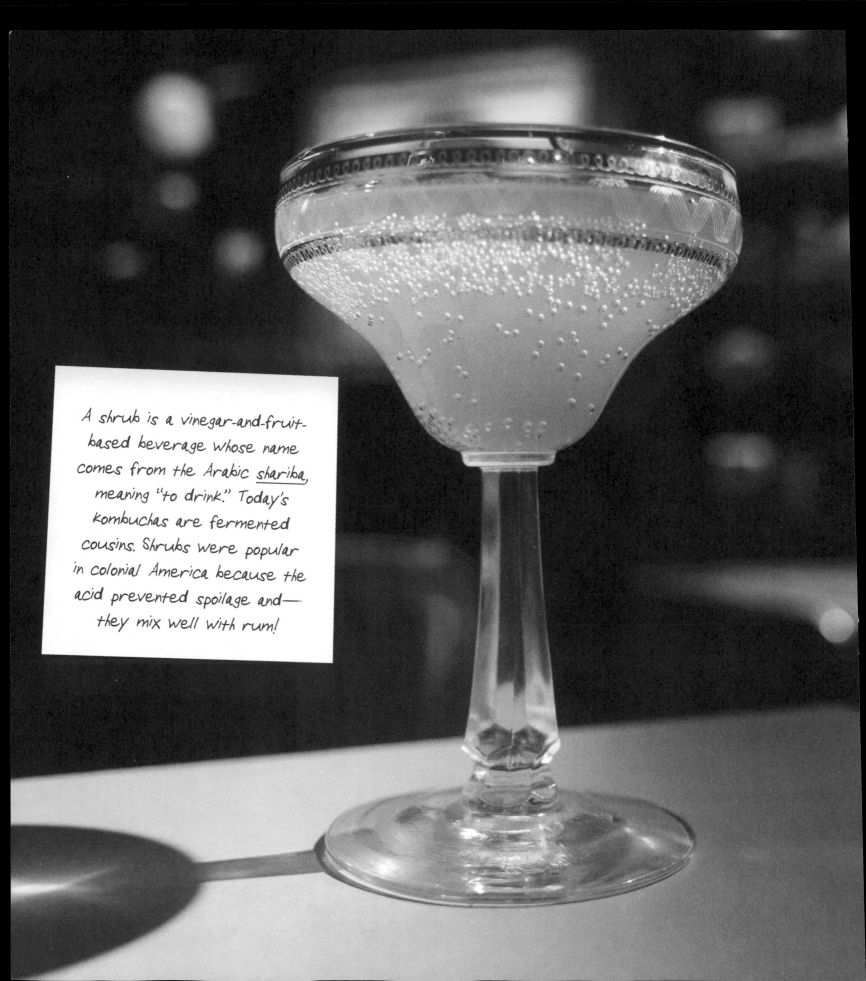

A shrub is a vinegar-and-fruit-based beverage whose name comes from the Arabic shariba, meaning "to drink." Today's kombuchas are fermented cousins. Shrubs were popular in colonial America because the acid prevented spoilage and—they mix well with rum!

CRANBERRY-APPLE SHRUB

YIELD:

2½ to
3½ cups

SOFTWARE

1 medium Fuji apple (235 g), seeded and cubed (about 2 cups)

1½ cups (160 g) fresh or thawed frozen cranberries

1½ cups (355 ml) apple cider vinegar

15 fresh sage leaves (2 g)

2 (4- to 5-inch) fresh rosemary sprigs, needles only (about 2 tablespoons)

¾ cup (136 g) turbinado sugar[8]

Peel of 1 orange, scraped clean of pith (about ⅓ cup or 28 g)

Peel of 1 lemon, scraped clean of pith (about ¼ cup or 20 g)

TACTICAL HARDWARE

- A blender
- A quart-size glass jar

PROCEDURE

1) Puree the apple, cranberries, vinegar, sage, and rosemary in a blender on high speed until smooth, 30 seconds to 1 minute.

2) Transfer to a quart-size glass jar, add the sugar, orange peel, and lemon peel, and tightly seal the jar. Shake vigorously to dissolve the sugar, then place in a cool, dark place until the shrub is very flavorful, 1 week, turning the jar over once a day.[9]

3) Strain the shrub through a cheesecloth-lined sieve set over a large bowl, pressing on the solids to release as much liquid as possible. Discard the leftover pulp and pour the shrub into a clean quart-size glass jar. Cover and refrigerate for up to 6 months.

4) To serve, combine 1 ounce of the shrub with 3 ounces of Prosecco or other sparkling wine. For an alcohol-free treat, swap the Prosecco for seltzer water.

SHRUBS

Ordinarily, if you placed lemon and orange peel in simple syrup, natural yeasts would go to work fermenting the fruit right away, but they don't want nothin' to do with the acetic acid in the vinegar, which staves off spoilage and also pulls more flavor compounds out of the fruit than simple syrup alone ever could. It's a win-win situation.

The word vinegar comes from the Old French term vyn egre, meaning "sour wine."

8 Turbinado sugar is a partially refined sugar that has a gentle caramel tinge. It's often sold as "raw" sugar, though there's no such thing as "raw" sugar, technically speaking.

9 Yes, I know this takes time and so does the dram. Don't you remember how good anticipation used to feel around the holidays? Embrace it!

CAMPARI MAI TAI PUNCH

YIELD:

1 cocktail

For when you want your holidays on the tropical side.

SOFTWARE

1½ fluid ounces (45 ml) Campari[10]

1 fluid ounce (30 ml) fresh lime juice (from 1 to 2 limes)

¾ fluid ounce (23 ml) almond orgeat[11]

½ fluid ounce (15 ml) fresh orange juice

¼ cup crushed ice, for serving

Fresh mint, for serving

Confectioners' sugar, for serving

TACTICAL HARDWARE

- A cocktail shaker
- A cocktail glass or Nick and Nora glass

If this had been an hour-long special rather than thirty minutes, I would have added this personal favorite, printed here for the first time.

PROCEDURE

Combine the Campari, lime juice, orgeat, and orange juice in a cocktail shaker. Dry shake for 5 to 10 seconds, then pour over the crushed ice in a cocktail glass of about 1-cup capacity. Serve immediately with mint and a dusting of confectioners' sugar.

For a large-format punch: Whisk together 1½ cups (355 ml) Campari, 1 cup (237 ml) fresh lime juice, ¾ cup (177 ml) almond orgeat, and ½ cup (118 ml) fresh orange juice in a medium bowl until the orgeat is evenly incorporated. Fill a 4-quart glass water dispenser with the crushed ice and arrange citrus wheels around the sides of the container. Transfer the cocktail to the dispenser. Serve out of the spout with fresh mint.

10 A complex and beguilingly bitter Italian aperitif that used to get its deep red color from crushed cochineal beetles. It's the heart of a Negroni and I love it very, very much.

11 Orgeat (pronounced "or-zha") has been referred to as liquid marzipan laced with orange water and vodka. There are plenty of recipes for it on the internet, but you can certainly purchase it premade. I have yet to come up with a method that beats store-bought.

SHERRY SYLLABUB

During the holidays, I typically serve this not as a beverage so much as a quaffable dessert.

SOFTWARE

¾ cup (177 ml) dry sherry

¾ cup (150 g) sugar

3 tablespoons (45 ml) fresh lemon juice

½ teaspoon grated lemon zest, plus more for serving

2 cups (473 ml) heavy cream

TACTICAL HARDWARE

• A stand mixer with whisk attachment

PROCEDURE

1) Combine the sherry, sugar, lemon juice, and lemon zest in the bowl of a stand mixer fitted with the whisk attachment. Mix on low speed until the sugar is completely dissolved, about 4 minutes.

2) With the mixer still running, slowly add the cream, then bump the speed up to medium and whip until soft peaks form, about 5 minutes.

3) Divide the mixture evenly among 6 medium or 8 small coupe glasses and refrigerate for at least 3 hours. Garnish with extra lemon zest to serve.

THE SYLLABUB

No historically inspired holiday spirits offering could be complete without a syllabub. The word is a portmanteau (apparently, though I still have some niggling doubts) of *sille*, an often-sweet French wine that I'm not even sure is made anymore, and *bub*, an old English slang term for "bubbles." Put them together and you have foamy wine. 'Tis an old drink and there are records of it actually being made under a cow, so that the milk could go straight from udder to punch bowl. (I can imagine some hipsters doing this into their lattes.) When made with a high wine-to-dairy ratio, you get a foamy drink, but when you increase the cream you get a spoonable dessert that will still take the edge off your mother's nagging about when you're going to get a real job even though you've been gainfully employed for thirty years. Oh, and this is a great place to break out the good sherry (not the cooking sherry—never the cooking sherry).

WHOLE LATKE LOVE

All my life I've been meshuggeneh for the deli life: lox and bagels, bialy, rugelach, brisket, pickles, whitefish, kugel, matzoh ball soup, and, of course, during Hanukkah—latkes, lots of latkes. Although *latke* is Yiddish (via Old Russian) for "little oily thing," there is so much more to the food as well as the story. Below you'll find our applications for the potato latke and ricotta latkes we made in the show, as well as for the cabbage latkes we had to leave out due to time, and homemade sour cream, which is, as far as I'm concerned, vastly superior to store-bought. But first, let's skim over the history of a simple food that came to be the poster dish for Hanukkah.

LATKE HISTORY

Nobody expects the Spanish Inquisition! And yet the expulsion of Jews from Spain played a large role in the development of the latke.

We'll go in chronological order here, starting with the dairy connection. The Book of Judith, part of the Apocrypha, a series of biblical books deemed not quite ready for the prime-time Bible by everyone but Catholics, tells of an Assyrian general, Holofernes, who's sent by his boss Nebuchadnezzar to take over Judea in something like 600 BCE. He's got his army parked outside a town called Bethulia, which happens to be home to the beautiful and wily Judith, who sashays into camp one night with a hamper of salty cheese, a few bottles of wine, and a plan. After charming the general and loading him up on the salty cheese, which may actually have been yogurt, she slakes his thirst with copious amounts of wine. He dozes off, she grabs his sword, and . . . off with his head. Leaderless and lacking a plan B, the Assyrians flee. Thus, dairy products become associated with saving Judaism.

To understand why latkes are fried in oil, we need to flash forward a few hundred years to 167 BCE, when another baddy named Antiochus IV decides to end Judaism and reinstate Hellenism (Zeus, Hera, et al.). He seizes Jerusalem and desecrates the temple, an act that seriously angered Judah "the Maccabee," which comes from the word for "hammer" in Hebrew. So Judah and his brothers wage a guerilla war on Antiochus and, after three years, run him out of town. The survivors rebuild the temple, but when they go to dedicate it (*Hanukkah* means "dedication") they find only enough oil to keep the temple lamp burning for one night, which is a problem when rededicating a temple. Miraculously, the oil burned for eight days, until they could get more oil. Thus, Hanukkah lasts eight days and celebrates the "miracle of the oil." And nothing celebrates oil quite like fried food. That said, latkes weren't made with potatoes, which are New World plants, until several years after Columbus landed in what we now call the Bahamas.

We don't know who fried the first latke, but my bet is on Jewish cooks in Sicily, who incorporated ricotta cheese into their oil-cooked pancakes. Although the ricotta cheese they likely used would have been produced by adding an acid to the whey left over from forming curds for other sheep's milk cheeses (thus the name *ricotta*, or "recooked"), modern versions available at most megamarts are made by acidulating whole or skim milk, thus creating a creamier cheese, which is why we actually drain it for this application.

The one on the right is really me—the one on the left is not my first-grade girlfriend.

RICOTTA LATKES

Sicilian Jews made latkes with ricotta, resulting in a fluffy, savory pancake worthy of celebration. Here's our take.

SOFTWARE

1¾ cups (425 g) whole-milk ricotta

½ cup (70 g) all-purpose flour

¾ teaspoon kosher salt

½ teaspoon baking powder

¼ teaspoon baking soda

¼ cup (60 ml) low-fat buttermilk

2 large eggs

¼ cup (8 g) roughly chopped fresh parsley

2 tablespoons (7 g) chopped fresh chives

1½ teaspoons grated lemon zest

Freshly grated nutmeg, to taste (if all you have is pre-ground stuff, skip it)

TACTICAL HARDWARE

- A large sieve or colander
- Cheesecloth
- An electric griddle[1]

PROCEDURE

1) Line the sieve with several layers of cheesecloth and set over a medium bowl. Plop (technical term) the ricotta atop the cheesecloth, gather up the edges, and twist to ring out as much of the moisture as possible. Park the parcel in the sieve-bowl combo and refrigerate overnight.

2) The next day, whisk the flour, salt, baking powder, and baking soda together in a medium bowl and set aside.

3) Take the drained ricotta for a spin in your favorite food processor, scraping down the sides of the bowl as needed, until smooth, about 2 minutes. Transfer to a large bowl and whisk in the buttermilk and eggs. Wash and dry the sieve.

4) Use the sieve you drained the ricotta with to sift the dry ingredients into the ricotta mixture, then stir in the herbs, lemon zest, and a few gratings of nutmeg. Fold together with a rubber spatula until just combined.

5) Heat an electric griddle to 350°F. Lightly apply nonstick cooking spray, then drop ¼ cup of the batter on the griddle for each latke.[2] Working in batches, cook the latkes until browned, flipping[3] only once, about 3 minutes per side. Transfer to a serving plate and keep warm while you cook the remaining latkes.

6) Serve straight up or with a bit of homemade sour cream (keep reading) and perhaps a wee spoonful of salmon roe or, better yet, caviar.

1 No, you don't have to use an electric griddle, but I do. You can go with a wide, heavy skillet, but turning the latkes will be a bit of a chore. I also like being able to set and forget the temperature control.

2 As for doling out the batter onto my large griddle, I go with the 3-4-3 configuration, so that I can fit 10 pancakes at a time. Your configuration may vary.

3 I use not one, but two flexible spatulas for flipping.

BRINGING THE POTATO TO THE PARTY

When the Decree of Alhambra (1492) made it illegal for Jews to remain in lands under Spanish rule (including Sicily), some Jews converted to Catholicism in order to remain in their homes and communities; many others left, heading north through the boot of Italy and up into eastern Europe.

In 1264 King Duke Boleslav the Pious of Poland had issued a charter granting Jews rights and privileges unheard of in the rest of Europe, and an open invitation to migrate to Poland. In 1567 Sigismund II Augustus okayed the construction of a Jewish academy, or yeshiva, and then in 1569 the "Union of Lublin" expanded Poland's borders to include much of Lithuania, as well as modern-day Belarus and Ukraine. So, as more and more of Europe became hostile to Jews, so for a time, Poland became a haven, and

the latkes they made there were made with . . . rye. Not a potato in sight. But when the Polish king, John III Sobieski, won the battle of Vienna in 1683, he returned to Poland with potatoes, which were planted in botanical gardens and viewed as curiosities rather than food.[4] But later, when the rye crop failed in in the mid-nineteenth century, the potato came to the rescue, and the humble latke adapted.[5]

Although the texture and acidity of a good applesauce are the perfect foil for any possible greasiness in the latke, I'd also like to point out a possible origin story. The Hebrew word for "apple" is *tapuach*, and "potato" is *tapuach adama* . . . as in "that" Adam. Perhaps a grocer just confused his order one Hanukkah and . . . adapted.

4 The same conflict supposedly resulted in the creation of multiple modern foods, including the croissant and the bagel. While these tales are apocryphal at best, historians agree on the potato part.

5 It should be noted, however, that much of Poland's newfound enthusiasm for the potato may have more to do with vodka than with latkes.

POTATO LATKES

YIELD:
About 2 dozen

While mealy potatoes like russets are best for this application, the key to this tasty sour cream and applesauce delivery system is the binder, and the best thing to bind potato is instant mashed potatoes. Trust me.

SOFTWARE

½ large white or yellow onion (160 g), peeled

1½ pounds (680 g) russet potatoes (see "Regarding the Potatoes" opposite, if you're curious), quartered lengthwise

1 large egg

¾ cup (171 g) schmaltz or light olive oil, plus more as needed[6]

½ teaspoon kosher salt, plus more for seasoning

½ teaspoon freshly ground black pepper

2 tablespoons (8 g) dry instant mashed potatoes

TACTICAL HARDWARE

- A box grater
- A food processor with grating disk

PROCEDURE

1) Grate the onion on the side of a box grater with the largest holes until you have ⅓ cup (82 g). Place in a large bowl and reserve the rest of the onion for another use.

2) Shred the potatoes in a food processor fitted with a grating disk with medium-size holes.[7] Remove and discard any large chunks.

Immediately and thoroughly toss with the onion.[8]

3) Line a smaller bowl with cheese-cloth and fill with the potato-onion mixture. Twist into a ball and wring out as much of the liquid as possible, reserving the liquid. Let the extracted liquid sit undisturbed for 5 minutes to allow the starch to settle.

6 I beg you to go for the schmaltz. It's easily procured from the interwebs and will make all the difference in the world.

7 You can use just the box grater or just the food processor for both onion and potatoes, but the resulting latkes won't have as nice a texture.

8 Since OEOs, or onion essential oils, prevent browning of raw potatoes, I strongly suggest you grate the onion first and have those juices standing by. We need exactly ⅓ cup onion, so I usually grate half a large onion and save the rest for my eggs or stir-fry or some such.

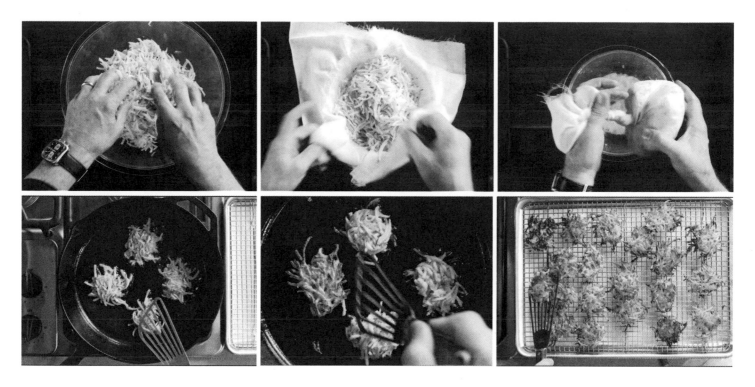

4) After 5 minutes, pour off the liquid so that only the starch remains. Whisk the egg into the starch and set aside.

5) Add ½ cup (114 g) of the schmaltz to a 12-inch cast-iron skillet. Measure the depth; if it is less than ⅛ inch deep, add more schmaltz. Place over medium heat until shimmering, 300°F to 330°F. Line a half sheet pan with paper towels, then place a wire rack on the paper towels.

6) While the fat heats, place the potatoes in a large bowl and add the salt, pepper, and the instant mashed potatoes and combine using your hands. Stir in the egg mixture.

7) Drop a mounded tablespoon's worth of the potato mixture into the pan and flatten with the back of a spatula. Fry in batches of four until browned, flipping once, 2 to 3 minutes per side. Remove to the rack set over a pan lined with paper towels.[9] Continue to add fat, 1 to 2 tablespoons at a time, in between batches to maintain a ⅛-inch depth in the skillet.

To serve, top first with a smear of sour cream followed by a dollop of applesauce; the dairy will help prevent the apple-sauce from soggifying the crisp potato goodness (and yes, *soggifying* is a technical term).

REGARDING THE POTATOES

I don't know the exact strain of potato those early Polish latke-teers used, but I'd guess we have fewer choices today, seeing as how modern marketers have managed to choke a plant with variants numbering in the thousands down to the five commonly found at the modern megamart—not including sweet potatoes, of course. The key to latkes, which are a lot like hash browns, is to avoid high-moisture or waxy potatoes, aka "boiling" potatoes, and to stick with the driest, mealiest potato we have: the Russet Burbank. Released by L.L. May & Co. in 1902, the russet was based on the spud developed by famed horticulturist Luther Burbank. Burbank developed his potato to resist potato blight, the microorganism responsible for the potato famine in Ireland. If a recipe tells you to shred a potato or fry a potato, this is the specimen to reach for.

9 If you're making a big batch, keep this drain-pan rig in a 200°F oven until you've got everything done.

HOMEMADE SOUR CREAM

YIELD:
2 cups

Potato latkes demand sour cream. And while I wouldn't say store-bought sour cream is flat-out bad, homemade is ridiculously easy, and delicious, and don't you just once want to taste sour cream without modified food starch, sodium phosphate, guar gum, carrageenan, or potassium sorbate?

SOFTWARE

2 cups (473 ml) heavy cream

1 tablespoon (15 ml) low-fat cultured buttermilk

PROCEDURE

Combine the cream and buttermilk in a pint-size glass jar with a lid. Cover and shake to combine. Leave in a cool, dark place until thickened to your desired texture, at least 24 hours but up to 48 hours (24-hour sour cream will be tangy, but still sweet, 36-hour sour cream will be thicker and tangier, while 48-hour sour cream isn't very sweet at all and quite tangy and is my favorite). Refrigerate until cold before serving. Use within a week.

Not a single serving. Well . . . maybe.

CABBAGE LATKES

YIELD:

9 latkes

A low-carb take on the classic potato pancake . . . not that I care about that kind of thing. I just really like cabbage.

SOFTWARE

1 small (300 g) savoy cabbage

1 teaspoon kosher salt

2 large eggs, lightly beaten

2 tablespoons (15 g) matzoh meal

1 teaspoon freshly ground black pepper

½ cup (113 g) schmaltz or light olive oil

TACTICAL HARDWARE

• Mandoline

PROCEDURE

1) Core and shred the cabbage with a mandoline (you should have about 4 cups). Toss the cabbage with the salt in a large bowl and let sit at room temperature for 1 hour to allow the cabbage to soften.

2) Meanwhile, line a half sheet pan with paper towels, and place an inverted wire rack on top of the paper towels. Set by your cooktop.

3) Add the eggs, matzoh meal, and pepper to the bowl with the cabbage and, using your hands, toss to evenly combine.

4) Heat 3 tablespoons of the schmaltz in an 11- to 12-inch cast-iron or stainless-steel skillet over medium heat until shimmering. Using a ¼-cup measure as a scoop, add three latkes to the pan. Use a fish spatula to press down to flatten, and cook until golden brown, 1½ to 2 minutes per side. Transfer to the prepared sheet pan.

5) Repeat with the remaining latke mixture, cooking in batches of three and adding 1 to 2 more tablespoons schmaltz for each batch.

Serve immediately with . . . hot sauce.

THE TURKEY STRIKES BACK . . . AGAIN

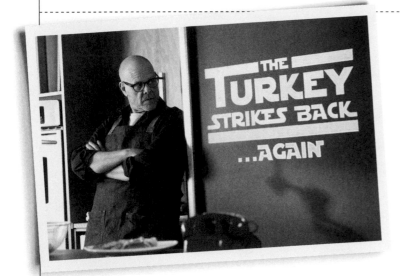

Nearly 90 percent of Americans consume turkey on Thanksgiving, then avoid it like the plague the rest of the year. Sure, we may have a turkey sandwich or two, but that doesn't really count, because that's just "folding meat," as my grandmother used to say. In any case, turkey is probably our most culinarily versatile New World critter and we owe it some kitchen time.

The way I see it, the trick to turkey is to approach it like a cow, breaking it down into primals, and giving each cut what it needs. So this episode (our last one-hour turkey-centric special), focuses on my three favorite applications for three different cuts: thighs, legs, and breasts, all of which can be purchased separately at most modern megamarts.

TALKING TURKEY

The turkey is a New World bird, originally from the region of Mesoamerica we now call Mexico. The turkey likely got its name when European conquerors[1] took the bird back to the Old World, where it was conflated with the guinea fowl, often imported by traders from Constantinople—i.e., Turkey. So, turkeys are no more from Turkey than Native Americans are from India.

We begin with my favorite turkey sub-primal: the thigh, which we will treat according to an ancient Scottish recipe that typically calls for chicken. I like turkey thighs for this because they sear well but can cook for quite a while without drying. Turkey thighs are also pretty much made for stewing, and this dish is nothing if it's not a stew. If you're up for some more history, check out the sidebar after the application.

1 We used to call them "explorers," but that sounds far too benign considering the things they actually did, so I'm going with "conquerors."

TURKEY TALK

Consider the turkey from a morphological standpoint. When left to their own devices, turkeys spend a fair amount of time walking around. This requires their legs to contain *slow-twitch*, aerobic muscles, which run on a substance called myoglobin and are made for endurance. Myoglobin carries oxygen within muscles the same way hemoglobin does in blood, and both are an intense red color. Made for endurance, slow-twitch muscles pull oxygen from the blood, thus turning the thigh and leg muscles reddish or "dark," as we say. The workload of these cuts also necessitates a considerable amount of durable connective tissue, some of which can be broken down to gelatin when cooked properly. (Although they are similar, I view the thighs and legs as different enough to recommend cooking them by different methods.)

Occasionally a turkey launches into flight, thus requiring anaerobic, or *fast-twitch*, muscles, fueled by a starch-like, glucose-rich molecule called glycogen. Built for quick getaways, fast-twitch muscles give out rather quickly, which may explain why turkeys don't fly south for the winter. And since these are anaerobic muscles, the meat of the breast lobes, responsible for the power of flight, have little myoglobin and are light in color when cooked.

The important thing to remember is that fast-twitch and slow-twitch muscles need very different treatment in cooking.

BUYING THE BIRD

When it comes to procuring turkeys and their respective parts, you have three choices, though you may not know it and your megamart may not tell you. The majority of national brands offer *traditional* birds—i.e., broad-breasted whites (the variety), which have been bred for huge breasts and rapid growth, reaching harvest weight in as little as twelve weeks. In my opinion, this results in a bird that delivers little in the way of actual turkey flavor. Next: heritage breeds, which grow slowly and, according to the Livestock Conservancy, must be capable of a long outdoor lifespan, typically five to seven years for a hen, though they usually reach market weight between twenty-four and thirty weeks. I've had a few such birds, and they're quite flavorful, but occasionally tough. The third category is a catchall populated by birds labeled "natural," "heirloom," and "free range"—all marketing words that don't really mean a whole lot, which is not to say the growers don't mean well. In the end, I find I get the best turkey simply by chatting with my poultry person.

Longtime associate and propmaster-cum-producer Tom Bailey

Although all those facts are fine, as far as they go, the truth is that if you just buy a whole turkey breast, or breasts, or legs, odds are you won't know what the heck you're getting. I'm hoping that will change one day, but we have to start cooking the turkey on a regular basis for that to happen.

TURKEY TIKKA MASALA

YIELD:

6 servings

Don't let the ingredient list scare you; this is not a complicated dish, even though I call for using three pans, one for the spices, one for the sauce, and one for searing the turkey. (And yes, even though I call for twenty-three ingredients.) Since I toast my spices in a hot-air popcorn machine (instructions in the footnote), I get my pan count down to two. If you have a grill pan but not a cast-iron skillet, you can toast the spices in the grill pan. If you don't have a grill pan but you do have a cast-iron skillet, you can sear the turkey in the cast iron. And, honestly, when it comes right down to it, if you have a lid, you could do all this in a 12-inch cast-iron skillet, but you'll have to work in stages and empty the pan between cooking the vegetables and the turkey. (And yes, I know it has tomatoes in it, and yes, you can cook those in a cured cast-iron skillet.)

SOFTWARE

1 tablespoon (4 g) coriander seeds

1 tablespoon (9 g) black peppercorns

1½ teaspoons (4 g) cumin seeds

¾ teaspoon (3 g) brown mustard seeds

4 whole cloves

1 (4-inch) cinnamon stick (2 g)

7 green cardamom pods (7 g)

¼ teaspoon freshly grated nutmeg

¼ teaspoon red pepper flakes

2 boneless, skinless turkey thighs (about 1¼ pounds/574 g)

1 cup (244 g) plain whole-milk yogurt (not Greek-style)

3 teaspoons (10 g) kosher salt, divided[2]

¼ cup (60 ml) canola oil, plus more for searing the turkey

1 large onion, diced (about 2½ cups/352 g)

2 tablespoons (35 g) grated fresh ginger

4 cloves garlic (10 g), grated

2 fresh red Thai bird chiles, thinly sliced (3 g)

1 (28-ounce) can whole peeled tomatoes, drained and roughly chopped

1 (13.5-ounce) can full-fat coconut milk[3]

2 tablespoons (30 ml) fresh lime juice

Cooked basmati or jasmine rice (see below), for serving

Fresh mint and cilantro, for garnish

TACTICAL HARDWARE

- A mortar and pestle or blade-style coffee grinder
- A 1-gallon zip-top bag

Coriander seeds come from the plant Coriandrum sativum, better known as cilantro.

PROCEDURE

1) Toast the coriander, peppercorns, cumin, mustard seeds, cloves, and cinnamon stick in a dry cast-iron skillet until fragrant, about 3 minutes.[4]

2) Transfer the spices to a spice grinder[5] along with the cardamom pods, nutmeg, and red pepper flakes and grind until fine. Depending on your technology, you may need to work in a couple of batches.

3) Transfer roughly two-thirds of the spice mixture (about 3 tablespoons) to a gallon-size zip-top bag, along with the turkey thighs, yogurt, and 1 teaspoon of the salt. Seal the bag, squish to fully coat the thighs, and refrigerate for 1 to 3 hours. (If interested, see the sidebar on page 199 on whey marinades.)

4) When ready to cook, put an 11-inch straight-sided sauté pan over medium-high heat for 2 minutes. Add the oil and, when shimmering, add the onion and the remaining 2 teaspoons

2 Yes, we need this much salt. For one thing, it helps to pull moisture out of pretty much anything, and that is going to help slow the browning, thus helping the onions to cook more evenly.

3 Coconut milk, not cream of coconut, which is much thicker, not to mention sweeter. Coconut milk is what you want for savory applications, and cream of coconut is what you want for piña coladas.

4 Alternately, toast your spices in a hot-air popcorn machine. Just load with the spices, cover the opening with cheesecloth, secure with a rubber band, and toast until fragrant, about 30 seconds.

5 You can use a mortar and pestle for this or a blade-style coffee grinder, which I would never actually use for grinding coffee.

salt. Cook, stirring occasionally, until the onion begins to brown around the edges, 6 to 8 minutes.

5) Reduce the heat to low and stir in the ginger, garlic, and chiles. Continue to cook, stirring occasionally, until the onion is evenly brown, 7 to 8 minutes more.

6) Add the remaining spice mixture and the tomatoes, increase the heat to medium-low, and cook, stirring every 5 minutes, until reduced and darkened in color, 15 to 20 minutes.

7) Stir in the coconut milk and finish with the lime juice. Kill the heat and cover to keep warm.

8) Park a grill pan over medium heat for 5 minutes, then lightly brush with oil. Remove the turkey from the bag, keeping as much yogurt on the meat as possible, and grill until the yogurt is well charred, about 5 minutes per side. Remove the thighs from the heat and let rest for 5 minutes before cutting into bite-size pieces.[6]

9) Add the turkey pieces to the sauce and return to a simmer over medium-low heat. Cover, removing the lid to stir occasionally, and cook until the turkey is cooked through, about 20 minutes. (Don't let the sauce boil or the yogurt may curdle.)

10) To serve, spoon over rice and garnish with fresh mint and cilantro.

By 2009, Brits were consuming 2.5 billion pounds of chicken tikka masala a year.

6 The turkey will not yet be fully cooked; this is okay, as it will finish cooking in the sauce. Also, this will make a mess, but it'll taste great.

RICE IN A HURRY

YIELD:
6 cups

SOFTWARE

3 cups water

2 cups long-grain rice

2 tablespoons unsalted butter

1 teaspoon kosher salt

TACTICAL HARDWARE

- A kettle. I prefer an electric model.
- A 2- to 3-quart saucepan with tight-fitting lid

PROCEDURE

1) Add the water to the kettle and bring to a boil.

2) Meanwhile, combine the rice, butter, and salt in a 2- to 3-quart saucepan and place over high heat. Cook, stirring constantly, until the rice just begins to turn light gold and smells like nutty popcorn, 2 to 3 minutes.

3) Position the lid halfway over the saucepan and quickly but carefully pour the boiling water into the rice. Immediately cover with the lid. Reduce the heat to its lowest setting and cook for 20 minutes.[7]

4) Remove pan from the heat, uncover, and let rest for 3 minutes. Then gently fluff the rice with a fork and allow to sit for another 2 to 3 minutes before serving.[8]

CHICKEN TIKKA MASALA

Chicken tikka masala, one of the unofficial official dishes of the United Kingdom, didn't exist in the West until 1971 when, legend has it, a customer whose name has been lost to history strolled into Glasgow's hip Shish Mahal restaurant and ordered a dish from Punjab, where *tikka* means "bits" or "pieces." The dish typically features marinated chicken cooked on a skewer. Well, this night, when it came, it seemed dry—and our hero with no name said so.

At that point, the cook, Ali Ahmed Aslam, fetched down his biggest pot and went to work. Of course, the first thing was simply to hit the pan with some oil over high heat. Then, he sautéed a bunch of aromatics, including onions, ginger, and garlic; then he had to dose in a little of his secret ingredient, curry powder. Then he looked around for other things he had on hand. He smoothed it out with a little water, and that's when he saw the tomato soup. Added that in, along with a little more water to thin things out. Then he returned the original dish to the sauce to coat and finished it with dairy and butter. Delicious. But how did tikka go viral in an age when social media meant shouting from the top of a roof?

According to my friend the writer and food historian Simon Majumdar, the answer is: cab drivers. Turns out a local cabby became a fan and started telling other cab drivers, and they spread the word faster than the plague. Within a few years, chicken tikka had gone and spread across Britain. Finally, in 2001, Robin Cook, the British foreign secretary, declared it in Parliament to be the British national dish.

GARAM MASALA

Garam masala translates to "hot spice mixture" from Hindi, and making your own is crucial to our Turkey Tikka Masala. I keep my garam masala spices in an airtight plastic bin—a riff on the classic Indian *masala dabba*.

The first British cookbook containing a recipe for curry was published in 1747.

7 I say "carefully" because there's going to be a lot of hissing and steam when the water hits the hot rice.

8 Resting allows the outer starch to set, preventing the rice from clumping.

TOASTING SPICES

Why bother? There are a lot of volatile compounds in spices—eugenol, linalool, cuminaldehyde, rotundone, stuff like that—and they are called volatile because, well, they're not stable, they fly off into the air, which is why we can smell them, which makes it feel like we can taste them. Heating them serves three functions. First, it drives off moisture. Heat also intensifies the flavor and aroma of spices, like turning the volume up on an amp—and no, mine doesn't go to 11. But heat also shapes the flavors in kind of the same way that adjusting the EQ on an old-school stereo shapes the sound. Without toasting, everything would just kind of taste flat. Not bad, but flat.

WHEY MARINADE

A critical ingredient in a tikka masala marinade is the whey, a lactic acid–laden liquid that makes up around 80 to 85 percent of most yogurts. Why is it important? Basically, because the whey is acidic, it has a lot of free-floating positive charge. When it diffuses into the meat's muscle-fiber proteins it acidifies them, adding positive charge until they are pushed past their isoelectric, or net-neutral-charge, point. With a net positive charge, they'll repel each other, drawing in more water and essentially swelling up like a sponge. The net effect: a softer, juicier, and, of course, tangier muscle, at least as far as the whey has time to infuse inward.

RENAISSANCE FAIRE

In 1960, Phyllis Patterson took a job teaching at the Wonderland Youth Center in the Laurel Canyon community in the hills above Los Angeles. To teach theater and history she created a "faire" improv event loosely based on the Italian commedia dell'arte. Thus was born the Renaissance faire. Today "Rennies," as they're called, have gone global.

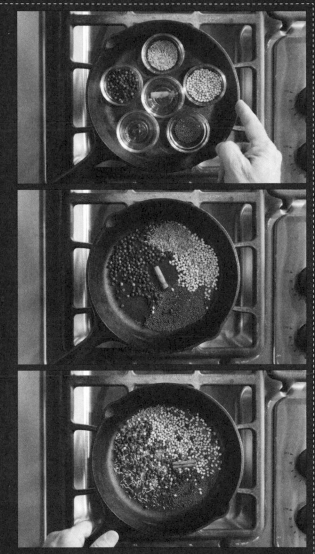

We could debate the political power of subversive satirical theatrical forms all day, but what's interesting is the notion that Renaissance faires, with their free-thinking, whimsical approach to social structures and sexual roles, may have, in the opinion of some scholars, ushered in the '60s as we know them: flower power, the Summer of Love, Hendrix, the Beatles, psychedelia, Ken Kesey, LSD, and all.

As far as I'm concerned, the real contribution of the Renaissance faire was the smoked turkey leg—cheap, easy to prepare, delicious, and very dramatic when waved about in the air in your Henry VIII cosplay rental suit. Problem is, of course, turkeys weren't exactly common in Renaissance Europe, seeing as how they didn't arrive until the early sixteenth century. Just sayin'.

SMOKED TURKEY LEGS

YIELD:
6 turkey legs

SOFTWARE

3 quarts (2.8 L) hot water

1⅓ cups plus 1½ teaspoons (225 g) kosher salt

1¼ cups (225 g) dark brown sugar

About 2½ pounds (1.1 kg) ice cubes

6 turkey legs

1 cup (237 ml) unsalted chicken stock

TACTICAL HARDWARE

- A 6- to 8-quart sealable container[9]
- A smoker (see my sidebar on cardboard box smokers below)
- A fine-mesh sieve
- A fat separator (optional but recommended)

PROCEDURE

1) Put the water, salt, and sugar in an 8-quart plastic container and stir until the salt and sugar are fully dissolved. Add the ice, then submerge the turkey legs in the brine. Cover and refrigerate for at least 4 hours or up to 24 hours.[10]

2) Set up your favorite smoker and add five 3-inch dry hardwood chunks. If you have heat control, set it to 200°F (many models will simply label this as "smoke") and allow the wood to smoke for about 30 minutes.[11]

3) While the smoker is heating, drain the legs, pat them dry, and arrange on a rack to dry. (This is the same rack I'll smoke with. Depending on your model you may need to transfer them.)

4) Place the legs in the smoker and cook, rotating the rack halfway through cooking, until the meat is firm and the skin is deeply browned, about 3 hours. Keep the smoker between 180°F and 200°F the entire time.

5) When the legs have about 20 minutes left in the smoker, heat your oven to 350°F. Make two pouches out of double layers of heavy-duty aluminum foil.

6) Divide the legs between the pouches and seal, leaving them partially open and pouring ½ cup of the stock into each. Tightly seal the pouches and place on a half sheet pan. Transfer to the oven and cook for 1 hour, or until the meat is fork-tender.

7) Remove the legs from the pouches and carefully strain the jus through a fine-mesh sieve set over the fat separator. Defat the jus and serve alongside the legs. (Personally, I remove the skin before consumption, as turkey leg skin is close enough to leather to make boots out of, but it's up to you.)

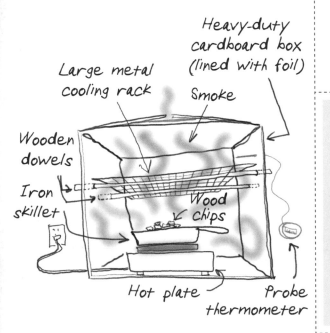

Heavy-duty cardboard box (lined with foil)

Large metal cooling rack

Smoke

Wooden dowels

Iron skillet

Wood chips

Hot plate

Probe thermometer

BOX SMOKER

After all these decades, my favorite smoker is still a cardboard box. Here's what you'll need: a new, large, heavy-duty cardboard box. (And yes, heavy-duty is important because it means more insulative power.) Also: two wooden dowels, one cooling rack, one 9-inch disposable foil roasting pan, and one cheap hardware-store-issue electric hotplate. You'll also need a small cast-iron skillet, and it can be beat to crap; five dry hardwood chunks; and a pie tin with a bunch of holes punched in it. And these days, I tend to line the box with heavy-duty foil. Oh, and always have a fire extinguisher standing by, and if I need to tell you to do this outside, just don't do it at all.

9 I'm a huge fan of the large, square storage containers made by Cambro, and no they don't pay me to say it. You can buy them online and in restaurant supply shops. They're tough, come with great lids, and I wouldn't want to live the kitchen life without them.

10 If you don't have room in the fridge, just combine everything in a clean cooler and stash in a relatively cool, out-of-the-way spot like inside your tub or shower. If you do this, you should give the container a shake every few hours just to make sure that the brine is evenly distributed.

11 The first 30 minutes of smoke typically contain some pretty nasty flavors.

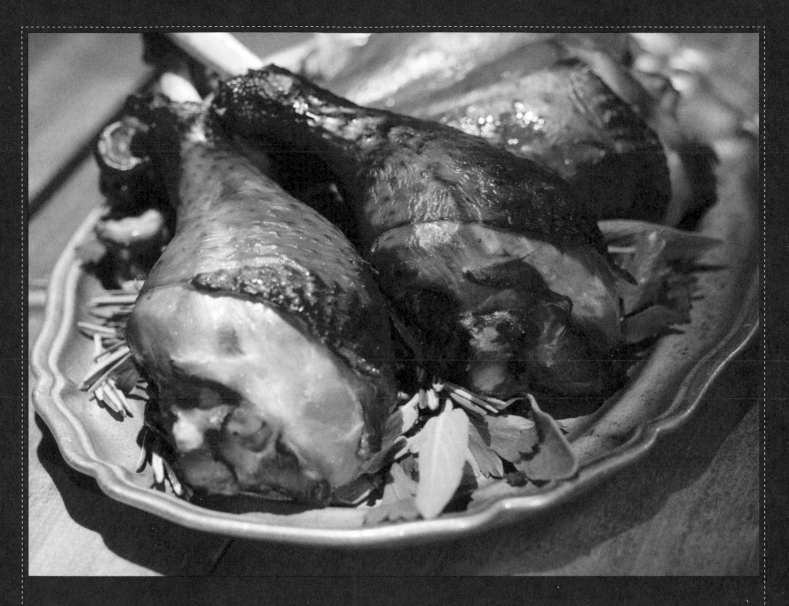

GETTING THE RIGHT FLAVOR OUT OF SMOKE

Any pit master will tell you that getting the right flavors out of smoke can be complicated business. Getting the wood to the right temperature is crucial. At around 400°F, pyrolization takes place, meaning real smoke flavor. Getting three to five hardwood hunks to that point takes about half an hour after you start seeing smoke. Remember, early smoke tastes pretty foul, so be patient. Using my box, I usually find that when the wood hits the right point it's easy to maintain 180°F to 200°F inside the box. Many of the bitter, acidic volatiles in colder smoke will have been driven off, leaving us with cellulose and hemicellulose's best properties: sweet, toasty, nutty flavors. Your patience will be rewarded.

PRIMING FOOD FOR SMOKE

Smoke particles will settle more readily on cold, moist surfaces than on warm ones, partly due to something called evaporative counterflow and another thing called thermophoresis, which should have been Morpheus's brother in *The Matrix*. The first has to do with the disruption on the surface of the meat from evaporating water molecules, while the second is kinetic force that tends to move particles from areas of high heat to areas of low heat. This means that to get the best flavor out of our smoked turkey legs, they should head to our smoker while they're still cold, moist, and straight from the fridge. Yes, they'll take longer to cook and may dry out a smidge more, but the flavor improvements are worth it.

SMOKED TURKEY SALAD

YIELD:

2 servings

If you happen to have any smoked leg leftovers . . .

SOFTWARE

2 smoked turkey legs (page 200), skin removed

⅓ cup (75 g) mayonnaise

¼ cup (35 g) diced celery

¼ cup (33 g) diced Granny Smith apple

1 tablespoon (9 g) toasted, chopped pecans

1 teaspoon (4 g) rice vinegar

1 teaspoon (1 g) finely chopped fresh parsley

¼ teaspoon (1 g) freshly ground black pepper

¼ teaspoon (1 g) kosher salt

PROCEDURE

Pull the meat from the turkey legs and chop into rough ½-inch cubes. (You should have between 2½ and 3 cups.) Transfer to a medium bowl and stir in the mayonnaise, celery, apple, pecans, vinegar, parsley, pepper, and salt. Stir well to combine. Serve.

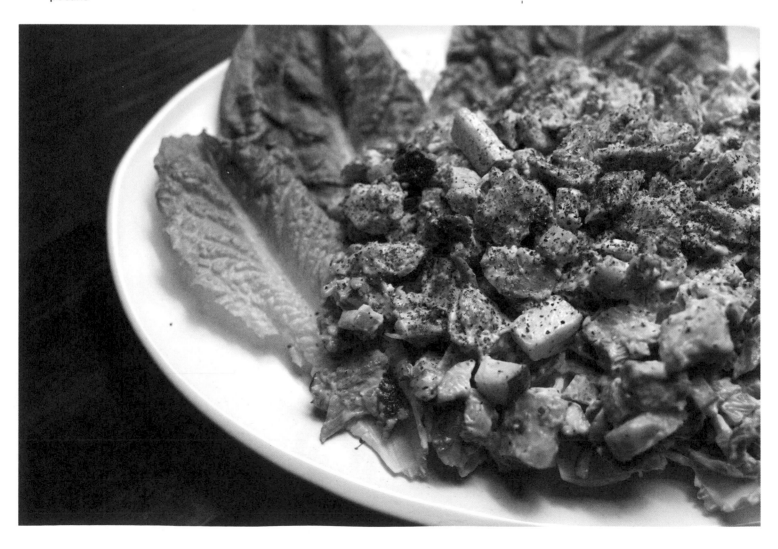

TURKETTA

Around 2015, the culinary vanguard took up a new Thanksgiving battle cry, a portmanteau of our American feathered friend and porchetta, an Italian dish composed of pork loin and belly, cured from the inside out and roasted. It was called turketta, and I hated it immediately for no other reason than that it was a fad and I'm a curmudgeon. Problem is . . . it's really good, and for turkey lovers craving a roast but not a roast turkey, this is the thing. It is a two-day procedure, but your patience will be rewarded.

SOFTWARE

8 ounces (226 g) premium unsalted butter, such as Kerrygold (2 sticks)

1 cup (24 g) loosely packed fresh parsley leaves

2 tablespoons (4 g) fresh rosemary needles

8 large fresh sage leaves (2 g)

1 (6- to 7-pound) turkey breast, skin-on and bone-in

5 teaspoons (21 g) kosher salt, divided

4 teaspoons (16 g) maple sugar, divided[12]

TACTICAL HARDWARE

- 2 half sheet pans
- Parchment paper
- Plastic wrap
- Butchers' twine
- A remote probe thermometer

Turkeys can run up to twenty-five miles per hour and fly as fast as fifty-five miles per hour. But man, does it tire them out.

PROCEDURE

1) Place a fine-mesh sieve over a small heatproof bowl. Line a plate or quarter sheet pan with paper towels.

2) Melt the butter in a small, deep saucepan over medium heat. When the butter starts to foam up, drop the heat to low and continue to cook until it reaches 300°F,[13] about 12 minutes.

3) Add the parsley, rosemary, and sage and fry until bright green and crisp, 1 to 1½ minutes. (Be careful: When you add the herbs, there will be sputtering and spitting.)

4) Strain the butter through the prepared sieve and transfer the herbs to the paper towel–lined plate. When cool enough to handle, roughly chop. Reserve both the butter and the herbs.

5) Carefully remove the skin from the turkey breast and lay it flat on a piece of parchment paper set inside a sheet pan. Cover with plastic wrap and refrigerate.

6) Debone the breast lobes, remove the tenderloins, and then flip the breasts smooth-side down.[14] Make a

shallow diagonal cut in the thickest part of each lobe and open them up so that the breast lobes are approximately 1 inch thick. Score them a few times in the perpendicular direction.

7) Cover a second half sheet pan with plastic wrap, allowing 8 inches of overhang in both directions. Sprinkle the center with 2 teaspoons of the salt and 1 teaspoon of the maple sugar and place the two breast lobes, with the long sides flush together, on top of the salt mixture. Cover with plastic wrap and lightly pound to an even ½-inch thickness.

8) Remove the top layer of plastic wrap, realign the breasts if they've separated, overlapping them just slightly, and brush the scored side with 3 tablespoons of the herb butter. Massage in all the chopped herbs and season with 2 more teaspoons salt and the remaining 3 teaspoons maple sugar. Starting from one long end, roll the breast into a cylinder and wrap tightly with the plastic wrap. Twist the ends to tighten. Place the sheet pan with the turkey on top of the sheet pan with the skin to keep it flat. Refrigerate for at least 8 hours or up to overnight.[15]

12 Maple sugar is what's leftover if you boil all the liquid out of maple syrup. It's not as common as syrup, but in baked goods it's darned useful, and in this case, it rounds out the flavor of a deceptively simple dish. If you can't find it, you can use dark brown sugar instead.

13 The butter will start to boil as the water cooks out. The better the butter, the less water there will be and the less time this step will take. You could simply use clarified butter or ghee (see page 250) if you have it on hand.

14 If you don't want to tackle butterflying, ask your butcher to do it for you, but trust me it's not as hard as it sounds.

15 During this time the salt and sugar will pull moisture out of the meat, create a brine, and be reabsorbed. Also, the butter will firm up, making the cylinder easier to finagle. As for flattening the skin, trust me, it'll make it a lot easier to roll come tomorrow.

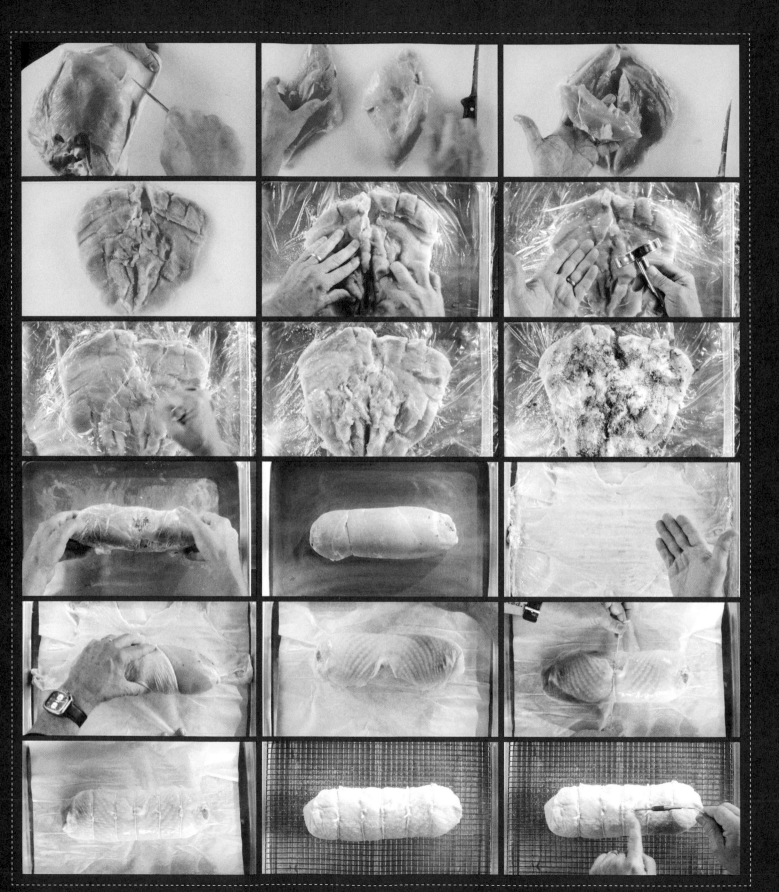

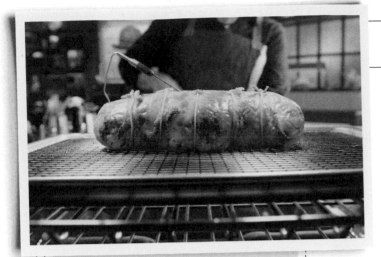

TURKETTA *(continued)*

9) When ready to cook, position a rack in the center of the oven and heat to 450°F. Set the sheet pan with the skin on your work surface with the long end facing you. Remove the plastic from both the skin and the roll. Carefully position the roll on one long end of the skin, closest to you. Roll it up as tightly as possible, tucking the skin's edges in as you go; we're looking for full coverage here. With the roll seam-side down, truss the roll with twine at 1- to 2-inch intervals. (See the note below on trussing.)

10) Place the roll on a rack set inside a half sheet pan, brush with 2 more tablespoons of the herb butter, and season with the remaining 1 teaspoon salt. Insert the probe of your remote thermometer into the center of the roll at a 45-degree angle. If the thermometer has an alarm, set it to go off at 100°F.

11) Roast the turkey until it hits 100°F, 30 to 40 minutes. Baste with an additional 2 tablespoons of the herb butter and rotate the pan 180 degrees. Reset the thermometer alarm for 150°F and continue roasting until you hit it, about 20 minutes more.

12) Transfer the turketta to a carving board and let rest for 15 to 20 minutes. Slice crosswise and serve. Save any additional herb butter for another use, like spreading on buttered rolls or biscuits, or just, you know . . . drink it.

NOTE

If you are serving a smaller crowd of, say, four diners, you can also make this recipe using a single turkey breast lobe. Cut all the remaining ingredients in half and follow the recipe as directed. You will likely have to Frankenstein the skin a bit more, but the twine will hold it in place. Adjust the cooking time as needed for the smaller roast, relying on the thermometer to guide you.

ASSEMBLY

First thing we want to do is remove the skin, but we want to do it carefully, because we're going to be using it as a nice, crisp wrapper later on. So, use gentle pulling motions and your boning knife to separate the connective tissue when necessary, but we want this in one large piece if at all possible.

Now remove the two breast lobes, using the keel bone and the ribs as a guide: Grab your boning knife and, using the ribs as a guide, just slice right up the bottom of the breast piece, the thin part; you'll feel the ribs, then turn the knife around the other way, slice through a few times, and bingo: There's the breast lobe. Repeat on the other side.

I use six individual pieces of butchers' twine for this, each about 18 inches in length. I start in the middle using a surgeon's knot, a variation on a reef knot with an extra twist at the first hitch. It gives you a bit more traction on wet meat. Beginning trussers tend to over-tighten. Resist this urge and just barely snug the twine, leaving room for expansion lest you end up with something that looks like you cut it off the Michelin Man. Repeat with more pieces of twine along the roll.

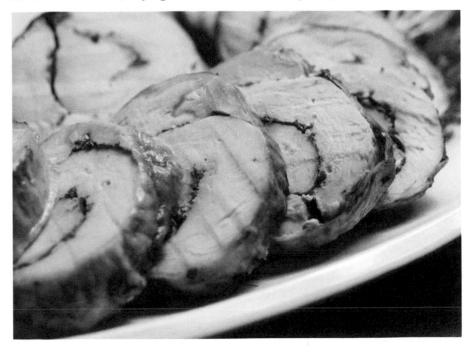

GOOD EATS

EATS
RELOADED

season
two

A CAKE ON EVERY PLATE: RELOADED

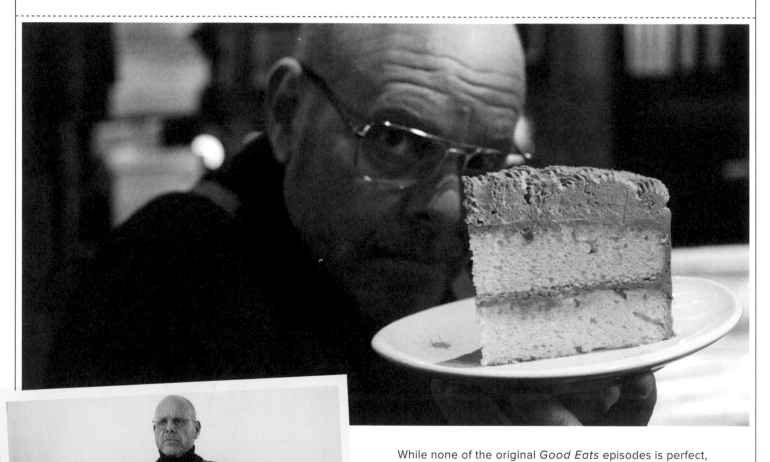

Why mess with post graphics when you've got an overhead projector?

While none of the original *Good Eats* episodes is perfect, few torture me like squirmy swamp leeches suckling at the soft underbelly of my soul quite like episode 83. The subject: yellow, or "golden" cake. I thought I'd nailed the recipe until I made it for a birthday party some years later and saw a small child of no more than five take a bite, one bite, then just walk away. I don't know where he is today, but I owe that kid a better cake, a cake he'd want to stuff two-fisted into his annoyingly cherubic face, laughing and drooling and probably choking a little at the sheer joy of it all.

By rejiggering my formulas, we were able to do just that—bake a far, far better cake.

Everything that goes into a cake either strengthens it, tenderizes it, moistens it, dries it, or flavors it:

- The top strengtheners include flour and egg whites, both of which bring structural protein to the party, along with water, which is on this list due to its gluten-forming capabilities.

- Tenderizers include all dry and wet sugars, which are hygroscopic, and fats and oils, including egg yolks and the cocoa butter in chocolate.

- Drying agents include flour again, milk solids, egg whites, cocoa powder, and assorted starches.

- Moisteners include water, milk, spirits, liquid eggs, and syrups.

- Finally: salt, spices, and extracts bring flavor; important for the final result, sure, but not so critical, structurally speaking.

You'll notice that things like eggs and flour are on multiple lists, which is why reaching a balance in a cake is not always a simple matter, especially when you consider that cake flour is a totally different animal than, say, all-purpose.

Cake flour is made from soft winter wheat, and this means 8 grams of protein per cup instead of the 10 to 12 grams typical in AP. The less protein there is, the less gluten can form, and the more tender the resulting cake. Cake flour is also chlorinated, which means it's slightly acidic, and that helps protein set faster for a smoother, finer texture. Chlorination also changes the surface of the starch, allowing it to take up liquid. We finally found a balance of tenderness and strength by using a 50/50 blend of flours.

A NOTE ABOUT CREAMING THE BUTTER AND SUGAR

It's tough to stress how important this step is. The lightening in texture and color is a sign that you've successfully used the sugar granules to punch tiny holes in the butter. These proto-bubbles will be blown up by steam, and the gasses produced by chemical leavening, thus creating the texture or "tooth" of the cake. If you under-cream, the cake will be dense. If you overbeat it and allow it to melt . . . it'll be even worse. This is why it's so important to start with butter at cool room temperature.

The faster you can get heat into a cake the sooner its structure will set and the finer its texture will be. But as anyone who's ever worn a black aluminum suit or driven a black car will tell you, dark metal absorbs heat very quickly. Bake in dark pans, and heat will move into the sides and bottom of the cake too fast, setting the edge prematurely and producing a cake that is dark and fallen in the

middle. Shiny stainless steel is pretty, but it's a lousy conductor. All that shine reflects radiant heat and slows cooking, which allows gas bubbles to either merge or escape, producing a cake that is crumbly and unevenly browned. I prefer to use heavy, rolled aluminum pans that have a dull matte finish. Why? Aluminum is an excellent conductor, and the understated finish allows heat to move in at just the right rate, creating a perfect cake.

A FAR, FAR BETTER CAKE

YIELD:

2 (9-inch)
round cakes

The 2003 version was dry, crumbly, and not nearly the cake the world deserves. After all these years I can finally say: We're golden . . . cake, that is. All we needed was more moisture and less starch, proof positive that small, balanced changes can radically improve a cake.

SOFTWARE

227 grams (8 ounces) unsalted butter, at cool room temperature (60°F to 65°F), plus extra for the pans

170 grams (1 cup plus 3 tablespoons) all-purpose flour, plus extra for the pans

170 grams (1⅓ cups plus 2 tablespoons) bleached cake flour

12 grams (1 tablespoon) baking powder

345 grams (1½ cups plus 3 tablespoons) sugar

¼ teaspoon fine sea salt or finely ground kosher salt

8 large egg yolks, at room temperature

1¼ cups (296 ml) whole milk, at room temperature

1 teaspoon vanilla extract

TACTICAL HARDWARE

- **2 (9-inch) round aluminum cake pans**
- **Parchment paper**
- **A sifter or wide sieve**
- **A stand mixer with paddle attachment**
- **A wire cooling rack**

PROCEDURE

1) Place an oven rack in the top third of the oven and crank the box to 350°F. Prep the cake pans by rubbing on a thin layer of butter on the bottoms and sides, then dust with flour.[1] Finally, line the bottom of each with a round of parchment. (See the sidebar on page 212.)

2) Sift the flours together with the baking powder and set aside.[2]

3) Load the paddle attachment onto your stand mixer and beat the butter on low speed until smooth, about 1 minute. Follow with the sugar and salt, then boost the speed to medium and beat until the mixture is light and fluffy, about 4 minutes, stopping to scrape down the sides of the bowl with a rubber spatula as needed. (To understand this step, see the sidebar on page 209, on creaming butter and sugar.)

4) With the mixer still running, add the egg yolks one at a time, fully incorporating one before adding the next. When all 8 are in, kill the mixer and scrape the bowl. Return the speed to low and slowly add half of the flour mixture.[3]

We painted the flames on this mixer twenty years ago.

1 I like to use one of my favorite multitaskers, the hotel shower cap, here. Add about a quarter cup of flour, place the cap over the pan, then shake, remove the cap, and dump the excess.

2 You can use a sifter for this, or a fine-mesh sieve.

3 I like to use a paper plate for dosing in the flour without making a mess—it's a great multitasker.

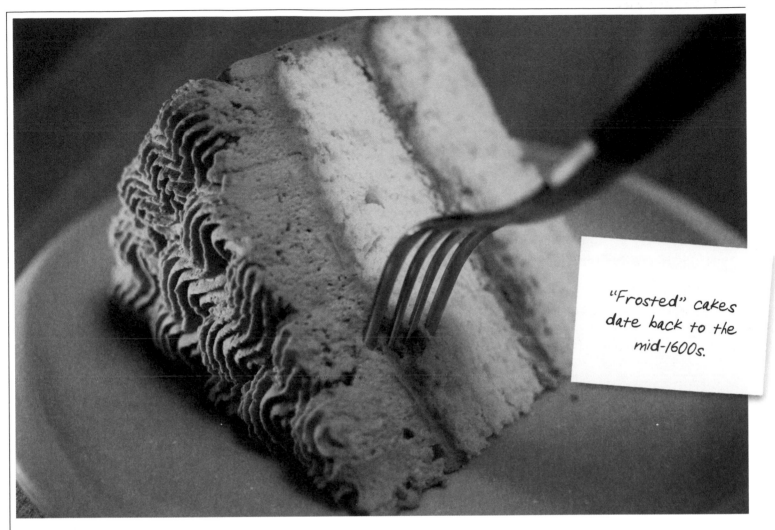

"Frosted" cakes date back to the mid-1600s.

5) When the first half of the flour mix is worked in, add half of the milk and all the vanilla. Stop and scrape the bowl yet again, then return to low speed and slowly add the remaining flour, followed by the milk. Stop and scrape the bowl one last time, to make sure there's no dry flour hiding in the bottom. Congratulations, you've conquered the creaming method.[4]

6) Divide the mixture between the two pans. I use a scale to ensure even distribution, and that means about 660 grams per pan.[5] Smooth the tops with a rubber spatula and tap the pans against the counter to remove any air pockets.

7) Bake until the cakes reach an internal temperature between 207°F and 210°F, which typically takes 30 to 35 minutes. The cakes should be golden brown, and a toothpick inserted into the center should come out clean.

8) Carefully remove the cakes from the oven and cool on a wire rack for 15 minutes, then de-pan onto the rack and cool to room temp before frosting. Allow me to suggest the American Butter(milk) Cream on page 255, the reloaded Buttercream on page 254, or perhaps the Cocoa Whipped Cream below.

4 This is how at least half the cakes currently existing in America were composed. "Cream" the butter with the sugar. Add the eggs. Work in half the flour mixture, followed by half the liquid, followed by the second half of the dry mix, followed by the rest of the liquid.

5 Even distribution of batter into pans is critical to cakery success. The best way is to weigh, as I often say. I know my mixer bowl weighs 776 grams because I weighed it empty and engraved it on the bottom of the bowl. And yes, I know how weird that is. With the batter inside, my bowl weighs 2,096 grams, which means we have 1,320 grams of batter. Divide by two and we get 660 grams per pan. So, pan goes on scale, zero out (or tare) the weight, and batter up. Obviously, we don't have to weigh the second pan, because we just extract all the batter we can.

TIP

Why sift the flour mixture? This step not only breaks up any clumps, but it also aerates the flour and any leaveners you're bringing along with them, which I think really does make the mixture integrate into the batter more easily. If you don't have a sifter you can use a fine-mesh sieve. Or you could skip it, I suppose.

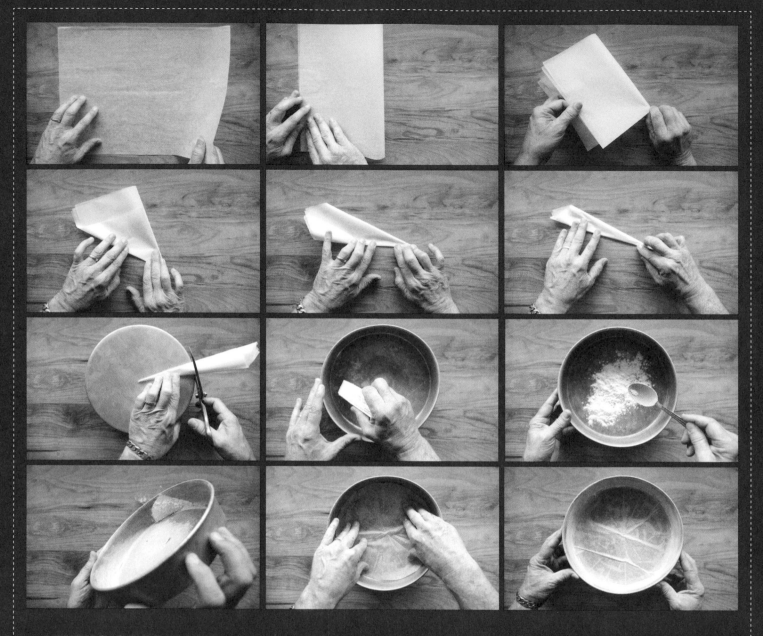

LINING CAKE PANS

Behold, proper pan prep:

Fold a sheet of parchment paper in half laterally, then in half again. Fold one of the long sides to meet a short side to form *almost* a triangle shape, with a bit of extra paper sticking off the end. Fold the two long sides toward each other twice more to form a very narrow triangle or long pointy thing, depending on how you want to think about it.

Flip one of your cake pans over, place the pointy end of the parchment at the center of pan, then use scissors to snip off the end of the parchment where it meets the edge of the pan. Unfold the parchment and you should end up with a circle that perfectly fits on the bottom of the cake pan. Repeat with a second sheet of parchment paper for your second pan.

Rub cold butter across the interior bottom, sides, and inside the "corners"[6] of the pan. Add a scoop of flour to each pan, cover with a plastic shower cap, and shake to coat the inside of the pan. Dump out any extra flour and discard. Place a parchment round inside the bottom of each pan. It'll stick to the butter-flour mélange.

6 Yes, I know round cake pans don't have corners, but you know what I mean.

COCOA WHIPPED CREAM

YIELD:
Enough icing for a 2 layer, 9-inch cake

This hot cocoa mix does double duty as a chocolate flavor agent in this light whipped-cream frosting. Although this chocolate frosting isn't anywhere close to being as rich as, say, buttercream, it has a fresh flavor that won't overpower the cake. Just remember to store any cake it sits atop in the chill chest.

SOFTWARE

2 tablespoons (28 g) water

1 teaspoon (3.5 g) unflavored powdered gelatin

2 cups (470 ml) heavy cream

½ cup (60 g) hot cocoa mix

1 teaspoon vanilla extract

TACTICAL HARDWARE

- A stand mixer with a whisk attachment is strongly recommended here, but if you're willing to put in the arm work, this can certainly be done with a large stainless-steel mixing bowl and a balloon-style whisk.

PROCEDURE

1) Place the bowl and whisk in the freezer for 10 minutes.

2) Stir the water and gelatin together in a metal measuring cup and set aside for 5 minutes. Then place over low heat for 1 to 2 minutes to dissolve. (I know measuring cups aren't really meant to use over heat, but I do it all the time. Just make sure you keep the heat low.) When you can't detect any gelatin granules, remove from the heat and set aside.

3) Retrieve the mixing bowl from the chill and pour in the cream, cocoa mix, and vanilla. Mix on low speed until thoroughly mixed, about 1 minute.

4) With the mixer running, drizzle in the dissolved gelatin solution, boost the speed to high, and whip until medium peaks develop, 1 to 2 minutes.

5) Use immediately or cover tightly and refrigerate for up to 6 hours.

Pondering a recipe mishap with longtime culinary lead Vanessa Parker

Cake making soared in the 1800s as stoves replaced fireplaces in American homes.

The word "cake" comes from kaka in Old Norse. So, yeah, Vikings ate cake.

ART OF DARKNESS I: RELOADED

When I was a kid, I wanted to grow up to be Willy Wonka, so there was no way I was not doing a chocolate show in the first season of *Good Eats*, especially since I didn't really expect a second season. And, given how bad this show is, it's a miracle we got one. Featuring bad sound, crappy production values, and two of my least-favorite recipes of all time, this is also the only show that left me literally in stitches.[1]

WHITE CHOCOLATE	0%
MILK CHOCOLATE	10%+
SEMISWEET	35%-59%
BITTERSWEET	60%-72%
EXTRA-BITTERSWEET	73%+

(top) You'd be shocked at how much food science can be explained with bubble wrap.

Chocolate contains more than six hundred flavor compounds.

DP Lamar Owen lights the infamous head-injury scene.

1 While running around the chocolate factory setting lights, I ran into a rollup door and opened up a serious gash in my forehead requiring something like thirteen stitches. I managed to shoot the rest of the scenes for the day thanks to careful camera placement and duct tape.

CHOCOLATE BY THE NUMBERS

Although chocolate originally came from Mesoamerica, nearly 70 percent of the world's supply is now grown in West Africa.

Back in '99, the artisanal chocolate boom of the 2000s was still at least a year away, chronologically speaking—bar wrappers rarely mentioned cacao percentages, and milk chocolates and semisweet chips ruled. American tastes have since turned dark, and cocoa percentages are de rigueur.

Let's review some standards.

Crush roasted cocoa nibs into a paste and you have *cocoa liquor*. Squeeze out the fat, or *cocoa butter*, and you're left with *cocoa solids*. Cocoa liquor typically contains 52% to 54% cocoa butter and 46% to 48% cocoa solids. If the cocoa solids are finely ground, you have cocoa powder. White chocolate delivers 0% chocolate solids but at least 20% cocoa fat, and milk chocolate is required to contain only 10% cocoa liquor, which is a combination of cocoa solids and butter. Semisweet chocolates today range from 35% to 59% cocoa liquor, while 63% to 72% rates as "bittersweet." This leaves anything higher than 72% as "extra-bittersweet" or "sinisterly dark" or whatever the marketing department dreams up.

But there's more: The numbers don't necessarily equate to quality, and a 63% chocolate can taste a heck of a lot more chocolaty than one in the high 70s.

CHOCOLATE NUTRITION

Cocoa butter contains steric acids, and steric acids don't raise your serum cholesterol, so that's good. Chocolate contains polyphenols, which are antioxidants, which are good for your heart and could decrease your risk of cancer. One ounce of cocoa has less caffeine than an entire cup of decaf coffee. It doesn't cause acne, and it increases energy, so it's not that bad. There's also phenethylamine, the love hormone, combined with theobromine. Strong stuff. And then there is anandamide, which works on the brain like some narcotics. But don't worry, you'd have to eat about twenty-five pounds of chocolate—in one sitting—to have a problem.

CHOCOLATE MOUSSE

No one, not even the French, knows who first concocted chocolate mousse. *Mousse* means "foam" or "froth," depending on which dictionary you use, and odds are good the French invented the form sometime in the early eighteenth century, though vegetable and meat foams predated the chocolate version. One thing is for dang sure, though: Chocolate mousse WAS NOT INVENTED BY HENRI DE TOULOUSE-LAUTREC! This is an even more popular origin story than Thomas Jefferson inventing macaroni and cheese, which, by the way, *he didn't*! Yes, I'm aware that HdTL published a recipe for "Mayonnaise de Chocolat" in his book *The Art of Cuisine* (published in France in 1930 and in English in 1966), but A. B. Beauvilliers's *The Art of French Cookery* has one too, and it was published thirty-seven years before Lautrec was freakin' born. So, stop perpetuating this drivel! (I'm talking to you, internet.)

Moving on, let me say that I don't think our original recipe is bad. It was developed specifically to avoid the use of raw eggs, which are, realistically, as critical to (I can't believe I'm going to type this, but . . .) "real" chocolate mousse as chocolate itself. Back when we shot the original, the network I was working for was not supportive of raw egg recipes, and pasteurized shell eggs weren't easy to find, so I punted and tried to use cream and gelatin. It's a fix but a far cry from authentic, but one does what one must. In reloading the show, I knew I wanted to try for simplicity, and that means nothing but chocolate and eggs—no added sugar, no cream, and certainly no gelatin.

WHAT'S GOING ON WITH THOSE EGGS?

Why add the eggs to the mousse in different stages? The added fat from the yolks will enrich the melted chocolate, while the natural emulsifier, lecithin, will smooth the emulsion that chocolate essentially is. As for the unwhipped white, its moisture will make the molten chocolate, which, after all, is a pseudoplastic non-Newtonian fluid, a lot easier to deal with when it comes time to fold in the beaten whites, and its protein will give us a tad more structural integrity when it chills in the fridge.

As for the beaten egg whites: If you checked out egg whites with, say, an electron microscope, you'd see a lot of little proteins all wadded up tight, and the fresher the eggs the tighter they'd be. Beating them with a whisk or mixer breaks up the bonds holding them together, a process called denaturing. These proteins, and there are a lot of different kinds—conalbumin, globulin, ovalbumin, ovomucin—all have parts that are attracted to water (i.e., they're hydrophilic) and others that are repelled by it (i.e., they're hydrophobic). So, as we beat them, some parts of the proteins grab water and others grab air, and, as a result, we get bubbles. Keep whisking and we get a finer and finer foam. But beware, you can overwhip and collapse all this.

TWO-NOTE MOUSSE: RELOADED

YIELD:

Serves 4

In the twenty years since I first concocted this confection, I've yet to meet one person who could tell me raw eggs made them sick. If you do feel wary, feel free to use pasteurized shell eggs, but beware: They won't beat to stiff peaks without the addition of an acid, like cream of tartar or lemon juice, which means this would no longer be a two-ingredient application.

SOFTWARE

3 ounces (85 g) 60% bittersweet chocolate, chopped

1 ounce (28 g) 72% bittersweet chocolate, chopped[2]

5 large eggs, 4 separated and 1 left whole

Pinch of kosher salt

TACTICAL HARDWARE

- A wide, straight-sided sauté pan with lid
- A stand or hand mixer with whisk attachment
- A large rubber or silicone spatula

PROCEDURE

1) Fold a kitchen towel into quarters and place in the bottom of the sauté pan. Fill the pan with an inch of water and place over medium-high heat. Bring to a bare simmer, about 190°F. (See the box on page 218.)

2) Put the chocolates in a heat-safe bowl—either metal or heavy glass will do—and park it in the water on top of the towel. Reduce the heat to medium-low and stir the chocolate with the spatula, moving back and forth on and off the heat until it's almost but not quite melted, 3 to 5 minutes. Move the bowl to a dry towel on the counter and stir the chocolate until completely melted.[3]

3) Whisk the egg yolks into the chocolate one at a time, followed by the whole egg and the salt. The mixture will look gnarly after the first two yolks, but it will smooth out once everything is in. Allow to cool to room temperature, then . . .

4) Beat the egg whites with your mixer's whisk attachment on medium-low until foamy, about 1 minute. Then boost the speed to medium-high and beat until the whites form stiff peaks, about 1 minute more. (You'll know you're there when you pull the whisk straight out of the foam, hold it facing up, and the peaks don't fall over.)

5) Using a hand whisk (or just remove the whisk from the mixer and use that since it's already been in the eggs), work one-third of the egg

2 Why two different chocolates? I found that for maximum flavor and minimum stress, chocolate in the 63% range is ideal. But for whatever reason, this percentage is hard to find at most megamarts, so I make my own with two more common chocolates. Also, I probably don't have to tell you that you should be using chocolate that tastes good here, right? And no chocolate chips!

3 You don't want to push the chocolate beyond the melt point, so better to coast to it off the heat than charge right through it on the heat.

TWO-NOTE MOUSSE: RELOADED (continued)

whites into the chocolate mixture. Switch to a large rubber spatula and gently fold in the remaining whites in two doses, rotating the bowl as you go. Stop while your mousse still has tiny streaks of chocolate and white throughout.

6) Chill the mousse until it begins to stiffen, about 45 minutes, then divide among four champagne coupes or custard cups. Allow to warm on the counter for 5 minutes before serving.[4]

It takes roughly four hundred cacao beans to make a pound of chocolate.

THE KITCHEN-TOWEL METHOD

I used to employ the standard double boiler rig for this and many other temperature-sensitive operations by positioning a mixing bowl over simmering water in a pot large enough to prevent the bowl from touching the water. Problem is, it's almost impossible to know what the water is actually doing, temperature-wise, because you can't see it. So now I go with the bowl-on-the-kitchen-towel-in-the-water scenario: Place an old kitchen towel or washcloth, folded into quarters, in the bottom of a wide, shallow vessel like a sauté pan. Add an inch of water (the towel will soak up some) and place over medium heat until the water hits a bare simmer: 190°F.

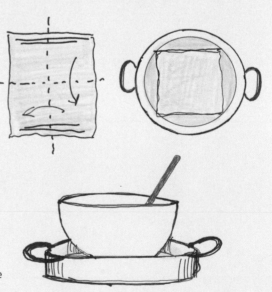

Reduce the heat to medium-low and park your mixing bowl on the towel, which will protect it from the direct heat of the pan bottom. This way I can see the water, easily temp it, and keep the heat where I want it, which is 180°F. The heat has dropped, of course, because it's slowly being transferred to the chocolate. You can't do this with a double boiler because it relies on steam, and steam is always hotter than boiling water.

4 This way the chocolate's aroma can be fully summoned.

MIDNIGHT MUG CAKE FOR TWO: RELOADED

YIELD:

Serves 2

This dessert application developed out of the original episode's lava muffins, little cakes that squirted molten chocolate when poked. (They were all the rage back in the '90s.) I never made them after we finished the episode, but most of those ingredients can be used in something I do make fairly often: chocolate mug cake. Yeah, I know, they were all the rage in the late aughts, but I don't care. Serve with ice cream, whipped cream, or . . . just consume straight from the mug, you animal.

SOFTWARE

50 grams (¼ cup) sugar

15 grams (3 tablespoons) Dutch-process cocoa powder

½ teaspoon baking powder

¼ teaspoon kosher salt

1 large egg

1 tablespoon (15 ml) canola oil

½ teaspoon vanilla extract

75 grams (6 tablespoons) high-quality semisweet or bittersweet chocolate chips

2 tablespoons (30 ml) whole milk

Whipped cream or ice cream, to serve

TACTICAL HARDWARE

- 2 (10-ounce) microwave-safe mugs
- A microwave to put them (safely) in
- A whisk small enough to fit into the mugs. Recommended but not required, as long as you can get your hands on a fork.

PROCEDURE

1) Whisk the sugar, cocoa powder, baking powder, and salt together in a medium bowl. In a second bowl, whisk the egg, oil, and vanilla together.

2) Evenly divide the chocolate chips and milk between the two mugs. Nuke on high for 30 seconds. Meanwhile, stir the egg mixture into the sugar mixture.

3) Carefully extract the mugs and whisk the mixture in each until smooth. Divide the batter between the mugs and stir to combine.

4) Park the mugs on a paper plate or paper towel in the center of the microwave carrousel and let them just sit there for 3 minutes. (Don't skip this step, we need to give the baking powder a head start.)

5) Microwave on high for 1 minute and 45 seconds. Be sure to gaze in wonder as the batter rises soufflé-like right up out of the mug, only to sink safely back into the confines of the mug moments before the final bell.

6) Cautiously remove the mugs and either turn the contents out into a bowl and devour with ice cream or— as I do because I have the discipline to wait—cool almost to room temp and devour out of the mug with whipped cream.

The word "mug" comes from the Norwegian mugge, meaning a jug for warm drinks. During the eighteenth century, many mugs were decorated with grotesque faces, or "mugs."

I like to let the ice cream melt halfway into a sauce.

CHOUX SHINE: RELOADED

Again with
the clown

Good Eats episode 79 was about a paste that dates back at least to the Renaissance. *Pâte à choux* (French for "cabbage paste," but don't worry, no cruciferous vegetation is involved) is unusual in that when it bakes, the resulting shape has a lot of empty space, which it's our duty as cooks to fill. I'm happy to report that there's nothing wrong with my original choux recipe, which you'll find below for reference. Alas, the crime for which I must atone is that when it came time to transition *pâte à choux* to its finest form, the chocolate éclair, I ran out of time and instead of making the pastry cream required to fill it, I shamefully shoved instant vanilla pudding in there instead and called it a half hour.

And so, for the reload, we stripped down the episode to make room for a real pastry cream, not to mention a new chocolate glaze.

PÂTE À CHOUX

Although the French do use *petit chou* or "little cabbage" as a term of endearment, it's more likely the term *pâte à choux* began as *pâte à chaud*, or "hot paste," which is exactly what it is: a batter cooked in a pot and then baked in the oven. Why? Because those wide-open spaces require steam, and steam needs water.

Take a quick look at the software list below and you'll notice there is a lot of water . . . so much so that the recipe could easily be for a crepe batter, a Dutch baby, or even Yorkshire pudding, all born of pourable batters. But choux paste is not pourable. It's pipeable, which is why you can make éclairs out of it. How can you have a batter be so sodden yet moldable? You make the flour carry the water for you. That requires gelatinization of starches, and the best way to do that is to boil it, along with the butter, beat it smooth to create gluten, then slowly add eggs, usually off the heat. Although there are plenty of hot-water doughs out there (scallion pancakes are on page 310), choux is the only dough I know that does what it does the way it does it.

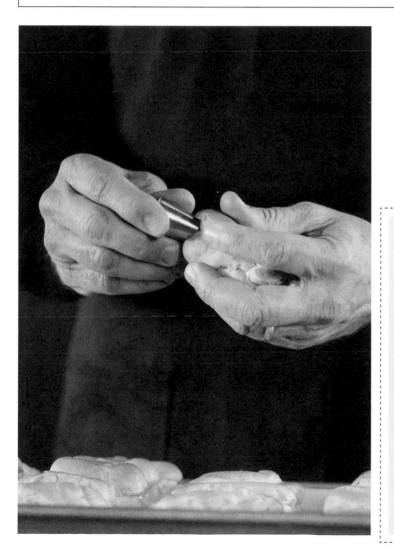

Don't confuse éclairs with Long Johns, which are made from doughnut pastry rather than choux.

ABOUT THE EGGS

Depending on how much water was cooked out of the choux paste, we'll need somewhere around 1 cup (270 g) eggs—as much as the paste can hold without breaking into a curdled mass. The eggs serve multiple purposes. They contain water of their own, and we need the emulsifying power of egg yolks to hold the butter and waterlogged flour together. And, of course, if our final pieces are going to have any structural integrity we'll need protein, which explains why we're using more whites than yolks; whites are where the protein is. Albumin, in particular, is an effective drying agent that will allow moisture out but doesn't let it back in, thus keeping our future éclairs (or profiteroles) from getting moist and falling apart.

PÂTE À CHOUX FOR ÉCLAIRS

YIELD:
36 small éclair shells[1]

SOFTWARE

237 milliliters (1 cup) water

85 grams (6 tablespoons) unsalted butter, cut into small cubes

15 grams (1 tablespoon) sugar[2]

Pinch of kosher salt

165 grams (1 cup plus 2½ tablespoons) bread flour[3]

4 large eggs (200 to 210 g), plus 1 to 2 large egg whites (30 to 60 g)

TACTICAL HARDWARE

- 2 half sheet pans
- Parchment paper (12⅛ × 16⅜-inch sheets fit the pans perfectly)
- A large wooden spoon
- A digital instant-read thermometer
- A stand mixer with paddle attachment
- A piping bag (I prefer reusable cloth) fitted with a ½-inch round tip

PROCEDURE

1) Heat the oven to 425°F and position an oven rack right in the middle. Line the half sheet pans with parchment paper.

2) Combine the water, butter, sugar, and salt in a 3-quart saucier[4] or saucepan and bring to a boil over high heat, stirring occasionally to melt the butter.

3) As soon as the mixture hits a boil, add all the flour at once and stir with a wooden spoon until the mixture starts to come together, about 1 minute. Decrease the heat to low and continue stirring until the mixture is shiny, pulls away from the sides of the pan, and registers 175°F to 180°F, about 2 minutes.

4) Quickly load the dough into the work bowl of your stand mixer and

paddle on the "stir" setting until no steam rises from the bowl, about 5 minutes.

5) Increase the speed to low and add the eggs, one at a time, making sure each is completely incorporated before adding the next. You may need to stop the mixer occasionally and scrape down the sides of the

1 Pipe into small rounds, about 2 inches across, for profiteroles.

2 If you're making these for savory use . . . say, you're going to fill them with chicken salad for a party, omit the sugar.

3 Back in 2002, I advocated for using bread flour specifically made for machines because of its extra-high levels of protein, which I claimed gave it extra water-absorbing powers. That's true when the dough or batter in question is raw, but choux paste is cooked, then baked, so starch gelatinization is actually the prime absorber. Still, the recipe works, so if you can get your hands on bread flour for machines, go ahead and use it. If not (I can no longer find it at *my* megamart), feel free to use whatever style of bread flour you can find.

4 A saucier is basically a wide saucepan with a curved bottom that makes sauce whisking a breeze.

bowl and the paddle. Add one of the egg whites and mix until completely incorporated.

6) Check the paste for consistency: Remove the bowl and paddle. Push the paddle down into the batter and lift it up, clear of the bowl. If the batter tears slightly as it falls from the beater, creating a rough "V" shape, you're done. If not, beat in the last white.

7) Transfer to a piping bag fitted with a plastic coupler and a ½-inch round tip (see sidebar). Pipe a dab of the paste into the four corners of the pan under the parchment paper to hold it in place. Pipe the mixture into 2½-inch-long strips on the parchment, making 4 rows of 6.

8) Bake for 15 minutes, then reduce the oven temperature to 350°F (don't open the door) and bake until golden brown, 10 to 12 more minutes. Remove from the oven and immediately pierce the end of each éclair with a paring knife to release steam.[5] Cool completely before filling. Éclair shells can be stored at room temperature for up to 1 week or frozen for up to 1 month.

5 And you've got to do this while they are warm, because if that moisture has a chance to condense, you're gonna have to warm them again to drive it out.

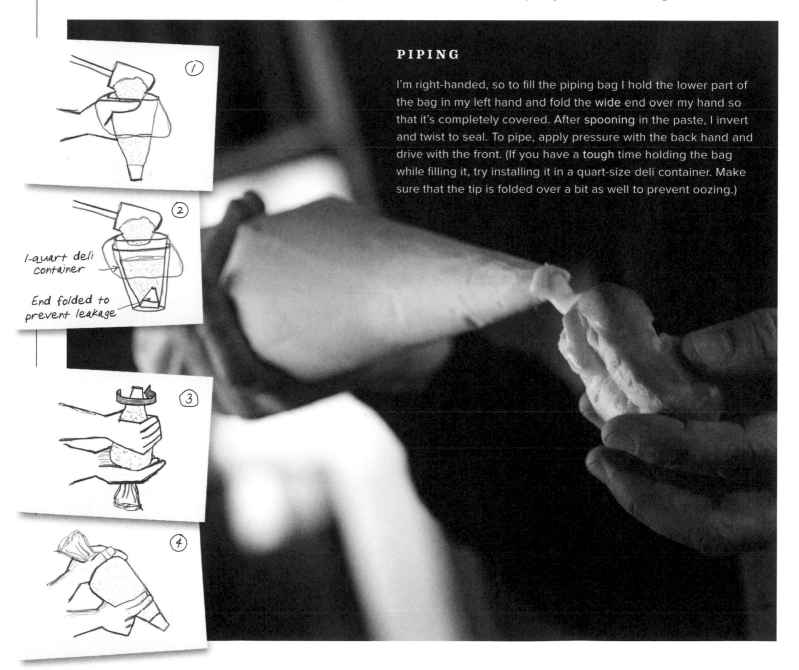

1-quart deli container

End folded to prevent leakage

PIPING

I'm right-handed, so to fill the piping bag I hold the lower part of the bag in my left hand and fold the wide end over my hand so that it's completely covered. After spooning in the paste, I invert and twist to seal. To pipe, apply pressure with the back hand and drive with the front. (If you have a tough time holding the bag while filling it, try installing it in a quart-size deli container. Make sure that the tip is folded over a bit as well to prevent oozing.)

GOOD EATS PASTRY CREAM: RELOADED

YIELD:
About 2 cups (473 ml)

Pastry cream is one of the great mother sauces of the dessert world and one of the few recipes I suggest you memorize, as thus armed you'll be able to concoct myriad tarts, trifles, and puffs (oh, my). It features the usual suspects—sugar, butter, eggs, cornstarch, milk, and vanilla—but what makes pastry cream unique is how they're brought together.

SOFTWARE

100 grams (½ cup) sugar

2 large eggs plus 1 large yolk (125 g total)

30 grams (¼ cup) cornstarch

473 milliliters (2 cups) whole milk

½ teaspoon kosher salt

30 grams (2 tablespoons) unsalted butter, cubed, at room temperature

1 teaspoon vanilla extract

TACTICAL HARDWARE

- A fine-mesh sieve

PROCEDURE

1) Combine the sugar, whole eggs, and yolk in a medium mixing bowl and whisk until thickened, pale, and foamy, about 3 minutes.

2) Sift the cornstarch through a fine-mesh sieve into the egg mixture then whisk to combine. Set the bowl on a wet towel (to prevent scooting) and park near the cooktop. Position the sieve over a second mixing bowl and set aside.

3) Combine the milk and salt in a 3-quart saucepan or saucier and bring to a bare simmer over medium heat, 3 to 5 minutes.

4) Drizzle about one-third of the hot milk into the sugar-and-egg mixture while continuously whisking the latter. Then, reverse course, whisking the now-warmed egg mixture back into the pot with the milk.[6]

5) Move the pan back to medium heat and whisk spiritedly. As the mixture just begins to thicken enough to resist the whisk, drop the heat to low and continue whisking until the mixture thickens considerably and just begins to bubble.

6) When the mixture begins to bubble, you'll know it's as thick as it's going to get, so quickly remove the pan from the heat and pour the mixture through the sieve into the empty bowl, coaxing it through with a rubber spatula. There will likely be some odd little scrambled egg bits left behind in the sieve, and that's the whole idea.

7) Whisk the butter into the strained mixture a piece at a time, making sure each piece has almost vanished before introducing the next. Finally, whisk in the vanilla. Cover the pastry cream with plastic wrap or parchment paper, making sure to get the wrap right down on the surface to prevent a skin from forming. Although the cream can be used hot, I prefer to pipe it when it's down to room temperature. Pastry cream can be refrigerated for up to 1 week if it is tightly sealed. Return chilled pastry cream to room temperature before using.

PASTRY CREAM THICKENING SCIENCE

Pastry cream thickens not so much because egg proteins coagulate but because starch granules are gelatinizing, a process that can happen very rapidly and probably needs some explanation. *Gelatinizing* is actually an unfortunate term, because *gelatin* (noun) is the protein derived from the partial hydrolysis of collagen. *Gelatinize* (verb) is to make *gelatinous* (adjective), which means jelly-like, but that is silly because jelly is set with pectin. And then there's *gelatinization* (noun), which is the process in which starch and water are heated, causing the starch granules to swell, forming a *gel* (noun), which means a thick, clear, slightly sticky substance. Now, the process of gelatinization is thermo-irreversible and will not melt with reheating the way gelatin will. The granules, however, can overcook, and when that happens starch molecules rush out, turning everything to glue (noun), a gooey adhesive.

6 Every time this maneuver appears in this book I'll point it out as "tempering," because it really is that important.

CHOCOLATE GLAZE 2.0: RELOADED

YIELD:

About
1½ cups

Good chocolate, heavy cream, and a dash of coffee (trust me) are all you need to make decadently delicious chocolate ganache, which you can put on everything from ice cream to your toothbrush, and, of course . . . chocolate éclairs.

SOFTWARE

230 grams (1¼ cups) semisweet chocolate chips

163 milliliters (11 tablespoons) heavy cream

25 milliliters (5 teaspoons) brewed coffee

20 grams (1 tablespoon) corn syrup

Pinch of kosher salt

TACTICAL HARDWARE

- A digital instant-read thermometer
- A heatproof glass mixing bowl large enough to set comfortably in a medium saucepan[7]

7 Glass is an insulator and is slower to heat than most metals, which is why I like it here. Use something thick like Pyrex or, even better, old Pyrex, which was made from a better recipe.

PROCEDURE

1) Place a folded kitchen towel in the bottom of an 11-inch straight-sided sauté pan. Add about an inch of water to the pan and park over medium heat until it reaches a bare simmer, approximately 190°F. You'll want to maintain this temperature throughout the process, so keep your thermometer handy and be prepared to drop the heat if the water starts to boil.

2) Combine the chocolate, cream, coffee, corn syrup, and salt in a glass heat-safe bowl that fits comfortably inside the sauté pan. Place the bowl directly on the towel and let sit in the water, stirring frequently with a rubber spatula, until the chocolate is almost (but not quite) melted, 3 to 5 minutes. Remove the bowl, place it on the counter, and stir until the mixture is smooth.

3) Temp the chocolate. If it's between 88°F and 90°F, it's ready to use. If it's over, park the bowl on the counter for a few minutes, temping often until it's in the zone.

Okay, let's put it all together.

CHOCOLATE ÉCLAIRS

YIELD:
36 small éclairs

SOFTWARE

1 batch Pâte à Choux for Éclairs (page 222), baked into éclair shells and cooled

1 batch *Good Eats* Pastry Cream (page 224), at cool room temperature

1 batch Chocolate Glaze 2.0 (page 225), between 88°F and 90°F

TACTICAL HARDWARE

- A piping bag with ¼- to ½-inch star-shaped tip

PROCEDURE

1) Use the piping tip to gently open up the hole you poked in the end of each éclair when they first came out of the oven. This will prevent the tip from ripping the shell when you pipe in the pastry cream.

2) Install the piping tip into its piping bag and load with the pastry cream using the same maneuver described above for the choux paste.

3) Using your dominant hand, twist the pastry bag to continuously press the pastry cream toward the tip (think toothpaste). Insert the tip into the first éclair shell, give the bag a squeeze right where you have twisted it, and, while squeezing, withdraw the tip from the éclair. You'll know the éclair is filled when it feels significantly heavier than before. Place the filled éclair on a half sheet pan or large platter. Continue with the remaining éclair shells until you've filled all of them, twisting the bag a little every few eclairs so that you keep a good grip on the cream. (Keep any extra pastry cream for another use, such as just eating it! It's basically pudding!)

4) Once the shells are filled, it's time to dip. Double-check the temperature of the chocolate glaze. If it's between 88°F and 90°F, it's workable. If it's over, just park the bowl on the counter for a few minutes, temping often until it's in the zone. If it's under, return the bowl with the glaze to its double boiler to heat up a bit. To glaze, quickly dip the long side of an éclair into the mixture, lift, and drain for a count of three, then flip right-side up. (It really is all in the wrist.) Transfer to a platter, refrigerate until chilled, and serve.

Éclair means "lightning bolt" in French. There are many stories supposedly explaining this, and I don't buy any of them.

A CHUCK FOR CHUCK: RELOADED

"This is a strange mix of ingredients, and I did not like the result at all."

—CINDY

"I have a house full of family members waiting for pot roast who are going to get a couple roast chickens from the local supermarket instead."

—ANONYMOUS

"I tried this and it's an epic fail. Meat is rubbery and I changed the recipe because it's an awful combination of flavor. I will never do this again."

—BOB (NOT REAL NAME)

Thus went the reviews for my original recipe for "pot roast." My fault, of course, but there were extenuating circumstances. For one thing, we'd lost our kitchen location, so I concocted a conceit whereby my previously established neighbor, Chuck (a clear rip-off of Kramer on *Seinfeld*), was living in a trailer next to his turkey-themed goofy golf course (a long story and not germane to the matter at hand), and the oven was so small I couldn't get a decent-size pot into it. So I decided to cook in foil.

I was obsessed with low-temperature cooking and the idea that I could braise effectively in a metal pouch. What I didn't factor in, however, was the fact that a heavy pot does more than provide containment. The headspace inside a pot allows room for vapors to circulate; it also acts as a radiant-heat source that browns any of the pieces of food sticking up out of the liquid, and that contributes to the flavors we think of when we think of the flavors of pot roast. We use an enameled Dutch oven here, because it's dense and, though it heats slowly, it remains at a very steady temperature once it is hot, and that helps to even out the heat curve that most ovens produce.[1]

Last note on the aforementioned disgruntlement: I included raisins and olives in that original recipe, and that was just plain stupid. People want pot roast to taste like pot roast, not like some "clever" take on what a pot roast would taste like in, like . . . Sardinia. In other words, I broke my oath to never try to make a dish not taste like what it's supposed to taste like.

And so we rebuilt this dish from scratch, and I'm happy to announce that version 2.0 does indeed taste like (wait for it) pot roast. It is, in fact, better than most, due to a range of doneness on the veggies, plenty of gelatin (from the meat, not an envelope), and the Maillard flavors that result not only from the initial sear but from giving the dish an overnight rest and heating it up again.

1 Why enameled specifically? For one thing, I like how they look. For another thing, acidity. Although I will cook acidic ingredients in a regular cast-iron skillet, this is a fairly long cook and could (maybe) degrade the cure on the pan. Also, my wife is on a low-iron diet, so I don't take any chances.

POT ROAST

Pot roast is all about economy. It's a one-pot dish meant to stretch the offerings of a meager pantry and root cellar, and to exploit the cheapest parts of a cow—those that do most of the work. Cuts like the chuck do just that, and although they're not as tender as the pricy cuts in the middle, they can deliver massive flavor if properly coaxed. If you ask me, the beef chuck primal is the most flavorful cut on the cow. It can also be the toughest cut on the cow.

The chuck primal can weigh more than 100 pounds.

Although "chuck" is old cowboy jargon for food, as in "chuck wagon," the word probably derives from "chunk," and quite a chunk it is, making up nearly 23 percent of the carcass. There's quite a bit of meat in there, but also plenty of bone (the entire shoulder, part of the arm, and five ribs), not to mention connective tissue aplenty. Unlike the ridiculous cake diagram we used in the original show,[2] chuck roasts aren't uniform throughout. So, when you cut into them, it helps to know where you're going.

Or rather it used to.

In the original episode, I went on and on about understanding the cross-cut, steak-like roasts harvested from across the shoulder, and the virtues of the "7-bone" roast, which was so called due to the cross-section of shoulder that indeed resembled the number 7. I no longer promote the use of this roast . . . because it pretty much doesn't exist anymore.

I mean, if you have your own steer and a saw you can make one appear, but odds are good that you'll never see one in a grocery store. That's because since we filmed the original episode, butchering techniques have evolved to give us "new" cuts like the flatiron steak, which didn't exist until a year after we shot the show.[3] So now, we're simply using a boneless chuck roast in the 3½-pound range, which you can find at just about any grocery store with a meat counter and a few that don't.

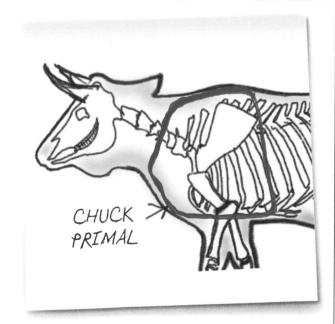

CHUCK PRIMAL

2 I'm fully aware that this looked like a pig and not a steer . . . I suck at cake, okay?!

3 The "flat iron steak," which does somewhat resemble the shape of a clothing iron, is cut from the "top blade" of the chuck. The old cooking methods wasted this piece, or at least minimized its value. Then, researchers from the University of Florida and the University of Nebraska, working in tandem, "discovered" it in 2002.

THE FINAL POT ROAST: RELOADED

YIELD:

6 to 8 servings

SOFTWARE

3½ pounds (1.6 kg) boneless chuck roast, cut into 3 to 4 pieces, all large hunks of fat removed

2 tablespoons plus 1 teaspoon (23 g) kosher salt, divided

2 tablespoons (30 g) ghee (page 250)

8 ounces (227 g) button mushrooms, washed and halved if large, divided[4]

15 ounces (425 g) carrots, peeled and chopped into 1-inch pieces, divided

1 (14-ounce/397 g) bag frozen pearl onions, divided

6 cloves garlic, sliced (20 g)

1½ teaspoons (2 g) herbs de Provence[5]

1 teaspoon freshly ground black pepper

1 cup (237 ml) low-sodium tomato juice

⅓ cup (79 ml) red wine vinegar

15 ounces (425 g) baby red potatoes, cut into 1½-inch pieces

TACTICAL HARDWARE

- A Dutch oven in the 6-quart range
- A fat separator (optional but strongly recommended)[6]

4 Mushrooms will bring a meaty texture and glutamic acid, aka umami, to the party.

5 Although I prefer to purchase my HdP from a reputable internet source, you can mix your own as long as you have, in alphabetical order, dried basil, fennel seeds, lavender, marjoram, rosemary, sage, savory, tarragon, and thyme. Exact proportions are up to you, or you can just, you know . . . buy it. Your call.

6 If you don't have a separator, you can simply let the liquid cool, then refrigerate overnight; the fat will float to the top and solidify so that you can easily lift it off.

PROCEDURE

1) Heat the oven to 250°F and park the Dutch oven over medium-high heat for 2 minutes. While the pot heats, rub the meat pieces with 2 tablespoons of the salt. (No, not sprinkle . . . rub.)

White button mushrooms make up 90 percent of all mushrooms sold in the United States.

2) When the Dutch oven is hot, add 1 tablespoon of the ghee, then add the meat, turn the heat up to high, and sear until deeply browned, 2 to 3 minutes per side. Do not crowd the pan or the meat will boil in its juices rather than brown. Work in batches, if necessary. As the meat is browned, move to a platter.

3) Kill the heat, allowing the pot to cool for 2 minutes. Then add the remaining 1 tablespoon ghee and return the pot to medium heat. Add half of the mushrooms and cook, stirring, for 2 minutes.

4) Add half of the carrots and half of the onions, along with all the garlic, herbs de Provence, pepper, and the remaining 1 teaspoon salt. Cook, stirring occasionally, until the garlic is aromatic, 2 to 3 minutes.

5) Add the tomato juice and vinegar and increase the heat to medium-high. When the liquid hits a boil, scrape up any cooked bits from the bottom of the pot and continue cooking until the liquid is reduced by half, 3 to 5 minutes.

6) Return the meat to the pot and nestle it down into the vegetables. Lid up, transfer to the oven, and cook for 2 hours.

7) Carefully remove the Dutch oven from the actual oven and add the remaining mushrooms, carrots, and onions, along with all the potatoes. Cover and return to the oven until the vegetables are cooked through and the meat is fork-tender, another 2 to 3 hours.

8) When the meat and vegetables are done, use a slotted spoon or spider to remove the hunks and chunks to a bowl, then filter the liquid through the sieve into a fat separator. Return the filtered and defatted liquid to the Dutch oven and simmer over medium heat until the sauce is reduced by one-quarter, about 5 minutes.[7] Kill the heat and return the meat and vegetables to the pot. Cool to room temperature, then refrigerate overnight.[8]

9) When ready to serve, place the covered pot back in the oven and turn said box to 350°F, allowing the roast to heat with the oven. In 45 minutes, the meat should be hot and the sauce bubbling. Serve directly from the pot to a grateful world.

7 Once you take various chemical changes into account, we've increased the flavor quotient by a whopping 33 percent.

8 Could you simply serve it right away instead of waiting for the next day? Certainly. And most of you will. But later, when you reheat the leftovers, you'll notice how much better they are than on the first day, and you'll be sad that you didn't have the patience to wait.

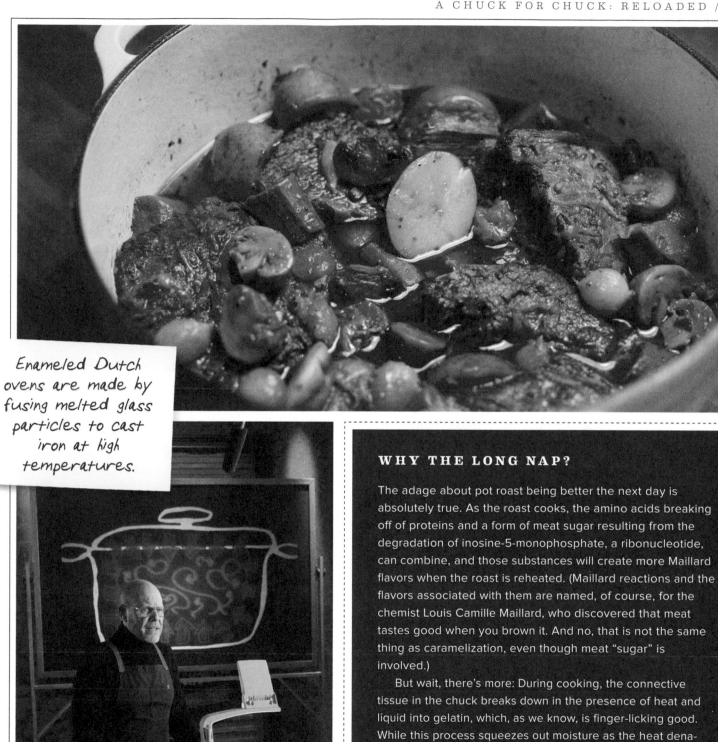

Enameled Dutch ovens are made by fusing melted glass particles to cast iron at high temperatures.

WHY THE LONG NAP?

The adage about pot roast being better the next day is absolutely true. As the roast cooks, the amino acids breaking off of proteins and a form of meat sugar resulting from the degradation of inosine-5-monophosphate, a ribonucleotide, can combine, and those substances will create more Maillard flavors when the roast is reheated. (Maillard reactions and the flavors associated with them are named, of course, for the chemist Louis Camille Maillard, who discovered that meat tastes good when you brown it. And no, that is not the same thing as caramelization, even though meat "sugar" is involved.)

But wait, there's more: During cooking, the connective tissue in the chuck breaks down in the presence of heat and liquid into gelatin, which, as we know, is finger-licking good. While this process squeezes out moisture as the heat denatures the muscle fibers, around a third of it will be reabsorbed as it rests in the fridge. This reabsorbed liquid is even more flavorful, since it's carrying flavors from the vegetables (hello, mushroom umami), and has reduced on the stovetop. Reheating just needs to be done carefully. So . . . let that roast rest overnight. It will be worth the wait.

THE EGG-FILES: RELOADED

Steam happens.

In episode 3 of *Good Eats*, we dealt with what I consider to be the protean protein, as malleable and adaptable as a T-1000, and if you don't get that reference, we can't be friends. So, why the reload? Because in the last twenty years I've cooked a great many more than myriad *Gallus domesticus* ova and have emerged with three evolved methods for cooking an egg.

Although eggs themselves haven't changed too much in the last couple of decades, salmonella data has. Outbreaks declined after the late '90s and stabilized during the mid-2000s.[1] The CDC's models project that between 1997 and 2017, over-easy eggs were responsible for five outbreaks of salmonella, twenty-nine actual illnesses, seven hospitalizations, and one death. For context, five people died in 2018 from *E. coli* on lettuce. You're far more likely to get salmonella from kissing your little pet turtle than you are from eating eggs. So, although it makes good sense to maintain good kitchen sanitation, you don't really need to treat fresh eggs like microbial hand grenades.

Over the years, a lot of folks have come to me with questions regarding fried eggs, and my general answer has been that practice, lots of practice, makes perfect—practice and a nonstick skillet. Then one day a friend asked me if it was possible to lead a first-time egg fryer to the perfect fried egg, which in their opinion had recently been experienced in a Parisian café. When queried the friend described the egg in detail; specifically desirable were the lacy crunch at the outer edge and the lava-like ooze of the yolk. The challenge forced me to start from scratch, but I think (six dozen eggs later) I finally have it.

One of the problems with fried-egg recipes, my own past efforts included, is that they make very vague references to heat. If doneness is key, as it is for lacy edges and a gooey yolk, we need more precision. This is why I've taken to frying eggs over indirect heat, preheating the pan, but removing it from the heat before adding the eggs. It sounds weird but it works, but only if you have a carbon-steel pan, a tool I consider essential despite the fact that I've gone twenty years without mentioning one on TV.

The final agents—the OG Marshall Millard (key grip) and Elizabeth Ingram

1 To qualify as an outbreak, there have to be at least two cases traced to the same source.

Most cast-iron pans are made by pouring molten iron into molds made of compressed sand. The process destroys the mold.

CARBON STEEL

Although I do keep one nonstick skillet around (see the Bibimbap on page 320), I rarely use it. Even if you set aside the fact that they can give off toxic fumes at very high temperatures, nonstick surfaces are ridiculously prone to damage, even with careful usage, and they're usually mated to aluminum pans, which are notorious for uneven heating.[2] I have come to swear by carbon steel, which is not the same as cast iron despite substantial metallurgical similarities.

While both pans are mostly iron, cast iron contains around 4 percent carbon and some silicon and manganese, while carbon steel contains only about 1 percent carbon, which seems strange given the name. Carbon determines how the pans are manufactured as well as their final shape.

Consider the differences between a dough and a batter: essentially the same ingredients but in different amounts. Like a batter, high-carbon cast iron is pourable and thus suitable for shaping in a mold. Low-carbon carbon steel, on the other hand, is like a dough: drier, pliant, and suitable for rolling, shaping, and cutting.

Because they're cut and rolled, carbon-steel pans can be shaped to have very shallow edges. Because they're worked under considerable pressure, carbon steel pans are thinner, lighter, and much smoother than modern cast iron. As is the case with cast iron, carbon pans only get better with use; when fully cured, both are slick and jet black. What's especially important to our egg endeavors is that although they're slow to heat, once cast-iron and carbon-steel pans get hot, they retain that heat for a long time. By heating in the oven, we can assure that heat is even with no hot or cold spots.

2 Exotic birds are especially vulnerable to these fumes: more than a few beloved pet cockatoos and parrots have been lost to their effects.

THE FINAL FRIED EGGS: RELOADED

YIELD:
1 to 2 servings

SOFTWARE

1 tablespoon (14 g) unsalted butter, softened at room temperature for 15 minutes

2 large eggs, cold[3]

1 heavy pinch kosher salt

TACTICAL HARDWARE

- A 10-inch carbon-steel skillet
- A lid that fits your carbon-steel pan[4]
- A thin metal spatula or fish turner

In the United States, a dozen large eggs weigh a minimum of 24 ounces.

PROCEDURE

1) Park the skillet in the middle of your oven and crank to 450°F. When the oven says it's reached its thermal destination, let it heat for another 30 minutes . . . just to be sure.

2) Meanwhile, measure the butter out onto a square of parchment paper about the size of a Post-it note.[5] The butter should be soft but not melted.

3) When the pan is almost ready, retrieve the eggs from the fridge and break both into a custard cup or small bowl.

4) Carefully remove the pan from the oven using a side towel, oven mitt, or potholder and place on the cooktop. Do not turn on a burner; this is just a heatproof place to park the pan. Add the butter and swirl the pan to coat. As soon as the butter coats the pan, but before it has fully melted, pour the eggs into the middle of the pan, season with the salt, and cover with the lid.

5) Set your timer for 4 minutes and warm a plate by either running hot water over it or briefly parking it in the oven.

6) When the 4 minutes have expired, remove the lid and, using the spatula, free the eggs from the pan.[6] Slide onto the warm plate and consume.

NOTE

For cooking just one egg: Use an 8-inch skillet with a tight-fitting lid, ½ tablespoon (7 g) butter, a smaller pinch of salt, and a 3½-minute cooking time.

For cooking . . . a lot of eggs: If you want to feed more of a crowd, heat two 10-inch skillets in the oven.[7] Pull out one skillet to cook two eggs at a time, then wipe out the used skillet and return it to the oven to reheat while cooking with the other pan.

3 Bringing the eggs to room temp will change everything about the recipe, so don't get them out until right before you're ready to cook.

4 I've never seen a carbon-steel pan sold with a lid, so odds are you'll have to hijack one from another pot. I usually use the lid from my 12-inch sauté pan, which is too big but still effective.

5 To tell you the truth, I usually just use a Post-it Note, but, as that's not a food-grade surface, I probably shouldn't tell you that.

6 There will be a bit of sticking around the edges.

7 Carbon-steel skillets are amazingly cheap compared with other cookware, so I definitely recommend having at least three of the large ones and two of the small.

A SCARY GOOD SCRAMBLE: RELOADED

YIELD:
1 large or 2 small servings

Best served with toast points or a bitter green salad, scrambled eggs are a quintessential culinary standard. The key to making them fluffy is consistent heat and just 30 seconds (yes, seconds) of cooking.

For flavor augmentation I reach for harissa, a paste-like mélange of North African provenance typically composed of red chiles, garlic, caraway, and cumin. Though available at many megamarts (not to mention the web), you can easily make harissa paste yourself[8] (see page 136). As for the mayo, since it is an emulsion of eggs, oil, and vinegar, it can help to keep our scrambled eggs (also an emulsion), smooth. Don't worry, with the harissa in the mix, you won't taste the mayo . . . if that's what you're worried about.

Yes, I'm aware that it may seem odd to heat a pan in an oven for 30 minutes for 30 seconds of cooking. But, this is how I got to what I feel is perfect. So . . .

SOFTWARE

1 teaspoon (4 g) unsalted butter, softened at room temperature for 10 minutes

2 teaspoons (5 g) mayonnaise

1 teaspoon (5 g) water

1 teaspoon (5 g) harissa (see page 136; optional but highly recommended)

¼ teaspoon (1 g) kosher salt

3 large eggs

Freshly ground black pepper (optional)

TACTICAL HARDWARE

- A 10-inch carbon-steel skillet
- A rubber or silicone spatula

PROCEDURE

1) Park the skillet in the middle of the oven and crank the heat to 350°F. When the oven says it has arrived at that thermal destination, let it heat for another 30 minutes.

2) While the oven and the pan heat, measure the butter out onto a 2-inch square of parchment paper. The butter should be soft but not melted.

3) When the oven and the pan are good and hot, whisk the mayonnaise, water, harissa, and salt together in a medium bowl. Whisk in the eggs, one at a time, until light and smooth.

(At this point, things are going to happen quickly, so have a warm plate or platter standing by to receive the goodness.)

4) Remove the pan from the oven and place over medium heat. Add the butter to the pan and swirl to coat. Pour in the egg mixture and count to 10. Stir twice with a rubber spatula and count to 10 again. Stir two more times and count to 5. Stir three final times, making sure any liquid egg makes contact with the pan, and

count to 5. Transfer immediately to a plate or platter and serve.[9]

TIP

As for cleaning carbon steel, I follow the same protocol as cast iron: While the pan is still hot, I pour in a bit of kosher salt and scrub with a piece of paper towel. If there's something particularly stubborn in there, heat the pan over a burner, then add water. Scrub with a wooden spatula and it will loosen or dissolve. Then dump, dry, oil, and hang.

8 I keep saying "paste" here to delineate it from harissa powder, which contains many of the same ingredients. Although you can add hot water and oil to the powder to create a paste, I do not consider that interchangeable with harissa paste.

9 The eggs may not look completely cooked when you move them, but look again in 10 seconds and they will be.

HARD NOT-BOILED EGGS: RELOADED

YIELD:

6 servings

I adore hard-boiled eggs but firmly believe steaming results in a creamier white and easier peeling. Although hotter than boiling water, steam is less dense so slower to penetrate the shells. Steam is also less physically violent, so you're less likely to crack any shells during the process. Steam is also more reliable because, unlike water, which drops in temperature when the eggs go in, steam is pretty much a constant temperature at standard pressure.

SOFTWARE

6 large eggs, preferably stored on their sides[10]

TACTICAL HARDWARE

- A folding steamer basket

Steamed eggs—one of my very favorite foods. (Just add salt.)

PROCEDURE

1) Add an inch of water to a 3- to 4-quart saucepan with a tight-fitting lid and bring to a boil over medium-high heat. Fill a large bowl with room-temperature water and have it standing by.[11]

2) When the water boils, retrieve the eggs from the refrigerator and place in a folding steamer basket. Carefully lower into the pot, cover, and steam for exactly 11 minutes for a set egg that still has a slightly creamy yolk. If you're looking for something more like a traditional hard-boiled egg, go for 13 minutes; 12 minutes will get you something right in the middle.

3) Carefully remove the steamer basket and transfer the eggs to the bowl of water. Allow them to cool enough to handle comfortably, 30 seconds or so. Carefully crack the shell by tapping it on a flat surface and peel under the water, being careful to remove both the shell and the membrane just underneath.

4) Pat dry and consume while still warm. If you're planning to use half for, say, deviled eggs, cool thoroughly before slicing. Once peeled, I keep

hard-cooked eggs refrigerated in a sealed container of water to prevent drying.

NOTE

Fresh eggs are harder to peel than older eggs for reasons including lower pH, adhesion of the outer membrane to the shell, and very small demons. Luckily, by the time most of us get our eggs home sufficient time has passed to resolve this issue.

EGG STORAGE

Because I like hard-cooked eggs, I stash my ova on their sides. It's my belief, over twenty years of testing, that the cord of twisted albumin called the chalaza, which acts as a shock absorber for the yolk, has a better chance of keeping the yolk centered if stored horizontally as opposed to on end. Although not a huge issue when fresh, as eggs age the albumin thins and the chalazae sag, and the yolk settles to the side.

11 I now eschew shocking the cooked eggs with ice water because it can constrict the membrane, making peeling a whole lot harder. I prefer to cool the eggs just enough to handle with a tepid room-temp bath instead. It's also way more comfortable to stick your hands into room-temp water than an ice bath.

10 To store eggs on their sides, secure the egg carton with several rubber bands. Place on its side in the refrigerator for at least 5 days.

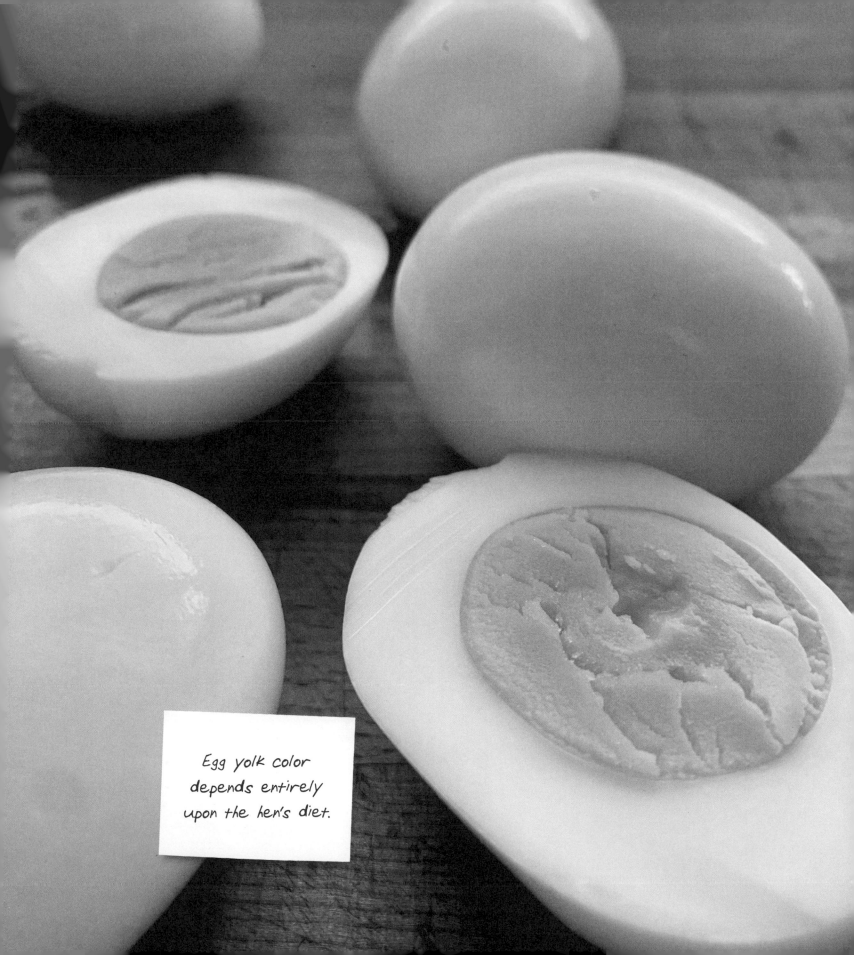

Egg yolk color
depends entirely
upon the hen's diet.

FLAT IS BEAUTIFUL II: RELOADED

Our second "Flat Is Beautiful" episode focused on flattened meat dishes. Now, I don't hate the original show or its first dish, carpaccio, but the chicken "Kiev" and turkey piccata require serious renovation.

Another stacked ingredient rig!

Bart's Russian accent is spot on!

HISTORY OF CHICKEN KIEV

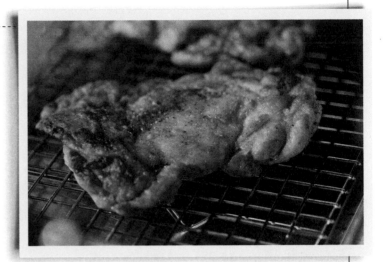

First things first: The modern world has rightly converted to spelling and pronouncing Ukraine's capital as "Kyiv." But the dish we know as chicken Kiev probably isn't Ukrainian or Russian. It's more likely an adaptation from a French dish that was probably renamed in America. Then again, maybe not. Point is, the city is Kyiv, but the dish is still Kiev.

As to culinary matters, the problem with traditional chicken Kiev is the rolling, which is a pain, and, honestly, who wants to cut into a chicken rollup only to be squirted with butter? For my money, the better way is to treat it like a schnitzel, flattening the meat, then coating in breadcrumbs and pan-frying. That way, the butter can go right on top! Traditional? No. Tasty? Yes.

MEAT POUNDERS

Ultimately, pounding is about controlling the strike to deliver the right amount of force. When shopping for a proper meat pounder, keep the following in mind:

- I've found that mallets with larger heads produce better results. The smaller heads require a lot more strikes and that can lead to . . . a big mess.

- Rounded edges cause less tearing, so stay away from meat pounders with hard, angular sides.

- Wood mallets are lighter than the metal ones, so you need a lot more strikes and a lot more work.

- A matte finish reduces friction, making for smoother pounding action.

Hammer-style tenderizers are great if you want to play Thor.

If you want to flatten cutlets, go with this shape.

SCHNITZEL KIEV: RELOADED

YIELD:

4 servings, with leftover herb butter

SOFTWARE

3 tablespoons (12 g) chopped fresh tarragon

2 tablespoons (8 g) chopped fresh parsley

1 cup (227 g) unsalted butter, cold, chopped into small pieces

2½ teaspoons kosher salt, divided

½ teaspoon freshly ground black pepper

4 (4- to 5-ounce/113 to 142 g) boneless, skinless chicken thighs[1] (see deboning diagram on page 239)

½ cup (70 g) all-purpose flour

2 large eggs, beaten with 1 teaspoon water

120 grams (2 cups) panko bread-crumbs[2]

2 to 4 cups (473 to 946 ml) 100% olive oil (not extra-virgin), for frying[3]

1 lemon, for serving

TACTICAL HARDWARE

- A stand mixer with paddle attachment
- Parchment paper
- Plastic wrap
- A smooth-sided meat pounder (see page 243)
- 2 sheet pans
- 2 wire cooling racks
- 3 pie or loaf pans or shallow bowls (they don't have to match)

PROCEDURE

1) Combine the herbs in a small bowl, setting aside 1 tablespoon for garnish.

2) Load the butter in your stand mixer's work bowl, and paddle on medium-low speed until the butter softens and lightens in color, stopping occasionally to scrape down the sides of the bowl, 5 to 7 minutes total.

3) Add half of the chopped herbs and ½ teaspoon of the salt, then beat on low speed until incorporated, about 2 minutes. Scoop the butter onto a sheet of parchment paper, fold the paper over the top of the butter, then, while holding the lower layer of the paper, push the straight edge of a sheet pan forward against the butter so that the top layer squeezes it into a smooth cylinder about 6 inches long. Refrigerate until firm, about 2 hours.[4]

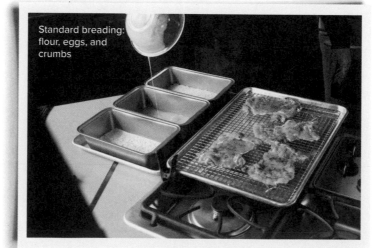

Standard breading: flour, eggs, and crumbs

4) Set a wire cooling rack inside a sheet pan and have it standing by. Clear enough room on the bottom shelf of your refrigerator to hold the pan/rack combo.

5) Place a long piece of plastic wrap (about 18 inches) on the counter and sprinkle an area the size of a chicken thigh with some of the remaining salt and pepper. Place a thigh on top, season the other side, then fold the plastic over so that the thigh is sandwiched between the layers. Spritz with water to provide lubrication, then pound gently with a smooth-sided meat pounder until the meat is approximately ¼ inch thick. Peel back the plastic and sprinkle on a pinch of herbs, flip and repeat with more herbs, then continue pounding until the meat is around ⅛ inch thick.[5] Peel off the top plastic and flip the meat onto the cooling rack. Remove the rest of the plastic, then repeat with the remainder of the thighs.

6) Refrigerate the thighs for 30 minutes or, if you can't manage the space, on the counter in a cool spot out of direct sunlight. (A cooler is another option.) Meanwhile, heat the oven to 250°F and position a second wire rack–pan combo on the middle rack. If you don't have another cooling rack, place a pan under one of the oven's racks to catch crumbs and just rest the cooked meat directly on the rack.

1 If you'd like to debone the chicken yourself, purchase thighs weighing 7 to 9 ounces each.

2 Panko breadcrumbs are lighter and coarser in texture than regular breadcrumbs.

3 How much you need will depend on your pan.

4 The butter can be stored for up to a week, but since butter readily absorbs funky flavors and aromas from the fridge, please wrap securely in plastic wrap or a large zip-top bag.

5 When it comes to meat pounding, take your time and let the weight of the tool do the work; otherwise you're likely to tear the meat or knock a hole in it.

In this version—the butter is on the outside.

7) Line the three shallow bowls or pans up and place the flour in the first, the egg mixture in the second, and the panko in the third. When the chicken has rested, coat each piece first in flour (being careful to shake off as much excess as possible), then the egg (count to 3 after each dip to allow excess to drain), then the panko, turning to dredge thoroughly. Return each piece to the rack and let rest for 15 minutes. Meanwhile, slice four ¼-inch-thick slices of the herb butter and set aside for serving.

8) Heat ½ inch oil in a large cast-iron skillet or wide sauté pan over medium-high heat until the oil hits 375°F.[6] Fry the thighs, one at a time, until deeply golden brown on both sides and the internal temp hits 165°F, 1 to 2 minutes per side. As each piece is finished, move to the oven to keep warm. Throughout the process, check the temp of the oil and adjust the heat to maintain 375°F. (Typically, I have to turn down the heat a couple of times during the process so as to not overheat.)

To serve, top the chicken with the remaining herbs and a medallion (or two) of the butter. Zest the lemon over the top, then slice into wedges and serve on the side.

6 To temp the oil, tip the pan so that it pools on one side and use your instant-read thermometer. Or just eyeball it. When the oil shimmers on the surface, you're good to go.

	YIELD:
GOOD EATS CHICKEN PICCATA[7]: **RELOADED**	4 to 6 servings

The flavor of this chicken dish is "piccata" indeed, with the acid of the lemon and the bracing brininess of the capers. There's also a rounded umami from the mushrooms. And to be honest, the chicken thighs are way better than the turkey breast I used in the original. Never send a breast to do a thigh's job.

SOFTWARE

½ cup (118 ml) low-sodium chicken broth

6 tablespoons (89 ml) white wine, such as Sauvignon Blanc

1 large lemon, half sliced into 6 slices and half squeezed for juice

6 (4- to 5-ounce/113- to 142-gram) boneless, skinless chicken thighs (see deboning diagrams, opposite)

3 teaspoons (10 g) kosher salt, divided

½ teaspoon freshly ground black pepper, plus more for serving

1¼ cups (175 g) all-purpose flour

4 tablespoons (57 g) unsalted butter, cut into tablespoon-size pieces

3 tablespoons (45 ml) extra-virgin olive oil

8 ounces (225 g) cremini mushrooms, thinly sliced

2 tablespoons (25 g) capers, drained but not rinsed

2 tablespoons (6 g) chopped fresh flat-leaf parsley

TACTICAL HARDWARE

- 2 heavy-duty gallon-size freezer bags
- An 11-inch, straight-sided sauté pan with a tight-fitting lid[8]

PROCEDURE

1) Combine the broth, wine, and lemon juice in a cup or bowl and set aside. Season the thighs with 2 teaspoons of the salt and all the pepper.

2) Dump the flour into a freezer bag and add one thigh. Push out as much air as possible, seal the bag, and shake to coat. Then lay the bag (and the thigh) flat on a counter or cutting board and gently pound with a meat pounder until the thigh is about ¼ inch thick.[9] Remove the thigh to a plate or pan and repeat with the remaining pieces.

3) Place the sauté pan over high heat for 1 minute. Then add 1 tablespoon each of the butter and oil and, when the butter just stops bubbling, carefully slide 2 thighs into the fat.[10] Reduce the heat to medium-high and cook, giving the pan a gentle shake every now and then, until golden brown, 2 to 4 minutes. Flip the thighs and repeat.[11]

4) Remove the thighs from the pan to a large plate or platter. Add another tablespoon each of butter and oil and cook another 2 thighs as before. Follow with the final 2 thighs.

5) When the last pieces of chicken exit the pan, immediately add the mushrooms and the remaining

7 Italian for "sharp."

8 A good braise requires a good seal. If your lid isn't exactly tight-fitting, have a large piece of heavy-duty foil standing by to use as an inner lid. Just place the foil over the top of the pan then press the lid down firmly to make a seal.

9 I especially like this method because it works the flour right into the surface of the meat so it's more likely to stay on during browning.

10 If the thighs are small, you may be able to get three in the pan at a time, but fight the urge to force them in there as food in a crowded pan rarely browns; it simply stews instead.

11 We're only browning to create flavor and color and to cook the rawness out of the flour, not to cook the chicken through—that'll happen later.

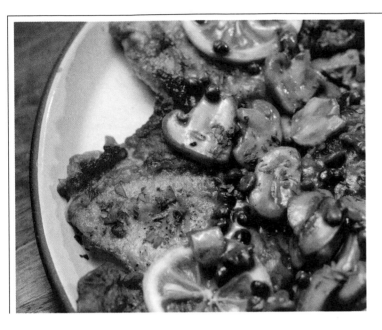

1 teaspoon of salt. Sauté until the mushrooms start to turn brown, about 5 minutes.

6) Stir in the capers and continue cooking for 1 minute. Deglaze with one-third of the wine-broth mixture, stirring to dissolve any browned goodness stuck to the bottom of the pan.

7) Return the thighs to the pan, overlapping pieces as needed, followed by the remaining wine mixture. Arrange the lemon slices atop the chicken, top with the lid, then reduce the heat to low and cook until the chicken is fork-tender, 5 to 7 minutes.

8) Remove the thighs and arrange on a platter. Boost the heat back to high, add the final 1 tablespoon butter to the sauce, and stir constantly until the sauce begins to thicken, 1 to 2 minutes. Pour over the chicken, then garnish with the parsley and serve.

BONING CHICKEN THIGHS

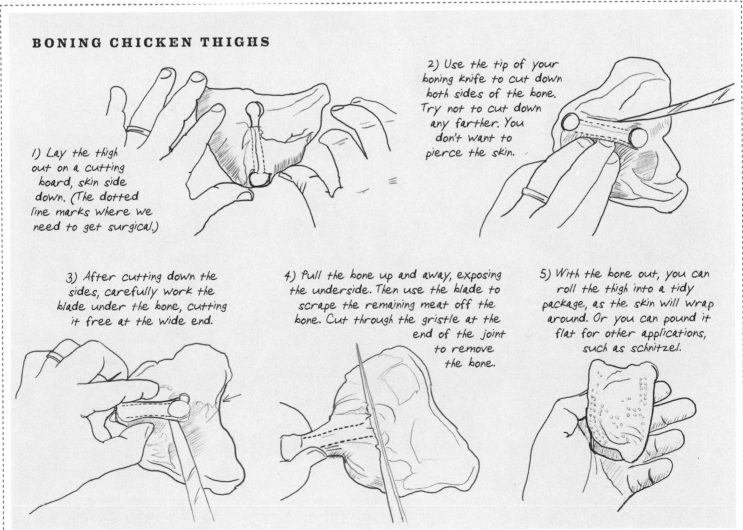

1) Lay the thigh out on a cutting board, skin side down. (The dotted line marks where we need to get surgical.)

2) Use the tip of your boning knife to cut down both sides of the bone. Try not to cut down any farther. You don't want to pierce the skin.

3) After cutting down the sides, carefully work the blade under the bone, cutting it free at the wide end.

4) Pull the bone up and away, exposing the underside. Then use the blade to scrape the remaining meat off the bone. Cut through the gristle at the end of the joint to remove the bone.

5) With the bone out, you can roll the thigh into a tidy package, as the skin will wrap around. Or you can pound it flat for other applications, such as schnitzel.

THE FUNGAL GOURMET: RELOADED

Sometimes when I look back at very early *Good Eats* episodes, I don't recognize myself or any of the cooking, either because my ways or tastes have radically changed, or because the marketplace has rendered ingredients once rare and exotic common if not downright ubiquitous. So it is with *Good Eats* episode 19, which sought to demystify matters of a mycological nature. My method for a simple sauté has changed radically, and I've dumped the stuffed cap recipe, which I don't think I ever made again after shooting the original show, in favor of a dish I make darn near every week.

Growing oyster mushrooms on coffee grounds

MUSHROOM SCIENCE

James Pace as "the Roach"

Mushrooms may contain many meaty elements, but the volume of the average mushroom is about 70 percent air and 27 percent water. Its primary structural component is chitin, a long-chain polymer derived from glucose that also makes up most of the exoskeleton of many insects, including the cockroach. The difference, of course, is that cockroaches are crunchy and mushrooms aren't.

Once you take their structure fully into consideration (something I clearly didn't do when writing the original applications), it's clear that the best way to sauté mushrooms is to cook them in water first. Since they're quite porous, hot water can easily move into mushrooms, deflating and compacting the air pockets, resulting in slices that are dense and meaty, yet also kinda floppy. At this point, fat can be used to brown the pieces, deepening the flavor in the process. And don't ever worry about overcooking mushrooms—it's dang near impossible due to the presence of chitin, which is very sturdy stuff.

MUSHROOM SHOPPING, STORAGE, AND CLEANING

Even though computerized, refrigerated trucks and pony express–style drivers are getting 'shrooms to the store quicker than ever, it still pays to be vigilant when shopping. For instance, don't assume that bulk or whole loose mushrooms are any fresher than mushrooms that are packaged. Freshness depends much more on what sells the quickest and gets restocked most often in your store.

If you see condensation inside the package, beware. The same goes for un-refrigerated mushrooms or mushrooms that are, heaven forbid, under the mister.

Back in the day, I said a bunch of stuff about mushroom storage and poking holes in plastic and whatnot, but . . . you can just leave mushrooms in their packaging if they come in it. Modern packaging and films provide reasonably well for mushrooms' respiratory needs. Loose specimens still go into paper bags, but I have no issues leaving these as is for up to four days.

When it comes time for cleaning, I treat different specimens, well, differently. It comes down to how they are grown and how many I may need. If I want a few for a raw application, like a salad, I give them a sweep with a semi-stiff brush like a pastry brush and go about my dish. If I'm dealing with a lot of mushrooms like these oysters, I give them a quick dunk in cold water. I used to spray them but have since found a dunk efficiently dislodges dirt and bugs and stuff. Oh, by the way, I always use a salad spinner for this task, because it's easy to fill the salad spinner with water, dunk your mushrooms, and toss them around. When they look clean, remove the inner basket, dump that nasty water, return the inner basket to the vessel, clamp on the lid, and take 'em for a spin, as you would salad greens. If they're still a bit damp, dry with a clean tea towel.

At least seventy-one species of mushrooms are capable of glowing in the dark.

Death's only official appearance on *Good Eats*—that's Todd Bailey behind the skull.

Squid Pro Quo

Raising The Bar Again

Celebrity Roast

Tomato Envy

...nk Made

Melondrama

I puy ṛuṃ ʍ əɥⱢ

Squash Court

MUSHROOM SAFETY

In the original episode (the only one to feature Death as a character), we talked at length about the safe purchasing of wild mushrooms from either reputable markets or mushroom foragers, preferably old ones. The gist? Never forage for mushrooms yourself unless you've been trained to do so, because it's too easy to get a hold of something that will make you very sick or even deceased. Don't think you can pull an Alma from *Phantom Thread* and kinda sorta poison your spouse to make them easier to handle. That almost never comes with a side of happy ending.

SAUTÉED MUSHROOMS, AGAIN: RELOADED

YIELD:

4 to 6 servings

Sautéed mushrooms are delicious all on their own, but they can also serve as a foundation for other dishes.

SOFTWARE

1 pound (454 g) button or cremini mushrooms, sliced[1]

⅓ cup (79 ml) water

2 tablespoons (28 g) unsalted butter

1 tablespoon (4 g) chopped fresh parsley or other fresh herb of your choice (I'm a fan of chervil)

½ teaspoon kosher salt

¼ teaspoon freshly ground black pepper

1 Truth is, you can use a lot of different mushrooms here, including oysters, shiitakes (sans stems), or any other firm mushroom . . . or a mixture thereof.

PROCEDURE

1) Heat an 11-inch, straight-sided sauté pan or other large skillet over high heat for 45 seconds. Add the mushrooms and water and cook until the mushrooms collapse, 2 to 4 minutes.

2) Add the butter and cook, stirring occasionally, until the mushrooms are deeply browned, 7 to 10 minutes. Kill the heat and stir in the parsley, salt, and pepper. Transfer to a bowl and serve.

Mushroom roots, or mycelium, can be made into a packing material that can be disposed of by simply tossing it into the yard.

MUSHROOM STROGANOFF TOAST: RELOADED

YIELD:

4 servings

The word "stroganoff" refers to dishes of (supposedly) Russian origin typified by the addition of sour cream and scallions or chives. Oyster mushrooms (my personal favorite) and plenty of black pepper make this toast special enough for company. Cut the toasts into small planks and top for hors d'oeuvres, or top with a poached egg for an elegant breakfast.

SOFTWARE

8 ounces (227 g) oyster mushrooms, tough ends removed, caps torn into generous bite-size pieces[2]

3 tablespoons (36 g) ghee (see recipe on page 250), melted, divided

1¼ teaspoons kosher salt, divided

1 teaspoon fresh lemon juice, plus more to taste

1 pound (454 g) mixed meaty mushrooms, such as cremini and button, trimmed and sliced ¼ inch thick

⅓ cup (79 ml) water

4 scallions, thinly sliced on the bias, white and green parts separated

¼ teaspoon freshly ground black pepper, plus more for serving

¾ cup (180 g) sour cream

2 tablespoons (30 ml) heavy cream

4 slices high-quality bread (¾ inch/ 2 cm thick), such as country French or sourdough

Oil or ghee to brush on the bread, for toasting

TACTICAL HARDWARE

• A toaster oven, ideally

PROCEDURE

1) Heat your toaster oven to convection roast at 400°F or your standard oven to 425°F.

2) Toss the oyster mushrooms with 1 tablespoon of the ghee and ¼ teaspoon of the salt. Spread in an even layer on a quarter sheet pan or the pan that came with your toaster oven. Cook for 10 minutes, then flip the mushrooms and cook until tender and well browned, another 5 to 8 minutes. Remove to a bowl, drizzle with the lemon juice, and set aside.

3) Meanwhile, heat a large, heavy skillet over high heat for 45 seconds, then add the sliced cremini or button mushrooms and the water and cook until the mushrooms collapse, 2 to 4 minutes. Add the remaining 2 tablespoons ghee and cook until the liquid has evaporated and the mushrooms have browned, 7 to 10 minutes.

4) Remove the pan from the heat and stir in the scallion whites and half of their greens, along with the remaining 1 teaspoon salt and the pepper.

5) Whisk the sour and heavy creams together in a large bowl, then fold in the cremini or button mushrooms.

6) Brush the bread slices with the fat of your choice and toast (I like to see the edges go nearly black) in whichever oven you cooked the oyster mushrooms.

7) Divide the sour-creamed mushrooms among the toasts and top with the oyster mushrooms and the reserved scallion greens. Finish with several grinds of black pepper and serve.

2 Oyster mushrooms come in pink, gold, and even blue, and are so named because they do in fact look a little like oysters. These are my favorites for a lot of reasons—flavor, texture, and the fact that they can be grown in a substrate of coffee grounds. I feed them, they feed me. The circle of life.

GHEE WHIZ: RELOADED

YIELD:
About 2 cups

Ghee is clarified butter cooked until it's golden and nutty. If refrigerated, it has a shelf life like uranium, and since it's pure butterfat with all the water cooked out and solids removed, it can be used to cook over high heat and is perfect for sautés.

SOFTWARE

1 pound (454 g) high-quality butter[3]

Because of the solids it contains, butter starts to burn at around 350°F. Ghee can be used up to 480°F.

PROCEDURE

1) Put the butter in a 2-quart light-colored stainless-steel saucepan.[4] Cover the pot with a small, overturned fine-mesh sieve that fits over the saucepan to catch any splatters. Place over the lowest heat you have.[5]

As the butter melts, the water will begin to boil out. There will be some popping and hissing during this stage, which explains the sieve. After this the milk solids will aggregate, sink to the bottom, and brown.[6] The entire process can take as long as 4 hours, depending on the butter, the pan, the heat, and so on.

2) When the liquid butter is clear and gold and the sunken solids have turned dark brown with only tiny bubbles still rising from the

Ghee: magical stuff

bottom, remove from the heat and strain through a fine sieve,[7] cool to room temp, then cover tightly to store on the counter or in the fridge.[8] The brown bits on the bottom of the saucepan are also delicious, especially sprinkled over vanilla ice cream.

3 I like Kerrygold, but the most important part about your butter selection is its water content. Higher-quality butters typically contain more fat and less water, making it quicker (and less explosive) to make both clarified butter and ghee. Plus, they just taste better.

4 When I made ghee on the show, and when I make it at home, I like to place the butter in a heatproof chemistry beaker covered in cheesecloth. This I set on top of one of my small carbon-steel skillets (to act as a heat diffuser) and cook over low heat. This rig allows me to see exactly what is going on with the butter at all times. If you've got both of those things, I encourage you to try this method. There isn't, however, a good way to jury-rig a similar setup without risking glass explosions, so if you can't locate said beaker, you'll want to make your ghee in a saucepan.

5 If you're lowest isn't that low, consider using a small cast-iron skillet as a diffuser between heat and pan.

6 These are assorted proteins, amino acids, and milk sugars, and we're going to brown them and steal their flavor souls. So wait. Wait.

7 I have a metal coffee filter that fits over a pint jar that's perfect for this, though I do have to pour rather slowly.

8 Because the water's been cooked out, cold ghee sets up pretty hard, so you may want to set the jar on the counter for a few minutes before use.

GOOD EATS PICKLED MUSHROOMS: RELOADED

YIELD:

About
2 cups

I'm a huge fan of Russian cuisine, and I'm particularly obsessed with *zakuski*, the hors d'oeuvre meant to be served between shots of ice-cold vodka. Pickles are always the heart of any *zakuski* lineup, and my favorites are *marinovannymi gribami*, pickled mushrooms. I always keep a jar on hand.

SOFTWARE

Water, for blanching, plus ½ cup (118 ml) for the brine

6 teaspoons (20 g) kosher salt

1 pound (454 g) button mushrooms, stems trimmed

6 black peppercorns

4 allspice berries or additional black peppercorns

1 clove garlic, thinly sliced

2 bay leaves

½ cup (118 ml) white wine vinegar

¾ teaspoon sugar

PROCEDURE

1) Pour 4 inches (10 cm) of water into a medium saucepan, season with 4 teaspoons of the salt, and place over high heat. When boiling, add the mushrooms and cover with a metal steamer basket if you've got one.[9] If not, use a smaller pot lid—anything to keep the little buggers submerged. Return to a boil and cook until the mushrooms begin to soften, about 2 minutes.

2) Drain the mushrooms, move to a clean towel, then roll up and squeeze to dry. Put half of the mushrooms in a pint-size canning jar. Top with the peppercorns and allspice berries, along with half of the garlic. Slide the bay leaves down the sides of the jar. Top with the remaining mushrooms and garlic.

3) Refill the saucepan with the ½ cup (118 ml) water, the remaining 2 teaspoons salt, the vinegar, and the sugar. Bring to a simmer over medium-high heat, stirring to dissolve the sugar and salt. Remove from the heat and pour enough of the brine over the mushrooms to fill the jar to the top. If you have any leftover brine after that, dump it.

4) Allow the mushrooms to cool to room temperature, then lid up and refrigerate for at least 3 days before enjoying. Enjoy within a couple of months.[10]

9 Since they're full of air and therefore float, mushrooms are tricky to blanch. Hence the folding steamer basket. BTW, this step will, as we saw with the sautéed mushrooms, soften their structure so they'll be more receptive to the brine.

10 In truth, they never "keep" in here for longer than one bottle of vodka. And yes, you can eat them before they've been in the fridge for 3 days, but if you want them at their best, have a little patience.

THE ICING MAN COMETH: RELOADED

The earliest "iced" cakes were painted with egg whites and sprinkled with sugar.

Good Eats episode 84, from back in 2003, explored the art of cake decorating and, with it, the creation of frostings. But the old version of me opened the show with a major gaff, speaking of frostings and icings as though they were synonyms, which they're not. Frosting is light and fairly fluffy and typically plopped onto a cake in a pile and pushed around. Icing is thinner and smoother and often sets hard like a glaze. Cakes get frosting, cookies get icing.

This show also contained one of my lowest-rated recipes of all time: buttercream frosting. One internet reviewer said the only reason they gave it a single star was because no stars wasn't an option. Well, I'm happy to report that long-overdue repairs and renovations have been made to that original recipe, and to make up for past sins, I've included a second buttercream, a buttermilk version, at no additional charge.

TYPES OF BUTTERCREAM

No frosting is more beloved, more versatile, or more misunderstood, than buttercream. This is probably due to the fact that there are about a dozen different ways to make buttercream that vary considerably depending on their country of origin. Besides America, France, Italy, Germany, and even noncommittal Switzerland have strong feelings about buttercream.

American buttercream: Made by whipping soft butter (and often shortening) with confectioners' sugar, then finishing with a bit of dairy, this is the simplest frosting on the list. Because many recipes use up to twice as much sugar as butter, American buttercream is often overly sweet and one-note. I counter that tendency in my recipe by finishing the frosting with a one-two punch of buttermilk and sour cream.

Swiss buttercream: The easiest of the true buttercreams, Swiss buttercream starts with a Swiss meringue—egg whites cooked with sugar over a water bath and then beaten to a foam—into which softened butter is beaten. This is likely the frosting you've eaten when you've eaten wedding cake, or just about any cake served at a restaurant.

French buttercream: Similar to a Swiss buttercream, but made with egg yolks instead of whites, French buttercream is rich and custardy, with a pale-yellow color. It can also be made with raw egg yolks beaten with a hot sugar syrup.

Italian buttercream: Italian buttercream is made using a raw egg white foam and a hot sugar syrup. (So, it's just like the uncooked French meringue, but made with egg whites instead of yolks.) It's slightly lighter than a Swiss meringue in texture but otherwise very similar in flavor.

German buttercream: Instead of using whipped eggs for the frosting's base, German buttercream starts out with a thick, homemade vanilla pudding that is chilled and then gradually beaten together with butter. It's got, not surprisingly, a custardy, dairy-filled flavor and creamy texture.

Buttercream Reloaded: My reloaded recipe is a combination of the Swiss and French styles for a buttercream all my own; it's flavorful, stable, and just rich enough. The Goldilocks of buttercreams, if you will.

SUCROSE

SYRUP SCIENCE

When you're making a syrup with something that's very pure, like table sugar (99.9 percent sucrose), and you evaporate off a lot of the water, the molecules are packed in there tight against each other and they tend to hop into their natural configuration, which is to say, they crystallize. Complicating matters is the fact that if agitated, even the tiniest crystals can aggregate, creating rock candy. This means you have to add more water to redissolve them, thus setting off a potentially vicious cycle. Since we're starting with corn syrup in the mix, we will avoid this problem, because glucose, the main sugar in corn syrup, prevents sucrose molecules from hooking up.

BUTTERCREAM: RELOADED

YIELD:

About 4 cups

Like just about every buttercream recipe, my version calls for the same simple ingredient list of eggs, butter, and sugar. Now, simple doesn't necessarily mean easy. I've certainly made some bad buttercream over the years. But I'm happy to report that this version is my most foolproof buttercream yet, and it's versatile enough to be used on just about any of your favorite cakes.

SOFTWARE

1 pound (454 g) unsalted butter[1]

2 large whole eggs plus 3 large whites, at room temperature

223 grams (1 cup plus 1½ tablespoons) granulated sugar

157 grams (½ cup) light corn syrup

⅛ teaspoon (½ gram) kosher salt

TACTICAL HARDWARE

- You really don't want to tackle this without a strong stand mixer with a whisk attachment.

PROCEDURE

1) Slice the butter into ½-inch-thick pieces and place in a single layer on a plate on the counter. Let sit on the counter until the butter has warmed up to between 63°F and 65°F, 35 to 40 minutes.[2] If the butter gets over 65°F, return temporarily to the refrigerator.

2) While the butter warms, place a folded kitchen towel in the bottom of an 11-inch straight-sided sauté pan or large skillet. Add an inch of water to the pan and bring to a bare simmer, about 190°F. Whisk the whole eggs, egg whites, sugar, and corn syrup together in your stand mixer's work bowl, then place the bowl in the water, atop the folded towel. Tilt the bowl as needed so the egg mixture is in contact with the submerged part of the bowl. (Some mixers have an added piece of metal at the bottom that necessitates this.) Cook, whisking constantly, until the sugar dissolves and the mixture reaches 160°F, 5 to 7 minutes.

3) Move the bowl to the stand mixer, load the whisk attachment, and crank the speed to high. Beat until the mixture thickens and cools to around 75°F, 10 to 12 minutes. Drop the speed to medium and add the butter, one piece at a time, making sure each piece is fully incorporated before adding the next, about 6 minutes.[3] The mixture may appear to curdle about halfway through this process, but keep adding the butter and it will come together.

4) Stop the mixer and scrape down the sides and bottom of the bowl. Add the salt, boost the speed to high, and beat until the buttercream is smooth and creamy, about 2 minutes.

Use immediately or store, tightly covered, in the refrigerator for up to 3 days.[4] If chilled, bring back to room temperature and quickly re-whip until fluffy, 1 to 2 minutes, before using.

1 Now, since this is a buttercream, it does make sense that we would use the best butter we can get our mitts on! And most of the time, that's gonna mean the butter with the highest fat content, and therefore the most expensive butter. But fat is not everything. It also needs to be fresh butter. As a matter of fact, I'd rather have fresh, cheap butter than old, expensive butter. Anyway, just look at the use-by date, and try to make sure you buy butter that's got a date as far away as possible.

2 And yes, if you want to use a probe thermometer with an alarm you'll make my heart skip a beat.

3 We've made the butter disappear like magic, so at this point we have a cooked emulsion that's also a syrup, which means we can make it take on quite a bit of air.

4 Since it's mostly fat and air, buttercream is vulnerable to rancidity, and to the absorption of other . . . well, less-appropriate flavors, like, say, fish. Keep it in an airtight container with a layer of plastic wrap right on top.

AMERICAN BUTTER(MILK) CREAM: RELOADED

YIELD:

About 4 cups

If you've ever had qualms about making classic buttercream because of the raw eggs, then this one's for you. American buttercream uses a similar roster of software, but eliminates the eggs and corn syrup, and uses fine confectioners' sugar instead of granulated, along with a bit of shortening. This version puts a twist on most of the American buttercream recipes out there by finishing with buttermilk and sour cream, which together provide a tangy rebuke to the cloying sweetness typical of the species. (Notice that this recipe has equal parts fat and sugar, which means we're using a lot less sugar than most American buttercream recipes.)

SOFTWARE

¼ cup (60 ml) low-fat buttermilk, cold

30 grams (2 tablespoons) full-fat sour cream, cold

18 tablespoons (255 g) unsalted butter, cut into ½-inch pieces, at cool room temperature (about 65°F)

7 tablespoons (85 g) unflavored shortening, at room temperature[5]

3 cups (340 g) confectioners' sugar[6]

1 tablespoon (12 g) vanilla extract

¾ teaspoon kosher salt

TACTICAL HARDWARE

- A stand mixer, this time with a paddle attachment

In Britain, confectioners' sugar is known as "icing sugar," while "castor sugar" is coarser but still finer than table sugar.

5 Shortening replaces some of the butter, which will make the frosting easier to work with even straight from the fridge. And since shortening has a different melting point, I think it's more interesting on the tongue, as butter melts just below body temp and shortening just above.

6 My favorite confectioners' sugar to use in this recipe is Domino. Other brands tend to yield a slightly grittier frosting.

PROCEDURE

1) Combine the buttermilk and sour cream in a small bowl and stir well. Park in the refrigerator until you're ready to use.

2) Put the butter and shortening in your mixer's work bowl and sift in the sugar. Install the paddle attachment and beat the mixture on low to incorporate. Add the vanilla and salt and increase the speed to medium. Continue to beat until light and airy, 5 to 6 minutes. Scrape down the sides and bottom of the bowl as needed.

3) Add the buttermilk–sour cream mixture and beat on low until integrated. Stop and scrape the bowl, then return the speed to medium and beat until smooth, about 15 seconds.

Use immediately or tightly seal and refrigerate for up to 3 days or freeze for up to 1 month. If frozen, thaw overnight in the refrigerator prior to use. The frosting is spreadable straight from the refrigerator, but it is even easier to use at room temperature. Since shortening has a melting point a bit higher than butter, this is my go-to warm-weather frosting.

REGARDING CAKE FROSTERY

Cake. I like cake.

TACTICAL HARDWARE

- A long serrated knife
- A rotating cake stand
- An offset spatula
- A triangular cake tool (optional but strongly recommended)

If your cake comes out of the oven with a hump on top, that hump's got to go, or the finished cake will never be level. A long, serrated knife is the easiest way to level. I do this with the cake on a rotating cake stand, which allows me to work the knife with one hand while rotating the cake with the other.

If you want to double up on your layers, you'll also want to split the cakes in half horizontally, a slightly tricky maneuver, but made easier by using a ruler to go around the cake to make guide marks by sticking toothpicks into the edge to rest the knife on. Next, take that same long, serrated knife you used to level the cake and, holding it horizontally, move it around the midsection of the cake (it helps to have the cake secured to a spinning cake round; see the next paragraph). Continue to move the knife around the cake, moving closer and closer to the center, until you are able to slowly, deliberately, slice through to the other side.

To frost, place one cake layer, cut side up, on a cardboard cake round (a little frosting placed in the center of the round works great as an edible glue), then place this arrangement on top of a spinning cake stand or a lazy Susan set on top of an overturned cake pan.

Next, use a plastic dough scraper to deposit frosting on top of the bottom layer. Spread it evenly to the edges using an offset spatula, spinning the cake as you work, then top with the second cake layer, bottom-side up. Repeat the frosting process with about a quarter of the remaining frosting, getting it in a thin layer and working it to the edges. Let it fall down the sides, then, slowly spinning the cake stand, use the edge of your offset spatula to smooth out the frosting on the sides. If necessary, slap on a little additional frosting as you go.

At this point, we're not trying to get a full coat of frosting on the cake—instead, we're aiming for a thin layer called a crumb coat (you can think of it as frosting primer). This'll lock any stray crumbs in place so when we go in with the final layer, it'll be nice and clean. Pop the cake in the fridge for 30 minutes to allow the crumb coat to set up a bit. But don't leave it in there much longer, or condensation will make adhesion difficult for the final coat.

When you're ready to finish, place all the remaining frosting on top of the cake, then (again using that offset spatula) slowly work it out toward the edges and then down the sides. If you get a little on your fingers, well, don't worry about it. Remember, frosting like this is a subtractive process: The idea is not to ever need more frosting, but to slowly remove it as you smooth the tops and sides.

Once the frosting base is in place, there's a clean canvas on which to create. This is where the tools can get special-ized. For instance, if a sleek modern look is desired, a cake comb can be employed. It's just a triangular piece of plastic with different patterns cut out on each edge. And, of course, various piping bags and tips can be employed; with skill, you can make everything from basketweave textures, to flowers, to borders. If the target cake is birthday oriented, writing chocolate or icing is employed via a parchment cone or piping bag.

Of course, I don't have many of these fancy tools, so I make do with what is already in my kitchen. My favorite method gives me a stucco look: Simply take a butter knife and touch it to the surface of the buttercream and then pull it straight away with a little snap to make something that looks, well, downright spiky.

OFFSET SPATULA

Spatulas basically come in two styles, straight and offset, and they come in all sizes, from little bitty one-inchers all the way up to massive specimens. I like offsets because they keep my knuckles up and out of the frosting.

OAT CUISINE: RELOADED

It's hot in here and it smells funny (rental bear).

"Granula," a dry cereal made of graham flour, was invented by Dr. James Caleb Jackson around 1863 and was composed of graham flour baked into sheets and then broken up and packaged. Although it required soaking in liquid for at least 20 minutes prior to consumption, it's considered the first commercial "dry" cereal.

Although the recipes from 2001's "Oat Cuisine" still work just fine, my methods have evolved enough over time to warrant reloading all three of the applications. Note, please, that the overnight oats no longer employ any cooking at all, slow or otherwise. But first, a brief review in case you're rusty.

The oat varieties you're likely to run into at your local megamart these days include:

Oat groats: The least-refined oat, which only has its outer hull removed. You *can* eat them, but they must be soaked overnight and simmered for hours.

Steel cut oats (aka Scotch oats, Irish oats, and pinhead oats): Made by running oat groats through steel cutters. They take quite a bit longer than rolled oats to cook but do produce a very creamy, nutty porridge.

Rolled oats (aka old-fashioned oatmeal): These are made by steaming oat groats, then pressing them thin between rollers and drying them. This process speeds up cooking time considerably but can make for mushy porridge if you're not careful about it.

Extra-thick rolled oats: Like rolled oats only thicker, these weren't widely available back in 2001, so we didn't feature them. Exact water amounts and cooking times differ per brand, so experimentation may be required. Personally, I'm not a fan.

Quick oats (aka instant oatmeal): If you take rolled oats and mash them even thinner, par-cook them with steam, then dry them, you get "quick" or "instant" oats, which if you ask me aren't good for much, despite the time savings.

OAT NUTRITION

Besides unsaturated fat, carbohydrates, minerals, protein, and vitamins, oats contain a heck of a lot of fiber, aka the portion of a plant that we eat but can't easily digest. There are two distinct brands of dietary fiber, soluble and insoluble, and they act very differently inside the ole gastrointestinal tract. Insoluble fiber doesn't dissolve in water (hence its name), so it moves through the body very quickly, taking just about anything nearby along with it. Everybody needs this kind of fiber on a regular basis.

Soluble fiber, which does dissolve in water, turns into a thick gel that moves very slowly through the digestive system. Translation? When you eat foods high in soluble fiber, you're going to stay full longer and likely eat less. This brand of fiber also slows the absorption of glucose into the body, which means you're less likely to experience a sugar high and its inevitable result—a sugar crash. What's more, soluble fiber will inhibit the reabsorption of bile into the body, which means your liver will get its cholesterol fix from your blood, lowering your overall cholesterol levels.

Multiple types of oats are commercially cultivated, but odds are good *Avena sativa* is what you'll find at the market.

JUST RIGHT OATMEAL: RELOADED

YIELD:
2 servings

Fluffy, nutty, and a tiny bit crunchy, thanks to a pre-simmer toasting and a micro-dose of quinoa, this oatmeal is pretty dang near perfect. I like to melt on a pat of quality butter and top with a spoonful of good fruit preserves. When they're in season, I add fresh blueberries for the last few minutes of cooking and then stir them in. Oh, and toasted walnuts are nice too.

SOFTWARE

120 grams (1¼ cups) old-fashioned rolled oats

25 grams (2 tablespoons) quinoa[1]

½ teaspoon kosher salt, plus more to taste (see box on page 263)

450 grams (1¾ cups plus 2½ table-spoons) boiling water[2]

TACTICAL HARDWARE

- An electric kettle (recommended but not required)[3]

Might be too much butter.

[1] I have invited quinoa to the party not only for protein but for a nice textural contrast to the oatmeal, that is: crunch. Could you skip it? Yes, but I don't. Also, when I cook a pot of quinoa, I always wash it first, but for this amount I don't bother.

[2] I use an electric kettle for this because it's fast and efficient. I may still own a cooktop kettle, but if I do I have no idea where it is.

[3] These days, many electric kettles allow you to set the exact temp you want your water at. This makes brewing things like green tea a snap. I love my home model and even have a collapsible silicone model for travel.

PROCEDURE

1) Spread the oats on a quarter sheet pan or the pan that came with your toaster oven and toast in said toaster oven until slightly brown and nutty smelling, 5 to 7 minutes. Watch the oats closely, as they can go from perfect to burned in the blink of an eye. Technically, toasting is an optional step, but it brings a lot of flavor to the party, so I take the time. (If you don't have a toaster oven, you can toast your oats in a regular oven set to 350°F for 12 to 15 minutes.)

2) Transfer the oats from the toaster oven to a 2-quart saucepan. Place over low heat and add the quinoa and the salt, followed by the boiling water. Give the mixture a quick stir, cover, and cook for 18 minutes without lifting the lid or messing with the pan in any way, fashion, or form.

3) When time is up, carefully remove the lid and use a fork to gently push down the side of the pan so that you can see if any water is puddled in the bottom of the pan. If it is, continue cooking over low heat, uncovered, until the water cooks out, 1 to 3 minutes.

4) Remove the pan from the heat and gently fluff the oatmeal with the fork. Don't stir or the porridge will go gummy on you. Season to taste with additional salt if needed. If fruit is desired (berries are a good shape and size, though strawberries should be halved and larger ones quartered), place atop the oatmeal, replace the lid, and wait for 5 minutes before serving.

OVERNIGHT COCONUT OATS: RELOADED

YIELD:

4 servings

Creamy, sweet, spicy, fragrant, tropical, and nutritious, these overnight coconut oats require absolutely no cooking at all. Yes, some other grains are involved (pseudocereals, to be exact), but oats are still singing lead. The flax enhances the texture, even after an all-night soak, and the chia seeds capture water to lend a very pleasing pudding consistency. (I confess to having occasionally added a few squirts of chocolate syrup to the bottom of each jar.)

SOFTWARE

¾ cup (120 g) dried fruit, such as cranberries, cherries, or blueberries

1⅓ cups (160 g) old-fashioned rolled oats

2 tablespoons (12 g) flaxseed meal

2 teaspoons (8 g) chia seeds

¼ teaspoon ground cinnamon

¼ teaspoon kosher salt

1⅓ cups (308 ml) full-fat coconut milk

1⅓ cups (308 ml) unsweetened almond milk

2 tablespoons (30 ml) dark maple syrup

1 teaspoon vanilla extract

½ cup (26 g) coconut flakes, toasted[4]

TACTICAL HARDWARE

- A canning funnel (not required, but sure makes putting stuff in the jars a lot easier)
- 4 (8- to 10-ounce) jars

PROCEDURE

1) Using a canning funnel, divide the dried fruit evenly among the four jars, then add ⅓ cup (40 g) oats to each, along with 1½ teaspoons flaxseed meal, ½ teaspoon chia seeds, and a pinch each of cinnamon and salt.

2) Whisk the coconut milk, almond milk, maple syrup, and vanilla together in a large measuring cup, then divide among the jars.

3) Lid the jars tightly and shake vigorously to combine. Refrigerate overnight or for up to 1 week.

Serve right out of the jar, topped with the toasted coconut.

4 I like to toast my flakes to golden brown goodness in my toaster oven. It takes 2 to 3 minutes on the, er, toast setting. If you don't have a toaster oven, you can toast in a dry pan over medium-low heat, stirring frequently, until golden brown, about 5 minutes.

GRANOLA: RELOADED

Packed with nutritious ingredients like almonds, pumpkin seeds, flaxseed meal, and coconut oil, this updated granola application is a pantry staple for me. Stored in an airtight container, it can keep for over a month, but it never lasts that long. The best way to get in your granola is of course on ice cream. And yes, I sometimes have ice cream for breakfast—don't you judge me.

Oh, another thing: If you want to measure out all the ingredients with spoons and cups, fine, but if you just weigh everything into a large bowl, and zero out the scale before every addition, you won't have to dirty up anything but the bowl. Saves a lot of time, too.

SOFTWARE

2¾ cups (283 g) old-fashioned rolled oats

1 cup (113 g) slivered almonds

¾ cup (85 g) pecan halves, roughly chopped

⅓ cup plus 2 tablespoons (85 g) packed light brown sugar

6 tablespoons (57 g) hulled pumpkin seeds, aka pepitas

9 tablespoons (43 g) unsweetened shredded coconut

2 tablespoons (15 g) flaxseed meal[5]

¼ cup (60 ml) dark maple syrup

2 tablespoons (30 g) coconut oil, melted

2 tablespoons (30 ml) grapeseed oil

½ teaspoon kosher salt

6 tablespoons (57 g) dried cranberries or other dried fruit (optional)

5 tablespoons (57 g) dried blueberries or other dried fruit (optional)

TACTICAL HARDWARE

• A large metal mixing bowl

• A digital scale (optional but strongly suggested)

PROCEDURE

1) Set the oven to 250°F and place a rack in the middle position.

2) Stir the oats, almonds, pecans, brown sugar, pumpkin seeds, coconut, and flaxseed together in a really big bowl. Then add the wet works: maple syrup, coconut oil, grapeseed oil, and salt. Stir together with your own two (clean) hands.

Serve on ice cream for breakfast... it's the only way.

5 Be sure you stash your flax tightly sealed and in the fridge—it's extremely vulnerable to rancidity.

NEW & IMPROVED GRANOLA

3) Transfer to a half sheet pan or a large cookie sheet with a lip and bake for 2 hours, stirring every 15 minutes to ensure evenness. When golden brown, transfer back into the big bowl and toss until cool.

4) Before storing in airtight containment, add the blueberries and cranberries, if desired.[6] Stashed in a cool spot away from direct light, the granola should keep for 1 month.

WHEN TO SALT OATMEAL

Back in '01, I made a big deal about not waiting to salt oatmeal until after it was cooked. Why? It's a long story, and I used a bunch of dolls to tell it. Violence was also involved . . . It was ugly. All you need to know is that when rolled oats are involved, you don't have to worry about salting after cooking; adding it right before the water is fine and, frankly, I usually notice I need less salt later if I do.

GLUTEN-FREE

Now, we all know that oatmeal is good for us, but one of the health considerations we didn't mention back in whenever is that oatmeal is gluten-free . . . er, "mostly" gluten-free. The reason is that many of the oats on the market are processed in factories with other grains and could therefore be contaminated by small amounts of products containing gluten—for example, wheat. We didn't mention that back in 2001 because most folks then didn't know what gluten was, much less that they might need to be free of it unless they had celiac disease, which is serious business indeed. By and large, oats are gluten-free. If you have celiac or gluten intolerance, look for oats that are specifically labeled gluten-free to avoid any cross-contamination.

6 I used to add raisins, but truth is I've never liked the nasty things, so I'm going with equal parts cranberries and dried blueberries. That said, if you don't dig fruit in your nuts, just skip it altogether.

RAISING THE BAR: RELOADED

This episode is dedicated to Deb Duchon and all the other nutritional anthropologists out there.

The Soggy Bottom Scientists!

We didn't get around to making a cocktail show until 2006, when we finally had the budget to build a bar set. (Yes, we could have tackled the subject in our kitchen set, but darn it, I've always wanted to own a bar, so I held out.) I can't remember exactly why I chose the martini, the daiquiri, and the mint julep, but the trio was probably selected for their spirits (gin, rum, and bourbon) and because they're all tragically misunderstood. Oh, yeah . . . and I like them. I've matured in my drinking habits since those days, and although the daiquiri recipe still holds its own I wanted to rework the martini from the ground up and the julep needed a mint syrup. But the real reason for reloading "Raising the Bar" was that I wanted to make some decent ice cubes.

First, let's review some hardware:

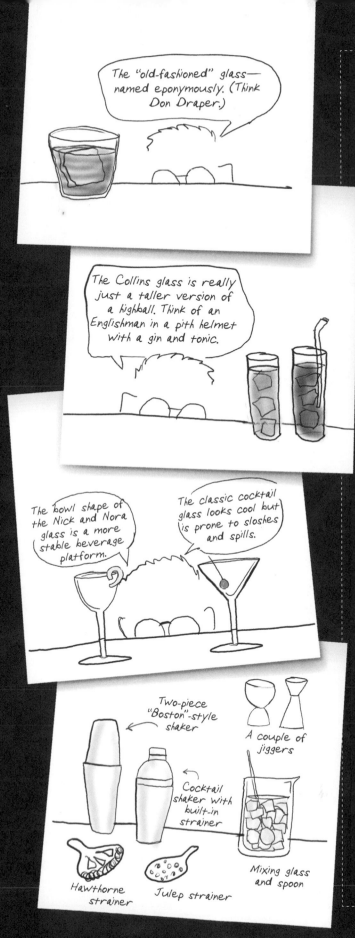

OLD FASHIONED GLASS (AKA LOW-BALL GLASS): This one is more often referred to as a rocks glass because it's a glass for strong cocktails typically containing one or two spirits that are mixed right in the glass in the presence of ice.

HIGHBALL GLASS: For drinks composed of a spirit and a fair amount of a nonalcoholic mixer. (A taller, narrower version is called a Collins glass.) The gin and tonic comes to mind, as does the Cuba Libre.

COCKTAIL GLASS: Ask any bartender worth their margarita salt and they'll tell you that the martini/cocktail glass, with its straight sides and pointy bottom, is a truly terrible vessel for the conveyance of potables. And yet it is an icon, and I blame two guys. Oswald Haerdtl, an Austrian designer and architect who collaborated with Lobmeyr, an Austrian glass firm, to create glassware for the International Exhibition of Modern Decorative and Industrial Arts mounted in Paris in 1925. Dubbed "Ambassador," the line featured conical shapes in keeping with the burgeoning aesthetic of the Art Deco movement. The shape caught on with gin-centric tipplers in the United States but didn't gain full eponymousity until James Bond started carrying them around. (I can only hope Q Branch frowned on the inefficiency.)

NICK AND NORA GLASS: These days my martinis, Manhattans, negronis, gimlets, and the like make it to my mouth via this glass, named for the sleuthing-while-swilling couple from the *Thin Man* movie series. The 5- to 6-ounce Nick and Nora features steeper sides, which greatly reduce sloshing while still welcoming garnishes such as twists, olives, pickled onions, and so on. This is an elegant multitasker that will never go out of style.

Although I use the small double cups called "jiggers" to mix at home, I don't use "jigger" as a measurement in recipes, because although most bartenders agree that a standard jigger equals 1.5 ounces, it's not gospel, nor is there any great advantage in saying "jigger" over "one and a half ounces."

SHAKERS AND MIXING GLASSES: Now, as for the shaker, sorry, Mr. Bond, shaking can produce a colder drink but it also tends to make a more diluted one, and that's not how I roll. My rule is simple: If the cocktail in question requires homogenization of, say, fruit juice or syrups or egg whites for a fizz, I shake. If, however, said beverage is composed of clear spirits, I stir in a mixing glass or pitcher with a cocktail mixing spoon and a strainer, either a Hawthorne or julep strainer. Either is fine, but make sure it fits the top of your pitcher or sad you will be.[1]

1 Can you mix in a Mason jar with a disposable chopstick? Of course you can. But part of the joy of drinking is the ritual of assembly, and I know that I enjoy having and using my own mixing glass and bar spoon, which are used for cocktails only.

MARTINI INGREDIENTS, METHODS, AND SUCH

In 1730 there were more than seven thousand gin shops in London. Since gin joints allowed women, the drink became known as "mother's ruin."

GIN

For my martinis I prefer a London Dry gin, that is a neutral, agriculturally derived spirit of 96% ABV[2] that is redistilled with aromatic botanicals such as juniper berry, citrus, and angelica to a minimum ABV of 70% before being diluted down to the high 30s. Or at least that's the case if the EU is watching over the process. Here in the United States, gin is rarely below 40% ABV, which means a martini here may be stronger than a martini on the

other side of the pond. London Dry gins don't legally have to come from London any more than bourbon must hail from Kentucky, though some of my favorites still do.

VERMOUTH

The name comes from the German word for wormwood, which used to be a common flavorant though not as much today. In the simplest terms: A vermouth is an aromatized and fortified wine—that is, a wine that has been steeped with aromatic compounds then spiked with a spirit to raise its ABV.

2 Alcohol by volume.

Although quality vermouths are made here in America, when it comes to martinis, I stick to European offerings and am especially fond of dry French vermouths in the styles of Chambéry and Marseilles.[3] But that's just me. As long as it's white or blanc and says "dry" or "extra dry" on the label it can probably play in your martini. Whatever you do, once it's open, treat it like the wine it is and keep it refrigerated. And even then, plan on finishing it off within two months. Luckily, I like martinis a lot, so I'm in the clear. If you don't, don't worry, there are a lot of other things you can do with vermouth in the culinary realm . . . but that's another show.

THE FINISH

I often go old school with a dash of orange bitters, which you should try if you haven't. As far as vegetation, I used to be an olive fan but I've gone over to a lemon twist because it kind of completes the gin rather than fighting with it.[4]

ICE

In my opinion, nothing can throw a cocktail off faster than bad ice. Since it physically mixes and chills the drink while also providing a bit of water to soften the drink, ice is both hardware and software, so it matters as much as any other ingredient. At the very least, freeze filtered water in trays and transfer the cubes to a freezer bag as soon as they're solid to prevent funky freezer flavors. Really, I shouldn't say "trays," because few things say "cheap" faster than cubes fro-

Ice is critical to good cocktails.

zen in the trays that came with your mom's refrigerator. There are plenty of silicone molds on the market these days that will allow you to make decent-looking cubes. But I'm getting ahead of myself. More on ice later.

I prefer my drinks on the strong side, so I keep my martini gin in the freezer. Some folks will argue that the water coaxed off the ice cubes during stirring is critical to melding or softening the drink and that room-temperature ingredients aid the endeavor. To each their own. Same can be said of the gin-to-vermouth ratio. Although the American obsession with "dry" martinis continues, I want to actually taste the vermouth, so I typically go with a 3:1 gin-to-vermouth ratio, though depending on what kind of day I've had I might just raise that to 5:1.

3 I can't name brands on the show, but this is a book, so . . . Dolin.

4 If I want olives in my drink, I have a filthy vodka martini, which really isn't a martini at all, just ice-cold vodka and olive brine with a few green orbs tossed in so you have something to munch on.

THE AB MARTINI: RELOADED

YIELD:

Serves 1

SOFTWARE

Ice cubes (filtered water, please)

2½ fluid ounces (75 ml) London Dry gin, very cold

¾ ounce (22 ml) dry vermouth

1 dash orange bitters

1 lemon[5]

TACTICAL HARDWARE

- A mixing glass and bar spoon
- A chilled cocktail glass or Nick and Nora glass
- A "Y" or harp-style peeler

5 Lemons are often coated with a food-grade wax, which keeps them looking nice in the market bin while preventing drying. Because I don't like the idea of wax in my drink, I usually soak my lemons in hot water for 3 minutes, then rinse and dry before use.

PROCEDURE

1) Fill a cocktail mixing glass half full of clean ice and place several cubes in the Nick and Nora to chill it.

2) Add the gin, vermouth, and bitters to the mixing glass and stir with a cocktail spoon five times in one direction, then five more in the opposite direction. Allow the drink to rest while you cut the twist.

3) Use the peeler to remove a 2-inch-long strip of peel from the lemon. (I tend to peel longitudinally and while holding the peeler at a slight angle, which tends to produce a strip with less of the bitter white pith.)

4) Dump the ice from the glass. (I'm not fond of martinis on the rocks.) Lightly run the peel around the rim of the glass, give it a twist to release its oils, and drop into the glass. Finally, strain the martini into the glass and serve immediately.

5) Repeat . . . responsibly.

The EU allows 0.1 gram of "sugar" per liter of gin. It's used as a chemical marker to spot counterfeits.

KNOWLEDGE CONCENTRATE

ICE AND DIRECTIONAL FREEZING

Your average home-frozen ice is cloudy and nasty-looking because it's full of air and other impurities that block and refract light. This happens because in the average freezer, water freezes fast and from all directions at once. For clear cubes we need to slow the process and freeze from one direction, so all the stuff we don't want in the cubes gets pushed out or at least to the bottom.

What's happening is referred to by ice-heads as "directional freezing." Since the molds are surrounded by water in an insulated cooler with the lid off (see the application below), the heat departs very slowly upward, and the water freezes from the top down, pushing impurities and bubbles downward. Now, in my freezer this takes around fourteen hours, but it may take up to two days, depending not only on your freezer's make and model but also on how full it is.

Using this technique will get you almost perfect ice with a layer of excess impurities that are pushed to the bottom as the cubes freeze from above. There is a way to avoid even this amount of cloudiness, but it requires cutting holes in the molds and is, frankly, a pain. It's much easier to just melt off that layer of impurities and call it a day.

D.N.P.C. (DANG NEAR PERFECTLY CLEAR) ICE CUBES

YIELD:

12 large, clear ice cubes

This procedure works best if you happen to have a chest freezer. You can make the ice cubes using a standard home freezer, but you will likely end up with more of a foggy bottom that needs to be melted away than if you use a chest freezer. If you only take one thing away from this application, let it be: The slower the freeze, the clearer the ice.

SOFTWARE

Hot water,[6] filtered if desired

TACTICAL HARDWARE

- **2 (6-count) silicone ice cube molds**
- **1 (9 × 11-inch/23 × 28 cm) Styrofoam cooler[7]**
- **A freezer, chest style preferred**

Many believe the first ice-cube tray was invented by Dr. John Gorrie in the 1840s. Gorrie was an early pioneer in the quest for artificial ice.

PROCEDURE

1) Place the ice cube molds in the cooler, making sure there is space between the molds and the walls of the cooler. Fill the cooler with hot water so that the molds and the space between them and the cooler are both completely filled. Do not add so much water that the molds float. Do not place a lid on the cooler.

2) Place the cooler in the freezer (without the lid!) and freeze until solid, 14 hours to 2 days.

3) Remove the cooler from the freezer. If frost has formed on top of the ice, pour on enough fresh water to cover, slosh and immediately dump the excess. Then, park the cooler on the counter until you're able to jiggle the molds free of the surrounding ice, about 1 hour.

4) When the molds are free of the cooler, push out the cubes. To remove any foggy bottoms, simply place on a wooden cutting board (or even the cooler lid) with the foggy bottoms facing upwards. Place an aluminum sheet pan on top of the cubes and move it around gently until the foggy parts melt away. Depending on the amount of fog, this step could take 30 seconds or up to 5 minutes.

5) Dry the cubes with a clean, lint-free towel and transfer to a zip-top freezer bag. Return to the freezer until ready to use. (Only use in drinks requiring one nearly perfect cube.)

NOTE

If you're willing to break your ice up, you can forgo the molds entirely and simply pour 2½ inches of hot water directly into the clean cooler. After freezing, turn the cooler upside down over a towel on the counter and just leave it until the block falls out. Then simply chip off what you need or break into chunks and return to the freezer. If you go with this method you'll want to go to a restaurant or bar supply shop and buy a chipper, which looks like this:

6 My experiments have led me to believe that hot water is best because it contains less dissolved air than cold.

7 I like the Styrofoam cubes that are used for shipping chilled foods. Since they're made to fit in boxes they have straight sides, which helps them fit in the freezer. If you haven't saved one from your last caviar drone drop, they're easily obtained from the interwebs and with a bit of care should last quite a while. Find a size that allows 2 silicone ice cube trays, also widely available on-line (not unitaskers because I use them for cranberry sauce, among other things), to sit side by side with space all around them. The fit is important for the proper freeze rate, as we want all the heat to depart via the top.

Mmm . . . mint syrup!

MINT SYRUP

YIELD:

1¾ cups

SOFTWARE

2 cups (400 g) sugar

8 cups (1.9 L) water, divided

2 cups (280 g) ice

10 sprigs (40 g) fresh mint

TACTICAL HARDWARE

- A blender
- A fine-mesh sieve

Mint juleps were once made with spirits such as rum and brandy. Now, bourbon is the norm.

PROCEDURE

1) Combine the sugar with 1 cup of the water in a small saucepan and place over high heat. Bring to a boil, then reduce the heat to medium-low and simmer, stirring occasionally, until the sugar has dissolved, 3 to 5 minutes.[8]

2) Remove from the heat and allow to cool for 10 minutes. Transfer to your blender and cool to around 80°F. Clean the saucepan.

3) Meanwhile, combine the ice and 2 more cups of the water in a large bowl and have it standing by near the cooktop.

4) Bring the remaining 5 cups water to a boil in the saucepan over high heat and tie the mint into a bunch with cotton butchers' twine. When the water reaches a hard boil, dunk the mint bouquet and count to 15, then immediately plunge the mint into the ice water to stop the cooking and set the color.[9]

5) Once thoroughly cooled, pat the mint dry, pluck as many leaves off as possible, and add them to the cooled syrup. Then blend on medium speed until the mint is reduced to very fine pieces. Strain through a fine sieve set over a 2-cup liquid measuring cup, then transfer to a plastic squeeze bottle and refrigerate for up to 2 months . . . or freeze forever.

NOW, THE MINT JULEP

The classic method of infusing mint into cocktails like mint juleps and mojitos involves muddling, or crushing the leaves with sugar. While fairly effective at extracting flavor, this procedure leaves you with clumps of green stuff in your cocktail, which are bound to get stuck in your teeth—how embarrassing.

These days, I employ mint syrup to do the job. Combine 1 tablespoon of your syrup with 2 fluid ounces bourbon in a rocks glass or julep cup. Fill with crushed ice and top with a splash of soda. Garnish with a fresh mint sprig and enjoy. This recipe makes a lot, so go ahead and invite a few friends over so they can be impressed by your cocktail wizardry.

8 This here process breaks some of them disaccharide sucrose molecules down into the monosaccharides fructose and glucose. The resulting elixir will resist crystallization and actually taste sweeter than the original sucrose, which they say is science but sounds like some kinda magic to me.

9 This technique is called "blanching and shocking," and it will shut down some of the enzymes inside the leaves so that the syrup will stay green rather than turning brown and nasty.

RAISING THE STEAKS: RELOADED

In *Good Eats* episode 93, "Raising the Steaks," we split the show between what I saw as two "budget" cuts: skirt steak and sirloin steak, specifically top sirloin. But now I realize this was a missed opportunity, because both steaks clearly deserve their own shows—sirloin in particular. Don't get me wrong, skirt is tasty stuff, and I dig the whole cooking-it-right-on-the-coals bit, but, for my money, no cut of beef critter is more versatile, or a better bargain, than sirloin steak. So we elegantly rejiggered the footage for this reload to make sure it is all sirloin, all the time, and ended up with two fairly radical new methods for cooking this versatile cut.

According to recent findings, 22.5 percent of Americans order their steak medium-rare. Only 2.5 percent order rare.

The things I do to get a shot.

SIRLOIN

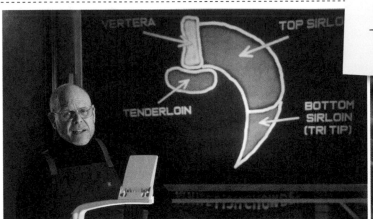

"My favorite animal is steak."
—Fran Lebowitz

The big-money steaks—the tenderloin, rib eye, and what-not—come from the middle of the cow, along the back. Since they're the farthest from hoof and horn, they do the least amount of work and contain the least amount of connective tissue. The closer you get to the hoofs and horns the more work is done, and the more connective tissue is required. Things can get tough and stringy, but there's also a lot of flavor to be mined from these cuts if carefully cooked.

I consider the sirloin to be a kind of transitional neighborhood. Although it's part of the loin primal, that hunk is typically divided into the short loin up front (next to the rib primal) and the sirloin, which is definitely a working-class neighborhood despite the fact that it houses a goodly portion of the coveted "fillet." The issue is that this far back on the critter, we're into the hip, and that means several muscle groups and a fair amount of connective tissue. If you move even farther back you cross over into the round primal, home to the often dry and chewy mega-roasts, typically found on wedding-reception carving stations.[1] Of course, as anyone who's ever bought real estate in a transitional neighborhood will tell you, the art is in knowing exactly where to look. And this is where the sirloin gets complicated, because the types of steaks one gets from it depends entirely upon how you fabricate the sirloin.

Take a look at this cow map. I drew this back in 1997, when we shot our first pilot episode, "Steak Your Claim."

Notice that the sirloin is cross-cut into three big steaks (really, more like small roasts) named after the piece of bone they contain: the pin-bone steak, the flat-bone steak, and the wedge-bone steak. Below those is the tri-tip, which is near mythic on the West Coast yet still something of a phantom back east, and that's not to be confused with the sirloin tip, which is actually part of the round primal.[2] But here's the thing: Very few butchers still break these big steaks across the grain, because it's more profitable to remove the muscle groups and cut boneless steaks from them. So now there's the "top sirloin butt"[3] (top as in closer to the back), which can be cut into the *top sirloin steak*, the *top sirloin center-cut steak*, the *top sirloin butt*, the *coulotte roast* and *coulotte steaks*, the *top sirloin petite roast*, and *top sirloin fillets*. Then there's the lower muscle group, or "bottom sirloin butt," which is typically broken down to give us the *petit sirloin steak*, the *bavette steak*, and the *flap*, as well as the coveted/obscure *tri-tip steak* and *tri-tip roast*.

For the sake of simplification, the recipes to follow are specifically intended for anything marked "top sirloin steak." Other words may be thrown in, but if you see those three, you should be good. Also, these steaks will typically weigh in at a pound to a pound and a half each. If you find one that weighs, like . . . 7 pounds, someone wearing an apron has some explaining to do.

1 Even these cuts have come into their own with the advent of the immersion circulator, as evidenced by the roast application on page 127.

2 Don't feel bad . . . even butchers have a hard time keeping this straight.

3 Not to be confused with the pork "butt," which is actually the shoulder. Fun, right?

ELECTION NIGHT SIRLOIN

YIELD:

2 to 4 servings

Every four years, when the polls close, I cook a steak. I got the idea one year when a friend said that elections are all "smoke and mirrors." I said, "You want smoke? I'll show you smoke." I always go with a sirloin because it's my favorite, and there's no political statement there whatsoever. Admittedly this procedure is a little unorthodox, but . . . it works. There really is going to be smoke, though, so open a window or two and turn on your hood. I would tell you to temporarily cover any nearby smoke detectors with foil, but that wouldn't be right.[4]

SOFTWARE

1 (1½-inch-thick) sirloin steak, about 1 pound, 5 ounces (595 g)

2 tablespoons (20 g) kosher salt

1 tablespoon (15 ml) neutral, high-heat oil, such as grapeseed or canola

TACTICAL HARDWARE

- A 12-inch cast-iron skillet (no, this won't work in any other kind of pan)
- Heavy-duty aluminum foil

PROCEDURE

1) Coat the steak with 1 tablespoon of the salt, set on a rack inside a rimmed pan, and leave at room temperature for 30 minutes. The steak should come up to somewhere between 45°F and 50°F. Tear off about an 18-inch-long piece of foil and have it standing by.

2) When 5 minutes of the salting time remains, place a 12-inch cast-iron skillet over the highest heat you've got for a full 5 minutes. You will want to crank up your ventilation hood to high and open a window; there's gonna be smoke.

3) Evenly sprinkle the remaining 1 tablespoon salt across the bottom of the hot skillet. Lightly coat both sides of the steak with the oil, then slap it right in the middle of the pan and do not touch it for 2 minutes. (Not so much as a poke with a fork— I mean it.)

4) When 2 minutes are up, flip and rotate 90 degrees so that the steak hits (mostly) fresh pan (and fresh salt) and cook for another 2 minutes, *uninterrupted.*

5) Turn the steak up on one long edge and cook for 30 seconds, then turn and cook along the opposite edge for another 30. If you care to check, the internal temperature should be between 70°F and 72°F. Transfer to the foil and wrap tightly for 3 minutes. During this time, leave the skillet on the heat. (Did I mention there would be smoke?)

6) After 3 minutes, unwrap the steak and place it back in the pan for 3 minutes, then flip and cook for another 3.

7) Flip the steak and cook for another 2 minutes, then flip and

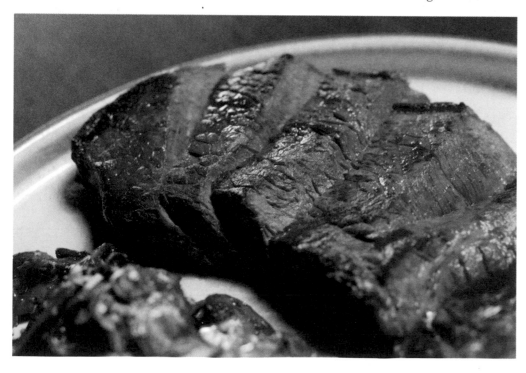

cook for a final 2 minutes. At this point the internal temperature should be 120°F.[5]

8) Return the steak to the foil and wrap tightly to rest for 5 minutes. Then unwrap and slice thinly on the bias. Serve with any accumulated juices. Consume with fingers, because. (Also makes an amazing French dip, but that's another show.)

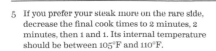

While etymologists can agree on the origin of the word <u>rare</u>, meaning unusual, no one knows where its culinary usage originated.

WHY FREEZE STEAK?

One night I was salting a nice juicy inch-thick sirloin steak with a tablespoon of kosher salt when the phone rang and a semi-emergency ensued. I had to drop what I was doing, so I plopped the steak between two quarter sheet pans and moved it to the freezer.

Something magical happened that night, as the salt pulled moisture out of the steak and was then reabsorbed. This raised the salinity of the interior and reduced the vapor pressure of the water, so that it would sublimate—that is, evaporate from a solid ice state to a gas, out of the steak more slowly. Those two pans? They helped the steak freeze faster due to their conductivity. Once the steak froze completely, I wrapped the sirloin in butcher paper, labeled it, then sealed in a freezer bag.

About a week later, hunger struck from out of the blue and all I could find was that rock-hard steak. Of course, thawing would be a pain. Then I thought of . . . a scene from this original episode. One involving a "broiler" and some strip lights and red theatrical gel. Total fakery. You shoulda seen the rig our key grip built to hold me like that. Ever try to talk into an oven about steak while hanging upside down? I have. My key grip just knew he'd get to use it again someday.

But I did end up using a broiler to cook the frozen steak, figuring that its ice-cold state would prevent it from overcooking while giving us time to build up a rich, flavorful sear. (Spoiler: It worked.)

5 If you prefer your steak more on the rare side, decrease the final cook times to 2 minutes, 2 minutes, then 1 and 1. Its internal temperature should be between 105°F and 110°F.

THERMAL SHOCK SIRLOIN

YIELD:
2 to 4 servings

A lot of people are purchasing steaks from the interwebs these days, and I support the move as it allows you to buy directly from ranches, farms, and processors who raise their meat the way you'd like it to be raised, and that matters, at least to me. A lot of these steaks arrive in a rock-hard frozen state, and that's fine with me too. You can thaw in the fridge, certainly, but that requires premeditation, and I'm a spur-of-the-moment kind of cook.

This application can certainly apply to steaks purchased in the frozen state, but it's written for those you freeze yourself. Now, I'm not suggesting you buy a steak and freeze it. My suggestion is that should you come across a great sale on sirloin steaks, you buy one to eat in the car on the way home, one to cook that night (or the next morning), and a couple to freeze for later.

SOFTWARE

1 (1-inch-thick) sirloin steak, about 1 pound (454 g)

1 tablespoon (10 g) kosher salt

1 tablespoon (15 ml) neutral oil, such as grapeseed

TACTICAL HARDWARE

- A cast-iron griddle. I've done this on the underside of a large skillet, but I'd suggest you spring for a cast-iron griddle, which you really should have anyway.

- Heavy-duty aluminum foil

PROCEDURE

1) The night (or several nights) before cooking: Season steak with the salt on both sides and place on a small sheet pan, cookie sheet, or even a small square or rectangular cake pan. Top with a second pan (aluminum is ideal due to its conductive properties) and freeze overnight.[6]

2) An hour before cooking: Position an oven rack to its highest position just under the broiler. Set a cast-iron griddle flat side up on this rack, ideally 3 inches (7.5 cm) below the broiler element. Set the oven to its highest temperature, at least 500°F, and leave it there for at least 30 minutes *after that temperature is reached*. Do not a ctivate the broiler at this point. Meanwhile, tear off about an 18-inch-long piece of foil and have it standing by.

3) Remove the steak from the freezer and coat both sides with the oil, using a pastry brush.[7] Carefully pull out the oven rack and deposit the steak right in the middle of the griddle. Push the rack back in, turn the oven off and the broiler on—to high heat, if that's a choice. Cook for 4 minutes, then carefully flip the steak and continue broiling until the interior temperature hits 110°F.[8] (Start checking the steak's temperature after 4½ minutes, but be ready to go as long as 7 depending on your broiler.)

4) Remove the steak and wrap in heavy-duty foil to rest for 10 minutes. Remove and slice thinly on the bias. Serve with any accumulated juices.

6 If you plan to leave it frozen for more than a couple of days, wrap the frozen steak in parchment paper and seal in a heavy-duty zip-top freezer bag. Keep frozen for up to 2 months.

7 Using your hands will hurt. Trust me.

8 Always insert the probe of your thermometer horizontally through the side of the meat to get the most even reading.

ME AND MY BROILER

If you ask me, the most underutilized cooking device in the American kitchen is the broiler. And that's a shame because it's essentially an upside-down grill, and who doesn't want that? Instead of the heat coming from below, where dripping fat can cause nasty flareups, the broiler's radiant energy emanates from above, like the sun! The broiler is also a highly adjustable device. Even if your range only has "high" and "low" settings, you can always move the rack closer or further from the element, which if you're lucky is gas powered. (Like a lot of unlucky folks, mine is electric, but I still love it.

I typically use a heavy, cast-iron griddle under my broiler and I thermo-load it to the max before introducing food. Since a lot of broilers will shut down when they get really hot (a safety feature), I tend to park the griddle in the cold oven then crank the box to its highest bake or roast temperature, usually between 500°F and 550°F. When everything is good and hot, I shift to the broiler then add the food.

WHY SO BIASED?

Many recipes for roasts and steaks call for slicing "on the bias." Simply put, this means to cut diagonally across the grain. In the case of a steak composed of meat fibers that run perpendicular to the cut side of the meat, like a sirloin steak, cutting straight down would result in long fibers and a chewy texture. Cutting diagonally or "on the bias" shortens the individual fibers resulting in a more tender piece of meat (a). In the case of a flank steak, which contains horizontal fibers, the bias cut assures an attractive, wide slice rather than a skinny strip (b).

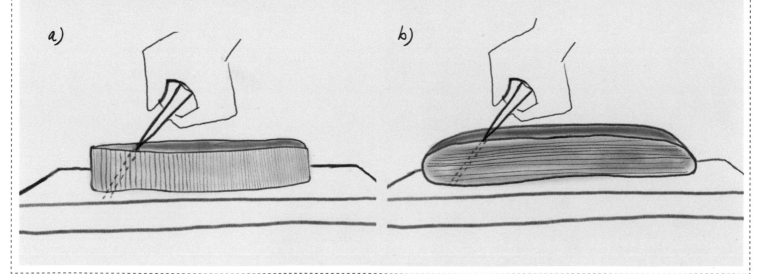

TAKE STOCK: RELOADED

In episode 91, we delved into the mysteries of chicken stock with the intention of creating an amazing chicken soup. In fact, the original title was "A Bowl of Bird," but I got so bogged down in stock making that we ran out of time, and I ended up basically shoving some aromatics and noodles into the stock and saying, "See you next time on . . ." So, in the reload, we picked up the pace, skipped the 6- to 8-hour simmer in a stock pot in favor of a pressure cooker, and cranked out a soup you'd really want to eat in one hour soup to nuts, so to speak. For more info on pressure cookers, the difference between stocks and broths, and tips for shocking them quickly before refrigeration, go back and read "Pressure," which starts on page 85.[1]

Linguistically speaking, a __stock__ is any liquid produced by the cooking of meat. But these days the word is typically used to mean a liquid in which bones have been simmered. A __broth__, on the other hand, is a liquid in which a grain or vegetable is cooked.[2]

1 "Shocking" means to cool down quickly, which is what you need to do to a large quantity of hot stock before you move it to the refrigerator.

2 The *OED* is the source here.

As we've discussed before, animals are held together by connective tissues composed of proteins like collagen, reticulin, and elastin, which make skin plastic and elastic, connect muscles to bones, and keep one's guts from just kind of floating all around. When some of these tissues are cooked, namely reticulin and elastin, they can become even stretchier and tougher than they are when they are raw. Collagen, however, can hydrolyze (melt and dissolve in hot water), and then we call it *gelatin*, which becomes a solid gel at refrigerator temperatures but returns to a lip-smacking liquid when reheated. Gelatin brings body to anything from pot roast to chicken soup, to more sauces than you can shake a Frenchman at, and it does it all without fat. Gelatin is, in fact, almost completely protein, so just assume it's good for you too.[3] What gelatin doesn't add, however, is a great deal of flavor, which is why I make my stocks with some meat, in this case, chicken, in the mix.[4]

Now, back in 2003, I advocated for starting all stocks with cold water, because I was under the impression that the hot water would coagulate the proteins and plug up the pores in the bones, preventing the collagen from passing through into the stock. Well, that theory was, er, wrong. In fact, a 2012 study in the *Journal of Food Science* found that a hot-started stock extracted more protein overall than a cold-started one, which is the opposite of what you'd expect if a hot start clogged the pores, which it doesn't do. I was wrong, fine, let's move on.

3 Gelatin is actually close to 98 percent protein, but it's an incomplete protein, so you can't actually live off it.

4 Since they contain bones and meat, my stocks are technically stocks and broths, which means you can call them "bone broths" if you want because I hear that's a thing.

CHICKEN SOUP À LA PRESSURE: RELOADED

YIELD:

4 to 6 servings

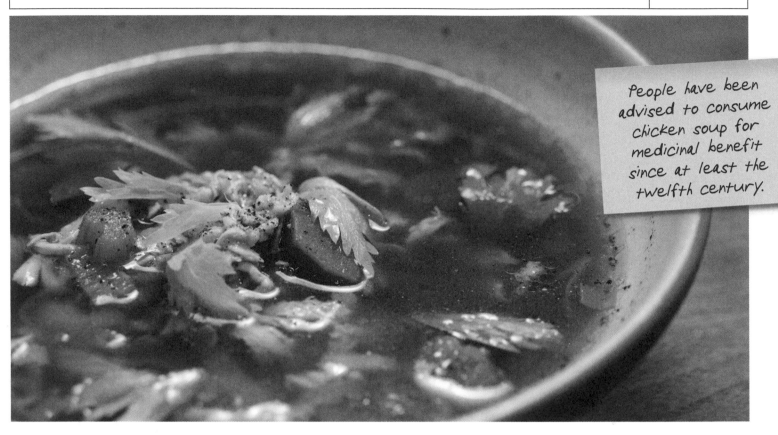

People have been advised to consume chicken soup for medicinal benefit since at least the twelfth century.

SOFTWARE

1 large onion (260 g), halved, with the skin on

4 medium carrots (300 g), 2 halved crosswise and 2 peeled and cut into half-moons

4 stalks celery (240 g), 2 halved crosswise and 2 cut into half-moons, with the leaves reserved for garnish

2 large leeks (900 g), green tops removed and reserved, whites cut into half-moons, well washed

1 (0.7- to 1-ounce/20- to 30-gram) packet mixed dried mushrooms[5]

10 black peppercorns

2 bay leaves

1 (5-pound/2.3 kg) roaster chicken, cut into 8 to 10 pieces (see below), with the skin removed[6]

2 quarts (1.9 L) water, filtered or good-tasting tap

¼ cup (60 ml) shoyu

2 tablespoons (16 g) kosher salt

1 to 2 teaspoons shichimi togarashi[7]

2 medium parsnips (200 g), peeled and cut into quarter-moons

Freshly squeezed lemon juice, to taste (optional)

Freshly ground black pepper, for serving

TACTICAL HARDWARE

- A 6- to 8-quart stovetop pressure cooker[8]
- A large bowl
- A colander
- A fine-mesh sieve/strainer
- Cheesecloth

5 My favorite mélange includes black trumpets, chanterelle, and morel, but really any dry 'shroom mix will do. These are a real soup-er hero. Soup . . . er. Look, keep these around, they're powerful and keep a really long time.

6 The skin we save for making crackers.

7 Shichimi togarashi basically translates to "seven-taste chile," and often includes chiles, nori (that's the stuff we wrap around sushi), and dry citrus peel. Mixtures vary, and since the good stuff is always labeled exclusively in Japanese, I recommend you start with one teaspoon and be ready to add another if need be.

8 Most modern cookers use a spring-loaded pressure control that uses a pop-up column or stem to show the amount of pressure applied. If you have an old-school "jiggle top" with the weight that goes over the heat stem, cook times may be different. If you have an electric cooker, I'm sure you can get into the manual and the menus and figure out how to adapt this application. I don't actually own one, so I'll stick with the classic version.

PROCEDURE

1) Park a 6- to 6½-quart pressure cooker pot on high heat. Place the onion, cut side down, in the bottom of the cooker and sear until well charred, about 5 minutes.

2) Add the 2 halved carrots, 2 halved celery stalks, the leek tops, and the dried mushrooms to the pot, along with the peppercorns and bay leaves. Follow with the chicken legs, thighs, wings, and finally the carcass. Add the water and use tongs or a large spoon to push as much of the chicken under the water as possible.

3) Attach and lock the cooker's lid (according to the manufacturer's instructions, of course) and bring up to pressure over high heat. When the cooker's whistle blows (it's typically annoying and discordant . . . all the better to get your attention), back off on the heat until the cooker just hisses but doesn't whistle. This means you're maintaining pressure but not just dumping a lot of steam into the room, which would waste moisture, not to mention energy. Cook for 30 minutes.

4) Remove the cooker from the heat and either vent the pressure by opening the pressure relief valve or simply place the covered vessel in the sink and run cold water over the lid for about a minute. At that point the pressure should have abated and the safety lock on the lid will open.

5) Strain the broth through a colander set over a large bowl to remove large solids. Then, place a cheesecloth-lined sieve over the now-empty pressure cooker and strain the stock back into it. You should have 8 to 9 cups of stock/broth. At this point you can stop, cool the stock, and then refrigerate for up to 1 week or freeze for several months.[9]

6) Make the soup: Add the shoyu, salt, and 1 teaspoon of the shichimi togarashi to the stock. Taste and add additional shichimi togarashi as desired. Add the chicken breasts to the pot, bring to a boil, then reduce the heat to medium-low and simmer until the chicken is just cooked through, about 5 minutes.[10]

7) Transfer the chicken to a large bowl using tongs or a slotted spoon. Add the remaining carrots and the parsnips to the broth and simmer for 3 minutes, then add the remaining celery and leeks. Simmer until the vegetables are just tender, 3 to 5 minutes.

8) While the vegetables are cooking, shred the chicken breasts with forks or with a hand mixer on low.[11]

9) Before serving, taste the soup and season with lemon juice, if desired. Ladle the soup into bowls and top with the chicken, reserved celery leaves, and a grinding of pepper.

The word broth has been used for almost one thousand years, while stock is much younger.

9 The disk on top of chilled stock is a fringe benefit: chicken fat, aka schmaltz. Lift that disk off, wrap so that it's airtight, and refrigerate. I save mine for making latkes (page 190).

10 We're just using the pressure cooker as a pot at this point . . . no lid required.

11 Yeah, I know, it sounds a little strange, but trust me, on low speed, a hand mixer can make very quick work of finely shredding chicken breasts, if you like it that way.

TRUE BREW: RELOADED

The year was 2000 and coffee was still just . . . coffee. Hipsterism was a decade away, Starbucks only had 3,500 stores, and espresso was still called *expresso* more often than not. And yet even then I considered a great cup of Joe to be a basic human right. And so, in episode 21 we attempted to lay the groundwork for better coffee. Get it? Ground . . . work.

Alas, the average sixth-grader today knows more about coffee than I did twenty years ago, so clearly this episode was due for a full-on facelift. But I did say one thing in the show that deserves repeating today: brewing is cooking. Never forget that.

This is what it looks like in your brain.

THE ABSOLUTE BASICS ONLY

Ninety percent of North American adults consume caffeine every day.

Coffee beans are seeds of a berry that grows on a shrubby tree in the Rubiaceae family. There are several species and dozens of varieties and cultivars, but any coffee you pick up from a quality roaster or coffee shop will be of the species *Arabica*.[1] Arabica beans deliver a sublime gestalt of flavor, acidity, body, and aroma. They actually have the ability to express the essence of where they were grown, through flavor. Like great wine grapes, Arabica beans deliver *terroir*, which means that not only are beans from the major world growing areas different from each other, but within each of these areas there are hundreds of subtle variations.

Coffees from Mexico, Central America, and South America tend to deliver traditional coffee flavor profiles with an edge of cocoa. Africa gives us beans with citrus, berry, and floral notes, while those from Indonesia and Sumatra are earthy, and just plain funky. Vietnam, Thailand, and India also grow a great deal of coffee, but those are another show.

ROASTING

Important as origin may be, nothing affects a coffee's flavor more than roasting, which brings out the aromas and flavors that we think of when we think of coffee. During this process, the beans go through what is called the "first crack," wherein the water inside the beans comes to a boil, the bean pops, and most of the chaff falls away. After that, the roasting time depends a lot on the flavor characteristics the roaster is trying to bring out for each type of bean, as well as personal preference.[1]

Depending on who you ask, there are between three and twenty-five roast styles. Some roasters deal only in *light*, *medium*, and *dark*, while others might go *light*, *medium*, *medium-dark*, then *dark*. If you really go crazy, you could say *light*, *cinnamon*, *New England*, *American*, *medium* or "*city*," *full-city*, *French*, *Italian*, and *Spanish*, which basically means burned. If you really want to taste the bean, I say go American to full-city. Classic French and Italian roasts deliver more burn than bean. Although many American drinkers associate it with darker roasts, *espresso* doesn't appear on the list because it's a brewing method, not a roast style.

STORAGE AND HANDLING

Once the beans are roasted, the clock is ticking on their freshness. Even if you keep the bag's factory seal intact and stashed away from heat, peak quality will begin to dissipate after three weeks.[2] And once this package has been breached, I'd brew the contents within a week to ten days, which is why I purchase small pouches, so I'm only bringing home what I know I'll use in a week.[3] In the original episode I advocated using a fancy canister with an "airtight" seal to store beans, but honestly it won't help. As with wine, once air hits bean, time is ticking away. And please remember, no matter what I may have said back then, neither the refrigerator nor the freezer is an acceptable storage option, because they create condensation, and that's even worse for coffee beans than air contact. Plus, freezers make everything taste funny . . . everything.

HOME-BREWING EQUIPMENT

Over the past twenty years I've owned a thrift store's worth of brewing equipment: grinders, drip machines, espresso machines both great and small, thermal carafes, things with vacuums, elaborate Japanese hand-blown percolators, presses, and whatnots, and I'm here to tell you that in the end, all you need is a decent burr-style (not blade) grinder, a digitally controlled electric kettle, a digital scale, something to hold a filter, and something to hold the coffee. Those last two can be replaced by a French press. I want to point out that the scale and the kettle are first-line multitaskers that you should have already. Also, a good coffee grinder can grind other things in a pinch (though the manufacturers will never say it's a good idea).

1 Arabica beans currently provide about 75 percent of the world's coffee, while Robusta provide the remaining 25 percent. Robusta beans deliver twice the caffeine of Arabica, and the flavor is considered inferior. However, Robusta beans are far easier to raise and so typically end up in budget blends and instant coffee.

2 By "factory seal" I don't mean the little wire thing that holds the bag closed. I mean the airtight seal that is found only on bags with a one-way valve on the side that allows the beans to "gas out" without allowing air in.

3 I also want to put out there that I never purchase coffee from a grocery store, simply because there's no way to know how long those beans have been there. Local roasters are the way to go, and every town in America has got one. If yours doesn't, call me and I'll come open one.

THE FINAL POUR-OVER: RELOADED

YIELD:

1 generous serving;
enough to get me moving without giving me the jitters

Coffee has come a long way in twenty years, but a few simple facts remain the same: coffee beans and water are ingredients, brewing is cooking, and just as you'd respect that fact in the case of a steak or a chocolate cake, so should you when something *really* important is on the line.

Many coffee pros espouse a 1:15 ratio, but I need more kick in the a.m., so I go 1:14, meaning every gram of coffee gets 14 grams of water.

SOFTWARE

500 grams (17 fluid ounces or a little over 2 cups) water, filtered if desired[4]

30 grams (⅓ cup) coffee beans, ground medium[5] in a burr grinder (after grinding, ⅓ cup plus 1½ teaspoons)

TACTICAL HARDWARE

- A burr grinder[6]

- A digital scale with tare function (zeroes out)

- An electric kettle. Digital control is best so that you can set for 207°F.

- A brewing carafe and filter holder (I like the Hario V60) and unbleached paper filters

It's said that Teddy Roosevelt drank one gallon of coffee a day.

A damn fine cup of Joe

4 If your water tastes good from the tap, make your coffee with it. If it doesn't, use filtered water. Do not use bottled water, because those bottles are a pernicious evil that will eat our world if they haven't already.

5 If your coffee is too sour or not full-flavored, try a slightly finer grind next time. Conversely, if it's too bitter, try a slightly coarser grind.

6 I prefer to dose out exactly the amount of whole beans that I need for brewing, because it's easier to weigh beans before grinding than grounds after grinding, but most machines with large hoppers will let you grind into a cup on a scale, so that works too. See the note below for more on grinders.

PROCEDURE

1) Heat the water to 207°F. If you have a digitally controlled electric kettle, this should be simple. If your kettle is old-school, bring the water to a boil, then let it sit off the heat for 30 seconds before using.

2) You only need 420 grams water (same as milliliters where water is concerned, and about 1¾ cups if you insist on it) for the brew process, so when the water is hot use a small amount to warm your carafe[7] and your mug or glass.[8] Dump the carafe after a few moments but leave the water in the mug until you're ready to serve.

7 You may recall I used to brew directly into a Thermos, and I still do if I'm taking Joe on the go, but these days I tend to brew into a robust, flameproof carafe that can be parked directly over low heat as needed. I prefer either a Chemex carafe with a paper filter or a Hario V60 drip rig over a Hario 02 carafe.

8 I like to drink out of Gibraltar-style glass often used by coffee shops for serving cortados.

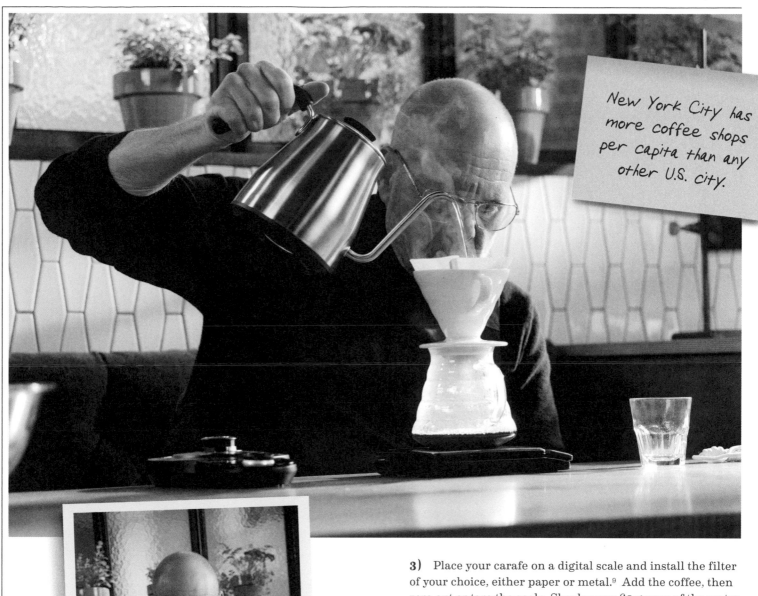

New York City has more coffee shops per capita than any other U.S. city.

3) Place your carafe on a digital scale and install the filter of your choice, either paper or metal.[9] Add the coffee, then zero out or tare the scale. Slowly pour 60 grams of the water evenly over the grounds and allow grounds to bloom for 45 seconds. (Return the kettle to its base to reheat during this time.)

4) After the bloom, slowly add water to the coffee grounds in a circular motion, pausing as needed so as not to overflow the filter, until the scale reads 420 grams (including the bloom water). If you've got your grind right this shouldn't take less than 3 minutes or more than 3½.

5) Dump the warm water from the glass or mug, refill with coffee, and consume. And no, you don't need sugar or cream. Seriously, give it a chance.

9 I prefer paper, because I feel it gives me a cleaner, less oily cup. I also feel they drain more slowly, giving me better extraction. Oh, and as for filter rinsing, I really don't bother.

WHY BLOOM COFFEE?

A roasted coffee bean is a complex world containing a lot of flavorful compounds like chlorogenic acid, melanoidins, and phenolics, and of course they also contain aroma compounds such as butyrolactone and 1-fusyfuryplatipus . . . and stuff . . . Brewing is simply the act of grinding said bean into small bits, thus allowing our solvent, hot water, to release the afore-listed goodies. There is, however, a challenge, because roasted beans are chock-full of carbon dioxide, the release of which is triggered by, you guessed it, water! Sounds good, but, if you simply pour on all the brewing water, the outward-bound gas will prevent its penetration, resulting in a weak brew. By blooming, we provide just enough water to flush this CO_2, which also puffs up the grounds to make them more receptive to the solvent, more hot water, to come. So, don't you skip it.

GRINDERS

Back in 2000, blade grinders were the norm. The problem is that while they're handy for spices, when it comes to coffee, they suck. Indiscriminate, random destruction. How are you supposed to get uniform extraction from that? You can't, which is why you need a burr grinder. Burr grinders pass the beans through a two-part mill made of either flat-toothed rings or a conical system where one knurled cone fits inside another. In this scenario, the beans are cracked and crushed and, since the distance between the wheels or cones is set, the grind is uniform. Most models allow you to change this distance, so coarse grinds for a French press are as easy to fabricate as a fine grind for espresso. The downside: Be prepared to spend $100 to $200 for a burr grinder, but also be prepared for your coffee to taste that much better.

Lloyd's of London started as a coffeehouse in 1668.

Coffee was outlawed in Sweden five times between 1756 and 1817.

COFFEE GRINDERS

Small-batch burr grinder

Hopper-style burr grinder

Blade-style—no good for coffee

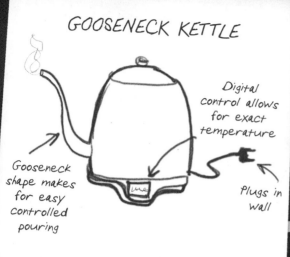

GOOSENECK KETTLE

Gooseneck shape makes for easy controlled pouring

Digital control allows for exact temperature

Plugs in wall

GOOSENECK KETTLE

My favorite coffee kettle is a digital thermostat-controlled electric model with a gooseneck. The precise temperature control means that we can dial in whatever temperature we want, not just boiling. And the gooseneck makes dosing water much easier and more precise. If your only kettle choice is an old-fashioned teakettle, you can still make pour-over. Bring the water to a boil, and then let it sit off heat 30 seconds before continuing to brew. You'll need to be a little more careful when dosing out the water than you would with a gooseneck, but I believe in you.

CAFFEINE

When I drink coffee, something curious happens besides my soul dancing in sunlight. Deep in my noggin 1,2,7-Trimethylxanthine, aka caffeine, is going about its curious work. Let's suppose we could see into my brain and that a fairly big chunk of it resembled a bio-version of a telephone switchboard.

The messages of the central nervous system are sent by various neurotransmitters, which function like the wires in the switchboard. The receptor for adenosine, an inhibitory neurotransmitter that signals the brain to feel fatigue, is also ready and willing to receive caffeine, which then will block the adenosine's message from getting through. In other words, it's a stimulant.

Caffeine also tinkers with the way neurotransmitters such as dopamine function. It is effective, addictive, and although it can sharpen our wits and turn our fight or flight instincts to 11, overindulgence has downsides, including jitteriness, mood swings, and heart palpitations.

Espresso means "pressed out" in Italian and refers to a brewing process, not a roast category.

ME ON TOO MUCH $C_8H_{10}N_4O_2$

GOOD EATS

THE RETURN

season
two

MARROW MINDED

Archaeologists have recently confirmed that early man munched on the nutrition-rich goodness that is bone marrow, going as far as wrapping hunks of bone in animal skins and stashing them in caves for later enjoyment. I like to think they hoarded them as much for their flavor as for their calories.

My own first taste of marrow came at the age of three, when I stuck a finger into the end of a ham bone to scoop out what I thought was jelly. I've been a fan of "God's butter" ever since. And thanks to the nose-to-tail movement, marrow is back in butcher shops and megamarts, making it a perfect candidate for *Good Eats*.

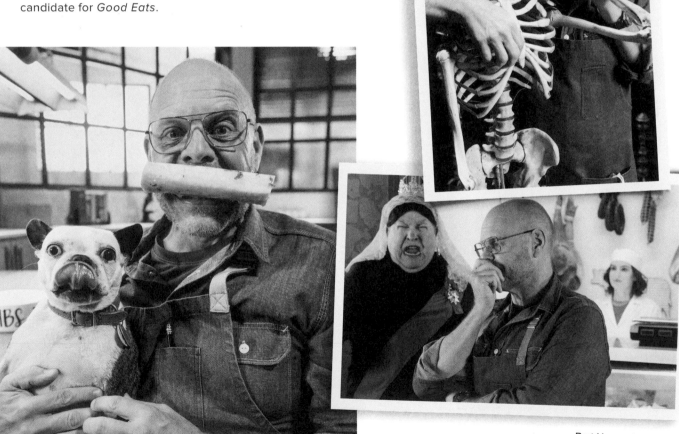

Bart Hansard, again!

WHAT IS BONE MARROW?

Simply put, marrow is a spongy tissue found inside mammal bones that contains stem cells that in turn make blood cells. But if you're thinking, "Eww, I don't want to eat a blood factory," fear not, because there are actually two different types of marrow: red and yellow. As an animal ages, there is less of the red stuff, and more of the yellow type, which mostly stores fat and contains mesenchymal stem cells, which produce bone and cartilage. It's the yellow stuff that we eat and it is concentrated in the center of bones, away from joints.

Although delicious marrow can be found in sheep and pigs, what you'll find at your butcher shop or megamart will no doubt be from our old friend *Bos taurus*. We are talking specifically about the heavy-duty leg bones of the cow, such as the upper arm and shank from the front end and the upper leg bone, or femur, in the back, which is by far the most desirable. But even with this one bone, there are options.

Most marrow at your butcher shop comes cut into either pipes or canoes, which are . . . what they sound like. Pipes are cross-cut sections 3 to 4 inches in length. You see these at restaurants, because they're easy to cook and reheat without losing a lot of fat. Harder to get at the marrow, though, without a marrow spoon, a curious unitasker with a longish scoop on one end for getting into boney places. During the Georgian and Victorian eras in England, high tables were typically set with marrow spoons right along with the rest of the silverware. In fact, it's said that Queen Victoria ate bone marrow on toast every day.

Canoes (also known as "boat-cut") are marrow bones that have been split lengthwise and usually come in segments about 6 inches long. Convenient, but, because there is less marrow per bone, they're also easy to overcook. One of the nice things about the canoe cut is easy access. You don't need a special spoon, you just need . . . any spoon.

When shopping, make sure the bones are clean and the marrow pale pink. Small droplets of blood are okay. Personally, I do my best to seek out marrow from organically raised, grass-fed beef. And as long as they're stored properly once processed, frozen is fine.

pipes

canoes

GRILLED BONE MARROW

YIELD:

2 to 4 servings

When roasting pipe-style marrow bones, the grill is my go-to heat source. This recipe is about as close as I'll get to the original caveman method of throwing bones into a live fire. You'll have plenty of smoky flavor without running the risk of losing any rendered fat, and the bones are short enough that you don't need to bash them with a rock to get at the goodness inside.

SOFTWARE

6 (3-inch/7.6 cm) pipe-cut marrow bones

2 slices country-style bread

Coarse sea salt, for serving

TACTICAL HARDWARE

- A charcoal grill and charcoal
- An 8- to 10-inch cast-iron skillet
- Long-handled spring-loaded tongs. I never grill without them.

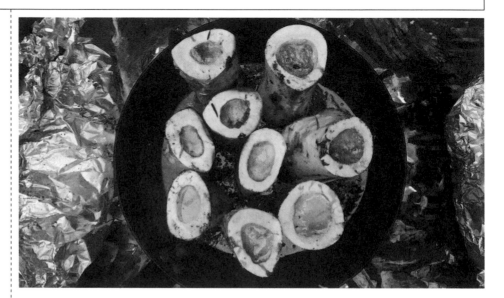

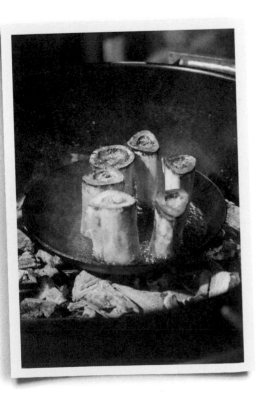

PROCEDURE

1) Prepare a charcoal grill for direct-heat cooking without the top rack. Place the marrow bones in the skillet, on end and close enough to touch.[1]

2) When the coals are coated in gray ash, park the skillet directly on the coals. Cover the grill and let the marrow cook until browned and lightly charred on the first side, 3 to 4 minutes.

3) Remove the lid from the grill and carefully flip each bone over to the second cut side. You'll notice a fair amount of fat will have rendered out, but don't worry, it won't go to waste.

Re-cover the grill and cook until the second side is browned and a skewer easily slides into the marrow, another 3 to 4 minutes.

4) Transfer the marrow to a platter with the tongs, then immediately lay the bread down in the rendered fat. Cook until lightly charred, 15 to 20 seconds per side. Remove to the platter with the marrow.[2]

To serve, use a couple of chopsticks[3] to poke the marrow out of the bones onto the toast. Spread, then top with a few pinches of salt. Consume.

1 I usually put one right in the middle with the other five surrounding.

2 If there's any fat left in the pan, pour it off into something heatproof and reserve for sautéing cubed potatoes.

3 Chopsticks are my utensil of choice here because I flatly refuse to purchase a marrow spoon.

ROASTED BONE MARROW WITH PARSLEY TOPPING

YIELD:

4 to 6 servings

When it comes to cooking canoe cuts, I go with something a bit more elegant, roasting the marrow and then topping the bones with an herbal mix to provide a foil for the fattiness.

SOFTWARE

6 to 12 cups (1.4 to 2.8 L) cold water

2 to 4 tablespoons (18 to 35 g) kosher salt, plus 1 pinch for the topping

4 (6-inch/15.2 cm) canoe-cut marrow bones, cleaned of any meat or fat on the exterior of the bones

4 to 8 cups (540 g to 1.1 kg) ice cubes

1 tablespoon (15 ml) extra-virgin olive oil

1 teaspoon (5 ml) fresh lemon juice

½ cup (25 g) packed chopped fresh parsley

¼ cup (15 g) packed chopped celery leaves or additional parsley leaves

1 tablespoon (10 g) finely chopped inner celery stalk

1 teaspoon (4 g) minced garlic

2 teaspoons (5 g) finely chopped lemon peel

1 teaspoon (6 g) minced shallot

1 teaspoon (5 g) capers, drained and chopped

2 to 4 slices thick-cut sourdough bread, toasted, for serving[4]

Flaky sea salt or additional kosher salt, for serving

TACTICAL HARDWARE

- Heavy-duty aluminum foil

4 I'm not saying that you always have to have bread with marrow, but if you don't, you will miss out on some of that fat, which would be a shame.

PROCEDURE

1) Fill a large 4- to 6-quart container with 6 cups cold water and stir in 2 tablespoons of the kosher salt until dissolved (just use your hand). Add the marrow bones, cut side down, then add 4 cups of the ice. Refrigerate for at least 24 hours.[5]

5 Although not 100 percent necessary, soaking the bones in brine will brighten the appearance of the bones, pull out any blood, and season the fat as well. In my tests, I found that the marrow bones brined for 48 hours were my favorite; they were clean-tasting and well seasoned. However, 24 hours is a perfectly acceptable brining time if you don't want to wait that long for marrow. I didn't notice any improvements in flavor or seasoning after 48 hours.

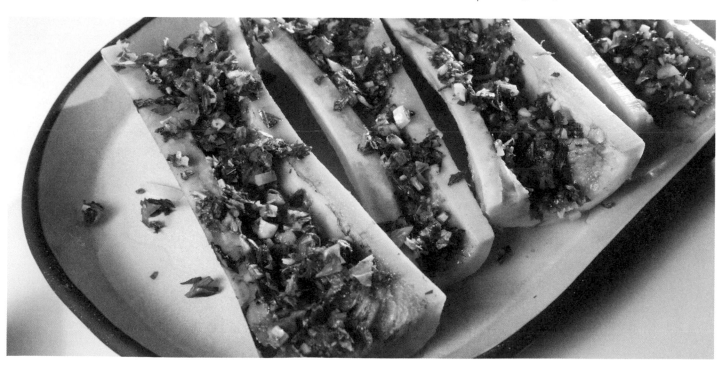

MARROW MINDED / 294

ROASTED BONE MARROW WITH PARSLEY TOPPING *(continued)*

2) When ready to cook, heat the oven to 425°F and move an oven rack to the center position. Drain the bones and pat dry with paper towels. Place cut side down on a quarter sheet pan. Crinkle foil around the bones, being sure to really get it down between them. Place a second quarter sheet pan upside-down over the bones, hold the two pans with the bones and foil sandwiched between, and flip the whole thing over. Remove the now top pan and you should have a very level platform for the bones, which is good, because we don't want them rolling around spilling their goodness.

3) Roast the bones for 15 minutes, rotating the baking sheet halfway through, until the bones have browned and the marrow is puffy and soft but not melted.[6]

4) While the bones roast, make the parsley topping: In a medium bowl, whisk the oil and lemon juice together with just a pinch of salt. Then toss in the parsley, celery leaves, celery stalk, garlic, lemon peel, shallot, and capers.

5) When the bones are done, immediately spread about one-third of the parsley mixture over the marrow so that it can warm from the residual heat for 5 minutes, then carefully transfer to a platter and serve with the toast, salt, and the remaining parsley mixture.

6 I would love to tell you that there's an exact temperature to aim for here, but honestly, getting a probe into this would be a challenge, so go by time and visual cues.

BONE MARROW PANNA COTTA

YIELD:

6 servings

While unquestionably delicious in savory applications, bone marrow works in many a sweet recipe where fat delivers most of the flavor, like panna cotta. This cooked cream dish from Italy is a prime candidate for a dessert made with meaty marrow, especially when topped with Luxardo cherries, which also happen to be Italian.

SOFTWARE

6 (6-inch/15.2 cm) canoe-cut marrow bones

4 grams (1¼ teaspoons) powdered gelatin

1 tablespoon (15 ml) cold water

1¾ cups (414 ml) half-and-half

45 grams (3 tablespoons) sugar

1¼ teaspoons (5 g) kosher salt

30 grams (1 cup) cornflakes

Pinch of smoked sea salt or additional kosher salt

6 high-quality maraschino cherries, such as Luxardo, for serving

TACTICAL HARDWARE

- Heavy-duty aluminum foil
- A fine-mesh sieve
- A large wooden spoon
- 6 (4-ounce) silicone molds

PROCEDURE

1) Heat the oven to 425°F with an oven rack in the center position. Place the bones cut side down on a half sheet pan and assemble the foil bone-marrow mold as for the roasted marrow above.

2) Roast until the marrow has just softened, 10 to 15 minutes, depending on the thickness of the marrow in the bones. Set aside until cool enough to handle, about 10 minutes.

3) Scoop the marrow out of the bones with a small rubber spatula into a small saucepan and place over medium-low heat. Cook, breaking up large pieces of marrow with the spoon, until all of the marrow has rendered into liquid, about 15 minutes.[7]

4) Strain the marrow fat through the sieve set over a heatproof jar or liquid measuring cup, reserving ½ cup. Cool

One of my favorite *GE* set pieces

the rest and reserve for another use.[8] (Did I mention sautéing potatoes?) Clean the saucepan.

5) Stir the gelatin and cold water together in a small bowl. Bloom for 5 minutes while heating the dairy mixture.

6) Combine the half-and-half, sugar, and kosher salt in the clean saucepan. Place over medium-low heat until steaming, 160°F to 170°F, 3 to 5 minutes. Transfer to a blender and add the gelatin. Blend on low speed until the gelatin is thoroughly dissolved, about 30 seconds. Add 6 tablespoons of the reserved rendered marrow to the blender, saving the remaining 2 tablespoons for the topping. Blend on medium speed for 1 minute.

7 During this time, we're also going to be coagulating the blood and other, well, potentially dangerous stuff like bone shards, which we will simply strain out.

8 Store tightly sealed in the refrigerator or freeze for long-term storage.

BONE MARROW PANNA COTTA *(continued)*

7) Strain through the sieve into a 4-cup liquid measuring cup or bowl, catching any bits of gelatin and as much foam as possible. Divide the mixture evenly among six individual 4-ounce silicone molds, small bowls, 4-ounce glass jars, or teacups.[9] There's almost always a little bit leftover, but you can pour that into a jar and save it for your own private treat later. Cover and refrigerate until the panna cottas are set, at least 5 hours.

8) Before serving, heat the remaining 2 tablespoons marrow in a small skillet over medium heat. When the marrow is shimmering, add the cornflakes and cook, stirring frequently, until they turn golden brown, about 2 minutes. Remove from the heat and stir in the smoked salt. Transfer to a paper towel–lined plate to cool.

9) Once cool, transfer the cornflakes to a gallon-size zip-top bag and seal, removing as much air as possible. Use a rolling pin to gently crush the flakes. Set aside.

10) When ready to serve, remove the panna cottas from the fridge and uncover. If you'd like to turn the panna cotta out onto a chilled plate, top with a small plate, flip over, then gently push on the bottom of the mold to dislodge. Top the panna cottas with the crushed cornflakes, a cherry, and a spoonful of the cherry juice from the jar. Serve immediately.

9 As far as molds go, I like silicone. The one I use for panna cottas was actually made for soap bars, but . . . that doesn't matter. The issue is how difficult it is to unmold something soft like our dessert. So, I simply cut them into individual molds. If you choose to go this route, make sure to place the molds on a sheet pan or other small tray or dish to hold them steady.

A real Luxardo cherry

PANNA COTTA

The Piedmont region of Italy is famous for dairy, and while cheese typically gets the front page, there is one dessert for which the region is particularly known: panna cotta ("cooked cream"), a dish that probably descended from an older dessert called blancmange, which sounds suspiciously French but definitely is not. With its use of gelatin, it's easy to see how blancmange could have morphed into panna cotta, but given the fact that panna cotta didn't appear in Italian cookbooks until the 1960s, I'm thinking that blancmange probably originated in Arab cuisine and then moved to Rome. It got its French-sounding name, I suspect, because the English thought it sounded better than "white food."

MARASCHINO CHERRIES

Perfect for cocktails like the Manhattan, and also my panna cotta, maraschino cherries are actually marasca cherries from Italy . . . technically, though, Croatia. Here's the story: Real maraschino cherries are sour marasca cherries soaked in a syrup containing the local cherry liqueur called maraschino—delightful. American processors just soak nasty Royal Anne cherries in almond flavoring and red dye. Real maraschinos are easily found on the interwebs or at reputable liquor stores—they are pricey, but oh so worth it.

IN COLD BREW

Even in our constantly caffeinated culture, misconceptions concerning cold brew coffee abound. And that's a shame, because cold can coax flavors and aromas from familiar grounds that further display the multidimensional galaxy of coffee. So, in this episode we tried to set the record straight on the most pernicious misconceptions around cold brew and explore three of my favorite ways to brew this delightful quaff.

We use a lot of mirrors.

It's quite possible that the country most responsible for the development and proliferation of cold brew coffee is Holland. As early as the seventeenth century, sailors on ships of the Dutch East India Company kept caffeinated by soaking coffee grounds in cold water and making a kind of syrup that would keep in the tropical climes. Many Dutch colonies in the "East Indies" began growing coffee, which the Dutch no doubt traded with the Japanese, who were already familiar with the cold brewing of tea and likely perfected methods of doing the same with coffee. Not that the Dutch would have been permitted to see any of these methods, despite the fact that they were the only Westerners allowed in the Land of the Rising Sun from the time the Portuguese were shown the door in 1639 until 1853, when Commander Perry sailed in.

But a compelling argument could also be made for cold brew having been invented in Mazagran, on the northern coast of Algeria, where, in 1840, a small French force manning an equally small fort held off an attack by a sizeable Arab and Berber force. Back home, the heroes were feted with a PR campaign promoting all kinds of Algerian goods, including the beverage that supposedly gave the troops their oomph: a mixture of coffee syrup and cold water.

Parisian cafés added lemon, and the habit spread.

These days I adhere to three distinct approaches to the cold brewing of coffee. Well, actually, there are two, plus a hybrid. Each has its own distinct characteristics. There's cold drip, aka the Kyoto method; cold immersion; and the hot pour-over style, aka the Japanese method. Yes, two of our methods have at least some of their roots in Japanese grounds (ha!) and that, of course, is because perfection is a Japanese national obsession and they have worked on this stuff a lot. Since coffee is my hobby, I actually brew via each of these methods.

Let's begin with the Kyoto method. The first time I visited Japan I saw one of these in a coffee shop and immediately wanted one:

The device was close to four feet tall and featured a top chamber for ice water that dripped through an adjustable valve into a brewing chamber, dosed with coffee grounds. The brewed coffee then spun down a spiral collector tube (of no actual value as far as I can tell), into a third vessel below. The resulting brew is clean and clear and lovely, and the tower itself is gorgeous, but it's also a huge, fragile, expensive unitasker. Luckily, we can make our own out of stuff easily scrounged around the average American domicile.

CAFFEINE CONTENT

I want to address the popular notion that cold brews deliver more caffeine than hot brews. Now, I have read peer-reviewed papers arguing that they do and that they don't, but I suspect that it all comes down to volume. We tend to guzzle cold beverages more than hot because, after all, when you guzzle a hot beverage . . . you just might burn your face off. So, we take in more caffeine when we drink cold brew because we just plain drink more cold brew. Just a theory, but seems legit.

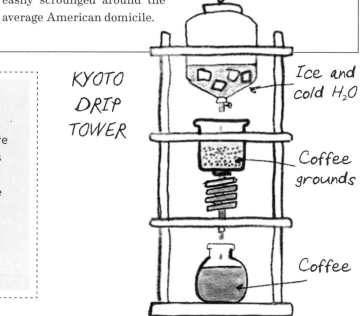

KYOTO DRIP TOWER

Ice and cold H₂O

Coffee grounds

Coffee

	YIELD:
# KYOTO-STYLE COLD BREW	About 1 quart

SOFTWARE

110 grams (1½ cups) coarse-ground coffee

125 grams (½ cup) filtered water, heated to 200°F[1]

900 grams (about 7 cups) ice cubes, plus more for serving (optional)

TACTICAL HARDWARE

- 2 (3-liter) plastic soda bottles, cleaned
- A utility knife (box cutter) with a locking blade
- A thumbtack
- A 10 × 2½-inch piece of cheesecloth
- A large glass pitcher
- 2 rulers or paint-stirring sticks
- 2 medium rubber bands
- A large (9½-inch) paper coffee filter
- A small (7¾-inch) paper coffee filter
- A digital scale

Back in the 1990s a popular American coffee chain named after a Moby Dick character created a beverage called a Mazagran, but you know what? It didn't go over so well.

PROCEDURE[2]

I'm just going to say this once: BE CAREFUL. We're hacking soda bottles with a box cutter here, so take precautions, go slowly, and always cut away from anything that can bleed. Also (and I hope obviously), don't let kids attempt this.

1) Set the blade of the utility knife so that it's sticking about ¼ inch out of its handle and cut the bottom 3 inches off both soda bottles. Discard the bottoms.

2) Remove the bottle lids. Cut an asterisk-shaped hole in the first lid.[3] Use the thumbtack to poke a tiny hole right in the middle of the second cap. Screw both caps back onto the bottles. Wad up the cheesecloth and stuff it into the neck of the bottle with the asterisk-shaped hole.

3) Place the bottle with the asterisk-shaped hole on top of the pitcher with the cap facing down and secure with the rulers/paint sticks, and rubber bands.

4) Place the coffee grounds in the large paper filter and pull the edges together to make a pouch. Set this inside the bottle, then open up the edges of the filter to expose the grounds. Position this entire apparatus on top of a digital scale. Zero the scale, then slowly pour the hot water in a spiral over the grounds to bloom the coffee. This step should take about 30 seconds. Top with the small coffee filter, which will act as a diffuser.

5) Nestle the bottle with the tiny hole, cap down, onto the bottle holding the coffee. Zero the scale again and weigh the ice into the top bottle.

6) Set your tower out of direct sunlight until all of the ice has melted and passed through the coffee, 10 to 12 hours.[4] If you're keeping an eye on the coffee-brewing process, you should see one drop of water moving through the coffee about every 7 seconds. I typically set up my rig in the evening so my coffee is ready to greet me first thing in the morning.

7) Once brewing is complete, remove the rig from the pitcher and discard or compost the coffee grounds. Serve immediately over additional ice, if desired, or transfer to airtight containment and refrigerate for up to 1 week.

1 If you want to be a purist, you can bloom the coffee using cold water, but, in my opinion, the hot bloom method tastes better.

2 Obviously, once you've built the tower the first time, you can simply jump down to step 4.

3 Try doing this with the cap upright rather than upside down. AND DO BE CAREFUL.

4 Size and shape will affect the melt rate, as some cubes have more surface area than others. Don't worry if you let it sit out longer than 12 hours; the coffee will be fine hanging out and waiting for you.

YIELD:
2 cups concentrate; serves 4

COLD BREW WITH CHICORY

Cold brew coffee infused with chicory is a simple, savory, and southern alternative to classic cold brew. It is more rustic and, dare I say, aggressive, than the Kyoto drip coffee, but it requires minimal equipment and very little effort. This version comes with a custom sweetener, which you may employ or not.

SOFTWARE

90 grams (1 cup plus 2 tablespoons) coarse-ground coffee

45 grams (⅓ cup plus 1 tablespoon) roasted chicory (see sidebar on page 302)

675 grams (2¾ cups plus 2 tablespoons) cold filtered water

60 grams (3 tablespoons) honey

60 grams (3 tablespoons) dark agave syrup

20 grams (1 tablespoon) molasses[5]

100 grams (6 tablespoons plus 2 teaspoons) hot water

Ice cubes, for serving (optional)

Whole milk or half-and-half, for serving (optional)

TACTICAL HARDWARE

- A digital scale
- A quart jar
- A squeeze bottle or pint-size glass jar (for sweetener)
- A fine-mesh sieve
- Cheesecloth
- A rubber band

PROCEDURE

1) Combine the coffee, chicory, and the 675 grams of cold water in a clean quart jar. Seal the jar tightly, shake vigorously, then set aside for 8 to 10 hours. Make sure to keep the jar out of direct sunlight.

2) To make the sweetener,[6] combine the honey, agave syrup, molasses, and the 100 grams hot water in a wide-mouth plastic squeeze bottle.[7] Lid up and shake to thoroughly combine. The syrup will keep for a couple of months in the refrigerator.

3) When the coffee is ready, give the jar a couple of shakes, then strain through a fine-mesh sieve into a large liquid measuring cup. Clean the jar, then place a piece of cheesecloth, folded over three or four times, over the mouth and push down to create a filter at least 2 inches deep. Affix with a rubber band. Pour the coffee through the cheesecloth to filter out any remaining sediment, stirring as needed with a rubber spatula.[8] Tightly seal and refrigerate for up to 1 week.

4) To serve, combine 4 fluid ounces (½ cup or 120 g) of the coffee with 1 tablespoon (15 g) of the sweetener (add more if you like it sweeter) in a pint glass, then fill the glass with ice, if desired. Top with milk, if desired, and consume.

6 It's pretty close to impossible to get granulated sugar to dissolve in cold coffee. You can, of course, sweeten with simple syrup, but frankly that's a bit one-note for me. This mixture actually brings flavor to the party and goes especially well with chicory.

7 This step is easiest if you place the squeeze bottle (sans lid!) on a scale, zero the scale, then measure the sweeteners directly into the bottle.

5 I prefer to use the darkest molasses I can get my hands on, ideally blackstrap molasses, which is about as burned tasting as sugarcane juice can get.

8 Dump the grounds, and either use in your garden as fertilizer or . . . they say you can exfoliate with coffee grounds, but I don't go in for that kind of thing.

CHICORY AND NEW ORLEANS–STYLE COFFEE

Cichorium intybus is the ground root of a semi-woody member of the daisy family with a blue, aster-like flower that goes by the name *chicory*—not to be confused with *Cichorium endivia*, leafy, bitter salad greens that are often called escarole or endive or frisée or curly chicory, depending on whom you ask. Nomenclature is a cruel mistress.

Teas, or more precisely tisanes, brewed from chicory root have been used to treat a host of ailments from jaundice to gout, going back all the way to ancient Egypt. Although chicory has long been used in brew form in Europe, especially in Germany, here in the United States chicory became a coffee mate of some renown when New Orleans was cut off from resupply by Union blockades during the Civil War. To this day, chicory coffee is associated with New Orleans.

I like New Orleans-style coffee and the funky pizzazz it delivers. I also like that roast chicory, easily obtained from the interwebs, is caffeine-free. And it is a prime source of inulin, a type of plant fiber that aids a host of digestive issues and ailments. Last but not least: It's darned tasty, especially with a plate of beignets . . . or Bonuts (page 23).

COFFEE FLAVOR

Coffee, once roasted, is complex stuff, and a lot of the substances therein are, to varying degrees, soluble in water. Hot water can extract a great many, like malic acid, chlorogenic acid, and hydroxycinnamic acid, not to mention various proteins, and, of course, aromatic compounds like gamma-butyrolactone and methylfurfural.

So, in the end, we get body, a snap of bitterness, and that wonderful coffee smell, but many of those compounds are volatile, and that volatility is accelerated by hot water. And though I'm waiting to find a peer-reviewed paper to back this, it has been suggested that once certain substances are coaxed out by the hot water, they're beset by oxygen, rendering them sour.

The point is, cold water doesn't release exactly the same proportions of flavor molecules as hot, so any given coffee may have two or more completely different flavor profiles, which, to my mind, makes cold brewing totally worth our while.

YIELD:
1 serving

HOT START, COLD BREW

Also referred to as Japanese iced coffee, hot cold brew is a hybrid quaff and my go-to when I'm in a hurry. When it comes to coffee intended for cold consumption, I prefer a 16:1 water-to-coffee ratio, which many baristas consider middle of the road . . . not too strong nor too weak. I suggest trying it my way first, and then adjusting this formula the second time if you want it stronger or weaker.

SOFTWARE

25 grams (⅓ cup) medium-ground coffee[9]

150 grams (about 1½ cups) ice cubes[10]

250 grams (about 1 cup) filtered water, heated to 200°F[11]

TACTICAL HARDWARE

- A pour-over coffee rig with carafe and filter holder, like a Hario V60 or a Chemex, and the proper-size paper filter
- A digital scale

PROCEDURE

1) Assemble a pour-over coffee rig using a carafe, filter holder, and filter set on the scale.[12]

2) Place the coffee in the filter and the ice in the carafe, carefully noting the weights.

3) Slowly pour 50 grams of the hot water over the coffee in a spiral pattern.[13] Zero the scale, wait 40 seconds, then, using the same spiral pattern, slowly pour the remaining 200 grams water over the coffee. This step should ideally take about 2 minutes. If you're using an electric kettle with a thermostat, you can dose out the water in batches, returning it to the heating element as needed.

4) When the coffee has finished brewing, remove the filter holder and discard or compost the grounds. Serve the coffee with any remaining ice or strain it out for a stronger brew.

ACIDITY

We food types love to go on about acidity. But what exactly is an acid? By definition, it is a substance that disassociates in an aqueous solution, releasing a hydrogen ion. And when we talk about how acidic something is or isn't, we use the pH, or "power of hydrogen" scale. If there are a lot of ions in the substance, it is low pH and therefore acidic. If, on the other hand, there aren't a lot, it's high pH and an alkaline or base. Right in the middle? Neutral.

Here's where things get interesting. Let's say that we have one coffee that's, say, pH 6, and another that's around 4.5. It is actually possible for the less acidic coffee to taste more acidic. That's because there are more than forty acids in a cup of coffee, and many are titratable, meaning they don't give up all of their hydrogens unless counteracted by a base like baking soda, or they're diluted by another liquid, like saliva. And get this: As our sour-sensing taste cells lock onto hydrogen ions, they actually make room for more to be released in the mix by this titratable reserve, which means that, flavor-wise, acidity happens in the mouth.

9 Why a medium grind here? Because we're only running about two-thirds of the usual amount of water through it. Finer grounds mean more surface area and a faster brew.

10 Quality matters here. If you don't like the flavor of your tap water, I suggest that you freeze filtered water in cubes for this procedure.

11 I like to use an electric kettle with a thermostat to heat my water. If you're using a stovetop kettle, just bring the water to a boil, and then let it cool off the heat for a couple of minutes before proceeding.

12 These supplies are all easily found on the interwebs and, frankly, in most decent coffee shops. You can use them to make regular hot coffee, too.

13 This is called the bloom, and it will allow CO_2 to gas off so that the grounds will be more welcoming to the water to come. Read more about coffee blooming on page 286.

FLAT IS BEAUTIFUL VI: FRY BREAD, FRY

Totally riffing on *Alien* here.

Bread. Nothing could be more basic. Some flour, water, yeast, a little salt. Of course, baking it does require an oven, and through most of human history, home cooks haven't had ovens—at least not ovens most modern cooks would recognize. Back in the day, many villages had communal ovens, but from the Middle Ages back into prehistory, breads were cooked on the home hearth. Such breads were, by necessity, flat, so as to make as much contact with the hot stone as possible. Great culinary traditions have risen from this meager necessity, including Navajo fry bread and hoe cakes here in America, both of which deserve episodes of their own. But in this episode, we concentrated on two of my favorites, each of which has an interesting twist in the starch department.

STARCH IN BREADS

If you're even a casual *Good Eats* fan, you've seen this:

That's our gluten model. It's just PVC and bungee cords, but it gets the point across. Gluten, of course, is the stretchy protein matrix that makes risen bread possible and gives gluten-intolerant folks a hard time.[1] But the truth is this model is incomplete, because bread is mostly starch, which manifests itself as highly ordered granules packed full of carbohydrates—that is, storage units composed of carbon, hydrogen, and oxygen. So, really, the model should look more like this:

Let's say that the yellow balloons are wheat starch granules. When heated they absorb water, swell, and often rupture, sending starch molecules out into the bread. Some of

these molecules, like amylose, crystallize as the bread cools, and that's a major factor in staling . . . or more technically, retrogradation.

But what if we invited another starch to the party? Potato starch granules, for instance, are bigger and hold more water than wheat starches, and might look something like this:

And, if the potatoes we added were cooked, those swollen granules would be far less likely to give up their water. That's why breads with spuds in them tend to be a lot softer and stale a lot slower than breads without spuds in them.

But wait, there's more: Potato starch contains negatively charged phosphates that help prevent retrogradation, and we could deep dive into that but it would only excite the scientists. The point is, adding potatoes or even potato flour or freeze-dried flakes can make a bread stay soft longer. Oh, and they taste good. Case in point . . .

1 And in the case of celiac, a really hard time.

HUNGARIAN LANGOS

YIELD:
8

Langos (pronounced "lang-osh") comes from the Hungarian word for "flame," and it might never have happened had most Hungarians had ovens back in the sixteenth century. And if the potato hadn't become popular there in the nineteenth century, we might not have my favorite version: *krumplis langos,* which is a ubiquitous street food across the region.

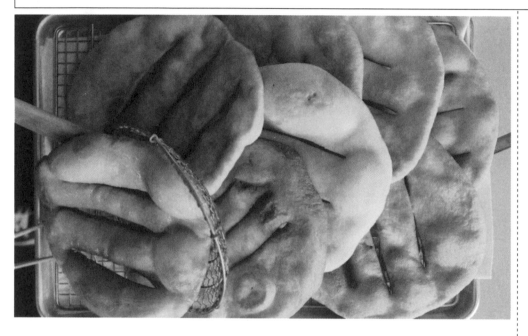

SOFTWARE

680 grams (1½ pounds) russet potatoes (about 2 medium potatoes)

650 grams (about 4⅔ cups) all-purpose flour, plus up to 75 grams (about ½ cup) more, if needed

200 grams (¾ cup plus 2 tablespoons) whole milk[2]

25 grams (1 tablespoon plus 1 teaspoon) neutral oil, such as safflower, peanut, or canola, plus 5 to 7 cups for frying

15 grams (about 1½ tablespoons) instant yeast[3]

12 grams (about 1½ tablespoons) kosher salt

7 grams (about 1½ teaspoons) sugar

TACTICAL HARDWARE

- A heavy-duty stand mixer with paddle and kneading hook attachments
- A large Dutch oven (enameled cast iron is my preference)
- 2 sheet pans and several sheets of parchment
- A cooling rack that fits over a sheet pan
- A clip-on fry thermometer[4]

PROCEDURE

1) Peel the potatoes and cut into 1-inch cubes. Measure out 580 grams (1¼ pounds) of the cubes and move to a medium saucepan.[5] Cover the potatoes with 1 inch of water and place over medium-high heat. Bring to a boil, then reduce the heat to medium-low and simmer until soft, 10 to 12 minutes.

2) While the potatoes are boiling, deposit the flour, milk, 1 tablespoon of the oil, the yeast, salt, and sugar in the mixer's work bowl and install the paddle.

3) Drain the potatoes well, then return to the saucepan and stir over medium heat, breaking up large pieces, until the potatoes are dry and crumbly, about 3 minutes. Transfer to the stand mixer's bowl.

4) Mix on low speed until the dough begins to come together, about 30 seconds. Then swap out the paddle for the dough hook and knead on medium speed until somewhat smooth, about 4 minutes. Inspect the dough. If very sticky, tearing, or smearing around the bottom of the bowl, add a tablespoon more of flour and mix on low speed for 30 seconds. If the dough is still smeary, add another tablespoon.[6] Return to medium speed and continue kneading until the dough is smooth, about another 3 minutes.

2 Do not use skim. If you do, you'll regret it, and I know what I'm talking about.

3 Yes, that's a lot, but *langos* is a fast riser. Also . . . do not attempt to substitute active dry yeast.

4 Old-school, perhaps, but I prefer analog when it comes to fry oil, because it's a better "trend instrument," which means it's easier to observe the rate of change so that you can make adjustments and not race through the target temperature.

5 Save any remainder for another use.

6 I've never needed to add more than 3 tablespoons, but this will depend on the moisture in the potatoes.

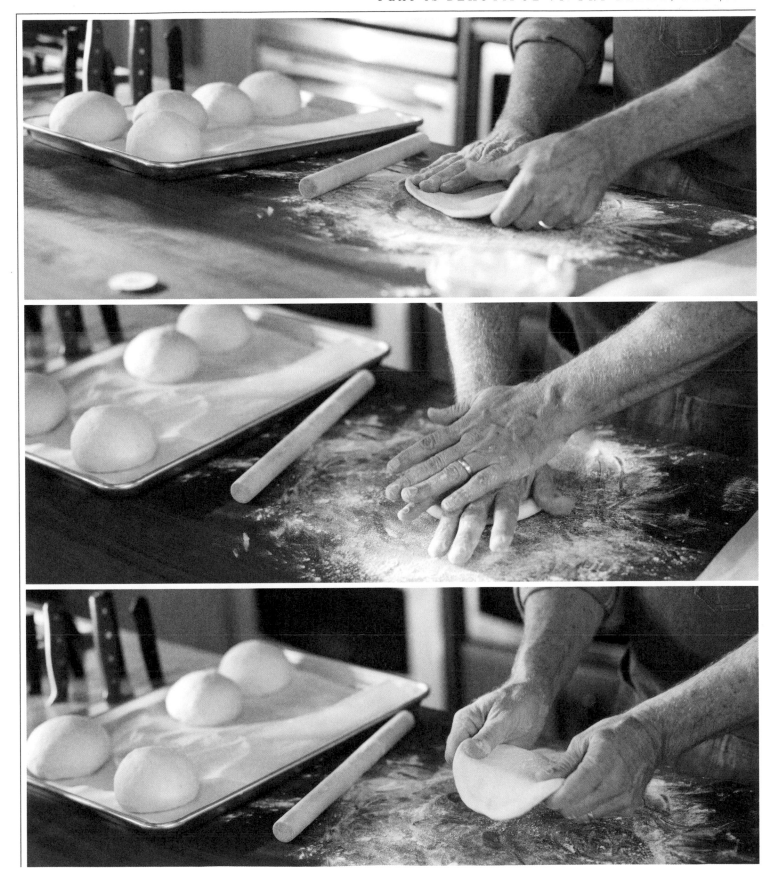

HUNGARIAN LANGOS *(continued)*

You can't plan this kind of thing.

5) Transfer to a lightly floured counter and knead by hand for a final minute. If the dough sticks heavily to your hands, work in a little more flour. The dough should be soft but not overly tacky.

6) Shape into a ball and place in a 2- to 4-quart container. Add a scant 1 teaspoon oil and rotate the dough to evenly coat. Press the top to flatten the dough, then mark the dough height on the outside of the bowl with tape or a rubber band. Cover the bowl with plastic wrap and let rise at room temperature for 30 minutes, or until the dough has doubled in size.

7) Punch down the dough to remove air bubbles.[7] Transfer to a lightly floured counter and divide into eight 175- to 180-gram pieces. Form each piece into a smooth, taut ball, then transfer to a parchment-lined baking sheet. Cover with a towel and rest for 10 minutes . . . the dough, not you.

8) Add 1 inch of the oil to the Dutch oven and bring to 350°F over medium-high heat.[8] Line a baking sheet with paper towels and top with an upside-down wire rack. Keep an eye on the thermometer while you roll the doughs.

9) Flatten each ball into a circle, then roll or stretch on a liberally floured counter into an 8- to 10-inch disk.[9] Transfer to a parchment-lined baking sheet or sheet pan and top with a second sheet of parchment. Repeat with the remaining dough rounds.

10) Give the first dough a final stretch to widen the round, then cut 3 slits across the center of the disk to help keep large bubbles from forming during the cook.[10] Carefully place in the hot oil and fry until puffed and golden brown, about 1 minute per side. Transfer the finished langos to the wire rack to cool and allow excess oil to drain. Keep an eye on the oil temperature and adjust the heat as needed to maintain 350°F as you repeat with the rest of the dough disks.

11) Consume warm, if possible, or cool to room temperature and enjoy. To keep for up to 3 days at room temp, simply wrap in a tea towel or paper towel and stash in a zip-top bag. For long-term storage, tightly wrap each langos in plastic wrap, then seal as many in a zip-top as will fit and freeze for up to 6 months. Reheat straight from the freezer in a toaster oven or directly on the rack in a 425°F oven for 10 minutes.

NOTE

If you don't want leftovers, here's my suggestion: Combine ½ cup sugar and 2 teaspoons cinnamon in a gallon-size zip-top bag. One at a time, add the hot langos to the bag, seal, and shake to coat. Consume immediately. There: no leftovers.

7 Not only is this fun, but it's also an important step, because we want to break up the larger gas bubbles and help to redistribute them.

8 A little hotter is better than a little cooler.

9 When it comes to rolling pins, I like to use a 10-inch-long by 1-inch-diameter dowel, as I find it gives me disks with better consistency. You can use whatever kind of rolling device you'd like.

10 These will also increase the surface area of the bread, maximizing golden-brown deliciousness. And they make it easier to flip!

Punching down the dough removes excess CO_2 and redistributes the gas that remains.

A TALE OF TWO YEASTS

There are three main forms of bakers' yeast. Old-school bakers still depend on cake yeast, which comes in little foil-wrapped blocks. The yeasties lurking inside are wide awake and ready to go straight out of the gate, but they're also highly perishable and even refrigerated have a relatively short lifespan. Active dry yeast and instant yeast, on the other hand, are like the crews of so many sci-fi space vessels, from the *Jupiter 2* to the *Nostromo*—they're in suspended animation.[11]

Active dry yeasts are encased in a sarcophagus of their dead brethren. To wake this guy up, manufacturers suggest soaking or "proofing" with warm water and sometimes sugar to wash away all the dead guys and rouse the sleepy ones. Instant yeasts are not only a different strain, they're dehydrated in such a way that allows them to spring to life as soon as they meet up with an adequate dose of moisture. No soak necessary.

In my opinion, these yeasts are not interchangeable in recipes. If a recipe calls for instant yeast, use instant, and if it calls for active dry, do what it says. People will tell you that you can convert one for the other, but I don't buy it and neither should you.

BOILING WATER DOUGH

Boiling water, or water just off the boil, is the key to many recipes, from the aptly named English water pastries to pâte à choux and *tangzhong*, a paste used in many Japanese breads. Again, it's about starch. When cold water is added to flour, proteins get first dibs, thus strong gluten matrices form. Think French baguette. When boiling water is added, the starch granules take the water and drink it up, preventing the proteins from getting what they need to do their thing. The result is a softer, more workable dough that can be filled, folded, twisted, and rolled.

11 If any of these references seem alien . . . (ha) then we need to talk.

SCALLION PANCAKES

YIELD:
4

SOFTWARE

10 to 12 scallions (about 230 g)

1 cup (240 g) neutral cooking oil, such as canola or peanut

2 cups (280 g) all-purpose flour, plus more for shaping, as needed

1½ teaspoons kosher salt

⅔ cup (158 ml) boiling water

PROCEDURE

1) Thinly slice the scallions, separating out the tender greens from the whites and light greens. Weigh out 60 grams (1 packed cup) of the tender greens and set aside for the pancakes. Add the remainder to a small saucepan. Add the oil, place over medium-low heat, and cook, stirring occasionally, until the oil begins to rapidly bubble, about 5 minutes. Continue frying, stirring more frequently now, until the bubbling begins to subside and the scallions turn crisp and golden brown, about 15 minutes total.

2) Carefully strain the hot oil through a fine-mesh sieve set over a pint-size heatproof glass liquid measuring cup. Cool to room temperature, reserving the fried scallions to use as a garnish on fried rice, omelets, or anything else needing a little crunch.

3) While the scallion oil is cooling, mix the flour and salt together in a large bowl. Pour in the boiling water and stir with a spatula or chopsticks until combined and cool enough to handle. Use your hands to knead in the bowl until the dough comes together. Transfer to a clean counter and knead until the dough turns soft

and smooth, 3 to 5 minutes. Return to the bowl, spray with nonstick cooking spray, cover with plastic wrap, and let rest for 1 hour at room temperature.

4) When the scallion oil is cool, measure out ½ cup to use in the recipe; save the remainder for another use.[12] The scallion oil will keep for about 1 month, refrigerated in an airtight container.

5) Divide the dough into four 100- to 110-gram (about 3¾-ounce) pieces and roll into smooth balls. Keeping the remaining pieces covered, roll one ball into an 8- to 9-inch circle measuring less than ⅛ inch thick. Brush with 1 teaspoon of the cooled scallion oil and then sprinkle with ¼ cup (about 15 g) of the scallion greens. Roll into a tight snake, making sure not to capture any air bubbles inside. Wrap the snake into a tight pinwheel with the seam facing inward. Tuck the end under and place on a parchment-lined baking sheet. Repeat with the remaining dough. Cover with plastic wrap and let rest again for 30 minutes at room temperature or in the refrigerator overnight. If chilling, bring to room temperature before proceeding with the next step.

6) Lightly brush your work surface with some of the scallion oil.[13] One at a time, roll the spirals into 7- to 8-inch pancakes.[14] Return to the baking sheet and top with a piece of parchment. Repeat with the remaining dough spirals, greasing the counter with additional oil as needed and placing a piece of parchment between each pancake.[15]

7) Heat a 10-inch cast-iron skillet over medium-low heat for 5 minutes. Line a baking sheet with paper towels and top with an upside-down wire rack. Place near the cooktop.

8) Add 2 tablespoons of the scallion oil to the hot skillet, followed by one of the pancakes. Fry, flipping every 30 to 45 seconds, until golden brown on both sides, 3 to 5 minutes total. Transfer to the prepared rack. Repeat with the remaining pancakes, adding an additional tablespoon of oil to the pan in between each batch. Slice into wedges and serve hot with your favorite dipping sauce. Mine is 50/50 soy and black vinegar with the reserved crispy scallion bits, but that's just me.

12 You can use this for your next batch of scallion pancakes, or use it in salad dressings or stir-fries, or use it to make mayo for frites.

13 Using oil instead of flour adds flavor to the bread and prevents sticking, without the risk of toughening the dough.

14 If some of the scallions poke through the dough, don't worry about it. They'll brown up and crisp in the skillet—yum.

15 Once you get really good at this you can probably roll one and cook while you roll the others, but I don't like having to move that fast, so I roll everything first.

IMMERSION THERAPY II: GONE FISHIN'

Our first immersion-circulator show, 2019's "Immersion Therapy," ended with me getting into a blue cardboard box (if you're not a *Dr. Who* fan, I'm not going to explain it) and disappearing into the future. Our second immersion-circulator show (shot in 2020) is set mere moments later as the box reappears and I hurry back into the kitchen, hiding my face mask and proclaiming that it's *so* good to be back in 2019. I clumsily suggest that we really should learn to cook fish at home because, hey, what if one day we couldn't go out to restaurants? Crazy, I know, but what if?[1]

We cook fish for three reasons: to improve texture, develop flavor, and kill anything that might want to kill us. Each of these things happens at specific temperatures, so temperature control is key. Because of their musculature, most fish are quite sensitive to overcooking, as their connective tissues dissolve at relatively low temperatures, and yet we still need to cook them hot enough (and long enough), to kill potentially harmful bacteria. To avoid the thermal pitfalls of ovens, grills, fryers, and simmering pots of water, I now do most of my fish cookery with an immersion circulator, the miracle invention first mentioned back on page 124. Digitally controlled, the circulator unit connects to a pot or other vessel containing water; the temperature is set and the controller brings the bath to that exact temperature. The fish and the desired flavorings go into heavy-duty bags. The bags go in the water and the fish is brought to and held at the exact temperature of our choice. We can then, if we so desire, quickly sear the fish in a pan to finish. One of my favorite fish for this treatment: halibut.

Clostridium botulinum, a bad hombre . . . unless you want Botox.

1 I'm writing this in June 2021 and the United States is reopening. I can only hope that by the time you read this, the trend has safely continued.

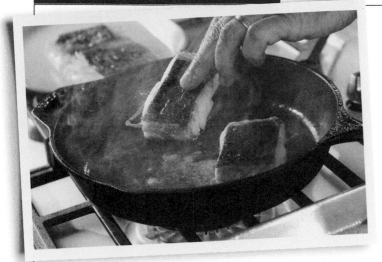

HALIBUT

Hippoglossus stenolepis and *Hippoglossus hippoglossus*, the Pacific and Atlantic halibuts, respectively, are the largest of the flatfish, capable of growing up to eight feet in length and weighing in at over five hundred pounds. Most of the halibut on the market these days are "chickens" harvested at around twenty pounds, though larger specimens are not unheard of. Also, you may notice a label that states that the fish are grown via aquaculture, but most are still caught wild and, due to sustainability issues, I'd avoid Atlantic varieties. As for cooking, halibut are meaty albeit mild and lend themselves to many a method, as long as you don't dry them out. Which is why they're perfect immersion fodder.

NOTE: ABOUT THE BATH WATER

The amount of water you'll need for the circulator to work depends on the vessel you decide to use and the size of the food going into it. I do most of my cooking in a 4¾-gallon (12 × 18 × 9-inch) vessel, which requires 12 quarts of water to reach halfway between the max. and min. lines. Most of the dishes in this section, however, could cook in a smaller vessel, say a stock pot in the 12-quart range (8 quarts to fill halfway between max. and min.). Consult the manual for your cooker for manufacturer recommendations, as they all say something different and, in the end, I'd rather have you yell at them than at me. In any case, that water amount is not included in the applications below.

BUYING FROZEN FISH IN THE MODERN AGE

The word *fresh* is often interpreted as "raw," though I would argue that *fresh* should mean "the state closest to that of the living organism," while *raw* should just be another way of saying "uncooked." I would argue that frozen fish can be fresher than "fresh," due to developments in freezing technologies and lightning-fast shipping.

When shopping, you can look for the country of origin. I used to rely on seeing "product of the USA" on the label, but what that really means is subject to ever-evolving regulatory hooey, so I don't give such info much credence anymore. You do want to see specific details about how the fish was harvested, and whether it was farmed or wild-caught. I also like to see the mark of the Marine Stewardship Council, a certification program that helps to ensure eco-friendly fishing practices. I purchase most of my fish from fisherman co-ops, but that's because I like fishermen more than corporations.

When ordering from the webs, here's what you want to see: a reusable cooler stocked with dry ice (careful not to handle that, or you could get burned) and your fish packaged in heavy vacuum-seal bags. Look out for signs of big ice crystals, sure evidence of thawing and refreezing. The fish should be hard as a rock and even in color. One of the nice things about purchasing seafood in a frozen state is that you can keep it that way at home for at least a month in a conventional freezer or up to six months in a chest freezer.

If you buy vacuum-packed frozen fish via the webs, as I often do, its packaging may include the words "remove from package before thawing." That's because low-oxygen environments are fine for frozen food, but once thawed could foster the growth of anaerobic microorganisms, such as *Clostridium botulinum*, the microbe that causes botulism, which, though rare, can be fatal. So I wrap my fish in plastic wrap to limit evaporation and park in a small, lipped container—no ice required at this stage. Once thawed, cook within a day if possible, as the "freshness" of thawed seafood depreciates quickly.

I know of no other cooking show with a talking fish.

I.C. HALIBUT WITH ALMOND BROWN BUTTER SAUCE

YIELD:

4 servings

SOFTWARE

10 tablespoons (141 g) unsalted butter

2 to 3 lemons, halved

4 (5- to 6-ounce/141 to 170 g) skin-on halibut fillets, 1 to 1½ inches (2.5 to 3.8 cm) thick, thawed if frozen[2]

2¼ teaspoons kosher salt

½ cup (88 g) raw almonds, finely chopped

2 tablespoons (30 ml) neutral oil, such as safflower

2 tablespoons (7 g) finely chopped fresh parsley

TACTICAL HARDWARE

- An immersion circulator
- A water bath holding at least 8 quarts water (if using a 12-quart pot)
- 2 heavy-duty zip-top freezer bags[3]
- A narrow metal spatula or fish turner
- A 10-inch cast-iron skillet

PROCEDURE

1) Assemble your immersion circulator, setting the water to 140°F (60°C).[4] If you like a slightly softer, less steak-y texture for your fish, go with 135°F (57°C).[5]

2) Melt the butter in a 2-quart saucepan over medium-low heat, 3 to 5 minutes. Stir frequently with a rubber spatula, until the butter solids turn light brown, about 5 minutes. Remove from the heat. Measure out 2 tablespoons of the browned butter, move to a small bowl, and cool to room temperature. Leave the remaining butter in the saucepan until you're ready to make the sauce.

3) Thinly slice one of the lemon halves into 8 slices. Juice 3 more lemon halves, which should produce ¼ cup juice. If you're shy on juice, squeeze another half. Strain the juice and set aside for the sauce.

4) Pat the fish dry with paper towels and season with 2 teaspoons of the salt. Divide between the two bags. Place 2 lemon slices on the skin side of each fillet, add 1 tablespoon of the browned butter to each bag, and

carefully work the butter between the fillets.[6]

5) Transfer each bag to the water bath, holding the open end of the bag as you let it sink into the water so that the air will be squeezed out via displacement. When the mouth of the bag is almost at the water line, carefully seal the bag. Cook the halibut in the water bath for 20 minutes.

TIP

Sometimes, if you don't get enough air out, the bags won't sink. That's why I keep some fishing weights and binder clips around. Straight to the bottom, baby.

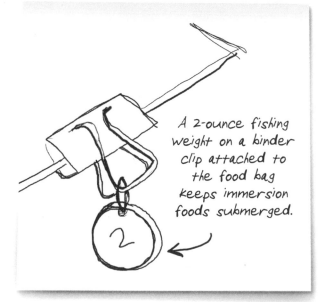

A 2-ounce fishing weight on a binder clip attached to the food bag keeps immersion foods submerged.

2 To thaw frozen fish, remove the fish from its packaging, wrap each fillet in plastic wrap, and place in a lidded container. Refrigerate overnight and cook the next day. Do not let the thawed fish sit in the refrigerator for more than 24 hours.

3 Just about any megamart carries brand-name high-density polyethylene, and polypropylene, which contain neither BPA or dioxins and won't soften or melt at typical immersion-circulator temperatures. Honestly, at temperatures below 160°F name-brand freezer-bags are fine, though I'd steer clear of generic and discount models. (My personal favorite are heavy-duty Ziploc freezer bags.)

4 I'm not a big Celsius fan, but am including here because a few of the circulators on the market default to Celsius.

5 Unlike many circulator recipes, this is not a "set it at the final temp and forget it" situation, as the fish will only reach an internal temperature of around 125°F. However, this method will produce a superior texture. And you'll still have a plus or minus five-minute safety margin.

6 I should mention somewhere in here that if you own a vacuum system like a FoodSaver-style vacuum bag system, you can use it here, but make sure you set the machine to "gentle" or "moist" or it'll suck that fish flat.

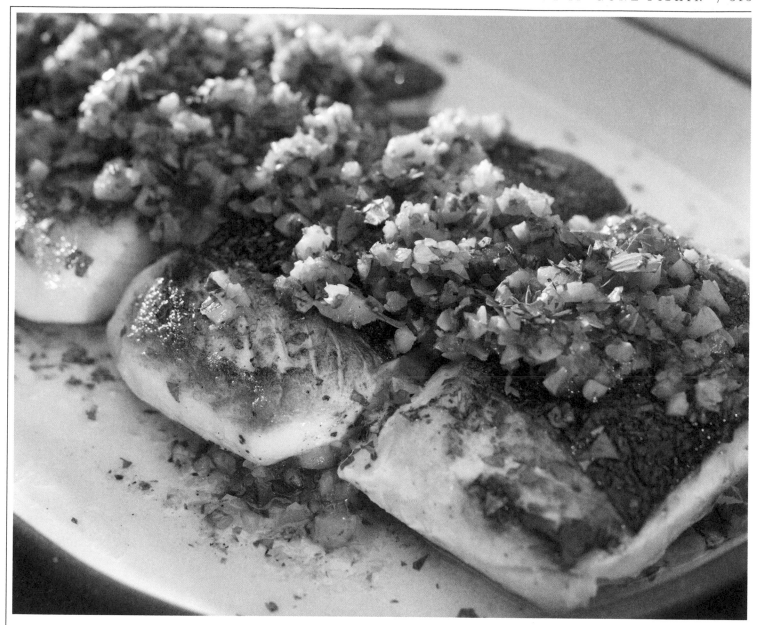

6) Return the butter in the pan to medium-low heat, add the almonds, and cook until the butter foams and the foam turns brown, 3 to 5 minutes. Remove from the heat and gradually stir in the lemon juice (the butter will bubble dramatically). Stir in the remaining ¼ teaspoon salt, cover, and set aside for serving.

7) When the halibut is finished, remove from the water bath and carefully remove the fish to a paper towel–lined sheet pan and pat dry with additional paper towels—the drier the better. Brush the skin side lightly with some of the neutral oil.[7]

8) Heat a 10-inch cast-iron skillet over high heat for 3 minutes. Add 2 teaspoons of the neutral oil, swirl the pan to coat, then add 2 of the halibut fillets, skin side down, and brush the flesh side lightly with additional oil. Cook until the skin is browned and crisp, about 1 minute, then carefully flip with a thin, narrow spatula or fish turner and cook on the second side until golden brown, about 30 seconds.

9) Carefully transfer to a serving platter and repeat with the remaining fillets. Drizzle the sauce over the top of the fish and garnish with the parsley to serve.

7 I know what you're thinking, "Why bother when I still have butter in the bag?" I know, but that's got a lot of protein-laden liquid from the fish, and if you use that instead of pure fat things are going to get sticky.

	YIELD:
# I.C. SALMON WITH DILL-YOGURT SAUCE	4 servings

When oily fish like salmon are cooked via immersion, they become slightly denser and meatier. And this is a good thing . . . in my opinion.

SOFTWARE

4 (6-ounce/170 g) pieces skin-on salmon fillet, ¾ to 1 inch (1.9 to 2.5 cm) thick, preferably wild-caught, thawed if frozen

3 teaspoons (9 g) kosher salt, divided, plus more if desired

1 tablespoon (15 ml) extra-virgin olive oil

1 lemon

1 cup (260 g) whole-milk yogurt (not Greek-style)

½ cup (23 g) chopped fresh dill

2 teaspoons (10 g) stone-ground mustard

1 teaspoon (6 g) prepared horseradish

3 grinds black pepper, plus more if desired

2 tablespoons (30 ml) neutral oil, such as safflower or canola

TACTICAL HARDWARE

- An immersion circulator
- A water bath holding at least 8 quarts water (if using a 12-quart pot)
- 2 to 4 heavy-duty zip-top freezer bags
- A narrow metal spatula or fish turner
- A 10-inch cast-iron skillet

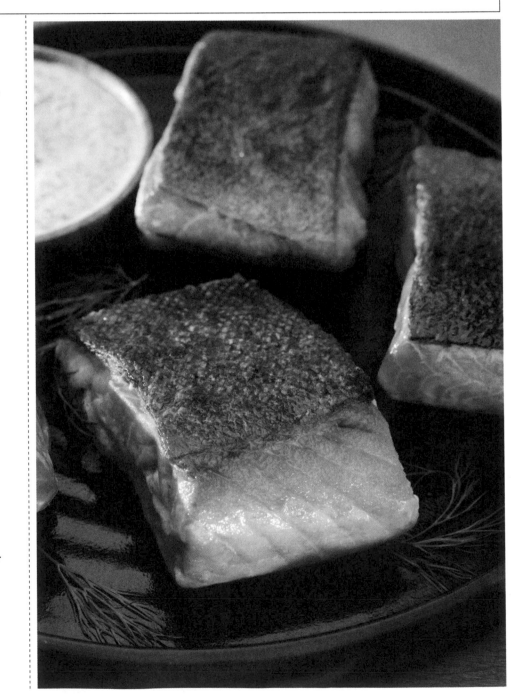

PROCEDURE

1) Place the salmon on a wire rack set in a rimmed baking sheet. Rub the fish with 2 teaspoons of the salt and refrigerate for 45 minutes. Meanwhile, set your immersion circulator bath to 124°F (51°C).

2) Pat the salmon dry with paper towels, then divide between two of the freezer bags. (If using farmed salmon, place each fillet in its own quart-size bag.)[8] Add 1½ teaspoons of the olive oil to each bag (if using separate bags for each piece, add 1 teaspoon of oil to each), then gently rub the fish to coat it in the oil. Use a peeler to harvest 8 strips of lemon peel and place 2 strips, pith side up, atop each fillet.[9]

3) Transfer each bag to the water bath, holding the open end of the bag as you let it sink into the water so that the air will be squeezed out via displacement. When the mouth of the bag is almost at the water line, carefully seal the bag. Cook the salmon for 45 minutes.[10]

4) Halve and juice the lemon and set the juice aside. Combine the yogurt, dill, mustard, horseradish, and pepper in a medium bowl, then stir in the remaining 1 teaspoon of salt and 1 tablespoon of the lemon juice. Season to taste with additional salt, pepper, and more lemon juice, if desired. Set aside until ready to serve.

5) When the salmon is done, remove from the bath. Open the bags and carefully remove the fish to a paper towel-lined sheet pan. Discard the bags and lemon peels and pat the fish dry with additional paper towels. Brush the skin side lightly with some of the neutral oil.

6) Heat a 10-inch cast-iron skillet over high heat for 3 minutes. Add 2 teaspoons of the neutral oil, swirl the pan to coat, then, when the oil starts to smoke, add 2 of the salmon fillets, skin side down. Brush the flesh side lightly with additional oil. Cook until the skin is browned and crisp, about 1 minute.

Carefully flip with a narrow metal spatula or fish turner and cook on the second side just until brown, about 30 seconds.[11]

7) Transfer to a platter and repeat with the remaining salmon and oil. Serve with the dill-yogurt sauce.

TIPS

>> Immersion circulators can be used to maintain the exact temperatures required for home photo developing. Simply attach your circulator to a large pot, fill with enough water to almost cover the sealed chemical bottles. Then just wait until the temp inside the bottle equals that of the bath. (Do I need to say "not for internal use?")

>> The next time you have a party and need to chill a bunch of beverages quickly, put them in a cooler or other vessel with ice water, attach your circulator, and set it to its coldest temperature. The convective movement of the water will chill the contents of the bottles two to three times faster than ice water alone.

>> Immersion circulators are also ideal for yogurt making, where maintaining a fairly exact temperature is critical. Although recipes differ, it's usually as simple as setting the circulator bath for the inoculation temperature, then dividing the mixture between tightly sealed jars with about an inch of headspace.

Elizabeth's first scene

> *If you're a Quarantine Quitchen fan, the activist who came to the door complaining about my cooking habits is*
>
> *indeed Elizabeth, who never complains about my cooking at home, even when it's terrible.*

8 Farmed salmon tends to be fattier than wild salmon, causing the fillets to stick together when cooked. Putting the fillets in separate bags keeps things tidy.

9 Again, if you're using vacuum-seal bags, use the "gentle" or "moist" setting to seal the bags.

10 If, for some reason, one of the bags floats, carefully open and try sinking and sealing again.

11 Technically, the fish is cooked and I consider this an optional step. If the fish feels to me like it's wobbly enough to fall apart if I flip it, I simply sear the flesh side with a standard hardware-store-issue propane torch.

BIBIMBAP 'TIL YA DROP

Just to be clear, I am (clearly) not Korean; nor am I an expert in the cuisines of that country. Heck, I've only been to Korea one time on a layover, and a screwup in scheduling prevented me from leaving the airport. That said, I've been drawn to Korean cuisine since the late 1980s, when I lived near a small Korean lunch place in Chicago. I'd never experienced the flavors of gochujang or doenjang before that, and they scratched some deep-down itch I didn't even know I had. One particular dish, *dolsot bibimbap*, was both immersive and transformative. I wasn't much of a cook back then, I could barely cook rice, and my homespun efforts to make my own bibimbap were, by and large, failures. I've got a few more skills now and, thanks to the internet (ingredients) and more time at home (pandemic), I decided to give it another try. My version will never be authentic, but until I finally do make that trip to Korea, it does scratch that itch.[1]

Although a few Korean staples are indeed required, bibimbap doesn't need much of a "kit" because, like hash or shepherd's pie, it's traditionally a dish of leftovers, albeit leftovers in balance.

Bibimbap gets its name from *bibida*, meaning "to rub or mix together" and *bap*, which means both "cooked rice" and "meal." Originally, it was kind of a jumble of a dish made from whatever ingredients were on hand, but when Korean restaurants commercialized it in the 1920s, the "mixed-up" components were segregated, enabling customers to customize the dish to their liking.

Bibimbap typically follows a set order of construction. There's a base of rice topped with vegetables including greens, sprouts, and mushrooms. There's a small amount of highly seasoned meat, fried eggs on top, and a sauce. Quick pickles are served on the side.

1 Don't think for a moment that I'm trying to pass off this dish as authentic. It's not. But it's the best I can do with what's commonly available.

Working the phones for my culinary travel agency

And while you certainly don't have to prepare it this way, we make our ours *dolsot* style, which means that it is assembled and served in a hot stone bowl or, in our case, a cast-iron skillet. This allows the bottom of the rice to crisp, and that's always good eats.

KEY INGREDIENTS

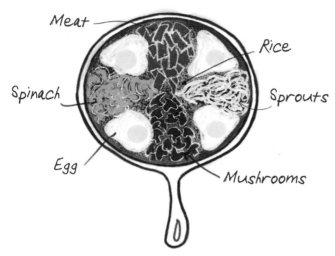

Meat — Rice — Spinach — Sprouts — Egg — Mushrooms

Composition, color, and overall presentation are a big part of the bibimbap experience. Called *obangsaek*, there are five colors that represent the five elements of the universe: yellow (earth), green or blue (wood), white (metal), red (fire), and black (water).[2] These colors capture the energy of the universe and allow people to absorb it through food, balancing the body. Traditional bibimbap is supposed to include all five colors, although it isn't always the case today.

For our red components, we'll be using beef short ribs and gochujang (more on both of those in a sec). For blue/green, we'll sauté spinach, make pickles from cucumbers, and use scallions in several different ways. Marinated and sautéed shiitake mushrooms will represent the black category and rice the white. Lastly, yellow will show up in both the eggs and sautéed bean sprouts.

Concerning short ribs: You'd think, given the name, that boneless beef short ribs would be cut from the rib primal, but they're not. "Short" ribs are either cut from the rib ends that reside in the plate primal, or from the first five ribs located in the chuck primal, both of which happen to be short. "Boneless" short ribs have simply had the bones removed. For this dish, I'd avoid "flanken" ribs, which are cross-cut and include short pieces of bone. Also steer clear of "country-style" ribs, which aren't actually cut from anywhere close to a rib.

Next, gochujang and doenjang, both made from fermented soybeans. Doenjang is kind of like brown miso, but also totally different: It starts out as a block of fermented soybeans called *meju* that is rehydrated with salt water and left to ferment outside in ceramic urns called onggi for several months. The resulting paste is thick and salty and serves as the base for much of Korean cuisine. Its red-chile-paste cousin, gochujang, also starts out as a fermented soybean block, but gets its unique sweet heat from the addition of glutinous rice, red chiles, malt syrup, and a three-month fermentation period. You can find gochujang at your neighborhood Korean market or international food store, or of course the internet. Just be sure to look for a red container with a pepper rating scale—two to three peppers is generally considered the sweet spot.

Our vegetables (spinach, shitakes, and sprouts) are getting a quick, light sauté in order to preserve their individual flavors and colors so they stand out in our final dish. This is the *namul*, or seasoned vegetable condiment component of bibimbap—a traditional accompaniment to meat-based main courses.

Unless you can get hold of Korean specimens, a hothouse or "English" cucumber, which almost always comes to market wrapped in plastic to prevent drying, is your best bet for the quick pickles. Although you can peel it if you like, there's a lot of flavor in that thin skin, so I never bother. For slicing, I prefer a ceramic slicer; my favorite one has a little bar on the back that allows the cuts to be finely tuned to 2 millimeters for our pickles. A sharp knife is fine too, of course.

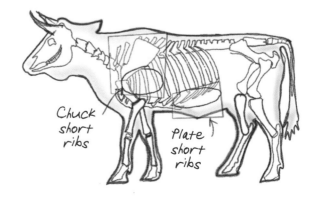

Chuck short ribs — Plate short ribs

2 Although this particular list came up fairly often in research, it's not a consistent list and regional variations abound.

DOLSOT BIBIMBAP

YIELD:
4 servings

There's a lot of cooking here, so my advice is to break it up, executing steps 1 through 6 ahead of time. Once the cast-iron skillet comes into play, I'm usually going straight on through to the table, but you could stop after step 8 and save the final assembly for later.

SOFTWARE

¾ cup (200 g) low-sodium soy sauce

2 tablespoons (35 g) doenjang or brown miso

4 scallions, thinly sliced, plus more for garnish as desired[3]

10 cloves garlic (38 g), grated

2 tablespoons (30 g) grated fresh ginger (from a 2½-inch piece)

2 tablespoons (30 g) dark brown sugar

8 ounces (227 g) boneless beef short ribs, very thinly sliced across the grain[4]

2¾ cups (628 g) water, divided, plus more for rinsing the rice

½ ounce (14 g) dried shiitake mushrooms (about ½ cup)

6 tablespoons (115 g) gochujang

2 tablespoons plus 2 teaspoons (40 g) rice vinegar

1 tablespoon (15 g) granulated sugar

2 teaspoons kosher salt, divided, plus more to taste

½ English cucumber (175 g), peeled and very thinly sliced

400 grams (about 2 cups) short-grain white rice or sushi rice

4 tablespoons (52 g) toasted sesame oil, divided, plus more for drizzling

1 cup (85 g) bean sprouts

6 ounces (170 g) whole-leaf spinach, washed

1 teaspoon neutral oil, such as canola

4 large eggs

TACTICAL HARDWARE

- A ceramic slicer for pickles (optional but recommended)
- A small hand sieve
- A large fine-mesh sieve (for rice)
- A pint canning jar or other container (for pickles)
- A 12-inch cast-iron skillet with a lid that fits[5] (see sidebar on page 323)
- A large nonstick skillet

Rice has been cultivated in Korea since at least 1500 BCE.

PROCEDURE

1) The meat: In a medium bowl, whisk the soy sauce with the doenjang, 2 of the scallions, 1 tablespoon (15 g) of the garlic, 1 tablespoon (15 g) of the ginger, and the brown sugar. Transfer ½ cup of this mixture to a gallon-size zip-top bag and add the short ribs. Seal, then massage the bag to thoroughly coat the meat. Refrigerate for at least 4 hours (overnight is fine too).

2) The mushrooms: Place the remaining soy sauce mixture in a small saucepan with ½ cup (118 g) of the water and the shiitakes. Bring to a simmer over medium heat, then reduce to low and simmer, stirring occasionally, until the mushrooms are tender, 20 to 25 minutes. Strain through a sieve into a measuring cup or bowl, pressing on the mushrooms to remove their liquid. Save the liquid and roughly chop the mushrooms. Refrigerate them for later or set by the cooktop to await assembly. Rinse the saucepan.

3) The sauce: Combine the gochujang and 2 teaspoons of the vinegar with 2 tablespoons of the mushroom cooking liquid in a small bowl and either refrigerate or set aside for serving.

4) The flavor base: Combine the remaining garlic, ginger, and scallions in a small bowl. Scoop 1 scant tablespoon of this mixture into the now-

3 I like to use a large cleaver for slicing scallions, because the pieces tend to climb up the blade instead of rolling around the room.

4 It's easiest to accomplish thin slices if you firm up the meat in the freezer for 15 to 30 minutes before cutting.

5 I purchased a glass one online so I can watch what's going on under there.

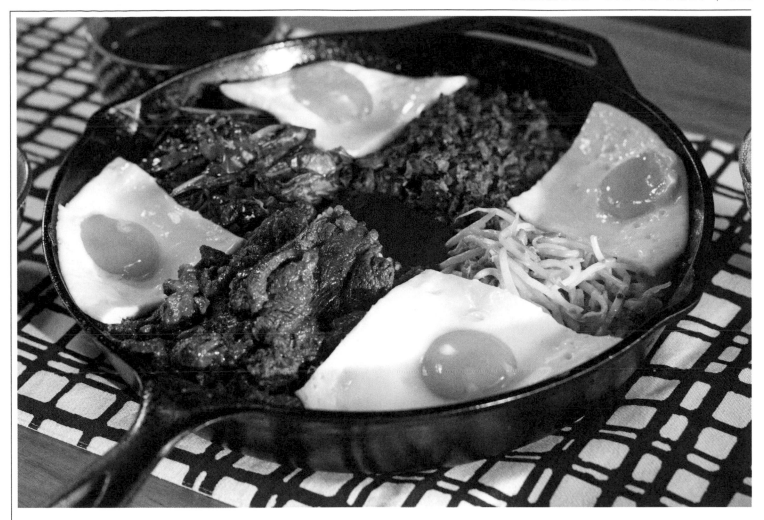

clean saucepan and set the remainder aside, as you'll need it for the final assembly.[6]

5) The pickles: Add ¼ cup (60 g) water, the remaining 2 tablespoons vinegar, the granulated sugar, and ½ teaspoon salt to the saucepan and bring to a boil over medium-high heat. Meanwhile, put the cucumber slices in a pint size glass canning jar. When the pickling liquid boils, pour over the cucumber. Cool to room temperature, cover tightly, and refrigerate until ready to serve.[7]

6) The rice: Place a large sieve inside a bowl large enough to hold it. Pour the rice into the sieve, then fill the bowl and sieve with cold water. Swirl the rice with your fingers for about 10 seconds, then remove the sieve to drain the rice. Dump the water and repeat with fresh water three times or until the water is mostly clear after rinsing. Drain well, then transfer the rice to a medium heavy-bottomed saucepan.[8] Add the remaining 2 cups (450 g) water and 1 teaspoon of the salt.[9] Place over high heat and bring to a boil. Give the rice a single stir, then reduce the heat to the lowest setting, cover, and cook for 15 minutes. Remove from the heat and let rest for 10 minutes, still covered. Finally, remove the lid and fluff the rice with a fork to release excess steam and to help the outer starch set. Transfer to a bowl and set aside until ready to use.[10]

7) The vegetables: Park a well-seasoned 12-inch cast-iron skillet over medium heat for 3 full minutes. When the skillet just starts to smoke, add 1 teaspoon of the sesame oil, followed by the bean sprouts, ½ teaspoon of the flavor base, and ⅛ teaspoon of the salt. Cook, stirring constantly, until the

6 You could cover and refrigerate at this point, but remember: Once grated, ginger often turns greenish due to loss of acidity and activation of anthocyanins. Doesn't matter, though; it remains safe and tasty.

7 These pickles can be made up to a week in advance. Save any leftovers for snacking.

8 If you have a rice cooker and prefer to use it, feel free. Simply follow the directions for your particular cooker. I don't own one, so . . .

9 I admit I've never seen an Asian chef from any country add salt to rice, but dang it, it's my rice and my kitchen and I like some salt in my rice.

10 If making in advance, my vessel of choice for refrigeration is a large zip-top bag, which allows you to work out much of the air and to break up the rice when you're ready for final assembly.

DOLSOT BIBIMBAP (continued)

sprouts start to soften, about 1 minute. Transfer to a small bowl and wipe out the skillet. Add another 1 teaspoon sesame oil, followed by the spinach, 1 teaspoon flavor base, and ¼ teaspoon salt. Cook, stirring frequently, until the spinach has wilted, 1 to 2 minutes. Transfer to a second bowl, wipe out the skillet, and add another 1 teaspoon sesame oil, followed by the rehydrated mushrooms.[11] Cook, stirring frequently, until browned, 2 to 3 minutes. Transfer to yet another small bowl.[12] Either kill the heat and clean the skillet or move on to step 8.

8) Cook the meat: Place the skillet over medium-high heat and, when it just begins to smoke, add 1 tablespoon sesame oil. Add the beef and its marinade and cook, stirring often, until the meat is cooked through and the sauce has reduced to a caramelized, sticky glaze, 3 to 5 minutes. Transfer to yet another bowl and remove the skillet from the heat. At this point, the vegetables, meat, and rice can be held at room temperature until ready to serve.[13]

9) Assemble the bibimbap: Off the heat, add 2 tablespoons sesame oil to the cast-iron skillet and swirl to coat the bottom and the sides.

10) Add the rice and, using a wide spatula or your hands, press into an even layer. Position the meat over one-quarter of the rice, then mound the vegetables, each in its own separate pile, leaving open space between them, over the rice. Cover the skillet and place over medium heat until the vegetables are heated through and the bottom of the rice is browned and crisp, 7 to 8 minutes. Then remove from the heat and leave covered while you finish the eggs.

11) Meanwhile, drizzle the neutral oil across the nonstick skillet. Evenly space the eggs in the skillet, shooting for 12, 3, 6, and 9 o'clock.[14] Leave at room temp for 5 minutes. Then place the egg pan over medium heat and cook, uncovered, for 4 minutes.[15] If the egg whites start to balloon up, just poke with a wooden skewer to deflate.[16] While the eggs cook, lightly lube a large plate with a neutral oil, like safflower. Slide the finished eggs onto the plate (they will have formed one large disk) and let rest for 1 minute before cutting into 4 individual egg wedges.

12) Uncover the skillet with the bibimbap. Place a dollop of sauce in the middle of the skillet and place the eggs between the vegetables. Sprinkle with the remaining scallions and drizzle with an additional tablespoon of sesame oil, if desired. After the diners all view the lovely spectacle of the dish, I like to stir everything together in front of them, just to remind them how mixed up and crazy the world is. Serve with the cucumber pickles and additional sauce on the side.

Yeah, it's a lot . . . but it sure is worth it. Also, the leftovers microwave well, so you can stretch this for days if you're lucky.

11 Even though the mushrooms are fully cooked, I like to brown them, because the process adds quite a bit of flavor.

12 Yes, there are lots of bowls. Sorry.

13 You can do all of this even up to a day or two in advance if you'd like.

14 I like to transfer the eggs individually to the skillet using custard cups, because I find that I bust fewer yolks that way and I get better distribution in the skillet.

15 If you're using an electric cooktop, begin heating the burner before adding the skillet.

16 Never let metal utensils touch a nonstick pan . . . ever.

Nonstick coating was first used to contain weapons-grade uranium during World War II.

A BRIEF AND SOMEWHAT HUMILIATING NOTE ABOUT PANS

As previously noted, most of the cooking will be done in a cast-iron skillet, and the final dish will come to table assembled in said vessel. Saucepans will also be required, as will a large nonstick skillet. Although I established back on page 233 that an oven-heated carbon-steel pan is my go-to for fried eggs, I must confess with considerable consternation that the best way to quickly fry four eggs to runny perfection for bibimbap is to cook them in a reasonably heavy nonstick pan, a device I have derided and demeaned for decades. The thing is that we need four eggs, we need them runny, and we need them quickly. If you have a well-seasoned steel pan wide enough for the job, great. Alas, I do not, so nonstick it is.

Recent scholarship from the Academy of Korean Studies and the Korea Food Research Institute asserts that bibimbap originated in the middle period of the Koryo dynasty (tenth century), when it's generally assumed the traditional Korean meal structure first emerged.

PANTRY RAID XIV: DEEP SEA GREEN

About 70 percent of the planet's oxygen is generated by seaweeds.

I'd been wanting to do a show on culinary seaweeds for over a decade, convinced that this country would eventually wake up to what so many of the planet's cooks have long known—that seaweeds, especially in their dry form (which can last a few months when properly sealed), are versatile, nutritious, sustainable pantry pals. And I think America is finally ready to hear it: Seaweeds are absolutely, positively good eats. But I get it, we need to start small, so in this episode we merely dip our toe in the pool of possibility with nori, wakame, and dulce.

But first, let's get some facts straight.

Seaweeds are not weeds; they're not even plants, at least not in the terrestrial sense. They are macro (that is, large) algae, members of an incredibly diverse group of marine organisms that produce oxygen via photosynthesis, or at least most of them do. Generally speaking, they are packed with nutrition, including protein, vitamins, and minerals, and are considered welcome additions to the human diet. In fact, seaweeds have been exploited for their medicinal properties for thousands of years. The earliest and most well-known uses of seaweed as an herbal remedy can be traced to classical medicinal practices in China, Japan, and India, though it's been a staple of coastal diets around the globe for generations, from Scotland, Ireland, Norway, and Iceland to New Zealand and the Pacific Islands.

The thousands of different forms of seaweeds fit into three basic categories: brown, green, and red, which is where we'll start.[1]

[1] Regardless of their color in the wild, most dried examples tend to look greenish brown.

Seaweeds are major sources of umami.

Carrageenan, agar-agar, and alginates are all gelling agents derived from seaweeds.

DESICCANT BAGS

Desiccant bags show up in almost all packages of dry seaweed, not to mention a host of other foods, sneakers, and electronics. Crack one open and you'll see lots of tiny beads, technically a xerogel of silicon dioxide. If you were to look at these under an electron microscope, you'd see these orbs are so riddled with nanopores that each has a surface area of around 800 m^2/g, bigger than the average American home. These pores are especially appealing to airborne water vapor. Once water molecules start to adhere to the surface of silica gel, they tend to line up in a crystalline formation resembling ice. The point is, even a tiny package can keep excess moisture from degrading things like homemade candy, chocolate, and crisp snacks like nori. And since they adsorb water rather than absorb it, our little beads can be recycled by simply drying them in a 250°F oven for a couple of hours. And yes, I leave them in their packs.

FURIKAKE SEAWEED SNACKS

YIELD:

32 snacks

Crispy, addictive, and nutritious, seaweed snacks (or seasoned nori) are easily found in most American megamarts these days. But I say, why buy something you can make yourself?

SOFTWARE

2 tablespoons (15 g) white sesame seeds, toasted and cooled[2]

2 tablespoons (15 g) black sesame seeds, toasted and cooled

4½ grams (3 tablespoons lightly packed) bonito flakes

1 teaspoon sugar

½ teaspoon wasabi powder[3]

¼ teaspoon shichimi togarashi (see footnote 7, page 280)

¼ teaspoon kosher salt

8 (8-inch) toasted nori sheets (reserve the desiccant packet from the nori packaging)

2 tablespoons (30 ml) water

¼ to ½ cup (60 to 118 ml) toasted sesame oil, for spritzing

TACTICAL HARDWARE

An oil spritzer (the fine-mist kind—not a trigger squirt bottle)

PROCEDURE

1) Adjust the oven racks to the upper-middle and lower-middle positions. Heat the oven to 300°F. Have two half sheet pans ready.

2) Combine half of the white and half of the black sesame seeds with the bonito flakes, sugar, wasabi powder, shichimi togarashi, and salt in a spice grinder. Pulse until coarsely ground, about three pulses. Transfer to a small bowl and mix in the remaining sesame seeds.

3) Place a sheet of nori on a cutting board and, using a pastry brush, lightly moisten with the water. Immediately sprinkle 1 teaspoon of the seasoning mix evenly over the sheet. It will start to curl up on the edges, but that's okay. Slice each sheet into 6 even rectangles with a large chef's knife, then transfer to a half sheet pan. Repeat with the remaining

NORI

Nori is a red seaweed that is typically made by harvesting *Pyropia yezoensis*, *Pyropia tenera*, and/or *Pyropia haitanensis*, shredding it, and drying it in frames, thus producing uniform sheets. These days, those sheets are easier to find than ever. Nori has a permanent presence in my pantry, as it can be applied to myriad dishes from sushi to salads, pizza, eggs, and, yes, snacks.

Generally, when it comes to nori, you get what you pay for. I prefer those from Japan and Korea. I want the sheets to be bright, deep green, shiny, and, preferably, toasted. I typically buy in bulk, then divide my haul among several zip-top bags, each with a desiccant pack for long-term storage. (More on those on page 325.)

(left) On the left we have a trigger-style sprayer, which is perfect for adding water to a pie dough, or wetting the plastic before pounding cutlets. On the right is a pump-style mister that uses air pressure to drive a fine mist. (The lid functions as an up-and-down pump handle.) That's the one you need to moisten the nori sheets.

2 I like using a hot-air popper for toasting spices, but unlike corn, which has the good manners to stay down in there until it pops, sesame seeds will just blow around the room, so I top the vessel with a wire sieve, turn the machine on, and count to about 15.

3 "Wasabi powder" is not a regulated term. Some versions contain horseradish and mustard powder with green coloring, which can still be tasty. The real thing can be quite pricey, but in this case the fake stuff off the interwebs will work in a pinch.

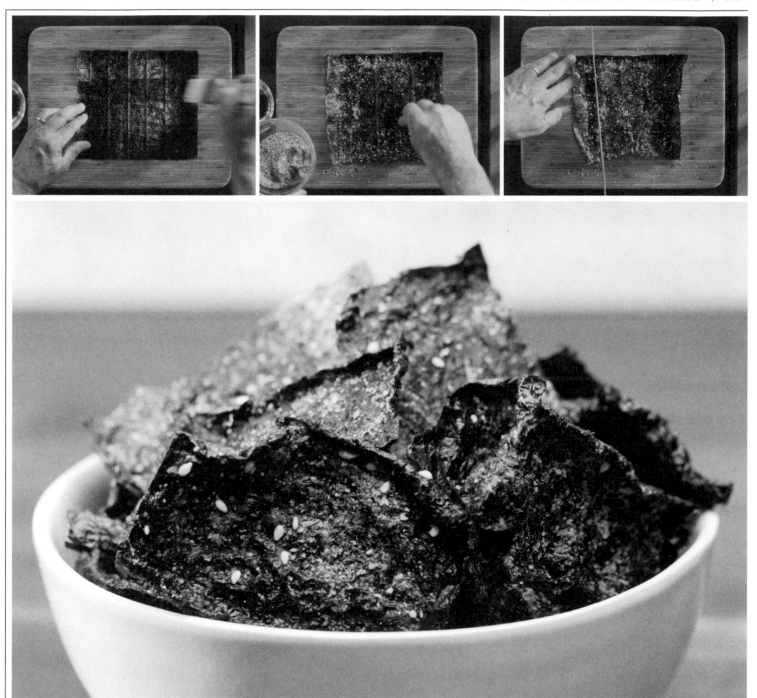

nori sheets, dividing them evenly between both sheet pans. Leave to dry for 30 minutes.[4]

4) After 30 minutes, fill an oil spritzer with sesame oil and evenly spritz the seasoned side of the nori sheets.[5] Transfer to the oven and bake for 5 minutes. Rotate the pans and continue to bake until the snacks are crisp but not yet brown, about 3 more minutes.

5) Transfer the nori sheets to a wire rack and cool. Consume or transfer to a gallon-size zip-top bag and add the desiccant packet from the nori packaging to keep it crisp. The seaweed snacks will keep for at least 1 week at room temperature.

4 You will have extra seasoning; save for another use, such as for topping popcorn.

5 You will have extra oil. The only reason we call for so much is that's typically what it takes for a spritzer to function properly. I use sesame oil enough, especially on cooked greens, to keep a spritzerful on hand.

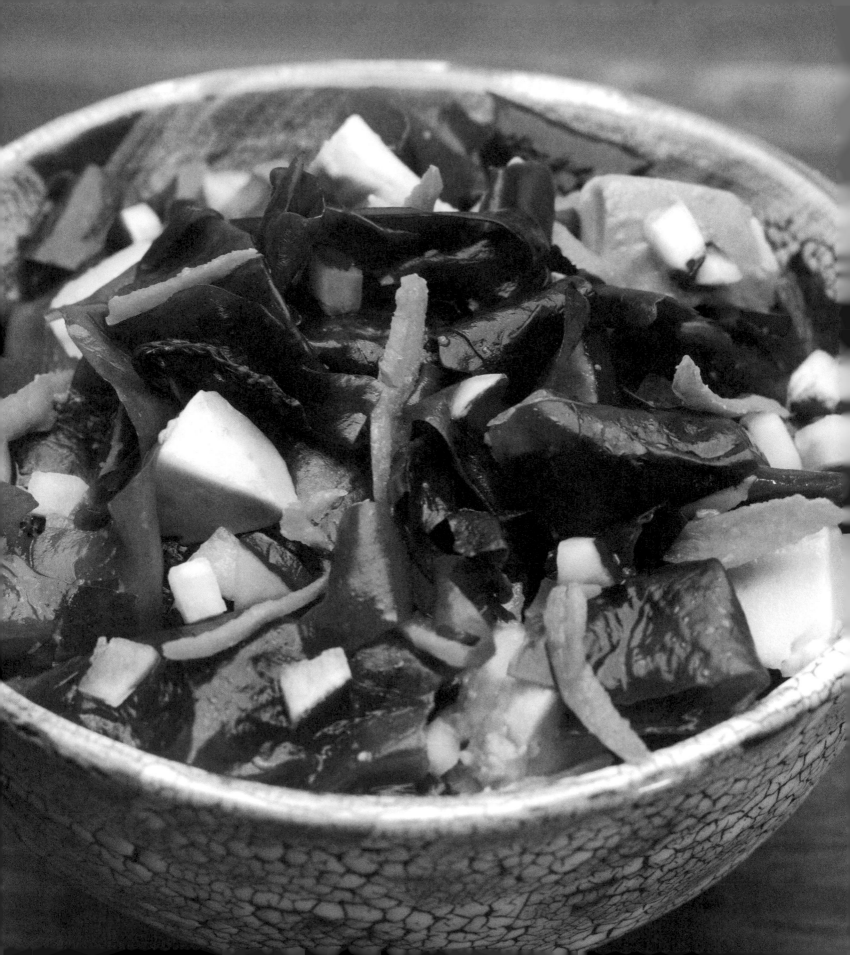

WAKAME SEAWEED SALAD

Though wakame may sound exotic, odds are that if you're a fan of sushi, you've munched on the brown algae in the form of a salad—a standard starter at most sushi bars. I adore seaweed salad almost as much as I love knowing that as long as I have wakame in the pantry, I can have salad whenever I want.

SOFTWARE

28 grams (¾ cup) dried, cut wakame seaweed[6]

4½ to 6 cups (1 to 1.4 L) cold water, for soaking

2 tablespoons (30 ml) rice vinegar, divided

2 tablespoons (30 ml) soy sauce

5 grams (1 teaspoon) grated fresh ginger

½ teaspoon sugar

¾ teaspoon kosher salt

1½ tablespoons (20 ml) toasted sesame oil

1 small avocado

1 small carrot, peeled and grated (⅓ packed cup)

4 small red radishes (about 50 g), cut into small dice (about ½ cup)

PROCEDURE

1) Put the wakame in a large bowl and cover with the water, adding more as needed[7] to keep it fully submerged. Soak until soft, about 10 minutes. Line a colander with a clean kitchen towel and set aside.

2) Meanwhile, whisk together 1½ tablespoons of the vinegar with the soy sauce, ginger, sugar, and ¼ teaspoon of the salt in a small bowl. Continue whisking while drizzling in the sesame oil to form an emulsion.

3) When the wakame is fully hydrated, drain thoroughly in the prepared colander. Gather the sides of the towel to form a pouch, then twist to wring out any additional water. Dry the bowl and return the wakame to it. Add the dressing and toss to coat. Cover and refrigerate until the seaweed is cold and the dressing has been absorbed, at least 30 minutes or up to overnight.

4) When ready to serve, peel and cut the avocado into small cubes. Transfer to a small bowl and toss with the remaining 1½ teaspoons vinegar and the remaining ½ teaspoon salt. Add the carrot and radishes, then fold this mixture into the wakame.

Serve chilled.

WAKAME

Native to the rocky shores of Japan, China, and Korea, wakame has gone global by stowing away in the ballast water of transoceanic ships and now grows on the coasts of New Zealand, Australia, and as far afield as France. Today it's considered an invasive species, so it's our responsibility to eat all the wakame we can.

6 Wakame is available in several forms in Japan, but in the States dried strips are the norm.

7 Wakame can drink deep, so add enough water to keep it covered for the entire soaking period.

DULSE SHORTBREAD COOKIES

YIELD:

16 cookies

Salty dulse flakes add an umami twist to classic shortbread cookies.

SOFTWARE

300 grams (2 cups plus 2 tablespoons) all-purpose flour

35 grams (¼ cup) white rice flour

1 teaspoon kosher salt, divided

2½ tablespoons (15 g) dulse seaweed granules, divided

8 ounces (226 g) unsalted butter, at cool room temperature (58°F to 62°F)

100 grams (½ cup) sugar

1 large egg, beaten with 1 teaspoon water

TACTICAL HARDWARE

- An 11-inch fluted tart pan with removable bottom
- Parchment paper or a silicone mat
- A heavy-duty rimmed cookie sheet or half sheet pan
- A stand mixer with paddle attachment

PROCEDURE

1) Heat the oven to 300°F. Grease the tart pan with a small dab of the butter and line a rimmed baking sheet with parchment paper or a silicone baking mat.

2) Whisk the flours, ½ teaspoon (2 g) of the salt, and 2 tablespoons (12 g) of the dulse in a medium bowl. Combine the remaining ½ teaspoon each dulse and salt in a small bowl and set aside for sprinkling over the tops of the cookies.

3) In a stand mixer, paddle the butter and sugar on medium speed until creamy and lightened in color, 3 to 5 minutes, scraping down the sides of the bowl and the paddle as needed. Kill the mixer, add the flour mixture all at once, then return the mixer to its "stir" setting until the flour is fully incorporated and the mixture is the texture of crumbly wet sand, about 30 seconds. Remove the bowl from the mixer and stir a few times with a rubber spatula to incorporate any stray flour.

4) Transfer the dough to the prepared tart pan and use your hands or the bottom of a cake pan to press into an even layer, working it into the fluted inner edge of the pan.

5) Bake until the shortbread is set and the edges are golden brown, about 1 hour. Cool in the pan on a wire rack for 5 minutes. Leave the oven on.

6) Place the tart pan on top of a 28-ounce tomato can or a similar-size jar. Let the outer ring fall off, then carefully transfer the shortbread, still on the tart pan bottom, to a cutting board. Brush with the egg mixture, then evenly sprinkle the dulse-salt mixture over the top.

7) Slide off the pan bottom and slice the mega-cookie into 16 even wedges. Transfer the cookies to the parchment-lined baking sheet. Return to the oven and bake until the egg wash is set, 8 to 10 minutes.

8) Transfer the cookies back to the wire rack and cool completely before serving. Store in a cookie tin or zip-top bag—again, with a desiccant pack if you have one.

DULSE

Palmaria palmata, aka dulse, dillisk, dilsk, or red dulse, is a red alga that grows on the northern coasts of the Atlantic and Pacific, including Ireland and the Bay of Fundy in Canada. It's sold in whole leaf as well as flake and powder forms for seasoning. When fried, the whole leaf tastes amazingly like bacon.

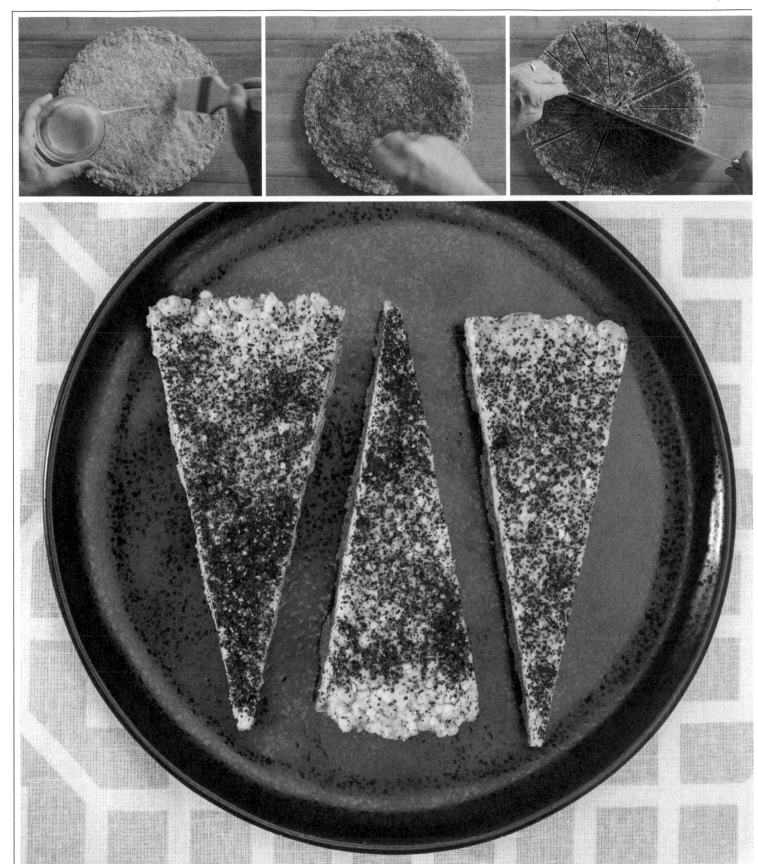

BAGEL ATTRACTION

Food history is slippery business. Murky myths, larcenous legends, and apocryphal apocrypha abound. Getting at the truth of something as basic as, say, the origin of the bagel is difficult. For one thing, history is full of round savory breads with holes in the middle. Among them: *taralli*, round hard hoops from Puglia, Italy; Roman *bucellatum*; and, of course, the *girde nan* of northwestern China.

The most direct ancestor of the modern bagel was probably the boiled *obwarzanek krakowski* of Poland, though even here fiction flavors the facts. Legend holds that to celebrate King Jan Sobieski's 1683 victory over the Turks at the battle of Vienna, local bakers created a roll resembling the king's stirrups, or *beugels*. The same battle is also said to have given us the croissant; I find both tales highly suspect.

What seems likely considering recent scholarship is that the modern bagel was born in New York City around the turn of the last century and went mainstream in the 1950s, possibly due to the popularity of a Broadway show of Yiddish humor called "Bagels and Yox" (*yox* meaning "belly laughs") that played more than two hundred performances in 1951 and 1952. In some ways that popularity is responsible for the bagel's current state of disrepair. The problem, of course: mechanization.

As the demand for bagels rose through the '60s and '70s, artisans, like the members of New York's bagel bakers Local 338 union, couldn't keep up. So machines took over and recipes were reformulated for their particular needs and that of the freezer case.

Today *real* bagels are so gosh darned hard to come by that unless you live in some very specific parts of New York City, and maybe one or two places in California, you're better off making your own.

Daniel Thompson invented both the commercial bagel extruder and the folding Ping-Pong table.

Another GE science model!

BAGEL SCIENCE

For all of our bagel recipes, we will turn to the usual suspects: bread flour (we need chewy, and chewy means gluten), water, salt, yeast (burp!), and barley malt syrup. Home brewers are no doubt familiar with the exceedingly sticky barley malt syrup, as it's one of the main ingredients in beer, but it's also a kind of secret weapon in the pro baker world.

To malt barley, the maltster fills a big dark chamber with the seeds and soaks them in water, thus triggering germination, which in turn activates enzymes that convert the seeds' starch into digestible sugar. The maltster then dries the grain, crushes it, and soaks it again. Since the enzymes

inside are still active, they continue breaking down the starches. To make syrup, the resulting goo is reduced and strained to a thick syrup containing maltose, a disaccharide composed of two glucose molecules that's about half as sweet as sucrose and possesses a complex malty flavor.

Although malt syrups have been used in Asia (especially China) for millennia, the United States didn't get hip until the Volstead Act shut down beer production in the 1920s. Some breweries survived by canning malt syrup and selling it as a health food, which actually makes sense, as it contains minerals and vitamins not found in other sweeteners.

Our immediate interest in malt syrup has nothing to do with skirting the Volstead Act (which I'm happy to announce was repealed in 1933 with the passing of the Twenty-First Amendment to the Constitution), but rather giving bagels their definitive flavor, and also helping them in the texture department.

Here's how: The chow of preference for *Saccharomyces cerevisiae*, or bakers' yeast, is sugars, specifically monosaccharides, simple sugars like fructose, which occurs naturally in flour, albeit in teensy amounts. Most of the sugar in the flour is sucrose, which is a disaccharide that yeasts can't consume. However, enzymes found in the flour, as well as those produced by yeasts themselves, can break energy up into consumable bits. (Amylase chops up large starch molecules, while invertase splits sucrose molecules.) But until they get to work, the yeasts have to just kinda wait around, and that means very little gas production in the beginning of the fermentation. Barley malt syrup contains maltose, a disaccharide made of two glucose molecules, which our yeast friends can consume—i.e., ferment. That means they can get to work right away. And, malt syrup gives bagels their unique color and flavor.[1]

Yeasts don't like sucrose . . . but they love maltose.

Bagel dough is traditionally refrigerated, and cold changes everything. Amino-acid production is slowed, increasing some flavors like malty aldehydes. Enzymes have time to break down proteins that can form gluten. Yeast activity, of course, slows way down, so the dough actually has time to absorb their goodness. Lactic acid bacteria that naturally occur in the flour get to eat and do some flavor-making of their own. This does take time, but your patience will be rewarded.

Another weird thing about *real* bagels: They're boiled, then baked. While the bagels boil, starch on the surface gelatinizes—swelling with moisture and forming a kind of thickened gel. If we boil for 30 seconds per side, we can expect two things: First, when baked, an outer crust will form that has a distinctive shine that'll be enhanced by the browning provided by the maltose. Second, this gelatinized coat will minimize expansion of the interior in the oven like a tight pair of spandex yoga pants, thus granting our bagels their signature chewy texture.

1 We add barley syrup to the boiling water bath as well. This dose will deliver reducing sugars to the surface of our bagels, which will be able to take part in Maillard reactions in the oven. That is to say, they'll brown.

BAGELS FROM SCRATCH

YIELD:
1 dozen

SOFTWARE

855 grams (6¼ cups) bread flour[2]

520 grams (2¼ cups) filtered water, at 85°F to 88°F, plus more for boiling the bagels

100 grams (¼ cup plus 1 tablespoon) malt syrup, divided[3]

75 grams (4 tablespoons plus 1 teaspoon) fine salt,[4] divided

4 grams (¾ teaspoon) active dry yeast[5]

TACTICAL HARDWARE

• A heavy-duty stand mixer with 6-quart bowl and kneading hook attachment[6]

• 2 sheet pans

• Parchment paper

• Wooden chopsticks for flipping bagels in the boiling water

2 What makes it bread flour? Protein. All-purpose flour can range between 8 and 12 percent protein, whereas the average bread flour is closer to 13. More protein means more gluten, and that of course is the springy 3-D matrix from which bread derives its body.

3 You might want to move your barley malt syrup from its jar to a plastic squeeze bottle, because this stuff is all kinds of sticky.

4 Don't buy this—take the same amount (by weight!) of kosher salt and spin it around in your favorite spice mill (aka a blade-style coffee grinder) until finely ground.

5 Word of warning: Do not use instant yeast by mistake. This is a slow-rise situation, and those guys eat too fast.

6 This recipe will work in a standard 4-quart mixer, but you will want to be careful not to overheat the motor. You will also need to pull the dough off the hook several times, pushing it to the side of the bowl so that it can continue to knead. You can also knead the dough by hand.

WEIGHING MALT SYRUP

Before we get started, this is how I weigh out the ultra-sticky malt syrup:

1) Weigh the salt.

2) Use a second bowl to make a divot in salt.

3) Remove second bowl and zero scale.

4) Squeeze syrup into salt divot to desired weight.

This way, all you have to do is dump the salt and syrup together into the mixer's bowl; the salt is holding the syrup, so no mess, and you always get the right amount into the actual recipe. (Works with flour and sugar, too.)

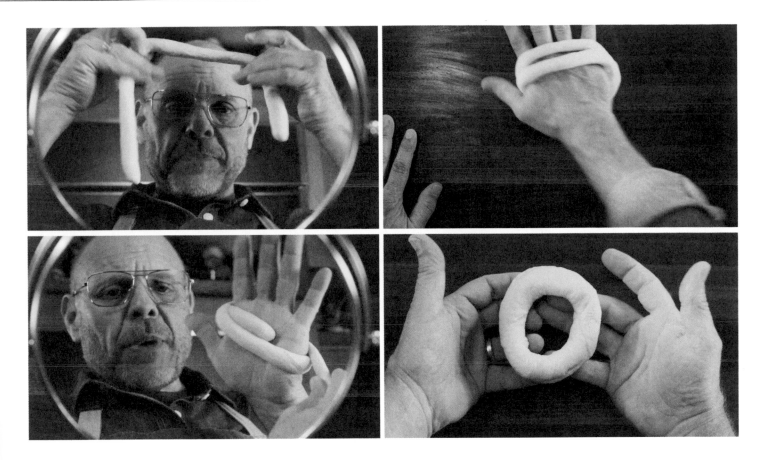

PROCEDURE

1) Combine the flour and water with 20 grams (1 tablespoon) of the malt syrup, 25 grams (1 tablespoon plus 1 teaspoon) of the salt, and all of the yeast in the mixer's work bowl. Install the kneading hook and mix with the hook attachment on the "stir" setting until the mixture forms a shaggy dough, about 30 seconds.

2) Increase the speed to low and knead until the dough is no longer sticky and bounces back when pressed with a finger, about 10 minutes.[7] It may still be slightly tacky, and that's okay. If the dough gets stuck on the hook, stop the machine and pull the dough off the hook as needed, pushing it to the side of the bowl so that it can continue kneading.

3) Dump the dough out onto the counter and shape into a ball. Place in a tall 2- to 4-quart transparent container or 8-cup liquid measuring cup, pressing down to flatten the top of the dough. Mark the dough height on the outside of the bowl with tape or a rubber band. Cover the bowl with plastic wrap and let rise at room temperature until the dough is about 1½ times its size and the dough bounces back when tapped, 1½ to 2 hours.[8] Meanwhile, line two half sheet pans with parchment paper and have them standing by.

4) When the dough has increased to 1½ times its original size, punch the dough down, then transfer to a cutting board and divide into twelve 4-ounce pieces and cover with a clean kitchen towel.[9]

5) Working with one piece at a time, roll each into a 16- to 18-inch-long snake, making sure to pop any large air bubbles, and then wrap around the palm of your hand twice to form a tight circle. With the seam side down and the snake still around your hand, roll your hand across the counter to seal the ends together.[10] Rotate the dough ring around your hand while rolling to seal the seam all the way around the bagel (see photos above). Continue rolling on the counter to seal the seam all the way around the bagel. Transfer to the prepared pans and repeat with the remaining dough, evenly spacing 6 bagels on each tray. Cover with plastic wrap and refrigerate for 18 to 24 hours.

7 Remember, this is tough stuff, so keep an eye on your mixer. I had one walk right off the counter once.

8 Rising time is highly dependent on the ambient room temperature. Making bagels in the summer? Check after 1½ hours. Cold in your kitchen? Give the dough a full 2 hours.

9 I'd definitely use the scale for portioning.

10 Sometimes, my wood board gets so dry that the dough just slides. If that happens, moisten the surface lightly with water. A spritz bottle is perfect for this.

BAGELS FROM SCRATCH *(continued)*

6) When ready to bake, heat the oven to 450°F with the oven rack in the middle position. You'll be boiling then baking the bagels, so set up a work area around your cooktop. You'll need to drain the bagels as they come out of the water (a wire rack over a pan or even a kitchen towel will suffice), and you'll need a fresh piece of parchment to put them on for baking.

7) Remove one pan of bagels from the refrigerator and set by the cooktop until they soften and register between 60°F and 65°F, about 30 minutes.

8) Meanwhile, bring a gallon of water to a boil over high heat in a large, wide pot, along with the remaining 80 grams (¼ cup) malt syrup and 50 grams (3 tablespoons) salt. Once the water boils, reduce the heat to a gentle boil. At this point, remove the second pan of bagels from the fridge so that they can warm up while you cook the first batch. (Think assembly line here.)

9) Check the temperature of the first pan of bagels. If they're at 60°F internal, carefully place 3 of them into the boiling water, using your fingers—again, carefully—making sure that they don't overlap. Boil for 1 minute, flipping if they rise to the surface in 30 seconds or less.[11] Remove the bagels with a slotted

spoon and set them on the cooling rack to drain and cool. Repeat with the next 3 bagels, returning the water to a rapid simmer before adding the next batch. As they drain, replace the parchment before returning the bagels to the pan.[12]

10) Bake for 10 minutes, then rotate the pan and continue baking until the sides of the bagels are golden brown and the bottoms are firm, 10 to 15 minutes more.

11) Remove the pan from the oven and transfer the bagels to a cooling rack, then repeat the same steps with the second pan of bagels.

12) Allow all the bagels to cool for at least 10 minutes before serving.

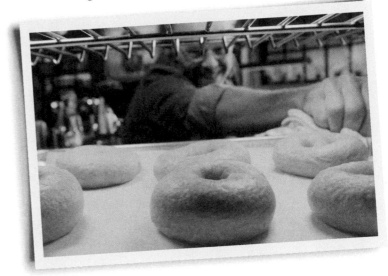

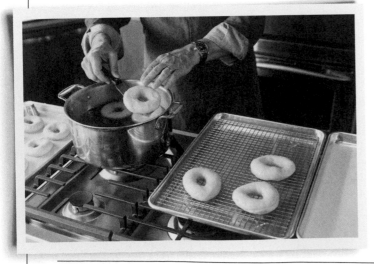

11 Do not worry if the bagels don't fully rise to the surface at all. Sometimes they do, sometimes they don't.

12 Trust me, they'll stick if you use the old paper again.

EVERYTHING BAGEL SEASONING

YIELD:

About
1½ cups

We ended up not having time for anything else in the episode. After all, it's only twenty-one minutes with commercial breaks. But if I'd had an hour . . .

SOFTWARE

10 grams (⅓ cup) dried porcini mushrooms

35 grams (¼ cup) dried garlic flakes

20 grams (¼ cup) dried onion flakes

15 grams (4 teaspoons) flaky sea salt, such as Maldon

75 grams (½ cup) sesame seeds

90 grams (½ cup) poppy seeds

6 grams (4 teaspoons) nutritional yeast

PROCEDURE

1) Blend the mushrooms in a blade-style spice (coffee) grinder until they are finely ground, about 15 seconds. Remove them from the grinder and sift through a fine sieve into a small bowl to remove any large, unground pieces. Transfer 4 teaspoons (7 g) to a pint jar with a lid. Discard any large pieces left in the sieve or toss them in your stock pot.

2) Add the dried garlic to the spice grinder. Pulse twice, or until slightly broken but not ground to a fine powder, then transfer to the jar with the mushrooms. Repeat with the dried onions.

3) Add the salt to the grinder and pulse once, or until broken but not ground to a fine powder. Transfer to the jar along with the sesame seeds, poppy seeds, and nutritional yeast. Screw on the lid and shake to combine. Store in a cool, dry place for up to 3 months.

To use to coat bagels, place ¾ cup (about 100 g) of the seasoning mix in a shallow bowl or pie plate. Place next to the cooktop as you bring the water–malt syrup mixture to a boil.

Once the bagels have been boiled, let them sit on the drying rig for 30 seconds, then invert one at a time into the bowl of seasoning mix, twisting to coat the top of the bagel. Place back onto drying rig, seasoning side up, and let dry for 2 more minutes, then transfer to the sheet pan. Bake as directed in the recipe, looking at the sides of the bagels to see when they turn golden brown.

LONG-TERM STORAGE

Bagels are notorious for staling rock hard. So, for long-term storage, I suggest you slice them in half, wrap tightly in plastic wrap, then transfer to a gallon-size zip-top freezer bag and freeze for up to 1 month. To reheat, remove all of the plastic and simply park on a plate or cutting board for 15 minutes to soften. If you're really in a hurry, wrap in a paper towel, and microwave on high for 15 seconds. Toast until crisp.

It's said that during their heyday in the twentieth century, legendary bagel bakers from Local 338 could roll

something like 832 bagels an hour, a requirement for membership, in fact.

BREAD KNIVES

Bagels should have a hard, shiny surface capable of fending off even the sharpest chef's knife. This forces some bagel lovers to turn to dark unitaskers like bagel slicers, which always kind of remind me of guillotines for dolls. All you really need is a good, serrated knife in the 10-inch range.

There are essentially two styles: the wavy and the toothed. When it comes to bread, I think wavy blades are pretty silly. Teeth are much better at grabbing, and I prefer a knife with fewer, deeper teeth over a bunch of shallow ones. Big teeth . . . better to eat you with, my dear.

1) Place bagel flat on board with holding hand flat.

2) Once cut is established, turn bagel on side and cut through to board.

wavy toothed

If you wish to avoid what are known in emergency rooms as BRIs (bagel-related injuries), you will never ever, ever, ever slice a bagel while holding it in your hand. What you want to do is this: Place the bagel on a cutting board, kind of near the edge so you've got clearance room for the knife handle. Put your hand over the bagel, fingers clearly out of the way. Holding the knife parallel to the board, begin a cut in the middle of the bagel; then, once you're about halfway through, turn the bagel up onto its edge with the knife still in place. Hold the bagel on the cut side, then finish cutting through to the board.

FERMENTATION MAN

When the end times come,
we're all on our own.

A lot of folks have looked back at our first fermentation show with a half-raised eyebrow. The premise of the episode is that the world has experienced a pandemic followed by a rushed vaccine that turned nearly everyone into a zombie, thus obligating the world's governments to nuke their biggest cities, which, by the way, also woke a dinosaur-like kaiju that now roams my abandoned city. Through means left unexplained, my dog and I have survived. Okay, so I called the pandemic eight months before the fact. Could have happened to anybody. The episode goes on to focus on wild yeast and sourdough starters (which, by the way, a lot of folks tried to wrestle with during our recent troubles). The new episode picks up a few months later, with my reliance on lactic acid bacteria (LAB) for much of my food supply.

Due to all our science-y stuff (including a nightclub for puppets) we ended up only having time for two applications, kimchi and kombucha, but there's plenty of space here, so I'm including my own interesting and delicious homemade sriracha sauce.

LABS

Another day, another science model.

Although home cooks are probably more familiar with the fermentation of yeasts in both bread and beer making, lactic acid bacteria are everywhere, and much easier to wrangle up and press into service than wild yeasts are. With names like *Lactobacillus*, *Leuconostoc*, *Pediococcus*, and *Streptococcus*, the unifying characteristic of LABs is that they produce (among other things) lactic acid. Beyond the fermentation of sugars, degradation of fats and proteins come into play as well, and the resulting flavors can be extremely complex (as anyone who's had a good homemade sauerkraut can attest). More importantly, though, the environment created by LABs, if managed correctly, can work to keep out other microbial players, thus preventing spoilage (as anyone who's had a good ten-year-old homemade sauerkraut can attest). As if that weren't enough, there's evidence that foods fermented by LABs can, in some cases, be more nutritious than the original foods.

As much as I love sauerkraut, we did cover it on an earlier episode (#106, "Eat This Rock"), so this time we turn to the far more complex poster dish for Korean cuisine: kimchi. There's a lot going on in this dish, and it may fall under the general heading of "hobby cooking," but if you've got the time and the produce, you can create one of the most majestically complex concoctions known to man.

Kimchi, baby.

KIMCHI

YIELD:
About 6 cups

SOFTWARE

2 pounds (907 g) napa cabbage,[1] trimmed, cut lengthwise into 4 to 8 sections, cored, and then cut crosswise into 2- to 3-inch rectangular pieces (about 15 cups)

2 tablespoons plus 2 teaspoons (24 g) kosher salt, divided

12 ounces (340 g) daikon radish,[2] peeled and cut into matchsticks measuring about ¼ × ¼ × 2½ inches[3] (about 2 cups)

1 teaspoon (5 g) granulated sugar

¼ cup (25 g) gochugaru (Korean red pepper flakes)[4]

2 tablespoons (30 ml) water

2 teaspoons (10 g) dark brown sugar

½ cup diced Asian pear (65 g)[5]

¼ cup diced yellow onion (35 g)

2¼ ounces (64 g) fresh ginger, peeled and cut into matchsticks, divided

4 large cloves garlic (25 g), peeled and cut into thin slices, divided

1 teaspoon (7 g) salted shrimp[6]

6 to 8 scallions (145 g), halved lengthwise and cut crosswise into 2-inch pieces

TACTICAL HARDWARE

- A really big mixing bowl
- A really big zip-top bag
- 2 wide-mouth quart jars and lids
- Disposable gloves (see page 347)

PROCEDURE

1) Put the cabbage in a large bowl, sprinkle with 2 tablespoons (17 g) of the salt, and toss to coat.[7] After 15 minutes, massage and squeeze the cabbage until it begins to release liquid. Set aside for another 15 minutes, then massage again and set aside for yet another 15 minutes.

2) When you're not rubbing your cabbage, put the daikon in a medium bowl and season with the sugar and 1 teaspoon salt. Set aside for 15 minutes.

3) Whisk the gochugaru, water, brown sugar, and 1 teaspoon salt together in another medium bowl to form a coarse paste.

4) To make the kimchi flavor paste, use either a mini-food processor, a mortar and pestle, or an immersion blender and a jar[8] to puree the pear, onion, 10 grams (about one-sixth) of the ginger, 6 grams (about one-quarter) of the garlic, and the salted shrimp until smooth. Stir this in to the gochugaru mixture.

5) Squeeze as much liquid as you can from the daikon without breaking the pieces and add to the cabbage, along with the scallions, the remaining garlic and ginger, and the kimchi paste. Wearing disposable

1 Napa is classic in this application because it brings a lot of texture but not too much flavor to the party.

2 Aka Chinese or Japanese radish, and, yes, it's just a radish, but much milder than most of the radishes Americans know.

3 This shape is what the French call *batonnet*.

4 These chile flakes are nowhere near as hot as the red pepper flakes most Americans are used to, but they're way more flavorful. I'd keep it on hand even if I didn't make kimchi all the time.

5 Asian pears are quite firm compared with American pears or apples, and they can give up a lot of liquid without losing their crispness.

6 These tiny salted and fermented shrimp are not to be confused with dried shrimp, which are also tiny and delicious for snacking, but totally different. They're easily acquired from Asian and international markets.

7 The salt pulls liquid out of the vegetables, which will result in a brine. That brine does a couple of things. It's an environment that LABs really like; they're not very crazy about air. It also provides a level of salinity that they're super crazy about but that other, bad things don't like.

8 If you want to double or triple the batch and save it in the fridge for later, then go up to a full-size processor, but a mini-choppy thing works well for this.

KIMCHI (continued)

The hand-drawn wristwatch was meant to signify that I'd lost at least some of my marbles.

gloves,[9] mix the kimchi paste into the cabbage mixture with your hands, being sure to thoroughly coat the cabbage.

6) Position a gallon-size zip-top bag inside a pitcher or some other vessel that will allow it to be held open for easy loading. Transfer the mixture to the plastic bag, then ditch the gloves and seal the bag, working out as much air as possible. The lactic acid bacteria that will magically transform these humble ingredients into kimchi prefer anaerobic environments.

7) Place the sealed bag flat on a sheet pan or large baking dish and leave at room temperature until it has bubbled enough to inflate the bag, at least 24 hours but possibly up to 3 days. (See the note below.)

8) Transfer the kimchi and its liquid into 2 wide-mouth quart-size glass jars with lids and refrigerate. Consume immediately for very fresh kimchi, or leave it for a month for a kimchi that's deeply flavored, well-rounded, and slightly effervescent. Wait 3 months and you'll dine upon pure funk. Refrigerated, kimchi will basically never go bad and will actually improve in flavor for months after going into the jar. Cooking will mellow its flavors, so if it gets too funky for you, it's time to make kimchi fried rice.

NOTE

Here's what happened while that bag sat at room temp:

The first thing we did was salt the cabbage, which pulled moisture out of the leaves, creating a brine the LABs (which were already on the produce) like because it helps keep them away from air and it provides a level of salinity that they like. However, that salt acts like a microbial bouncer, preventing other, nastier microbial life from thriving (that's the preservation part of the puzzle). Finally, we created a heavily spiced paste, which infused the brined vegetation with complex flavors and aromas.

So, while it sat at room temp, the LABs dove right in, breaking down carbohydrates and producing "metabolites," including lactic and acetic acids and other flavor and aroma compounds. As the solution became more acidic, certain LABs died off, only to be replaced by others more comfortable in low pH. It takes a village, and building that village takes time. Once refrigerated, the action continues pretty much forever but at a much slower rate.[10]

9 Can you skip the gloves? Sure, but once the chiles get on your hands, they'll be *en fuego* for quite a while. The choice is yours.

10 As of this writing I have about half a jar of kimchi leftover from what we made on the show. It's a year old and still funkilicious.

FERMENTED SRIRACHA

You think you like the stuff at the market with the chicken on the bottle and the green squeeze top. Well, once you taste this, you might still like it, but odds are good you'll like this a lot better. Yes, it's a project, a short-term hobby, even. But honestly, the aromas alone are worth it, and the flavors LABs can coax out of chiles . . . magic.

SOFTWARE

1 cup (240 g) plain whole-milk yogurt with active live cultures and without thickeners or stabilizers such as pectin (e.g., Dannon whole milk plain yogurt)

1½ pounds (680 g) red jalapeño or Fresno chiles, stems snipped off, leaving the green tops intact

6 cloves garlic, peeled (20 g)

¼ cup (50 g) lightly packed light-brown sugar

1 tablespoon (9 g) kosher salt

½ cup (118 ml) distilled white vinegar

¼ teaspoon (0.7 g) xanthan gum[11]

TACTICAL HARDWARE

- A large fine-mesh strainer or sieve
- Paper coffee filters
- A 1-quart canning jar with two-piece lid

PROCEDURE

1) Line a fine-mesh strainer with a triple layer of coffee filters and set it over a liquid measuring cup. Spoon the yogurt into the strainer, cover, and refrigerate until the yogurt has released ¼ cup of liquid whey, 1 to 2 hours. Keep the thickened yogurt for a snack; it's the whey (and the LABs) we're after for this sauce.

2) Put the jalapeños, garlic, sugar, and salt in a food processor and pulse until the chiles are finely chopped, stopping to scrape the sides of the bowl as needed, about 1 minute. Add the whey and pulse to combine.

3) Transfer the mixture to a 1-quart glass canning jar. Turn the flat lid piece upside down so that the rubberized ring is facing up and loosely screw on the outer ring. We want gas to be able to vent out.

4) Park the jar out of direct sunlight, at room temperature, and stir it once a day for 2 weeks. After a few days, the mixture will start to separate and should rise and fall in the jar several times over the first week.

5) Transfer the fermented mixture to the bowl of a food processor, add the vinegar, and puree until completely smooth, about 1 minute. Pour this puree through a fine-mesh strainer set over a 4-cup glass measuring cup and use a rubber spatula to push through as much pulp as you can; you should get around 2½ cups. Transfer the strained mixture to a 2-quart saucepan and rinse the food-processor parts.

6) Bring the mixture to a boil over medium-high heat. Reduce the heat to medium-low and simmer, stirring occasionally, until the sauce reduces to 1¾ cups, 15 to 20 minutes.

7) Transfer the mixture back to the food processor. Add the xanthan gum and process until thickened, about 30 seconds. Transfer to a glass jar or plastic squeeze bottle and store in the refrigerator for up to 6 months.[12]

11 A thickener/stabilizer that's easily found online and in the baking aisle of many megamarts.

12 I promise you it won't last nearly that long.

KOMBUCHA

When in doubt, puppers.

If you have a friend you suspect of being a hipster, a hippie, or even just a *Portlandia* fan, you've probably at least heard of kombucha, that fizzy, fermented tea that's taken over megamart drink coolers over the past few years. I'm going to skip over the myriad health benefits they're said to deliver and just say that kombucha is delicious and insanely easy to make at home.

Well . . . mostly easy.

You'll need a SCOBY, of course.

Technically, a SCOBY (symbiotic community of bacteria and yeast) is a cellulosic pellicle, a mat of hydrocolloidal cellulose secreted by LABs and yeast living and working happily side by side, and it is to kombucha what a starter is to sourdough. If you don't have a SCOBY, you can either ask that hipster friend for a chunk of theirs or you can easily purchase one off the interwebs, which frankly I think is a better way to go, because they tend to be more robust and reliable. They also come in their own little bags floating in a pool of

concentrated kombucha, which in and of itself is quite useful.

When you unleash your SCOBY on lightly sweetened tea, yeasts living inside it ferment the sugar, releasing CO_2 and producing alcohol, which is in turn gobbled by bacteria like acetobacters, which produce acetic acid. Meanwhile, our friends the LABs are working to create flavors and aromas. Again, it takes a village . . . in this case a village floating on a slimy cellulose disk that looks and feels something like a flat jellyfish. The best thing about a SCOBY is that it can be stored in a jar almost forever and unleashed to do your bidding whenever you should so choose. Hahahaha (maniacal laughter).

My favorite combination of the sour-sweet drink is made with frozen mango and freshly chopped ginger. This application assumes you're using a purchased SCOBY and the liquid it came in. Yes, this will take some time, but when the pandemic hits, and the nukes scorch the zombies and you're hiding from a giant lizard, what else you gonna do?

Nitrile gives you thicker coverage and greater tactility (not to mention make you look like a Bond villain).

Cheaper, less flexible vinyl gloves (which are always clear/translucent) are just fine for handling hot chiles.

GLOVES

For fit, dexterity, and security you can't beat latex gloves. These are the gloves you want when heading into the OR. Latex is made from natural rubber, so it's biodegradable. Alas, some folks suffer from a latex allergies, and that can be an issue for anyone who eats the food you prepare while wearing them. Though not as elastic as latex, nitrile gloves are highly puncture resistant, have a long shelf life, and mold well to the hand. I like them because they come in black, so I can look like a Bond villain. Vinyl gloves have a looser fit and are good for low-risk, short-term tasks that don't require fine dexterity. Polyethylene gloves are very loose and okay for, say, making a sandwich, but they're not ideal for handling chiles or other irritants. If I had to choose one, it would be the nitrile. Again: Bond villain.

SCOBY HOTEL

Over time, the SCOBY will grow so large that it will take up too much space in your kombucha-making vessel. So, no matter if you make kombucha continuously or if you only want to make it occasionally, at some point you will need to establish a storage vessel (aka hotel) for your SCOBY.

To do so, start a batch of kombucha using the same amounts of tea, water, and unpasteurized kombucha in a clean 1-gallon jar as directed above. Place the SCOBY in the jar and cover with a coffee filter secured with a rubber band. Every 2 to 3 weeks, add about 1 cup cool sweet tea to the jar to feed the SCOBY. Over time, it will grow additional layers; when you're ready to make a new batch of kombucha, either peel or cut off the top ¼ inch of the SCOBY to use in the recipe. When your SCOBY hotel gets jam-packed, portion off ¼-inch-thick pieces to give away. Or just dump it in a storm drain and retreat to the safety of your home.

MANGO-GINGER KOMBUCHA

YIELD:

6 to 8 servings

SOFTWARE

11 cups (2 L) filtered water

2 tablespoons (8 g) unflavored black tea, such as Assam

¾ cup (150 g) sugar

1 mature kombucha SCOBY plus 2 cups (473 ml) of the unpasteurized, unflavored kombucha that will come with it. Or you can use store-bought kombucha as long as it's unpasteurized and unflavored.[13]

1 cup (140 g) frozen mango cubes

1 cup (120 g) chopped, unpeeled fresh ginger

TACTICAL HARDWARE

- A 1-gallon glass jar
- Large paper coffee filters
- A big rubber band
- Six to eight 12- to 16-ounce **plastic** soda bottles (clean) with tight-fitting lids. Do not use glass, as expanding gas and glass can result in . . . boom.

PROCEDURE

1) Heat 3 cups of the filtered water to 200°F in an electric kettle and place the tea leaves in a 4-cup liquid measuring cup.[14] Pour the water over the tea leaves and steep for 10 minutes.

2) Strain the tea into a 1-gallon glass jar. Add the sugar and stir until dissolved. Discard the tea leaves.

3) Add the remaining 8 cups filtered water to lower the temperature to lukewarm. If the water is still over 100°F, park it on the counter for 10 minutes, then recheck; you don't want to scald the SCOBY (that would make it angry, and you wouldn't like SCOBY when it's angry).

4) Move the SCOBY into the jar and add the kombucha. Cover the jar with a coffee filter secured with a rubber band and place in a warm, well-ventilated area out of direct sunlight until the mixture begins to take on a pleasantly sour and tangy flavor and is lightly effervescent, 2 to 3 weeks. The ideal fermentation temperature is between 75°F and 85°F.[15]

5) When you're happy with the flavor, wash your hands very well and gently transfer the SCOBY to a clean bowl. Reserve 2 cups of the fresh kombucha and add to the bowl with the SCOBY.

6) Add the mango and ginger to the jar with the remaining kombucha. Re-cover with the coffee filter and rubber band. Leave at room temperature until the kombucha has taken on the flavor of the fruit and ginger, 2 to 4 days. Meanwhile, you can start a second batch of kombucha with the SCOBY and reserved 2 cups of plain kombucha, or you can start a SCOBY hotel (see the sidebar on page 347).

7) When the flavored kombucha is ready, strain through a fine-mesh sieve into a large measuring cup or bowl. Discard the solids, then divide the kombucha[16] evenly among the soda bottles being sure to leave at least 1½ inches of headspace in each bottle for gas to expand. Twist the lids on tightly and park on the counter until the bottles are firm to the touch, indicating that the kombucha is carbonated, 1 to 3 days, then move to the fridge and chill before drinking. The kombucha will keep in the refrigerator for up to 1 month.

13 Once you've got your kombucha setup going, you'll be able to use your newly grown SCOBY and a bit of the unflavored kombucha to keep successive batches going, so you only need to purchase the store-bought stuff once.

14 If you're using a traditional kettle or pot, bring the water to a boil, then let it cool for 2 minutes before using.

15 I start tasting after about a week. In my house the process usually takes about 16 days.

16 A funnel is very helpful here.

Scabs's mohawk inspired by *The Road Warrior*

THE HOUSE THAT DRIPPED CHOCOLATE

I buy an old cookbook, and inside is a journal of mysterious chocolate recipes. The notebook has a big "W" on it—just think about that one for a minute.[1] The recipes appear to be for prototypes of popular candies we now all know and love: the Butterfinger, the Peppermint Pattie, the 3 Musketeers bar. We couldn't name those in the show, of course, because there are rules about those kinds of things. As I start to cook my way through the book one stormy night, strange happenings happen, bumps bump, lightning lights.

1 As in Wonka?

As for the candies, each requires that a filling be made and that a chocolate coating be applied. This means tangling with the specter of tempering, which for many cooks is way scarier than a pissed-off curse wraith with a butcher knife. Read on . . . if you dare.

SLIPPING INTO DARKNESS

Halloween 1894: two hundred boys attacked streetcar commuters with sacks of flour in Washington, D.C.

Candymaking is all about controlling crystallization. I don't care if it's caramel or ice cream, chocolate or nougat, our job is to either promote, prevent, or in some other way manipulate the formation of crystals, be they from water, sugar, fat, or something I've forgotten to list here. You may not think of chocolate as containing crystals, but indeed it does. In fact, the fat molecules inside chocolate (aka cocoa butter) are polymorphic, meaning they can stack into different crystalline forms—six, to be exact. This is ever so inconvenient, because five of these polymorphs make chocolate that is either crumbly, gooey, ugly, or streaky. If we want our chocolate to be shiny, smooth, and snappy (what's known as being "in temper"), we must reduce the number of polymorphs one through four and six, and concentrate on polymorph five, also known as beta prime, not to be confused with Optimus Prime, who turns into a

truck, not a candy. We can make things easier on ourselves by using a couverture chocolate, which has a higher ratio of cocoa butter to cocoa solids, while avoiding chocolate morsels or chips intended for use in cookies, which are formulated to hold their shape at oven temperatures.

The traditional method of tempering requires that the chocolate be heated to a temperature high enough that all the crystal forms melt. The temperature is then lowered and the chocolate is agitated to encourage the growth of new crystals, both good forms and bad. The temperature is then increased again, slightly, to melt out the bad ones. Sound easy? Sure, if you have years of training and a giant marble slab or a professional-grade tempering machine. However, with the help of a good digital thermometer, we can coax chocolate into a fluid state without forcing it to lose its temper at all by bringing dark chocolate up to only 91°F and milk chocolate to

only 88°F.[2] To avoid redundancy and to save space, we'll deal with the tempering here just once, as its own procedure, which you can reference when making any of the three candies. And yes, I know there were only two in the show. I was holding out.

A word about chocolate brands: While I couldn't mention them on TV, I can here. Although there are a quite a few good-quality couverture chocolates out there, I still tend to turn to either Callebaut (Belgian) or Cacao Barry (French), which merged in 1996 to form Barry Callebaut. Although they're one company now, there are still differences in their chocolates, but they're great for melting and coating. If I can't find those, I go with Valrhona. None of them is cheap, but in my experience cheap chocolate can only reliably be tempered with a machine, and that's going to cost you a few grand.

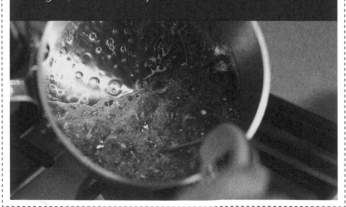

CORN SYRUP

By adding corn syrup—mostly glucose, as opposed to high-fructose corn syrup, which contains more fructose and is typically used only in processed foods—we can prevent sucrose molecules from joining together and forming crystals in the crowded environment of the syrup, thus keeping our candy amorphous or glasslike. Again, it's all about crystallization.

2 Milk chocolate, by the way, is trickier than dark, because it contains milk powder, which contains butterfat, and those fat molecules tangle up with those of cocoa butter to form an alloy that actually has a lower melting point than either of the crystals would have on their own.

"The House That Dripped Chocolate" took longer to produce than any other <u>Good</u> <u>Eats</u> episode and is the only one ever delivered in black-and-white. The hardest thing about making the episode wasn't the food but keeping track of the continuity of my injuries. The woman who played the vengeful spirit also played the really creepy balloon clown in "Let Them Eat (Icebox) Cake."

CHEATER'S TEMPERED CHOCOLATE

YIELD:

1 to 2 pounds melted, tempered chocolate

A good digital thermometer, careful use of a double boiler, and a whole heck of a lot of stirring will allow any cook to coax both milk and dark chocolates into a fluid state without forcing them to lose their temper.

Note spooky hand

SOFTWARE

1 to 2 pounds high-quality chocolate, in couverture disks, Callets,[3] or finely chopped bars

TACTICAL HARDWARE

- A straight-sided sauté pan
- A heavy metal mixing bowl, preferably a bit wider than the pan (see the note about seizing)

3 Callets are like flatter, dome-shaped versions of chips designed for easy melting. It's a registered name, owned by Barry Callebaut, but people are starting to use it like Xerox and Kleenex.

It's estimated that 300,000 tons of candy are sold during the Halloween season. That's almost the same weight as six Titanics.

PROCEDURE

1) Place a folded kitchen towel in the bottom of an 11-inch straight-sided sauté pan or large skillet. Add 1 inch of water and place over medium-high heat. When the water hits a bare simmer, about 190°F, reduce the heat as low as it will go. Fold a second towel and position it on the counter right next to the cooktop.

2) Put the chocolate in a metal bowl that will fit in the sauté pan, and set it atop the towel in the skillet. Stir constantly for 5 seconds. Remove from the heat, set on the dry towel, and stir vigorously for 30 seconds. Return to the hot water and stir for another 5 seconds, then go back to the dry towel for another 30 seconds. Repeat this cycle until the chocolate is half-melted.

3) Once you feel the chocolate is about half-melted, reduce the time the bowl is on the heat from 5 to 3 seconds. Maintain the off-heat stir time at 30 seconds. Also, start taking the melted chocolate's temperature. The goal is to melt all of the chocolate while keeping the temperature below 91°F for bittersweet and semisweet

chocolate or 88°F for milk chocolate. The process can take anywhere from 10 to 20 minutes, depending on the size of the chocolate pieces. If the chocolate begins to creep up above your target temp, leave the bowl on the counter and stir like crazy until the temperature drops back down.

NOTE

I often still have a couple of solid pieces of chocolate in the bowl when I start dipping. I consider that insurance against the temperature getting too high.

And another thing: One drop of water in the chocolate can cause the cocoa solids to seize up, and that will ruin your whole day: You'll still be able to use your chocolate for, say, ganache or chocolate sauce, but not for coating. Using a bowl that's a little wider than the sauté pan can help prevent steam from condensing and rolling down into the bowl.

4) Once the chocolate is mostly smooth, with maybe just one or two small chunks remaining, stir vigorously for another minute off the heat. Place 1 piece of candy (see applications below) into the bowl of chocolate and, using a fork, flip it over to coat both sides. Pull the candy from the chocolate, then tap the fork on the side of the bowl to remove as much excess chocolate as possible. Transfer to a silicone- or parchment-lined baking sheet and repeat with the remaining

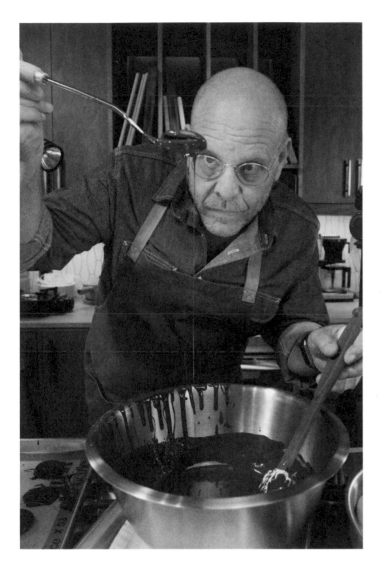

candies. (If the chocolate becomes too thick or hard to work with, return it to the hot water for a few seconds, stirring constantly. Do not let the temperature rise above its target temp.)

5) When you're finished dipping, dry the bottom of the bowl thoroughly (again, water is the enemy), then then use a rubber spatula to coax the brown goodness into a deli container or other airtight vessel. Cool, then cover and store in a cool, dry place. Don't refrigerate. If you treated it nicely it should be eligible for re-dipping, as long as you add fresh chocolate to the mix.

Now, let's make some scary good candy, starting with a riff on a famous treat that celebrates the bite of dark chocolate and the cool of peppermint. Remember, when it comes to coating, use the application above. That said, you'll notice the fillings all utilize the same double boiler-esque rig.

The curse comes full circle.

DEEP DARK DISKS OF MINTY MAGIC

SOFTWARE

575 grams (5 cups) confectioners' sugar, divided

1 large (30 to 35 g) egg white

110 grams (⅓ cup) light corn syrup

⅛ teaspoon peppermint oil[4]

½ teaspoon water, if needed

¼ cup (70 g) cornstarch, for rolling

565 grams (1¼ pounds) high-quality bittersweet cocoa (around 70% cocoa), in coverture disks or finely chopped bars

TACTICAL HARDWARE

- A wide, straight-sided sauté pan
- A stand mixer
- A 2-inch ring cutter (part of a set)[5]
- A silicone baking mat

There are more than six hundred types of mint, including pineapple mint, water mint, and horsemint.

4 Peppermint oil, not extract. This is strong stuff and the best way to get mint flavor into candy. It'll only take a few drops.

5 Ring kits, as they're called, typically contain eleven or twelve circular cutters ranging from 1 to 4.5 inches in diameter. They come conveniently nested in a round tin. You think you don't need one of these sets, but you do: major multitaskers.

When mixers attack!

PROCEDURE

1) Place a folded kitchen towel in the bottom of an 11-inch straight-sided sauté pan or large skillet. Add 1 inch of water and place over medium-high heat and bring to a bare simmer, about 190°F.

2) Combine 30 grams (¼ cup) of the confectioners' sugar with the egg white in the bowl of your stand mixer, then park the bowl on the towel in the water. Tilt the bowl as needed so the egg mixture stays in contact with the part of the bowl that's touching the water. (Some mixers have an added piece of metal at the bottom that may necessitate this.) Reduce the heat to medium and stir often with a rubber spatula until the mixture is smooth, foamy, and hits 160°F, which will take 7 to 10 minutes. Remove from the water and transfer the bowl to the mixer. Kill the heat under the sauté pan but leave it on the stove; you'll use it later for the tempering.

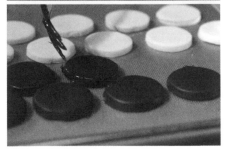

Death by chocolate

3) Add the corn syrup and mint oil to the egg mixture. Using the paddle attachment, beat on medium-high speed until combined, about 30 seconds, scraping down the bowl as needed. Reduce the speed to low, add one-quarter of the remaining confectioners' sugar, and beat until combined, 30 to 45 seconds. Continue to add the sugar in this manner until it's all incorporated, then continue beating until the mixture forms a dough, about 1 minute.

4) Remove the paddle attachment and bowl and knead a few times (still in the bowl) with your hands to smooth out the dough and form it into a ball. If the dough does not form a ball, add ½ teaspoon water, return the bowl to the mixer, and beat with the paddle until smooth.

5) Lightly dust the counter and a rolling pin with the cornstarch. Transfer the dough to the counter and roll into a rectangle around ¼ inch thick. Stamp out 25 to 30 rounds of the dough using a 2-inch ring cutter. Place the rounds on a parchment-lined half sheet pan, then re-roll and stamp the scraps. You should have about 3 dozen rounds of dough.

6) Place the pan with the peppermint rounds near the cooktop and position a second pan next to it lined with either a silicone baking mat or a second sheet of parchment. Place a folded kitchen towel right next to the stovetop . . .

You know what to do from here on—temper the chocolate and coat the peppermint rounds with it, as instructed on page 354.

7) When you're finished dipping, let the candies sit at room temperature until the chocolate hardens completely, about 1 hour. Devour 1 (or 2) immediately and store the remainder in an airtight container at room temperature for up to 2 months.[6]

6 Since moisture is the enemy of chocolate and I live in the South, I add a food-grade desiccant pouch, which we talked about back in "Deep Sea Green" (page 324).

MOVE CAMERA OUT

28

AB removes pro-lid
bends down and looks
at blade (need dialogue)

29

DUMP IN INGREDIENTS

30

LIGHTS
COME
BACK

HIGH OVERHEAD
AB struggles with machine

31

blade spins and rises suddenly

(LIGHTNING)

32

Eyes wide with terror

(LIGHTNING)
35

Flying blade sequence

PISTACHIO BUTTERDIGITS[7]

I substitute pistachios for peanuts in this homemade hack of one of Halloween's favorite milk chocolate–covered candies. This recipe isn't as scary as it looks and, if you watch the show, it'll be a snap. Also, if at any time during the folding the candy becomes too hard to work with or starts to crack, simply stash in the warm oven for 5 minutes to soften.

SOFTWARE

142 grams (1 cup) roasted, salted pistachios

260 grams (1¼ cups plus 1½ teaspoons) sugar, divided

14 grams (½ cup) cornflakes

½ cup (118 ml) water

64 grams (3 tablespoons plus ½ teaspoon) light corn syrup

1 teaspoon vanilla extract

454 grams (1 pound) high-quality milk chocolate, in couverture disks or finely chopped bars

TACTICAL HARDWARE

- **A silicone baking mat**
- **A plastic dough/bowl scraper**
- **Parchment paper**

Pistachios, <u>Pistacia vera</u>, are a member of the sumac family native to parts of Asia and the Middle East.

PROCEDURE

1) Crank the oven to 200°F and line a half sheet pan with a silicone baking mat.

2) Take the pistachios and 35 grams (2½ tablespoons) of the sugar for a spin around your food processor, until the mixture appears damp and begins to clump, 1 to 2 minutes. (You may need to stop two or three times to scrape the sides and bottom of the bowl with a rubber or silicone spatula.) Add the cornflakes and pulse until crushed and the mixture is fairly uniform, 5 to 10 pulses. Transfer to a bowl and set aside.

3) Combine the water, corn syrup, and vanilla in a small (2-quart)

saucepan. Move to the stovetop and add the remaining 225 grams sugar. Turn the heat to medium and cook until the mixture reaches a rolling boil. Swirl the pot occasionally to help the sugar dissolve completely.[8]

4) Continue boiling the syrup, without stirring, until the mixture registers 275°F, 8 to 12 minutes. Reduce the heat to low and continue cooking until the syrup reaches 285°F, another 30 to 60 seconds. Immediately remove from the heat and carefully pour out in a rectangle in the center of the silicone mat you set into the half sheet pan back in step 1.

5) Tilt the sheet pan to coax the syrup into a rectangle measuring roughly 12 × 9 inches. Place the pan

7 See what I did there to stay out of trouble with the law?

8 Relax, candy classicists, the corn syrup is there to prevent crystallization.

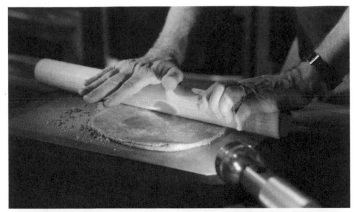

flat on the counter and turn so that a short side is facing you. Evenly spread the pistachio mixture over the bottom two-thirds of the candy. Using the mat, fold the candy as you would a business letter, folding the empty third over the middle, then folding that over the bottom third to create 3 layers of candy and 2 of pistachio filling. (If the mixture sticks to the mat, let sit for 2 to 3 minutes longer to continue to cool; it will release when it's ready. You can also use a plastic dough scraper to help.) Fold the packet in half widthwise to form a 5 × 4½-inch rectangle, then transfer to the oven for 5 minutes.

6) Move the candy back to the counter and use a rolling pin to roll it back out to a 12 × 9-inch rectangle. Some force and patience will be required, and it won't necessarily be pretty, but neither is sausage making. Some of the nut mixture may punch out through the candy layer, but you should not hear the candy cracking. If you do, return the mat (yes, with the candy) to the sheet pan and heat for another few minutes in the oven. Once the candy is rolled out, repeat the folding process from step 5. Return to the oven for another 3 to 5 minutes.

7) Repeat step 6 once more, then return the candy to the oven to soften one final time.

8) Remove from the oven and roll the candy out to about ¼-inch thickness. Transfer the candy from the mat to a piece of parchment paper and place on a cutting board. Trim the edges, if desired, then use a chef's knife to slice into 24 to 32 fun-size candies. (Exact precision is not required here.)

9) Wipe off the silicone baking mat and return it to the sheet pan. Place it next to the board with the candies. Place a folded kitchen towel right next to the stovetop. Place a second folded kitchen towel in the bottom of a high-sided sauté pan or large skillet and add about 1 inch of water.

And . . . you know the rest.

10) When you're finished dipping, let the candies sit at room temperature until the chocolate hardens completely, about 1 hour. Devour 1 (or 2) immediately and store the remainder in an airtight container at room temperature for up to 2 months.[9]

TIP

If you're concerned about meltage due to warm kitchen conditions or summer weather, a short stay in the fridge won't do any harm, but after a while, condensation can result in sugar bloom, a cloudy whitish formation on the surface caused by sugar dissolving up out of the chocolate. So, unless your kitchen's wicked hot, I'd skip the chill chest and go with a cool pantry.

9 Again, since moisture is the enemy of chocolate and I live in the South, I add a food-grade desiccant pouch, which we talked about back in "Deep Sea Green" (page 324).

the
lost
season

GOOD EATS
RELOADED

I think of this as the "lost" season, because when I started writing this book, I was pretty sure we'd be going into production; after all, plenty of episodes were still screaming out for renovation. We dove headlong into development, and I have to say some of the resulting applications are the best we've ever devised. Alas, circumstances are prone to change, and I never got a shot at shooting the final chapter. But the food is darned tasty, and the various complaints about the originals (I'm talking to you, lasagna) have been addressed. So, here are the applications for the never-aired, never-before-seen *Reloaded* season 3, presented for the first time. By the time you read this, I hope *Good Eats* will have evolved into its next iteration. It is a journey, after all, and this particular one has defined my life. In the meantime, enjoy the chow.

CHURN, BABY, CHURN: RELOADED

SERIOUS VANILLA ICE CREAM: RELOADED

YIELD:

About 6 cups

Reason for Reload: Our original recipe from 1999 relied on peach preserves to provide pectin to tune in the mouthfeel and slow the melt. It was only 2 ounces, but still . . . that's a tough flavor to get around when you're supposed to be making vanilla ice cream. So, here we replace that pectin with liquid pectin, easily found at most megamarts (especially late in the summer and early fall, when jelly and jam season is at its height. Also, the webs, of course.) We've also shifted from vanilla bean to paste, which is a heck of a lot easier to work with than whole bean. I'm a fan of Nielsen-Massey, which comes in 4-ounce jars.[1]

SOFTWARE

150 grams (¾ cup) sugar, divided

¼ cup (60 g) water

1 tablespoon (15 g) liquid pectin (see box, opposite)

2 cups (480 g) half-and-half

1 cup (245 g) heavy cream

40 grams (2 tablespoons) vanilla bean paste, divided

⅛ teaspoon kosher salt

TACTICAL HARDWARE

- An ice-cream machine, either continuous churn or frozen core[2]

- A stand mixer with whisk attachment (for No-Machine Variation below)

PROCEDURE

1) Combine ¼ cup (50 g) of the sugar with the water in a small saucepan. Place over medium-high heat and bring to a boil, stirring frequently, about 3 minutes. Stir in the pectin and return to a full rolling boil, then continue stirring at a boil for exactly 1 minute. Remove from the heat and leave at room temperature to cool, about 25 minutes. In our recent test, the temperature was 89°F.

2) While the pectin mixture cools, combine the remaining ½ cup (100 g) of the sugar with the half-and-half, cream, 1 tablespoon (20 g) of the vanilla bean paste, and the salt in a medium saucepan. Place over medium heat and, stirring frequently, bring the mixture to 185°F, 5 to 7 minutes. Remove from the heat, cover, and steep for 20 minutes.

1 Although I don't mind using imitation vanilla extract for baked goods, when it comes to ice cream, I want the real thing and I prefer paste to whole bean.

2 Continuous-churn machines use an electronic compressor system to produce the cold needed for churning, and as long as it stays plugged in, a good one can go all day long. That's great if you own a small restaurant or other commercial concern, but for most home cooks, looking to only make a couple of quarts here and there, a frozen-core model, which requires that the core be stashed in the freezer for at least 24 hours before churning, is typically the way to go. I'm partial to those made by Cuisinart, but I've had several Krups machines as well. If you want to go with a compressor model, you might want to check out the Lello 4080, which is going to run you about $750.

PECTIN

Pectin is basically a plant glue, and it's often used to set jams and jellies. It also works well as a stabilizer or texture modifier in ice creams, as it helps to limit crystallization (candy is all about crystal control, and yes, ice cream is a candy), and it slows melting by binding up water. If you've ever raced to eat your homemade ice cream before it melted, pectin can help.

3) Thoroughly stir the cooled pectin mixture into the cream along with the remaining 1 tablespoon (20 g) vanilla bean paste. Set the pan inside a bowl of ice and stir to "shock" the mixture down to room temp. Transfer to airtight containment and refrigerate for at least 6 hours or up to 24 hours.[3]

4) Assemble your ice-cream churn according to the manufacturer's instructions. If you're using an electric machine—with or without a frozen core—turn it on, then pour in the ice-cream mixture to prevent seizing.

5) Churn the ice cream until it reaches soft-serve consistency, 20 to 30 minutes, depending on the ice-cream maker. Quickly transfer to 3 pint-size containers and freeze until scoopable, at least 4 hours, before serving.[4]

3 This resting period allows for chemical changes to take place in the dairy that will result in improved texture in the final ice cream.

4 First-time churners often think their machines should produce ice cream in a hard-but-scoopable-state, like it comes out of a store-bought carton. This is not the case; machines only freeze and work in air. Once it hits soft-serve consistency it needs to "harden," and that can only be done by moving it quickly to as cold a box as you've got.

SERVING TIP

Once hardened, leave the container at counter temp for 5 minutes before scooping.

NO-MACHINE VARIATION

Do you have to have an ice-cream machine to make ice cream? No, you do not. But you will need a decent stand mixer, and a good bit of time, and some patience. The software is the same as above, as is the procedure through step 3. We'll pick up with the new move at . . .

1) Transfer the ice-cream mixture to the bowl of a stand mixer, cover the bowl with plastic wrap, and stash in the freezer until the mixture begins to freeze around the edges of the bowl, about 1 hour.

2) Place the bowl in its mixer, load up the whisk attachment, and beat on medium speed until any ice crystals have been fully incorporated into the mixture, about 30 seconds. Remove and re-cover with the plastic wrap and freeze for 45 minutes.

3) Return to the stand mixer and beat on medium speed again until the ice crystals have incorporated, about 30 seconds. Cover and return to the freezer.

4) Repeat the beating and freezing, scraping down the sides of the bowl and increasing the mixing time up to 1 minute as needed, until the ice cream has lightened in color, doubled in volume, thickened dramatically, and is the texture of very soft soft-serve, 5 to 6 hours total of mixing and freezing time.

5) Transfer as quickly as possible to three pint-size containers and freeze until scoopable, at least 4 hours, before serving.

COFFEE GRANITA: RELOADED

YIELD:

About 1 quart

Reason for Reload: The original version called for coffee liqueur, which honestly didn't do anything for the dish but make it too sweet. What it needed was the addition of something that could provide a counterpoint to the coffee, and for that we settled on Nonino amaro, a great amaro to start with if you're amaro-curious, because it's balanced and not as phunkily pharmaceutical as the stuff I sip before bedtime every night.

SOFTWARE

2 cups (475 g) unsweetened cold brew coffee[5] at room temp (see pages 298–303)

100 grams (½ cup) sugar

2 tablespoons (28 g) Nonino or other bittersweet amaro

TACTICAL HARDWARE

- A 9 × 13-inch metal cake pan

PROCEDURE

1) Whisk all the ingredients together in a large bowl or measuring cup to dissolve the sugar, then pour into a 9 × 13-inch metal pan (it will only come about ¼ inch up the side of the pan) and place on a level shelf in the freezer until the mixture begins to freeze on the edges of the pan, 20 to 30 minutes.

2) Remove from the freezer and use a dinner fork to scrape and mash the mixture to break up all of the ice crystals that have formed on the side or bottom of the pan. Return to the freezer and repeat the scraping and mashing process every 20 to 30 minutes until the mixture has turned into a fluffy pile of dry brown crystals, 90 minutes to 2 hours.

3) Once the mixture is thoroughly frozen, fluff with a fork and allow the flakes to dry in the freezer for another 30 minutes before serving topped with Slightly Sweet Whipped Cream (opposite). If you'd like to make the granita ahead of time, transfer to two pint-size storage containers after the drying step. Cover and freeze for up to 1 week.

NOTE

The freezing time is highly dependent on your freezer's temperature. Err on the side of longer rather than shorter freezing times, unless you know that your freezer runs quite cold.

5 Why cold brew and not just cold hot brew? Because hot coffee often clouds when cooled, due to different substances falling out of the solution, and that can make your granita look muddy.

SLIGHTLY SWEET WHIPPED CREAM

YIELD:

1½ to 2 cups

This may be the most versatile dessert topping in existence. Anything you put this on actually becomes dessert. It's a miracle. I like mine only slightly sweet, because I really like to taste the cream itself, but if you prefer sweeter, boost the sugar to 3 tablespoons.

SOFTWARE

1 cup (240 g) heavy whipping cream

13 grams (1 tablespoon plus 2 teaspoons) 10X (confectioners') sugar

1 or 2 drops vanilla extract (optional)

TACTICAL HARDWARE

• A stand mixer with whisk attachment

PROCEDURE

1) Stash the mixer's work bowl and the whisk in your freezer for 10 to 15 minutes.

2) When the bowl and whisk are good and cold, assemble the mixer. Add the cream and about half of the confectioners' sugar. Whip on medium-high speed until the cream is thick and frothy, about 3 minutes.

3) Add the rest of the sugar and the vanilla, if using. Continue whipping just until the cream reaches stiff peaks. Store any unused portion in an airtight container for up to 10 hours. When ready to use, re-whisk for 10 to 15 seconds. Use immediately or refrigerate in airtight containment for up to 2 hours.

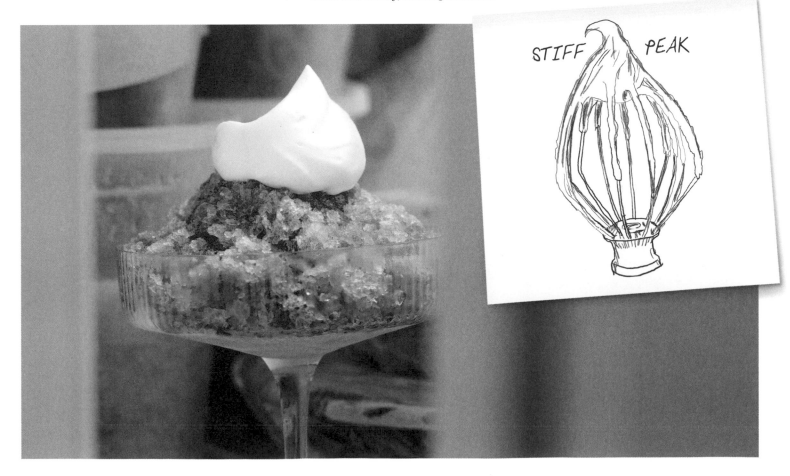

STIFF PEAK

CRUSTACEAN NATION: RELOADED

SHRIMP COCKTAIL

YIELD:

4 to 6 servings, depending on the size of the shrimp

Reason for Reload: Shrimp cocktail is one of my favorite foods of all time, and over the years I've continued to tinker with mine. I went with a smoky almond version for my book *EveryDayCook*, a nod to romesco sauce. I've kept the almonds in this version, but they're roasted, not smoked. There is still smoke flavor, but it comes from a bottle . . . I adore Lazy Kettle–brand liquid smoke, and even use it in cocktails. As for the spice side of the equation, the original called for "chili sauce," which meant leaving a lot of the flavor driving to someone else. Here we depend on sambal, horseradish, and smoked paprika, which was still hard to find back at the turn of the century.

Oh, and that original version called for the shrimp to be brined then broiled, the thought being that I could get more flavor out of the shells and into the shrimp. The results, however, were often chewy, so I've gone to brining and steaming.

SOFTWARE

For the sauce:

75 grams (½ cup) almonds, roasted[1]

1 (28-ounce) can whole tomatoes, drained

½ cup (155 g) ketchup[2]

2 tablespoons (37 g) sambal oelek chili paste (the brand with the rooster on it)

¼ cup (65 g) prepared horseradish (not horseradish sauce)

1 tablespoon (15 ml) fresh lemon juice

1 tablespoon (9 g) Old Bay Seasoning

30 grams (2 tablespoons plus 2 teaspoons) dark brown sugar

2 tablespoons (29 g) Worcestershire sauce

1 teaspoon (2 g) smoked paprika

½ teaspoon liquid smoke (Lazy Kettle brand)

For the shrimp:

1 cup (237 g) room-temperature water, plus more cold water for the water bath

2 ounces (57 g) kosher salt

2 ounces (57 g) granulated sugar

8 ounces (226 g) ice cubes

1½ pounds (680 g) tail-on large shrimp (21–25 count)

TACTICAL HARDWARE

- A food processor with chopping blade
- A folding metal steamer basket

1 I could tell you to buy raw almonds and roast them yourself, but you and I both know that's not going to happen. You're going to buy a can of roasted, salted almonds and go from there. Fine; just know that different brands have different levels of salt added, so I'd at least dump them into a sieve or fine strainer and tap it on the side of the sink a few times to get as much excess salt off as possible.

2 By "ketchup" I mean Heinz, and no, they don't pay me to say that.

SHRIMP COCKTAIL *(continued)*

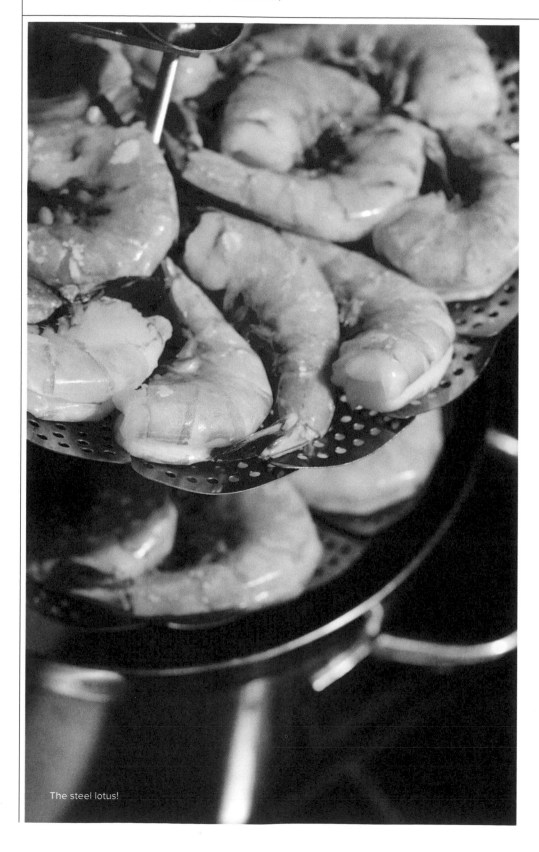

The steel lotus!

PROCEDURE

1) Make the sauce: Pulse the almonds in a food processor until the pieces resemble coarse meal, about 20 one-second pulses. Add the tomatoes, ketchup, sambal, horseradish, lemon juice, Old Bay, brown sugar, Worcestershire sauce, paprika, and liquid smoke. Pulse to the desired consistency (I like mine a little on the chunky side).

2) Refrigerate for at least 3 hours before serving . . . overnight would be better. (Continue with the application below and assemble a shrimp cocktail. But save some for the pasta dish on page 372.) This sauce will keep for up to 1 month in the fridge.

3) Make the shrimp: Combine the 1 cup room-temperature water, the salt, and sugar in a large bowl and stir to dissolve. Add the ice and set aside.

4) Fill a medium bowl with cold water. Use a pair of kitchen shears to cut the shrimp open across the back, from front to tail, exposing the inner vein.[3] Submerge in the water and remove the vein, which should float off and sink. Avoid removing the shell if possible. As each shrimp is deveined, transfer it to the cold brine. Once they're all in, leave to brine for another 30 minutes.

5) When you've got about 10 minutes remaining, bring an inch of water to a boil in a saucepan large enough to accommodate your steamer basket, over high heat.

3 Why bother? It's not a vein, it's a poop tube, that's why.

6) Drain the shrimp and briefly rinse under cold water. Arrange on your steamer basket, minimizing overlap. (You may need to do this in a couple of batches unless you have a steel lotus, an illustration of which can be found below.) Drop the heat to medium-high, cover, and steam for 3 minutes.

7) Meanwhile, rinse out the bowl and add 2 to 3 cups of ice to it.

8) Transfer the shrimp to the ice bowl and toss a few times to stop the cooking process. Toss every couple of minutes until the shrimp have chilled through, then either serve or refrigerate in airtight containment for up to 24 hours. Place in the freezer, tossing every few minutes for 15 minutes to 20 minutes or until thoroughly chilled.

9) Peel the shrimp and serve with the cocktail sauce. Or serve with the shells on and let your guests do the peeling. That'll slow them down a little.

THE STEEL LOTUS

You can use any old steamer, but if you have three metal steamers and some threaded stock from a hardware store, and a few nuts and washers, you can construct your own steel lotus.

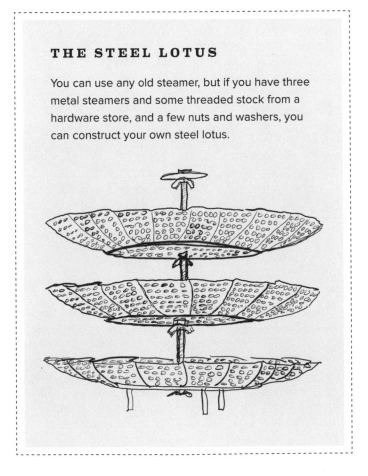

1) End of scissor goes into vein opening.

2) Cut carefully down length of vein.

3) Remove "vein" in H_2O.

SHRIMP PASTA

YIELD:
2 entrée servings, but it's easily doubled for 4

Reason for Reload: Again, not so much a reload as an add-on. One of the reasons that shrimp is by far the most consumed seafood in the United States is because they're so ridiculously easy to work into myriad dishes. They're quick cooking, they plump nicely, and they're usually more sweet than savory. The following is hands down the dish you would get if you just dropped by for dinner and I'd either forgotten you were coming or you weren't invited. Although fresh shrimp would be best, I could probably thaw these in the amount of time it would take to make you a drink. In that spirit, there are no weights other than for the pasta . . . it's that kind of dish.

SOFTWARE

1 tablespoon kosher salt, plus 2 teaspoons for the pasta water

½ cup hot water, plus cold water and ice

8 large shrimp, peeled, split, and deveined

4 ounces dry spaghetti (one-quarter of a standard box)

2 tablespoons unsalted butter, melted

2 large cloves garlic, finely chopped

1 tablespoon olive oil (just plain olive oil, not extra-virgin)

3 ounces white wine (Sauvignon Blanc is my usual cooking white, as it's fairly neutral)

¼ cup Shrimp Cocktail Sauce (page 368)

1 tablespoon chopped fresh parsley

TACTICAL HARDWARE

- A straight-sided sauté pan just wide enough for dry spaghetti to sit flat in it without you having to break it (the spaghetti)
- Spring-loaded tongs
- A large sieve (optional)

PROCEDURE

1) Put 1 tablespoon of the salt in a quart-size container, dissolve in the hot water, then fill three-quarters of the way to the top with cold water and ice. Add the shrimp and soak for 30 minutes. (Technically, this brining step is optional, but it's highly recommended as it will enhance the shrimp's flavor and texture.)

2) Put the pasta in a large straight-sided sauté pan and add just enough cold water to cover (about ¾ inch total depth). Sprinkle in the remaining 2 teaspoons salt, place over high heat, and bring to a boil, stirring the (still stiff) pasta from time to time as the water heats. When big bubbles break, decrease the heat to medium or even medium-low just to maintain a simmer.

3) Place the butter and garlic in a small heatproof custard cup and float in the water with the pasta to melt.

4) When the pasta has been cooking for about 8 minutes, set a 12-inch skillet (preferably carbon steel) over high heat for 3 minutes.

5) By now the pasta should be almost al dente. Drain the shrimp, pat dry, then toss with the oil and add to the skillet, shaking constantly. Count to 10 and add the melted butter and

garlic. Toss for another 5 seconds, then add the wine and the cocktail sauce. Cook for about 10 seconds, then reach into the pasta with your tongs and lift as much of the pasta as you can get a hold of. Let it drain for about 3 seconds, then add it to the hot pan. It will probably take you about three trips to get all the strands. Shake the pan and stir with the tongs for 30 seconds or so, tossing to combine. If the sauce looks a little dry or just isn't sticking to the spaghetti, add 2 to 3 tablespoons of the pasta water.

6) Toss in the parsley and serve immediately.

The average American eats over 4½ pounds of shrimp a year, more than any

other seafood. (Only Japan consumes more per capita.)

NOTE

Starting pasta in a small amount of cold water means there will be a lot of starch in the water when the pasta is cooked. This elixir is the magic ingredient that good Italian restaurants use to thicken their sauces and give them body. Not butter or cream, starch alone. Now, I usually do just pick up the noodles with my tongs and transfer them, but if you have to cross some space, you can lift them into a hand sieve, briefly drain, then move to the pan, but seriously don't waste the water.

And another thing: Ideally you don't want the shrimp to sit around in the hot pan waiting for the pasta, so pay attention to what "almost" al dente feels like between your teeth. And no, you're not throwing it at the wall to see if it sticks.

Also notice: At no time in this recipe did I refer to the pasta as "noodles." I made that mistake once . . . once.

The words "shrimp" and "prawn" don't have actual scientific meanings and are strictly colloquial in their delineations. Different countries and regions apply different meanings, and in much of the world a prawn is just a really big shrimp. In others, it's a different variety with more sets of claws.

PANTRY RAID II: SEEING RED: RELOADED

CANNED TOMATO TOMATO SAUCE: RELOADED

YIELD:
About 5 cups

Reason for Reload: It wasn't very good. Seriously, the wine went in at the wrong time, there was too much red pepper, too many capers . . . it just wasn't balanced. Also, it's really mission critical that you use actual and for-real San Marzano tomatoes. For more details than you probably want, look back at "American Classics X: Chicken Parm" in season 1 of *Good Eats: The Return* on page 98. Oh, and I changed the name of the recipe from "Pantry Friendly . . ." because that's lame.

SOFTWARE

2 (28-ounce) cans whole, peeled San Marzano tomatoes

½ cup (113 g) white wine, such as Pinot Grigio or Sauvignon Blanc

¼ cup (55 g) sherry vinegar

1 teaspoon dried oregano

¼ teaspoon red pepper flakes

1 small onion, finely diced (155 g or 1 cup)

1 small carrot, peeled and finely diced (45 g or ⅓ cup)

1 stalk celery, finely diced (35 g or ¼ cup)

4 cloves garlic (15 g), smashed

6 tablespoons (55 g) extra-virgin olive oil

1 teaspoon kosher salt, plus more to taste

1 tablespoon (14 g) brined capers, drained[1]

¼ teaspoon freshly ground black pepper

TACTICAL HARDWARE

• Nothing special here.

PROCEDURE

1) Heat the oven to 450°F.

2) Set a large fine-mesh sieve over a 3- to 4-quart saucepan and pour in the tomatoes, allowing the juice to run into the saucepan. Gently press on the tomatoes to extract any additional juice. (Depending on the brand, you should have 4 to 5 cups tomatoes and 1½ to 2 cups juice.) Set the tomatoes aside.

3) Add the wine, vinegar, oregano, and red pepper flakes to the juice and bring just to a boil over high heat, stirring often.

4) Reduce the heat to medium-low and simmer, stirring occasionally, until the liquid is reduced by half[2] or until it's thickened to the consistency of tomato soup, 20 to 25 minutes. Remove from the heat.

5) Meanwhile, toss the onion, carrot, celery, and garlic with the oil and salt in a small bowl and then spread on a half sheet pan. Roast until the onion begins to soften, about 10 minutes.

6) Remove the sheet pan from the oven, stir in the drained tomatoes and capers, and return to the oven to roast, stirring every 5 minutes, until the vegetables are softened and the tomato juices begin to darken and caramelize, 20 to 30 minutes.

7) Carefully transfer the tomato mixture to the saucepan. Use a hand masher or immersion (stick) blender to work the sauce to your desired consistency. Finish with the black pepper and season with additional salt if desired.

Serve immediately or cool to room temperature, seal in an airtight container, and freeze for up to 1 year.

TIP

Sure, you can use this sauce on pasta and pizza and scrambled eggs, but it's also a great base for soups, stews, and even pot roast.

2 The few, the inquisitive, will ask, "How do we really know it's reduced by half?" Because when you first put the pan on the heat, you're going to grab the stainless-steel ruler you keep in the upturned bongo drums where you store all your loose tools and you're going to stick it in the pot and measure how deep the liquid is. Then, during cooking, you'll periodically check until the depth is half what you started with.

1 As opposed to dry-cure capers, which are packed in salt.

TOMATO SOUP ON THE FLY

Reason for Reload: All we made in that original episode was the sauce . . . that's it. You deserved another application, not a bunch of lame science skits, so here's the soup that I've been making ever since we reloaded the sauce. Look at the ingredient list and think about all the rainy Sundays you *didn't* have tomato soup. Feel free to play a little loose with the measurements here, as you wish. This is meant to be as unfussy as it comes.

SOFTWARE

16 ounces (455 g) Canned Tomato Tomato Sauce (turn back to page 375)

6 ounces (175 ml) chicken broth/stock

8 ounces (235 ml) half-and-half

2 teaspoons (40 g) red or brown miso

1 teaspoon (5 ml) sherry vinegar

2 dashes Worcestershire sauce

½ teaspoon (1.5 g) garlic powder

⅛ to ¼ teaspoon white pepper

TACTICAL HARDWARE

• A decent blender

PROCEDURE

1) Combine the tomato sauce and 5 ounces of the stock in your blender and blend until smooth, 1 to 1½ minutes.[3]

2) Transfer to a medium saucepan and whisk in the half-and-half, miso, vinegar, Worcestershire sauce, garlic powder, and white pepper. Bring to a simmer over medium heat, whisking often.

3) When small bubbles break around the edges, reduce the heat to the lowest setting, cover, and let barely simmer for 10 minutes.

4) Adjust the consistency with the remaining 1 ounce stock if desired.

NOTE

Miso (fermented soy bean paste, often with other grains like barley) is one of those things that just wasn't widely available back in 2000. Luckily, not only is it widely available now, it keeps for a long time in the refrigerator, so use it whenever you need some umami to pull the room together.

3 Extra points if you toss in a couple of anchovies at this point.

USE YOUR NOODLE IV: RELOADED

CLASSIC AMERICAN LASAGNA

Reason for Reload: My original Slow Cooker Lasagna is, I believe, the most hated *Good Eats* recipe of all time, with our original pot roast a close second. For those who wisely chose to avoid it, the noodles ran up the side of the slow cooker and, well . . . dried goat milk was involved. I'm just going to leave it at that. What you all wanted then, and want now, is a lasagna that Garfield would have given eight of his lives for. You want the classic, only better.

Fine, this is the most *lasagna* lasagna that I know of. And yes, I've been to Hoboken.

Note: This dish is quite a project, what with making the ricotta and the ragu and all, but it is beyond worth it. Trust me.

Lasagna, frozen for six months, thawed overnight in the refrigerator, covered with foil, baked for 45 minutes at 350°, uncovered for 15 minutes. Better than the day it was made.

RICOTTA CHEESE

YIELD: 2 cups

SOFTWARE

8 cups (1.9 L) whole milk

1 teaspoon kosher salt

6 tablespoons (3 fluid ounces/90 ml) distilled white vinegar

TACTICAL HARDWARE

- A large colander
- A digital instant-read thermometer
- Cheesecloth

PROCEDURE

1) Line the colander with two layers of cheesecloth. Place in a large bowl and stash near the cooktop.

2) Combine the milk and salt in a large pot and place over medium heat. Stir occasionally until the milk hits 190°F.

3) At 190°F, kill the heat and add the vinegar. Give the milk three gentle stirs, then leave undisturbed for 5 minutes. Large curds will form almost immediately.

4) Remove the curds and whey to the prepared colander with a large ladle. Leave the ricotta to drain at room temperature for 2 hours, then transfer to airtight containment and refrigerate for up to 3 days.

RAGÙ ALLA BOLOGNESE

YIELD: About 8 cups

This is the engine room of lasagna. Without it, the lasagna does not exist. It is quite a bit of work, so I suggest you make it ahead and then take a vacation before assembling the final dish.[1]

SOFTWARE

8 ounces (225 g) pancetta, cut into small dice

2 large onions, finely chopped to yield 600 grams (about 4 cups)

3 stalks celery, finely chopped to yield 125 grams (about 1 cup)

1 tablespoon (8 g) kosher salt, divided, plus more to taste

½ teaspoon freshly ground black pepper, plus more to taste

¼ cup (70 g) tomato paste

1 tablespoon (2 g) dried oregano

5 cloves garlic, minced to yield 20 grams

¼ cup (56 g) extra-virgin olive oil

8 ounces (227 g) ground beef chuck

8 ounces (227 g) ground pork

1½ cups (340 g) dry white wine (Sauvignon Blanc will do nicely)

2 (28-ounce) cans whole, peeled tomatoes, pureed in a food processor

3 cups (700 g) unsalted beef broth

1 cup (245 g) whole milk

1 ounce (28 g) dried porcini mushrooms, finely chopped

½ cup (50 g) finely grated Parmesan cheese

1 tablespoon (15 g) sherry vinegar

TACTICAL HARDWARE

- A heavy Dutch oven in the 8-quart range

1 You want better lasagna . . . this is what it's gonna take, so get cooking.

PROCEDURE

1) Place an 11-inch sauté pan over medium-low heat. Add the pancetta and cook slowly, stirring occasionally, until crispy and the fat has rendered, 20 to 25 minutes.

2) Add the onions, celery, 1½ teaspoons of the salt, and the pepper and continue to cook, stirring occasionally, until the vegetables are translucent, 25 to 30 minutes. Stir in the tomato paste, oregano, and garlic and continue to cook, stirring, until aromatic, 1 to 2 minutes.

3) While the vegetables are cooking, place the Dutch oven over medium-high heat. Add the oil and, when it shimmers, add both ground meats and the remaining 1½ teaspoons salt.

Cook, breaking up the meat with a wooden spoon, until the meat browns and a deep-brown fond forms on the bottom of the pot, about 10 minutes. Deglaze with the wine, bring to a simmer, and cook, scraping any browned bits from the bottom of the pot, until the liquid has evaporated, 8 to 10 minutes.

4) Add the onion mixture to the meat, along with the tomatoes, broth, milk, and mushrooms. Return to a simmer, then reduce the heat to low and continue cook, stirring every 30 minutes until the sauce is very thick and the fat has reincorporated, 2 to 2½ hours.

5) Remove from the heat and stir in the cheese and vinegar. Season to taste with salt and pepper. Use immediately for lasagna or store in an airtight container in the refrigerator for up to 1 week (or a freezer for up to 3 months).[2]

APPLICATION

THE FINAL LASAGNA[3]

YIELD:

One 9 × 13-inch pan (6 to 8 servings)

SOFTWARE

1 pound (454 g) dry lasagna noodles

1 pound (454 g) fresh mozzarella cheese, sliced ¼ inch thick

2 cups (335 g) Ricotta Cheese (homemade, opposite)

¼ cup heavy cream

½ teaspoon kosher salt

½ teaspoon freshly ground black pepper

1 cup (100 g) freshly grated Parmesan cheese

8 cups Ragù alla Bolognese (opposite)

TACTICAL HARDWARE

- A 9 × 13-inch baking dish
- A 4-ounce ladle

PROCEDURE

1) Heat the oven to 400°F with an oven rack in the middle position.

2) Place the noodles in a 9 × 13-inch baking dish and pour enough hot water over to cover them. Set aside until pliable, 20 to 30 minutes. Drain and separate the noodles and set aside. Dry the baking dish.

3) Place the mozzarella between double-thick layers of paper towels and leave to wick for 20 minutes. Then tear into bite-size pieces and set aside.

4) Stir the ricotta, cream, salt, and pepper together in a medium bowl.

5) Use a large (4-ounce) ladle to dose out and spread ½ cup of the Bolognese sauce in the bottom of the baking dish. Top with a layer of noodles, then spread ⅓ cup of the ricotta mixture over the noodles. Dot with ½ cup of the mozzarella and sprinkle with 2½ tablespoons of the Parmesan.

6) For the next layer, start with about 1 cup sauce, spread with the bottom of the ladle, followed by noodles, ricotta, mozzarella, and Parmesan. When the final layer of noodles goes on, top generously with sauce, then the remaining mozzarella and Parmesan.

7) Lightly spray a 15 × 20-inch piece of aluminum foil with nonstick cooking spray. Tightly cover the lasagna with the foil, lube-side down, then place the baking sheet on a half sheet pan. Transfer to the oven and bake until the sauce is bubbling and the center of the lasagna is about 150°F, 30 to 45 minutes. Remove the foil and continue to bake until the top is deeply browned and crisp, 20 to 30 minutes more.

8) Remove the lasagna and cool on a rack 20 minutes before serving.

2 I'd say peak flavor is achieved after about 3 days in the fridge.

3 Seriously, this is it. Don't even mention another to me.

STOVETOP MAC-N-CHEESE-N-SPINACH

YIELD:

4 side-dish servings, 2 main-dish servings, or 1 serving for me

Reason for Reload: This is one of the five most beloved *Good Eats* recipes of all time. But it could be better. I started stirring spinach into it to get my daughter to eat more vegetables, back in the day. Then I added the feta and the Aleppo pepper, and then I never went back. Also, this application reflects my current thoughts on cooking dry pasta, which is starting it in a small amount of cold water.

SOFTWARE

8 ounces (230 g) dry elbow macaroni

2 teaspoons (6 g) kosher salt

6 ounces (179 g) canned evaporated milk

2 large eggs

1 tablespoon (15 g) brown mustard (Gulden's)

1½ teaspoons (3 g) Aleppo pepper[4]

10 ounces fresh spinach, stemmed, washed, and spun dry (or patted dry with paper towels). If you just want to toss in one of those bags of "triple" washed baby spinach, go for it.

2 tablespoons (28 g) unsalted butter

6 ounces (170 g) sharp cheddar cheese, grated

3 ounces (85 g) feta cheese, crumbled

PROCEDURE

1) Put the pasta in a small saucepan and just cover with cold water. Stir in the salt, then bring to a gentle boil over medium-high heat, stirring the pasta every few minutes.

2) Meanwhile, whisk the evaporated milk, eggs, mustard, and Aleppo pepper together in a small bowl or measuring cup.

3) When the pasta is almost done (5 to 8 minutes) but the water is still visible, add the spinach, reduce the heat to medium-low, and cook, stirring often, until the spinach is wilted. Add the butter and stir to melt.

4) Remove from the heat and stir in the milk-egg mixture. Return to low heat and stir constantly until the mixture is creamy, about 3 minutes. (Heat management is important here, as the eggs will curdle if heated too quickly.)

5) Remove from the heat, stir in both cheeses, cover, and let rest for 5 minutes before serving.

4 This ground chile, named after the city in Syria, has gotten increasingly hard to find as the civil war continues. So, if Aleppo pepper isn't available, use Urfa biber from right over the border in Turkey.

BEAN STALKER: RELOADED

THE FINAL GREEN BEAN CASSEROLE

YIELD:

8 side-dish servings

Reason for Reload: If I'm counting correctly, this is v4.0 of our Green Bean Casserole, which is just further proof that you should never call the first of anything "Best-Ever." Truth is, lots of people have had troubles with the application, especially the onion topping. The original is also a lot drier than any good casserole should be. The seasoning is boosted here with double the nutmeg, black pepper, and a healthy dose of sherry vinegar. So, this is my final green-bean casserole, but I know better than to call it "best." Oh, the real upgrade to the fried-onion topping is rice flour rather than all-purpose.

SOFTWARE

20 grams (2 tablespoons plus 2 teaspoons) kosher salt, divided, plus more to taste

454 grams (1 pound) green beans, trimmed and halved

Neutral oil, for frying

2 large onions, peeled and thinly sliced on a mandoline to yield about 600 grams

40 grams (¼ cup) rice flour

70 grams (5 tablespoons) unsalted butter

340 grams (12 ounces) button mushrooms, quartered

1 teaspoon (2 g) freshly ground black pepper

4 cloves garlic, minced (10 g)

1 teaspoon freshly grated nutmeg

45 grams (⅓ cup) all-purpose flour

1 tablespoon (15 ml) sherry vinegar

2 cups (473 ml) unsalted chicken broth

2 cups (473 ml) half-and-half

TACTICAL HARDWARE

- A Dutch oven
- A salad spinner
- A digital instant-read thermometer
- A mandoline or other slicing device featuring an adjustable slide and a fixed blade[1]
- A 12-inch cast-iron skillet
- A sieve or sifter

1 No one knows why the name for this class of devices (which are both useful and treacherous) is so similar to the stringed, lute-like musical instrument. Lies abound, but I would point out that there is an Italian device called a *chitarra*, which uses guitar-like strings to cut fresh pasta. So there is a precedent for stringed cutters to be named after instruments. But the mandoline has a blade, so what gives? We may never know. In any case, I have to tell you to use a hand guard, or else.

PROCEDURE

1) Heat the oven to 350°F and position a rack in the middle.

2) Bring 3 quarts water and 2 tablespoons of the salt to a boil in a large, heavy pot, such as a Dutch oven. Add the beans to the boiling water, return to a boil, and cook until just tender, about 8 minutes. Meanwhile, remove the basket from the salad spinner and add enough ice and water to the main bowl to come halfway up the side.

3) Drain the beans in the spinner's basket, then immediately transfer to the ice bath and cool for 5 minutes. Then remove the basket insert and pour out the ice water. Spin the beans dry. Dry the pot or Dutch oven.

4) Pour ¾ inch of oil into the now-dry pot and bring to 375°F over

THE FINAL GREEN BEAN CASSEROLE *(continued)*

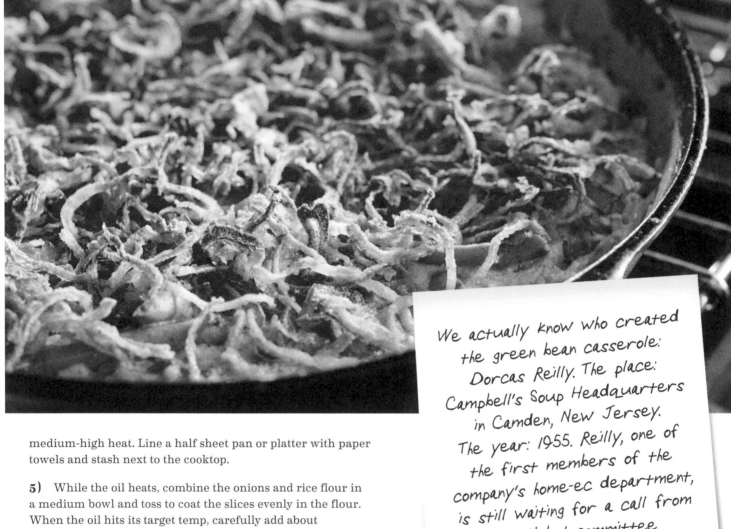

> We actually know who created the green bean casserole: Dorcas Reilly. The place: Campbell's Soup Headquarters in Camden, New Jersey. The year: 1955. Reilly, one of the first members of the company's home-ec department, is still waiting for a call from the Nobel committee.

medium-high heat. Line a half sheet pan or platter with paper towels and stash next to the cooktop.

5) While the oil heats, combine the onions and rice flour in a medium bowl and toss to coat the slices evenly in the flour. When the oil hits its target temp, carefully add about one-quarter of the onion slices to the oil and fry, stirring occasionally, until golden brown, about 5 minutes. Use a spider to transfer them to the prepared sheet pan and season lightly with salt. Repeat with the remaining onions, then set aside. (The onions can be made up to 1 week ahead and stored in airtight containment at room temperature.)

6) Melt the butter in the cast-iron skillet over medium heat. When the butter is foamy, add the mushrooms, the 2 teaspoons salt, and the pepper. Cook, stirring frequently, until the mushrooms give off almost all their liquid and have browned, about 10 minutes.

7) Add the garlic and nutmeg and cook, stirring constantly, until aromatic, about 30 seconds. Sift the all-purpose flour over the mushrooms and continue cooking, stirring constantly, for 1 minute.

8) Stir in the vinegar and cook until it has mostly evaporated, about 1 minute, then follow with the broth, slowly stirring and scraping up any browned bits from the bottom of the skillet. Bring to a simmer, then stir in the half-and-half. Return the liquid to a simmer, then reduce the heat to low and continue simmering, stirring frequently, until the mixture thickens, about 12 minutes. Remove from the heat.

9) Stir in the green beans and half of the fried onions, then top with the remaining onions. Transfer to the oven and bake until the sauce is bubbly around the edges and the onions are deeply browned, about 10 minutes.

ROLL CALL: RELOADED

APPLICATION

BROWN & SERVE DINNER ROLLS

YIELD:

14 rolls

Reason for Reload: This isn't an actual reload, it's just the rolls we should have made. I love classic Parker House rolls as much as the next cook, but brown & serves from scratch are far more valuable when the holidays come around. Although the software is nearly identical, the procedure has some significant changes from the Parker House originals.

SOFTWARE

425 grams (3 cups plus 1½ teaspoons) all-purpose flour

237 milliliters (1 cup) whole milk, warmed to about 100°F by microwaving for 60 seconds

65 grams (⅓ cup) sugar

2 large egg yolks

14 grams (1½ tablespoons) active dry yeast

6 grams (2 teaspoons) kosher salt

113 grams (8 tablespoons) unsalted butter, at room temperature, divided

TACTICAL HARDWARE

- A stand mixer with paddle attachment and dough hook
- A 9 × 13-inch metal baking pan
- A bench knife

PROCEDURE

1) Combine the flour, milk, sugar, egg yolks, yeast, and salt in the bowl of a stand mixer. Install the paddle attachment and mix on low speed until the mixture forms a rough dough, about 5 minutes. Rest the dough for 15 minutes. Switch out the paddle for the dough hook.

2) Add 57 grams (4 tablespoons) of the softened butter and knead on low speed until incorporated, about 30 seconds. Slowly increase the speed to medium and knead until the dough pulls away from the sides of the bowl, 5 to 8 minutes.

3) Turn the dough out onto a work surface and roll with your hands into a smooth ball. Return the dough to the bowl, cover with plastic wrap, and stash in a warm spot to rise until doubled in size, about 1 hour.

4) Meanwhile, heat the oven to 275°F and position a rack in the middle position. Lube a 9 × 13-inch baking pan with nonstick spray.

5) Remove the dough from the bowl and use a bench knife to portion into 14 (57-gram/2-ounce) portions. Roll each portion of dough on the counter until it tightens into a small round. Place in the greased pan, cover with plastic wrap, and set aside in a warm, draft-free place to rise until doubled in size, 30 to 45 minutes.

6) Melt the remaining 57 grams (4 tablespoons) butter and *gently* brush it on the tops of the risen rolls. Bake until the rolls are set and reach an internal temperature of 185°F to 190°F, about 25 minutes. They should still be fairly pale on top.

BROWN & SERVE DINNER ROLLS (*continued*)

7) Cool the rolls, still in the pan, on a wire rack for 10 minutes, then de-pan the rolls, keeping them right-side up, and cool to room temperature, 30 to 45 minutes. Wrap the rolls tightly in plastic wrap, then seal in a gallon-size freezer zip-top bag. Freeze up to 3 months.

8) When ready to bake, remove the rolls from the bag and park at room temperature for 1 hour. Heat the oven to 400°F.

9) Move the rolls to a parchment-lined sheet pan or cookie sheet and bake, rotating the pan halfway through baking, until the rolls are deeply browned, 10 to 12 minutes. Wrap loosely in a clean tea towel and serve.

Legend has it a baker and volunteer fireman from Florida, Joe Gregor, accidentally invented "half-baked" rolls in 1949, when he had to respond to a local fire and pulled rolls out of the oven only half baked.

SEND IN THE CLAMS: RELOADED

CLAM CHOWDER: RELOADED

YIELD:

7 cups (6 to 8 servings)

Reason for Reload: No one thought the original was anywhere near clammy enough, though they also didn't like the idea of dealing with littlenecks in their shells. So we switched from canned to frozen clams (much higher quality), added clam juice as well as kombu for umami, and switched the milk to half-and-half. And now there's a fried clam topping, so . . . fried clams.

SOFTWARE

1 (16-ounce) container (463 g) frozen clams and their juices, thawed, divided

169 g (6 ounces) salt pork, tough skin removed, finely diced

192 g (1½ cups) finely diced white onions

1 small stalk (65 g) celery, finely diced, plus ¼ cup (7 g) celery leaves, chopped, for garnish

30 g (3 tablespoons) all-purpose flour

300 g red potatoes cut into ½-inch dice (2 cups)

6 g (1½ teaspoons) kosher salt, divided, plus more for serving

1 teaspoon freshly ground black pepper, plus more for serving

235 g (2 cups) clam juice (I use Snow's Bumble Bee)

1 (8 × 3-inch) piece kombu (10 g)[1]

3 bay leaves

485 g (2 cups) half-and-half

450 g (2 cups) neutral oil, like safflower or peanut, for frying

35 g (3 tablespoons) cornmeal

30 g (3 tablespoons) cornstarch

TACTICAL HARDWARE

- A wide strainer
- Cheesecloth
- A heavy pot for frying
- A deep-fry thermometer

[1] This wide, flat form of kelp looks like something you'd make a wallet out of at camp. It's also the base of many Asian-style broths and soups, including the ubiquitous dashi of Japan. It keeps forever in the pantry. The kelp itself is never left in the broth, because it is actually as tough as a wallet you made at camp.

PROCEDURE

1) Put clams and their juice in a mesh strainer or sieve lined with a few layers of cheesecloth, or a large coffee filter over a medium bowl. Meanwhile, fill a large bowl with cold water. When the liquid has drained from the clams, remove and discard the cheesecloth or filter but leave the clams in the strainer. Reserve the strained juice.

2) Position the strainer in the bowl of water so that the clams are completely submerged. Leave them for a few minutes, gently stirring the clams occasionally with your fingers so that any grit can fall to the bottom of the bowl. Lift the strainer and clams out and discard the gritty water.[2] Place the clams on a cutting board, pat dry with a paper towel, and gently run a knife

[2] I've tried simply rinsing them under running water, but there always seems to be grit left behind.

CLAM CHOWDER: RELOADED (*continued*)

through to break up any large pieces. Set aside while you make the chowder. (Also, take a moment to thoroughly rinse the strainer and set it aside to dry; you'll need it in a bit.)

3) Render the salt pork in a large, heavy-bottom pot over medium-low heat, until just crisp and golden brown, 5 to 7 minutes. Add the onions and diced celery and cook in the pork and fat until tender but not browned, 4 to 5 minutes. Sprinkle in the flour and stir with a wooden spoon to incorporate and cook out the raw flour taste, about 1 minute.

4) Add the potatoes, 1 teaspoon of the salt, the pepper, bottled clam juice and reserved clam juice, the kombu, and bay leaves. Stir until fully combined and no lumps of flour remain. Bring to a boil, then reduce the heat to low, cover, and simmer, stirring occasionally, until the potatoes are soft, 15 to 20 minutes.

5) Remove and discard the kombu and bay leaves. Add the half-and-half and 1 cup of the clams and leave over low heat to gently warm while you fry the clam topping.

Note: At this point the chowder is technically done and no one would blame you for just walking away. But the fried clam bits really do pull the dish together.

6) Heat the oil (1 inch deep) in a medium saucepan over medium-high heat and attach a deep-fry thermometer. Bring to 375°F, then reduce the heat to medium-low. Have a plate lined with paper towels and a slotted spoon or spider standing by.

7) Combine the cornmeal, cornstarch, ½ teaspoon salt, and a pinch of pepper in a medium bowl. Add the remaining clams and toss to coat. Place clams in the strainer and shake off the excess cornmeal mixture. Working in batches, carefully place half of the clams into the hot oil and cook for 30 to 60 seconds. Carefully remove with the slotted spoon and place on the paper towel–lined plate. Repeat with the remaining clams. When they're all out of the oil, season with extra salt and pepper if desired.

To serve, ladle soup into a bowl and top with the fried clams and the celery leaves.

NOTE

This chowder freezes well. Simply split up the leftovers between pint-size deli containers (or other airtight containment), refrigerate overnight, then freeze for up to 3 months. Thaw in the refrigerator for 2 to 3 days, then bring to a bare boil and hold for about 3 minutes before serving.

CELEBRITY ROAST: RELOADED

DRY-AGED STANDING RIB ROAST AND YORKSHIRE PUDDING

YIELD:

Servings for
6 people or
2 Vikings

Reason for Reload: I have a love/hate relationship with this show, as it's the only episode of *Good Eats* that was originally rejected by Food Network.[1] The concept was that I was going over to my brother's house for holiday roast. Now, anyone familiar with B.A. knows that he's me only silent and often in jail. His apartment was very much like the hotel room Elwood took Jake home to after Jake shook out of Joliet. The set was small and unattractive and funny as hell, and the oven was in such bad shape that I had to hack a way to actually roast in it that involved a terra-cotta pot. The network, citing the overall unattractiveness of the scenes, rejected the episode, which we had to reshoot on our own $. Lesson learned.

As for the food, although Elizabeth and I have moved more and more toward a plant-based diet, Christmas *is* standing rib roast for us, and I make Yorkshire pudding for no other reason than to use it to taco medium-rare beef slabs. I'm a monster and an animal and if you ate like me, you'd have a lot more fun.

This is the latest incarnation of our Christmas Day procedure. Next year it'll probably be different, but for now, this'll do.

SOFTWARE

1 (4-bone) standing rib roast, preferably cut from the loin end, with the fat cap in place (7 to 10 pounds/3.2 to 4.5 kg)

2 tablespoons neutral oil to coat the roast, plus more for the pudding, if needed

Kosher salt, 2 teaspoons per bone, plus 1½ teaspoons for the pudding

1 tablespoon freshly ground black pepper

2 cups (280 g) all-purpose flour

2 cups (473 ml) whole milk, at room temperature

4 large eggs, at room temperature

TACTICAL HARDWARE

- Cheesecloth
- A food processor or blender
- A 12-inch cast-iron skillet
- A long slicer or narrow chef's knife

PROCEDURE

1) Place the standing rib roast upright on a rack set inside a half sheet pan. Wrap in a double thickness of cheesecloth and park in the refrigerator for 5 days.[2]

2) When you're ready to cook, remove the roast from the refrigera-

[1] I also had an episode of *Feasting on Asphalt* rejected, and for the exact same reason. That's a story for another time and there will need to be a cocktail involved . . . your treat.

[2] This is not classical dry aging, which is about taking advantage of enzymatic changes in the meat and requires a lot longer than 5 days, as well as highly controlled temp and humidity. This is simply about allowing some moisture to depart the scene, thus intensifying the flavor of the meat while creating a better final crust. The cheesecloth holds some moisture against the exterior so that it doesn't turn to bark. (To skip the dry aging, see the tip on page 389.)

DRY-AGED STANDING RIB ROAST AND YORKSHIRE PUDDING *(continued)*

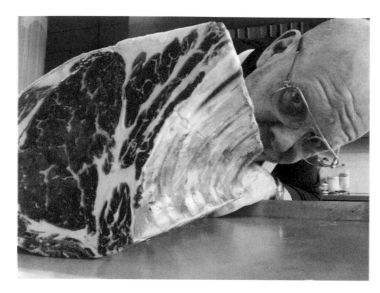

tor, unwrap and discard the cheesecloth, dim the lights, put on some spa music, then massage the roast with the oil. (You can leave it on its rack/half sheet pan.) Once the roast is rubbed down and totally relaxed, cover with salt, using about 2 teaspoons per bone, then the pepper. Leave uncovered at room temperature for 1 hour.[3]

3) Place a probe thermometer into the roast through the top cap area, aiming to get the tip of the probe as close into the center of the roast as possible. Set the alarm for 118°F and position the roast on the lower middle rack in a cold oven. Crank the heat to 250°F and roast until the meat hits its target temperature, about 3 hours for a 3-bone roast or up to about 4 hours for a 4-bone roast. (Temp is more important than the time here, as times will vary depending on the exact weight and shape of the roast.)

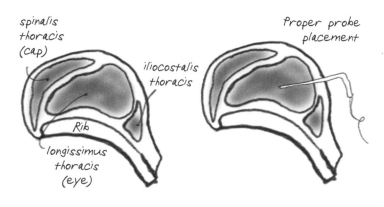

spinalis
thoracis
(cap)

iliocostalis
thoracis

Rib

longissimus
thoracis
(eye)

Proper probe
placement

4) When the thermometer alarm goes off, remove the roast from the oven, cover with foil, and let rest while preparing the pudding.[4]

5) Place your skillet on the lower middle rack in the oven and increase the oven temperature to 400°F. Once the roast has rested for about 10 minutes, set the roast on a cutting board and drain any drippings from the sheet pan into a heatproof liquid measuring cup. Return the foil-covered roast to the pan.

6) Measure out 2 tablespoons of the roast drippings and add to a food processor or blender, along with the flour, milk, eggs, and 1½ teaspoons salt.[5] Process until smooth, about 30 seconds.

7) Carefully slide out the rack holding the hot skillet. Add an additional 2 tablespoons drippings (or oil) to the skillet and swirl to coat the bottom of the pan. Pour the batter into the skillet, then return to the oven and bake until the pudding is puffed and golden brown, about 30 minutes.

8) Once the pudding has finished, remove it to a rack or trivet and cover loosely with foil. Crank the oven as high as it will go and return the roast to cook until the exterior is deeply browned, about 10 minutes.

To serve, simply carve the roast (see tip below) and serve with the pudding. No need to rest the meat, as the interior will have rested before returning to the oven.

4 The roast's internal temperature will rise to around 130°F, then very slowly start to fall.

5 I can't imagine a culinary reality in which you don't have at least 2 tablespoons of drippings, but if you don't, make up the difference with a neutral oil, or better yet, melted beef tallow or bacon fat.

3 No, bacteria will not drag it off to their cave during this time. Nothing will really want to grow on all that salt and, after all . . . we're going to cook that sucker.

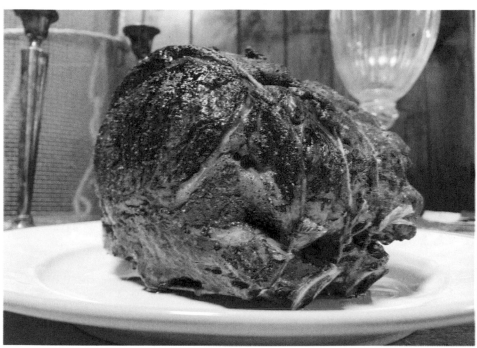
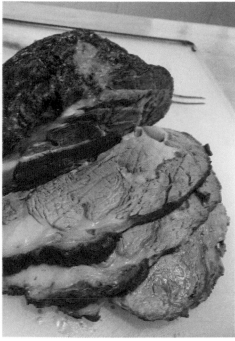

TIPS

>> If you would rather not dry the roast (or you forgot to plan days ahead—happens to all of us), season the meat with kosher salt, using 2 teaspoons per bone, and place on the same wire rack and sheet pan setup described above. Let sit, uncovered, in the refrigerator for at least 12 hours, or up to 24 hours, before proceeding with the recipe. You don't need to add more salt before roasting, but you will still want to rub the roast with oil and pepper.

>> When carving, I start by removing the rib slab so that I can easily slice the main roast. The ribs I then separate, sprinkle with smoked salt, and brown in the toaster oven set to its highest "toast" setting. I then selfishly barehand the ribs in the pantry while no one is looking. (The bones I later smuggle out like they did the excavated dirt in *The Great Escape*.)

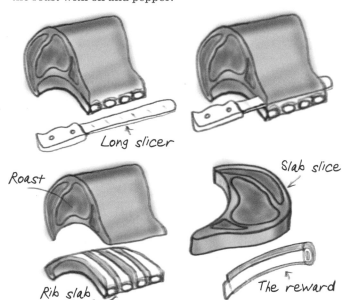
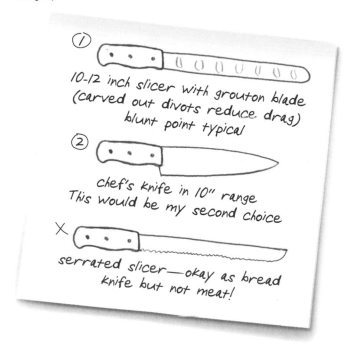

THIS SPUD'S FOR YOU, TOO: RELOADED

APPLICATION

COLD-FASHIONED POTATO SALAD: RELOADED

YIELD:

4 to 6 servings

Reason for Reload: For one thing, the original recipe makes no sense, unless you really think diced potatoes should be cooked and then have their tiny skin patches rubbed off. The real problem, though, is flavor; the whole overnight marinade isn't really that effective. So here we put some of that vinegar to a better use: pickling the celery, which gives the finished dish an acidic kick. Also, the garlic and onion have been replaced by shallot, which is softer overall. The real change-up, though, comes from using both Yukon Gold potatoes, which hold their shape, and russets, which don't. This way the mealier russets work with the mayonnaise to hold the salad together, in both flavor and texture.

SOFTWARE

1 cup (130 g) diced celery

½ cup (118 g) water

8 tablespoons (118 g) apple cider vinegar, divided

1 tablespoon (13 g) sugar

¼ cup (40 g) kosher salt, divided

1¼ pounds (567 g) russet potatoes, peeled and cut into ¾-inch dice

1¼ pounds (567 g) Yukon Gold potatoes, peeled and cut into ¾-inch dice

¾ cup (160 g) mayonnaise

½ cup (65 g) diced shallots

1 tablespoon (18 g) Dijon mustard

2 tablespoons (15 g) chopped fresh parsley

2 tablespoons (15 g) chopped fresh celery leaves

1 tablespoon (4 g) chopped fresh tarragon

PROCEDURE

1) Put the celery in a medium bowl. Combine the water with 6 tablespoons of the vinegar, the sugar, and 1 teaspoon of the salt in a small saucepan and bring to a boil over medium-high heat. Pour the hot mixture over the celery and leave at room temperature until ready to use in the salad.

2) Put the potatoes in an 8-quart pot. Cover with cold water to 1 inch above the potatoes, and add 3 tablespoons of the salt. Cover the pot, place over high heat, and bring to a boil. Remove the lid, reduce the heat to medium, and simmer until the potatoes are fork-tender, about 7 minutes. Drain thoroughly.

3) Meanwhile, combine the mayonnaise, shallots, mustard, and the remaining 2 tablespoons vinegar and 2 teaspoons salt in a large bowl. Stir in the hot potatoes and cool on the counter for 1 hour. Transfer to the refrigerator and chill until the potato salad is at room temperature, about 1 hour.

4) Drain the celery, then stir it into the potatoes along with the parsley, celery leaves, and tarragon. Cover and chill for at least 1 hour before serving.

This is me any day during picnic season, totally packed with potato salad.

Despite its French moniker,
vichyssoise is all-American,
created at the Ritz
in New York City in 1917
by Chef Louis Diat.
And yes, he was French.
The name comes from Vichy,
the famed French spa
and resort town.

PRESSURE COOKER VICHYSSOISE

YIELD:

12 appetizer servings, or 6 main-course servings

Reason for Reload: Not so much a reload as a complete replacement. The soup we made in the original episode calls for four large leftover baked potatoes. Who ever had four leftover baked potatoes? Maybe people who cancel a dinner party at the last minute, but other than that . . . nobody. So, let's be honest and just start from scratch and use a pressure cooker. And since it happens to be summer as I'm typing this, let's make it cold.

SOFTWARE

2 tablespoons (28 g) unsalted butter

4 medium leeks (or 3 large), white and light-green parts only, cut in half lengthwise and then into thin half-moons, well washed (235 g)

¼ cup (9 g) fresh celery leaves, picked but not chopped

1½ teaspoons (6 g) kosher salt, plus more to taste

1½ pounds (680 g) potatoes (a mixture of russets and whites or all russets)

2 cups (473 g) chicken broth, home-made if possible

3 cups (710 ml) heavy cream

½ teaspoon finely ground white pepper

Salmon roe and chopped fresh chives, for garnish (optional)

TACTICAL HARDWARE

- A pressure cooker in the 4- to 6-quart range (see pages 84–85)
- A blender

PROCEDURE

1) Melt the butter in a 4- to 6-quart pressure cooker over medium-low heat. Add the leeks, celery leaves, and 1 teaspoon of the salt and cook, stirring often, until soft, about 8 minutes. Manage the heat to prevent any browning.

2) Meanwhile, peel and dice the potatoes and add them to the pot, along with the broth. Bring to a simmer over medium-high heat, stirring often, then clamp on the cooker's lid (according to the manu-facturer's instructions) and bring to full pressure over high heat.

3) Once pressure is attained (most modern models will whistle loudly to let you know), back the heat down to medium-low to just maintain pressure (you'll hear the hissing of steam but no whistling) and cook for 8 minutes.

4) Kill the heat and release the pressure by opening the dump valve or by setting the cooker under cold running water until the pressure lock releases. When the lid can be removed, carefully transfer the mixture to a blender carafe. (If the mixture fills your carafe more than two-thirds full, work in two batches!)

5) Top the carafe with the main lid, but remove the center lid so that air can escape as it heats and expands.[1] Cover the lid tightly with a tea towel and blend on low for 1 minute before slowly increasing the speed to smoothly puree the soup.

6) Transfer the mixture back to the pot and whisk in the cream and white pepper. Taste and adjust the season-ing. (I always need the rest of the salt.) Chill thoroughly, by placing the pot in a sink of ice water and stirring frequently for about half an hour. Then refrigerate for at least a few hours before serving.

Serve in chilled bowls or cups topped with a small spoonful of roe and some chives if desired. Tightly covered, the vichyssoise will keep for up to 1 week in the refrigerator. The soup can also be frozen in ice cube trays, transferred to freezer bags, and kept in the freezer for up to 3 months.

1 Removing the center portion of the blender lid will allow for the expansion of air, which is going to rapidly take on heat from the soup. The towel will make sure steam is the only thing that comes out. For safety's sake, don't put your hand right over the opening.

POTATO, MY SWEET: RELOADED

CHIPOTLE SMASHED SWEET POTATOES: RELOADED

YIELD:

4 to 6 servings

Reason for Reload: The original application, with only five ingredients, was really a one-note dish, and that one note was sharp and spiky due to a chipotle/adobo punch with no supporting flavors to round things out. So, we've added maple syrup and one of my favorite heat sources, Urfa biber, the Turkish cousin to Syria's Aleppo pepper. The biggest upgrade, though, comes from moving the cooking from a steamer to the oven, where dry heat can create stronger flavors.

SOFTWARE

2 large (685 g) sweet potatoes, peeled and cubed

2 tablespoons (28 g) peanut or safflower oil

2 tablespoons (36 g) dark maple syrup

½ teaspoon (2 g) kosher salt

1 teaspoon (2 g) Urfa biber

3 tablespoons (42 g) unsalted butter

1 chipotle chile in adobo sauce (20 g), chopped

1 teaspoon (5 g) adobo sauce from the can

PROCEDURE

1) Heat the oven to 400°F.

2) Toss the sweet potatoes with the oil, maple syrup, salt, and Urfa biber in a large bowl. Scatter the sweet potatoes evenly on a half sheet pan.

3) Roast for 20 minutes. Stir, then roast for 10 more minutes until caramelized and smashably soft.

4) Transfer back to the large bowl, add the butter, and mash with a potato masher, or run through a food mill with a fine sieve. Add the chile and adobo and continue mashing to combine.

Serve immediately.

YOU SAY POTATO . . .

Despite similarities in shape, sweet potatoes are not yams . . . they're not even closely related. Yams are related to lilies, and 95 percent of them are grown in Africa, where some varieties can grow in excess of thirty pounds. Sweet potatoes are related to morning glories, and they hale from Peru and Central America. The nomenclatural conundrum arose in part because enslaved peoples from Africa referred to sweet potatoes as "yams," because of their similar appearance; when growers needed to differentiate between hard varieties and newer softer varieties of sweet potatoes they decided to market the latter as "yams." Today, the U.S. Department of Agriculture requires that if the word "yam" is used for marketing, "sweet potato" must be used on the label as well.

SWEET POTATO PIE: RELOADED

YIELD:
8 servings, or just 1 if it's late at night and I have a spoon

Reason for Reload: "This had a funky tangy taste. Sweet potato pie should taste better than this. This was the least popular dessert at our potluck—waahwaah." Thus spoke "swingle1" on the Food Network website. Well, swingle1, you're right on all counts. You'll be happy to know that the yogurt is gone, as is the maple syrup and the pecans. What's more, we've gone with 2 whole eggs in lieu of the original 5 yolks that left you with meringue fodder you didn't ask for. This is a better pie and I can only hope you'll give it a chance at your next potluck.

SOFTWARE

595 grams sweet potatoes (2 to 3 medium/21 ounces)[1]

¾ cup (177 ml) heavy cream

150 grams (¾ cup) dark brown sugar

1 teaspoon ground cinnamon

½ teaspoon freshly grated nutmeg

2 large eggs

¼ teaspoon kosher salt

1 (9-inch) premade pie crust, fully baked and cooled (we use the same crust recipe as for the pie on page 70)

TACTICAL HARDWARE

- A stand mixer with paddle attachment

You can totally sell this as pumpkin pie. No one has ever once called me out.

PROCEDURE

1) Heat the oven to 400°F.

2) Place the sweet potatoes on a quarter sheet pan or baking dish and roast until fork-tender, about 1 hour. Transfer to a plate and cool at room temperature for 30 minutes. Meanwhile, reduce the oven temperature to 350°F.

3) Peel the skin from the potatoes (I use my fingers) and discard. Transfer the sweet potato flesh to a stand mixer fitted with the paddle attachment and beat on medium-high speed until smooth, about 1 minute, then turn off the mixer and scrape down the paddle and sides and bottom of the bowl. Add the cream, brown sugar, cinnamon, nutmeg, eggs, and salt and beat on low speed until well combined, 30 seconds to 1 minute.

4) Place a fine-mesh sieve over a medium bowl and pour the sweet potato mixture through it, pressing on the solids to get as much filling through as possible while leaving the potato fibers behind. This will take some effort, but it's well worth it for a silky-smooth pie.

5) Pour the strained filling into the crust and smooth the top. Bake until the pie just jiggles slightly in the center and has reached an internal temperature of 165°F to 170°F, 40 to

45 minutes. Remove and cool on a wire rack for at least 1 hour before slicing and serving. (I prefer my pie chilled, so I cover and stash in the fridge overnight, but that's just me.)

Keep leftovers covered and refrigerated.

1 My preferred varieties for this application: Jewel, Garnet, or Beauregard.

THE MAN FOOD SHOW[1]: RELOADED

APPLICATION

CORN DOGS V2.0

YIELD:

8 corn dogs and about 18 hushpuppies

Reason for Reload: The original application was good, but some folks had a hard time getting the batter to stick properly, so we traded out the cornstarch dredge for flour, which serves as a better primer. Also gone: the jalapeño and the cream corn. The result is more familiar for those of us who look back on carnivals with gustatory nostalgia; it's a cornbread-coated wiener on a stick.

SOFTWARE

1½ cups (206 g) stone-ground corn-meal (medium grind, if you have a choice)

1¾ cups (244 g) all-purpose flour, divided

1 tablespoon (8 g) kosher salt

1 tablespoon (12 g) baking powder

¾ teaspoon (4 g) baking soda

¾ teaspoon (1.7 g) cayenne pepper (optional but recommended)

2 cups (490 g) low-fat buttermilk

2 to 4 quarts peanut oil, for frying (I often go with one-half peanut, one-half safflower)

8 standard-size all-beef hot dogs, patted very dry

Mustard, for serving

TACTICAL HARDWARE

- A large pot for frying (I prefer an enameled cast-iron Dutch oven). The pot must be wide enough to hold a hot dog plus a 2-inch handle.

- Clip-on-style deep-fry thermometer (or candy thermometer)

- 16 (6-inch) wooden skewers

- Tall, narrow glass like a Collins glass or a pilsner glass

> Depending on who you ask, the corn dog was introduced either at the 1941 Minnesota State Fair (where they're still called Pronto Pups) or at the 1942 Texas State Fair.

PROCEDURE

1) Combine the cornmeal, 1½ cups (208 g) of the flour, the salt, baking powder, baking soda, and cayenne, if using, in a large bowl. Stir in the butter-milk just until the batter comes together; there will be lumps and that's okay. Set the batter aside to rest for 45 minutes.

2) When there are about 15 minutes remaining, pour 2 inches of oil into the Dutch oven and attach your thermometer. Bring the oil to 325°F over medium-high heat, then reduce the heat to medium so that the temp slowly coasts up to 375°F.

3) Line a half sheet pan with paper towels and place a wire rack upside-down on the towels and position next to your frying station.[2] Line a second sheet pan with a wire rack, right side up.

1 Although the title may seem a bit sexist now, I was goofing on a popular Comedy Central show at the time, *The Man Show*, starring Jimmy Kimmel and Adam Carolla.

2 People always look sideways at me for this, but I could swear it's better for wicking fat away from fried food.

4) Carefully push two 6-inch wooden skewers into the bottom of each hot dog, leaving about a 2-inch handle sticking out the bottom. Scatter the remaining ¼ cup (35 g) flour onto a paper plate. Hold the plate bent, like a big taco, and roll each dog in the flour, making sure you cover completely. Tap well to remove any and all excess. Place on the right-side-up rack.

5) When the batter has rested and the oil is at temp, fill a tall, narrow drinking glass about three-quarters full of the batter. Dip a dog into the batter, swirling it around to coat in the batter. Remove from the glass, twisting it again as you remove it. Immediately (and carefully) place in the oil and quickly repeat with 2 more dogs. Fry, flipping with tongs after about 1 minute, until deeply golden brown, 2 to 3 minutes total. Keep an eye on the thermometer and adjust your heat to hold the oil between 350°F and 375°F. Once crispy and brown, transfer with the tongs to the upside-down rack to drain. Continue frying the corn dogs in the same manner, cooling on the rack for at least 3 minutes before serving with mustard to a grateful world.

NOTE

If you have extra batter, turn it into hushpuppies: Leave the heat on once you extract the last of the dogs. Using two spoons, scoop out heaping table-spoons and gently set them down into the oil, cooking no more than 8 hush-puppies at a time. Fry, flipping about every minute, until deeply golden brown, 3 to 4 minutes. Transfer to the rack with the corn dogs. The hushpup-pies are particularly good served with honey butter, which you can make by stirring together 4 tablespoons softened unsalted butter, 1 teaspoon good honey, and a pinch of salt.

BEEF SLIDERS WITH GRIDDLED ONIONS

Reason for Reload: The original procedure tapped the classic mini-burger/slider vibe, but the flavor was off, simply because I didn't go full-on onion. Now we're full-on onion with pickles and American cheese. And the build procedure makes it easy to crank out eight at a time.

SOFTWARE

½ teaspoon garlic powder

½ teaspoon freshly ground black pepper

2¼ teaspoons (6 g) kosher salt

2 small onions, finely chopped to yield 300 g (about 2 cups)

1 pound (454 g) ground beef chuck

2 tablespoons (30 g) yellow mustard

8 (3-inch) hamburger buns or rolls, split

3 tablespoons (45 g) finely chopped dill pickles, ice cold

8 slices American cheese (yes, the ones wrapped in plastic)

TACTICAL HARDWARE

- An electric countertop griddle with nonstick surface
- A pizza wheel–style cutter
- A nylon or plastic pancake spatula (safe for use on a nonstick surface)

PROCEDURE

1) Combine the garlic powder, pepper, and ¼ teaspoon of the salt in a small bowl and set aside.

2) Combine the onions and the remaining 2 teaspoons salt in a bowl and set aside until you can see liquid pooling in the bottom of the bowl, 15 to 20 minutes. Drain in a fine-mesh sieve set over a medium bowl, pressing on the onions to remove additional liquid. You should have between 1 and 2 tablespoons onion liquid. You'll need the onions and the juice.

3) Place the ground beef in the middle of a 12 × 16-inch sheet of parchment. Cover the whole piece of parchment with plastic wrap. Roll out the meat with a rolling pin (the plastic is between the meat and pin) until it forms an even, 2- to 3-millimeter-thick rectangle completely covering the parchment paper.

4) Carefully peel off the plastic wrap and evenly spread the mustard over the meat, then season with the garlic powder mixture. Pick up the edge of the parchment and fold the meat in half, widthwise. Press the meat together to seal the two layers and square off the edges as best you can. At this point, the meat should be about ¼ inch thick. Slide onto a sheet pan or cookie sheet and refrigerate for 10 minutes.

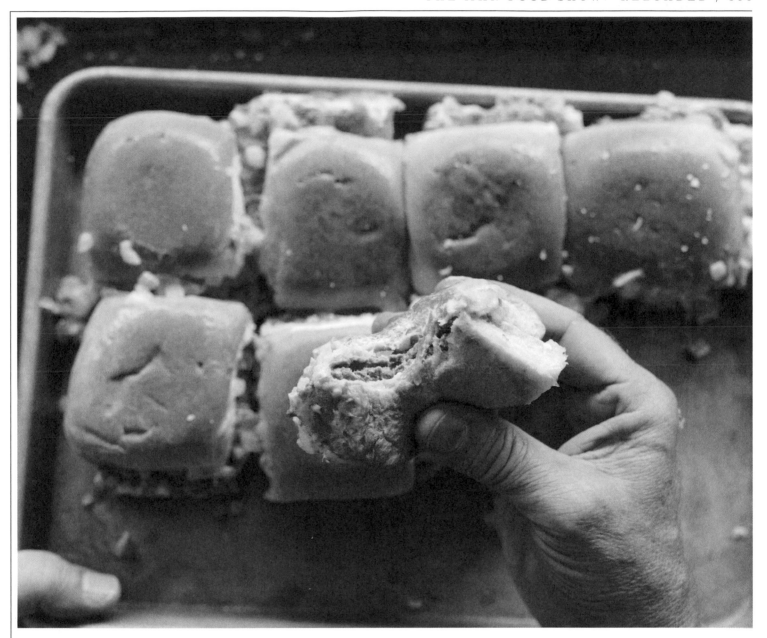

5) When the meat has had time to firm up in the refrigerator, fold back the top layer of parchment and use the pizza cutter to portion the meat into 8 (3 × 4-inch) rectangles. Use a spatula to gently separate the patties.

6) Set your electric griddle to 350°F.

7) Spread the onions out on the griddle in an even, 12 × 8-inch rectangle. Put the patties on top of the onions, resisting the urge to press them with your spatula. Pour over about 1 tablespoon of the reserved onion juice to create steam, then top each patty with a slice of cheese and the bottom half of a bun. Cover the griddle with foil (but do not seal) and let

the burgers steam until cooked through and no longer pink, 3 to 5 minutes.

8) While the burgers steam, add the pickles to each bun top. Using a large spatula, pick up a burger-and-bottom-bun stack and place it on the top half of a bun. Repeat with the remaining burger stacks and bun tops until there's nothing left to build. Flip the burgers right-side up and consume in mass quantities.

NOTE

This is as close to an original White Castle burger as I can get.

THE BIG CHILI:
RELOADED

PRESSURE COOKER CHILI: RELOADED

YIELD:
6½ cups (6 to 8 servings)

Reason for Reload: Flavor, dang it! More flavor! We've upped the chili powder, added cumin, and although we've cut back on the adobo sauce, we've upped the chipotles themselves. What's more important is that we've done away with the store-bought salsa altogether in exchange for twenty-eight ounces of fire-roasted tomatoes, which pretty much didn't exist in 2004. Oh, and there's no pork here, it's 2:1 beef and lamb, a far more earthy mixture to my taste.

SOFTWARE

2 pounds (920 g) beef stew meat

1 pound (455 g) lamb stew meat

2 teaspoons (6 g) kosher salt

2 tablespoons (16 g) good-quality chili powder (not grocery-store stuff)

1 teaspoon (2 g) ground cumin

28 ounces (795 g) canned fire-roasted tomatoes, undrained

2 ounces (57 g) tortilla chips

3 whole canned chipotle chiles, roughly chopped (35 g)

1 teaspoon (5 g) adobo sauce from the can

1 tablespoon (8 g) dried chopped garlic (not powder)

1 tablespoon (6 g) dried onion flakes (not powder)

1 teaspoon (1 g) dried rubbed sage

2 teaspoons (8 g) dried Mexican oregano

1 or 2 dashes liquid smoke (I use Lazy Kettle brand)

1 (12-ounce) bottle lager beer

2 tablespoons (28 g) peanut oil

TACTICAL HARDWARE

- A 6-quart pressure cooker
- A potato masher

PROCEDURE

1) Half an hour before cooking, toss the meat in a large bowl with the salt, chili powder, and cumin.

2) When ready to cook, put the tomatoes, chips, chiles, adobo sauce, garlic and onion flakes, sage, oregano, liquid smoke, and half of the beer in the pressure cooker pot and bring to a simmer over medium heat.

3) Meanwhile, park a 12-inch cast-iron skillet over high heat for 5 minutes. Toss the meat with the oil.

4) When the pan is hot, brown the meat in two batches until deeply browned on all sides, about 7 minutes per batch, transferring each batch to the pressure cooker as it's finished.

5) When all the meat has been seared and moved to the pressure cooker, deglaze the skillet with the remaining beer. Scrape the pan to thoroughly release any solids. Add to the pressure cooker and stir to combine.

6) Lid up and bring the cooker up to pressure over high heat, according to your cooker's manufacturer's instructions, as models can differ quite a bit.[1] When the cooker starts to whistle, back the heat down to low to maintain pressure.[2]

7) Cook for 40 minutes, then kill the heat and allow the pressure to release naturally, about 5 minutes. Carefully open the cooker and mash things up with the potato masher, or simply stir with a big spoon if you like things a little chunkier.

Serve with some fresh parsley or cilantro or a dollop of sour cream.

*"Wish I had time for just one more bowl of chili."
—last words of Kit Carson (famed frontiersman)*

1 Always read the instructions that came with your cooker. (It's the only way to be sure.)

2 For more on pressure cookers, see pages 84–85.

SUB STANDARDS: RELOADED

APPLICATION

GLUTEN-FREE BUTTERMILK BISCUITS

YIELD:

8 biscuits

Reason for Reload: When we made the original episode, I was really trying to concentrate on substituting ingredients that someone might be caught off guard by; it was about convenience. In the case of our biscuits, that ingredient was buttermilk. These days, however, folks are a lot more likely to want to make a substitution based on health choices. Eggs, dairy, and, of course, gluten are the usual targets. So here is our updated biscuit; the buttermilk is back, but the wheat flour is gone. In its place is our gluten-free flour mix, as outlined way back in "The Cookie Clause" on page 90. I'd relist it all here, but dang it, this book is long enough already.

Confession: I actually prefer these biscuits to the gluten-ized versions that I make.

SOFTWARE

315 grams (2 cups plus 6 tablespoons) AB's Gluten-Free Flour Mix (page 92), plus ½ cup for dusting

20 grams (5 teaspoons) baking powder

½ teaspoon (3 g) baking soda

1 teaspoon (4 g) kosher salt

100 grams (7 tablespoons) unsalted butter, sliced into very thin pats and chilled, plus 2 tablespoons to melt for the tops

1¼ cups (305 g) low-fat buttermilk, chilled

PROCEDURE

1) Sift the GF flour, baking powder, baking soda, and salt together in a large mixing bowl. Working quickly (so the fat doesn't melt), rub the butter into the dry mixture, using your fingertips, until it resembles small flakes.[1]

2) Make a well in the center of the flour-butter mixture and pour in the chilled buttermilk. Stir with a wooden spoon until the dough just begins to come together. It will be very sticky. Trade the spoon in for a plastic dough/bowl scraper and use it to turn the dough out onto a floured work surface.

1 If your hands tend to run warm, you may want to chill your fingers down in some ice water before attempting . . . just be sure to dry them well before diving in.

3) Dust the top of the dough (lightly) with flour and, with floured hands (and the scraper), gently fold the dough over itself eight more times, turning one quarter turn after each fold. You may need to continue flouring your hands as you fold. Press dough into a 1-inch-thick round. Cut out biscuits with a floured 2½-inch cutter, being sure to press straight down through the dough without twisting. Flour the cutter between cuts as needed.

4) Center the biscuits on a baking sheet or sheet pan, shoulder to shoulder, so that they just touch. Re-form the leftover dough, working it as little as possible, and continue cutting until you only have enough to make what I call the "dog." Odds are it'll be a longish scrap, so just wind it

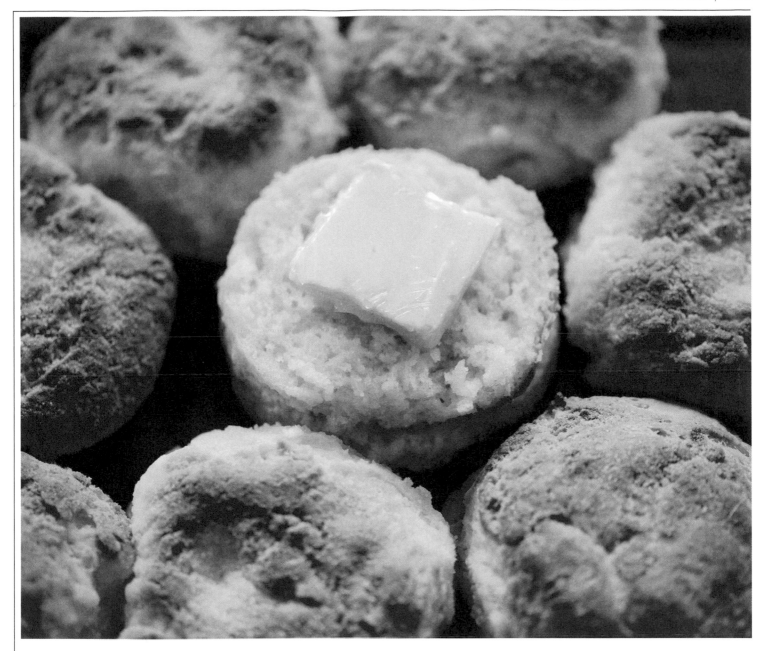

up kind of like a cinnamon roll. Put it on the pan with the others and look at your dog and say, "That's for you."[2]

5) Wrap the pan lightly in plastic wrap and chill in the refrigerator for 30 minutes.[3] Go ahead and heat the oven to 500°F.

6) When the time is almost up, melt the remaining 2 tablespoons butter in a metal measuring cup over direct, low heat. Remove the biscuits from the fridge and brush the tops with the melted butter.

7) Move the biscuits to the oven and immediately drop the heat to 450°F. Bake for 10 minutes, then rotate the pan 180 degrees and bake until tall and lightly gold on top, 8 more minutes. Remove the biscuits to a bowl lined with a clean kitchen towel and fold the towel over to preserve warmth and steam.

Serve fresh and hot to a grateful (and at least momentarily) gluten-free world.

2 This, of course, is a lie. You will eat this biscuit yourself as soon as it's cool enough to touch. Just don't let the dog see this, because they remember everything.

3 More often than not, baked goods assembled with non-gluten flours profit from a hydration period to prevent grittiness in the final product.

GLUTEN-FREE CORNMEAL PANCAKES

YIELD:
8 pancakes

Reason for Reload: Not a reload, but an addition that clearly demonstrates that our gluten-free mix works as well in batter-based quick breads as it does in a dough. This is another case of the remake surpassing the original. I don't miss the gluten a bit, and, frankly, the cornmeal lends these cakes an earthy sweetness my original flapjacks never had. Be sure you dress these in an amber (what we used to call "B-Grade") maple syrup.

Note: This batter is assembled via the muffin method, which calls for all the dry ingredients to be mixed in one bowl, the wet ingredients in another, and then the wet dumped on the dry (so the dry doesn't fly around the room). And yes, in most baking, sugar is considered a "wet" ingredient because it so easily dissolves in liquid.

SOFTWARE

1 cup (140 g) AB's Gluten-Free Flour Mix (page 92)

¼ cup (40 g) stone-ground cornmeal

1 teaspoon (4 g) baking powder

1 teaspoon (3 g) kosher salt

½ teaspoon (2.5 g) baking soda

1 large egg

1 cup (240 g) whole milk

1 tablespoon (15 g) sugar

3 tablespoons (42 g) unsalted butter, melted and cooled slightly

1 tablespoon (15 g) fresh lemon juice

Nonstick cooking spray

TACTICAL HARDWARE

- An electric countertop griddle with nonstick surface
- A large sieve or sifter

PROCEDURE

1) Sift the gluten-free flour, cornmeal, baking powder, salt, and baking soda together into a large bowl and set aside.

2) Whisk the egg, milk, sugar, melted butter, and lemon juice together in a medium bowl until the sugar dissolves.

3) Pour the wet ingredients into the dry and quickly whisk to combine.[4] Cover with a clean kitchen towel and set aside at room temperature for 30 minutes. When 15 minutes are up, crank your griddle to 350°F.

4) When the batter has rested, lightly coat the griddle with nonstick spray. Dose ¼-cup portions[5] of the batter onto the hot skillet and repeat until you have 4 to 6 pancakes on the griddle. Cook until tiny bubbles appear on the edges, 2½ minutes, then flip and cook for another 2½ minutes, or until golden brown. Transfer to a plate and repeat with the remaining batter.

If I have leftover pancakes, I stack them and frost them and serve them a "cake" with fresh corn ice cream. (Sorry, but that's another show.)

4 Stirring creates gluten, and that can be tough stuff, so whisk ten times and just walk away, even if you still see some dry stuff.

5 Since I want ¼ cup to actually get to the griddle, I typically portion with a ⅓ cup measure, because you can never really get everything out unless you hit the measuring cup with nonstick spray every time and I'm just not going to do that.

RAISING THE BAR AGAIN: RELOADED

APPLICATION

YIELD:

HRENOVUHA (HORSERADISH VODKA)[1]

16 ounces
(0.5 liters)

Reason for Reload: My original Bloody Mary application sought to up the ante with a homemade tomato vodka. My thought was that tomatoes are berries and contain alcohol-soluble compounds that I could coax out and employ for flavor's sake. In retrospect, this makes zero sense. Imagine making a screwdriver with orange-flavored vodka; once you pour 4 ounces of orange juice into 2 ounces of orange vodka, none of that subtle shading would remain. It would be like shining a flashlight at the sun. If you're going to the trouble of flavoring vodka, why not invite an ingredient that can actually bring something to the bloody party *and* give you something you'd actually want to do shots of? Why not make a traditional horseradish vodka, aka hrenovuha?

SOFTWARE

½ liter (470 g) vodka[2]

25 grams horseradish, grated on the small holes of a box grater (⅓ cup grated)[3]

1½ teaspoons (10 g) honey

5 grams lemon peel, from about ½ lemon (harvest with a vegetable peeler, avoiding the pith as much as possible)

¼ teaspoon whole caraway seeds

TACTICAL HARDWARE

- A quart-size glass jar
- A funnel large enough to hold a paper coffee filter
- 3 paper coffee filters
- A clean glass bottle that can hold the finished vodka[4]

PROCEDURE

1) Put all ingredients in the quart-size jar. Lid up, shake to combine, and steep at room temperature, out of direct sunlight, for 18 to 24 hours.

2) Triple straining is required. First, strain through a fine-mesh sieve into a large measuring cup. Dump the solids, then line the sieve with a coffee filter and filter the vodka into a second vessel. Then line the funnel with two filters and slowly pour through into the bottle.

3) Stash in the freezer for up to 6 months. (The refrigerator is fine, but I do like a straight shot of this stuff every now and then, and I like my vodka shots numbingly cold.)

1 Although I've seen the term refer to various flavored vodkas, *hrenovuha* typically refers to horseradish-flavored vodkas (typically homemade) in Russia and Ukraine.

2 I usually use Tito's, a grain-based American vodka from Texas of all places.

3 You'll want a good-size doorknob of horseradish to make the grating easy.

4 I like using used beer bottles that have lids attached with a wire bale, like big Grolsch bottles. They make good gifts, too.

The prairie dog is one hundred years old. Its name is Smedley.

HORSERADISH VODKA 1/22

BLOODY MARY MIX

YIELD:

Just over
28 ounces
(1000 g)

Reason for Reload: Our original mix completely depended on the quality (and availability) of ripe tomatoes. Since it seems to me that really good tomatoes are increasingly difficult to find (unless you grow your own), it makes more sense to turn to the pantry. The only non-pantry ingredients required are lemons and limes, which are, as of this writing, plentiful.

SOFTWARE

1 (28-ounce/795 g) can whole, peeled tomatoes (with juice)

12 ounces (340 g) beef stock[5]

3 ounces (90 ml) fresh lemon juice, from about 3 lemons

2 ounces (60 ml) fresh lime juice, from about 2 limes

2 ounces (60 ml) Worcestershire sauce

1 teaspoon (5 ml) hot sauce (Tabasco recommended)

1½ teaspoons (3 g) freshly ground black pepper

1 teaspoon (2 g) celery seeds

1 teaspoon (3 g) garlic powder

1 teaspoon (3 g) kosher salt

TACTICAL HARDWARE

- A large sieve
- A blender
- A quart-size jar or bottle with lid

PROCEDURE

1) Place the tomatoes and juice in a mesh sieve set over a medium bowl. Break up the tomatoes with a wooden spoon to extract as much juice as possible. (You should end up with 2 cups.) Discard the solids or save them for another use.

2) Combine the juice and the remaining ingredients in a blender and blend until smooth, about 30 seconds.

3) Pour the mixture into a clean jar or bottle, lid up, and chill for 4 hours before use.

Keep refrigerated for up to 1 month.

BLOODY MARY 2.0

YIELD:

The first of
several

Reason for Reload: Just putting it all together here.

SOFTWARE

3 ounces AB's Bloody Mary Mix (above)

1 ounce Hrenovuha (page 406)

Ice

1 leafy celery stalk, for garnish

PROCEDURE

Stir the Bloody Mary mix and hrenovuha together with ice in a Collins glass and serve with a leafy celery stalk.

For a more elegant presentation (as for a proper evening cocktail), strain 5 ounces of the above cocktail through a fine sieve to remove pulpy stuff. This should render 4 ounces of thinner liquid. Shake with ice in a cocktail shaker for several seconds to chill, then strain into cocktail glass. Garnish with a cocktail olive.

5 Ideally this would be homemade, but I'm a realist, so . . . just get the best beef broth you can. (But know, if you made beef stock, your Bloody Marys would indeed be superior.)

ORANGE LIQUEUR

Reason for Reload: A lot of folks who tried my original margarita were rightly riffled by the absence of an orange liqueur like triple sec, which is classically included not only to up the alcohol content, but to lend a complexity you can't get from tequila and orange juice, which is basically what I tried to sell as a margarita. Problem is, I don't like triple sec. So the first step toward my reloaded margarita is to make orange liqueur.

SOFTWARE

2 cups (440 g) vodka

½ cup (110 g) brandy

Peel of 5 oranges (85 g), with as little pith as possible

75 grams (¼ cup plus 2 tablespoons) sugar

1 tablespoon (6.7 g) dried bitter orange peel[6]

TACTICAL HARDWARE

- An immersion circulator rig with a bath that can hold at least 5 gallons
- Heavy-duty dishwashing gloves for removal (optional but nice)

PROCEDURE

1) Assemble your immersion circulator, setting the water to 160°F. (Take a look at "Immersion Therapy" on page 124 for more about circulators.)

2) Put all the ingredients in a heavy-duty zip-top freezer bag and seal, removing as much of the air as possible.

3) When the bath hits 160°F, add the bag and let cook for 1 hour.

4) When the cook time is almost up, fill a large bowl with ice and water. Carefully extract the bag from the bath and submerge it in the ice bath to cool for 10 minutes.

5) Once cool, strain the liqueur and store in a glass jar in the refrigerator for up to 6 months.[7]

6 Easily acquired from brewer supply sites on the webs.

7 I'll be honest, I'm saying 6 months not because that's as long as it will keep; it's just how long I've managed to go without drinking it all. It might last forever, as far as I know.

MARGARITA 2.0

YIELD:
1 drink

Reason for Reload: As mentioned in the section regarding orange liqueur, folks basically dissed the original application because, well . . . it wasn't a margarita. Fine. Drink this, then come at me.

SOFTWARE

2 ounces blanco tequila

2 ounces AB's Orange Liqueur (page 409)

½ ounce fresh lime juice

½ ounce agave or simple syrup (optional)[8]

Ice

Kosher salt to rim the glass, if desired

Although I'm a tequila fan, darn fine margaritas can be made with white rum or even vodka. And yes... even gin.

PROCEDURE

1) Combine the tequila, orange liqueur, lime juice, and agave syrup (if using) with at least 1 cup ice in a cocktail shaker and shake until thoroughly chilled, about 20 shakes.

2) Strain into a cocktail glass (lightly rimmed with salt, if desired).

RIMMING A GLASS

Take two short deli containers, or other vessels 4 inches across and at least ½ inch deep. Fold a single sheet of paper towel into quarters and place in one of the containers. Pour in enough water to thoroughly saturate the towel. Add enough kosher salt to the second container so that it's evenly ¼ inch deep. Invert your first glass and press the rim down into the wet towel to moisten, then press down into the salt. Pull straight up and you should have a perfect rim of salt.

By the way, I've been known to lace my salt from time to time with a small amount of ground dried chipotle chile.

1) Rub glass rim on a folded paper towel soaked with H₂O.

2) Rub damp rim in shallow dish of kosher salt (or salt and seasoning)

3) Invert, fill, enjoy.

8 Be forewarned, I am not a fan of sweet drinks, and my take on liqueur is strong and fairly bitter. If you prefer a slightly sweeter drink, go with the agave or simple syrup.

ROMANCING THE BIRD:
RELOADED

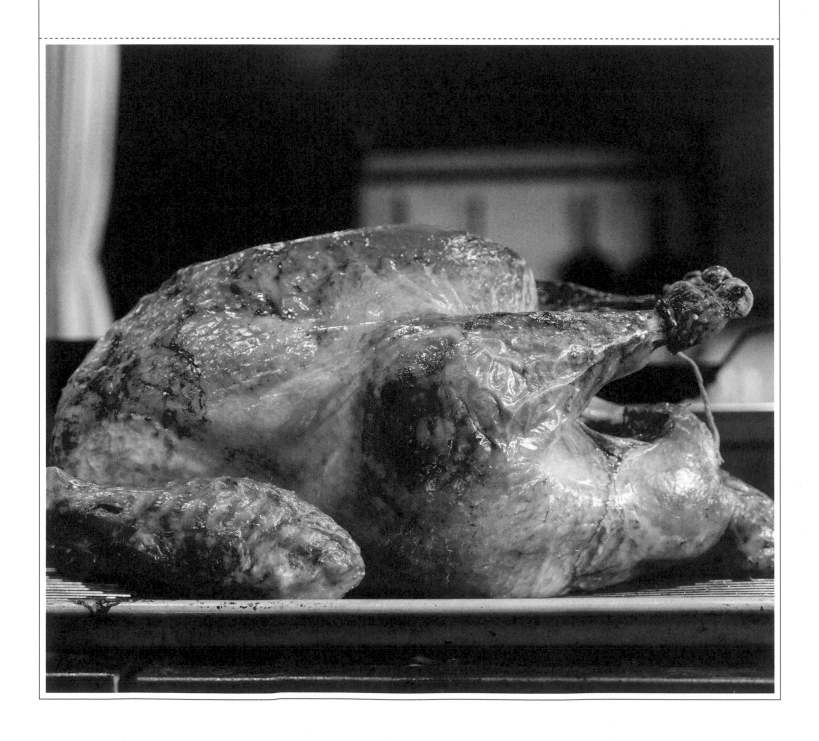

THE REALLY FINAL TURKEY, WITH GRAVY

YIELD:
10 to 12 servings

Reason for Reload: It still just wasn't quite right. Now, it is. I'm done here.

SOFTWARE

1 (14- to 16-pound/6.3 to 7.3 kg) turkey[1]

6 quarts (5.7 L) hot water

284 grams (2⅓ cups) kosher salt, plus ½ teaspoon for the gravy

222 grams (1¼ cups) dark brown sugar

5 pounds (2.26 g) ice

4 medium carrots, cut to yield 400 grams ¼- to ½-inch-thick half-moons

1 medium leek, cleaned and cut to yield 225 grams ¼- to ½-inch-thick half-moons

113 grams (4 ounces) cremini mushrooms, halved

6 sprigs fresh rosemary (about 14 grams/½ ounce)

Neutral oil (safflower, sunflower, peanut) for the turkey

1 quart (907 g) unsalted chicken or turkey broth

56 grams (4 tablespoons) unsalted butter

45 grams (5 tablespoons) all-purpose flour

1 tablespoon chopped fresh thyme

1½ teaspoons apple cider vinegar

¼ teaspoon freshly ground black pepper, plus more to taste

TACTICAL HARDWARE

- A construction-site-(or sport sideline)-style beverage cooler with a spout at the bottom, in the 5-gallon range

- 2 rimmed half sheet pans with wire racks

- A probe-style digital thermometer with alarm

- A chef's knife or, better yet, an electric knife for carving

PROCEDURE

1) The night before cooking, brine the bird: Combine the hot water, salt, and brown sugar in a 5-gallon upright drink cooler. Stir to dissolve the salt and sugar. Add the ice and stir until the mixture is cool. (There should still be visible pieces of ice in the water.) Gently lower the turkey into the cooler, breast-end down. Weigh down if necessary to keep the bird submerged.[2] Cover the cooler and set in a cool place for 12 to 18 hours.

2) When you're ready to roast, heat the oven to 500°F and adjust the oven racks so that the turkey will fit on the rack on the second-lowest level in the oven. Spread the carrots, leek, mushrooms, and rosemary in a single layer on a half sheet pan and top with an oven-safe wire cooling rack.

3) Remove the turkey from the brine and rinse inside and out with cold water. Discard the brine and pat the bird as dry as you can with paper towels. Place the bird on the wire rack above the veg-rosemary mixture and tuck the wings underneath the bird.

4) Pre-form an aluminum shield (aka a turkey triangle) by folding a large sheet of heavy-duty aluminum foil to form a triangle. Place over the turkey breast so that the point is toward the legs. Press on the sides of the foil to form it to the breast and hold its shape. Remove and set aside

Applying the "turkey triangle"

FOIL + FOIL = FOIL

1 If you go with a frozen bird, give yourself about 4 days to thaw in the refrigerator before brining.

2 Some folks make extra brine and put it in a zip-top bag for this; I have a length of plastic-coated marine chain that does the same thing.

THE REALLY FINAL TURKEY, WITH GRAVY (*continued*)

next to the oven for now. Brush the turkey skin lightly with oil.

5) Roast in the oven for 30 minutes. (If you have an exhaust fan, turn it on. If you don't, open a window; there will be some smoke.) Carefully remove the turkey from the oven and, working quickly, insert a probe thermometer into the thickest part of the breast, avoiding any bones. If the breast skin is already very dark, top with the turkey triangle. If it is golden brown, don't add the turkey triangle, but keep an eye on the skin and add it if it is getting too dark.[3]

6) Return the turkey to the oven and reduce the oven temperature to 350°F. Set an alarm on the probe to go off at 155°F. A 14-pound turkey should take an additional 1½ to 2 hours, but the temperature of the meat is more important than the time it takes to get there, so keep an eye on the thermometer.

7) When the alarm goes off, transfer the turkey to a second cooling rack set on a second half sheet pan and leave the bird to rest for 45 minutes before transferring to a cutting board for carving.

8) Meanwhile, make the gravy: Remove the wire rack from the roasting pan and put the rack in the sink. Use a metal spatula to scrape up all of the vegetables and drippings from the bottom of the pan, and transfer to a 4-quart saucepan or saucier. (If the sheet pan is dry, pour in enough of the broth to coat the bottom of the sheet pan, then place over medium-high heat and bring the broth to a simmer. Use a wooden spoon or spatula to dislodge the turkey drippings from the bottom of the sheet pan. You'll need to rotate the pan around on the heat—use an oven mitt—as you go. Carefully pour into the saucepan.)

9) Add the rest of the broth to the saucepan, place over medium-high heat, and bring to a simmer. Reduce the heat to medium-low and hold the simmer until the broth is flavorful, about 10 minutes.

10) Strain the broth through a fine-mesh sieve set over a large heatproof measuring cup or bowl, pressing on the solids to extract as much liquid as possible. Discard the solids. Remove most of the fat using a ladle or fat separator. Measure out 4 cups of the fortified stock, saving any remainder for another use. Wipe out the saucepan.

11) Add the butter to the now-empty saucepan and return to medium heat to melt. Once the butter has melted, briskly whisk in the flour, followed by the thyme. Continue whisking until the flour and fat (the "roux") lighten in color and foam, about 1 minute. Then, still whisking, slowly pour in the 4 cups fortified broth. Bring to a simmer, then reduce the heat to medium-low and continue to cook, whisking frequently, until thickened, about 7 minutes. Remove from the heat and stir in the vinegar and pepper. Taste and season with additional pepper and/or salt. Serve with the turkey.[4]

NOTE

When it comes to carving turkey, I'm a huge fan of electric carving knives, whose reciprocating blades make quick work of the bird while minimizing tearing.

3 There are a lot of factors at play when it comes to browning, including the exact size of the turkey, the composition of the turkey, and the exact size of the oven cavity.

4 Since flour-based gravies thicken as they cool, I always skip the gravy boat and keep mine sealed in a Thermos.

	YIELD:
# SWEET CORN BREAD PUDDING: RELOADED	6 to 8 servings

Reason for Reload: The canned creamed corn called for in the original application has always bothered me. First, there's no standardization among brands, other than that they all taste like crap. I only used the stuff because I felt I needed something relatively quick to make up for all the work I was asking people to do in regards to the turkey. Well, now it's frozen corn, which is a step in the right direction, and the sweetness comes from molasses, which also brings its particular funk . . . though not too much of it. A few other nips and tucks make this a far, far better side.

SOFTWARE

2 cups (265 g) frozen yellow corn[1]

1 cup (230 g) heavy cream

½ cup (75 g) stone-ground yellow cornmeal

½ cup (40 g) freshly grated Parmesan cheese

2 large eggs, lightly beaten

20 grams (1 tablespoon) molasses[2]

1 teaspoon (4 g) baking powder

¼ teaspoon (1 g) baking soda

2 teaspoons (5 g) kosher salt

1½ teaspoons (3 g) freshly ground black pepper

4 slices (165 g) white sandwich bread, cut into 1-inch pieces

4 tablespoons (60 g) unsalted butter

½ large (160 g) onion, finely chopped

2 teaspoons finely minced fresh rosemary

TACTICAL HARDWARE

- A food processor with chopping blade
- A 10-inch cast-iron skillet

1 The stuff that comes loose in bags is "individual quick frozen," or IQF, and is to my mind a better product than the stuff that comes frozen in blocks. Easier to measure out, too.

2 I strongly recommend that you weigh this into a small plunger-style measuring cup, because the stuff is just ridiculously sticky. Or, you can weigh the cream, then zero out the scale and weigh the molasses into the cream . . . Seriously, it's sticky.

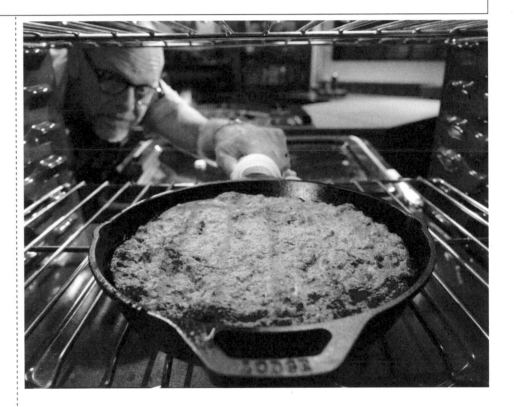

PROCEDURE

1) Heat the oven to 350°F.

2) Put 1½ cups (208 g) of the corn in a food processor and process until the corn is somewhat smooth, about 45 seconds. Transfer to a large bowl along with the remaining ½ cup (57 g) corn, the cream, cornmeal, cheese, eggs, molasses, baking powder, baking soda, salt, and pepper. Stir to thoroughly combine, then stir in the bread until evenly coated with the batter. Set aside for 10 minutes.

3) Meanwhile, melt the butter in the skillet over medium-low heat. Add the onion and rosemary and cook, stirring occasionally, until softened but not browned, 5 to 7 minutes. Dump the onion mixture into the batter and stir to evenly combine.

4) Pour the batter into the skillet and smooth the top, then transfer to the oven. Bake until brown and set (190°F), about 40 minutes. Cool for 10 minutes before serving.

CRANBERRY APEROL COCKTAIL

YIELD:
1 cocktail

Reason for Reload: Although the show is a reload, the recipe is new. I always kinda felt bad for not including a cocktail in the original, because, after all, Thanksgiving is a family holiday and that means stress and let's face it, alcohol helps. This drink is fairly low in alcohol by volume, so hopefully it can assuage frayed feelings without fueling feuds. The software list is all stuff you're likely to have around at Thanksgiving anyway.

SOFTWARE

1 large fresh rosemary sprig, for garnish

¼ cup (about 25 g) fresh or frozen cranberries (yes, more cranberries!)

1 ounce Cranberry Syrup (opposite)

2 ounces Aperol

5 dashes walnut bitters

3 ounces club soda

Ice cubes

TACTICAL HARDWARE

- A cocktail shaker
- A cocktail strainer
- A muddler[3]

PROCEDURE

1) To make the garnish, strip the leaves off the bottom 3 inches of the rosemary sprig. Poke holes through the center of 3 of the cranberries with a toothpick and then thread the cranberries onto the bottom of the rosemary sprig.[4]

2) Put the remaining cranberries in the bottom of a cocktail shaker.[5] Add the syrup and muddle until the cranberries are broken up into small pieces. Add the Aperol and bitters, then fill the shaker with ice. Cover and shake aggressively until the shaker is very cold, about 30 seconds.

3) Strain into an ice-filled highball or Collins glass and top with the club soda. Place the cranberry-rosemary garnish in the glass with the rosemary sticking out. Use a match or a blowtorch to light the end of the rosemary on fire to create a little smoke. Blow out any flames before serving.[6]

NOTE

Since this only makes 1 cocktail, which isn't going to be nearly enough, I suggest the next round you just shake 2 jiggers vodka with 1 jigger syrup . . . and strain into a cocktail glass. Garnish with a cranberry, not.

Although Campari is usually my bitter aperitif of choice, the sweeter, softer flavor of Aperol provides a better balance to cranberries.

3 It's like a little baseball bat used for crushing things in a cocktail glass or shaker. You can use a piece of wooden dowel or the end of a French-style rolling pin.

4 I suggest you do this before you do any drinking, as this gets tricky as blood alcohol levels rise. Or better yet, make the kids do it.

5 If you're making multiple drinks, I wouldn't try to turn out more than two at a time.

6 I know . . . I can't believe I'm suggesting you go to such theatrical lengths, but it really does smell good and the char does season the drink. Consider it an optional step.

CRANBERRY SYRUP

SOFTWARE

2 cups (about 186 g) fresh or frozen cranberries

200 grams (1 cup) sugar

1 cup (235 ml) water

35 grams peeled fresh ginger (about a 2-by-1-inch piece, peeled), sliced into ¼-inch rounds

1 (2- to 2½-inch) cinnamon stick

4 whole allspice berries

½ teaspoon (2 g) black peppercorns, coarsely cracked with a mortar and pestle

1 (3-inch) fresh rosemary sprig, bruised with mortar and pestle

TACTICAL HARDWARE

- A fine-mesh sieve
- A squeeze bottle

PROCEDURE

1) Combine the cranberries with the sugar, water, ginger, cinnamon, allspice, and peppercorns in a medium saucepan. Place over low heat and bring to a bare simmer, 180°F to 190°F, about 20 minutes. Keep cooking, stirring often, until the cranberries are very soft, about 20 more minutes.

2) Kill the heat, add the bruised rosemary, steep for 5 minutes, then strain through a fine-mesh sieve set over a 4-cup glass measuring cup. Press on the cranberries to get out all of their juices. Discard the solids.

3) Place the measuring cup in a large bowl filled with ice, and stir the syrup until it cools to room temperature, about 15 minutes. Transfer to a squeeze bottle and refrigerate until ready to use. (The syrup will keep for up to 1 month in the fridge.)

THANKSGIVING POT PIE

YIELD:
6 servings

Reason for Reload: So, this dish is not a reload, more like a consolidation. It is, in essence, an entire Thanksgiving dinner . . . in a pie, making it perfect for traveling over the river and through the woods to wherever you want your Thanksgiving to be. The only problem is that if you want pie for dessert, that's another pie; I haven't figured out how to get the entrée and sweet pies together under one crust.

Reminder: If grams are listed for a piece of produce, say an onion, then that doesn't indicate the weight of the whole onion but rather the amount you need after you've cut it. But to be honest, none of these amounts needs to be that exact. Since we weigh pretty much everything around here, we're providing the data.

Oh, and yes . . . there are 14 steps in this application; it's a bit of a project, but it's an entire meal, dammit!

Recent archeological finds suggest that participants at the first Thanksgiving did actually wear elastic-waist pants.

SOFTWARE

5 slices (about 245 g) hearty white bread, cut into ½-inch cubes

9 tablespoons (128 g) unsalted butter, divided

1 medium onion, diced (200 g/1½ cups), divided

4 medium stalks celery, cut into ¼-inch pieces (200 g/2 cups), divided

½ teaspoon dried thyme

1 teaspoon dried rubbed sage

2 tablespoons plus ½ teaspoon kosher salt (20 g), divided

2 teaspoons freshly ground black pepper, divided

2¾ cups (650 ml) unsalted chicken broth or stock[7]

1 large egg, whisked with 1 cup of the broth or stock listed above; plus 1 egg yolk (for the mashed potatoes)

2 tablespoons (25 g) vegetable (or other neutral) oil

12 ounces (340 g) turkey meat, any combination of breast and thigh meat, cut to ½-inch cubes

4 ounces (115 g) cremini mushrooms, thinly sliced

1 medium carrot, peeled and cut into ¼-inch rounds (60 g)

1 clove garlic, minced (4 g)

2 teaspoons (2.5 g) chopped fresh sage

1 teaspoon chopped fresh thyme

35 grams (¼ cup) all-purpose flour

3 fluid ounces (85 ml) dry white wine

¾ cup (180 ml) milk (anything but skim), at room temperature

4 ounces (112 g) frozen peas

3 medium russet potatoes (1½ pounds/680 g), peeled and cut into ½-inch dice

½ cup (60 g) half-and-half

TACTICAL HARDWARE

- 2 (9-inch) deep-dish pie pans
- Parchment paper
- A heavy 11-inch skillet (cast iron would be fine)
- An electric hand mixer

PROCEDURE

THE DRESSING LEVEL

1) Position a rack in the middle of the oven and heat to 400°F.

2) Place the bread cubes on a half sheet pan and bake until dried out, about 8 minutes. Transfer to a large bowl.

3) Heat the skillet over medium heat for about 3 minutes. Add 2 tablespoons of the butter and cook until foamy. Follow with ¾ cup of the diced onion, 1 cup of the diced celery, the dried thyme, rubbed sage, 1 teaspoon of the salt, and ½ teaspoon of the pepper. Cook, stirring occasionally, until soft and fragrant, about 5 minutes.

4) Add ¼ cup of the stock to deglaze the pan and cook for 30 seconds. Transfer to the bowl with the bread cubes, then stir in the egg-broth mixture.

5) Lightly lube one of the pie pans with nonstick spray. Cut a 12-inch square of parchment paper and lube one side of it as well. Pour the stuffing mixture into the pan and top with the parchment, lube side down. Press

7 This will be added at different points of cooking and doesn't need to be too precise, so I just keep it all in a measuring cup by the cooktop so I can add as needed.

THANKSGIVING POT PIE (*continued*)

down on the parchment with your hands to evenly distribute the mixture around the pan and level the top. Place the second pie pan on top of the parchment and press firmly down so that some of the mixture comes up the sides of the bottom pan.

6) Place the stacked pie pans (still with the parchment between) on the middle rack of the oven and bake for 30 minutes. Carefully remove the top pan and the parchment and bake until golden brown and crisp on the edges, 5 to 8 minutes.

THE TURKEY AND VEG LEVEL

7) Meanwhile, add 1 tablespoon of the oil into your now-clean skillet and place over medium-high heat. When the oil shimmers, add the turkey, season with 2 teaspoons of the salt, and cook, turning occasionally, until the turkey starts to brown, and brown bits have started to stick to the bottom of your pan, about 5 minutes. Remove the turkey from the skillet and set aside in a medium bowl.

8) Lower the heat to medium and add the remaining 1 tablespoon oil to the skillet; heat until it shimmers. Stir in the remaining ¾ cup of the onion, the remaining 1 cup celery, the mushrooms, carrot, garlic, 1 teaspoon salt, 1 teaspoon pepper, as well as the fresh sage and thyme. Cook, stirring occasionally, until the vegetables have softened, 5 to 6 minutes.

9) Stir in 2 tablespoons of the butter, and as soon as it's melted sprinkle the flour evenly over all, stir in, and cook for 1 minute. Add the wine to deglaze, scraping the bottom of the pan until it is almost dry, then gradually stir in the remaining

1½ cups stock and the milk. Bring to a simmer, stirring constantly, until the sauce thickens, about 2 minutes. Remove from the heat, stir in the peas and the turkey, and set aside.

THE MASHED POTATO LEVEL

10) Cover the potatoes with cold water in a medium saucepan and season with 2 teaspoons of the salt.[8] Bring to a simmer over high heat but drop to maintain a simmer as soon as bubbles break the surface. Cook until tender, 10 to 15 minutes.[9]

11) Meanwhile, combine the half-and-half, 4 tablespoons of the butter, the last ½ teaspoon salt, and ¼ teaspoon pepper in a microwave-safe container and nuke until the butter has melted, 30 to 45 seconds depending on your microwave.

12) Drain the potatoes and return them to the saucepan over low heat. Mix the potatoes using a hand mixer set to low until they're just smooth, 30 seconds, then add the hot half-and-half mixture and mix just long enough to combine. Finish by stirring in the egg yolk.[10]

PUTTING IT TOGETHER

13) Pour the turkey filling into the stuffing crust, top with the potatoes, and gently spread them to cover the filling using a rubber spatula. Melt the final 1 tablespoon butter. (I usually do this in a metal measuring cup right on the cooktop.) Brush the butter evenly onto the top of the pie.

14) Bake on the center rack in the oven until the filling is bubbly and the potatoes have started to brown on top, 25 minutes. Let rest for 10 minutes before slicing and enjoying.

8 This can be set up hours early and kept in the fridge.

9 I try to never boil potatoes, as they tend to blow apart and waterlog.

10 The yolk will help the mashers to set a bit and brown.

FINAL THOUGHTS

I didn't set out to be a cook, and certainly not a chef. I was a frustrated commercial director/cameraman who wanted to tell stories. *Good Eats* became the vehicle for that ambition, and I feel incredibly fortunate to have found an audience for the stories. In the process, I think I've actually become a decent cook, which is nice because I'm usually hungry. I even feel I can offer some sage advice for those wishing to undertake culinary projects:

Never bring a knife to a scissor fight.

Make friends of your scale and your thermometer. Use them often.

If you want to learn to cook, start with eggs.

Read before you cook.

Buy your spices whole whenever you can, and grind before use.

Food can sense fear better than a dog.

There are a lot of bad recipes out there.

People like good cooks, but they like good dishwashers better.

Martinis are food.

Avoid unitaskers at all costs.

If cooking isn't fun, you're doing it wrong.

I would tell you what's next, but that's another show.

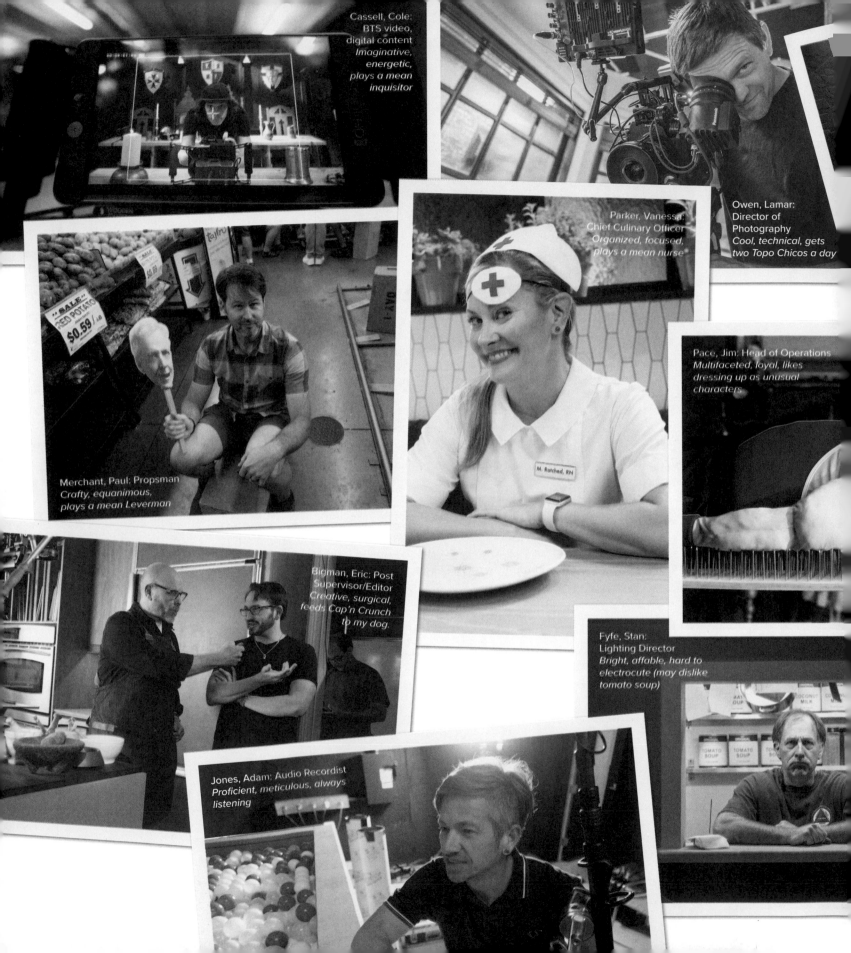

Cassell, Cole: BTS video, digital content
Imaginative, energetic, plays a mean inquisitor

Owen, Lamar: Director of Photography
Cool, technical, gets two Topo Chicos a day

Parker, Vanessa: Chief Culinary Officer
Organized, focused, plays a mean nurse

M. Ratched, RN

Pace, Jim: Head of Operations
Multifaceted, loyal, likes dressing up as unusual characters

Merchant, Paul: Propsman
Crafty, equanimous, plays a mean Leverman

Bigman, Eric: Post Supervisor/Editor
Creative, surgical, feeds Cap'n Crunch to my dog.

Fyfe, Stan: Lighting Director
Bright, affable, hard to electrocute (may dislike tomato soup)

Jones, Adam: Audio Recordist
Proficient, meticulous, always listening

Caperton, Stephanie: Script Supervisor
Sassy, omnipresent, good with highlighters

Bailey, Todd:
Set Producer,
erstwhile propsman
Jovial, efficient,
excellent with
a rivet gun
(not his real hair)

ACKNOWLEDGMENTS

Sincere thanks go to Michael Sand and his crew at Abrams; everyone at BrainFood Industries, especially Jim Pace and Lynne Calamia; Dr. Arielle Johnson for keeping me from committing egregious scientific sins; my literary agent, Eric Simonoff; and my most excellent attorney, Joel Behr. Finally, special thanks and gratitude go to Elizabeth Ingram, whose design work helped to define the look and feel of the final *Good Eats* seasons, as well as the pile of paper you're now holding. She has also tolerated a fair amount of wretched behavior from me during these endeavors.

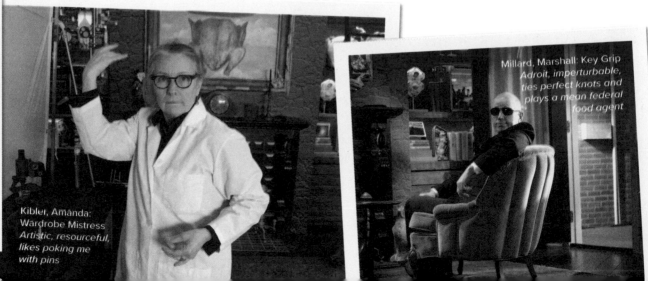

Kibler, Amanda:
Wardrobe Mistress
Artistic, resourceful,
likes poking me
with pins

Millard, Marshall: Key Grip
Adroit, imperturbable,
ties perfect knots and
plays a mean federal
food agent

INDEX